DEEP INSIDE THE BLUES

American Made Music Series

ADVISORY BOARD

David Evans, General Editor
Barry Jean Ancelet
Edward A. Berlin
Joyce J. Bolden
Rob Bowman
Curtis Ellison
William Ferris
John Edward Hasse
Kip Lornell
Bill Malone
Eddie S. Meadows
Manuel H. Peña
Wayne D. Shirley
Robert Walser

DEEP INSIDE THE BLUES

PHOTOGRAPHS AND INTERVIEWS

MARGO COOPER

FOREWORD BY WILLIAM R. FERRIS

UNIVERSITY PRESS OF MISSISSIPPI / JACKSON

Publication of this book was supported in part by the Jane Hiatt Fund for Books in the Arts and Humanities, in honor of Dr. Wood Hiatt.

The University Press of Mississippi is the scholarly publishing agency of the Mississippi Institutions of Higher Learning: Alcorn State University, Delta State University, Jackson State University, Mississippi State University, Mississippi University for Women, Mississippi Valley State University, University of Mississippi, and University of Southern Mississippi.

www.upress.state.ms.us

The University Press of Mississippi is a member of the Association of University Presses.

Any discriminatory or derogatory language or hate speech regarding race, ethnicity, religion, sex, gender, class, national origin, age, or disability that has been retained or appears in elided form is in no way an endorsement of the use of such language outside a scholarly context.

Text and photographs copyright © 2023 by Margo Cooper
Foreword © 2023 by William R. Ferris
All rights reserved
Manufactured in China

First printing 2023

∞

Library of Congress Cataloging-in-Publication Data

Names: Cooper, Margo (Photographer), author. | Ferris, William R., writer of foreword.
Title: Deep inside the blues : photographs and interviews / Margo Cooper ; foreword by William R. Ferris.
Other titles: American made music series.
Description: Jackson : University Press of Mississippi, 2023. | Series: American made music series | Includes bibliographical references and index.
Identifiers: LCCN 2023017022 (print) | LCCN 2023017023 (ebook) | ISBN 9781496847416 (hardcover) | ISBN 9781496847423 (epub) | ISBN 9781496847430 (epub) | ISBN 9781496847447 (pdf) | ISBN 9781496847454 (pdf)
Subjects: LCSH: Blues musicians—Mississippi—Portraits. | Blues musicians—Mississippi—Interviews. | Blues (Music)—Mississippi—History and criticism.
Classification: LCC ML3521 .C57 2023 (print) | LCC ML3521 (ebook) | DDC 782.421643092/2—dc23/eng/20230607
LC record available at https://lccn.loc.gov/2023017022
LC ebook record available at https://lccn.loc.gov/2023017023

British Library Cataloging-in-Publication Data available

Dedicated to my parents

Ronna and Harold Cooper

Contents

Foreword by William Ferris IX
Preface XVI

PART I. CHICAGO CALLED

1. Willie "Big Eyes" Smith 2
2. Kenny "Beedy Eyes" Smith 25
3. Calvin "Fuzz" Jones 28
4. Luther "Guitar Junior" Johnson 45

PART II. THE DELTA

5. Sam Carr 67
6. Robert "Bilbo" Walker 84
7. James "Super Chikan" Johnson 109
8. Joshua "Razorblade" Stewart 124
9. Betty Vaughn 137
10. Joe Cole 140
11. Irene "Ma Rene" Williams 145
12. David Lee Durham 148
13. "Cadillac John" Nolden 151
14. Bill Abel 160
15. Monroe Jones 163
16. "T-Model" Ford 165
17. Eddie Cusic 174
18. "Farmer John" (John Horton Jr.) 186
19. Mary Shepard • Club Ebony 192
20. Eden Brent 194
21. "Mississippi Slim" (Walter Horn Jr.) 198
22. Mickey Rogers 205

PART III. BEYOND THE DELTA

23. L. C. Ulmer 219
24. Willie King 239
25. Jimmy "Duck" Holmes 240
26. Bud Spires 242

PART IV. HILL COUNTRY

27. Remembering Otha Turner 247
28. Abe "Keg" Young 259
29. Calvin Jackson 263
30. Earl "Little Joe" Ayers 271
31. Kenny Brown 281
32. Garry Burnside 286
33. Cedric Burnside 294

Acknowledgments 309
Notes 311
Index 335

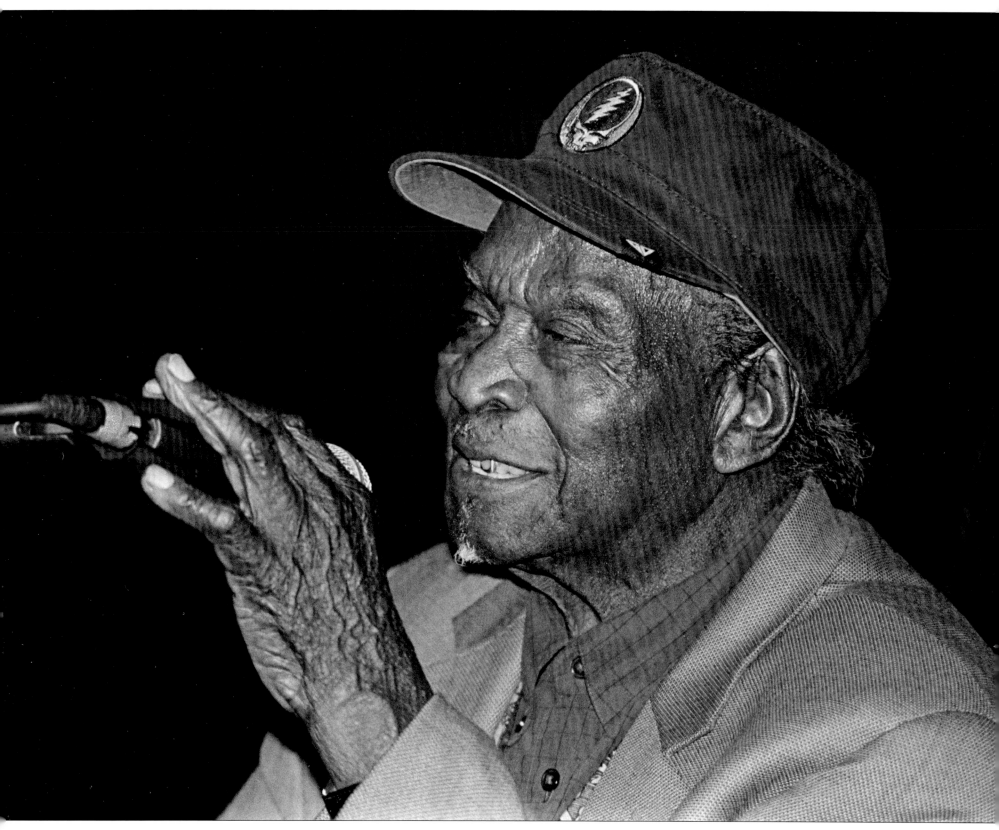

Honeyboy Edwards, King Biscuit Blues Festival, Helena, Arkansas, October 2005

The Old Home Place, the Delta, March 2000

Foreword

The publication of Margo Cooper's *Deep Inside the Blues* is a major contribution to how we understand blues and the State of Mississippi. Her photographs and oral histories with musicians are a powerful complement to classic works like Richard Wright's *Black Boy*, Robert Palmer's *Deep Blues*, and James Cobb's *The Most Southern Place on Earth*. Cooper carries us into the heart of the music as performers describe the bleak conditions they faced and how music helped them survive. She features musicians from different regions of Mississippi—including the Delta, the Piney Woods, and the Hill Country—and the Delta of Arkansas. While Delta blues artists are widely recognized for their musical legacy, Cooper positions them alongside performers throughout the state. Each region of Mississippi produced its own style of blues, and performers proudly claim that region as their home.

These interviews carry us beyond the flattened blues stereotype as musicians describe their journeys through rich, creative worlds defined by music and travel. On the road and at home, they bond together over meals they cook and share as a blues family. Black creativity, intellect, and joy are on full display as they master the blues and perform for their admiring audience.

Margo Cooper listened carefully as musicians spoke candidly about their lives, racism, violence, food, and music. Musicians relate their journeys from rural Mississippi communities and towns to the streets of Chicago, and to concerts around the nation and overseas. For all these speakers, Mississippi hovers like a cloud above their lives. Many who leave the state for musical careers in Chicago returned to Mississippi to live, to perform, and to be buried in small churchyards in the communities where they were born. The most famous of all, B.B. King, is buried on the grounds of the B.B. King Museum in Indianola, where his life and the generations of performers who aspired to his success are showcased.

These interviews deftly unlock and reveal the soul of a people and their music. Their voices have hypnotic power as they speak. Cooper focused on their rich language in her interviews and tried to capture "not only the exact content of what the musicians had to say, but the way they said it, their emotions, the rhythm of their speech, which was its own music. I began to see the possibilities of a deeper kind of blues story." She views their stories as "part of our national heritage. For me, remembering is sacred, a duty."

Cooper embraced blues from the moment she heard the music, later through photographs she took of musicians. Then she decided to pursue the question, "*What are the stories behind the music?*" and recorded interviews with them. These interviews reveal the trust and respect musicians felt for her as they speak eloquently about their childhoods, lives, and music. The interviews take us to the birthplace of blues, the plantation with its grim face of poverty, violence, and survival through music—blues and gospel. Many of these musicians were born on plantations that shaped their lives and music in enduring ways.

Harmonica player and drummer Willie "Big Eyes" Smith was born on Dr. Ryder's Plantation in Phillips County outside Helena, Arkansas, in 1936. While picking cotton he dreamed about doing "anything but what I was doing." Smith went to school on the plantation, only January to May, "when there was no work to do. . . . Just Black kids went there. White kids had their own schools. . . . The white kids got all new buses. . . . We got the books that somebody else had." In Helena, "everything was segregated."

It was in Helena that Smith first heard Muddy Waters and Robert Nighthawk on the radio. Smith declares, "You can't imagine how excited I was. . . . I also knew that I wanted to play music." Smith saw Sonny Boy Williamson, Robert Junior Lockwood, and Pinetop Perkins at the Miller Theatre. He heard Arthur "Big Boy" Crudup on the Seeburg. Smith informs Cooper, "Back then Arthur was the big man. I was always crazy about his music. . . . Kids was crazy about the blues at that time."

Many of the musicians whom Cooper interviewed mention the murder of Emmett Till as a pivotal moment in their lives. Smith recalls, "I went to the funeral home in Chicago and seen him in the open coffin. . . . You've seen the pictures with his face, right? But I'm looking at it with my natural eyes. I was only eighteen years old. I was mad as hell. Damn right! That was really the beginning of the civil rights movement. If you was Black, you was involved in it one way or another. Everybody had a role that had to be played."

Calvin "Fuzz" Jones tells Cooper that he "was born on a plantation around Money, Mississippi, on June 9, 1926. . . . I didn't go to school too much because I had to work in the fields. You don't get through farming 'til just about Christmas. After Christmas, maybe I'd go to school two to three months. In March, you start back working in the fields. . . . The school was in a little old church. It was just for the farm kids, for Blacks only. . . . You were taught white folks had their ways and you had your ways. They went to their schools and churches and you went to yours. . . . They go to their street, and you go to your street. That's the way it was."

"Our house had fifteen acres of land to sharecrop, a barn and a lot to keep the mules. You didn't get no pay. You just worked. That was it. . . . My parents raised a garden wherever we lived. . . . The feedlot sat right by the river. While the mules were eating we'd go down and swim—that's the Tallahatchie, the same river where they dumped Emmett Till's body."

Luther "Guitar Junior" Johnson's parents were also sharecroppers. For Johnson and his family, "A day in the field was hard." The family worked from "sun to sun."

Music brought Johnson excitement and joy. He led the church choir for three or four years as a teenager. He "felt good singing. Everybody was happy." Johnson tells Cooper, "I always loved music, but the blues is what really struck me." Johnson enjoyed watching his uncle Arthur play guitar at the Saturday night fish fries. And when Johnson saw Muddy Waters and his band rehearse at the home of Jimmy Roger's mother, he thought "what they were doing was great; to come from Chicago to the country to play at a juke house. . . . I used to dream about Chicago all the time."

Sam Carr started out playing the harmonica. He learned by listening to records and tried to play the Sonny Boy songs he heard. Carr distinctly recalls the time he heard someone cover Robert Johnson's "Terraplane Blues": "That was something I never got out of my brain."

Carr's father was the bluesman Robert Nighthawk. Carr advises Cooper, "Robert had a good reputation in Mississippi. . . . For guitar playing he was the greatest." Bluesmen were known for their stylish dress. Carr remembers his father as a guitarist who "dressed neat, clean cut. Robert wore jitterbug pants—blousy pants that got tight around the ankle, and keen toe shoes. He always wore a long-sleeved plaid shirt and a brown hat. When Carr heard his father play on a radio show in Helena, he thought his father "was just like the president."

Robert Bilbo Walker recalls the country blues scene outside towns where musicians played "in people's houses. The people stayed all night long into the next day. Musicians would go from one house to another, playing for them old country jukes. They would sit in a chair, and someone would bring their beer and whiskey. They'd play the drum with their foot on the floor. Peoples didn't have to play but two songs to be a good musician. They played them songs over and over. Sometimes they would play the same song

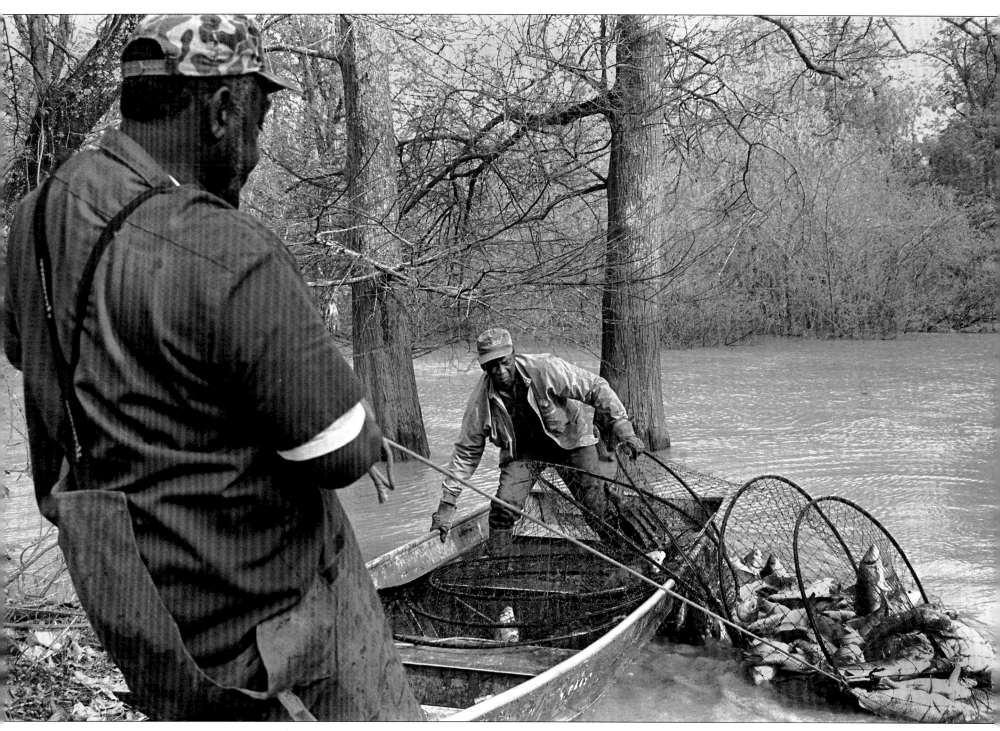
Sam Carr and his neighbor Albert, Moon Lake, Mississippi, April 1999

for an hour without stopping, just stomping, playing and hollering that one song—'Baby Please Don't Go,' 'Roll and Tumble Blues,' and 'Crawling King Snake.'"

Walker aspired to be a successful gospel singer and "prayed from morning 'til night, asking the Lord to give me a good voice. And He did! I'd say, 'Please God, *please God*.' . . . Finally one day, I'll never forget. We were picking cotton on the Borden Plantation. I was out there singing. Daddy, my Mama, and my sister was up front. . . . Daddy stopped to see what I'm doing. He getting him a stalk ready to come back and whup the heck out of me. But then Daddy heard me singing. He told Mama, 'Listen, *listen!*' Mama stopped. My sister, she stopped. Daddy said, 'When did you learn to sing like this?' My sister say, 'He be trying to sing every day.' Daddy said, 'No, he ain't *trying* to sing now, that boy *singin'*!'" That moment launched Walker's gospel, and later blues career. Music liberated him from "slave time" bondage where he planted, cultivated, and harvested cotton on plantations.

Every musician in this book vividly recalls a similar moment. Willie Smith, Calvin Jones, and Luther Johnson went on to have memorable careers with Muddy Waters. When they left Muddy, Smith and Johnson fronted their own bands.

James "Super Chikan" Johnson endured an austere life as a child when his family of twenty-two people lived in one shotgun house. Children worked alongside adults in the cotton fields of the plantation where Johnson lived. "It was a hard time but being a kid you looked forward to going to work for fifty cents for a hundred pounds of cotton so you could have some money. Money was very important. No money means no food, no clothes. What little we got we did the best we could with it. As far as I'm concerned, sharecropping is still slavery."

Johnson's grandmother relied heavily on her garden and game killed to feed her family. "Sometimes we only had enough money to buy a bag of flour. Then we would go pick poke sallet or wild greens. We'd get a rabbit or a squirrel or something to add a meat flavor to it and make a big pot of gravy. Then you use the bread to soak up the gravy.

Betty Vaughn grew up in Jonestown, Mississippi, in the 1930s at a time when "Black children weren't allowed to go to the white schools." She heard about people being lynched. When she left for Chicago to find a better job away from the cotton fields, "Black people couldn't vote."

Years later Vaughn came back to Jonestown. She opened a restaurant called Betty's Café. Vaughn describes the scene to Cooper. "On Friday and Saturday nights I played some blues and some gospel records—for the older people. Mahalia Jackson, Al Green, B.B. King, and Little Milton were favorites. I cooked soul food—fried chicken, greens, peas, and ribs, you name it." Oh yes, I cooked catfish, buffalo fish, chitlins, French fries, the food of the day."

As a child, "Cadillac John" Nolden grew up on two plantations. His parents were sharecroppers. Nolden recalls, "We all worked in the fields. The men would be singing and hollering. They'd be singing blues. I started off as a water boy. The boss man hired me when I was about eight. It get hot. The people would sing, '*Water boy, Water boy. Bring your water 'round. Don't like your job, set your bucket down.*'" For Nolden, "Blues comes out of my life experience: the hard times, the lonely times, the poor times."

Mickey Rogers, like Emmett Till, traveled from Chicago to visit his family in Mississippi during the summer of 1955. "I was there that same summer, visiting my mother and grandmother when Emmett got killed. My mother and grandmother told me how prejudice went down. They said Emmett whistled at a white lady. I asked, 'Why did they kill him?' They said, 'That's what they killed him for.' 'Just for whistling?—you can kill somebody for *that*?'"

As an adult, Rogers reflected on the meaning of blues in his life. "The blues come from Mississippi—out of hard labor. Work all day long from sunup to sundown and you ain't got a dollar when the day's over. You ain't made nothing but make yourself tired. By the time you lay down and take a nap you got to get up and get tired again. End of the year, you still ain't made nothing. If you look at the real side, you ain't did nothing for yourself but survived. It's a blessing to be survived. So, we couldn't do nothing but sing the blues."

Po' Monkey's exterior, Merigold, Mississippi, March 2000

L. C. Ulmer was born in Stringer, Mississippi, in the Piney Woods, and he notes with pride, "Wasn't none of them plantations down here; they was in the Delta. . . . My granddaddy Ulmer didn't sharecrop; he had his own land. . . . He was a big strong man, taller than a door. He carried his cotton to the gin by horse and wagon."

Ulmer's father played music for breakdowns at the Saturday night fish fry where "they fried fish in the same big old wash pot that they wash the clothes in. They take that fish and throw 'em in there. That grease be hopping up out of the pot. They go down and come up, ready, soft. You pick it up it's falling off the bone. . . .

"The white folks would be there at the breakdown to get their fish sandwich and see the Black folks dance. You'd hear them say, 'We going to the colored dance tonight.' Yeah, they dance, too—when you play that old banjo and that old mandolin.

"Sometimes it would be white and Black together playing. One had the banjo, one had the guitar, and one had the fiddle. You sit and wait your turn to play your song, take turns backing each other up. I was little but I ain't forgetting. And I say, 'One day I got to do that!'"

Calvin Jackson was born in Looxahoma, nine miles east of Senatobia, Mississippi. His parents took him to fife and drum picnics in the field by L. P. Buford's store in Gravel Springs where he heard Otha Turner, Napolian Strickland, and Ed and Lonnie Young perform. Jackson recalls, "Napolian, back in them days, was just as good as he wanted to be. He had so much funk about himself. I used to love to see him blowing."

"Napolian would talk some. They'd hit the drums, start playing something like 'My Babe Don't Stand No Cheatin'.' He'd blow one long note then he'd run out from the guys. They come behind him. Then he'd turn around, walk back to them a little bit. 'Now play it to me, boys!' Ooh, it would sound so *good*. It's like a hot cup of coffee on a cold morning. It just *stimulates*. The sound gave me a rush. That definitely made me want to play drums."

Earl "Little Joe" Ayers was born further north in Benton County between the towns of Lamar and Ashland. He sang the blues as he plowed a mule. "The mules get the blues too. They would enjoy peoples singing behind their labor. You won't believe this but it's the truth. If you sing a fast song a mule will walk fast, but if you sing a slow song a mule will walk slow. The mules stepped to what you were singing the best they could."

Ayers played with Junior Kimbrough at house parties in the countryside. "You could hear the guitar playing half a mile away. You could hear peoples dancing, good timing. People get up, and here they come. They would ride horses and mules to a house party. The next thing you know you got a house full of folks. Some back there gambling by lantern, drinking whiskey, just doing everything. We're talking about Benton County. That's where the Hill Country music originated, from North Mississippi."

Cedric Burnside was raised by his grandparents Alice and R. L. Burnside—whom he called "Big Mama" and "Big Daddy." He learned to play drums from his father Calvin Jackson and was inspired by his grandfather's guitar playing.

"Big Daddy, his music would hypnotize you. Big Daddy would hold one note for one, two, or three minutes until he felt he should change it. That note would drive straight through you just like a train and put you in a trance. Big Daddy and Mr. Kimbrough's music had a rhythm that was very much their own, a very unorthodox rhythm."

These musicians eloquently describe their blues roots. Many chronicle their journey north to Chicago, and from there to venues around the nation and overseas. Beautifully woven together by Margo Cooper, *Deep Inside the Blues* is a treasure of memories and stories that clearly demonstrate how blues provided both an escape from poverty and racial violence, and a platform for creative artistic expression.

Cooper's beautiful photographs capture the faces of each speaker and the homes, neighborhoods, and landscape in which their music is set, giving the book added power. Readers will embrace this book as a unique portrait of the blues and the artists who define it.

—**WILLIAM FERRIS**
University of North Carolina at Chapel Hill

Thursday Night, Po' Monkey's, Merigold, Mississippi, March 2000

Preface

My friend Meg introduced me to the blues when we were in high school in upstate New York in the early 1970s. Our lives were far removed from the West and South sides of Chicago, the Mississippi Delta and the Hill Country of North Mississippi, yet the music moved something inside us. As I listened to the song "Messin' with the Kid" by Buddy Guy and Junior Wells, the beat and the sound of Junior's vocals and harmonica captured my attention and my heart.

But it would take another twenty years before I was able to explore the blues in a meaningful way. In the meantime, I took photography classes at college. After working several years, I decided to go to law school and chose to become a public defender. Six years later I took a break; the desire to get back to photography became compelling. In 1990 I travelled to Maine and completed a three-month course at the Photography Workshops in Rockport.

Even though I didn't expect to become a professional photographer, I was dedicated to the craft of photography. I moved to Boston in the early 1990s, established a solo law practice in New Hampshire, and took photography classes at the Art Institute of Boston with Polly Brown, a documentary photographer with a strong photojournalist background. These were the halcyon days of film and darkrooms; I honed those skills at the New England School of Photography. I enrolled in weeklong intensives at the Maine Workshops with Mary Ellen Mark and Jerry Berndt, who became a mentor and a friend, as well as my most enduring photographic influence.

New England's blues scene was thriving in the early nineties. The first House of Blues opened in Harvard Square in Cambridge in November 1992 and quickly became a hub for national blues acts. The same year, Johnny D's in Somerville received a Handy Award for "Keeping the Blues Alive" from the Blues Foundation in Memphis. Harpers Ferry was in Allston. Charlie Abel, the owner, had an annual Battle of the Blues Bands and a Blues Festival every February.

I was finding my way, listening to the music, meeting people, and learning how to photograph musicians in the clubs. That first year was a whirlwind. Chicago legends and talented local musicians were everywhere, gigging around New England weeknights and weekends.

There was an "All Star Tribute to Muddy Waters" at Harpers Ferry in April 1994 with a group of Muddy's former bandmates put together by "Big Daddy" Kinsey, to honor Muddy and tour behind Big Daddy's album, *I Am the Blues*: Willie Smith on drums, Calvin "Fuzz" Jones on bass, Pinetop Perkins on piano, Paul Oscher on harp, Luther Johnson on guitar. Jimmy Rogers was with them, and Big Daddy sang the vocals. That night I made one of my early portraits of Pinetop. A couple of weeks later I followed them up to their gig at the State Theatre in Portland, Maine, with my friend, blues pianist David Maxwell. Backstage at the theatre, I photographed the whole band together (except for Luther, who had slipped off somewhere).

David brought along a bottle of Hennessy to share with Pinetop, and they went off to one of the dressing rooms in the back of the

Shemekia Copeland, House of Blues, Cambridge, Massachusetts, March 1996

theater, which is where I found them, pouring shots, elated to be in one another's presence.

After the show, David visited Pinetop in his hotel room; the two of them sat on the edge of the bed, gleefully pretending they were at the keyboards. When Pinetop died in 2011, David wrote a very moving tribute to him on his Facebook page.

By 1994 I was contributing photographs and stories to the magazine *Blues Wire*, published by Harry Sleeper out of Bedford, Massachusetts [Blues Wire: All the Blues in New England, *first issue 1993*]. I wrote an appreciation of "Earring George" Mayweather when he died in Boston in 1995. I wrote a short review of Carey Bell's show at the Rynborn, a cool little place in Antrim, New Hampshire. I submitted photos and short articles on Robert Junior Lockwood, Smokey Wilson, Willie "Big Eyes" Smith, and one on Johnny Copeland and his daughter Shemekia. After Johnny fell ill during his performance at the House of Blues in 1996, Shemekia took the mic and finished his set without missing a beat. My first cover for *Blues Wire* was a photograph of David Maxwell at the House of Blues in Harvard Square.[1]

I first saw Luther Johnson at Harpers Ferry in 1993. He was popular and made frequent appearances at the clubs. Luther had grown up in Mississippi and migrated north to Chicago before moving

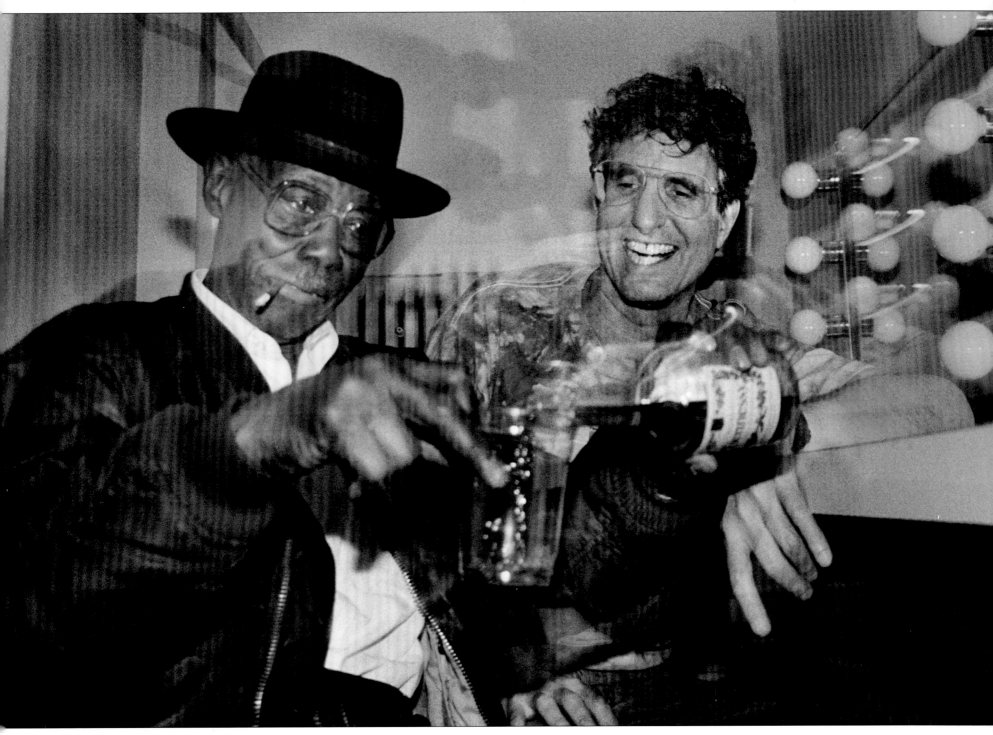

Pinetop Perkins and David Maxwell, State Theatre, Portland, Maine, April 1994

Pinetop Perkins

"The great blues pianist Pinetop Perkins brought so much joy to so many people through his playing and singing. To me, he was a lifelong 'blues father,' mentor and dear friend. What's interesting is that Pinetop died on Otis Spann's birthday. Otis initially provided me the inspiration and spark to play the blues. It was Pinetop, who lived forty-one years beyond Otis, who really showed me what it was all about—the turn of a melodic phrase, the gift of simplicity, the way to express with space and breadth, the sweetness and overall mellow quality of a slow blues, the way to vary one's touch to get that special lilt or emphasis, and most of all, how to 'dig in' with 'grease' and reach the core of what we call Deep Blues.

"Pinetop, I can see you now, just the way you did over all those years, turn to me while I was intently studying your fingers at a gig, and flash me a special twinkle in your eye indicating, 'Watch this.' Thank you, Mr. Perkins, for opening up so many hearts, mine included."

—DAVID MAXWELL, March 21, 2011

to Massachusetts in the early 1980s. Although I was interviewing other touring musicians, Luther was the only one in easy driving distance from Boston. I asked Luther if I could write his story for *Blues Wire*. Luther was then living in Antrim, New Hampshire. That's where I made the *Blues Wire* cover shot of him sitting on that motorcycle.

While we were working on Luther's *Blues Wire* story, he was scheduled to go to Chicago for a two-night record release performance of the Muddy Waters Tribute Band's album *You're Gonna Miss Me (When I'm Dead and Gone)*. This was in April 1996. I asked Luther if he would show me around Chicago. Of course, it was exciting; I'd never been to Chicago, home to so many famous blues musicians, clubs, and recordings. On the first day I went with Luther to see "Little Addison" [*Nathaniel Addison*] at his garage on the West Side. Little Addison played with Luther in Chicago as far back as 1958. He kept all kinds of memorabilia at the garage, including a poster advertising a Magic Sam show, another announcing Mighty Joe Young's two-day birthday celebration at the Tyrone Davis Entertainment Center. Their pal saxophonist Eddie Shaw joined them for a memorable reunion. Eddie grew up in Mississippi, played with Muddy, Howlin' Wolf, and many other blues luminaries, and fronted his own bands. I took pictures of the three old friends together.

The Tribute Band's shows were booked at Buddy Guy's nightclub Legends. It was there for the first time I *saw* Buddy Guy and Junior Wells. I was holding my camera when suddenly Junior threw his arm around Buddy; they were holding hands and smiling, posing for pictures—I was transported back to the moment when I first heard "Messin' with the Kid." I raised my camera and took the shot.

Before leaving Chicago I visited Willie Smith and his family at their home on the South Side. I photographed Willie with his sons Kenny and Javik as well as with his wife and mother. Over the next two decades I'd catch more of Willie's gigs in New England and the Delta.

Soon after I got back from Chicago, my *Blues Wire* story on Luther Johnson was published.[2] The story featured three pages of written text and six photographs plus my cover shot—my first real photo essay. Before Luther's interview I handwrote notes as fast as I could when talking with musicians. I began using microcassettes for Luther's story so I wouldn't miss a word.

Transcribing the audio tapes was labor-intensive, but I wanted to get not only the exact content of what the musicians had to say, but the *way* they said it, their emotions, the rhythm of their speech, which was its own music. I began to see the possibilities of a deeper kind of blues story.

Luther agreed to collaborate with me on his story for *Living Blues*. Because of its connection with the Center for the Study of Southern Culture and the University of Mississippi, *Living Blues* is more than a music magazine. It has a mission to document the African American Blues tradition, which was exactly what I was now wanting to do.

Luther's oral history was my first story for *Living Blues*. We worked on it all through 1996 and 1997 and it was published in 1998.[3] Luther and I remained friends, and we added to his story as he lived it. I continued to photograph "Junior" over the years. Luther moved to Florida in 2017, but whenever he came to New England for gigs, he always had a room in my home, with a closet full of performance outfits and his favorite guitar—a Fender Stratocaster he called "Anna"—waiting for him. I drove him to his last gigs in New England in February 2022. Luther died ten months later, on Christmas Day.

Over the years from 1993 to 1997 as I was photographing, I really wanted to learn more about the roots of the music. Meeting and listening to the performances of many musicians who grew up in the Delta led me to wonder—*What are the stories behind the music?* To find out, I went to Mississippi in late August 1997.

Calvin Jones was the only person I knew in Mississippi. I had photographed Calvin in a variety of venues up north and began my trip with a stop at his home in Senatobia, on my way to the 2nd Annual Howlin' Wolf Memorial Blues Festival in West Point. Calvin's mother, Lessie Jones, happened to be visiting from Chicago. Lessie beamed as she talked about her son. Lessie was in her mid-eighties then; she was the first person of her generation that I had a chance to have a conversation with about life in Mississippi. The warmth and kindness I would experience in the coming years of this journey

Buddy Guy and Junior Wells, Buddy Guy's Legends, Chicago, April 1996

started at Calvin's, Day One of my arrival in Mississippi. I would go on to write Calvin's oral history for *Living Blues*, gratified to be able to include a sidebar with some of Lessie's remembrances.[4]

After I arrived in West Point, Dr. Joe Stephens, one of the founders of the Howlin' Wolf Society, introduced me to Annie Eggerson, a treasured friend of the society. Annie married Wolf's cousin, Levy Eggerson, and knew Wolf from the time they were children and neighbors in White Station. Annie welcomed us into her home and showed me the bedroom where Wolf stayed when he returned to the area; pictures of Wolf were on the headboard. When Annie stood in front of a wall that had pictures of Martin Luther King, John Kennedy, and his brother Bobby, I created her portrait.

I met David Nelson, then editor of *Living Blues*, at the concert. I had nothing planned for the next afternoon, so I asked David if he had any suggestions. It happened to be the Otha Turner Picnic weekend; he drew a map and said that's where I should go.

I drove to Gravel Springs where Otha lived; the first person I met was his daughter Bernice. I learned that Bernice started playing drums at fife and drum picnics when she was just a youngster. Now her sons Rodney and Andre and their cousin Bill would be the ones drumming behind their grandfather as he sang and blew the fife. Otha's granddaughter Shardé was seven years old; she had already begun to play the fife and did so that day. Right there, I was witnessing how a family's and community's traditions were passed on to children and grandchildren.

Earlier that morning Otha's family and friends worked alongside Otha preparing for the picnic. They built fires for the barbeque and butchered the meat and simmered it in big cookpots. Hours later, people from the neighborhood came by to hear the music, socialize, dance, and eat goat sandwiches. The music started in the afternoon and went all night long.

Attending the picnic became an annual event for me. I would arrive early and help load the coolers, cut the meat off the bone, sell sandwiches, beer, and cold drinks, and clean up the mornings after the picnic, whatever was needed. Otha would always say "Come by whenever you want."

Early Sunday morning I went back to thank Otha. There he stood, in great spirits, after performing all day and night, holding a cigarette in one hand and a can of beer in the other. He had just turned ninety. Otha's presence and energy were impressive; he could be playful, but no one dared cross him. Otha was respected by everyone.

From Otha's I drove down to Bryants Farm in McComb for the Southwest Mississippi Blues and Heritage Festival. I was looking forward to Bobby Rush's performance. You can see in his picture Bobby's own physicality and emotion, the weight of the moment and the grand finale. I've seen Bobby many times over the years as he headlined festivals around the Delta. Watching grandmothers sing along with Bobby while holding their grandchildren, seeing people in line to buy his records and have their photograph taken with him, it's easy to understand why he is so beloved in Mississippi.

That was twenty-five years ago. One promise I made to myself: *I'm gonna keep going to Mississippi.* I had a lot to learn, but I was open to the journey and looked forward to each visit. Those first days in Mississippi I felt like the luckiest person in the world. And that feeling never left me. Serendipity was my friend. Discoveries I had only dreamed of kept me energized. One Sunday morning I met Joseph Burnside. Unbeknownst to me, his mother-in-law Mama Jean was getting ready for church. Her Bible was in her hand. "Yes, you may take my picture," she said. During my travels on Mississippi country roads I photographed many beautiful churches; the image of the small octagonal church I found in Sharkey County remains with me to do this day.

In the country and the towns of Mississippi I spent special moments with grandparents, mothers and fathers, children and grandchildren. R. L. Boyce's daughter Latisha had been visiting her father when we met. She was radiant in the light, cradling her twins. I often visited T-Model and Stella Ford in Greenville. Stella's grandchildren kept us company. Here, Stella and her granddaughter are on the front stairs of their house, and young Stella is standing up there with her little guitar as if she were on stage.

I took a picture of Frank Frost blowing harp at the Sunflower River Festival in 1998—one of my favorite performance shots. At

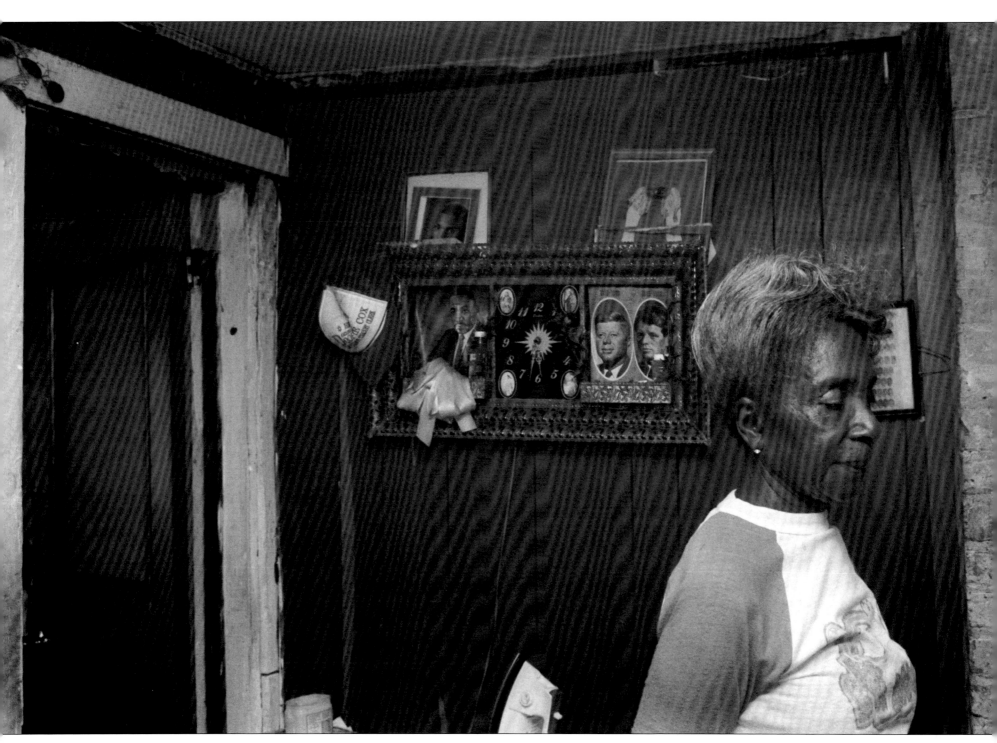

Annie Eggerson, White Station, Mississippi, August 1997

Bernice Turner Pratcher and Shardé Thomas, Gravel Springs, Mississippi, August 1999

the King Biscuit festival in '99 I asked Sam Carr if he could bring me over to Frank's so I could give him a print, but Frank was too ill and died just a few days later. No one had ever done a full, in-depth oral history of Frank, and now he was gone. I believed it was too important to let another blues musician pass without making a record of their story. So I dedicated myself to doing as many oral histories of the musicians in Mississippi as I could, particularly the older generation.

I met Sam Carr in 1998. Sam and his wife Doris lived in Dundee, in Tunica County, Mississippi. Their home was a renowned meeting place and layover for blues people, going back to the days of his father, Robert Nighthawk. I soon became a beneficiary of their famous generosity, often staying with them when I was in Mississippi. As they aged, I'd help with chores and errands. I'll never forget the day I photographed Sam and his neighbor Albert hauling their nets from Moon Lake. The work was strenuous; Sam was tired; he was seventy-two years old. I put down my camera and helped Sam throw the catch of fish from his boat into the back of his pickup.

After Luther Johnson's story, Sam's was the first of many oral histories I would write based on my travels to the Delta—and beyond.[5] My oral histories sometimes took years to write, especially in the beginning, as I was gradually and naturally building

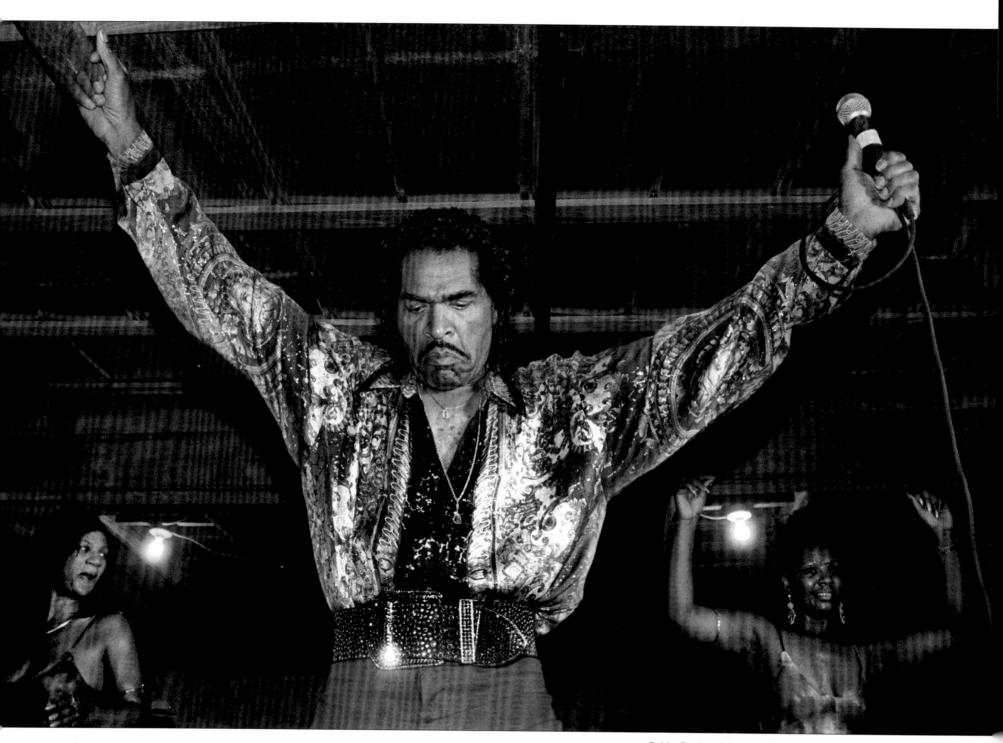

Bobby Rush and dancers, McComb, Mississippi, August 1997

Latisha and twins (Memory and Miracle) Como, Mississippi, August 2008

rapport and trust with the musicians and their families. I tape recorded the interviews in Mississippi. When I returned north I began the painstaking process of transcribing the interview by hand. Then, on my next trip, I'd review the draft with each interviewee, ask more questions, learn more details, and fill in the gaps of the story.

When I publish an oral history, the conversations and relationship don't end. I continue to visit musicians and attend their shows. Many of the photographs of musicians in this book were made *after* their "stories" were published. And many of my *Living Blues* interviews have been significantly enhanced since their magazine appearance with additional material as our friendships continued to develop. In some cases I watched the children and grandchildren of musicians grow into their own successful careers.

For years I'd drive Cadillac John Nolden back to Sunflower to see old friends and have one of Jeannie Russell's home-cooked meals at Russell's Grocery on Quiver Street, his favorite spot.

Long after *Living Blues* published my story on Robert Walker, I'd stop by and hear about his dreams for Wonder Light City, the club he created on his family's land outside Alligator. Despite multiple setbacks over the years, Robert lived to see the juke joint's grand opening in June 2017. Only a few months later I was at Cat Head's

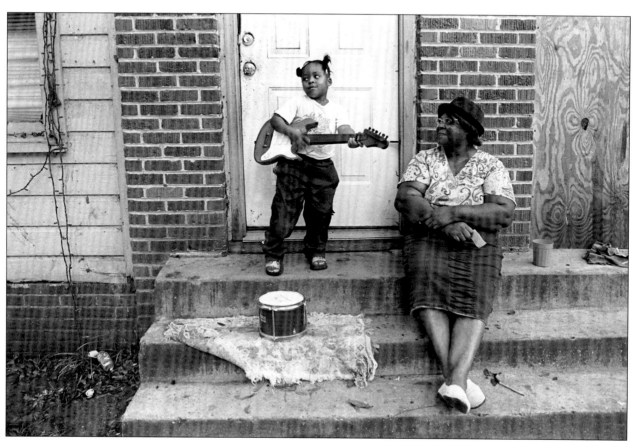

T-Model Ford's wife Stella and her granddaughter Stella, Greenville, Mississippi, October 2003

Mini Blues Festival for what would turn out to be Robert's final performance. He had recently been diagnosed with cancer; he was resolute, but frail and wearing a neck brace. I knew I would not see Robert again and struggled to hold back my tears. I watched as one of his young granddaughters hugged him at the end of his set. Robert died seven weeks later.

I saw Willie Smith almost every year at King Biscuit and Pinetop Perkins's Annual Homecoming the day after the festival. At Hopson Commissary in Clarksdale, we would have a beer and catch up. One of my most memorable phone calls with him was on the night of Barack Obama's election in 2008. Willie, who as a teenager on Chicago's South Side had filed past the open casket of Emmett Till, had lived to see a Black man elected President of the United States. Willie was exuberant. "I'm one of the happiest men on Earth!" he declared. "America has been rebirthed! I knew this day was coming, I just didn't know when."

I first saw Shirley Lewis in 1993, when I was photographing in the clubs around New England. The picture of Shirley here was made at a benefit for Luther Johnson in Greenfield, New Hampshire, in 2002. Luther was on the waitlist for a kidney transplant, which he

Shirley Lewis

I'm a country girl. I was born on February 25, 1937, in Sicklerville, New Jersey [thirty miles southeast of Philadelphia]. We were poor and lived in a small shack, but we grew up with a lot of music and a lot of love.

My father raised chickens and pigs, and he sold them. We worked in the fields, side by side with Mama since we were little. We learned to be independent, not to be selfish. We didn't have a lot, but whatever we had we shared with the other people. We were raised to respect all people and not to hate the white man.

Music kept us grounded and focused as children. Most of the time music made us happy. When I was a little girl I'd take a stick and beat on the pots and pans while my brothers would be singing. I started singing with my brothers when I was four. Our act was a mixture of church songs and songs that Dad wrote and taught us. Dad would take us to perform at different church halls, ball games, and fairs. I sang at the church with my family. We performed at other churches around New Jersey, New York, and Pennsylvania. We were called the Lewis Gospel Singers.

When I was in my early twenties, some scouts came to our church. They were looking for a singer to sing with their band and open for B.B. King. They hired me as soon as they heard me sing. We opened for B.B. in Chesilhurst, New Jersey. Everything happened after that. I was singing with someone all the time. I opened for B.B., Ike and Tina, Wilson Pickett, Ray Charles, and many others. I got really close to B.B. He was top notch in the Black community. We were proud of B.B.; he was already a star to us.

The blues came out of the roots of our gospel music and from people being free. It's a freedom music. Being free and being able to speak your mind, sing your songs and say what is going on and how you feel. Music makes me feel complete. When I sing, I send out love. I'm hoping people receive my love in the way it is given. I believe love is the bottom line. If you give love, you're gonna get love in return.

Shirley Lewis, Greenfield, New Hampshire, May 2002

Toni Lynn Washington

"Boston's Queen of the Blues"

I was born on December 6, 1936 in Southern Pines, North Carolina. My step-grandmother Lena used to work in white people's homes doing their housework and laundry. The nuns and priests from the Catholic Church would also bring their laundry to her. We had a nice little system. Before we got a washing machine we used to set up three huge tubs of water. One tub was for the wash; we used a scrub board to clean the clothes. We had another tub for the rinse, and a third tub for the second rinse, and she'd put in a little of what we call "bluing," which would make the whites come out sparkling white. We would sing hymns while we were doing laundry and chores around the house. We sang "I Shall Not Be Moved," "Jesus Loves Me," "Glory, Glory Hallelujah," "Go Tell It On The Mountain," "He's Got The Whole World In His Hands."

Lena took me and my brothers to gospel shows at different church venues. Some gospel groups were quartets, and some were huge choirs. I liked everything about it—the sound, the spirit, the clapping, the happiness and positivity. People would get overcome with joy and start shouting. Some days I think back on those times and how wonderful it was.

My mother and stepfather moved to Boston. When they got established they came back to North Carolina and got us. It was around 1950—Boston was a whole new world. One night when I was a few years older I went out with my mom to Estelle's, a club on Tremont Street in the South End. There was a dance hall upstairs and a big swing band playing. I liked what I was hearing. I went up to the stage. I asked the bandleader, Wilbur Lucar, if I could sing a song. He said, "Little girl, can you sing?" I said, "Yeah!" They helped me up on stage and I belted out "Mama, He Treats Your Daughter Mean"—one of Ruth Brown's greatest hits. Every young woman wanted to be like Ruth Brown, including me! People began making their way to the stage to hear me. They were clapping. That moment was the start of everything. I was in high school, just a teenager.

Music is my passion, my life. It gives me my drive. Music is a part of me. I don't connect music with hard times. I connect music with getting dressed, going to the club and doing my job. When I get up on stage, I'm living Toni Lynn Washington. I'm nowhere else but on that stage in my heart. Life is fabulous when I'm on stage.

Toni Lynn Washington, King Biscuit Blues Festival, Helena, Arkansas, October 2000

did get—from his loving daughter Patricia in 2003. Shirley gave a powerful performance that day. Years later I wrote her oral history for *Living Blues*. She'd been diagnosed with cancer, and we worked on her story together to make sure it was completed before she passed away—and it was.[6] Shirley died five months after it was published, on May 5, 2013, in Newton, Massachusetts.

Gordon "Sax" Beadle asked me to write Toni Lynn Washington's story for *Living Blues*.[7] "She's one of our greatest treasures," he said, and hadn't received the recognition she deserved. I had taken pictures of Toni Lynn but didn't know her personally yet. Working with Toni on her oral history led to a dear friendship. I brought my mother to some of Toni Lynn's shows so she could see what I was doing, share the joy that the music brought me. Toni Lynn and I adored our mothers, and this experience only strengthened our bond. When my mother passed in 2015, Toni Lynn gave a beautiful performance to celebrate her life. For many years she's given an annual concert in my mother's name and honor.

I think we might ask the question, what are our own roots? For myself, knowing my past is essential to understanding who I am today. Who are my ancestors? What did they do? Why did they come to America? What challenges did they face? What are the values they instilled in me?

Both of my parents enjoyed taking pictures. My father created an archive of photographs and memories from his childhood and his service in World War II. Over the decades, my mother took pictures of me and my brother and my dad with a Rolleiflex, documenting our lives from the time we were born until we went off to college, carefully placing them in leatherbound photobooks. I made a scrapbook from the documents my dad saved and did the same from what was left behind from other family lines. There were pictures from the old country, newspaper articles, school and war records, telegrams, and wedding announcements. Photos, documents, and memorabilia were lovingly preserved; they told stories. At times photos and text were combined.

My parents saved the photobooks from their families. The books were all kept in a cabinet in our living room. I loved to take them out when my family was together. I found great pleasure in sitting with my parents and grandmothers learning about my ancestors and our family stories. We would look at pictures and I would ask questions about each person and how we were related and started writing down the stories they told me at a very young age, almost as soon as I *could* write. I'm still researching and adding to these family histories today. So, all these projects have continued for decades. It started clearly when I was a child with my own family, but I have always been interested in meeting other people and learning their stories.

Each trip to Mississippi—setting aside a week or two away from my juvenile law practice—to spend time with musicians and their families, to record and photograph and listen to the blues in the Delta and Hill Country has been meaningful. The men and women I interviewed were my teachers; they patiently shared intimate stories about their families, childhood, and work, including the hard times and injustices they experienced. We talked about the music they heard and made, the solace and joy that gospel music and blues brought to them. My hope is to bring attention to their stories. These stories are part of our national heritage. For me, remembering is sacred, a duty.

Part I
CHICAGO CALLED

Willie "Big Eyes" Smith

I was born on Dr. Ryder's Plantation in Phillips County outside Helena, Arkansas, on January 19, 1936. There were about twenty-five or thirty families on the plantation. My dad, William McKinley Smith, was a sharecropper; he drove a tractor. My mother's maiden name was Lizzie Mae Wilson. She married my daddy and became Lizzie Mae Smith.[1]

I know now that my dad weren't making no money. One night he just got tired of it and said he was leaving, and he split. He went to Memphis for a while; then he decided to go to Chicago. I was about four.[2] My mom stayed in Helena for a while, but she left there for St. Louis in 1943. Then, just like my dad, she went on to Chicago.

All I know is my daddy and my mama, they loved me. When it come to me, they gave me what I needed. I knew they seen to that. So I didn't have no problem with them being separated. I always knew where my daddy was ever since I knew *who* he was. We were in touch all the time.

My grandparents from both sides raised me. Before I started school I'd stay two weeks with my mom's folks and two weeks with my dad's folks. My mom's parents, Pott and Janie Wilson, worked on a plantation. My grandfather worked 'til he wasn't able to work no more. I was nine years old when he died, May 25, 1945.[3] I never will forget that day.

My grandmother Wilson was in very good shape. She pulled corn, chopped and picked cotton, whatever needed to be done except plow a mule and drive a tractor. In 1955, my mother went down and got her and brought her back to Chicago. She lived to be ninety-six years old.[4]

My dad's parents, the Smiths, they lived about five miles away on another plantation.[5] My dad's parents farmed until they died. My dad's mother passed about 1942 or '43. I remember World War II hadn't been too long started—a lot of things were rationed. I can't think of the month she passed, but thinking how tall the cotton was, it had to be June or July. Her name was Lela, and her husband's name was Will—not Willie Smith, it was Will.

Now, people would call my dad's side religious fanatics, but on my mama's side it was a little more open and you had a bit more fun. But when it got down to being strict parents and whipping booty, you was gonna be disciplined by both sides.

Religion was the whole part of my life growing up. You had to go to church—Baptist on both sides. When Sunday came it didn't matter whose house I was at, I was *going* to church, until I was of a certain age. I knew I had to go or I was gonna get a whuppin'. They'd raise so much hell if you didn't go to church, you'd rather go than sit around and listen to *them*. Half the time I didn't know what the preacher was talking about. When I went home my grandmother Smith would ask did I understand what was said, and if not, *they* were gonna tell me. I had to sit in a chair and listen because they were gonna tell me anyway. They tell you all this shit—"The Devil gonna *get* you!" and "The Devil gonna get *in* you!" They'd haunt you to death so you'd have a self-conscience

Willie "Big Eyes" Smith, Hopson Commissary, Clarksdale, Mississippi, October 2002

and know right from wrong. I was a teenager when I was starting to make up my own mind.

No matter what you did, you didn't forget morals, how to treat people. One of the main things I learned growing up was to treat other people like you wanted to be treated. The basics of right and wrong—that was being taught. You could get it from the preacher, but I got it from my grandmothers. In their view, it was all one religion. As long as you did the right thing, it didn't matter what you call yourself.

I was six years old when I started school. I only went from January to May when there was no work to do. At that time, when school was out, you could take your books home. You knew all them books by heart. The teacher would ask you questions about this book and that book; then you could go on to the next grade. The school was on the plantation. Just Black kids went there. White kids had their own schools. When I got in high school, we got a school right here, they got a school right here—Didn't no Black kids go over there. The white kids got all new buses. We didn't get no new buses. We got the old buses they had. We didn't get no new books. We got the books that somebody else had. I ain't going to sugarcoat nothing.

After a white kid got a certain age you'd hear older people saying "*Mister* So-and-So" and "*Miss* So-and-So." I didn't do that; I couldn't see that. The plantation owner had a grandson the same age that I was. He used to bring his grandson by the house and put me in the car with him. We'd go riding over the plantation and I'd be asking questions. I wanted to know why we had to say "Yes sir" and "No sir" to *him*. He explained to me in the best way he could that this was the way it was. I couldn't understand; why is it got to be? That's why I'm asking the question in the first place. I was never satisfied with the answer. I was determined that I wasn't gonna call his grandson "Mister." He was always "Buck" to me and I was always just "Willie" to him.

I guess being as young as I was asking these kinds of questions, I sure enough would have been a smart little baby n-----! So that was strike one against me right there. I used to ask my grandparents these same questions. They couldn't answer either—that's "the way it was." One day, I said if a white man ever hit me, I'm gonna hit him back. My grandmother Wilson said, "You gonna be *dead*!" First thing out of my mouth—"Well, I'm gonna *be* dead!"

Janie Wilson's fears for her grandson were well founded. Seventeen years before Willie was born, at the end of the so-called "Red Summer" of 1919, the Wilson family lived through the Elaine Massacre, one of the most horrific mass killings of African Americans in US history—"an orgy of bloodshed," according to antilynching activist Ida B. Wells.[6] Between 100 and 237 Blacks were killed in Phillips County, Arkansas. Lambrook Plantation, where the Wilsons lived, and where Willie's mother was born, was one of the central locales of the terror.[7]

Everybody was scared of the Ku Klux Klan. The same people that was supposed to be helping you was probably KKK. I heard stories coming up how they hung people, where they hung them and what they did with them. My grandmother used to live in Tunica.[8] I used to hear her talk about how they used to lynch people and throw them into Moon Lake. That's why they was scared for the younger people. After I grew up, I realized that. They couldn't tell you *why* they were afraid, because that's "the way it was." But the younger people weren't gonna take that kind of bull.

You could see from what my parents my uncles and aunties told me from their time to my time things were changing. Slowly, but it *was* changing. But the things that I would say to white folks when they would piss me off, my family wouldn't dare to say! They'd be flinching. It didn't faze me. I wouldn't "talk back" to white folks, but I told you what I thought was *right*. If I thought that you were lying, I told you "That ain't so!" If you're lying, you're *lying*. That's the bottom line.

The family moved to a placed called Wooten-Epes Farm. [*Note that Sam Carr also lived on Wooten-Epes Farm, in 1946. Sam located the farm on Highway 20. See Sam Carr's oral history, page 71.*][9] We lived in one big house. It was right down the road from Helena about three or four miles. I was there when the war started in 1941. So they must have moved there in 1940.

Before I was ten I was picking cotton, but it was nothing I *had* to do. When I was ten years old, then they *put* me to work doing the same thing everybody else was doing, mostly on our crops, sharecropping. You plant, chop, thin, plow, pick, and bale the cotton, whatever needed to be done. I liked plowing behind the mule. You go out in the fields and they give you the plow handle and you wrestle with it. They tell you, "Don't cut up the cotton!" So your job is to keep the plow from getting too close to the cotton.

You're a farmer; it's something you automatically learn. Just like driving a tractor. You get on the tractor with your uncle or somebody. The first thing they're gonna do is get up off the seat and let you sit down and drive the tractor. The boss man see you doing that, pretty soon he's gonna give you a tractor and you're gonna start working around the horse barn, the cattle barn, whatever. You get to moving hay around. The next thing they might tell you, "Get a tractor; have someone go out there with you and set the plow." Then they turn you loose on the tractor.

My Uncle Pott Wilson Junior taught me how to drive a tractor. I drove a tractor in the field, plowing corn, plowing cotton, setting up rows for the cotton. I learned how to drive the rig that hauled the cotton to the gin. I did that 'til I was seventeen and left.

We all picked cotton. It was on the halves with the man. Whatever it came to, he got half and you got half. Between the two families, the four of us [*Willie and his grandmother, Janie Wilson, his Uncle Pott Jr., and his wife Mary Alice*], we'd pick maybe two, two and a half bales of cotton a week [*1,000–1,250 lbs.*]. When we finished our crop we'd go pick cotton for whoever was paying the most for a hundred pounds. I had a cousin who could pick five hundred pounds a day [*one standard bale*]. My Uncle Rich Wilson, he had one arm. *He* could beat me picking. 150 pounds was about top dog for me in a day. So if they was paying three dollars a hundred, I'd make four and a half dollars a day. You want to start early in the morning when the dew's on the cotton. Then it's heavy. You can pick a hundred pounds a little quicker.

The cotton fields was a place I didn't want to be. I was slow because I was always daydreaming about doing something else. But I'd be picking my heart out. They told me once I got 150 pounds I could quit and go home. By the time I got 150 pounds the sun was down. My dream was to do anything but what I was doing.

At the end of the year, if you were lucky you might have $300—but out of that you buy your winter clothes, maybe a suit, two hundred pounds of flour, fifty pounds of corn meal, fifty pounds of sugar, and fifty pounds of lard. By January you're broke.

We always had a garden. We grew beans, corn, popcorn, greens, okra, tomatoes, watermelon—everything you could buy in the store, you planted. We had pear and persimmon trees. Everyone took care of the garden. Everyone had chores; everybody helped.

We raised our own hogs. I had to leave home when they slaughtered the hogs because I always had a pet hog. We had a henhouse and a cotton house. Mostly you'd do your smoking in the cotton house. You'd knock some planks out of the bottom and set your fire in the ground.

For fun I had a bicycle. I'd fish according to how I felt. Sometimes I'd go out rabbit hunting. I'd kill me two or three rabbits, bring them back, skin them and hang them up. My grandmother would cook them. At night you'd go coon hunting. As a country boy, using a gun is something you pick up. They tell you all about the dangers. Then you go outside, get a target, and start shooting. I played some baseball. The kids on the plantation played other country teams from Helena, different plantations. It was a Sunday thing.

When I started working, you was definitely working Monday through Friday. Saturday you worked 'til noon, then you'd take a bath and go to town and party. You'd go in the cafés, where you could get some good soul food—greens, beans, corn, vegetables, ham hocks.

There were cafés owned by Blacks for Black people. The cafés had Seeburgs [*jukeboxes*]. Kids was crazy about the blues at that time. You'd hear Arthur "Big Boy" Crudup, Tampa Red, Leroy Carr, Little Brother Montgomery . . . Back then Arthur was the big man. I was always crazy about his music. I remember him singing "Rock Me Mamma."[10] Oh man. Oh, my goodness. Oh, boy. I remember him singing "I bought her three gold teeth and pretty earrings in her ear, doo, doo, doo."[11] He was *howling* the blues. I mean I was *influenced*. The white people didn't listen to our music—"N----- music," that's

what they called it. They were just too dumb to know what they had in their backyard. Only a handful realized the potential of this music.

People would dance. During the weekend, the few hours they had to party was special to country folks. You couldn't buy liquor after 11:00 p.m., but there was always bootleg. Town would shut down except for the gambling houses. I remember Phillips Street in Helena, that's where the Black people went. Rogers Café was at the corner of Phillips Street and the alley. You come out of Rogers Café and step right into The Hole in the Wall. Dreamland was on the corner of Phillips and Missouri Streets; the Silver Moon was diagonally across the street. Helena used to be wide open.

Everything was segregated—cafés, toilets, everything. A few years later, one theater had whites downstairs and Blacks went upstairs. There was a little place right around the train station called the Busy Bee. We had enough Black places to go, and we wasn't going in there no way. Not for nothing to buy something out the back window. They wasn't going to do that.

Helena had one major street, Cherry Street; there was a general store, a bank, a post office. That was mostly where all the white people hung out. We knew what was going on there, but we didn't deal up there unless we were going to the five-and-ten. You could get your clothing up there. We bought clothing once a year, when we got settled up for the cotton. [*Katz Clothing Store, a major retailer on Cherry Street, was the sponsor of Muddy Waters on KFFA in 1949.*] Everything belonged to someone white because if you were Black you weren't able to own one of them stores no way. Your store was probably one of them little shack stores out in the country.

I remember hearing music on the radio ever since we were able to buy one. I remember the first radio my grandparents bought. It cost forty-three dollars—fifty cents a week to pay it off. You bought a battery. Depending on how much you played the radio, it was good for at least six months. I doubt if I was ten years old yet.

The blues was all I wanted to hear. I was listening to the blues stations because they were playing that good old stuff—Sonny Terry and Brownie McGhee, Blind Boy Fuller, Leroy Carr, Memphis Minnie, Tampa Red, Big Joe Williams. We used to have programs come on pretty much every day, starting out at five o'clock in the morning. I used to listen to Muddy Waters right from Helena. [*From September to November 1949, Muddy had an early morning radio slot on KFFA.*][12] Most of those programs would last about fifteen minutes. You would have programs come on and they'd play two or three records, talk a little bit, and then play two or three records. Then it'd be somebody else coming on and doing the same thing, so you had an hour of nothing but blues between two or three different people. I heard Robert Nighthawk play. He used to have a radio show on the same station as King Biscuit. [*Beginning in 1948, Howlin' Wolf also had a radio show on KWEM from West Memphis.*][13] *Willie could also have easily tuned in to WROX from Clarksdale, WDIA from Memphis, and with good weather conditions, WLAC from Nashville.*]

This is *my* music now! I felt like a kid getting a new toy. You can just imagine how excited I was. The feeling on the inside I can't describe. All I know is that I felt *good*. I also knew that I wanted to play music. That was the spirit in me telling me I had to do that.

I remember King Biscuit. The radio show was on fifteen minutes a day during the week. On Saturday it was on like two hours. Every Saturday the musicians would be at the Miller Theatre in Helena; that was the Black theatre in town. They would play there from eleven a.m. to twelve; it was like a jam. Then at twelve it was broadcast time.

My stepdaddy used to take me there. I heard Sonny Boy Williamson, Robert Junior Lockwood, Houston Stackhouse, Joe Willie Wilkins, Pinetop Perkins, and another piano player, Robert "Dudlow" Taylor.

I'd see Sonny Boy Saturday after the show. He'd be sitting in front of Rogers crap house blowing harmonica for tips with his cap and a bottle of whiskey.[14] If people came out of the crap house winning, they'd throw the change in the cap. I'd sit there and talk to Sonny Boy a bit. He told me he had been all over the world. I'm trying to picture in my mind—"What is it that you all did see?"

There was a store called the Shady Grove. This was a place where you bought your wine, beer, and groceries. They had a Seeburg. You know how at night the sound carries; it sounded like the jukebox

was just sitting out in the field. I'd be hearing "Big Boy" Crudup. I'd run to the back porch to hear the music. I'd be sitting back there, singing them reels.

On my daddy's side, the blues was "Devil's music." No way on this side of heaven did they want me to listen to *that*. My grandmother Lela, she'd come to the back porch and say, "Boy, come in this house!" I had to get up and go in. I'm saying (to myself), "I'll be glad when I get grown; I'm sure enough gonna listen to some blues." It made me feel 100 percent better than church music. As I grew up I learned different. It's all God's music; it depends on what you do with it.

We did have a little teenage choir at church. We used to listen to WROX in Clarksdale. Every Sunday morning you had the Dixie Hummingbirds, the Mighty Clouds of Joy, and Five Blind Boys on the radio. All the youngsters, we were gonna form us a group. The preachers were willing for you to sing if you wanted.

We had a quartet. We'd go to one another's house and practice. We were singing spirituals. You made your music with your mouth; you made your drums with your hands. It was *soul* music. You couldn't shake your booty like you wanted, but you could damn sure *play*.

Teenagers had house parties. There wasn't no drinking, there was no smoking. We played what we called the "jukebox." We got electricity from a radio battery; you would hook up a turntable.

We done moved into people like Louis Jordan. I heard him on the radio and the Seeburg. Louis Jordan was the James Brown of his day. He was a hell of a musician. Each word he sang *meant* something; it told some kind of little story. People could relate to that. It was the time of the big swing bands. Louis Jordan took a smaller band and did twice as much with it as they did. He took it from jazz swing; now he's playing this thing with blues ["*jump blues*"]. People went crazy. They did a dance called the Hucklebuck;[15] there was a lot of swinging going on, a lot of dances. The song that captivated all the people was "Saturday Night Fish Fry" [*Recording by Louis Jordan and His Tympany Five, a national hit on the R&B charts in 1949; Chuck Berry later called it the "first rock 'n' roll record"*].

I couldn't afford any instruments when I lived in Arkansas, so I'd just beat and knock on wood. I messed around with my cousin's guitar, but I didn't really want to play it. My dream was to blow a saxophone or play the piano. I was influenced by Louis Jordan on sax and Roosevelt Sykes on piano.

I was seventeen when I left for Chicago. I took the train to visit my mama. She was living on the South Side, 4345 State Street [*in the Grand Boulevard neighborhood*]. I got to Chicago July 25, 1953. I had good impressions of Chicago. It was a place you wanted to be—"bright lights and big city."[16] The South Side was real beautiful then. I got in on a Saturday and went to work that Monday after I got here. The following weekend we all went to see Muddy Waters—at Zanzibar, 13th and Ashland. It was jam packed. I know what kind of music Muddy played and I liked it. His sound then was just like his records—deep rooted.

The band was Muddy, Otis Spann on piano, Elgin [*Elga Edmonds*]—he was the drummer—and Jimmy Rogers. But the thing that really influenced me at the time was the harmonica. Henry Strong [*1928–1954*], the boy who got killed—his nickname was "Pot"—he was blowing harmonica with Muddy.[17] After seeing him and hearing that sound, I definitely wanted to play the blues.

I started to work at a junkyard. After two weeks, the car I wanted came in. I bought it. Now I'm gonna work another two weeks and make me enough money to drive it home. I was looking forward to going back to Arkansas and flashing the money.

I was having a good time. Every day was like a Saturday. So when time comes to start picking cotton, I told my grandmother to write me and let me know. She did. I thought about it. I said I'll go back next week. I put it off for another week. Then I wrote her and said I'm not coming back. I was making about forty-five, fifty dollars a week working eight-hour days in Chicago. At home we was working ten to twelve hours a day and wasn't hardly making twenty a week. You had to get out of the South to make a living.

I started going to the clubs from day one. I'm seeing names up on the outside, so I knew where the music was, but there were a lot of places I wasn't able to get in because I wasn't old enough. The clubs that I could go, the main one was the Zanzibar—where Muddy was playing—and Silvio's [*2254 West Lake Street*], and the 708 [*708 East 47th Street*]. Muddy, Howlin' Wolf, Elmore James

all played at Silvio's—a lot of times they'd be there together. Three bands in one night! The fifties was prime time for blues.

I bought my first instrument, a keyboard harmonica [aka melodica, pianica—a free-reed instrument with a keyboard and a mouthpiece] in 1954. Little Walter had come along and put a new twist on the harp, different from Sonny Boy. Walter was on all Muddy's early records. A lot of people didn't recognize him until he came out with "Juke" [July 1952].[18] Walter's playing was a revolution of the harmonica.

I used to go in the clubs and Walter would give me his harp. He told me, "You're blowing good, but don't try to sound like me, put you into it." There is no way I could make the chords like him, and even if I did, they wouldn't sound like him. Damn, I put me into it.

I learned under Walter; I was listening to him everywhere he played. At this time Walter had left Muddy Waters and taken over the Aces [Louis Myers, guitar; Dave Myers, bass; and Fred Below, drums] from Junior Wells. [Wells then joined Muddy Waters. The Aces, now led by Little Walter, became known as Little Walter & His Nightcaps and Little Walter and His Jukes.]

Little Walter, Louis and Dave Myers, and Fred Below was a revolution of the blues. You had a lot of rhythm in there. It was more like a jump swing thing. It was in the swing style, but you got the real blues now with a harmonica doing this thing that's never been did like this before. And you got the Myers brothers playing the bass and guitar, and Fred Below on drums. That is a different sound, different beat of the same music. It's like going in the shaft and coming out brand new again.

Little Walter, Sonny Boy Williamson, Big Walter Horton—I heard all of them.[19] I take a little of this and a little bit of that and a little bit of me. I practiced at home. I'd play sixteen hours a day, seven days a week when I wasn't working. I really liked the drums, too. My mama told me go buy a set—"nothing over a hundred dollars." I'd practice harmonica and drums from the time I'd get up 'til they made me go to bed at night.

I was practicing one day, and this boy, he was doing some plumbing in our house, brought his brother over. Clifton James was a little younger than me. He must have been about seventeen. Clifton started playing drums and I started blowing harmonica. Bobby Lee Burns was learning too. He'd be over every weekend.

People would be drinking whiskey and playing cards at the cleaners downstairs. It was a party place. You set up a table and brought your whiskey with you. We'd go down there, keep learning and playing until we got good. I played harmonica, Clifton played drums and Bobby Lee played lead guitar and sang—We called ourselves Bobby Lee and the Rockers, the Rockets, his House Rockers, or some kind of name like that. It must have been early spring 1954. Our first gig in Chicago was at the 1145 [1145 West Madison Street on the Near West Side].[20] We were there for a month or so. We played wherever we could get a gig. We played Muddy Waters, Howlin' Wolf, Little Walter, and Elmore James songs. I made six dollars a night—And I would have played for less than that! Sometimes I just got a half a pint. But I'd be drinking and having fun; that's what mattered to me. Besides, during that time you was going to have a week job anyways, so if you made any money on the weekend that was your fun money.

By this time Bo Diddley came along. He played at the Sawdust Trail at 44th and Wentworth on the South Side. Billy Boy Arnold was his harmonica player. I used to sit in with them. When we rehearsed on Clifton's back porch, Bo would be out there, too. We'd be telling jokes, playing music, just having fun in general. When Bo needed a drummer, Clifton went with him.[21]

I started playing harmonica with Arthur "Big Boy" Spires [1912–1990]. He played the old style of guitar. Another guitar player, Uncle Johnny Williams, played with us. Like Arthur, he had been playing by himself. Sometimes Johnny Shines played with us. [Spires's group was known as "the Rocket Four."]

I played with Arthur about a year and a half. I'm on an album cover with him [*Wrapped in My Baby*]. I remember we were doing a recording for Al Smith. He was a big band leader. He recorded us in the fifties and kept the tapes. A lot of Blacks were recording in the fifties. But what the company would do, you'd get paid for the record, but they would never release it. They'd sit on it. [*Wrapped in My Baby was "recorded in late 1954 or early 1955," according to its liner notes, but not released until 1989, on Delmark.*]

Bo Diddley, Harpers Ferry, Boston, Massachusetts, February 1997

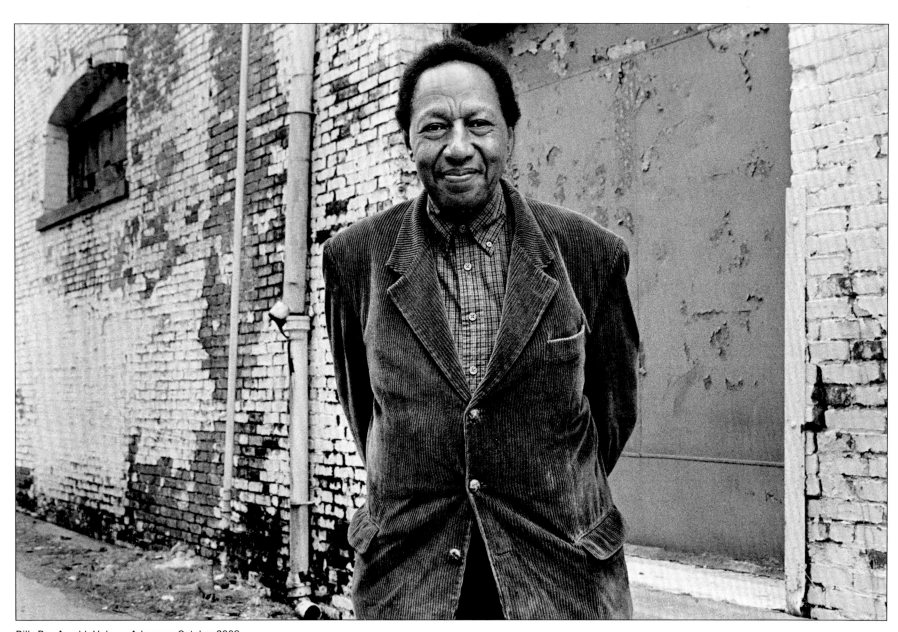
Billy Boy Arnold, Helena, Arkansas, October 2009

Billy Boy Arnold

The real Sonny Boy Williamson [John Lee Williamson, 1914–1948] was my idol. He was an innovator and made the harmonica what it was. I was fascinated by the sound I heard on Sonny Boy's harmonica. I was eleven when I heard his record "Mellow Chick Swing." "G. M. & O. Blues" was on the other side. When I was twelve I rang his doorbell. I said, "I want to hear you and learn how to play." Sonny Boy gave me two lessons before he died.

When Sonny Boy got killed Little Walter became king of the harmonica. He surpassed Sonny Boy. He did things other people didn't do. Sonny Boy played acoustic. When Walter played, the sound was electrified, heavily amplified. Little Walter set a pace, a direction; he was more up to date. We all admired Walter. When Little Walter made his first big hit "Juke," me, Willie [Smith], [James] Cotton, and all the harmonica players jumped on Little Walter, followed him, and sung his songs because that's what people wanted to hear in the clubs. But we put our own personalities into what we were doing.

Playing with Bo Diddley was the greatest thing that ever happened to me. I have the highest regard for his music—and special feelings for Bo; he was the first one who gave me the opportunity to play in front of an audience. He was playing in the streets, in different parts of Chicago. Ellas McDaniel and the Hipsters—that's what the band was called. [Ellas McDaniel was Bo Diddley's family name.] He let me do a few numbers. I was only fifteen.

I was eager to play. Castle Rock on the South Side of Chicago [West 50th and Princeton Avenue] was the first club I played in with Bo. This was the end of 1954. When Bo Diddley made his first record, "Bo Diddley"/"I'm a Man" [Chess, 1955] we had a regular gig there on the weekends. When the record came out, we started traveling around.

I left Bo to front my own band. My goal from the beginning was to make records like Sonny Boy and Little Walter, and I did. I reached the goal I set. I feel great my records went everywhere. I toured around the country. Carey Bell gave me one of the best compliments regarding my harmonica playing. He said, "Billy Boy, you're a bad motherfucker."

I blowed harp when Bo made "Diddy Wah Diddy" for Chess Records. [*Billy Boy Arnold had left Bo Diddley to front his own band.*] When Bo did that record it was a whole different ball game—a different style of music, more on the rock 'n' roll side.[22] [*Written by Willie Dixon and with "Little Willie" Smith on harmonica, "Diddy Wah Diddy" was released on the Checker label in 1956.*]

From the first time I started with the harmonica, that's what everybody used to call me—"Little Willie" Smith—because everybody wanted to be "little" something, but I didn't start calling myself Little Willie nothing. Like they had Little Willie Foster, Little Willie John. Everybody wanted to be Little Junior Wells something. Junior and I used to laugh about that. Don't call me little *nothing* because I ain't little nothing.

I started playing drums at the end of 1956 or early 1957, somewhere along there. Elvis came out with "Heartbreak Hotel" and it was a smash [*released January 27, 1956*]. Rock 'n' roll went on an upsurge. I was right in the middle of blues and rock 'n' roll. I had a choice to go either way. I started gigging on drums because there were always a lot of harmonica players playing the blues, and not enough gigs around. I had to play faster stuff. I played some rock 'n' roll, but I didn't *feel* it like I did the blues. I knew rock 'n' roll *was* the blues, but I didn't like it with that much energy. I liked to sit back and just groove it.

Little Hudson Shower [*1919–2009*] was playing at the Hobnob, a little joint at 5200 South Wentworth. I happened to walk by. I went in and asked if I could play. Little Hudson didn't know what I could do, but he was willing to give me a chance. He threw a couple of backlashes to test me out; that's what the old people used to do. Little Hudson hired me to be part of his Red Devil Trio. He played guitar, Lee Eggleston played the piano, and I played drums.

Little Hudson, Big Bill Broonzy, and Memphis Slim—they was all friends. Little Hudson was something like a cross between Big Bill Broonzy and B.B. King. We weren't traveling, but around Chicago we had a pretty good following, which was important. Once you went into a place to play, you'd be there for *years*. Little Hudson must have played the Hobnob for ten years or better. Little Hudson was a nice guy. He bought me a car. He signed for it, and I paid him back. He bought me a good set of Slingerlands drums.

I left the Red Devils Trio for better times. I guess I was never the kind of person to be in one place too long. I turned down some damn good jobs because I knew I wasn't gonna stay.

I was practicing on the drums all the time. The drummer is very important because he sets the pace. It wasn't about how many notes can you put into a bar; it was always about how good could you make it sound. At the time, Fred Below [*1926–1988*] was top dog. Everybody wanted to play drums like Fred. Below was a jazz drummer. He took the swing from jazz and put it into the blues and made a backbeat out of it. That hadn't been thought of yet. You've got the feeling of jazz and you're settling down putting this blues thing in there. The blues players, especially the drummers, ate it up because the music's upbeat and got more bounce to it. That's where I got my running start.

They say I'm a "shuffle drummer." Everybody says a "shuffle beat."[23] A beat goes with everything, but I like *rhythm*. I know how to put this rhythm in here. Actually, I could play the drums, and you could just dance to *them*. You don't need the rest of the music. It was a swing beat, back beat. To me it was a *rhythm* beat.

Says Bob Margolin, who played with Willie for more than thirty-five years: "Willie did put the rhythm in his playing. His drumming propelled and uplifted everything. His playing is characterized by, along with standard backbeat, tapping out the melodies of vocal, harp, or guitar solos. He hears and plays the whole song, not just a drum part. He always swings—his parts always feel good. He's one of the best blues drummers ever."[24]

I started messing around with Little Smokey Smothers, Big Smokey Smothers, Jo Jo Williams, and Alex "Easy Baby" Randle. We all got a band. We were playing clubs around the city wherever we could get the gig. Jo Jo had a record out; we didn't. So we were doing everybody's else's music. I was playing with them when I started recording with Muddy.

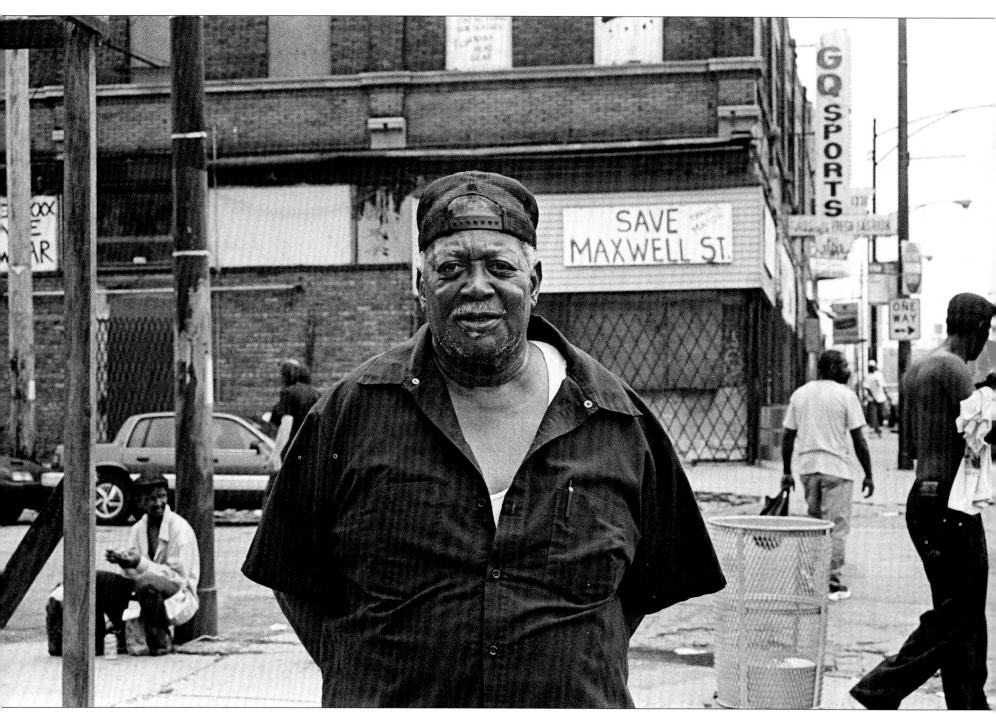

Alex "Easy Baby" Randle, Chicago, June 1999

I used to go out and hear other musicians all the time. I was always going to learn something. All through the 1950s and '60s there used to be matinees on Sundays, starting about one o'clock in the afternoon. We had "Blue Monday" parties, too. Sometimes we start at noon and play 'til one o'clock in the morning.

They'd have jams and matinees all over the city. Many times you wouldn't even know there was a jam session going on unless you cruising the street and hear this noise. You'd stop and check it out. I'd jam with everybody—Otis Rush, Memphis Slim, all the musicians here at the time. When you got a chance to jam with Howlin' Wolf, Muddy Waters, Little Walter—that was special, an inspiration that made you want to do it all the more.

Muddy had a "junior band" in addition to his touring band. George "Mojo" Buford was in charge. Mojo knew Muddy's music. They lived in the same building and practiced a lot. When Muddy went out of town, the junior band covered Muddy's gigs. If somebody messed up, Muddy would pull somebody out of the junior band. From time to time, Mojo would need a drummer and I would play with him. It wasn't a constant thing. I was playing wherever I could. I was in the junior band no more than a year.

Muddy used to give a matinee every Sunday at Smitty's Corner [*35th and South Indiana*]. All the musicians would go there. A lot of times I would sit in with the band. I could just walk in when they are getting ready and instead of Francis Clay [*Muddy's drummer beginning in 1957*] going up, I'd go; we was friends.

How I met Muddy—I knew Muddy's chauffeur, James Tribelet. He used to babysit me when I was down South. He introduced Muddy to me at one of the jams at Smitty's. Muddy liked the way I played. It wasn't long after that Muddy came by the house. He was doing a gig out in Gary, Indiana, a place called the F&J Lounge, and he wanted me to work with him that night. He wanted to see what I was all about. I went and did the gig. I played two Thursdays there because Francis couldn't go.

It wasn't too long later that Muddy wanted me back. He was going to do a tribute LP for Big Bill Broonzy. Big Bill had died in 1958. [*Muddy was the lead pallbearer at Broonzy's funeral in Chicago.*] I heard Big Bill's music ever since I can remember. Muddy asked me to be part of the recording. He come back to the house and we go down in the basement and rehearse for the record. That was '59.[25] After that, the ball just started rolling.

One day Muddy fired the whole band. It had to be right after Newport, late '60 or early '61, when I joined. The members at that time were Mojo Buford, Luther Tucker, Pat Hare, Otis Spann, and myself. Muddy was playing at Pepper's Lounge, but most of the time the band was going out of town. We were playing clubs all over. We played in juke joints in the country and city. When we was in Chicago, Robert Nighthawk used to sit in with us at Pepper's. He was around us all the time, just about every day.

From 1958 into the mid-1960s, Pepper's Lounge, at 503 E. 43rd Street, was Muddy Waters' main Chicago club. His name was painted on the front of the building in the early 1960s.[26] In recognition of the connection, Mayor Harold Washington in 1985 designated a section of East 43rd Street as "Muddy Waters Drive."[27]

We toured the South. We played at a prom at Ole Miss in 1961. Muddy pretty much knew where we were going. But we'd been up North so long you kinda get turned around. When we got to Mississippi, we started asking people, "How do you get to Ole Miss?" Everybody we asked, especially Black folks, looked at us like we were *crazy*. Ole Miss was still all white [*integrated October 1962*].

We found the place, and the gig was all right. We set up and started to play. Then, the kids started to get down because they had moonshine. They had it in them fruit jars [*mason jars*] and they take a drink, and they give you some. You looking at this, and you know that this shit not supposed to be going on. "Ah, take a drink. Take a drink!" There was a lot of northern peoples going to Ole Miss; they didn't look at things like southerners did. The northern white boys, if they was drinking moonshine, they wanted to be drinking with *you*. The southerners didn't take to that too well—"You don't drink after no n-----."

These are youngsters now. I could imagine how the young men could feel. Because you see some of them just standing back there

Mortuary (where Emmett Till's mother recovered his body), Tutwiler, Mississippi, October 2015

not saying nothing but just looking. We started talking to the northern boys, but we didn't say nothing to no girls, period.

And the girls was getting down; they just having fun. They spin around, and dresses fly up and you see them panties. They didn't care. They try to mingle with you, and you got back in the corner as far as you could and just look. You know your place. You didn't want the white women getting too close, too friendly. You didn't want nothing to get out of hand. I'd heard about how women would frame Black men and stuff like that. You is on your P's and Q's.

We didn't want nobody to get the wrong idea and start some shit down there. The crackers looking at you might want to do something to you. And they was quick to do that because you was Black. As far as they were concerned you was in the wrong place in the first place. It wouldn't have took much for them to want to start some shit with us.

Emmett Till was killed in 1955. I went to the funeral home in Chicago and seen him in the open coffin. It was only about three blocks from my mother's.

Emmett Till's viewing was held at the A. A. Rayner Funeral Home at 381 East 71st Street in the Park Manor section of Chicago's South Side, on September 6, 1955. Days later, his funeral was conducted at

Roberts Temple Church of God in Christ at 4021 State Street, three blocks north of where Willie was staying with his mother.[28]

I went there and seen him with my own eyes. You've seen the pictures with his face, right? But I'm looking at it with my natural eyes. I was only nineteen years old; I was mad as hell. Damn right! They went to stopping cars from the North going South because *everybody* was mad. That was really the beginning of the civil rights movement. If you was Black you was involved in it one way or another. Everybody had a role that had to be played.

After Ole Miss we went to Birmingham, Alabama.[29] It was too early to be down there; it was just a few weeks after the big riot. [*On May 14, 1961, nineteen Freedom Riders traveling by bus through the South to challenge segregation laws were attacked at the Birmingham bus station by a white mob, including men of the KKK and out-of-uniform officers under orders of police chief "Bull" Connor. The riders were beaten with baseball bats, iron pipes, and bicycle chains. Thirteen were hospitalized.*] The civil rights movement was starting to move. Birmingham was like any other southern town. Whites had the upper hand. That was the bottom line. [*"Probably the most thoroughly segregated city in the United States," wrote Martin Luther King Jr. in his "Letter from Birmingham Jail" in April 1963.*]

We played at some kind of big hall. The audience was Black. We stayed on the Black side of town. We had some whites come out and be outside. They talk to you, but you didn't mix, associate, like you do now. They weren't going to cause a problem for us. They were going to create a problem for themselves. At that time the KKK had a pretty good strong hold so you didn't want to get tangled up with those people because you would have to kill somebody or be killed. So you try to stay your distance.

We were staying mostly in rooming houses in the Black sections of town. Things were still segregated. I've seen people go to the back door, but I would never do that. If I had to go to the back door, I would do without. You weren't making no restaurant money. You was eating baloney, salami, hot dogs, and pork and beans out of the can, in the car, wherever.

Harmonica player Paul Oscher, who was on the road with the Muddy Waters Band from 1968 to 1971, recalled: "When I travelled down South with Muddy, we didn't stay in motels much. We played mostly Black clubs—often they had a place for us to stay, either a Black motel or with people in town who put us up. Sometimes we'd drive to the next gig and just sleep in the car."[30]

You'd always see signs of the KKK driving down the country roads. That didn't bother us. [*Paul Oscher remembered seeing a large billboard while touring Mississippi with a white-hooded klansman on horseback and a warning: You are now entering Klan country!*][31] Even in the late eighties I saw a Black doll with a rope around its neck hanging up from a porch. Me and "Fuzz" [*Calvin Jones*] just laughed at that. It wasn't funny, but it wasn't *scary*. We weren't paranoid. I'd think—"What kind of a mind you got to be that stupid?"

Muddy was a big man amongst the Blacks in those days. He always would have a big audience down South. He sounded like a good preacher belting out the truth. People wanted to be in his presence. He was a big man amongst the whites, too, but the whites was terrorized. If they went to hear Muddy they'd be called a n----- lover. They didn't want to be called that so they'd buy the music, but didn't come to the clubs.

I remember when Nat King Cole came South and they jumped on him in Birmingham. By this time I guess he thought that things had kind of changed a little bit. . . . Nat King Cole and people like Harry Belafonte, they was classified different from us, because most of their audience was white anyway. So, when they brought him down there they put him in one of the nicest places that white people played. But you've got some in there saying, "This n----- ain't got no business in here!" You know what I mean? It's just that simple.

Singer Nat King Cole was attacked by members of the KKK while performing before an all-white audience at the Municipal Auditorium in Birmingham, Alabama, on April 10, 1956. After the attack, Cole cancelled three upcoming concerts and returned

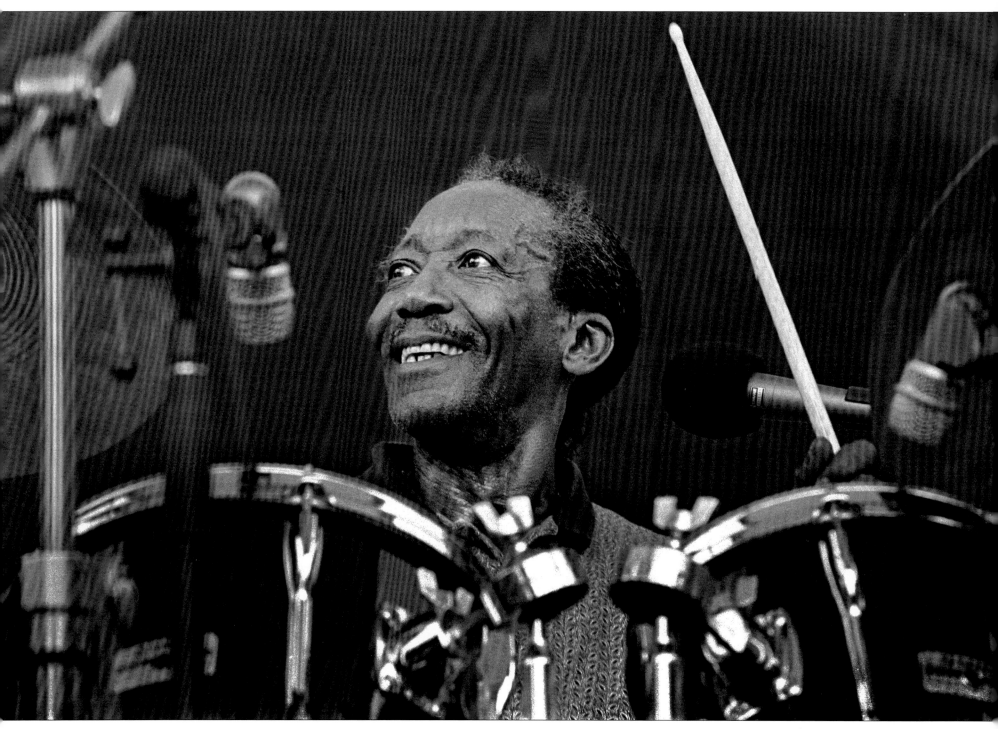

Willie "Big Eyes" Smith, Boston Globe Jazz Festival, Boston, Massachusetts, June 1999

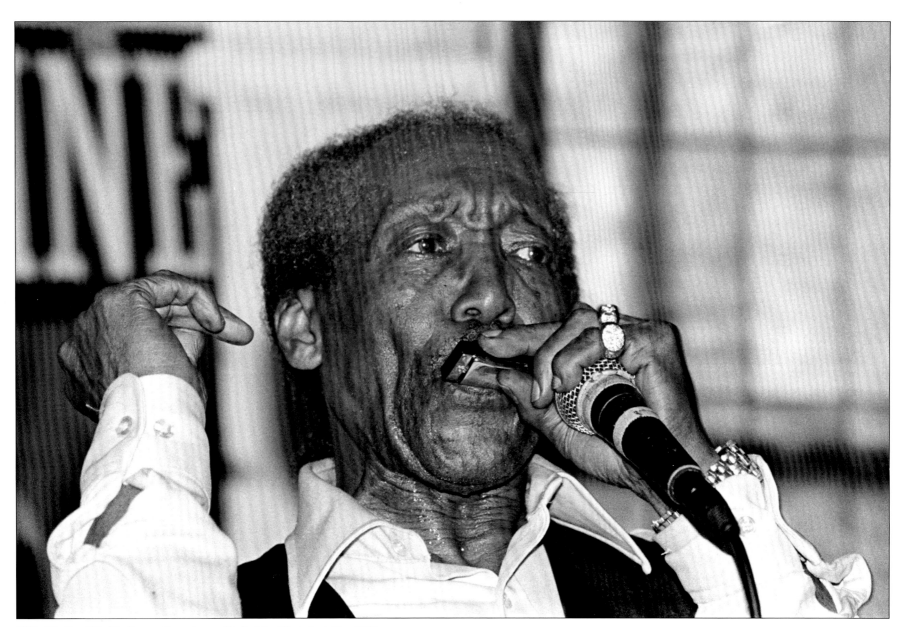
Willie "Big Eyes" Smith, Hopson Commissary, Clarksdale, Mississippi, May 2007

to Chicago to recuperate. He never performed again in the Deep South. Singer Harry Belafonte was never physically attacked in this manner; however, his life was often threatened as he marched with Dr. Martin Luther King Jr. in the 1960s.

Down South we had a big audience, but the pay was still nothing. We were just glad to be a part of the wheel turning. Most of the time the band was going out of town for ninety days; that was a long time not making no money.

I always had a day job 'til I started working with Muddy. After my first job at the junkyard, I went to work with my mother at Western Tables, making tables. I worked there 'til about 1956. Then I worked for a construction company that had a contract with the Air Force. We made platforms for the jets. Before playing with Muddy I was a short order cook at the East Gate Hotel. No matter what, I wouldn't take a job that required me to work the weekend. I was definitely gonna play my music on the weekend. But not being able to have a day job when I worked with Muddy was one of the reasons I quit in 1964.[32]

We weren't making enough money. I had a family to take care of. When the band got ready to go out of town again, I told them I wasn't going. I started driving cab. I didn't go back to Muddy until '68.

Although it is true that Wille stopped going on the road with the band in the mid-1960s, he maintained a vital connection with Muddy, playing on a number of Chess studio recordings when Muddy was in Chicago. He played drums on three Chess singles from 1964–66 and on the 1966 album Muddy Waters: Brass and the Blues.[33]

I happened to pick up Muddy's wife and son in my cab and brought them home. I chatted with Muddy for a few minutes. The next day he called and asked if I would do a gig with him over Christmas. I said yes. Then he called the next week and asked if I would play New Year's Eve and New Year's.[34] I did those, too.

I went to his house and we talked about the difference in pay. He's paying $150 a week which ain't no money compared to what I'm making as a cab driver. Honestly, I'm making this kind of money damn near every day. But at that particular point, my first wife and I weren't seeing eye to eye, and I needed to get away. So it was a good chance for me to go. The rest is history. I replaced S. P. Leary on drums. We went out to California from January to April. At that time, 1969, Muddy's band was Paul Oscher on harp; Otis Spann, piano; Sammy Lawhorn and Pee Wee Madison on guitars; and Sonny Wimberley, on bass.

The name "Big Eyes" came in the early seventies. Muddy was introducing everybody on stage—George "Mojo Dreamy Eyed" Buford, James "Pee Wee" Madison, Samuel "Longhorn" or "Greenhorn," whatever he wanted to call him. Everybody had a nickname except me. When he got to me, he just looked around and said, "Motherfucker, I got to call you *something*." I'm laughing. Muddy said, "Ladies and gentlemen, Willie 'Big Eyes' Smith!" And it stuck just like that.

Muddy was like a second daddy to me; he was my daddy when I first got out on the road. He knew all the things I was gonna run into, what was gonna take place. He warned me in advance to stay away from certain things—women, *period.* He'd talk about pride just like I tell my son how pride can get in your way, forget about that pride thing. Just be you, but be *right*. Some people will end up six feet under because of pride. Every young man has his pride. If you don't know how to handle it, you can hurt somebody or be hurt, especially in the music business. There's a lot of ego out there. Used to be you were pretty much despised by men because you was a musician. Because the womens gonna come to you first. Muddy taught us to be cool, do the right thing.

Muddy had uniforms for the band. That was a big thing back then. We used to have to wear them tuxedos, ties, a cummerbund. You had to dress like that in all the bands. I was so glad when they cut that shit out.

I didn't look at Muddy as "Muddy Waters," not even my kids did. We didn't look at him as being famous. We looked at him as being one of the family. I could go to his house any time of day or

Pinetop Perkins, Harpers Ferry, Boston, Massachusetts, April 1994

night. And that was the way his kids felt about me. Matter of fact, his kids used to stay with me. We was one happy family. [*During the early 1970s, the Willie Smith and Muddy Waters families lived two houses apart in the North Kenwood neighborhood of Chicago.*]

I used to go to Muddy's just about every other day. Our kids would play together. When I went over to Muddy's, the kids wanted to eat. Muddy was a good cook, country cooking. You name it, he could cook it: beef, chicken, short ribs, sweet potatoes. Greens was his favorite. Muddy liked them hot. Muddy was crazy about pepper. He'd put the whole cayenne pepper in there.

I was the leader of Muddy's band. I took care of everything that needed to be done. Whoever promoted the band came to see me. When the pay time came, it was me who got the money. When the band got paid, it was me paying them. Muddy trusted me completely. He knew I wasn't gonna take a match.

When we were on the road with Muddy, all we did when we weren't playing was drink whiskey and gamble. Everybody was a gambler—a lot of times we would be doing a show and we'd be back in the dressing room gambling between show times or before show time. And we'd be *gambling*, too. We wouldn't be bullshitting. We all trying to win that money. Shooting dice, you want it to hit! Pop your fingers! Rolling—you got to hit! Pop the skin off your finger gambling. Me and Fuzz use to do some *hard* gambling. We all did. Me and Fuzzy just keep going, shifting the money back and forth. We wouldn't stop 'til one of us was broke.

We had a car accident, October 26, 1969. Muddy was in the hospital for six weeks.[35] Three people died. We didn't play until the next year. [*Muddy first began playing again in Chicago at the end of March 1970. The band began touring again in May.*] During this time, I recorded with Arthur "Big Boy" Crudup. As I told you, he was one of my childhood idols. We did one session in 1970 for an LP. It was never released. It's in the can somewhere. [*The album was finally released on Delmark in 2013 under the title* Sunny Road.][36]

In the 1970s the band changed. Jerry Portnoy replaced Mojo Buford; Calvin "Fuzz" Jones replaced Sonny Wimberley; Luther "Guitar Jr." Johnson replaced "Hollywood Fats" [*Michael Mann*]; Bob Margolin replaced Sammy Lawhorn; Pinetop Perkins had already replaced Otis Spann.

The Muddy Waters Band of 1974–80 was one of the great bands in blues history. Together, they created six Grammy-winning albums;[37] regularly toured Europe; made major forays into Japan and Australia; and touched down in North Africa and Mexico City, playing the blues in parts of the world that had never before heard the music live. In 1978 the band was invited to play at the White House by President Jimmy Carter. According to Bob Margolin, Muddy once told him that the band was the best group he'd put together since the early fifties with Little Walter, Jimmy Rogers and Otis Spann.[38]

By the end of the 1970s there were management problems. We left Muddy as a group in June 1980 and formed the Legendary Blues Band—"Fuzz," Jerry Portnoy, Pinetop, and myself.

Bob Margolin and Luther "Guitar Junior" Johnson went their own ways after the breakup. The core group of Willie-Calvin-Pinetop-Portnoy added guitarist Louis Myers and began to tour as the "Legendary Blues Band" within a few weeks of the breakup, and released their first album, Life of Ease, in December 1980.[39]

We made seven CDs under the name the Legendary Blues Band.[40] [*Pinetop left in 1985,[41] and Jerry left in 1986.*] Calvin stayed almost to the end. When he left, there wasn't anybody from the original band but me.

Calvin's last album with the Legendary Blues Band was Prime Time Blues, released in June 1992. His last gigs with the group were that spring.[42] After Calvin's departure, Willie began booking the band as Willie "Big Eyes" Smith & His Legendary Blues Band,

or sometimes Willie "Big Eyes" Smith and the Legendary Blues Band. The band's final CD, Money Talks, *was issued on November 16, 1993. Willie continued to tour as Willie "Big Eyes" Smith & His Legendary Blues Band for two more years, until the end of 1995 and the release of his first solo album.*

In 1993, as the Legendary Blues Band was winding down, with only Willie remaining from the original band, new efforts were underway to recreate the Muddy Waters sound. In April 1993, on the tenth anniversary of Muddy's death, promoters in Boston organized a series of reunion gigs to honor him, bringing together all six members of his late-1970s band—not only the core members of the Legendaries (Willie, Fuzz, Pinetop, and Jerry) but also Bob Margolin and Luther "Guitar Junior" Johnson—for the first time since June 1980. The group played five nights in the Boston area.

In the summer of 1994 this reunion band got together again for a national "Tribute to Muddy Waters" tour. In December of that year they went into the studio in New York officially under the name the Muddy Waters Tribute Band and cut the album You're Gonna Miss Me (When I'm Dead and Gone)—*the definitive salute to the master, by the original members of his last and perhaps greatest band. In a gesture of respect, each man took lead vocal on one of Muddy's signature tunes. Willie sang "Sugar Sweet"; Calvin did "Honey Bee."*

In 1995, studio performances by a dozen big-name special guests were mixed in, and the CD was released in 1996. All through the late 1990s and into the new century, the Muddy Waters Tribute Band toured for several weeks each year.[43]

I changed the name of the band to Willie "Big Eyes" Smith and His Blues Band when I did my first recording for Blind Pig in 1995 [Bag Full of Blues, *featuring Pinetop Perkins and Kim Wilson*]. I kept doing the same thing—fronting a band. I hung in there. I was trying to keep the same momentum I'm used to. For a while I opened for Jimmy Rogers. Then I started booking gigs for myself. It made a different person out of me. It was all business, a lot of pressure, dog-eat-dog. As long as we was with Muddy we didn't have nothing to worry about. He was the light shining. Finally I decided to go back and do my own thing, the way I wanted to do it. Thank God for Pat Morgan and Hugh Southard; good, honest booking agents make all the difference. Here I am.

Willie began to transition from drums to harmonica, his original main instrument, in 2002 with five tracks on the album Harmonica Blues Orgy *(Random Chance, 2002). During his many years singing with the Legendary Blues Band, he'd already established himself as an excellent vocalist. Now he also began writing his own songs.*

The harmonica is supposed to just be the lead instrument. Everybody do it different. Like you got some guitar players never quit grinding on the guitar, and you got some that take their time and pick their notes out. Harmonica players, you've got some just blow his brains out blowing loud, loud, loud and keeping up a lot of noise but it don't mean nothing. When a harmonica player picks out certain notes or do certain things, then when he do speak on it, it *means* something.

When I play the harmonica, I'm communicating a story and a feeling. I came from the day where you heard all these *stories* on the radio. You had to picture in your mind what's going on in these stories like *The Shadow* and *True Confessions*, because you couldn't see it on the radio. You can't communicate the story without the feeling.

This late-life burst of creativity was made possible, to a great degree, through his collaboration with his son Kenny, who happily began taking over the drums from his father, allowing Willie the full freedom to come out front and blow, sing, and write his own new tunes. On the CD Way Back *(2006), Kenny played drums on the majority of the tracks. By the time of* Born in Arkansas *(2008), the transition was complete, with Willie on harp and vocals throughout, and Kenny backing him on drums on every cut. According to Bob Margolin: "Kenny 'Beedy Eyes' Smith is the only drummer I've ever heard who can sound like Willie."*[44] *Their*

collaboration reached its peak on Willie's last album with Pinetop Perkins, Joined at the Hip.[45] *On that CD, Willie and Kenny also co-wrote four of the songs.*

It feels good to have my son, Kenny, playing drums in the band. When Kenny was only four years old, I saw that drumming was something he wanted to do, so I bought him a junior set of drums. I taught him just like Muddy and everybody else did me. Go down in the basement and bam away and listen to the wax LPs. I used to be practicing every day. He'd sit right there with me. Kenny's got the feeling for the blues.

Willie toured throughout the second half of 2010 and early 2011 with Pinetop Perkins behind Joined at the Hip. *On February 13, 2011, the CD won a Grammy for Best Traditional Blues Album of 2010. Pinetop, at 97, was the oldest recipient of a Grammy in the history of the awards.*

Pinetop died in March 2011. Willie spoke at Pinetop's funeral in Austin, Texas, and a few days later at a "homegoing" celebration in Clarksdale, Mississippi, where Willie "pulled out his harmonica, cut loose with a wail and stomped his foot to the beat of 'How Long'—He's in heaven!" said Willie.[46] *In June, Willie led the Saturday night tribute to Pinetop at the Chicago Blues Festival. Later that summer Willie fell ill; he died on September 16.*

Nothing settles back in your soul the way the blues do—it grooves right in there. Your soul and blues go together like red beans and rice. I still feel that moment of movement inside anytime I hear the good music. You hear something good and I don't know what—it makes chill bumps. It's something you know you feel but until you is *there yourself* you can't describe it to nobody else. It's an experience that you have to have your*self*. And the music, I mean, I guess you might call it something like a religion . . . Just like the disciples of Jesus Christ, they's carrying the Word. He was the true one, but he had disciples. They can't tell you really why he said it; they carrying it on. That's the way I feel about the blues—I am a disciple, I'm not the pioneer of this thing. I'm a disciple from those other older guys. None of us at this point and age is really the pioneers. They are a disciple the same as me. Just trying to carry it on in your own way—carrying the true part of the art that you know along with you and trying to pass it on.

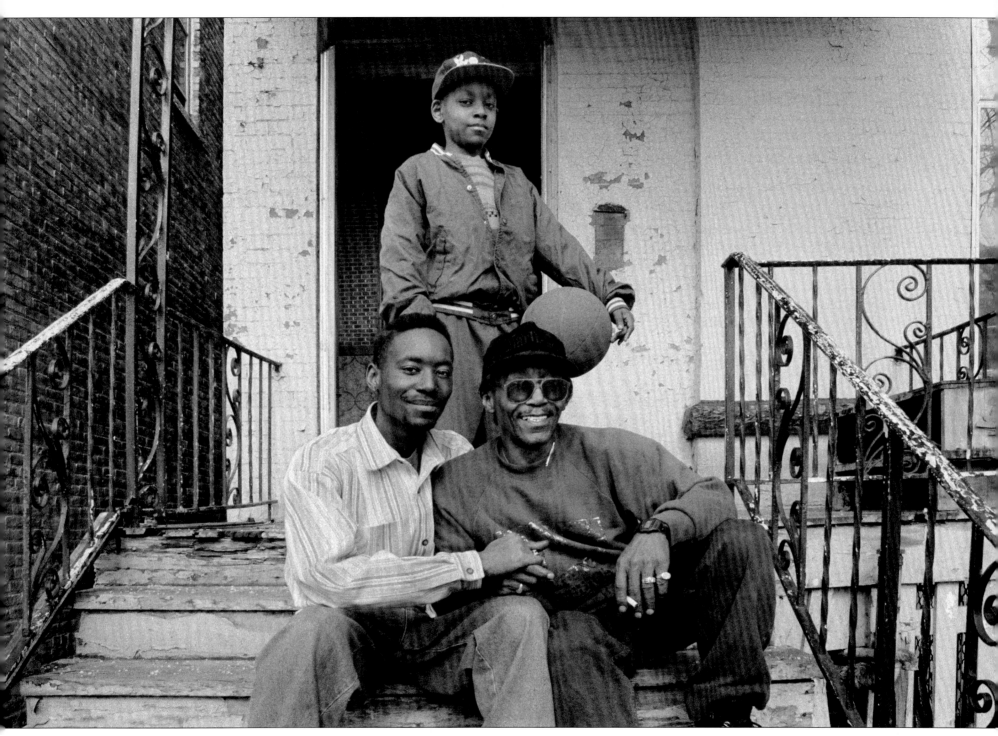
Willie "Big Eyes" Smith, with his sons Kenny and Javik, Chicago, Illinois, April 1996

Kenny "Beedy Eyes" Smith

From the time I was two or three, I watched my dad playing drums. He used to beat on his drum pad. I would sit on his lap trying to play on the pad with him. Like any son you try to follow in your father's footsteps. That's the way I was then and that's the way I am now.

My dad bought me my own drum kit when I was four. We would practice at home. I would listen to a lot of music—his CDs pretty much, a lot of Muddy Waters. I would get to see his shows with Muddy from the age of five and six and on. It was always in Muddy's rider that the kids could go and have a place to sit in the front and see the show. The music would grab me instantly. I says, "Oh yeah, I love this." I would sit and stare at my dad and see how he played. I couldn't wait to wake up the next morning and emulate how he played. It was a turning point for me. I can remember saying, "I'm going to do that one day!" And I stuck with that.

My dad would teach me if I couldn't get the song right. He would come in and sit down next to me and show me how it's done. I would practice hard and I would get it.

By the time I was thirteen I was playing a couple of songs at the end of the night with the Legendary Blues Band. My dad would get up and let me sit in—just get the feel, how to get up on stage and play. I'd go to the festival at Antone's [*venerable blues club in Austin, Texas*] every summer and some weekend festivals.

Through my teens I'm sure I drove my mother crazy—beating the drums at home. But they encouraged me, they never discouraged me. I played every day. In the summertime, I would just bury myself into the music, practicing from ten o'clock in the morning until late at night. A lot of Muddy's music. Even my grandmother, my father's mother, she used to listen to Muddy Waters, too.

I started writing songs when I was a kid. "Stuck in the Bottom"—I wrote that song when I was eleven or twelve and called it "Stuck in the Hole." Dad reworked it for the Legendary Blues Band [*on* Keeping the Blues Alive, *Ichiban, 1990*].

The first CD I was on with my dad was *Money Talks*. I played drums on a couple of tracks. [Money Talks *was the last CD released by the Legendary Blues Band, in November 1993. Kenny was nineteen. He is credited as "Kenneth Smith."*] I was overjoyed to be part of it. I knew it would happen one day and I wanted to give him my best. I was honored to play behind my dad because he was my teacher, my ace.

Working together on the CD *Born in Arkansas* [2008] was special to both of us. He dedicated it to his mother, my grandmother—"Lizzie Mae Smith, who was born in Arkansas, March 20, 1919." We both loved her. She lived in our house when I was growing up. As a family we used to go to Arkansas every summer to visit relatives. Dad's hometown was Helena; he'd point out where things happened. After I outgrew the junior drum kit my dad bought me, my grandmother bought my first drum set to gig with—same as she did for my dad when he was in his teens. I can remember my dad writing the lyrics for the songs in the upstairs room she lived in.

Kenny Smith, King Biscuit Blues Festival, Helena, Arkansas, October 2015

Working on *Joined at the Hip* [2010] was an everlasting experience. I grew up around Pinetop. He was family. Dad had an inseparable bond with Pinetop, like he did with Calvin and other musicians he played with. Co-writing songs with my dad for his album with Pinetop was fun. At times we would look at each other and start laughing. We collaborated on just about everything in life.

My dad was one of my best friends in the world. I idolized him. Everything I learned, everything about me comes from him. I lived through him and he lived through me. Nothing we wouldn't do for each other. I could talk to him about anything and he always had the best answer. My dad was funny. He was the coolest person I know. He just *had* it.

Starting in 2007 and whenever I could, I backed my father and Hubert Sumlin on drums at the King Biscuit Festival. In 2011, just a few weeks after he passed, I played the Main Stage with my father's band. I stepped to the front, waved to the audience and performed a few of my dad's originals in his memory. I choked up at first, but I sang and blew a little harp. Then with Bob Margolin and Bob Stroger and the rest of the band we went to the Front Porch Stage as my father always did. We dedicated our performance to my dad. It was a real somber day—singing the blues, thinking about my dad, and wishing he was there.

I always felt my dad when we were on stage together and now even more so. I always try to do a little harp for him. It's bittersweet. Certain songs—Muddy's songs or songs dad taught me—will bring tears to my eyes; I feel happy. I remember watching him, learning from him—the unique way he played, and practicing what he did in Muddy's band. Today my hands move in the same way my dad's did on those songs. I can feel the same vibe, body movement that he had. It's unconscious, but it's there. The sound coming out is the same sound I heard when I was a kid.

The blues is the primary music that I play. It's in my blood. Carrying on the music is a big part—just to follow in the old guys footsteps. The Muddy Waters Band is definitely the ones that taught me; those are my mentors. When I'm playing, I feel connected. I would hope that if Muddy was alive, he would say "Yeah, I like what that fellow is playing there."

Calvin "Fuzz" Jones

I was born on a plantation around Money, Mississippi, on June 9, 1926. I don't know the one I was born on. I stayed on plantations in Mississippi 'til I moved to Chicago. My daddy's name was Tom Jones. He was a sharecropper his whole life. I loved my father. He took me with him wherever he went. My mother and I were very close. My mother, Lessie, was a hard-working woman, I can tell you that right now. She used to go to the cotton fields and at eleven a.m. had to quit and go out to the house, cook dinner for the family. We'd work 'til noon then we'd eat and go back at one p.m. She'd go back out with us. That was hard for a woman—and for men too. [*"I had to fill a woman's shoes. It was hard work in the hot sun. Oh Lord, it was really hot," remarked Calvin's mother, Lessie Jones, in her 1997 conversation with Margo Cooper.*][1] My mother's father was Calvin Walker. He was a sharecropper. I have his name. My full name is Calvin Walker Jones, but everybody used to call me "C. W."[2]

My grandfather was a churchgoing man. I had to go to church too. Everyone definitely had to go to church on Sunday and a lot of times during the week. We belonged to a Baptist church.

My father, he moved about. We were staying at a plantation near Money when I was about six years old. We had high water there in 1932. [*Calvin is referring to a major flood on the Tallahatchie River on New Year's Day 1932. More than ten thousand people were left homeless.*][3] People were scared. Water came up all over the houses. The fields, everything got flooded. There was no dry ground. People down in the lowlands, their houses was totally covered. The house we stayed in was up on a hill. There was water in it. My mother's father came and got us in a boat. All we had was the clothes on our back. We had chickens in the yard. They all got drowned. The garden got washed away.

We had to leave off the plantation and move to Greenwood for a few months. The governor [*Theodore G. Bilbo*] put the people up in freight train car boxes. A lot of people were living in the car boxes all up and down the tracks. We left out of the car boxes and moved to a farm, not far from Indianola. Then we moved to Inverness in 1935 or 1936. That's when I started working on plantations, going out to the fields. I worked five or six days a week. I was chopping cotton first and I started picking cotton later. This man who owned the plantation, Joe Lee, he learned me when you work, you do good work. He's the one who showed me how to chop cotton, pick cotton.

Joe Lee was so nice and his wife was, too. She's the one who taught me how to ride a bicycle. She'd push me around the house. She'd cook me birthday cakes. They treated me like their son. Me and her son, we'd be together every day.[4] They carried me to town with them in their brand-new Chevrolet. Inverness had a big cotton gin, a drug store that sold pop and ice cream, a couple of grocery stores.

I didn't go to school too much because I had to work in the fields. You don't get through farming 'til just about Christmas. After Christmas, maybe I'd go to school two to three months. In March,

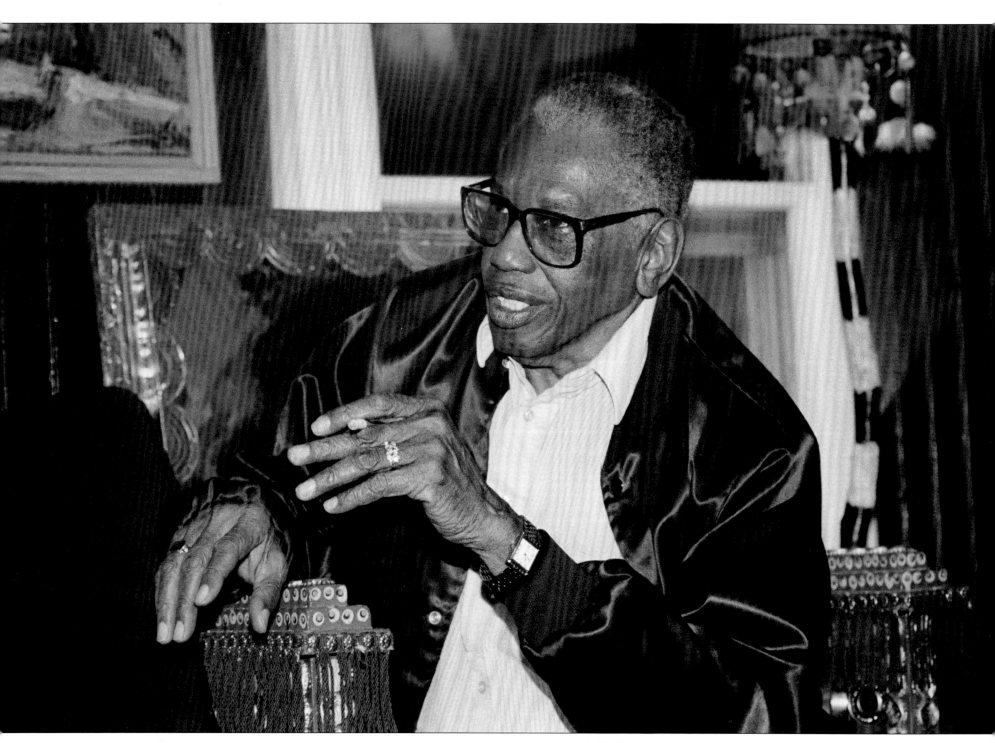

Calvin "Fuzz" Jones, House of Blues, Cambridge, Massachusetts, June 1995

Vital Records, Greenwood, Mississippi, October 2000

you start back working in the fields. The girls went to school more than the boys. The school was in a little old church. It was just for the farm kids, for Blacks only. When you're born into something, that's what you're taught. You were taught white folks had their ways and you had your ways. They went to their schools and churches and you went to yours. Whites go that way and you go your way. They go to their street and you go to your street. That's the way it was.

We left Inverness and came back to Money in 1939. We moved to a plantation called Wildwood. Wildwood was a company plantation. It stretched from Money to Greenwood. The plantation was huge and had hundreds of houses on it.⁵ The people who owned the plantation came down from New York and Chicago maybe once a year. They'd come around and look in their fancy cars. [*Wildwood Plantation was owned by Charles E. Merrill of New York, co-founder of Merrill Lynch, the Wall Street securities firm.*]

There were hundreds of mules at Wildwood. Everything on the plantation was done by mules. For me it was going backwards from Joe Lee's where everything was done by tractor and truck. My daddy taught me how to handle the mules and plows. I'd be out in the field with him, and I'd watch him. I didn't like chopping cotton too good. It didn't fit my personality. You had to be patient to get the grass cut and loosen the dirt. I didn't want to do that. When I

learned how to use the mules to plow, my daddy would chop the cotton and I'd do the plowing.

Our house had fifteen acres of land to sharecrop, a barn and lot to keep the two mules. You didn't get no pay. You just worked. That was it. On Wildwood the boss got 60 percent. We could keep 40 percent, but you paid for everything. There was one store on the plantation for food, clothes, and shoes. What could you do? [*Wildwood Plantation operated on the "Furnish System," whereby sharecroppers were paid not in legal tender but in company scrip, redeemable only at the plantation commissary.*][6]

My parents raised a garden wherever we lived. In Money they had greens, cabbage, collard greens, onions, peppers, carrots, peas, tomatoes, potatoes, popcorn, beans, corn, everything you could name. My mother she take care of the garden most of the time. I helped with everything. We had chickens and hogs. I had to go out there every morning and feed the animals. My daddy and granddaddy would kill the hogs. They'd cut them up and hang them in the smokehouses they built—smoke them hogs and have meat all year. That's the way we got by. There wasn't a whole lot of money being made, but we could live good, though.

There wasn't too much fun. I'd play baseball, hunt. My daddy taught me how to hunt. I'd hunt by myself, mostly for rabbits. My mother fried the rabbits and cooked them with some big biscuits—catheads—and put gravy to 'em. That would be so good, yessiree.

I fished every day when it's fishing time. You watch people fish as a kid, you know how to fish. I'd catch perches, catfish and grinner. We used to take the mules to the feedlot at noon every day. The feedlot sat right by the river. While the mules were eating we'd go down and swim—that's the Tallahatchie, the same river where they dumped Emmett Till's body [*August 1955*].

In Money there was a service station, a gristmill, a restaurant, and a grocery store. The Bryants wasn't there then. [*Roy Bryant, one of the men who killed Emmett Till, and his wife Carolyn, whose sexual accusations instigated Till's murder, operated Bryant's Grocery & Meat Market in Money from 1952 to 1955.*][7] In the back of the restaurant there was a Seeburg and a slot machine. Didn't nobody bother nobody. You stayed your distance and they stayed their distance. There were different doors to get in the restaurant. Whites went in the front and Blacks went in the back. If you saw a white woman in those days you didn't say nothing to her; you just keep going.

My daddy, he told me stories about way back a long time ago, things that he knowed that happened, like they used to tar people and burn them up, stuff like that—but as far as me knowing something like that happened, no.[8]

I did see something happen in Greenwood when I was about seventeen [*1943*]. Me and this guy were walking down the streets. I was looking in the windows. He was in front of me. These white guys were standing ahead of us; one stood in the doorway and the other one was on the sidewalk. This guy tried to walk between them. They said, "Don't you see us here talking, n------?" So he had to come back and go around them and walk where the cars were running. He couldn't walk between them. Why you gonna walk out in the street when you got plenty of room?

We had been in Money the Christmas before Emmett Till was killed. My daddy still lived there. Me and a few other guys, we come down from Chicago and took a little old amplifier and guitar. They still had that restaurant, and we went back and played. There was dancing and going on. The next thing, Emmett got killed. I was shocked. I didn't think it was that bad down there at that time. There were more Blacks than whites in Money. Why someone would want to do that kind of stuff I can't figure that out. When I was down there, My God they had segregation, but it wasn't *that* tough.

I'd hear music ever since I was little because people would give house parties. Folks would be drinking, frying fish, and gambling. There'd be dancing, singing—some cat sitting in the corner playing the guitar, hollering the blues.

Sometimes people be coming through and play. One guy come through with an amplifier. That was the first amplifier I saw. He hooked up his guitar and started playing. Oh man, the kids went crazy over that stuff! The sound was so loud and so clear.

Black Bayou Bridge, near Glendora, Mississippi, October 2016 (Emmett Till's body found downstream, August 1955)

The first blues song I can remember really getting into was Sonny Boy Williamson's "Bluebird" [*Bluebird Blues," 1937*].⁹ My mother bought that record. We had an old thing called a Grafonola you wind up, then it played the record. I heard the song and the blues got into me from then on. It just *hit* me. I must have been around eleven or twelve.

The next blues I caught onto was when King Biscuit Time came on the radio. King Biscuit was the greatest thing I ever heard. The show came on every day around noon. I'd run home from the fields to hear Pinetop Perkins and Sonny Boy Williamson [*II, aka Rice Miller, not the same "Sonny Boy" who recorded "Blue Bird"*] on King Biscuit. I was sure enough gonna make it home to hear them. Being down on the farm you didn't hardly see or hear nothing, so the show was a treat, a big deal. It would take your mind off what you be doing in the fields. For fifteen minutes you could be happy. I enjoyed the way Pinetop played the piano. I had never heard boogie woogie or blues on the piano before. Hearing Sonny Boy was something else, to blow the harp and sing like that. Robert Nighthawk used to play on there, too. I liked his guitar playing—the slide. You'd go back to the fields and try to sing some blues yourself.

I used to nail bale wire on the wall and put a bottle up there and a bottle or a brick or whatever down there to tighten it up—like someone playing with a slide. There was this girl, she taught me how to put the string up against the wall. She could play the thing and she could thump it. I could never play something on the single wire except "The Saints Go Marching In."

When we lived in Money there were plenty of records on the Seeburg. They had big band music, but there wasn't no blues on the jukebox for a while. The onliest Black artist, blues man, I know was on there was Arthur "Big Boy" Crudup. "That's All Right Mama" [*1947*]—that song stayed with me a long time. [*Big Boy Crudup cut his first single in September 1941—"If I Get Lucky," on the RCA Bluebird label. From 1941 on, Crudup had new songs released every year on Bluebird into the 1950s.*]

My mother went to Chicago. My father told her she could go, so she cut on out. [*Lessie Jones: "I started working when I was eight years old, picking and chopping cotton. After twenty-five years, I wanted to leave. I was tired of the field work. I went to South Bend, Indiana, in 1944 and moved to Chicago in 1946."*]¹⁰

I stayed on the farm. My mother would come down to visit every year. She'd say, "Calvin, come back home with me." My sister Rosetta was up there, too. I finally decided to make a change. I said, "I'll go; I have nothing to lose." There was nothing happening on the plantation no way.

I got on a train in Money and went to Memphis. Then I got the *City of New Orleans* train straight to Chicago. That was in 1947. My mother lived on the West Side. I didn't really care too much for Chicago when I first got there. It was smoky and foggy-looking. The smokestacks and factories were burning coal. The slaughterhouses stank. When the wind blew out of the southeast it would be stinking on the West Side. At first I said, "I don't know about this Chicago. I'm gonna go back home."

I got a job at the bakery where my mother worked. I mopped the floors and cleaned up after the night-shift went home. I worked there for about a year or better. It was great to me. I was used to getting up early, five or six o'clock in the morning. In Chicago I'd go to work at nine a.m. and get home six p.m. There'd still be daylight sometimes. On the farm you worked sunup to sundown. I was making three dollars and fifty cents a day in Mississippi, but in Chicago I was making a dollar fifty an *hour*. That's a big difference.

I was going out to the clubs at night. I lived at Madison and Wood streets on the West Side, right by the Chicago Stadium [*the "Madhouse on Madison"*].¹¹ They had clubs all up and down Madison Street. One was the "1145" and I think one was the Horseshoe. Homesick James [*James Williamson (1910-2006)*] used to play the "1145" pretty good. Earring George ["*Earring George" Mayweather, a harmonica player who arrived in Chicago in 1949*] played up on Damen and Madison.¹² I remember when I first heard Otis Rush play on the South Side. He had a great voice for singing. I used to go hear Sunnyland Slim [*Albert Luandrew, 1906-1995*]. I'd go from club to club, stay for a set, and then I leave for somewhere else.

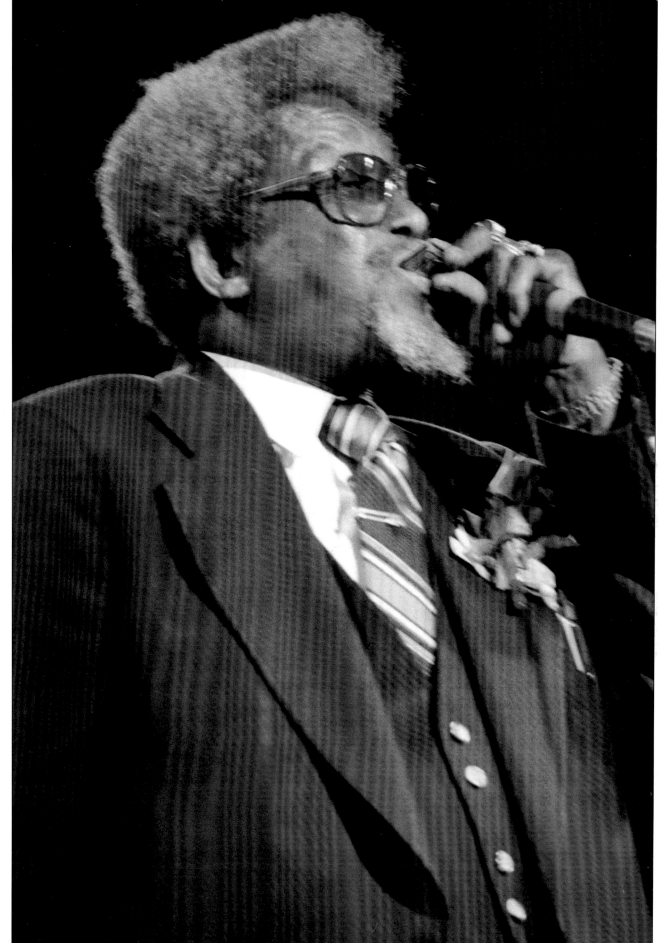

"Earring George" Mayweather, Harpers Ferry, Boston, Massachusetts, September 1993

Every Sunday I'd go down to "Jew Town" and listen to the guys playing music—one here, one there, one over there.[13] Little Walter used to play there,[14] and Floyd Jones—he put out "Stockyard Blues" [*1947*]—I used to see him on the street, too. It would be packed with people, thousands. All the stores and streets were wide open; full of people selling everything—suits, shirts, socks, records, pots and pans. Polish sausages, hot dogs and hamburgers.

When I first came to Chicago, I used to hang out with a bunch of guys that gambled. I was a gambler before I came to Chicago. In Mississippi my daddy used to go to parties where there'd be gambling. He would take me with him. I'd stand around and watch him. That's how I learned. I played both cards and dice.

There was a little old tavern on Paulina and Madison [*Lover's Lounge*].[15] A bunch of us was gambling across the street. It was hot so I went and put the window up. I heard a slide going. I hadn't heard no slide since Robert Nighthawk playing King Biscuit. I wanted to see what was happening, so I went over. I met Muddy and talked with him.

I used to go around every Saturday night to hear him. Muddy played at the Club Zanzibar for a long time [*"The West Side's Most Beautiful Club Zanzibar, 13th & Ashland"*]. Jimmy Rogers and Little Walter was playing with him then.[16] Jimmy Rogers was a heck of a singer and guitar player; he could also blow the harmonica. He had a different style from Muddy. Jimmy just picked the guitar. Muddy and Jimmy played beautiful together.[17] They were the top blues men around Chicago and their records were played on the radio.

I got friendly with Walter. Jimmy Rogers and Little Walter used to hang out together. After their gig with Muddy, we'd go to different places that stayed open until five o'clock in the morning—Silvio's, the 708 Club, the Wagon Wheel, the "1145." We'd go to listen to the music.

I moved out from my mom's and got a room in the same building where Jimmy Rogers lived, on South Peoria and Roosevelt Road. I worked at Driscoll Plate shop where they made chrome plates. Then I sold sand and cement about a year, I guess. I went to this other plate company and worked for them people for a long time, about ten years. After a while, a friend started calling me "Fuzzy," Then, everyone started calling me "Fuzzy," "Fuzz."

I bought a guitar and amplifier at the pawnshop. I'd hear the music in the clubs and come home and practice. I'd blam on it, blam on it, and couldn't get nothing out of it. I'd leave it alone, then I'd go back to it. Homesick James taught me how to pick and play chords. A bass player named Hayes Ware started teaching me.

I met Freddie King. He lived about two blocks from where I stayed. Freddie would come by and borrow my guitar to play on the weekend. We'd hook up the amplifier and he showed me how to play some B.B. King licks. I was playing pretty good then. I'd go to the clubs where Freddie was playing. When he got off, we'd go somewhere and gamble the rest of the night. Me and him used to hang out every weekend until he left for Texas.

I learned how to play slide by watching Elmore James. I'd go by Silvio's and listen to him all the time. I didn't have no guitar then, but years later I remembered how he played. Sometimes I'd go by where he was, sit in for a few tunes and play the bass notes behind him.

My brother-in-law Charlie Anderson had a Kay bass. He had it in the pawn shop; it was brand new. He said, "You can have it." He gave me a ticket, and I went and got it out of pawn. Now I had a guitar and a bass. After I learned how to pick a little more, I started up my own band—the Chicago Flames—probably 1952. At that time we was just kicking around. I was playing lead guitar. Earring George was on harmonica; Fats—we called him Fats, I don't know his regular name—played drums, and Walter Arnold played guitar. We hung out together and jammed. We wasn't gonna make too much money, but might as well make *some* money.

We were playing the blues—Muddy Waters, Elmore James, everybody's stuff. We played Friday and Saturday nights at a club on Damen and Roosevelt. Earring George left. Good Rockin' Charles [*Charles Edwards (1933–1989), who came to Chicago from Alabama in 1949*] started playing harmonica and sang. With Good Rockin' Charles we played at Ann People's Club [*Roosevelt Road and South Pulaski*] about a year or better. We left there and went to the Cotton Club on the North Side [*Clybourne and Halstead*]. We played there for three or four years at least. It was a nice club, like Silvio's. People got dressed up to go to the clubs. Men wore suits; women wore dresses. What started me singing? Good Rockin' didn't show up for

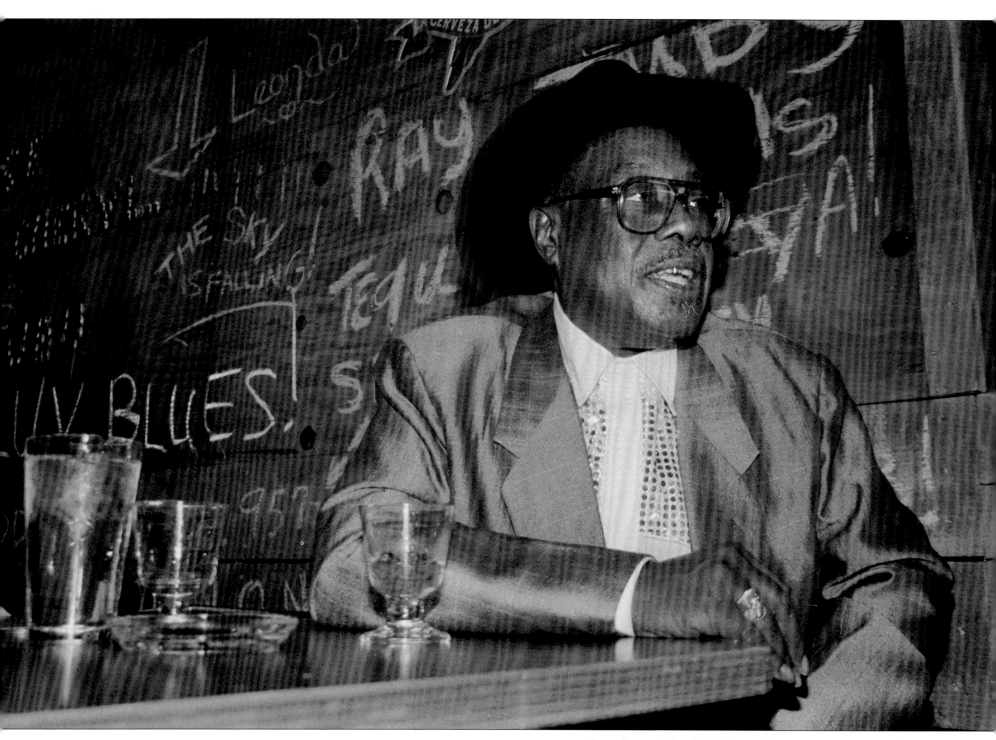

Jimmy Rogers, El Dorado Steakhouse, Dracut, Massachusetts, March 1995

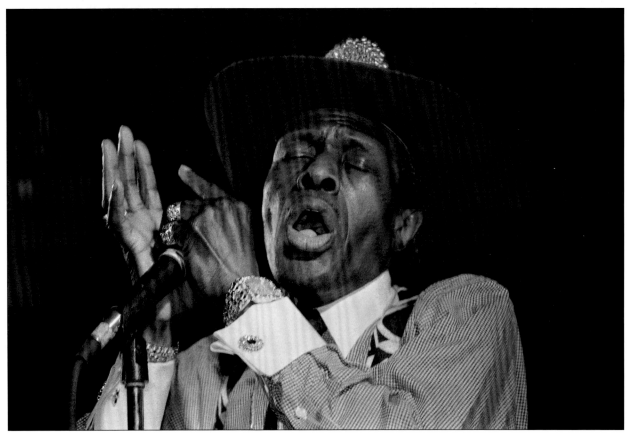

Junior Wells, Pearl Street, Northampton, Massachusetts, April 1995

a gig. The guitar player and me was playing together. He couldn't sing. I couldn't sing. I had no choice—I gotta start singing. The Chicago Flames disbanded. Guys wouldn't show up. They'd be drunk. I ended it.

I played all over the West and South Sides with Junior Wells for about a year. I played some gigs with Sonny Boy Williamson. He was living in Milwaukee, and sometimes he needed a bass player for gigs in Chicago. He'd buy hundred proof whiskey by the quart. He'd drink all night long while he played.

Me and J. B. Lenoir were good friends. When one of us wasn't gigging we'd go to where the other was playing. Then we'd sit in with one another. J. B. played a lot at the White Rose. He had a real high voice. His songs were popular around Chicago: "Mama Talk to Your Daughter," "Been Down So Long," and "Don't Dog Your Woman."

I played with Little Walter in the early 1960s for a year or better—not constantly playing with him but certain gigs he'd call me. Before Little Walter, everybody used to play like Sonny Boy. Little Walter came up with a different sound. He would *swing* with his harp. He had a sound something like a horn. After that, everybody tried to play like Little Walter.

Little Walter was kind of rough and tough now. He wouldn't take no stuff off nobody. He'd get mad real quick. He'd fight in a

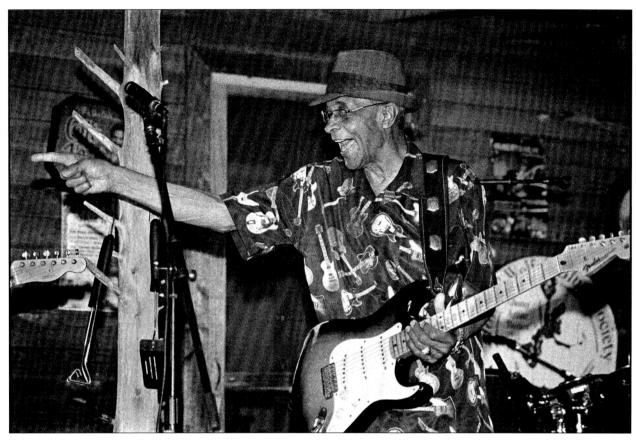

Hubert Sumlin, Wolf's Juke Joint Jam, West Point, Mississippi, May 2008

minute. He'd get a plank or board or something. I'm pretty sure he carried a gun, but not all the time because he would have killed someone. It always got crazy in the bars in the fifties and sixties. People would have a good time 'til they got crazy. You do what you have to do to protect yourself.

I started playing at Bobo's Lounge, a blues club on the West Side. I played there for a long time in the 1960s. A drummer named Scotty—Ray Scott—came by. Me and Ray been knowing one another for a long time. He said Howlin' Wolf needed a bass player. I went by where they were playing and sat in for a bit. Wolf hired me; this was about 1967. Once I went to play with Howlin' Wolf I didn't need a day job. You could live. You could eat some beans.

We played in New York, Canada, Austin, down south in Selma, Alabama, all over. Wolf had a station wagon. In Selma, we stayed in a little motel, for colored only. We didn't go to white motels or nothing like that. Wolf would know where to go. It was that way in Chicago too. A lot of hotels and restaurants Blacks couldn't go in. I knew clubs in Chicago, right in the Black neighborhoods, Black people couldn't go to.

Wolf really sang and played the blues about as good as anyone to me. When I played with Wolf, Ray Scott played drums, Willie Young

blew horn, and Hubert Sumlin played guitar. Wolf and Hubert were characters. They would get to arguing.[18] Wolf used to fire Hubert every weekend and hire him back that Monday. He'd fire him because he'd be getting drunk. Wolf would say, "You're fired, go home!" Hubert would have to leave the stage.

A lot of times I wouldn't go on the road; I'd just play in town with Wolf. I left Wolf somewhere around 1969 and went with Johnny Littlejohn [*(1931–1994);*][19] *Calvin played bass on four singles with Littlejohn during 1968-69, on the small West Side label T.D.S. at 3937 West Roosevelt Road*]. Then me and Fenton Robinson [*1935–1997, arrived in Chicago in 1961*] played together one or two years. He sang the blues great. His guitar playing was something like jazz. He played a lot of notes. He had "Hub Cap" [*Richard Robinson*] drumming. We played at the 708 Club and Pepper's Lounge on the South Side.

When I left Fenton, I started playing with Muddy Waters full time. He needed a bass player and I got with him in '71.[20] [*Calvin replaced Sonny Wimberley, who had been Muddy's bass player since 1967.*] The band at that time was Pee Wee Madison (guitar), Sammy Lawhorn (guitar), Willie Smith (drums), Pinetop Perkins (piano), and Paul Oscher (harmonica). That was the band when we did that live album at Mr. Kelly's. It was a big club, big names.[21]

Mr. Kelly's was an upscale nightclub at North Rush Street and Bellevue Place on Chicago's Near North Side. Billie Holiday, Ella Fitzgerald, Sinatra, Streisand, Lenny Bruce and Bill Cosby performed there, among others. Live at Mr. Kelly's was recorded in June 1971 over two nights of the band's three-week gig.

Muddy was a great guy. We used to have a lot of fun together. We'd go out and play, then we'd go back to our rooms and gamble. We played cards—poker and blackjack—and shoot craps. I was lucky with dice; but I could beat them all playing poker. See, poker is kind of a strategy game.

Muddy, Willie, and Pinetop played all through the day. They'd wake up and start playing. Muddy quit gambling because we wiped him out a couple of times. He didn't want me to get his money. So I'd get his driver's money—Bo Bolton. Bo used to gamble. But he'd be broke before he even got into the game. I'd take all his money. Bo was so mad. I told him, "Go tell your boss man to give you some money. Go tell your daddy!" He says, "I'll be back, I'll be back." He went to Muddy for some money, come back, and I got that off him real quick. I said, "Bring your boss around here and I get his money, too!" [*Jerry Portnoy, harmonica player for the band during those years, recalled, "Fuzz was quick to laugh. His voice goes up an octave when he's laughing. He was always in a good mood except when he's gambling. Then it's all business."*][22]

The band changed in the early 1970s. Bob Margolin replaced Sammy Lawhorn and "Guitar Junior" [Luther Johnson] replaced Hollywood Fats [Michael Mann]. Carey Bell replaced Paul Oscher. Then Mojo Buford replaced Carey. Finally, Jerry Portnoy took over on harp, from March 1974 to June 1980.[23]

With Muddy we toured all over Europe, Japan, Australia, and New Zealand. Pinetop and Muddy were good cooks. Sometimes they would cook short ribs, greens, and peas at the hotel if we had a stove. Good home cooking.

I stayed with Muddy 'til 1980. When me, Pinetop, Willie, and Jerry went out on our own, we were called the Legendary Blues Band. We had different guitar players coming in over the years [*Louis Myers, Duke Robillard, Peter Ward, Billy Flynn, among others*]. We played Muddy's tunes and our own music.

Without Muddy's voice, the Legendary Blues Band relied heavily on Calvin as a vocalist in its early years. On the band's first two albums (with Rounder Records), Fuzz sang lead vocals on ten of twenty-one tracks. Even before this, when touring with Muddy in the 1970s, Calvin was maturing as a singer.

"When he was with Muddy, he and Luther Johnson would sometimes do vocals before Muddy came on," remembered guitarist Peter Ward, "—and Fuzz was among the very few who could sing Little Walter songs with authority, like 'It Ain't Right' and 'Just Your

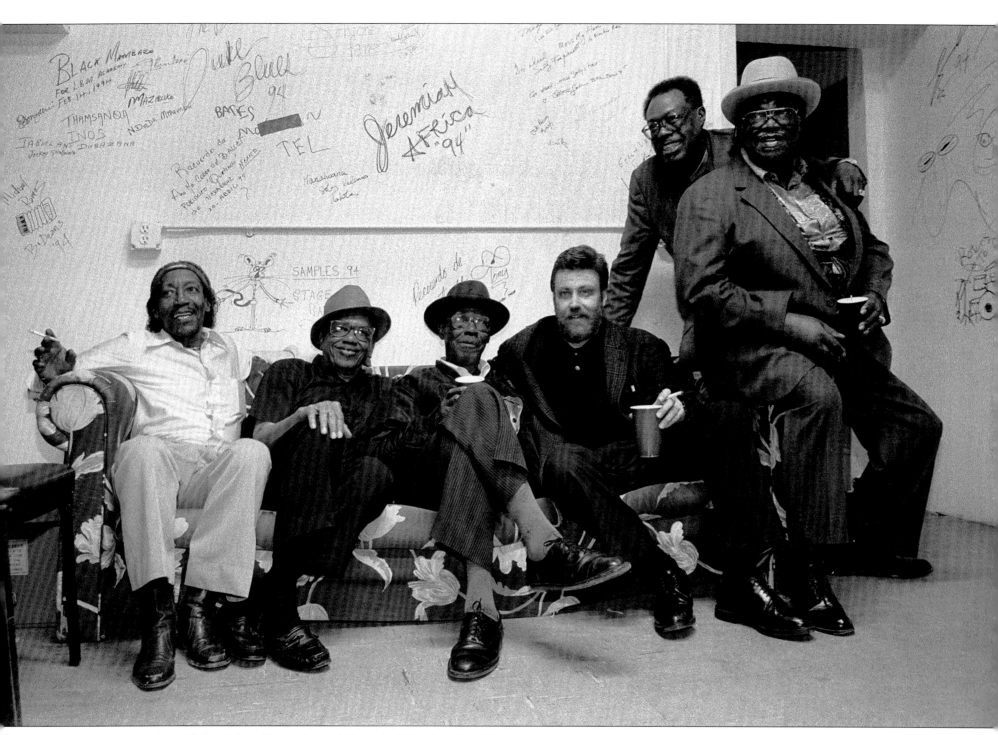

"Muddy Waters All-Stars," State Theatre, Portland, Maine, April 1994 (L to R: Willie Smith, Calvin Jones, Pinetop Perkins, Paul Oscher, Jimmy Rogers, Big Daddy Kinsey)

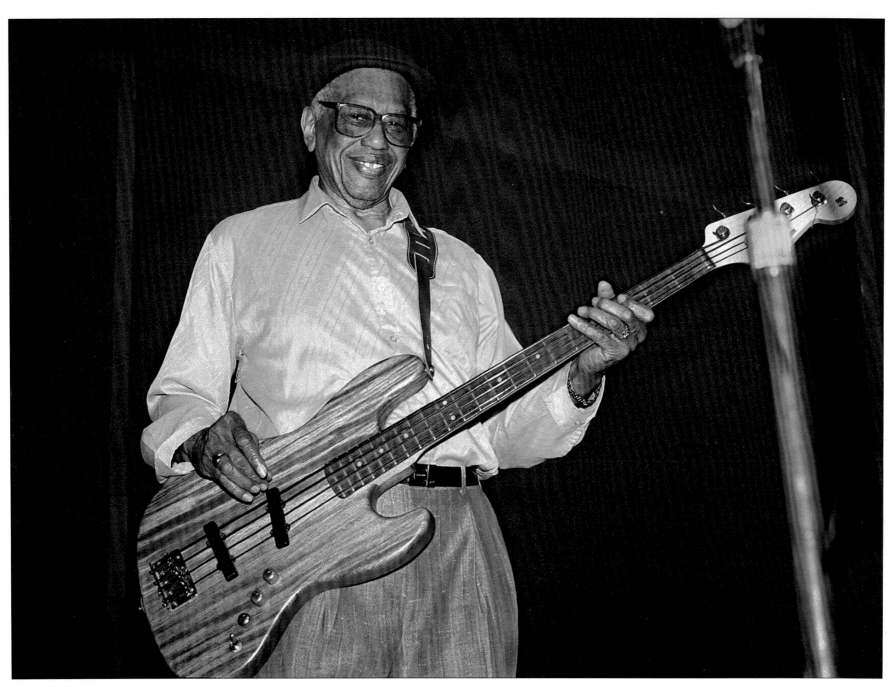

Calvin "Fuzz" Jones, Buddy Guy's Legends, Chicago, April 1996

Fool.' He also sang those with the Legendary Blues Band. We really killed on 'Just Your Fool.' It's one of blues' best songs."

"Calvin is a particularly fine blues singer," said Bob Margolin, of his former bandmate, "often delivering his own vocal interpretations of famous songs by bandleaders he's worked with. . . . On the bass, his signature sound was deep—all the treble is completely rolled off and when he plays a walking bass line, he really drove the band."[24]

Calvin Jones passed away in August 2010 in Southaven, Mississippi, at eighty-four. Bob Margolin, touring in Mississippi at the time, saw Calvin in the hospital the day before he died. Calvin's daughter, visiting from Chicago, was at his bedside.[25]

Willie, reflecting on more than four decades of their friendship in our 2007 interview, said, "Me and Calvin could sit down and talk about things we wouldn't talk to with anybody else. The music brought us together. We locked in and understood one another. We was communicating spiritually through the music before we was communicating physically."

Bob Margolin stresses that "Calvin and Willie should be considered together as well as individually. Along with Pinetop Perkins on piano, they really defined what Muddy Waters' band sounded and felt like during those years. Regardless of the different guitar and harp players, who all brought their own flavor, Willie and Calvin had a sound together that is very recognizable. Calvin's feel, in combination with Willie, could bring back the sound of Muddy's band, even so many years after Muddy was gone."[26]

"It had a relaxed, loping swing to it," said Jerry Portnoy, harp player and Muddy Waters bandmate from 1974 to 1980. "This is a sound you rarely find today. . . . Their style is the way the blues should be played. Fuzz and the old guys said the same thing, 'Take your time. Never play two notes when one will do.'"[27]

My style of playing is no way-out thing. I just try to back whoever is singing or whatever they are playing. I don't try to do no fancy stuff. Playing bass, the most important thing is you play behind the leader and make them sound as good as possible. That's what the bass man is supposed to do. That's the way I see it.

You ask me, "What is the power of the blues?" I don't know what the power of the blues is. I just like the blues, I *love* the blues—Don't ask me why. You ask me, "What's special about the blues?" Ain't much special about it, it's just a thing that you grow up with, and that's where it's at. It just sounded good to me and that was it. I tell you, I feel good over it, I liked it. I wouldn't know what to say to somebody who had never heard of the blues, I wouldn't even try to explain it. The blues is everything I was raised up with. It's just in me.

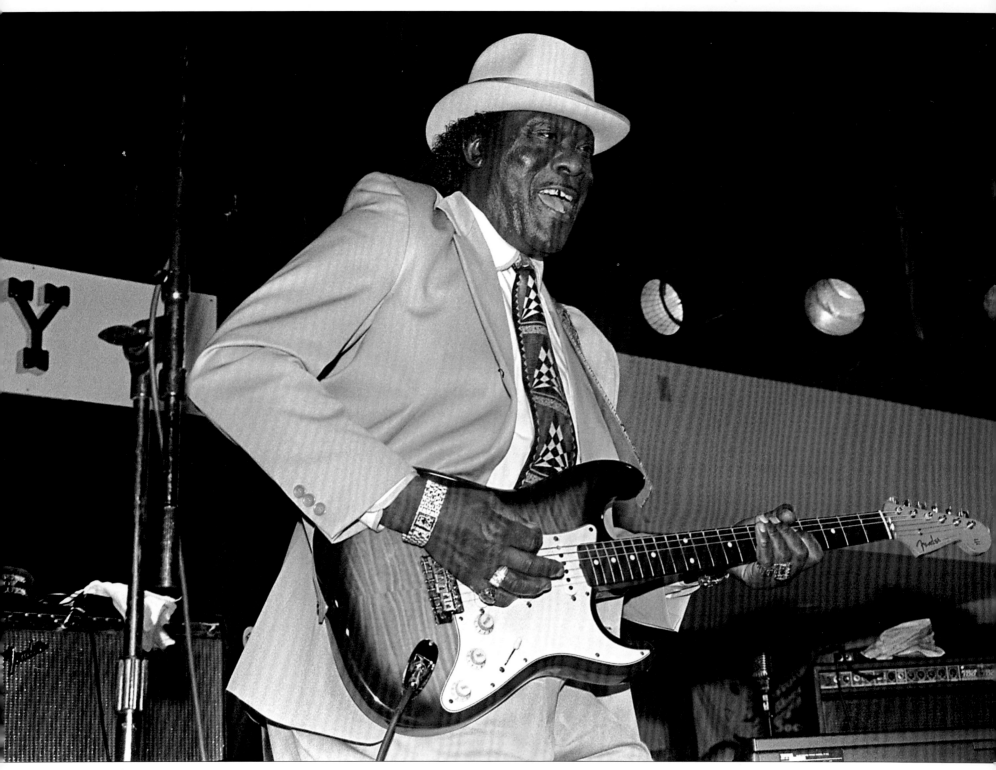
Luther "Guitar Junior" Johnson, Harpers Ferry, Boston, Massachusetts, February 1998

Luther "Guitar Junior" Johnson

I'm a very spiritual person and I come from a spiritual family. The living was hard but there was plenty of love to go around. I was born in Itta Bena, Mississippi, on April 11, 1939. My parents were Luther and Lucille Johnson. Everyone called me Junior. I have two older sisters, Margaret and Daisy, two younger sisters, Bertha and Eleanor, and a younger brother named Shelton. I loved my father and mother—loved all of them. We grew up on our parents' farm, about three miles outside Minter City, Mississippi.[1]

My parents were sharecroppers. We'd all go out to the fields every morning. A day in the field was hard. I had to work from sun to sun—from when the sun come up 'til the sun go down. When you see the stars you were through. You would just do the day's work; it was nothing exciting. It's pretty rough growing up on a farm. Mostly I worked by myself. I cut wood, pumped water, feed the chickens, hogs, turkeys, and ducks, bring the cows out, and plant and pick cotton, corn, beans, and rice. With sharecropping you know what you got to do to take care of your part of the plantation.

We moved around. [*Luther's sister Daisy remembers the family lived on Schlater's Plantation and the LeFlore Plantation before moving to another plantation, Forty-Mile Bend.*][2]

While living on the Forty-Mile Bend Plantation my dad and I used to cut twenty-five wagonloads of wood each year to get us through the winter.[3] The plantation was surrounded by woods. In the winter, when things were quiet, I'd hunt with my dad, cousins, and different kids from the plantation. We'd hunt for rabbits, squirrels, raccoons, possum, pheasants, and other birds. I'd catch so many rabbits my mother couldn't keep up with me! We'd have fried rabbit for breakfast with gravy and rice. I'd catch birds—blackbirds, robins, yellowhammer—with a dead-fall trap that used a stick and weighted plank. We'd go out fishing. I'd catch brims, perch, catfish, buffalo fish, and turtles. On Saturdays, the kids would use nets to get crawfish from the ditches between the highland and lowland of the plantation. Then we'd have a big crawdad fest at night.

Some days you'd go to school, and some days you worked. I went to a school in the Baptist church we went to on Sundays. It was just for Black children. There was one teacher and something like thirty-five kids. We sat in the pews. The teacher would start off with the small kids then teach different grades. I had to get wood to heat the school. We had a tin heater. The boys would keep the heater going. Different boys would take turns going to get water for the school. We had to walk about a mile, a mile and a half, to the well. At least two of us would go, and each of us would carry two pails on a sling.

In the summertime, I herded, milked, and helped brand three hundred cows that belonged to the plantation owner. When I was ten or eleven, my dad started to teach me how to drive a tractor, and we'd drive out in the fields together. By the time I was fourteen I ran the tractors for planting and harvesting the crops. I drove a machine that watered the cotton and kept the bugs off. If equipment break down I take it to the shop and have it fixed.

I became a jack-of-all-trades; anything they needed me to do, I could do it.

At that time, I worked for Archie Sturdivant, the owner of the plantation.[4] Mr. Anderson had the adjoining plantation. I drove his tractor to make extra money when I had time. They didn't bother me; no one did. Everybody I worked for respected me. My bosses liked me because I was a good worker. They'd call me crazy because I was never scared of nothing. They would get all red at me with the shit I'd put in their head, but they'd always give me what I asked. I'd tell them I wanted to go to town, and they'd tell me to walk to town like the other Black people did. I'd say, "I'm not gonna walk, you got a truck out there with a full tank of gas!" Then they'd let me use it. Mr. Sturdivant gave me the best recommendation when I went to Chicago.

Prejudice never stopped me. In Mississippi where I lived if you saw a white woman coming down the street, you better cross to the other side and go around. They had signs, "Black Only" and "White Only." You couldn't go in the white places and buy no food. Black people had to go in the back and order "Black food." They had sliding windows for you to buy food; only whites could go inside. But I went in the front. I'd stand and wait for a long time, but I'd get mine. A lot of Black people used to go knocking on the white man's back door. I never go to no back door. I always went to the front door if I needed something or was returning something. I tell him what I want and I got it. It's all about how you carry yourself in this world.

My parents taught me to be proud of myself, that it's important how you carry yourself. It's not the color of your skin. It's what's in your heart. If I cut myself what do I bleed?—red blood. If you cut yourself, what do you bleed?—red blood. Don't get down on me because I'm Black, I'm not going to get down on you because you white. We're all God's children.

Every Sunday we went to the New Hope Baptist Church and Sunday school on the plantation. I listened to the woman who played the piano at our church, and soon I started to play piano and sing gospel songs in the choir. From the age of thirteen I led the church choir. I did that for three or four years. I'd shake the congregation up the way I'd sing. I can still remember singing some of my favorite songs—"God Is Good to Me" and "Precious Lord Take My Hand."[5] I felt good singing. Everybody was happy. There was shouting and everything going on when I was singing. The congregation loved it, and they'd sing along with me. My mother, she'd be singing in the choir with me and my sisters.

Me and my cousin John Lee got a gospel group named the Spirit of Minter City. We performed in community churches and either Johnny or I would play acoustic guitar. We sang "Ain't No Grave Gonna Hold My Body Down" and "This Little Light of Mine."[6] We didn't get paid, we were doing it for church singing. Some of my songs that I sing today show a little church, have a little spiritual music in them. The blues is spiritual; it carries the feeling of gospel music with it.

I always loved music, but the blues is what really struck me. Dad tried to play harmonica. I used to see him play a Jew's harp. My mom had a phonograph—a RCA wind-up—and she'd play spirituals and Muddy Waters—"Baby Please Don't Go" and songs like that. I'd grab my guitar and start playing, but she'd send me outside. She didn't want me to play or even hear that music when I was young. People back then used to call it the "Devil's music." I could only play spiritual music around her. But my ears stayed open even after my mom sent me out.

We had a battery radio. Wasn't no electricity. We heard stations from Memphis, different places. We heard gospel, blues, country and western. My mother had to leave the field around eleven-thirty to fix dinner for the family. The lady of the house would go home and cook. My parents would be listening to King Biscuit.

We'd go to Minter City on Saturday. My mother used to take me out to different places in town, buy me clothes. The town was a place where people would go to have fun and drink. My old man, he used to go to the juke joints. My mom never did go to juke joints but she'd go to the café in town. There were five or six cafés in Minter City. There would always be somebody selling hot dogs, fish sandwiches; you could eat and listen to the music and have a good time. They had a Seeburg in the café. You put a nickel in the slot and let the juke box rock. I'd hear the music of B.B. King, Jimmy Reed, Elmore James, T-Bone Walker, and Howlin' Wolf. Walking

Luther "Guitar Junior" Johnson, State Theatre, Portland, Maine, April 1994

past a juke house, people hollering and screaming, the music gave me goose pimples. It was too rough—I was too young to take it. The feeling was so *powerful*. I couldn't eat, drink or sleep when I heard the music.

My father's brother, my uncle Arthur Johnson [1914–1994], was a sharecropper, but on the weekend, he'd play his guitar at the local juke joints and house parties. [*Luther's cousin, Nettie Bea Griffin (Arthur Johnson's daughter), remembered: "My dad used to go up and down the road playing the guitar. And when he'd get angry with us, he'd get out on the front porch and practically play all night long—those old-time blues."*][7]

When I was about ten or eleven, he brought me with him to the Saturday night fish fries. He'd take me out something like seven o'clock, take me home around ten; then he'd go back and play all night. He'd play and sing by himself. He'd play stuff that Muddy and them did with acoustic, like Robert Johnson, that style. I remember a song, "Don't Your Peaches Look Mellow Hanging Way Up in the Top of Your Tree."[8] [*Seventy years later, in the summer of 2020, Luther recorded an acoustic version of this song on* Won't Be Back No More]. People would give him dimes and quarters for playing. The house was packed. It was crazy—men and women would drink whiskey, gamble, dance, and sing 'til 5 or 6 in the morning,

sometimes right up until church started. I was small but old enough to know what I'm doing. I thought it was fun and I said to myself, "I want to be like my uncle when I grows up."

I got my first guitar, a Stella [*Harmony*], when I was about eleven [*1950*]—a Roy Rogers Special.[9] My mom bought it for me; I'd been asking her to buy me a guitar for years. I never thought it would happen.

Luther's sister Daisy recalled: "Before that he put a string of wire on the wall and put a Coca-Cola bottle behind it. Luther would slide up and down the wire with the bottle and sing. He'd really hit a note."[10] *Cousin Nettie Bea added, "I can remember when my brother John Lee and Luther used to get some wire off the broom and fix this guitar thing upside the wall. A bunch of us boys and girls used to get out and dance off that."*[11]

I learned some on my own and watched my uncle. My uncle's son, John Lee, showed me what he learned from his daddy. A guitar player named Bo Parker lived on the plantation and drove a truck for the white man. I'd go over to his house. My old man was a bootlegger so I'd bring Bo some of his moonshine whiskey, or beer that my mother made. Then he'd play for me.

It was about that time that the electric guitar came to the country. I heard one for the first time in Minter City, someone was playing it on the street. It really got a hold of me. In the country you could hear the sound of an electric guitar for miles and miles around. My uncle Arthur even got one. The sound—*whooo*—just go *through* you.

Once a year, radio station WDIA in Memphis had a thing called the Goodwill Revue.[12] I was able to see Muddy Waters, B.B. King, and the Staple Singers live.[13] Teacher got a couple of cars, and she would take us to Memphis, whoever wanted to go. I always wanted to go. You heard about them guys back then—like guys playing basketball now—Magic Johnson, guys like that. I wanted to play with Muddy Waters, B.B.—big guys in the name of the blues.

One time, Muddy Waters, Jimmy Rogers, Otis Spann, and Little Walter came to the area where I lived. Jimmy grew up on the same plantation as me [*Forty-Mile Bend*] and his family lived not too far from us.[14] The band was playing at a juke called the Roadhouse in the country, outside Minter City.[15] That's where everybody played; Robert Nighthawk and his blues band came there. I was too young to get in, but before Muddy's show he rehearsed at Jimmy's mother's house where I had the chance to watch them practice. I remember popping my fingers, dancing and screaming because of the music. It was a thrill—beautiful. Muddy was my idol. I told my mom, "Someday I'm gonna play with Muddy Waters! You're gonna pay to see me! I'm gonna make it big!"

I admired Muddy, Jimmy, Otis, and Little Walter. I thought what they were doing was great: to come from Chicago to the country to play at a juke house. If you were from Chicago, you were *somewhere*. Chicago meant so much to me. I'd think "Here I am a country boy, if I ever get old enough, if I can get to Chicago, there's so many things I can do."

I used to dream about Chicago all the time. I wanted to be a musician. I wanted to start making records. I'd tell John Lee, "I'm gonna move to Chicago one day and get me a band." He would say I'd never do it. I'd answer back, "You'll hear me on records!"

In 1955, I finally did get to Chicago. I came to visit my sisters. I was sixteen. I really liked Chicago, but I had to go back to Mississippi; I was still driving tractor. When my sister Margaret needed someone to babysit her two children, I took a bus to Chicago from Minter City junction off 61 Highway—you had to flag it down. White people sat in the front and Black people sat in the back. This time I stayed.

Chicago was jumping. On every corner someone was playing guitar. My sister, Daisy, lived over Scotty & Darlene's Rock 'n Roll Inn [*3649 West Roosevelt Road*].[16] Not long after I got to Chicago, she asked the manager if I could sing at the jam session. I'll always remember that night. I'd just come up from the South, catching the bright lights of Chicago. It's exactly what I had in mind back in Mississippi. I wanted to be part of it.

Luther's sister, Daisy, remembered: "Margaret and I lived together. Luther stayed with us when he came to Chicago. Scotty and

Darlene's had jams on some weeknights, and they had a Sunday jam. I told Darlene, 'My little baby brother is here. He sings the blues.' Darlene said, 'We'll let him come in and do a few tunes.' They couldn't let him stay too long because he was underage."17

Daisy and me, we used to dance at different clubs, halls, and house parties. People had "Waist Parties"—whatever you weighed you had to pay to get in. A lot of people would stop dancing and watch us. We won a lot of dance competitions.

I'd ease in and out of the West Side clubs, like the Happy Home, Foxy Lounge, and the Wagon Wheel. I wasn't old enough to be there; to get in I'd put on a big hat and make a false mustache. I'd go straight to the bar and order 100 proof Old Granddad. That way the bartender took me seriously and I got served. I saw Elmore James, Otis Rush, Jimmy Rogers, Magic Sam, Rice Miller, Little Walter, and Howlin' Wolf—Wolf used to be something to see. He'd sing, shake his butt and clown on stage. I liked all the guys I was hearing. I liked the way Elmore James played slide. I liked the way Jimmy Reed sang and played. I heard his records in Mississippi. I was listening, just trying to get ideas. I would watch their style and how the audience would react. I usually stayed long enough to hear a few numbers and drink a shot before someone saw I wasn't old enough and kicked me out.

Another one of my West Side hangouts was Walton's Corner [*"The Show Place of the West Side," 2754 Roosevelt Road*]. Old man Walton was a good guy. He would hire a lot of local musicians. But you had to be *clean*. Men had to wear a suit and tie. I loved to sit at the bar and drink some wine, dance, smoke my peace pipe, and just observe what was happening. Women there used to call me "Coffee" because I danced so smooth and percolated so regular.

Daisy introduced me to Ray Scott [*the "Scotty" of Scotty & Darlene's—aka Walter Spriggs*]. I started in singing with Ray, Gene Brownlow, and Floyd Murphy in the late fifties. We called ourselves Little Ray Scott and his Rock 'n Roll Band. We were doing a lot of Chuck Berry tunes. I sang and danced on stage. I didn't want to play no guitar. The guys could play so good I didn't want to be embarrassed. We'd end the show with a dance we called, "Putting the Cows in the Pasture." It was wild and full of energy, everyone in the house joining in, slinging their bodies, twisting, shaking, hollering, "One more! One more!" People couldn't take it; we were so hot.

I didn't feel ready to play guitar because the level of playing in Chicago was so good. It was different from down South. I went to St. Louis on a visit and while I was there I joined Little Jr. Robinson's band. When I returned to Chicago I got back with Ray Scott. He taught me how to make different sounds on my guitar "by mouth." He'd say, "Make it go *Dit dit ditto, dit ti dito* on the guitar like this." He taught me a lot that way—that's most of the way I started playing the guitar out in Chicago. [*Ray Scott: "He'd come to my house every day to practice. He couldn't play guitar when I met him, he could only sing. Made him squeeze the guitar just like the sounds from my mouth."*]18

We led the jam sessions every Sunday at Scotty & Darlene's Rock 'n Roll Inn. All we had to do was open the show. Enough bands came by to keep going 'til closing time. Every once in a while, Otis Rush, Magic Sam, and Mighty Joe Young would drop in. I used to be crazy about Sam and Otis. I liked the way Otis played guitar, his smooth blues style—"singing blues" I used to call it. I would go hear him and match his sound." [*Ray Scott: "Sam would come to jams. No one could beat him playing the guitar. The guitar would be talking, squeezed so hard, it's crying."*]19 The jams were a great way to keep learning more notes and songs. On Mondays after work, I'd usually join the band for the "Blue Monday" parties that started first thing Monday and went all through the night.

I got my own band—Little Junior's Blues Band. I'd play gigs with my friends, Little Addison, Jimmy Dawkins, Willie Kent, and Bobby Rush and their bands.20 I met Little Addison [*Nathaniel Addison, b. 1936*] playing in a club on Roosevelt Road. We met in 1958 and played together on and off over a twenty-five-year period. He had a garage on the West Side. Everybody used to come over with their cars and he'd work on them. We'd all meet up, drink, talk, and have fun—Willie Kent, Eddie Shaw, and all of us.

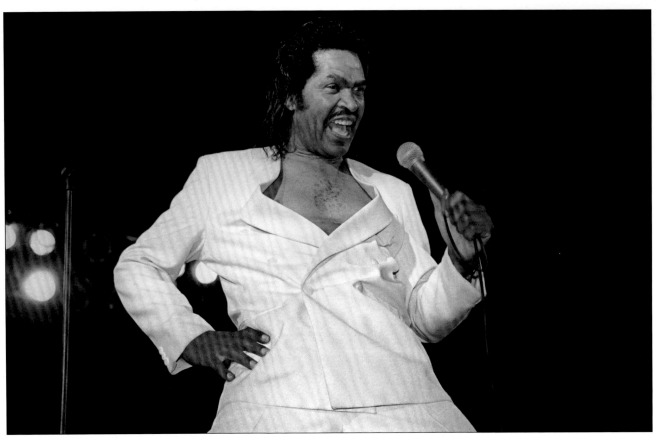

Bobby Rush, Sunflower River Blues & Gospel Festival, Clarksdale, Mississippi, August 2000

I also played guitar with Bobby Rush. I first met Bobby at the Squeeze Club, a bar at 16th and Homan on the West Side.[21] At that time Bobby called his band Bobby and the Four Jivers.[22] Bobby was on bass and I played lead. We did blues with funk, and when we hit the stage me and Bobby would put on a show. We were dancing fools! Bobby danced and clowned while he played the bass. After the show, we'd stay up all night drinking and riding around. We always had a lot of fun.

Bobby Rush remembers, "Luther played with me off and on from the late fifties 'til 1963, when he went with Magic Sam. In '62 or '63 I had an old Cadillac. We were going to Rock Island, Illinois. Luther said, 'I'll drive; you can sleep.' Then he drove for about two hours in the wrong direction while I was sleeping. He went 150 miles east of Chicago instead of west! He burned the car up driving back to get to the club!"[23]

With my band we played anywhere and everywhere around Chicago—Mel's Hideaway, Lovia's Lounge, 007, Happy Home, Globetrotter's Lounge, the Copacabana, Theresa's, Walton's Corner. There were jam sessions all over town. Dance halls offered plenty of work, and house parties went on with entertainment 'til eight or

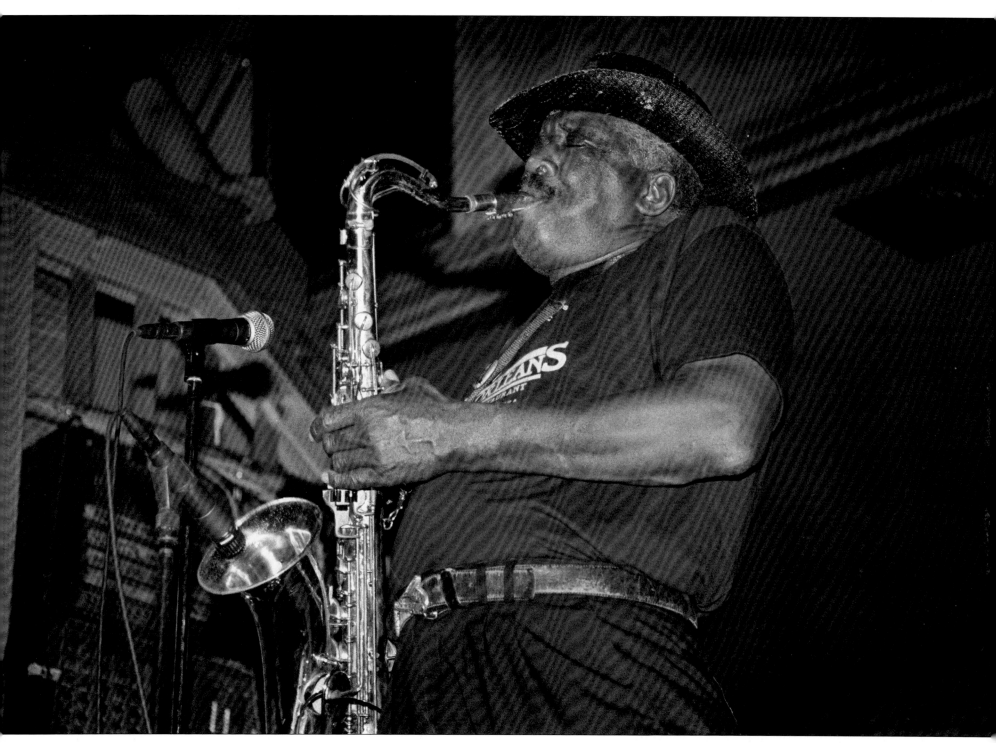

Eddie Shaw, The Rynborn, Antrim, New Hampshire, July 1997

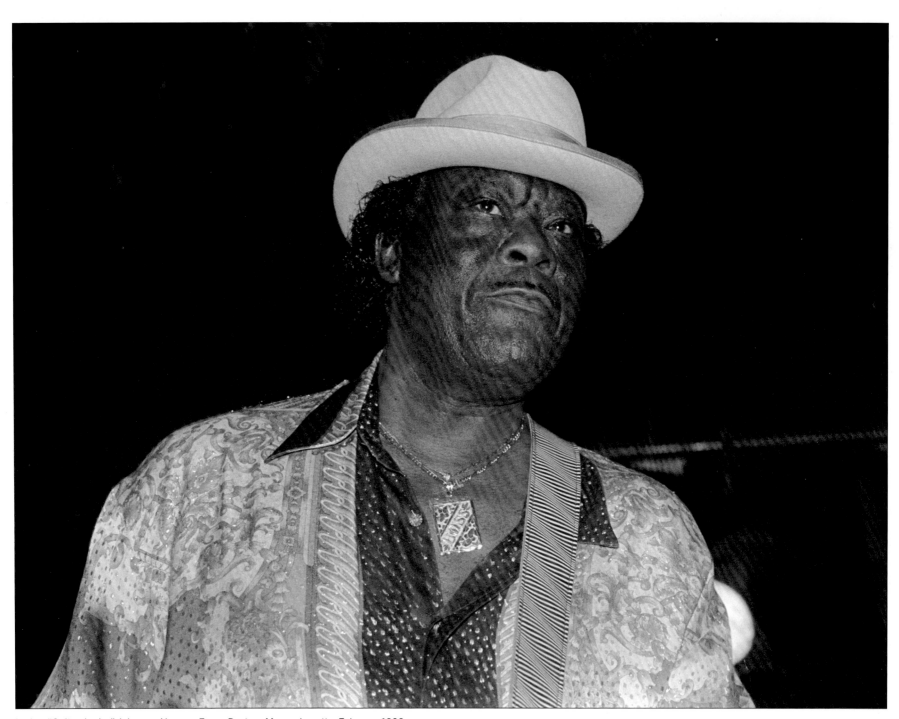
Luther "Guitar Junior" Johnson, Harpers Ferry, Boston, Massachusetts, February 1999

nine in the morning. I might be running or jamming with Carey Bell, Tyrone Davis, Freddie King, Magic Slim, or Mighty Joe Young. I remember backing Koko Taylor up at some of the jams when she was starting out. There were times when I played with Big Mama Thornton and her band. She'd tear the house up every night.

You had to *play*. If you didn't, they "put you on roller skates"—show you out the door. You had to keep up with what was happening. I was playing everybody's music. I see what the audience wants and play it—blues, rock 'n' roll, funk. I had all kinds of moves—I'd jump, hop, and skip. I'd do the splits with my guitar and jump right back on my feet and onto the tables. I'd walk up to the bar and take a shot while I was dancing.

The money I earned from the clubs would never cover my booze. You might make seven or eight dollars playing in a joint. Maybe the bandleader would get twelve dollars. I'd drink all that up in my bar tab. When I'd go to get paid I'd have nothing. Sometimes fifty or seventy-five cents would be charged at the door. When it would come time to pay off it seemed the manager would have the same story . . . "Well a lot of people were here tonight, but they weren't buying nothing. I'll give you a half pint of whiskey and maybe next week we'll make it up." I remember many times I'd walk out of the club, the sun is shining and I'd get in my car and go home. I'd have gone to the club with my gas tank on empty and I'd go home with it still empty. If I had half a man [*a pint*] in my pocket, I was still feeling good, ready to keep partying.

Sometimes I'd get one or two hours of sleep a night. I remember when my sister Margaret used to wake me up to get ready for work. I'd be so mad. I wouldn't say anything to anyone at work and they wouldn't say anything to me. By about two p.m. I'd start to get myself together. I'd say I'm gonna go home and catch up on my sleep. Then someone would come by and say, "So-and-so is playing at such-and-such a place!" Oh boy, there I go again—killer nights!

I had to hold a day job; that's the only way to survive with the money we were making off the music. I worked at Children's Memorial Hospital. I've done construction, steel mill work, transit work, I worked at my sister Bertha's soul-food restaurant at 71st and South Michigan Avenue on the South Side. We made barbecue so tender, black-eyed peas and ham hocks, lots of chicken dishes, and burger specials named after all us kids—"Daisy Burgers," "Margaret Burgers," and yes, "Junior Burgers." I was the bartender and told jokes and kept the people happy.

People were tough in those days and a lot of musicians carried guns. I carried two guns; in case someone took one I had another one. You had to be ready to protect yourself. Big cities like Chicago everyone was trying to play Al Capone. People went to bars looking for a fight or they'd get drunk and want to do something. I've seen people pull a gun for no reason. I always spotted me a place so if somebody starts something I could get out quick.

One night I was playing at a club on the West Side called Sweetheart. I was singing, "Shotgun, shoot him before he runs!" Sweetheart was the owner of the club and her husband, Daddy-O, thought I meant that I was gonna shoot *him*. So he went out, brought back a double-barreled shotgun, and cocked it at me while I was performing. The crowd managed to get the gun away from him. Then I continued my show.

I remember another time. I was playing with my band at the Globetrotter's Lounge. I was wearing a tux and vest and little string bow tie. I owed a guy some money for tires I got from him, but I didn't have the money to pay him before I played my gig. This guy came right up to the stage and suddenly took a hook blade knife out of his pocket. He tried to cut my throat. With the first nick, he slashed the bow tie off my suit. Then he slashed my pants and jacket, I jumped and got a chair and put it across his head. We fought for a while and finally he left. The people who came in later thought I was starting something new, wearing a "slashed suit."

I was very lucky in Chicago, getting the chance to play with Magic Sam [*Sam Maghett, 1937–1969*]. One night around 1963, I sat in with him at Scotty & Darlene's. Sam hired me on the spot and I stayed with him for the next two and half years.

I was drinking a lot back then, and I'd sit in a corner and get high while Sam started up the band. He'd tell the audience, "Let him sleep. When he wakes up, he's fired." Sam would play five or six songs and then he'd come over to my table. "Hey, we done played

six songs while you were sleeping, I'm gonna fire you." Then Sam would play another two or three more songs before calling me up to the stage. I had the Sam Cooke fever, and I always sang his tune, "Somebody Have Mercy." I'd tear the house up and Magic Sam would hire me back.

Sam was a great guy to work with. I played just to be with the man. I always liked his style, the West Side sound. I learned a lot from Sam, but during the time I was playing with him, my music was swinging, too. The music was happy; it would make people get up and dance. We were playing in Black clubs that hold 175–200 people. If you had a three o'clock license you could play until four, mostly that's what I was doing with Sam. We'd start at ten p.m. and play until four. Then we'd go from one club to the next, wherever the bands were still playing. After my time with Sam I played with my own band. I still love Sam's style. I want to keep his sound alive and turn younger fans on to him.

The first forty-five I recorded was a Magic Sam song—"I Been Down So Long." I cut it one Saturday morning in 1968, with Willie Kent on bass, Jimmy Dawkins playing second guitar, "Big Moose" Walker on keyboards, and Robert Plunkett on drums. Big Beat released the single in 1970.[24] It wasn't no hit, but it did pretty well down in Mississippi. [*Big Beat Records was a small independent label distributed from Greenville, Mississippi, from 1962 to 1972.*]

In the sixties I played every chance I got. I lived on 16th and Harding. I would walk down from Roosevelt Road to 16th and Pulaski on the West Side singing and playing my guitar. It got to the point where people started calling me "Guitar Junior."[25]

In 1973, I became a member of Muddy Waters' band. Muddy's guitar player, Hollywood Fats [*Michael Mann*], was going to leave the band. My friend, Calvin Jones, was playing bass with Muddy. He called and asked me, "How would you like to work for Muddy Waters?" Calvin and me go way back—1959. I'd run into him at different West Side bars, like the Happy Home and 1145. I remember him playing with Junior Wells and Little Walter, about 1961, '62; later I saw him playing bass with Howlin' Wolf. We used to jam together. When I had a band I'd call him if I needed a bass man.

Calvin said, "Muddy told me to give you his number and said for you to call him." I was working at the National Cast steel mill, running the overhead crane, pouring steel.[26] That night I called Muddy. He told me he was going to be playing at a place called the Stables in East Lansing, Michigan, on a Friday night [*November 16, 1973*].[27] Muddy said he heard about me and wanted me to come by. He thought we might be able to get something going.

I pulled up to the club—it was big and it was packed.[28] I went to the dressing room and Muddy asked "'Guitar Junior'?" I said, "Yes, that's me." He told me he was gonna do about three numbers and then call me to the stage. I got nervous. I had to play his guitar because I didn't have mine. Muddy played with steel strings, high on the guitar. He played with a slide; I had to play with my fingers. I was worried about how his guitar was going to sound and at the same time my mind was telling me to just go up there and do it. I can do the slide, but I like my style. The fingers do the walking.

Muddy played just one song and called out, "Guitar Junior! Let's give him a hand!" I got Muddy's guitar, told the boys what key I was in, hit it, and went on to play. Soon as I started, people jumped up to dance. Afterwards, Muddy told me, "You're just like they said you was." Two weeks later, Muddy called and said the job was mine. I stayed with Muddy Waters for seven years. I didn't have to keep my steel job anymore. . . .

According to Bruce Iglauer, who later recorded Luther on his Alligator label, "Muddy liked to have two guitar players, one who played more traditionally (Bob Margolin) and one who could squeeze strings and deliver more contemporary material. Luther was more than ready for the big stage and delivered night after night with Muddy."[29]

When Luther joined the band at the end of 1973, the personnel was as follows: Muddy Waters, vocals and guitar; Bob Margolin, guitar; Calvin Jones, bass; Pinetop Perkins, piano; Willie Smith, drums; "Mojo" Buford, harmonica. Mojo Buford would soon leave, to be replaced by Jerry Portnoy. At that point, the group that Muddy would come to introduce as "the Legendary Blues Band!" was set for the next six years.

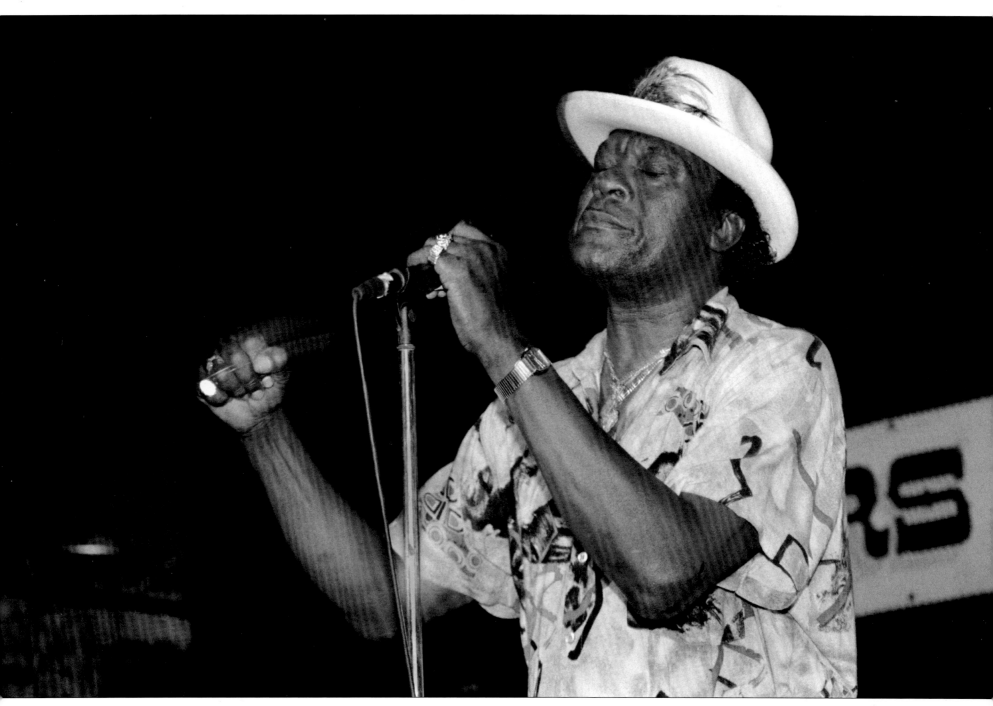

Luther "Guitar Junior" Johnson, Harpers Ferry, Boston, Massachusetts, June 1995

"Luther was a huge part of that band's legendary power," in Bob Margolin's opinion. "Luther had a high blues with a touch of West Side Soul voice and played clear, singing lines and built long solos on his Stratocaster.... He felt and delivered his music powerfully and the audiences always responded."[30]

I first saw Willie [Smith] around '58. He was blowing harmonica with Hudson Shower's Red Devil Trio at the Hob Nob on the South Side. I met Pinetop when he was playing with Earl Hooker [*in the late sixties*].[31] And like I told you, Calvin and me already know each other a long time. I called Fuzz "Uncle Fuzzy"; he called me "Junior." We all became tight; we all was good—"Tighter than a frog's booty, and that's water-tight!" Willie used to say.

The band would do three numbers and I'd call Muddy up to the stage. Muddy was a great man and I couldn't wait to go to work to hear his sound. Muddy had his own style. I just loved that voice he had, the way he played with his guitar. I learned stage presence from Muddy. We'd go out there and do our work and satisfy Muddy. I wanted to make Muddy's job easy for him.

According to Brian Bisesi, who was road manager and backup second guitarist for the Muddy Waters Band in the late 1970s, Muddy was just as much impressed—"tickled"—with the presence Luther brought to their shows.

"Junior tickled Muddy," reported Brian. "He loved it that Junior was always dressed sharp. Muddy turned to me several times and said, 'That Guitar Junior, he's a natural born showman.' Muddy loved it that Junior could stir up a crowd. When Muddy was tired he would send Junior out to front the band for an encore. He'd say, 'Get 'em, Junior!' Junior could really command the stage."[32]

We all cooked on the road, except Calvin—he stayed away from cooking. We carried hot plates, but most of the time we had a kitchen, stove, refrigerator. We'd have steak, fish, whatever your taste buds call for. Pinetop cooked beans, black-eyed peas, greens, anything. Willie used to make fried chicken and rice. You'd have chicken bones flying everywhere. Muddy used to cook beans. If you wanted rice and pinto beans, neck bone, put 'em on early that morning. Dinner time come, you're *eating*—eating well.

When we were traveling with Muddy in Europe, we'd all go down to Willie's room 'cause when we got there we didn't have nothing to eat. Willie was known for having that chicken; he'd bring chicken wings on the plane in a bag in his suitcase. It would last a couple of days. The first time I was going over there with Muddy [*for Montreux Jazz Festival, June 1974*], I didn't know how it was. I saw Fuzz getting candy bars and cookies and things in his bag. I thought he was a sweet mouth. I get over there and about ten o'clock I looked out the window and nothing is open. I'm *hungry*. So I knocked on Fuzz's door—"Why don't you get something for us?" He says, "Man, you ain't going to find nothing in this town. I got three or four candy bars." I said, "Give me those motherfuckers!" I was eating candy like I was eating *steak*.

Muddy was crazy about Willie 'cause Willie drove the van and took care of the business. I started driving for Muddy in 1975. Before me, Muddy's driver was Bo Bolton [*Andrew "Bo" Bolton, a childhood friend of Muddy's*]. Bo got ill. He couldn't drive so I taken his place. Muddy started riding with me in the car behind Willie in the van. Muddy used to call Willie on the CB; he'd call him "Chicken Bone" because when Willie ate chicken he'd leave the bones in the van—"Breaker one nine for the Chicken Bone!"

On the road with Muddy, Fuzz and Willie used to gamble all the time. I have seen them gambling for two days and two nights straight—dice and poker. Sometimes Willie get Fuzz and sometimes Fuzz got Willie; most times Fuzz had Willie's money in *his* pocket. Payday come, Fuzz be, "C'mon, c'mon"—ready to roll the dice again. Sometimes Bo and Pinetop would gamble. Fuzz used to have all our money in his pocket and laugh about it. Muddy used to say we was in Las Vegas 'cause there was so much gambling going on.

Muddy was no big gambler. If he's winning, he be right there. You give him a couple of licks, he says, "Whoa, whoa." He goes home.

I gambled a little bit. I get down two or three licks, then if I win, I'm gone.

Said Calvin: "Luther hit you and he's gone. You don't get that back." Willie Smith added, "Luther was like a duck—you had to catch him quick. When he comes in to gamble, he was either lucky or he wasn't. If he was lucky he was going to hit a couple of hands and he was out of there."

In October 1975, two years after joining Muddy, Luther took part in a series of historic recording sessions when the French blues label, MCM, came to document the Chicago scene.[33] MCM's point man in Chicago was Luther's friend, Jimmy Dawkins, who had met the French producers while touring in Europe five years before. In 1972–73, Ma Bea's had been home base for Jimmy's band, so he knew it would be a "crowded, lively, and fun" venue for MCM's project.[34] Over the course of five nights (four at Ma Bea's and one at Sweet Queen Bee's Lounge on the South Side), MCM recorded enough material for five LPs.

When we had time off from Muddy we could do our own thing—even make our own recordings. People come from Europe to record us in 1975. Jimmy Dawkins was going to Europe pretty good then. He spent a lot of time in France. Jimmy got a bunch of us to come to Ma Bea's to record for MCM. A lot of recordings was going on with different guys. MCM would give them three or four hundred dollars each.

Ma Bea's was a good place. Many nights I played there with Willie Kent and his band, Sugar Bear and the Beehives. Jimmy Dawkins, Jimmy Johnson, a lot of us used to play at Ma Bea's. [*Bruce Iglauer remembers: "I used to see Luther often at Ma Bea's on West Madison, and he never failed to tear up the joint. He always played hard, with plenty of attack, pushing the songs forward, exuding energy."*][35]

Willie had a regular gig there. For MCM, Willie and I played on each other's first albums, which we recorded at Ma Bea's on the same night [*October 17, 1975*]. Mine was called *Ma Bea's Rock*; it featured me and Jimmy Johnson. Willie backed me on bass. [*Willie Kent's album was Ghetto; Luther played on two of Willie Kent's tracks*].[36]

During my years with Muddy we traveled the world, performing at concerts and festivals all over the US and Canada, Europe, North Africa, Australia, and Japan. We were touring in Europe with Muddy in 1976. Because of *Ma Bea's Rock*, the Black & Blue label wanted to record with me. So the six of us [*Muddy's band minus Muddy*] went into a studio in Zurich, Switzerland, and made the album, *Luther's Blues* [*Black & Blue, 1977*].[37] Two years later on another tour in France I made a second album for Black & Blue—called *I Changed*—with Pinetop, Willie, and Calvin [*recorded live in July 1979 at the Grande Parade du Jazz in Nice*].

While working with Muddy, I was on three of his albums—*Unk in Funk* on Chess (1974); and two on the Blue Sky label—*Muddy Mississippi Waters Live* (1979) and *King Bee* [*released in 1981, after the band had broken up*].[38] During the recording of *Muddy Mississippi Waters Live*, the audience was dancing and stomping their feet so hard they put a hole through the floor at Harry Hope's joint.[39]

The band broke up in early June 1980 after returning from a tour of Japan. We all came to agreement that we would quit at the same time. Three bands came out of the break-up with Muddy—my band [*the Magic Rockers*], the Legendary Blues Band, and Bob Margolin had his own thing.[40] We all remained friends; we always be glad to see each other when we meet up on the road. We continued to play and record some of Muddy's songs with our own groups.

When I left Muddy's band in 1980, I decided to leave Chicago. There were too many blues bands there, so I said it would be best to go somewhere else and make a new foundation—start my own band. That's why I came to Boston. I knew there were a lot of clubs around from my years with Muddy. [*Paul's Mall, the Paradise, the Berklee Performance Center, the Boston Garden, Club Boston, and the Orpheum—Muddy's band played them all in the 1970s.*]

When I first came to Boston I stayed with "Mama Rose." She was everybody's home away from home. She used to cook for all the bands that come to town. She would show up when we played at the Jazz Workshop and invite us to her place. She'd have beans and greens, chicken, fish, corn bread; her food was delicious.

Mama Rose was a hospital worker who lived on Francis Street in Boston; her full name was Rosie Lee Hooks (1923–1984). Ron

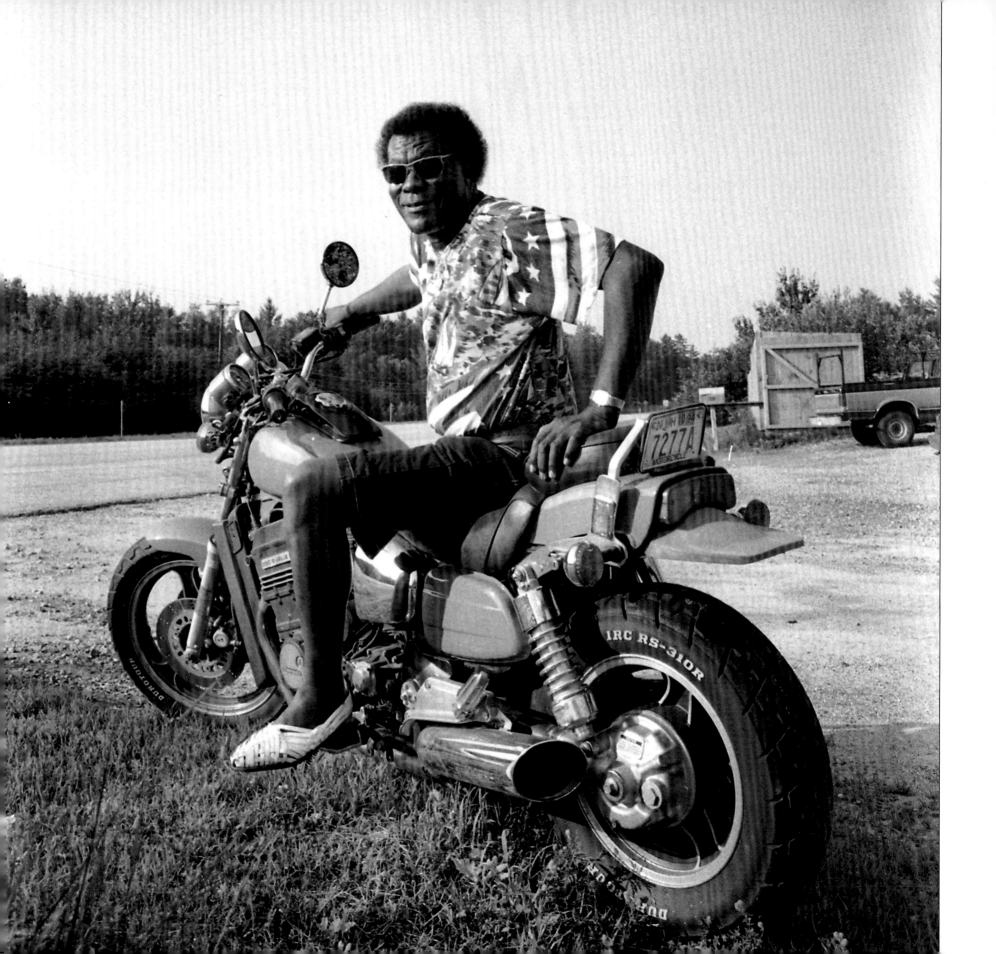

Levy in his book Tales of a Road Dog, recalls her as "... loving, dignified, smart, wise and sharp ... a truly good human being..."[41] According to her daughter, Rosa Mae Bentley, "My mom grew up in Alabama. She was a supervisor in housekeeping for Children's Hospital.... She got her nickname 'Mama Rose' from her cooking and feeding people, letting people stay at her home. She raised us to take care of others, help each other.... Muddy's band used to come to Boston a lot and the band would come over."[42]

I got a four-piece band and called them the Magic Rockers—Michael "Mudcat" Ward on bass, Ola Mae Dixon on drums, and Brian Bisesi second guitar. I came up with the name the Magic Rockers to honor the memory of Magic Sam.[43]

Muddy always told me I could make it on my own, and he was right. But when you get on your own, you have to make your own name. People said, "Hey, you just played with Muddy." They wanted to see what *I* could do. Starting over wasn't so easy. When I first come to Boston, I used to sit and play at the Charles River. I painted houses to get by. I remember when I used to run my phone bill up to $700 just to get two gigs a month. The people I'd call would try to get me to play for the least amount of money. I worked so long for $250–300 that when I started collecting $500 I thought I was making some real money. I started getting more work after my agent, Paul Kahn, began booking me.

According to Paul Kahn, founder of Concerted Efforts, "Musicians in the tight-knit Boston blues scene suggested that I work with Luther, who had just moved to Boston from Chicago. Michael 'Mudcat' Ward, bass player with Sugar Ray and the Bluetones, started telling me about Luther and how he was a great performer and a high-energy showman. I recalled seeing Luther slay the crowd as a member of the Muddy Waters band. Luther became a client of Concerted Efforts in 1980 or 1981."[44]

Left: Luther "Guitar Junior" Johnson,
Antrim, New Hampshire, August 1995

In 1982 Luther was invited to Europe for the Montreux Jazz Festival. Although he'd played the festival for several years with the Muddy Waters band, this was the first time he was featured under his own name. Luther's performance was recorded and issued two years later as part of Atlantic Records' Blues Explosion. The album was awarded a Grammy in 1985.[45]

While in Europe that same summer, Luther also performed at the first Cahors Blues Festival in the south of France. Today the festival is the longest-running blues festival in France and is commemorated on a Mississippi Blues Trail marker in Cahors. Luther's name and photo are featured prominently among the greats on the plaque.[46]

Over the years there have been a lot of people in and out of the band. I had beautiful guys that played with me—wonderful guitar players, sax players, and harmonica blowers. The Magic Rockers was *strong*. That's the reason I made it on the East Coast. The Magic Rockers is my company, whoever plays with me, and we're still going strong today.[47]

I dedicated my first album with the Magic Rockers, *Doin' the Sugar Too* [Rooster, 1984], to both Magic Sam and Muddy Waters. We made that album in June 1983, just two months after Muddy died. *["One of the best blues albums to come out of Chicago in twenty years." according to* Real Blues *magazine.]* On the album I recorded "I'm Ready" for him [*a Willie Dixon song but made famous by Muddy*] and I wrote "Hard Times (Have Surely Come)" using Sam's music [*"All Your Love" from Magic Sam's album* West Side Soul]. That song was nominated for a Handy award for Blues Song of the Year in 1984.

Being part of the Grammy-winning album *Blues Explosion* was a great moment for this Mississippi kid. Koko Taylor, Stevie Ray Vaughan, J. B. Hutto, John Hammond, Sugar Blue, and me—we all got Grammys for the songs we did at the 1982 Montreux Jazz Festival on the album. It won Best Traditional Blues Album of the Year for 1984; my contribution was a cover of Rufus Thomas's "Walkin' the Dog," with J. B. Hutto's "New Hawks" rhythm section behind me. The awards felt good; they let me know I was doing something right.

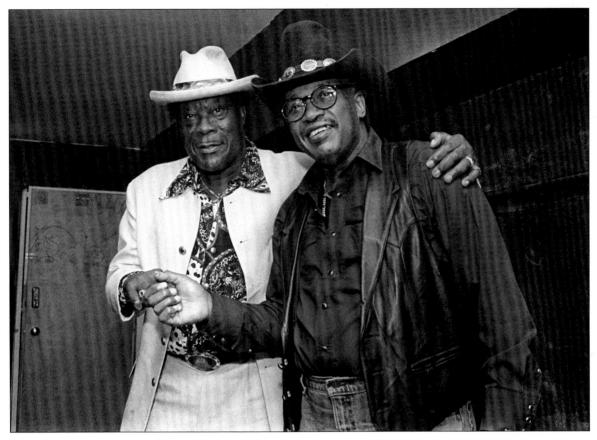

Luther and Otis Rush, Iron Horse, Northampton, Massachusetts, October 2000

In 1988, I wrote and recorded two singles for the Pulsar label in St. Louis. One was "Woman Look What You're Doing to Me"—I got a Handy for Best Blues Single of the Year for that one. I did Sonny Boy Williamson's "Nine Below Zero" for the flip side. The other single was "Love Your Sexy Ways" with "In My Younger Days" by Sonny Boy on the B side. [*On these singles, Luther was backed by Oliver Sain—considered the "Godfather of Soul" in St. Louis—on horns, and Rock and Roll Hall-of-Famer Johnnie Johnson on piano.*][48]

Over the years I spent more time touring with the Magic Rockers than I spent at home. We traveled all over the United States, Canada, and Europe. In 1989, the US government sent me to the Caribbean and Central America as a goodwill ambassador. There have been many memorable shows over the years. . . .

During the 1996 Summer Olympics in Atlanta, a special House of Blues was set up in the city. Dan Akroyd invited me to perform as one of his featured guests for a live broadcast. I knew Dan from the *Blues Brothers* movie [1980]. I'm in the opening scene on Maxwell Street in front of Aretha Franklin's restaurant.[49] With the Blues Brothers Band backing me up, I did "Call Me Guitar Junior."

In September 1996 I did a tour with the Magic Rockers in Europe. At the Handzame Blues Festival in Belgium, we went on just before Luther Allison. Toward the end of his set, Luther called me up on

stage. The two of us got going and the crowd went nuts. It felt like old times in Chicago when we used to jam with one another on the West Side. I felt the same way when Bobby Rush and I played together during his show at the House of Blues in Cambridge, Massachusetts, in 1997. That was a great reunion; it had been over twenty-five years since we last saw one another. I always tried to see my Chicago friends when they came around. I played with Carey Bell at the Rynborn. I shared top billing with Eddie Shaw at the Rockland Blues Festival [1997] and with Eddie Clearwater at the Boston Blues festival [2005]. I visited Otis Rush backstage at the Iron Horse. That's what's fun about this work. You get to play and catch up with old friends.

Tours as the Muddy Waters Tribute Band kept us together. In June 1996, Telarc released a CD to honor the memory of Muddy Waters—*You're Gonna Miss Me When I'm Dead and Gone*. It was nominated for a Grammy and featured all of us as "the Muddy Waters Tribute Band." The tune I did on the CD, "You Can't Lose What You Never Had," reminds me so much of Muddy. I always liked to hear Muddy sing that song.

I played in Shanghai, China, and Hong Kong in 1997. My performance with the Magic Rockers at the Shanghai Center Theater was broadcast across Mainland China. The promoter said, "Don't feel bad if the people don't dance." I told him, "*I'll* have them dancing"—and I did. After the show in Shanghai I flew to Hong Kong with my sax player, "Cookie" Lynwood Cook. The people in Hong Kong liked us so much that the club changed my return tickets and booked me to play an extra night.

In April 1999 Luther received a Distinguished Achievement Award from the University of Massachusetts, Amherst. This was a two-day symposium ("The Blues Lives On"), part of UMass's 28th annual Black Musicians Festival. Along with Luther, Clarence "Gatemouth" Brown was honored. The two participated in a panel discussion of "Personal Reflections" and each gave acoustic-solo mini-concerts.

I always wanted to make an acoustic album. After years of playing and being on the road, I did. In June 2020 I sat down in my living room and recorded *Won't Be Back No More* [*a solo acoustic CD of sixteen blues standards and Luther originals, including the eleven-minute autobiographical "Florida Blues"*]. A few months later I sent for the Magic Rockers. I told them I wanted the band to come down to Florida to make a live recording with me. We made *Once in a Blue Moon* at the Hideaway Café in St. Petersburg on Halloween [*October 31, 2020*]. I've been promoting these albums while playing around Massachusetts, New Hampshire, and Rhode Island [*2021*]. On some of these shows Magic Rockers Michael "Mudcat" Ward and Gordon "Sax" Beadle joined me; so did Peter Ward—he played with the Legendaries. I sung "The Luther Johnson Thing" on his album, *Train to Key Biscayne*.

Looking back over the decades, Gordon Beadle proclaimed, "You couldn't top Luther when it came to getting over with the audience. He had, and still has, that something you can't explain. Maybe the reason I play hard and don't hold much back partly comes from my years touring with Junior. He encouraged the band to go for it because nothing we could do would take the spotlight from his voice, his guitar, and his command of the stage."[50]

The blues is my thing, but I can play many styles of music. I never plan ahead what music I'm gonna play and I often change the way I play a song. Depending on the audience I might mix in some soul, R & B, funk, and gospel numbers. But, whatever I'm doing, I always play the music of the bluesmen who came before me. The songs of Muddy, Magic Sam, Howlin' Wolf, Elmore James, Jimmy Reed, Sonny Boy Williamson, and the others are great, and it's important that my generation keeps the music alive. For some people, it's the only way they learn about the music. I try to record one or two of the older guys' blues numbers on each of my records. I like to do my own arrangements to their songs and I play them my own way. Then, when the song goes out, it's got my soul into it.

I never rehearse with the band 'til I get in the studio. I don't have anything written down. I can walk in a place and get an idea for my blues, write a song just from the words that come out of

Luther "Guitar Junior" Johnson, at Margo Cooper's, July 2021

someone's mouth. When I'm playing to the people I watch them and see how they react. If they dance and like it, I record it. I have a computer in my head. I write songs out of my head, keep them in my head and record them.

When you see "Guitar Junior" you are going to see a *show*. I work hard to keep that name. When I get to the stage it's magic—magic that I have in me. I'm trying to give the audience that piece of me. Once I sting you with my music I *got* you. You always coming back for more.

Michael "Mudcat" Ward, who has seen that magic many nights in his years playing with Luther, recalls "In the early eighties the Magic Rockers played a big hall in Winnipeg, Canada. We were cooking. Junior started the set from the opposite side of the hall from the stage. He had a wireless guitar and worked his way through the crowd—he wore a satin shirt and had a gold medallion around his neck. Junior was wailing on the guitar—playing the "Sugar Too." The audience was going nuts! He was having a ball. People were all around him. Junior walked through the crowd like he was parting the Red Sea."[51]

The love is what I give people. I'm like a preacher preaching to a congregation. I could be a preacher if I wanted. I bring my audience to me. Just a touch of my music is so strong. Sometimes I talk to people and they *tremor*. It's more than just playing. It's spiritual; it's a feeling and it's pure. Got to be God sent. I believe in God very strong.

Being on the road can't bother you. It would worry me if I wasn't on the road. That's my job. If I wasn't on the road where would I be? It don't matter how much money I have, if I was to hit megabucks, I'd still be on the road. It don't matter nothing to me because that's what I like and what's keeping me happy.

Members of the Magic Rockers can testify to this. "Luther's either got a guitar or steering wheel in his hands," wrote Ron Levy some years ago in the liner notes to Country Sugar Papa. "To have 50,000 miles on a two-year-old van is normal . . . When I was in the band a ten-hour drive was considered a 'local' gig, and still is."[52] *And Gordon Beadle, longtime sax player for the band, recalled: "Luther was legendary for his power drives. One time we drove fifty-eight hours straight from Portland, Oregon, to Boston."*[53]

From the time I was a kid, I've wanted to reach other people through my music. My life is the people, the road, and playing the blues. You got to have a feeling for *people*. If you don't have a feeling for nobody, what can you do? Nothing. The feeling for music is in me and it's just got to come out. Each song that I sing, I'm looking to hit someone softly. Music is powerful; it can heal you and it can kill you. It's got to be played with a feeling. I feel every damn thing I'm playing. My music is a gift from above and I want to use it as a gift, share it with my fans. If I couldn't play and sing, I could be back in Mississippi, I could be locked up in jail. You never know.

According to how my life as it is now, I'm glad I am able to play guitar and the people still love what I'm doing. It makes me proud of myself. On stage I feel like an apple. Somebody always picking me because I do a good job. I love performing. And I love playing to peoples. I still love it. Like I can't give them enough. [*"I can see him now," said his old friend and bandmate Bob Margolin, "—pounding, burning, crying solos on the edge of the stage, sweat pouring off him in big drops."*][54]

I feel lucky. For all the years I dreamed about playing the blues, my dreams came true. I'm glad I can carry on the blues tradition and bring this music to people all over the world. I've had the chance to play with many of my heroes, and I've got great friends playing the blues today. As long as I got life in my body and I can move my fingers, I will play the blues. Just like the Little Walter song says, "I love the life I live and live the life I love."

Luther passed away in Florida on Christmas Day 2022.

Margo Cooper: I visited Luther in the hospital in early December 2022 and spoke to him just days before he passed. It was Luther's fervent desire to return to New England, reunite with his Magic Rockers, record a new CD, and be back on stage.

Luther was diagnosed with diabetes and kidney disease before we met. I witnessed Luther courageously fight to live and perform throughout the rest of his life. Luther learned how to do self-dialysis while waiting for a kidney transplant. Despite the logistics and risks, Luther carried on, bringing equipment and jugs of solution with him during one of the Muddy Waters tribute tours. No way was he going to miss the gigs!

Luther's repertoire was immense. Blues was his passion, so was soul, any music with a feeling. Luther was the consummate professional. He always arrived early for a gig. Luther dressed with a flair and an impeccable style all his own. Luther owned the stage. He swaggered, danced with his guitar, shook his hips, pumped his fist in the air, and kicked his leg while playing. Luther hollered, howled, and screamed. He took the audience higher with his performance and fabulous vocals. Fans danced; young men gathered at the front of the stage, in awe, intently watching Luther. Luther was known for exceeding set limits—even into his eighties. Luther gave his all to every performance and expected the same from the Magic Rockers.

When Luther sang "I suffer so hard for the blues," he meant it. Luther savored every opportunity to sing and play and bring joy to his fans. As it started to pour at an outdoor concert in Canton in 2021, Luther invited the audience to join him under the open tent and dance the night away. And we did! When rain threatened an afternoon backyard party at my home, Luther stepped outside; the rain clouds moved on. Playing and singing the blues with friends always raised Luther's spirits and the spirits of those around him. Luther looked and felt years younger; he was rejuvenated, so happy.

Luther had a deeply spiritual side. At night, even after a late night performing, Luther quietly said his prayers while seated at the side of his bed. At one of his last outdoor shows in 2020, Luther proclaimed, "I sure wish my mother and daddy were here tonight. I know they're looking down on me."

I sure wish I could have put this book in Luther's hands. . . .

Part II
THE DELTA

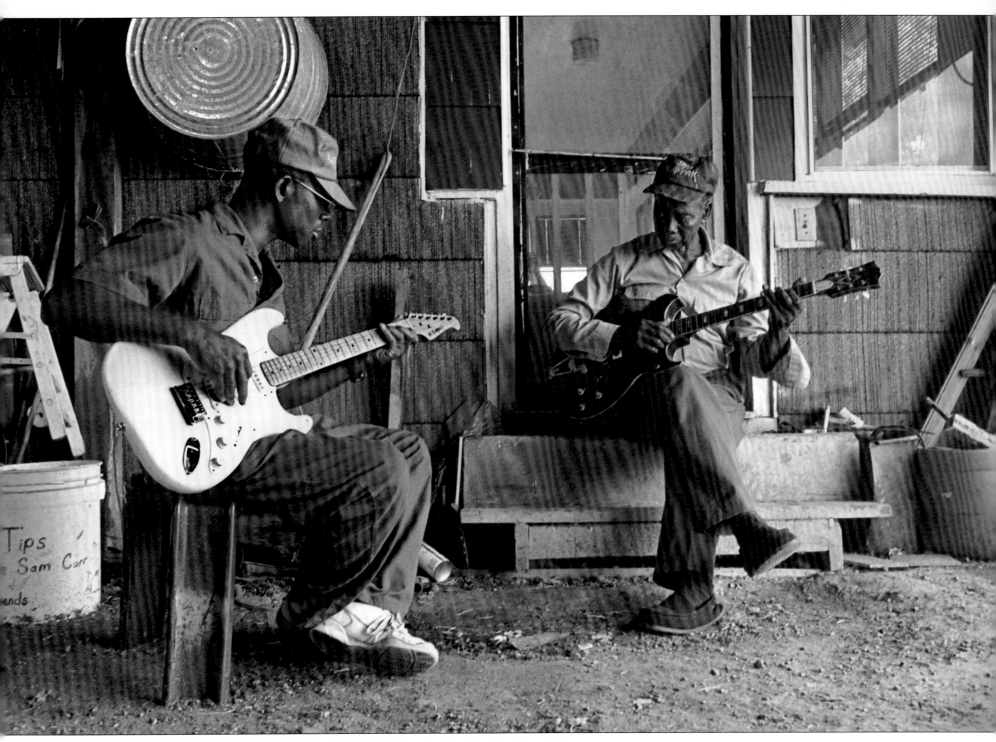
Andrew "Shine" Turner (left) and Sam Carr at the home of Sam and Doris Carr, Dundee, Mississippi, June 2001

Sam Carr

Samuel Lee McCollum—that's my real name. I was born April 17, 1926, about twenty miles from Helena, near Marvell or Marianna, Arkansas, I don't know which.[1] My mother's name was Mary Griffin. That was her first name; then she wound up being Mary McCollum. Robert Nighthawk was my father. He wasn't called that yet; his real name was Robert Lee McCollum. [*McCollum was not known as Robert Nighthawk until around 1940; he also sometimes recorded under the name Robert McCoy.*]

They married and had two children—me and my younger sister, Ludy Mae. [*Mary Griffin was eighteen when she married Robert McCollum on December 4, 1925; Robert was only sixteen.*][2] Something slipped up there. They didn't want no children. She wanted to be out in the world with Robert playing and didn't have time to feed a baby.

After I was born my mother came over to her auntie, Mary Ford. They were on Frank Alexander's farm, three miles west from Dundee, Mississippi.[3] We was livin' in a little one-room house. The Carr family [*Garfield and Mozella Carr*] lived close to us, just about next door. One day my mother left me by myself, so the Carrs came to see about me. I was covered with sores. I would have died if the Carrs had not taken me in; they got me to their house and cleaned me up. They took me to the doctor's and the doctor straightened me out. I had something they called the "seven year itch" [*scabies*].[4]

My mother told the Carr family they could have me if they want. The Carrs kept me about six months and went back and got an adoption when I was one and a half years old.[5]

The Carrs farmed; they raised cotton. They had a garden for themselves with cabbage, okra, tomatoes, snap beans, beets, corn, lettuce. They raised corn for the mules. I took some of it to the gristmill to have it ground into meal, but flour they had to buy. They had cows for milk, mules to work the farm, and chickens. They raised their own hogs, for meat. They did all the killing and I help clean them. I just run around the house when they shoot them. I raised up them pigs, played with them, pet them. I didn't have the heart to kill them.

When I got big enough, I helped with the garden and the cotton. And watering the hogs, slop 'em, feed 'em, cut the grass for them in the summer and give them corn in the winter. You had to cut the yard with a hoe clean down to the ground, cut all the weeds and rake them back to the edge of the yard. All that work was rough. And when the leaves died, you burned them. You did all that after you finished chopping in the fields. You didn't do nothing until you finish chopping.

My mama would come by once a year. She was glad the Carrs took me in because they took care of me real nice. The Carr woman wanted me to know my mother. My mother never tried to get me to leave them because I was living better than she was. The Carrs told me my daddy was a musician and my mama went around with him.

I saw my daddy for the first time in 1933. I was seven years old. He came by in a T-model Ford with Henry Townsend. Robert told me: "I know you ain't seen me or know nothing about me. I just

want you to know I'm your daddy, whether you believe it or not." He was right; I *didn't* believe it. I said, "You ain't! My daddy's Garfield Carr!" Robert didn't look more than a boy to me. Mama Carr had to make me believe he was my daddy. Robert was there for about ten minutes; I didn't see him no more until 1937.

In 1935, the Carrs bought their own farm, forty acres on Annie Collins Road, about three miles from Dundee.[6] That's where I finished being raised up. Dundee was busy every day. The old 61 Highway ran out through the town. People came to Dundee from miles around to do their business. All the stores were run by white people. There was a blacksmith shop and next to it was a general store, Mr. Fisher's store. On the other side was Terry's store, clothing and shoes. Baldwin's general store was across the alley. There was another store, more like a café. It had a Seeburg with all kinds of music, blues, and fox trot. People would dance. Anyone could go in, Black or white, which really wasn't happening back then.

I went to school 'til I was sixteen. After the Carrs bought their land I went to the Prospect grade school. Prospect was a church and school together. There were about fifteen to twenty kids in the school, all colored. The last school I went to was called Rosenwald.

"Rosenwald schools" were financed by the Julius Rosenwald Fund in Chicago to support public education for African Americans in the South. From 1917 to 1932, more than six hundred Rosenwald schools were built in Mississippi.[7]

What racism did I experience? All of it. I had to respect the white man as much as possible. There were always some Black children plum scared of the white people. I wasn't one of them. My brother, Willie Carr, gave me the devil because I used to walk with my head down.[8] He'd tell me, "Never look down, always hold your head up. You ain't scared of nobody!" I was taught never let nobody whup me. In my childhood when I was going to school, Mama told me I better fight anybody that jumped on me thinking they were going to whup me—that was wrong, white or Black. That's what started me looking out for myself. I didn't wait for nobody to get their two cents too far, before I let them know they had something else to contend with before they decided they were gonna jump on Sam Carr. That way I never got hurt.

When I was a boy, I heard a man named T. C. Glisper play guitar. T. C. played the blues. I thought his playing was the greatest. I wanted to be like him. He'd be walking down the road and sometimes he stopped and played at people's houses. People turned their houses into a place where you could shoot craps and dance. He left Dundee walking with a guitar on his back. I never seen him no more.

I started to play the harmonica. Mama Carr bought one for me. I learned from hearing records in the store. I heard someone cover "Terraplane Blues" [*first recorded by Robert Johnson in 1936 and released in 1937*]. That was something I never got out of my brain. Terraplane was a kind of car in the 1930s. I also heard the older Sonny Boy on records and tried to play his songs.

My father, Robert, came back over to see me when I was about fourteen or fifteen and asked if I wanted to stay a few days with him. "You come to Helena I'll buy you a gabardine suit." Mama Carr said, "You can go if you want. Be back here Monday morning. There's farm work to be done." So when Saturday come, I walked the railroad track down to the river and caught the boat. Robert bought me a blue gabardine suit. I was in heaven. I never had suit like that. He was sharp and I was sharp. Robert said, "When you get a little bigger, you can come stay with me and go hear me play."

There came a day that I was feeling like I was grown enough to get out—and I ran off from home. I walked to Walls, Mississippi, where I knew some people, and worked two weeks ploughing. I drew more money than I had ever made in my life! Then I went to West Memphis. I stayed with my Uncle Barto, who was married to Robert's sister, my Aunt Ethel.[9] Chopping cotton was steady work, but too tough for me. Every cotton truck I got on, they fired me. My aunt's neighbor had a push lawn mower. Her son showed me how to cut the yard. I went to cutting yards, making three dollars a day. You weren't getting but seventy-five cents to chop cotton all day.

I had enough money to buy a bicycle. I was a big shot by buying one. The bicycle was a Henderson with red stripes on the fender and balloon tires. It was the best they made, like buying a Cadillac. I dressed it up with flaps. I wanted to show people I had done good. Not too many boys had a bicycle.

I got to be the ice boy in West Memphis. I hauled ice all day long, twenty-five pounds in the front basket, twenty-five pounds in the luggage carrier. I'd buy a block of ice for a dime, sell it and pocket a nickel. Some of the well-off people gave me a quarter. People would flag me down to get ice.

I stayed in West Memphis for about two months. Everyone wanted to see my bicycle. A white man wanted to shoot me because I wouldn't sell it to him. "I got to have that bike for my boy! I'll give you twenty-five dollars!" No sir. "Boy you crazy!" He got mad. I got on the bike and rode away. I had twelve dollars and rode my bicycle back home in one day.

I came by the Carrs' and helped them get the hay in. Then I went to Helena where my dad was. I stayed with him for a week or two and went where he played at. I felt so big listening to my daddy. I felt like a rich person. To me my dad was the greatest thing that lived.

Now I'm about sixteen. Mrs. Carr asked me, "Do you want to stay with your daddy or us? We aren't gonna try to hold you. You've grown into a young man."

I said, "I'm gonna stay and help daddy Carr with the cotton and corn crop." We'd load it up in a wagon and take it to the gin one bale at a time. Mama was getting old. She had to sit on a bucket to pick. She'd put the cotton in a cotton sack, and I'd pull it for her.

I moved in with my daddy. We lived in a Black neighborhood in Helena at 308 ½ Franklin Street, in the rear. I learned more about life and the town living with my daddy.

Sam remembered when there were at least five or six gambling houses in Helena. "Horn dice" was popular. The cafés were open twenty-four hours a day. Sam worked at Montgomery Ward, cleaning the store and fixing furniture. At the white-only bowling alley, Sam cleaned and racked the balls.

Some of the old places around Franklin Street were called the Dreamland Club, Hole in the Wall, Silver Moon. Dudlow [*Taylor*] and Sonny Boy [*Rice Miller*] played at the Hole in the Wall. James Starky had a band.

Most of the people would buy wine or "seal whiskey"—whiskey with the government seal on it. Corn whiskey was illegal. They catch you with corn whiskey, you was gone. There was always a fight amongst customers. They had something called Bobcat. If you drank Bobcat, you'd become a drunken fool, it made you stupid. Make you want to fight.

The clubs had to be Black. If you were caught in a white night club you'd probably be beaten, get thrown out. People then, they'd talk about that color. White man could go in where he wanted to; the Black person couldn't. A white lady couldn't go in where she wanted. A Black man and a white lady were more under slavery. They would look down on her for going into a place where colored go. They'd throw her on out of the race if she'd be in there too much.

Robert was playing at the [*KFFA*] studio on a radio show sponsored by Mother's Best Flour.[10] I thought he was just like the president.

Robert was playing country jukes and fairs around Mississippi—Drew, Moon Lake, Marks. He was still playing clubs in Helena. He played all through the week. I used to work the door for him. People would push you off the door. They found out soon that wouldn't work with me. They used to call me "Little Sam" but I was six feet tall.

Old man Vogel had a store in Wabash out from Elaine, south of Helena off Highway 20, where colored people could go.[11] The place had a huge crowd. Robert Nighthawk gonna play, they was going to be there. The crowd was all Black. Everybody drinking, laughing, talking, having a good time. Jitterbugging was a popular dance. Truckin' was a dance you slide your shoes out.

Vogel was a big white man; he was the law there. You wouldn't want to go against him. That was the only place I'd seen where the man didn't call no law. If there was a problem, he'd settle it one way or the other.

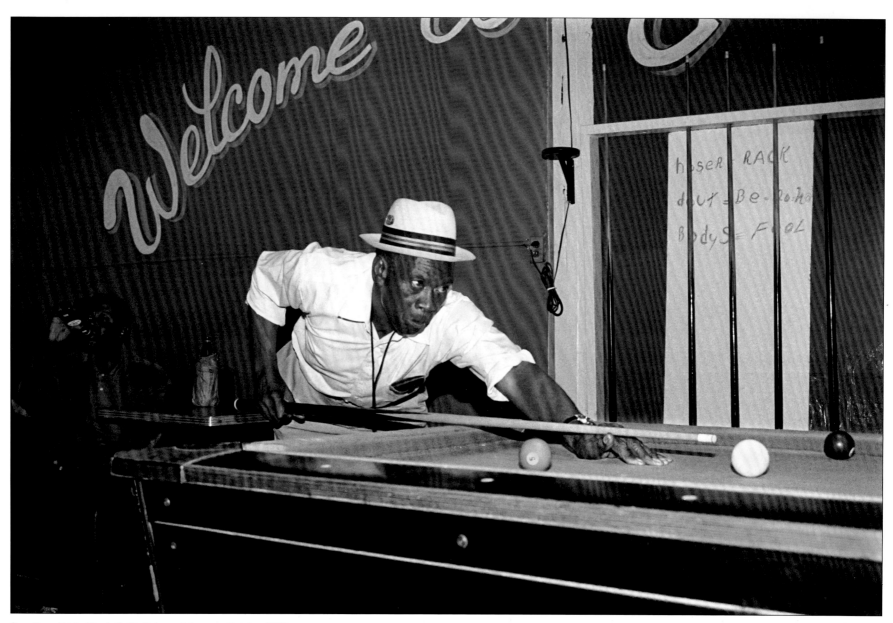
Sam Carr, Eddie Mae's Café, Helena, Arkansas, October 1999

Robert had a voice for singing. He carried his voice long. You couldn't tell Robert's age by looking at him. He had smooth skin. He dressed neat, clean cut. Robert wore jitterbug pants—blousy pants that get tight around the ankle, and keen-toe shoes. He always wore a long-sleeved plaid shirt and a brown hat.

Robert had a good reputation in Mississippi. For guitar playing, he was the greatest. He played mostly with a slide on his finger, a brass pipe he cut and filed down to fit his finger—I still got it now. [*John Mohead recalls learning slide guitar from Sam in the early nineties: "Sam, he'd play slide with his dad's brass slide."*][12] Everywhere he had two hundred, three hundred people listening. Robert played "Sweet Black Angel," "Anna Lee," "Honey Hush," "Bricks in My Pillow." The people danced to the music.

Then he got two or three girls to dance and put on a show. They could really get down and dance. He kept the dancers about three or four years I reckon.

Robert played electric from when I remember. In juke joints, they had a dynamo generator. I would listen to the music and it would stay with me. When Robert wasn't looking, I'd play his guitar, a Gibson. That's the only kind he would buy. I started playing upright bass in my daddy's band in 1944. I had learned by watching Albert Davis play. When Albert left, I'd lay the bass down and ride it, get on my back and play it. I'd just hit the bass, the crowd be around me like flies, "Play it, man!" Robert let me put on a show for five minutes, then he'd start back playing.

I remember Houston Stackhouse was with my dad for a long time. He played slide guitar. We went down there to Crystal Springs to get Stackhouse to play with him. Pinetop Perkins played with Robert, too. He played guitar when there wasn't a piano around.[13]

Me and Robert come down to Drew [*Sunflower County*] and get Kansas City Red [*Arthur Lee Stevenson (1926–1991)*]. Robert knew how to play drums and learned him how to play.[14] I wanted to learn, but Robert kept me on the door.

I asked him, "Let *me* learn how to play the drums. I'm right here with you."

He said, "You'll never be able to play no drums. You ain't never gonna be a musician."

I said, "You never tried to learn me. I am seventeen, eighteen now. I'll tell you what—One of these days you are gonna want to play with *me!*"

Oh, he fell out laughing. That day did come, but I never did mention it to him.

I first saw my wife Doris [*Doris Godfrey*] picking cotton outside Dundee.[15] Doris was tall—and skinny. I talked to her every time I had enough nerve to say something. She'd laugh. Doris was one of the top jitterbug dancers in Helena—they called her "Long-Legged Lizzie." We courted over two or three years. I worked. Doris continued school. I asked Doris's mama if I could marry her. We got married by a justice of the peace in Helena on January 15, 1946.

A few months after we married, I worked on the Wooten-Epes Farm on Pike 20, outside Helena. [*Note that Willie Smith was living as a boy on the Wooten-Epes Farm during this same period. See Willie "Big Eyes" Smith oral history, page 4.*] We weren't on Wooten-Epes too long, maybe a couple of months. Doris and I were sharecroppers. We got a shotgun house.

Mr. Valentine was a white man, a manager for the owner of the land. I was twenty and he was probably thirty. The man didn't like me. He would let me work, but he wouldn't let me work on my land. I was the last one he'd give the mule to plow—and he did that intentionally. He called me a lazy so-and-so.

I said, "Well I couldn't take no plow 'cause you all wouldn't give me one."

Then one day he said I could have a mule and plow on Friday evening after everyone got through. You had a full day's work to do with your mules. By the time you get them on Friday, it was just a couple of hours. On Saturday, everyone went to get their groceries. Saturday was the one day I needed to go to Helena. I had ten acres of land. He told me not to get no groceries 'til I got through plowing that land. He told me I better plow before I get my little furnish—"You Black son of a bitch!"

I said, "Yes sir!" But I had nothing to eat since Thursday. Doris had cooked some corn bread with hair grease. We didn't have no lard. I plowed a little bit Saturday morning. After everybody went

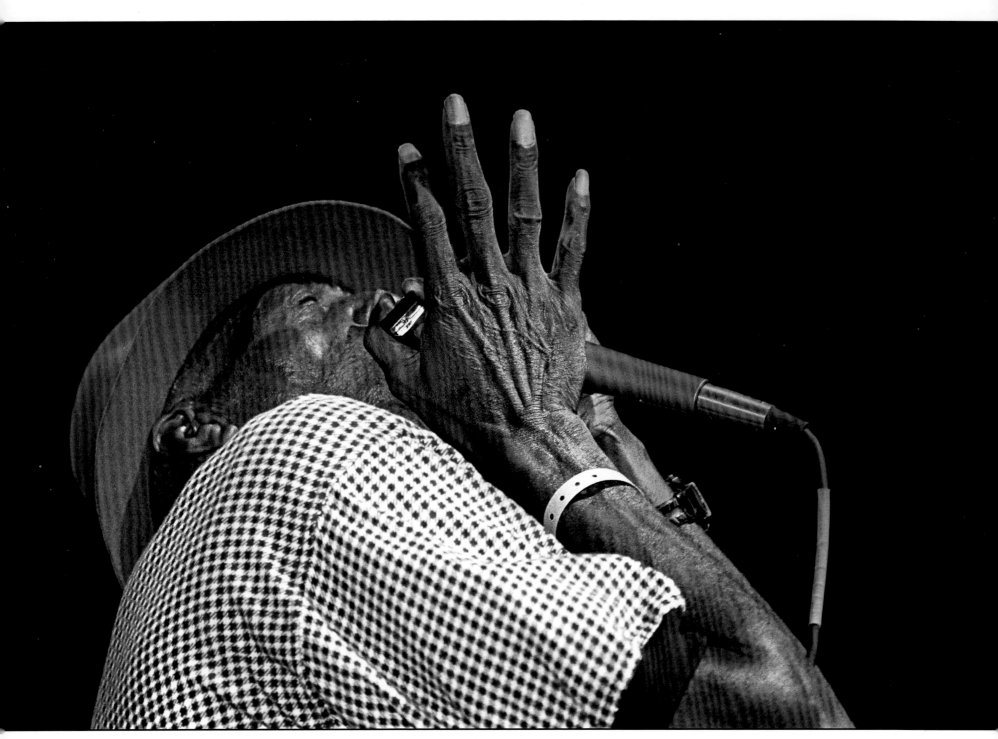
Frank Frost, Sunflower River Blues & Gospel Festival, Clarksdale, Mississippi, August 1998

to Helena, I turned the mules loose and went to the Wooten-Epes store in Helena. My name was in the book because I was working for the company. The man gave me my furnish—twenty dollars a month, so I got some groceries. I also bought one of them old switch knives. I bought a bike, too—that was my car. Once I got to Helena, I was there 'til Sunday night. I stayed in town because my daddy was playing music.

On Monday morning I went and got the mules early. I was ready to finish ploughing. The boss man was sore at me 'cause I should have been through Saturday night, so the mules could have gone to somebody else early Monday—that's what he was squawking about. So here he comes with his great big old horse, big cowboy leggings, boots on, and a mule whip—that's a whip with leather handle and a paddle on the end to make that mule go. He come down there cussin'—"You didn't plow that cotton like you told me! I'm gonna whup you! I'm gonna teach you a lesson."

I said, "No, I'm not gonna let you whup me." When he started off his horse he got off the side I was on. He had one foot in the stirrup. I was scared and mad. I wasn't gonna let him whup me. That was plumb out of the question. I'm a grown man now. I cut them leggings off and went toward the little two-room house I was living in. He couldn't fight me. I was out-of-sight strong. He went back to the shop hollerin', "We'll get you tonight! We'll teach you!" From that day on, white people called me crazy.

Me and Doris boarded the house up. We know first thing that come through that door, we was dead. All we had was a single-blade ax. A boy came by the house when he got off work and said, "They coming at you tonight. Another boy who stayed here and stood up for himself, don't nobody today know what happened to him."

We loaded all the stuff we had on that bike and cut through the fields and got to the blacktop where I could ride. Doris was on the seat and I pedaled in front of her. Every time we saw a car coming we'd go into the fields and kind of squat down. By the time the boss man got his men together and got down there we was in Helena.

Robert didn't have the money to buy me a ticket to Chicago, but he played at Moon Lake that night and made enough to send me.

I caught the ferryboat and came back over yonder to my Mama's house in Dundee. I knew where Papa kept his pistol. I know she thought I'd come to visit; I came to steal the pistol.

When I got to the train station in Helena, the police were looking. They were looking for someone else. Had to be. I told my daddy, "I'm not gonna let them arrest me!" I'd just be dead. Whatever it was, the Lord protected them from knowing who I was and I stepped on that train. They called "All aboard!" The Pullman said, "You gotta go in the back." I said, "Yes, sir!"—and handed Robert the pistol wrapped up in a paper bag.

I went to Chicago to my uncle, Sam McCollum. He got me a job working with him loading boxes on freight trains. I sent for Doris when I got my first check. After I made another payday, Doris and I came to St. Louis. We moved in with my mother [*Mary, his birth mother*]. We stayed in St. Louis from 1946 to 1960.

The first person I played with in St. Louis was Tree Top Slim—Willie Ealy [*1926–1970*].[16] I first met Tree Top in front of the corner liquor store blowing harp. He played for drinks.

My daddy came through and stayed with us a couple of nights. He had a guitar, a Gibson; the hollow bar had busted. He glued it. The strings were high. He bought him another guitar. He said, "That guitar's no good. I'm going to give it to you."

I told Tree Top, "I got an old guitar. I can play Jimmy Reed bass." When we started playing we was having fun. The people crowded around. The owner of a grocery store heard about us. He gave us a dollar fifty a piece to play an hour in front of his store. We played juke house music. People would hoot and holler, some would dance.

I could play fast or slow. Tree Top was a good harmonica player. A man across town said he'd give us three dollars apiece to play at his club. We filled the place. Then I hired a drummer. Someone fifty miles outside of town [*in Robertsville, Missouri*] heard us over the phone. They offered us fifty dollars to play in their club. That was our first big gig. People liked it, but I couldn't really play no lead. I was just playing bass on guitar. Ralph Yogi came up during the break and said he could play lead. He got his guitar and became part of the band.

One day the drummer got mad and quit. So me and Doris went down to the pawn shop. We bought one drum piece at a time—snare drum, bass drum, and a cymbal and a stand. It took about three weeks to buy the set. I was playing drums, Tree Top was blowing harp and Ralph was on guitar. We had a bass and piano player.

That's when Robert Nighthawk's wife "Earlie B." started playing with us.[17] She was a better drummer than me back then. None of us were no singers. She used to play drums and sing with Robert. They separated; Earlie B. stayed with us until she moved to her auntie's. Then I had to play the drums. I named my band Little Sam Carr and the Blues Kings.

I had learned to play from watching Robert Thomas when he was in my daddy's band. He was my idol. That's where I got the idea of playing drums. He was the best drummer I ever heard in my life. He could beat anybody. Sometimes he'd play with us. But Robert was so good he'd go wherever the most money was. He went around some of the big clubs in St. Louis where the big bands was and run the drummers off. Being with him I could go in better clubs. Door man would put him in. If Robert Thomas was going to be there it was going to be a packed house.

Playing music, the first thing you got to have is time. So I learned to play time, mostly by practice, from having messed around with my daddy's drums whenever I got a chance. Whatever time you start out in, you got to keep that time. No matter what you do, if you don't get that time, one split second you can throw the whole band off. A lot of people can play good, but if they don't got timing, they can't play. [*"Sam's a time machine," said Big Jack Johnson. "You could walk on his timing."*][18]

We played in clubs on 18th Street, Franklin Street. Nobody but colored went at that time. They was rough places. Mostly we played Jimmy Reed style and Muddy Waters. Doris and I were now living at 1310 Biddle Street. There was a club on 20th and Cole, a couple of blocks from us. I went by because there were so many people around I wanted to see what was happening.

This is where I first heard Willie Foster [*1921–2001*] and Frank Frost. Willie could blow like he did down here. Not Frank. Frank came out and said, "He just lets me sit in and I blow one." Frank couldn't do much on the harp. I told Frank I'd pick him up the next weekend. I let him play with me. I don't know how come nobody else didn't pick Frank up. Frank could sing and play the piano. He was a church player, he said. I hired Frank to sing with the band because I never could learn no songs.[19]

Frank was learning to blow the harp. He could blow the keen part of the harp, make it sound like Jimmy Reed. He couldn't blow the bass part. I could, so I taught Frank what I know. He picked that up right away. So between what he know and I know, that was it. That made him a good harp blower.[20]

What made our friendship run so deep and last as long as it did? Well see, Frank was really out to learn songs and play. We'd stay up all night playing guitar and harmonica and listening to a Nashville radio station that played blues music. Frank would pop his fingers. He wouldn't forget what he heard. I showed Frank what I knew about the guitar. He lifted that guitar into bed with him every night. It didn't take much for him to catch on.

We got to where we could play together really well. Frank didn't want nobody else to play, just me and him. We carried a crowd behind us in St. Louis and Mississippi. We played low-class juke joints because we was playing low-class music—blues. What we was playing was to people that drank whiskey, danced, got out there and didn't care what they did or said, liable to pull their pants off right there on the floor and make somebody look at them. Well, after you do that for so long, you pull yourself out of that and go to a higher class.

I had met Sonny Boy Williamson in the forties through my father at radio station KFFA when Robert and his band played for Mother's Best Flour and Sonny Boy played for King Biscuit Flour. One night, Frank and I were playing in a juke joint in Sikeston, Missouri.[21] Sonny Boy Williamson and Joe Willie Wilkins were playing upstairs. Sonny Boy said, "When you quit tomorrow night, pick me up. Joe's going back to his wife, and I want to go back with you and Frank and play with you." Me and Frank brought him back to St. Louis.[22]

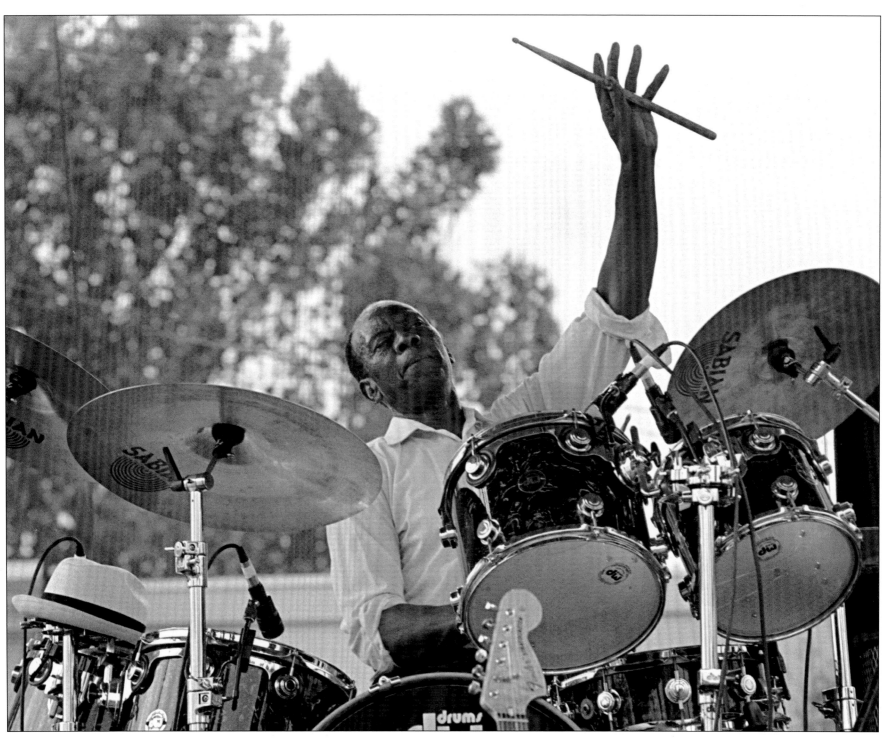

Sam Carr, King Biscuit Blues Festival, Helena, Arkansas, October 2002

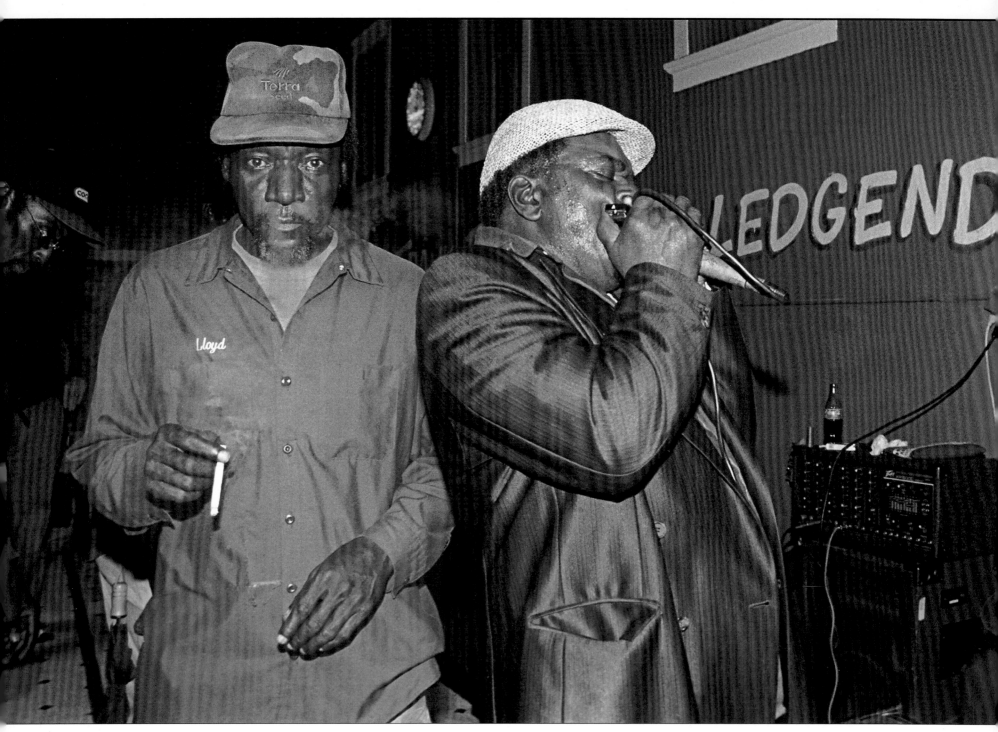

Arthur Lee Williams (right), Eddie Mae's Café, Helena, Arkansas, October 1999

When Sonny Boy was with us, Frank played guitar and Sonny Boy did most of the singing. The band was still called Little Sam Carr and the Blues Kings, but Sonny Boy had his own style. He decided what we'd play. He had records out, so that's what we were playing—"So Sad to Be Lonesome" [*Checker, 1960*], "Fattening Frogs for Snakes" [*Checker, 1957*].[23] He always dressed well. He'd wear a suit and a hat.

It got where me and Frank were like sons to him. At some shows Sonny Boy didn't want no one but me and Frank. He played with us until they called him to come to Chicago to make a record.[24] We were supposed to play with Sonny Boy, but when we got up there, he had to play with a studio band because they were in the union, and Frank and I weren't.[25]

In 1960 me, Doris, and Frank came back to Mississippi together. Mama Carr had a stroke. I came down to be with her 'til she got better or worse. She still had the farm. Me, Doris, and Frank picked the cotton crop. I could pick about two hundred pounds of cotton. Frank could pick three hundred to four hundred pounds and go and get him some whiskey. Frank could pick some cotton, ooh God. We stayed in the tenant's house for four or five years after mama died. [*Mrs. Carr died April 8, 1961.*]

Me and Frank started playing in the little jukes. I kept the name Little Sam Carr and the Blues Kings. Frank was the guitar player and harmonica blower. I made him a harmonica rack—"Frank, now you can blow the harp, play the guitar, and sing." I was on the drums. Further on down the line I bought a piano.

We didn't have no bass. I was using the drums as a bass. I wanted the kick drums and snare to be heard. If I couldn't hear the drums, I couldn't keep time. That's why I needed to hear the drums, so I could make sure I'm hitting the right lick at the right time.

A lot of people relate to the sound of the drums. Eighty percent of people that dances, they go right along with the drum. Just for the fun of it, I'd make a couple of loud beats, a couple of loud runs on the drum, and they'd fly to pieces. The drum is what got them. The drums got to be heard just right. My way of playing is just blues, barrelhouse drumming or country drumming whatever you want to call it. It's a beat. It comes with a feeling.

I had a lot of stuff up my sleeve then—do a lot of tricks. I'd be playing my snare drums. I'd start running my sticks up to the top of the house, let the sticks fly up in the air and catch them. I'd take the snare drum off the drums, go out play the tables, play the glasses, whatever they were drinking out of, beer bottles. Play on back, sit down and play all around the front of the drums. I learned to play the fastest song you could play, play drums with my right hand, and bring a whiskey glass up to drink. Whatever I was doing, I didn't forget the time. That's how I got to be the best drummer down here. I could beat any drummer with my way of playing.

We had a full house and make fifteen dollars for playing. Fifteen dollars was a week's work on the farm. All we wanted was whiskey. They'd give us all you want to eat and drink and we'd turn around and walk back to the crap table and lose every bit of it. Gambling dice kept me in bad. I'd get back home and we didn't have nothing.

So Doris and I moved in a house on the Jeffrey's Plantation, where I started working. We were sharecropping, picking cotton. Doris would save money. Things got better for us.

I was driving tractor on Jeffrey's Plantation, near the Carr's land. I never was a farm man but I always stayed on it. I farmed all my life. All that looked like it was beneath me because I was trying to play music. I told the man a long time ago, "You got to show me what you want me to do again, because it's not really on my mind, driving the tractor."

Frank stayed across the field with a woman. He always had a woman.

People had told me this guy Arthur Lee Williams in Tunica could play good harp. Frank wanted to hear him, so me and Frank went to Tunica to find him. If he's that good, we might want him to play with us. We were inquiring about him in a café [*Hardface Café, now gone, owned by Harold "Hardface" Clanton*] and Arthur Lee was just sitting there. Someone pointed him out. Arthur and Frank went out to the car and had a jam session. Arthur Lee had a different sound on his tone.[26] He sounded so good, we got together and played from time to time. Arthur or Frank would blow lead and the other would blow chords.[27] Frank would play the guitar. Arthur, me, and Frank were *tight*.

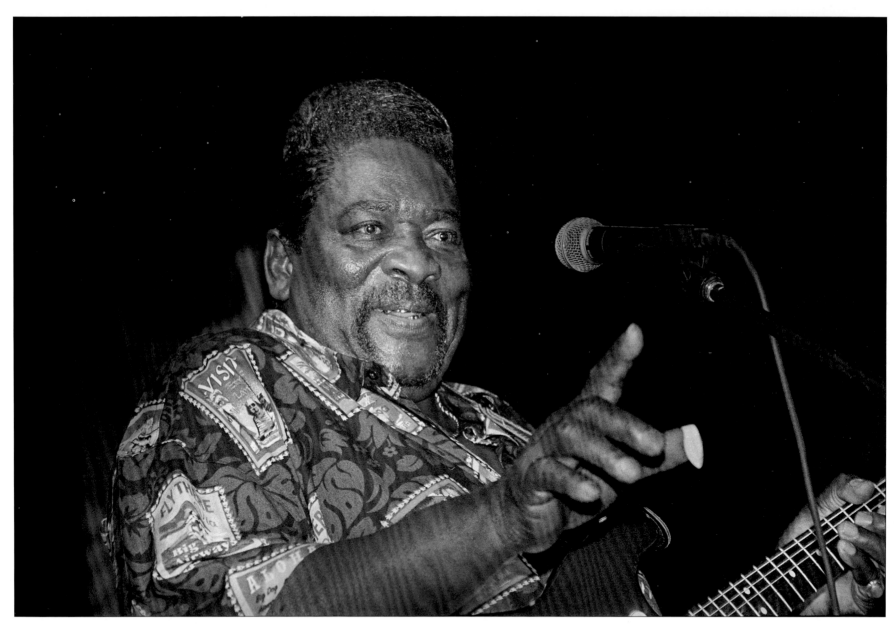
Big Jack Johnson, Sunflower River Blues & Gospel Festival, Clarksdale, Mississippi, August 2004

Arthur played with us until he went into the army in 1961. Then Big Jack Johnson hooked up with us. We had gotten a job down in Clarksdale at the Savoy Theater. The first band had four or five pieces, then we came on. During a break, someone went and got Jack. Jack came with his little old small guitar and played. The crowd jumped for us.

Jack was quiet and serious about music; he knew the basics, so I hired him. He played similar to B.B. King. That was good for us, broadened our songs. Our stuff was more like Muddy and Jimmy Reed. He played bass on lead guitar. Doris was working the door. One night, she started singing with the band. Everybody liked the way Doris sang so she became part of the band for two or three years.[28]

A white man, Lee Bass, took an interest in us. Lee had a service station [*Bass Oil Company*] in Lula.[29] He used to manage B.B. King, he said;[30] he was the booking agent for other blues bands. So we played a few tunes for Lee.

Many years later, Lee Bass recalled: "Sam, Frank, and Jack was at the station one afternoon and said they could play music. I said, 'Bring your instruments down here tonight and play. Let me listen to you.' They drew a crowd. They were real good. They had tremendous music."[31]

Lee asked us, "How would you like to make a record?" He said, "I talked to Sam Phillips and he's interested in you." So we made a date for the three of us to make a record. I had never recorded for anyone. Frank was singing, playing the guitar and the harp, so the name went to him on the record.

The band's first record on Phillips International was a single called "Crawlback" with "Jelly Roll King" on the B-side, released in May 1962. Both songs are credited solely to "Frank Frost." Later in 1962 Phillips issued the LP Hey Boss Man! Under the name "Frank Frost and His Night Hawks."

Bass booked Sam, Frank, and Jack in juke joints, Black clubs, and all-white venues in southern Mississippi, Alabama, Arkansas, Tennessee. On the road, when night came, the band would stay in a room "for Colored" and Bass would check in somewhere on the white side of town.

Lee Bass booked us at Conway Twitty's Club on Moon Lake and other white segregated clubs. They didn't want us to walk among people so they'd bring food and drink to us. We played there on and off for a year. One night everyone got drunk and was fighting amongst themselves. They had knives and guns. They didn't bother us, but we didn't want to go back after that.

Lee would bring us down to the club. It was too early for Blacks and whites to be together. One time we were driving in Arkansas. We stopped at a white man's house to get water because the car was overheating. He laid on Lee for riding with us. He made Lee get another ride before he'd help us. Lee stuck up for us as well as he could. People in the clubs didn't say nothing, but things happened on the way home. The police made him get out of the car two or three times because the car was in my name. Police would pull us over and say, "You can't ride together in my town." Lee had to find his own way back. Lee finally had to leave it alone.

Bass knew the racial problems they faced, but it didn't stop him. "Never show fear or you're defeated," was Bass's philosophy. "Sam and Jack would look after me and I would look after them."

Sonny Boy went to Europe on tour. When he came back we heard him on the radio in Helena. We played once or twice with him on King Biscuit. Sonny Boy played with me and Frank around here a couple times up until he died.

Sonny Boy Williamson II toured in Europe in 1963 and 1964 with the American Folk Blues Festival. After both tours he stayed on in England, where he made albums with the Yardbirds and the Animals. When he returned to the United States in early 1965, he came to Helena and began broadcasting again for King Biscuit Time, which was still airing on Radio KFFA after more than twenty years. Although he was only fifty-two at the time, Sonny Boy told

his old friend Houston Stackhouse, "Stack, I done come home to die now. I'm just a sick man." According to Stackhouse, "He (Sonny Boy) had me carry him all around where he used to be all up and down them roads."[32] Sonny Boy died of a heart attack in Helena, Arkansas, May 24, 1965.

Frank and I played with my dad time after time in Mississippi. Arthur found us after he got out of the army. (Williams was discharged in December 1962.) Sometimes me, Frank, Arthur, and Cedell Davis (slide guitarist, 1926–2017) backed my daddy up.[33] I proved to him that I could play the drums as good as Robert Thomas, but I never got to show Robert Thomas what I learned. (Robert Thomas had been killed some years before by a girlfriend in St. Louis.)[34]

In early 1964, Robert Nighthawk returned to Chicago, where he enjoyed a surge of renewed interest during the so-called "blues revival." In May that year he performed at the University of Chicago with Johnny Young.[35] In the summer and fall he was featured prominently in the Maxwell Street documentary And This Is Free, *and also recorded tracks for the album* Masters of Modern Blues: Vol. 4 *(Testament Records, 1968). During the making of* And This Is Free, *Nighthawk was interviewed by guitarist Mike Bloomfield, who asked him: "Is there anybody you've got kind of picked out to follow in your footsteps?" Nighthawk referred vaguely to having two sons, whom he had "started out to playing." One was obviously Sam, though Nighthawk did not acknowledge him by name. "I got one on the road already playing. He's down in Mississippi, he's playing down there. He plays guitar and he plays drums, playing drums for Sonny Boy."[36]*

At the time of Sonny Boy's death, Robert Nighthawk was playing some of his last gigs in Chicago. Nighthawk returned to the Delta for his own final years. According to his cousin Houston Stackhouse, Robert came back to Helena, hoping to replace Sonny Boy on the King Biscuit radio hour. He played on the air a few times but was unable to put together a regular show. Sometimes Nighthawk played with Sam and Frank during this time, at jukes in Prichard and Crenshaw, Mississippi.[37] As it turned out, one of Nighthawk's very last recordings was made at Sam Carr's house in Dundee, in late August 1967.[38] The music historian George Mitchell, then a twenty-three-year-old graduate student on summer vacation from the University of Minnesota, made "field recordings" and shot photographs of Nighthawk, Stackhouse, and drummer James "Peck" Curtis.[39] Soon after, Nighthawk fell ill from long-standing chronic heart disease. Stackhouse took him to a folk healer in Widener, Arkansas, who "read cards on him" and told Nighthawk, "It's just that old-time Dropsy done overtaken you."[40] The traditional diagnosis was congenital heart failure. Nighthawk went into doctor's care in early October and died three weeks later (November 5, 1967) at the Helena Hospital in Broads Alley.[41]

Although Sam would tell me, "I'm proud to be Robert Nighthawk's son," and would insist, "That's who I am. He influenced me. That's my point of view now," Sam Carr was always his own man. When his father passed away in 1967, Sam was forty-one-and-a-half years old—at the exact midpoint of his life. Sam would live for another forty-one-and-a-half years; his greatest musical accomplishments and his own legacy still lay ahead.

I really got started in music to show my daddy I could play—and I did. I carried on after that for the love of the blues and that's what I stuck with.

For the rest of the 1960s and into the '70s Sam, Frank, and Big Jack played in small clubs in Clarksdale and in the jukes throughout the Delta.

We did our next recording for Scotty Moore on the Jewel label.[42] Later we made records for Michael Frank.[43] Frank Frost and I went our own way for a few years. Frank left for Greenville to live with Charlene. He started his own band. Jack went out on his own. I played with different people. I played with Johnny B. Moore. For about five years, I hooked up with Willie Foster and T-Model Ford around Greenville. We were called Willie Foster's Band. He was hustling for himself when me and T-Model played with him. We played old blues; we didn't get far from Muddy Waters' and Jimmy Reed's music.

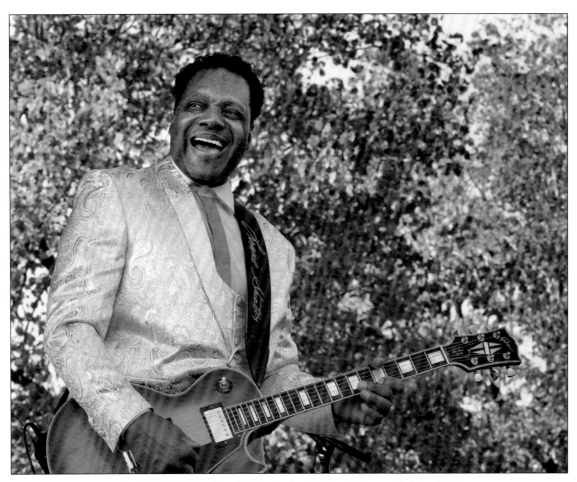

Lonnie Shields, King Biscuit Blues Festival, Helena, Arkansas, October 2022

Sam brought Lonnie Shields along with him. Says Lonnie: "Starting about 1979, 1980 we'd meet Willie and T-Model where the gig was—mostly country jukes. Sometimes Frank played with us. Then Sam added bass and organ and we became Sam Carr and the Floorshine Blues Band. People danced on the floor and dust would come up from the boards. We were a party band and played blues, R&B, and funk. When 'Big Jerry' Parnell joined us the band was called the Unforgettable Blues Band. Andrew Turner, Michael James. David Porter, Rip Butler, Wesley Jefferson might sit in with us. The places we played in was rough. Sam protected me numerous times. He would jump anyone who would mess with him, me, or the equipment.[44]

"Over the decade everyone would play with one another, bands and players would change. Robert Walker might sit in. Little Jeno Tucker organized revues. Sometimes the Jelly Roll Kings had their own shows."[45]

Me and Frank played together until he died.

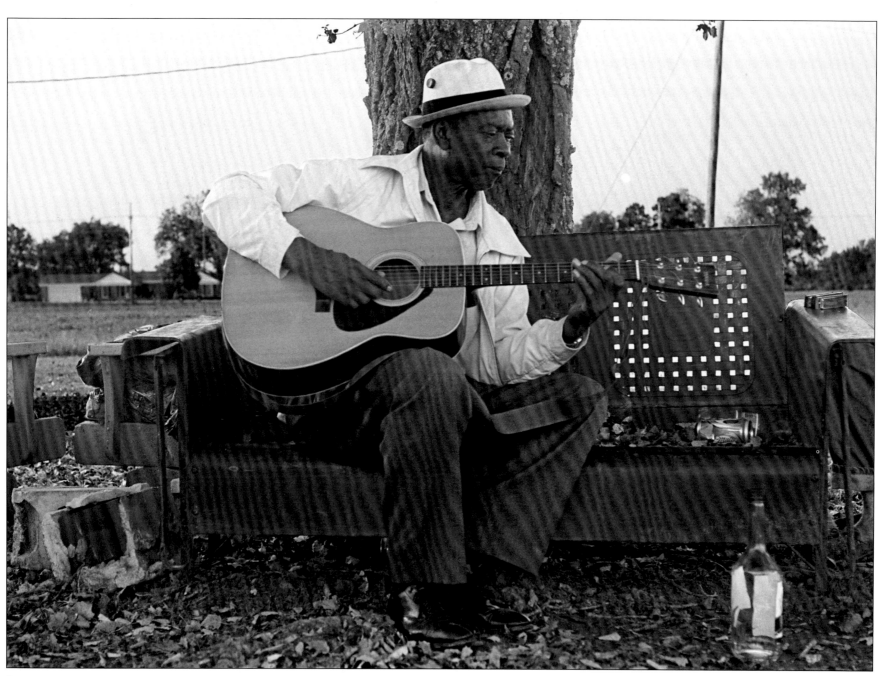
Sam Carr at home, Dundee, Mississippi, October 2003

In the summer of 1998 Sam made his last recording with Frank, The Jelly Roll Kings *(HighTone, 1999), at the Sonny Boy Williamson Memorial Hall in Helena. In the fall they did their last European tour together to the Lucerne Blues Festival in Switzerland (Frank Frost,* Live in Lucerne, *2004); and in December performed at Red's in Clarksdale for a blues documentary for a Norwegian National Television crew. Frank died October 12, 1999, in Helena, four days after appearing behind the keyboards in a wheelchair at the King Biscuit Festival, with Sam on the drums. Sam was the first person notified of Frank's passing. Eddie Mae Walton, Frank's longtime companion, was with him at the time of his death. She told the Clarksdale* Press-Register, *"I had him in my arms, that's when he left. I went to the phone and called Sam and said, 'Frank is gone.'"*[46]

Frank's death left a big hole in the music. When Frank was living, I didn't need nobody else to play. We always had each other. We'd talk about our lives, the past, the fun we had, the music. After Frank died the drums just sat in the back room and got dusty, 'cause he wasn't around to practice with.

Sam's drums did not stay dusty for long. Then seventy-three, Sam carried on, making his mark in the blues for another ten years. He soon formed a new band, the Delta Jukes, with Dave Riley (bass), Fred James (rhythm guitar), John Weston (harp, vocals), and occasionally Shine Turner, touring from Lucerne, Switzerland, to New South Wales, Australia, and recording four CDs from 2001 to 2010. Sam Carr's Delta Jukes regularly played the King Biscuit and Sunflower River Blues and Gospel festivals. The Sunflower River festival honored Sam in August 2006, officially designating that year's festival "Sam Carr's Houseparty."

A few months after the Delta Jukes performance in New South Wales in 2003, Sam performed with his old pal Arthur Williams at the Rauma Blues Festival in Finland as part of the Jelly Roll All-Stars. Sam and Arthur were the core members of the Jelly Roll All-Stars along with the Muddy Waters rhythm section, Willie "Big Eyes" Smith and Calvin "Fuzz" Jones. The group performed at the Sunflower River Blues and Gospel and King Biscuit festivals that same year and their recording Must Be Jelly *was released in 2004.*

Sam made other recordings. He played drums on Robert Bilbo Walker's live album Rock the Night *(Rooster, 2010), Buddy Guy's* Sweet Tea *(Silvertone, 2001), T-Model Ford's* Jack Daniel Time *(Mudpuppy, 2008), and with Bobby Rush on Corey Harris's* Mississippi to Mali *(Rounder 2003, recorded on Sam's front porch in Dundee).*

Sam continued winning Living Blues *critics' awards for Outstanding Blues Musician on Drums every year—a position he first captured in 1993 and did not relinquish until 2005—a phenomenal streak, considering his age and the competition (Willie "Big Eyes" and Kenny "Beedy-Eyes" Smith, Calvin Jackson, and Cedric Burnside, to name a few just in this book). Sam made recordings, appeared in documentary films [Martin Scorcese Presents the Blues; Scott Jennison's* Echoes 'Cross the Tracks; *Bill Wyman's* Blues Odyssey; *and, with Honeyboy Edwards, in Mississippi Public Broadcasting's* Native Sons] *and played at festivals in the Delta and overseas from Finland to Australia. He was honored with "Sam Carr days" and acknowledged with some of the most prestigious awards in the blues, including the Mississippi Governor's Heritage Award in 2007, with then-governor Haley Barbour declaring Sam a "cultural treasure" at the official ceremony in Jackson—no doubt a bittersweet vindication for a Black man who had to flee for his life from the state sixty years before, merely for refusing to be "whupped."*

One of the most touching and appropriate of Sam's many accolades was the Early Wright Blues Heritage Award, presented to both him and Doris, recognizing not only Sam's musical inspiration but Doris's decades of moral and material support for blues musicians from their home in Dundee. Doris died in Clarksdale, age eighty, in November 2008. They'd been married more than sixty-two years. Sam followed her nine months later, in September 2009. He was eighty-three.

Robert "Bilbo" Walker

There's a place not too far from Clarksdale, they call it New Africa Road. When I was born, wasn't nothing out here but Black people 'cept the Boss Man. They called the area New Africa because the people came here in slave days from Africa.

I was born on February 19, 1937, on the Kline Plantation.[1] My parents moved from one plantation to another back and forth their whole life. I grew up and worked on the Kline, Borden, and Oscar Carr plantations. Oscar Carr's [*Mascot Planting Company*] is just a few miles from where I was born at, on New Africa Road.[2] From here to Alligator to Clarksdale to Bobo was always my stompin' ground. I could walk to all them places. I done walk to Clarksdale as many times as you got fingers and toes.

My mother was named Estella Hoy [*1919–1970*] before she was a Walker. She was the daughter of Bell and Lizzie Hoy.[3] My mama's parents, and her people, half of them were a little bit crazy, but they were good people. Some of them went to the crazy house; some of 'em died crazy; some of 'em lived to get old and be crazy all their life—born mental and stayed mental. Ain't but one thing they had to learn in them days, how to chop cotton and pick cotton. It didn't make no difference to learn anything in school 'cause you didn't hardly ever get to go to school no ways.

There was a whole lot of crazy peoples in them days. So it wasn't no surprise to meet a crazy person walkin' up and down the street, plowin' a mule, going to town on Saturday, crazy as a June bug. You could always learn a crazy person how to pick cotton, chop cotton. You could get along better with the crazy people than the ones you thought had all the sense.

My daddy was named Robert Bilbo Walker [*1917–2003*]. That's how come I came by Robert Bilbo Walker, because I was the first son. They had a governor here, at that time, named Bilbo. They said my daddy was an honest man, could keep his word, do anything he said, like the governor. So they gave him the nickname, Bilbo, as an honor—not that I know whether he really wanted that honor or not, with the type of governor we had here at that time. [*Theodore G. Bilbo (1877–1947) served two terms as Governor of Mississippi (1916–20, 1928–32) and twelve years as US senator (1935–47). He was a lifelong member of the Ku Klux Klan and one of the most outspoken white supremacists of his time.*][4] After I became a musician, they started using that "Bilbo" Walker with me. I was a faithful guy who kept his promises to everybody.

My grandparents lived not a mile apart from us. My daddy's parents, they were smart.[5] His daddy [*Adam J. Walker, aka "A. J."*] was mixed with white. The white folks said he was more white than he was Black. So he had a little of the white folks' ways in him. He knowed how to save a dollar. He was a sharecropper, but I growed up knowing him as a blacksmith. In them days a blacksmith was very important for the plantation. They made the farm equipment, the plow, the wheels, the shoes that go on the horses feet, and the tools that people worked with.

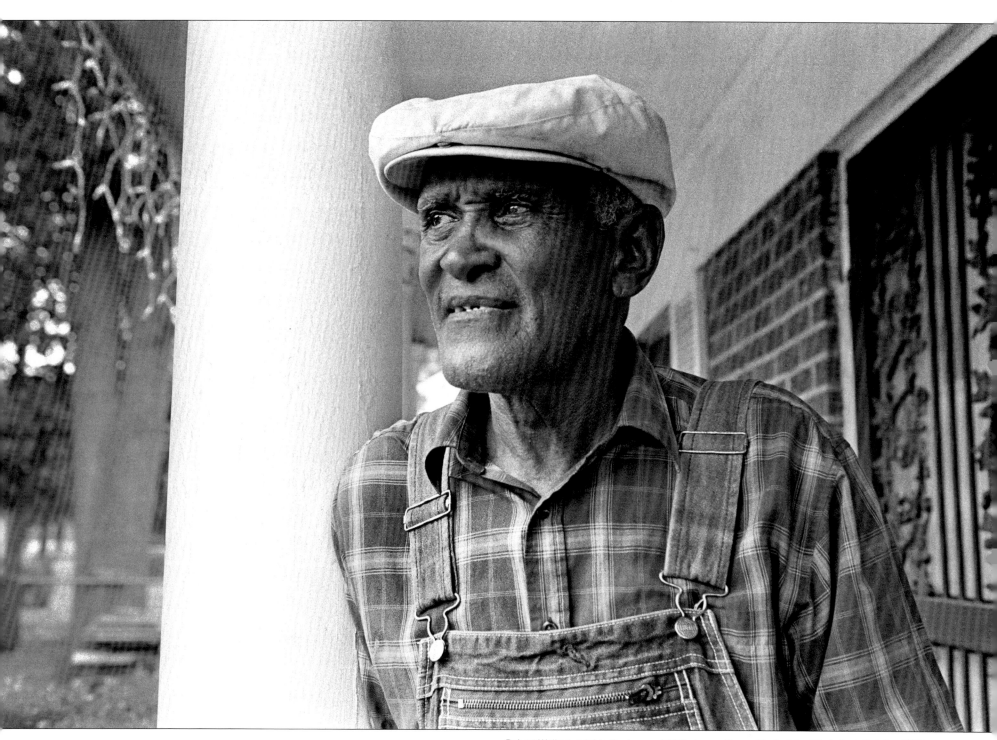

Robert Walker, outside the home of Willie James Kemp, Clarksdale, Mississippi, October 2012

In the old days the mule pulled everything. Then the tractor was very important 'cause it can run all day and never get tired. The man would be more tired from driving the tractor than the ones drove the mules 'cause the mules kept you exercising your body. Tractors were so hard to drive, your arm would be sore when night come but your arm would be supple holding a plow.

My parents were sharecroppers. They had twenty kids. I had a sister Elizabeth two years older than I am.[6] The rest of 'em was all under us. Somehow or another they always had bad luck with the kids. Different sicknesses would hit them and they would die. Only four made it to adulthood. One brother was twenty-six years old when he got shot in the back of the head in Chicago. The baby brother of the family [*Willie James Walker*] stayed in the penitentiary 'til he was practically thirty-five or forty years old. When he was just a young boy, he started going around with me playing at the big clubs. He was a great drummer.

Life was hard, but no harder than the rest of the peoples had. It's the life that my daddy and mama lived that made it so hard on the kids. They fought all the time. They gambled all the time. They drank heavy.

To be honest with you, when we growed up, we could have had a good life. My daddy's parents had brand new cars and tractors. Granddaddy saved his money 'til he got enough to buy land. He died and left it with us.

My daddy and mama drunk that plantation up—eighty acres and two tractors, two mules and a milk cow—in less than a year and a half. My parents got cash borrowing money against the land. They got $3,700 in debt. There was no way they could pay it. My daddy lost everything and had to go right back to sharecropping. That was a hurting thing to me as a young boy growing up. I swore from that day that I would never drink alcohol. I can go out and play all night and I will never touch a bottle of beer, alcohol, or cigarettes.

I learned life was hard, but it wasn't no harder on me than it was on a poor white man. Don't let nobody tell you different 'cause it wasn't. I know this from the experience of my life and livin' around white folks.

Some poor white peoples had it more hard than the Black folks did. The Black man in them days had the white man, the boss man, to depend on. We could go from one plantation to another. A white man didn't allow another white man to own his job unless he was an agent. I can remember when a white family came in from the hills and had nowhere to stay. They made friends with my daddy. My daddy talked to the boss man. He gave them a house and a little ground to sharecrop.

I was five years old when I started pickin' and choppin' cotton. Daddy and Mama forced us in the fields every day. We worked five days and a half. Saturday we stayed around the house and played ball. Black people went to church on Sunday.

They took the schools out of the churches and built a school for all the Black folks over in New Africa that went to the twelfth grade. I never went to school. When I was young I never thought I really needed an education. I always said I could be anybody I wanted to be. I never could figure out how people read and write. I could never get no sense out of that. After I got grown then I see why I need that education, with everything I wanted to do. But I still had to prove a point to myself. I could do whatever I wanted to do with or without an education. I wanted to be a deputy sheriff down here when I was thirty-something, and I was. You could only arrest Black folk. You couldn't arrest no white folk.

When they did try to send me to school, when the weather be so bad in the dead wintertime, I take the few books I had, 'cause I never learned nothin' in no books no way, lay 'em up on a stump in the woods and go huntin'.

I had a bunch of dogs I could holler "Oo-ee!" they come runnin'. Don't care how far I was, they could hear that sound. Everybody's dog come and live with me 'cause I hunted all the time. The rabbits didn't stand a chance. I'd go back home with fifteen or twenty rabbits every day. That's what my family practically lived off of. I was the one feeding the whole family. I'd get fifty cents for the big ones and twenty-five cents for the little ones. Daddy would be waiting to take all the money I made selling rabbits. Only fifty cents he'd leave for me.

I remember the first radio my family got. I was real young. Daddy cleared about eighteen dollars and bought a radio for Christmas. We juked all night by that radio. Boy, you could turn that radio on and hear music night and day, country music. Thirty or forty people would come to the house just to hear the radio. Kids would sit on the floor and people would sit on the beds and in the chairs around the fireplace. Most of the kids, we'd be around the radio trying to see the peoples up in the radio. We'd go outdoors looking upside the walls trying to see if we can see the people. We know we could hear 'em. We thought we should be able to see 'em. People didn't have enough understanding back in them days, especially little children about no darn radio.

The only blues on the radio going back then was Sonny Boy Williamson and the King Biscuit Boys. That's what you'd hear every day at twelve o'clock. Black peoples was in the fields, choppin' cotton. When they'd go home for lunch, sometimes they'd hear the King Biscuit Boys.

Ed Powell, "Kokomo," Howard Johnson, and Richard Veal grew up on plantations around New Africa.[7] They were the oldest musicians around and were famous in those days. They'd play for house parties, little country jukes. Ed Powell was a sharecropper on the Oscar Carr plantation. Ed and Kokomo could play piano and guitar. They could play two or three songs all night. When they really want to have a big ball they get on the piano 'cause you can hear it half a mile down the road. When people like Ed Powell came around who could really play the blues, Lord have mercy, that was the biggest enjoyment for peoples they ever seen.

Howard Johnson used to blow nothing but his fist. He could blow that fist and sound like Little Walter came along sounding later. Richard Veal only had two fingers on the left hand, his guitar hand. He could still play the hell out of a guitar. [*According to Richard Veal's son, Richard Thomas: "They called him the 'Nub Finger Man.' He had half a thumb and two fingers on each hand with three nubs. His fingers were blown off by dynamite, by the blasting caps (when) the owner of the plantation was trying to dynamite a beaver dam on his land."*][8] Howard and Richard played as a duo. They was a real good band. I heard Richard and Howard play around New Africa. People would see them and ask them to play. They'd play all night for a dollar and a half a piece. When a person made two dollars in the early forties, shit, he had *money*. He had money to last him all the week.

There were no streets, just gravel roads. It used to rain a lot. It was good and muddy all the time. In the winter, when the people did a lot of jukin', the mud didn't stop them. Some of them riding mules, some of 'em have galoshes on, some of 'em arrive with one shoe, one boot and one shoe, but they were gonna be there.

They had picnics, outside parties, and parties in peoples' houses. The people stayed all night long into the next day. Musicians would go from one house to another, playing for them old country jukes. They would sit in a chair and someone would bring their beer and whiskey. They'd play the drum with their foot on the floor. Peoples didn't have to play but two songs to be a good musician. They played them songs over and over. Sometimes they would play the same song for an hour without stopping, just stomping, playing, and hollering that one song.

People would get up and dance to it. Half of them would never sit down no way. They'd get them another beer, a shot of that old moonshine, and dance again. They'd go outside and talk to a woman a while, get back on the floor and dance to the same song they'd be playing that whole time. In them days people was rolling and they was tumbling and crying all night long. Half the time they was hungry. They done spent the money they made. When Sunday morning come, it was gone.

Daddy always run a juke joint at his house. He had a still in the woods; he sell bootleg whiskey. Daddy bought a piano and guitar for the musicians. Half the musicians ain't got no equipment. Folks would save enough money to buy a piano so musicians would play for their juke. You couldn't move a piano around in them days. You had to have four mules to pull it. I first heard Kokomo and Ed Powell playing the piano at my daddy's house. Children wasn't allowed to associate with grown men like they do now. Me and my sister used to sit 'round the back door. They'd throw

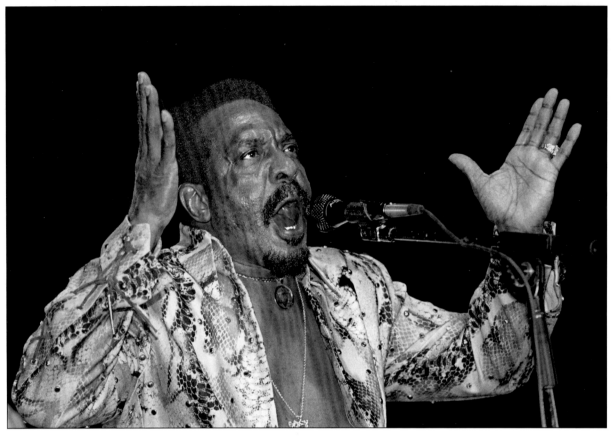

Ike Turner, King Biscuit Blues Festival, Helena, Arkansas, October 2002

parties and we'd look through the screen doors at them. We'd sit under the house and listen while they played. They played boogie woogie; that's the first thing I learned on the piano. Hearing those guys made me want to play. When I seen all the women pullin' after them, that's why I wanted to be a musician. A man play the guitar or piano, everybody wants him.

Kokomo and Ed moved further up the road to another plantation. When daddy didn't have nobody to play, he put me behind the curtain to play piano, 'cause I wasn't old enough to be in a juke. I was about eight years old. I taught myself everything I know. I was makin' my own sounds, hittin' chords on the piano, turnin' them into different kinds of music. I could turn church hymns into blues. Folks be dancin' all over the house.

When I first started, I put a string up on the tree in the yard. I'd take a snuff bottle and make that one string say what I would say. You could play "Crawling King Snake" on one string. Laying in bed, different types of music would come in my head, and when I get up I could play that music that I had never played before. I'd go to the piano and know what key to go to and how to get that sound and play it. I be singing with my mouth at the same time I'm playing the piano and that would keep me going. Then if that chord didn't go right, I know it wasn't right. Right today from here to the gas station I

could make half a song. From downtown and back I could complete a whole song. Just in my head and come right back and play it.

Alligator was a jumping town, a fun-havin' place for Black people. People would be walking and falling down to get to Alligator. They came here for the good times, Saturday and Sunday. The rest of the week was "slave time." Five to six hundred people would be out in this little place. The streets would be packed. You couldn't get down them. This town was booming with money. We had three gin houses. There were stores on both sides of Front Street. You could buy anything you wanted: hardware, clothes, groceries. There were cafés, juke joints, and gambling houses. White folks go to the stores. Black folks go to the cafés. All the cafés were practically owned by Black folks. They had jukeboxes—Seeburgs—in the cafés. The people played blues and church music. Some of them got half drunk, put the church music on. They be crying, "Oh Lord, forgive me!" and still got a whiskey bottle in the other hand.

Robert Fava Jr., who was the mayor of Alligator for thirty years (1979–2009) told me in 2010: "We had a whole line of brick buildings on Main Street in Alligator. There used to be an office for the Butler Plantation, a dry goods store owned by Aaron Kline, Tom's Grocery Store owned by Sol Kline and run by a Chinese man, and three cafés—Tussie's, Bill Romious's, and Perches Place."[9]

Bill Romious's daughter, Claudette, remembered: "People socialized and shopped in Alligator. Friday and Saturday nights were busy. My daddy's café was the most popular place. He had a jukebox and a pool table inside. People would come into daddy's after they finished working. On the jukebox was a lot of soul and blues. The blues entertainers would come in and play. Many had makeshift instruments. Daddy sponsored a Rabbit's Foot Minstrel Show every year.[10]

"At the time I was growing up, this town would be closed by ten p.m. for curfew. They had an open air jail in the alley behind the old post office on Main Street. People would go by and look and see who got arrested. So daddy turned the music off at 10 p.m.

People would go to the juke joints in the country or towns like Mound Bayou after that. In Mound Bayou, an African American community, they would stay open 'til two or three a.m."[11]

The Five Blind Boys was famous in them days. The first thing they put out, "I Can See Everybody's Mother but I Can't See Mine," was on the jukebox and Lord have mercy.[12] People played one blues, one Blind Boys song. They'd dance on one song and cry on the other. When Muddy Waters came out with "I Wish I Was a Catfish," that's all you could hear the peoples in the field trying to sing.[13] We'd be looking up in the air just wishing one day we could see Muddy. We thought he was the greatest singing man in the world.

Town Site was a little town for the Black people. Black people owned it. They had a juke called the Town Site juke. It was like a store but hundreds of people could get inside and dance. They'd have one-man bands come from Drew, Clarksdale, all them kind of places. That's where the people would go on a Friday, Saturday night.

At that time Clarksdale was a booming town [*population 16,539 in 1950*]. Thousands of people would be there every Friday night, Saturday and Sunday. You couldn't walk up and down the street. You couldn't drive down the street. You had to ease down the street 'cause so many peoples going to stores, cafés, and movies. The sidewalks couldn't hold the people.

Black people had certain sides of town they could be in. Fourth Street, Issequana, and Yazoo were the Black sections of Clarksdale. Some parts the Blacks could only go for business, to spend your money. The white folks owned all the stores where you buy everything. Then they had to get away from there and get back on the Black side. If you was on the white folks side when you wasn't supposed to be, the police gonna carry your ass to jail. If you didn't have a mighty good boss man to get you out then you be in jail just for being over there.

Raymond Hill [*saxophone player for Ike Turner's Kings of Rhythm band*] and Ike Turner and them started playing out in the streets of Clarksdale on Saturday evening. They played every juke joint

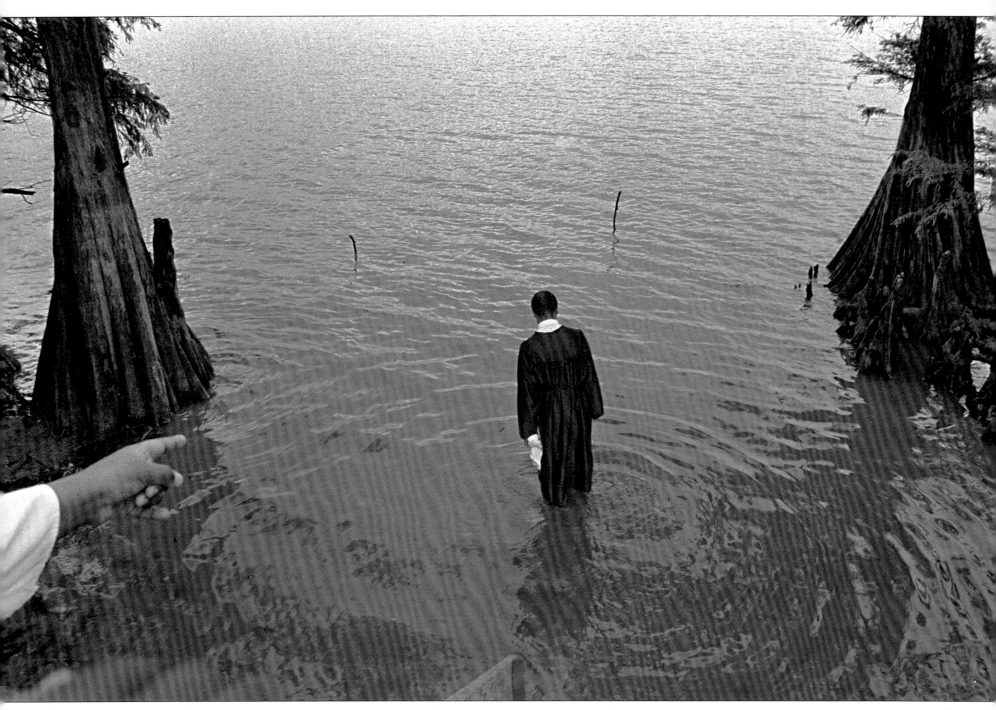
Baptism, Moon Lake, Mississippi, September 2001

there was between here and Dublin. They was playing all kinds of places, even in the daytime. In Clarksdale they played on 4th Street and Raymond Hill's daddy's café—Henry Hill's on 15th Street.[14] Everybody would go hear them. They was taking all the girlfriends. Raymond Hill would throw a kiss. Lord have mercy, you didn't have no girlfriends the next week.

Practically everybody went to church. Even if they did a little jukin' on the weekends, they were still gonna be in church on Sunday. They thought it was a sin to work on Sunday. We walked to church, walking around rough, cloddy roads with holes in them and walking through the woods. Hickory Grove seemed like a long way from where we were staying, but it didn't take very long. Hell, they'd walk more than twenty miles every day behind the mule plowing and chopping cotton.

We didn't know nothing but Baptist churches. Them preachers was something else. They tell you all kinds of lies. Them preachers don't know how to save people any more than I know how to fly one of them big old jet airplanes. We'd be out in the fields talking. "Reverend told us just to believe. Man say, 'Look at that light. If that light done blink, you know God done heard your prayer.'" You could make a fool out of more peoples so easy in them days. Pastor's dues was twenty-five cents a month. Every preacher looking to get his church full of members. They had hundreds of people in them churches. You were taught to believe, get baptized and they never come take you to hell.

I remember when I was baptized in the Sunflower River. I got baptized 'cause the rest of the little children was getting baptized. The man leaned down and told me, "You don't want to be caught sitting on this bank for another year. Give him your soul, Brother Walker. Come on and just believe." I sat there for a long time. I didn't feel nothing. Half the time when they be praying for me I be thinking about when it's over how far we had to walk down the road to get them girls by ourselves. There were about two of us left. I said I wasn't gonna be the last one. I jumped up and gave the man my hand. This boy jumped up and gave him his hand. They got us ready. I was so scared when I was going out in the water. We were afraid of the Devil. One boy seen a snake out there that day. He run out; he muddied the water. Didn't nobody see no snake. People used to tell you, if you lie and go to get baptized, the snake—that was the Devil—will run you out of the water.

When they baptize you, they send you straight to the choir. They pick out who had the good voice and who could sing. I went to the choir, but my voice wasn't good. I couldn't hold a tune. They got me right out of there.

Singing was very important. Gospel singers was all Black people. If you was a good gospel singer, you was famous. I wanted to be famous. That's why I took up singing. I had a terrible voice. But I just kept on a-praying. I kept going to church, asking the Lord, "Let me be a singer!" All the girls liked you if you was a singer. I always wanted to be something the womens looked up to. I wanted to be out front people looking up at me instead of being down looking up at somebody. I wanted everybody to be calling my name. That's all I wanted all my life.

I prayed from morning 'til night, asking the Lord to give me a good voice. And He did! I'd say, "Please God, *please God*." I'm out in the field picking cotton, chopping cotton, plowing mules, praying from one end of the row to another. All day long—'til noontime when you go eat dinner—and then 'til it's dark. I'd be singing church songs to the mules. I'd pray for a while, then sing a while.

Finally one day, I'll never forget. We were picking cotton on the Borden Plantation. I was out there singing. Daddy, my Mama, and my sister was up front. I was way behind. Daddy was mad, fussin' about me. "If you don't come up the row, I'm gonna get a cotton stalk and wear it out on you!" I was so busy praying and singing I couldn't keep up.

Daddy stopped to see what I'm doing. He getting him a stalk ready to come back and whup the heck out of me. But then Daddy heard me singing. He told Mama, "Listen, *listen!*" Mama stopped. My sister, she stopped. Daddy said, "When did you learn to sing like this?" My sister say, "He be trying to sing every day." Daddy said, "No, he ain't trying to sing now, that boy *singin'*!" They all

got quiet. Daddy look back there and say, "I ain't gonna whup you. Sing that song again. You better sing it just like you sung it, or I *am* gonna whup you." I struck out on that song—"There Will Be Peace in the Valley."[15] Daddy said, "Pull off that sack, come on up here." Him and Mama crying. He said, "Bilbo, son, we been hard on him. Now look what the boy doin'. You know that boy didn't have no voice. The Lord done blessed him. Listen how good that voice!"

Daddy quit early that evening. He said, "Go to the house, and put on a change of clothes. I'm gonna carry you over to meet the Kemp Boys. They ain't got their quartet going; they ain't got no lead singer. I'm gonna try and get you connected with them."

Daddy, Mama, me, and my sister got into Daddy's Ford pickup. We went to the Kemps. They hadn't even quit out of the field. Daddy parked and walked down the field to talk to James Kemp.[16] He told James he wanted me to sing with them. James said, "We ain't got no group no more, Mr. Walker. 'Man Furniture' quit and we ain't had no lead singer."[17] Daddy said, "Well, I think I got you all a lead singer. My boy can sing beautiful."

"You mean Little Junior?" "I heard him sing a long time ago, but he ain't good enough." Daddy said, "Well, he good enough now. I don't know if God give him the talent or not, but that boy's a great singer *now*." James said, "You go up to the house and talk to Mama about a rehearsal." She said, "You all come tomorrow evenin'. I'll knock 'em all out of the field early and let 'em hear the boy sing."

Well, they had done invited a lot of people over. The porch and the yard was full of people. I was a little bit skittish 'cause I had never sung with a group before. Their old lead singer came back just to hear what was going on.

Daddy told 'em what we were gonna try and do, try to get this group going back. J. B. Kemp, the bass singer, said, "Boy, they tell me you can sing. All you got to do is do what you can 'cause I'm gonna back you up, be here behind you." There wasn't no guitar. The group made music from the mouth, the sound of their voice.[18] We sung a couple of songs. They called Man to lead one of the songs—"I Can See Everybody's Mother, But I Can't See Mine." I ain't never sung that song. He sung it once or twice. I'm listenin'. I was the second lead singer. I caught that song, and when I caught it, my voice was so much different from what they had ever heard. All the peoples on the porch run to the windows. People started patting on one another, "Listen to that boy sing!" When I heard that, that give me more encouragement. The voice come from everywhere then. I mean it just *come*. Girl, you talking about Sam Cooke!? My voice was closer to Sam Cooke's than anybody alive. [*Willie James Kemp remembered: "Robert's daddy sent him to us when he was a teenage boy, to make something out of him. That little rascal could sing. Robert has a beautiful voice. He was the lead singer of the group."*][19]

When we got through singing, almost like a church at the house, everybody prayin' and comin' around. They elected James to be the manager of the group. Mrs. Kemp said, "Well boys, you should rehearse at least twice more this week, so you all be ready for Sunday. I'm gonna get you a program at my church, Hickory Grove Church. I really want you all to turn that church out! Junior, we gonna fix you the best Sunday dinner you ever wanted."

All that week I was singing and picking cotton. Daddy said nobody could keep up with me. I picked my three hundred pounds of cotton before they could think about getting theirs. I was *ready* for that Sunday. Daddy went and bought me a new coat to match my pants. He got me a necktie and a white shirt. Oh girl, and some new shoes. Hadn't had them in a long time. Them little round-ass shoes. You shine them and spit on them all day long 'til they got a gloss on them for Sunday. Most of the time you'd be in the field barefoot. If you had a nice pair of Sunday shoes you weren't gonna wear them to no field, believe me, because the shoes got to last a whole year 'til selling time come again. That's the way life was. You buy one suit for Sunday, a couple of pair of pants for Saturday, if you was able. A pair of overalls a couple pairs of pants during the week. That gonna carry you all winter.

We got to that church. In them days people coming to church in wagons, a few cars. Some of them drivin' old tractors, walkin'. There'd be three hundred people comin' down the road. All of 'em could never get into church, be in the windows and everywhere.

Daddy said, "Look Junior, all these folks comin' today to hear *you*." The gospel group was standing at the back of the church.

Robert Walker and Willie James Kemp, outside the Kemp home, Clarksdale, Mississippi, October 2010

When they called their name they'd march through the back door. I come out behind the group and started singing, "Through the Years I Keep on Toiling."[20] I ain't never sung it with this group, but I had sung it in the fields by myself. By the time I got two verses of the song, everybody in the church was standing up looking over. I was nothing but a boy, singing with these grown men. That's the reason people started callin' me Little Sam because Sam was nothing but a child when he started singin'. They said, "Little Sam Cooke is here today, Lord have mercy!" Let me tell you, people just fell out of the church. They had to pour water on them.

The Lord was encouraging me. There was something in my life he wanted me to express to the world. I could feel it. When I caught that song I could feel a different power that I didn't have. I had never rehearsed it before. That's when I really started believing in God.

I still turn the churches out with that same song, every funeral around here, right today: "Through the years I keep on toiling / I toil through storm and rain." That's my favorite song. I sing it today and it still takes a toll on people all over the world. I sung it in Switzerland just last year [2008].

We were called the Hickory Grove Specials, named after the church. Then we wanted to be as close to the Soul Stirrers as we could so we changed the name to the Soul Revival. We was one of the top groups. We could out-sing everyone. We couldn't wait for Sunday to get here. Go where all them girls and people gonna be, shouting and standing outside waiting for us. They'd go to waving and pointing. "Honey, the Soul Revival in the house! You ain't heard nothing 'til you hear Little Junior Walker sing." When we hit our opening song—"Just Anyhow"—we was untouchable.[21] All the girls was gonna be over where we was. All the old people gonna come up and say, "Boy, you made me feel *good*!"

In them days if you was a gospel singer you just sung in the churches. You had enough churches to keep you busy. Where there was a Baptist church we was there. Willie James had a brand new DeSoto. We went to churches in style. You should have seen them little blue pointed suits we were wearing. Lord have mercy. Suits was real short then, come up to your waist.

The churches would pay seven or eight dollars for expenses to gospel groups. That was money back then because people didn't expect to be paid at churches. You did it for pleasure, because you were a church member or you felt you was serving God. We'd sing at two churches on a Sunday. Dinner time you had to get some rest 'cause you had to get ready for the field the next day.

When I was a teenager my parents moved to Waukegan, Illinois.[22] We stayed there for four or five years. I wasn't old enough to get a job. I had to put my age up to twenty-one and get a phony birth certificate to work at American Motors. They was the Nash Company, making Nash cars when I went to work for them. They changed and went to American Motors and started making Hudsons, then Chryslers. As long as they know you're from Mississippi, they know you could work. I painted and drove a forklift. I was working every day. I always got a job everywhere I went. In Chicago I worked at South Water Market and for the Alcoa Aluminum Company. I was a real good worker. When I wasn't workin' I was playin' and singin'.

In Waukegan I started singing gospel with the Gospel Trumpets.[23] That was the big group in Waukegan. I was the lead singer. At that time I was really singing like Sam Cooke. I sung with them about a year.

Big Jack and Little Jess come from Alabama and was playing blues around town. I left the Gospel Trumpets alone when I started singing with them. Waukegan had a lot of juke joints. You go from one joint to another and play them two songs you can play.

I came back to Mississippi for about a year or so. Everybody wants to come back to Mississippi and show the world what they can do. I started playing at Thompson's Place at the Four Forks. And I'd play in the cafés and jukes around Alligator. While I was back in Mississippi my folks moved from Waukegan to Chicago. That gave me a chance to come to Chicago. Every Black man in the world wanted to go to Chicago. You go to Chicago and stay a while you had a name for yourself. I wanted to meet the Soul Stirrers and the Highway QCs.

I sang with the Highway QCs for about six months, after Johnnie Taylor went to the Soul Stirrers [*in 1957*].[24] The QCs let me come in for a few rehearsals 'cause I could play guitar. They really had me on trial. I was glad to get with 'em but I wasn't good enough to stay. I left and went to Maxwell Street and started singing.

That's where I wanted to be. When I came to Chicago I seen all this music happening every Sunday up and down Maxwell Street. I'd set up on the corners, wherever guys were playing music, and sing. People stayed up all night long around Chicago. People would walk the streets. Half the people didn't have nowhere to stay. Maxwell Street stayed open all night.

Sometimes I'd be singing gospel songs with Blind James [*Blind Jim Brewer*], Old Man Johnson, and Mama Carrie Robinson. We called them sanctified people. That's 'cause they dance, shout around like they sanctified. They would sing behind me, dance and shout. They put a bucket out there. You be getting dollars and quarters. We'd divide the money up. Then I'd leave and go with another group. When night come, I done made me fifteen, sometimes thirty dollars.

When I stopped doing that, I started to play blues. You never was doing the two things at the same time on Maxwell Street—they didn't allow it. I switched over to the blues because you could be

your own boss and make your own money. I was teaching myself. I'd go on Maxwell Street and listen to the music. They had every kind of music you wanted to hear. Some of the owners from the clubs would come by and decide who they wanted to hire.

I had made up my mind I wanted to be a musician. I didn't want to just be doing the singing and somebody else be doing the playing. I wanted to do it all. I always wanted the spotlight for myself. Wherever the most recognition was, that's where Robert Walker wanted to be.

That's when I put my band together. Playboy Venson—we called him "Coot" for short—played drums.[25] He'd recorded with Eddie Taylor. Little Buddy Thomas played bass and Left Hand Arthur played guitar.[26] I called my band Robert Walker and the Starlights. We played on Maxwell Street then we started going into the clubs.

I sure enough learned to play guitar because one of the boys I had taught, Little Monroe [*Monroe Jones Jr. (1939-2012), arrived in Chicago 1956*], showed me up and took my girlfriend.[27] Monroe was playing at the Cotton Club on the North Side [*North Halstead and Clybourne*]. Monroe introduced me and made me look like a fool up there with my Jimmy Reed numbers. "Sweet Sixteen" had just come out by B.B. King [*January 1960*]. Monroe played that and blowed everyone's mind. Monroe was just as good as B.B. King at that time.

I had to get revenge because I had got showed up and got my feelings hurt. I lost my girlfriend. I was very much in love with her. After a week I bought a new Fender guitar. I was crossing blues and rock 'n' roll. I had a hell of a music style. I was coming up with something beautiful and didn't even know what I had. For weeks when I get off of work I sit up all night trying to play. One night Chuck Berry came on TV playing "Go Johnny Go!"[28] The next day on the job, up and down the highway everywhere you turned on the radio, all you could hear was Chuck Berry. I wanted to be like that man badder than anything in the world.

One night I got down on the floor and asked the Lord to let me be like that man. For two weeks I'd work in the daytime and stay up all night. Once I got the music, I told myself, "You got to do what he does with his foot." Anytime I get caught up at work, I'd go in the bathroom, lock the door and get on the broom. Like a witch riding the broom, that's the way I'd be running around the bathroom, trying to get his footwork. Then I got the guitar and learned how to do it like he do. Then I said I got to do something different than he do. Chuck Berry could always go to the end of the stage, but when he get there he got to turn around and come back. I said if I can do it forward, why can't I do it coming back? I did it all night long in the room for about a week. I come out ready. I told Buddy, "We're going back to the Cotton Club!"

I went to the Cotton Club with Playboy Venson and Buddy. I told the manager, "Tell Monroe his friend is here and I want to play a little bit tonight." Monroe made a pronouncement to the audience. "I'm gonna do a few numbers then I'm going to turn it over to the man who taught me how to play guitar." I come out with "Sweet Sixteen." The peoples who never heard me stood up cheering. The ones who booed me before sit back and look like fools. They wondered how this guy learned so much in such a short time. I did "If I Go a Million Miles Away I'd Write a Letter Each and Every Day" by Sam Cooke.[29] That's fresh out. Boy, some of them women over there crying. I went out on one of Elmore James's numbers—"The Sky Is Crying."[30] I could play with my finger, didn't need to have no slide. I did about half of that song, stopped right in the middle, and did "Go Johnny Go!" I slid to the edge of the stage, went back across, did the duck walk, and Good God almighty, everybody in there was standing up all in cheers. I took the guitar off my head, introduced myself and started dancing, swinging with one hand and playing with one hand. When I stopped and come down, everybody was around me. Everybody wanted me back on stage, but I wouldn't go. I had done what I wanted to do. The man asked if he could hire me for the next weekend. Monroe and me laughed about it years later. If it hadn't been for him taking my girlfriend, I would never have become a famous musician.

After I got Chuck Berry's style I changed the name of the band to Chuck Berry Junior and the Starlighters. I looked so much like Chuck Berry people started calling me Chuck Berry. I used "Chuck

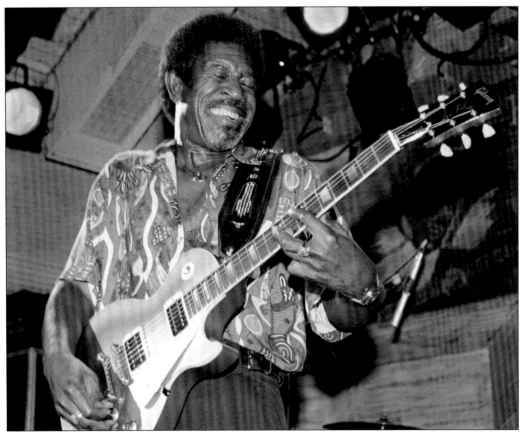
Luther Allison, House of Blues, Cambridge, Massachusetts, August 1995

Berry Junior" so people would know the difference. The band went by that name for years in Chicago. That's all the people booked me by, known me by.

I branched out to the blues and rock 'n' roll then. I always believe in having your own band, your own everything. When I go out to play, I have to be formally dressed. I believe in having everything looking right.

I was playing with my band on the West Side at the Bungalow. Elmore James was playing there one night. Elmore didn't need no band. He's the only man I seen who was a one-man band and could entertain people the way he could. He'd take the guitar with that slide on the guitar, play drums with his foot, and you'd swear he had a four-piece band. He played the bass and the lead at the same time.

Elmore played a couple of hours. Luther Allison came in with his bass man, Willie James [*Lyons*], because he wanted to hear Elmore. Miss Mary, the owner, said I should meet them and try to get something going. We played the rest of that night. She needed a regular band and it became our regular gig. We played all over Chicago, for whoever offered us the most money. I had a nice automobile we traveled around in. They did most of the playing. I did the singing. I'd be on the floor dancin'. Half the time I'd miss

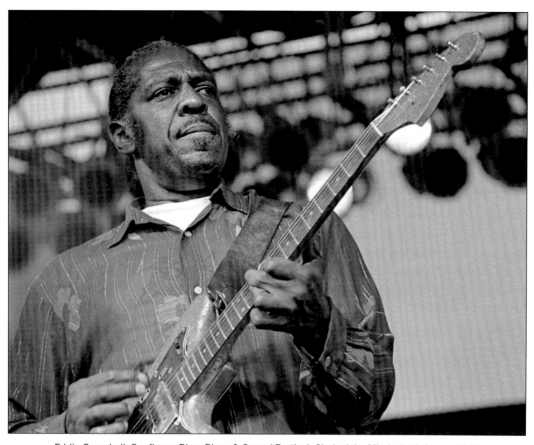

Eddie Campbell, Sunflower River Blues & Gospel Festival, Clarksdale, Mississippi, August 1999

the chords I'd be playing, but I keep on dancin'. Them boys behind me fillin' it in. I kept my band with Playboy Venson and Buddy but some nights I played with Luther and Willie James.

Over the years Luther, Eddie Campbell, and I played music together. I used to go out to Waukegan and play with Eddie all the time. He just came off the sidewalk and overnight come up to be one of the top Chicago music players. He cut heads from one side of Chicago to another. He was the kind of guy, he let you play on his show. But if you come on his show trying to show you're the best, that boy can reach back in his bag and come out with stuff the average musician didn't have. His style was so deep.

According to guitarist Eddie Campbell: "Me, Bilbo, and 'Bo Dud' (Oscar Coleman) hung out and played together on and off for ten, fifteen years. A group of us would go out with Magic Sam. Sam would sing and people would take turns behind him—head cutting sessions at Alex's and the Hideaway. After Sam played, Bilbo would do his Chuck Berry thing. He was very good at it. The women would go crazy! Sometimes they thought he was Chuck Berry. Chuck's in town! We didn't tell them nothing."[31]

From the time I was twenty-five I stayed between Mississippi and Chicago 'til I moved to California. I ain't never stayed a whole

year in Mississippi. I'd get broken down on money, and I'd come right back to Chicago long enough to buy me a car and things. Come right back to Mississippi. Then I went out to California to do a two-week thing. The people fell in love with me. I ended up making Bakersfield my home. I'd go back and forth between California and Mississippi.

How did I deal with segregation? Like everybody else did. Mind my own business and leave other people alone. It didn't bother me that much, to be honest with you. I wanted to go to Chicago because it was the "land of freedom," but you go to Chicago, certain parts of it was segregated just like it was in Mississippi. You go out to California, it's segregated right now. So why in the hell am I gonna let something bother me that's been going on ever since the world began? My parents taking all my damn money from me and drink it up—that bothered me more than segregation.

Mississippi always been my hangout. I played for years by myself when I came back. I played at people's homes, Thompson's Place, anywhere they had a juke joint going. When I organized a band, I brought Playboy Venson, Arthur, and Buddy down with me. Then I'd change the name of the band to Robert Walker and the Starlights. We played little clubs, juke joints around Clarksdale and Alligator.

Robert Fava Jr. recalled: "Robert used to play in all the jukes around here in the sixties. When I first came down Robert was mostly by himself. Then he put a band together and always drawed a crowd. You could hear him all up and down the streets. Mostly a Black crowd back then, but even some white people out of Clarksdale would come down and listen to him. Back in those days that was unusual."[32] Claudette Romious also remembered Robert playing at her father's café: "When people heard Robert play, they'd gravitate to him. The place would be packed. People would dance all night 'til it's time to go."[33]

I knew Big Jack Johnson in Clarksdale before I went to Chicago, when we were both working guys, still teenagers. I wasn't doin' no playin' when I first met Jack. Later on, in the sixties, one night I went to get him to play with me at the Town Site juke in New Africa. They told me he was a good bass man. Big Jack got up there and played so much guitar I like to forgot to play the bass 'cause I'm trying to watch him to see what he was doing. They never told me he was a hell of a lead man like he was.

Adds Michael Frank, president and CEO of Earwig Music Company: "I met Frank, Sam, and Big Jack at a roadhouse in Lula, Mississippi, April 1975. I heard the Jelly Roll Kings the next night at this club Jack owned in Clarksdale called the Black Fox. I knew right away Jack was this amazing musician. Jack had such technique, and he played so tastefully whether it was a really slow blues, super fast instrumental, or whatever. Jack played rhythm and lead guitar together. He is one of the few guys that could do that. Jack could really finger pick an acoustic guitar too. Jack was very inventive in the way he played.

Jack's solos were inspirational and moving. They were always full of tone and passion and great chops. It was impossible to listen to Jack and not feel the depth of his emotion and the depth of the blues in terms of the way he played. His singing was just as powerful."[34]

I met Sam Carr in the first of the sixties at a club in Clarksdale. I had my own band and Sam had his. Sam, Frank, and Big Jack were together then. They would do a show and I would do a show. Sam and Frank were the two original Blues Kings. Then Jack became the next Blues King. I became the fourth Blues King.

Later on Sam Carr put all of us together—me, Big Jack, Frank Frost, and Sam.[35] Little Jeno Tucker came in later.[36] I would go to Chicago and stay six months but I'd always play with the Blues Kings whenever I was back in town. Mostly juke joints and house parties in the back woods, late hours at night.

Believe me, we *was* the king of the blues. Frank, Jack, and Sam was the best combination I ever heard. They really knew how to play with each other. If they didn't have nobody else, just them three, they was great together. Frank could play the organ, bass, and lead. Jack could play lead guitar, anything you wanted to hear. Sam's drum playing was the top of the world.

Robert Walker (Preston Rumbaugh, bass; Stan Street, drums) Red's, Clarksdale, Mississippi, October 2012

I got Sam and his band to go and play for the sanctified white churches in Clarksdale and Rena Lara. All of us were originated from the church. We could do it all. Sam would take his drums; we go and have as good a time in church as we would have in a nightclub. We were making as much playing for a church as we were in nightclubs. Only we save more when we got to church. At the clubs we got to the dice tables and gamble the money off, so we'd never get home with no money.

Me, Big Jack, Sam, and Frank Frost were the first Black band playing for the white folks around Clarksdale. Some of them people sat around and looked at us like we were crazy. And the other people would love us. We were the first Black band that ever played the Holiday Inn in Clarksdale. The owner didn't hire anything but white bands until he heard me play at Master Ferguson's fish fry; then he hired us to play. I thought I was a movie star looking at my name lit up in big lights! Then we started playing for white folks in Tunica. Tunica was the worst place in the world against Black folks, but every time you look around the white folks were calling Sam for a dance. I could do country and western, and I could yodel. They was so surprised to see a Black man who could stand there and had the voice I had.

When I came back here in 1971, I started renting land, farming land, and buying combines.[37] If my car or truck break down I just get on my tractor and drive. I didn't have to depend on nobody. I used to have three, four combines lined up. Going down the road working for different people. I was getting help from other white people 'cause I didn't have the money to buy this stuff. Master Ferguson [*likely referring to Massey-Ferguson, Inc., international agricultural machinery company with a branch in Clarksdale*] down in Clarksdale heard me play and started helping me.[38] He let me use two or three combines and tractors. All I had to do was play for his fish fry every year, right here on 49 Highway. "Walking the Floor Over You" was the main song they wanted to hear.[39] I was the only one playing for them white dances then 'cause I could play Ernest Tubb's music. I learned country songs from the radio. I thought the world of Loretta Lynn and thought she was the greatest singer that ever lived. I learned practically all her songs. In the early days I got to be careful where I sing at. Around some white folks I couldn't sing them songs 'cause they say you trying to sound like the white man. I couldn't do that 'til years later. So then when I go out to play for white folks I can do blues, rock 'n' roll and country.

I started getting a name for myself coming to Alligator. Every weekend I'd come out here on Saturday and Sunday. The road was full of folks, girls and guys, old and young coming to hear Bilbo play. I formed a band with David "Pecan" Porter [*1943–2003*] and Rip Butler when I moved back to Mississippi in the seventies. I met David when we were the Soul Revival Quartet. When I got into the blues he started playing bass and lead guitar with me. He went back to Chicago and California with me, here, there, and everywhere. He learnt my style so perfect. He was the only one who could play the guitar and dance like me. He's on all them records with me. He's on that motor home with me. He played with me over twenty years—'til he died. Rip was on bass and Cornelius Riley on drums.

Jim O'Neal [*founder of* Living Blues *magazine and Rooster Records label*] traced me from one town to another for years 'til he caught up with me. That's how come I'm on a recording company, because of Jim O'Neal. I had been living in California, but I came to Mississippi every year to play music and go back. He'd come from Chicago and Kansas City trying to find me and I'd be gone again. He finally caught me one night down there in Merigold. Sam Carr brought him to the club. Jim heard me play and asked if I'd make a trip back down here to record for him.

Robert's first album, Promised Land, *was recorded at Stackhouse Recording Studio in Clarksdale in 1993, and released on cassette by Rooster Records in March 1996, with Sam Carr on drums, David "Pecan" Porter bass, and Frank Frost organ on three tracks.*[40] *The album was named Best Blues Album of 1996 by* Pulse *magazine.*

I got two more CDs since then [Rompin' and Stompin' *(Fedora, 1998) and* Rock the Night *(Rooster, 2001)*] and they put "Robert

Robert Walker with wife Audrey, and their daughters, Sariah, Sonia, and Destiny at Sam and Doris Carr's home, Dundee, Mississippi, August 1999

Robert Walker, Cat Head Mini-Blues Fest, Clarksdale, Mississippi, October 2017

Bilbo Walker" on 'em. I started moving on up in the world. I wanted to make my own name famous and I did. There were people didn't know my real name was Robert Bilbo Walker. It went for so long Chuck Berry Junior, everybody knew me as that. But after I started making records for myself I didn't want to wear nobody's name. I wanted to wear my name. I wanted Robert Bilbo Walker to get the credit. No, Lord I changed that stuff and started giving my own self credit for what I do.

Now I'm at the point where I don't care if I never get no bigger, 'cause I did everything. I had all the fun I wanted to have. I've been everything in my life but get rich.

When the people say they need me here I come no matter when it is or where it is. I hit the road and get here. Sometimes I don't even make gas money for coming here and going back. But I'm a man of my word and I just come to play for the people and have a good time.

In October 2017 Robert returned to Mississippi from California, for what would be his final appearances in the Delta. Battling cancer, and visibly weakened, Robert still performed at the King Biscuit Festival on October 6, spoke on the panel of the annual blues symposium on the 7th, and played at the Cat Head Mini Blues Fest in Clarkdale on the 8th. After sitting down for most of his set in front of the Cat Head Store, Robert slowly got himself to his feet, then valiantly raised his guitar with one hand in his trademark salute to his family and fans.

As he told me during one of our last interviews, "I always loved Mississippi. I was born here, it's where my roots is at. There ain't nowhere I ever been, nowhere I ever go that I ever love like I do Mississippi. This is home. This is where I want to be. I made sure when I die this is where I'm gonna be buried, in Mississippi. Doesn't matter if I'm in California. Gonna bring my body right back here and spread my ashes in the lake down here, Harrison Bayou."

Robert did die in California, on November 29, 2017. And his body was flown back to Mississippi one last time for a celebratory service at the Union Grove Baptist Church in Clarksdale on December 16. That night there was a party for him at Red's.

Baptism candidate, Moon Lake, Mississippi, September 2001

Four ministers, Moon Lake, Mississippi, September 2001

"Mama Jean" (Mrs. Eva Jean Jones), Looxahoma, Mississippi, October 2007

Church, Sharkey County, Mississippi, October 2008

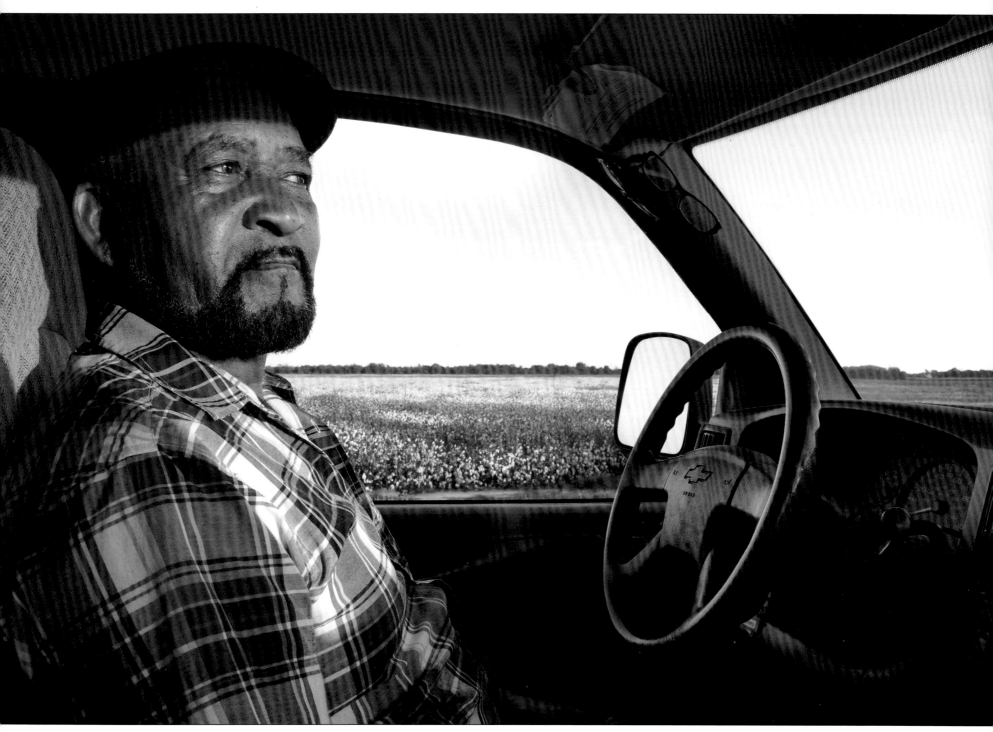

James "Super Chikan" Johnson, Quitman County, Mississippi, October 2014

James "Super Chikan" Johnson

I was born on February 16, 1951, in Darling, Mississippi, about a twenty-minute drive east of Clarksdale. Christine Johnson Coleman was my mother. Pearl Johnson was my grandmother and that's who raised me, because my mother was a teenager when I was born. I never did call my grandmother "grandma," I always called her "Mama," because she *was* my mama from the time I was a baby. When I finally met my mother, I called her "Mama" too. My mom was a sweet, funny person, very loveable. She was the sister of Big Jack Johnson [1940–2011]. So Big Jack was my uncle. We were raised up together.

I'm the oldest one of my mom's kids. She had eleven kids and raised the rest of them. I would walk five to ten miles back and forth from one house to another depending on which plantations they were on.

My father was a Mullen. I never knew him. At the time my mom got pregnant they were in school. The Mullens was sanctified people and pretty well-to-do. When they found out that their son got one of the poor folks pregnant, they didn't want to have anything to do with us. They moved away before I was born.

Everybody in this family knows my grandma Pearl was some kind of woman. She was sweet, strict, and hardworking. At that time she had at least twelve or fourteen kids of her own at the house. Her oldest daughter, Eva, my auntie ["*Geneva*"], got sick. She had seven kids, and they had to move in with us. So it was like twenty-two of us in one shotgun house.

We slept four and five to a bed, sometimes six to a bed—three at the head and three at the foot—and all that couldn't get in the bed made pallets on the floor. We made our mattresses. We'd go out in the cotton field and pick some cotton, take a couple of cotton sacks and sew them together, make a big place to hold the cotton, and make it wide enough to fit the bed. We had blankets and homemade quilts made from pillowcases and flour sacks.

Pearl had to make it work. She was married to Ellis Johnson. My grandpa was a big man, a Cherokee Indian. He was *mean*. That man didn't work for nobody. He stayed on the road. He was a Mason. Masons was there to help people. They would provide food and clothing for widows and their children.

I remember my grandfather playing the fiddle. When he wasn't on the road, he was doing house parties for the rich people, the farmers, and plantation owners. They liked that fiddlin' music. Sometimes he would come home with a bag of groceries or a bag of meat. I think sometimes he would be paid.

He'd sit on the front porch and play. Neighbors and people from adjoining plantations would come to the house. They brought their instruments: guitars, diddley bows, harmonicas, fiddles, and gutbuckets—a washtub with a broomstick and a string tied to it—they would use that for a bass.

Everybody brought moonshine—and everybody had a .44 or .45 down in their coat pocket. All the kids be out in the front yard dancing and what have you. "Front porch party" we used to call it.

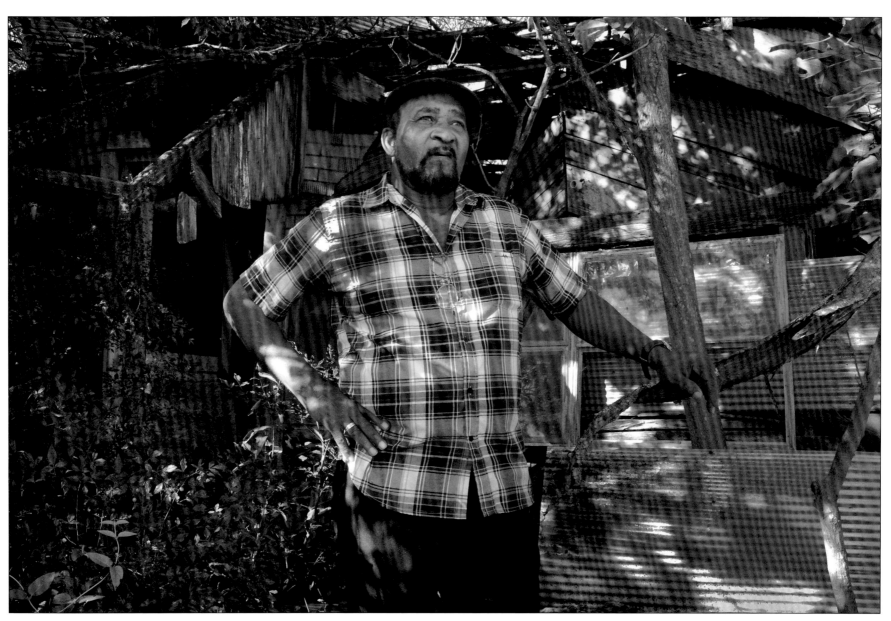
James "Super Chikan" Johnson outside the remains of his childhood home, Rena Lara, Mississippi, October 2014

They would have them pretty regular on the weekend. Listening to the music was a traditional thing. A variety of music was played. There was some sentimental songs, sometimes they sounded like gospel songs with blues. They were songs that make you remember the past, something that was special to you or made you sad, a long time ago. The songs would just melt your heart. I can hear 'em sometimes in the back of my head today. I know everybody's favorites: "Mama Killed a Chicken and Thought It Was a Duck" and "You Are My Sunshine."[1] My grandpa used to play those songs on the fiddle. And they would always be playing some Robert Johnson music. There were people from neighboring plantations that could play better than any of the musicians today.

I was plucking a diddley bow at four or five. You get a string of baling wire and a nail. You put the wire on the wall on the side of the house and slide a can or something under it and start plucking. With a diddley bow you have to use a slide to get the sound out 'cause the strings are too high for notes and chords and the neck is too small for frets We used snuff bottles and tin cans for the slide. That's when Pearl did her most fussin': "Who's making all that noise out there? I'm gonna whup your butt!"

We had plantation bells, dinner bells. They would come out and ring the bell at noon so everybody knows it's twelve o'clock. The churches had bells. The church would toll that bell in a way to let you know a baby was born, someone was sick, someone died, or there was a funeral. My grandpa could walk out in the yard, hear the bells, loud and away. He'd make everybody be quiet. He could tell you what was going on. If they had light sounding bells, grandpa would say somebody had a baby. But if it's ringing slow and got that low tone to it, somebody died.

It was common for my grandparents to argue and fistfight. My grandpa didn't like my grandmother to tell him *nothing*. She was always trying to tell him right from wrong. One day my grandma and my grandpa gets to fighting. We kids were out in the yard playing. My grandpa was swinging at my grandma with his fists and cutting at her with a knife. She grabbed a straight chair out of the house. She was holding the door with one hand and pushing him out of the door at the same time. He stumbled and dropped his knife. My aunties grabbed my grandma and brought her to Aunt Mag's. Grandma got a shotgun and sat in the door and wait for him. He had the devil in him that day, and he was gonna kill her. My grandma got him first.

We went from farm to farm when I was a kid. Widowed women have a hard time getting a house on the plantation. All the kids have to work to make up for the man not being in the house. Pearl was in the fields with us. We picked two bales of cotton a day—a bale in the morning and a bale in the evening. Each person had a certain amount to pick during the day and if you didn't get it, you got whupped with a cotton stalk by grandma. Younger kids were expected to pick 150 pounds; younger teens 200 to 250 pounds; older teens 300 pounds; and in your early twenties 400 pounds. She expected more from me. I'd tell her, "I can't pick that much!"

"You ten years old, you can pick 200 pounds of cotton, I *know*!"

She raised all of us like she was raised, to work. I got a couple of whuppins before I got that 200. She said, "You pick alongside me and I'll show you how to get 200 pounds of cotton." I was about twelve. The method—shut up and work. Don't stop, keep your head down, keep your eye on the cotton balls. Pick as fast as you can. So I done that. I picked right along beside her. When she shook her sack, I shook mine. I got 200 pounds that day. She said, "You got to do that again. You got to ignore those kids. When they start doing something and want to include you, you tell them you got work to do. You can't stop and play."

When my grandmother wanted 300 pounds I'd be scared to death when I came up with 225 pounds. She said, "That's all right, baby. Mama ain't gonna whup you today. But you try for that 300 pounds tomorrow." I said, "Yes ma'am." I be so glad that I didn't get a whuppin' I tried hard as I could to get 300. One day I actually did. I was the happiest kid!

It's so quiet out in the field you can't hear nothing but sacks bumping and maybe a field song or two once in a while. The train going by had a rhythm, and people would be working and swatting mosquitoes to that rhythm. We had no idea where that train was going or why it was going or what the name of it was. All we wanted to hear was that whistle and them wheels clicking on the tracks. We

used to sing the old train songs. Now I got me a train song and the words to the song are true: "Living in the country / Growin' up in a tin-top shack / Workin' to the rhythm of the train comin' down the track / picking that cotton and popping that sack." It's called "Work Train," on my CD *Organic Chikan*.

It was a hard time but being a kid you looked forward to going to work for fifty cents for a hundred pounds of cotton so you could have some money. Money was very important. No money means no food, no clothes. What little we got we did the best we could with it. As far as I'm concerned, sharecropping is still slavery.

Whenever one of us got in trouble Pearl wanted to beat us. You run, she had somebody there to catch you. "Go get him. Bring him back here!" Sometime she'd come up, be real nice to you, tie a little rope to the belt loop of your pants and tie you to a tree. Then she'd tell you, "I'm gonna whup your ass for what you did. I was saving this one for you. Do you remember?"

"Yes ma'am."

My grandma used to say, "You are my little sunshine." That was her favorite song. Whenever I got in trouble I'd run and get my diddley bow and play it for her, to try and keep her from giving me a whuppin'. One time she said, "Boy it's nice of you to sit down and play Mama's favorite song but lately you've been getting a little rough. As soon as you get through with that song I'm gonna tear your tail up."

I was pretty much like her—funny and charismatic. I would do something funny that would make her tickle, and she would stop whupping me. One day she said, "You got a knack for running, boy. I'm fixing to whup your butt. I'm not gonna tie you up today. You better not run, and if you run, you better not move."

You know that thing I do on stage sometime—they call the "running man"? I stand in one place and shuffle my feet. They call that "the skip." I started doing that when she was whuppin' me. She stopped and looked at me and said, "What are you doing?" I said "I'm running." She said, "Do that again." She started hitting my legs and I started doing it again. She got tickled and stopped whuppin' me.

We worked six days, sometimes seven days a week. My grandmother went to church. She made us go every Sunday. But if there was work to do, we'd go to the fields. I went to a Baptist church 'til I was a teenager. All the kids would go to church barefooted. I got baptized at the age of nine on the Markham Plantation in a little pond out in front of the boss man's house. Whenever we were gonna have a baptism, they would call all their friends to see the Black baptism. They'd be sitting up there on the porch or in their yard watching us out there.

The preacher put a towel over my nose, dunked me down in the water. The first thing I saw when I come up was a big snake hanging out of the tree. If you saw a snake you got to be rebaptized. I didn't tell my grandma 'til after the baptism was over. She said, "You ain't got no religion, boy. You done saw the Devil soon as you come out of the water."

We grew up drinking pump water. We had to carry water, sometimes for miles, depends on how close you live to the headquarters. That's where they had the shops and the well. That's where the boss man lived. To get the water we'd get three or four buckets and hang them on a stick. You had to do it every day. We hated when washday come 'cause you had to carry so much water.

We used to have "quilt water." Every house in the country had a 55-gallon drum sitting at the corner of the house where the rain would run off the roof. There were several quilts over the top of the barrel to filter that water. They used that water when the midwife come and needed some sterile water, to bathe wounds and for the sick person to drink. They'd boil it on the stove.

For bathtubs we had a "number three" tub or a feeding trough, what they fed horses with. A number three tub is not that big. Kids could sit down in it, but most people would stand up in it or just get down on their knees in it.

When we were living in the country, when it come night time, there's no lights. You can't see where you're walking. It's *dark*. We'd be on our way to town on a Saturday night and see the lights before we get there, we're like, "Wow! we going to a big city look at all them lights!" That would be Clarksdale. We couldn't wait to get up in those lights. It was exciting. Walking the streets, it was like going from one world to another, from a dark world to a world with lights.

Everybody in our family was poor. People had old raggedy cars. It was a big thing if our kinfolk visit us from up north. They would come down in a new car or a newer one than the ones around here. We'd gawk at that thing like it was a UFO.

Sometimes we only had enough money to buy a bag of flour. Then we would go pick poke sallet or wild greens. We'd get a rabbit or a squirrel or something to add a meat flavor to it and make a big pot of gravy. Then you use the bread to soak up the gravy.

Or we'd cook up some poke sallet, turnip greens, or what have you out of the garden and make a big old pot of "likker"—the juice from the greens that you cook. Then you make a couple of pans of cornbread and dump them into the pot likker. Put it all together and call it "Double O Joe."

We would go rabbit hunting without a shotgun. It was up to us to go out in the field and form a big circle and beat the bushes. The rabbit would run round and round in a circle and we'd keep closing the circle in. Pretty soon the rabbit would be tired and give out. We'd just reach down and pick him up.

We got a chance to go to school some, but not much. If it was light, freezing rain we'd pick cotton. But when it was just too bad we'd go to a one-room school with a wood-burning heater. We'd walk about a mile and a half each way. We finally got to ride on a school bus when I was eleven or twelve. If you was big enough to chop wood you'd have to chop wood sometime at school as well as you did at home. Each kid had a turn at feeding the heater because the schoolhouse was just an old shack. It had cracks in it like our house.

We managed to get us one set of clothes for school—one pair of shoes, one nice pair of pants, and a shirt. We had to make those shoes last a whole year, maybe two years, 'cause we might not be able to get none the next year. We would carry our shoes 'til we got to the schoolhouse, then put them on and wear them in school. When school turn out we take them off and carry them. We made special shoes for the winter. We had brogans. We would wrap them with the stuff they made cotton sacks out of, burlap, wrap it all around the shoes. Whenever we got them dirty or muddy or something we'd just take that wrapping off and put on some more.

The school was for Blacks only. You wouldn't think of seeing a white person in our schoolhouse. We were afraid of white people. We felt they were afraid of us too.

It was against the boss's rules for guys to have their shirts off around the house. If you were way off in the field you could take your shirt off, but if you were around the big house where the women folk were, you weren't allowed. And you didn't whistle around them because they would think you were whistling *at* them.

Grandma told us, "When you go by the white folks house I want you all to quit whistling," She said, "If you get trash in your eye, don't be batting your eye. Just put your hand over your eye 'til you get past the house. If you bat your eye they'll say you winked at them." She said, "They'll hang you in a tree somewhere where everybody can see you hanging. And don't let the boss man see you trying to write." We always sat in the dirt writing our ABCs. "They'll run you off the place or do something to one of you."

I would hear the older people talk about Emmett Till and how he got murdered when I was young and when I was growing up. There was a lot of anger from the family and community about what was done to Emmett, but you wasn't allowed to show it and wasn't allowed to say nothing about it. We talked about it among ourselves but we didn't talk about it among the white folks. They didn't want to hear about it anyway. And if you mentioned it—"Why them folks did Emmett Till like that?" The old folks say, "That's for the rest of you all to know to behave yourself. If you walk in a store and there's a white woman in that store you look up the side of the wall and tell her what you want. You don't look at her." They said, "The only thing we can do is hope and pray for the best. One of these days something will be done about it."

I've seen things go and come in my years. It was just before things started to change. I remember 1961 was pretty bad. That's when all the protests in the cities were going on. We'd hear about it in the country. We heard about the Freedom Riders.[2] We were scared to go anywhere. If we walked on the road and see a car

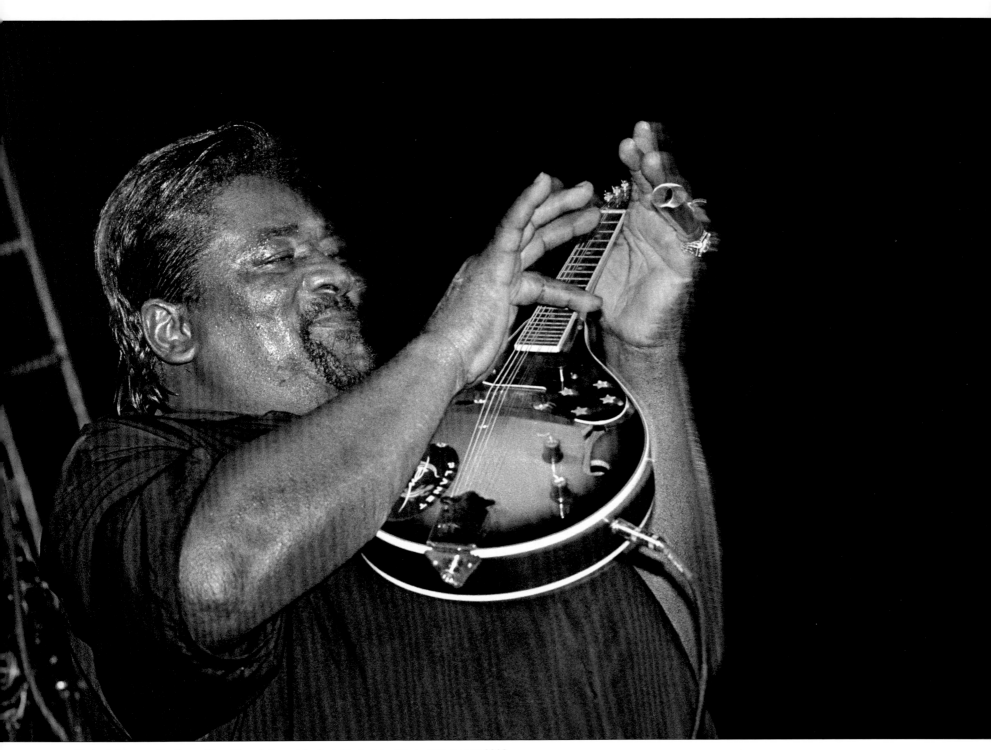
Big Jack Johnson, Sunflower River Blues & Gospel Festival, Clarksdale, Mississippi, August 2002

coming, we'd run out across the field and hide in the bushes, ditch, or something. They might throw something, hit you, shoot at you, or try to run over and hit you. If they stopped, we'd be boogieing. They couldn't catch us. We know how to run.

We were out in the country. While all the protests were going on, the boss man would come by and talk all kinds of trash to you. "You better not do this. You better not go over there." So we didn't do nothing. We just stayed in the house. Grandpa used to say that in his time it wasn't nothing for them to walk out and see a Black man hanging in a tree by a rope or something where everybody in the plantation could see him.[3] It was supposed to be a lesson to you to behave, not to be lazy, to work when you're supposed to, to stay away from them white women.

There were always two or three guitars around the house. My uncles, aunts, mom, my grandpa, and Jack [*Big Jack Johnson*] all played. My mother picked the guitar, and I learned a couple of notes from her. When I got big enough I played every chance I got when nobody was looking. Kids weren't allowed to mess with guitars when we were small. They'd thump you on the head if they caught you. That's why I played the diddley bow.

When I got fifteen, I went to work in the cornfields. I pulled corn for a whole week and bought my first guitar in Clarksdale at Campassi's. The guitar only had two strings on it. I'm plucking that thing around the house, and one of the family walked by looking at me. "When you gonna put the rest of the strings on it? You see those six keys up there? That means it needs four more strings."

So the next week I went back and told the owner my guitar didn't have but two strings on it. He gave me a free pack of Black Diamond strings. When I put them on, everybody played my guitar because it played better and sounded better. It was actually a good guitar.

I was about sixteen or seventeen when I went to work for the Mennonites.[4] I started out learning how to survey. Pretty soon I was running the land-leveling rig, hauling dirt, leveling the fields for the farmers, building fish ponds.[5]

I was living with Big Jack in Lyon when I met Ollie Myles, my wife. I moved to Clarksdale so I could be closer to her. I was seventeen, and she was sixteen when we married—Christmas Day 1968. I knew I could do enough to take care of me and my wife. By the time we was twenty we had three kids. I was already into the music. I always had a guitar in the house.

I was driving a cab in my twenties in the winter when it was too wet to work in the fields. That's when I got the name "Super Chicken." When I was a kid I took care of the chickens. I could talk to them chickens. The chickens would obey and do what I wanted. People called me "Chicken Boy."

I had a little red car that I drove as a taxicab. They called me "Fast Red." One day I was driving and dispatch called me "Super Chicken." There was a lady from the home place where I lived. She said, "Tell Chicken Boy to come by here and pick me up." Dispatch said, "We don't have nobody here named Chicken." She said, "Yeah, that boy that drive the red car, he's named Chicken." A second lady told dispatch, "He's a super fast chicken. He'll come right over as soon as you call him." Dispatch kinda got it screwed up. She said, "Okay. I know who you are talking about. 'Super Chicken come by the cab stand!'" I didn't answer. I didn't know who Super Chicken was. She said, "Don't you know your name when you hear it?" I said, "Yeah, it sure ain't no Super Chicken." She said, "Well it is now." The rest of the cab drivers started calling, "Hey Super Chicken!" and the name stuck.

Clarksdale was like a big city. On the weekend Issaquena Avenue was like Beale Street. It was full of stores, a lot of people. There was music everywhere. You had to be twenty-one to go in the clubs. That didn't stop us from standing outside and listening. Ike [*Turner*] had left by that time, but he was in and out. I'd hear him singing "Rocket 88" when he was in town.[6]

Big Jack had a club on Ashton Street called the Black Fox. Ernest Roy Sr., David Porter, Robert Walker, and many others was in there playing with Jack. Ernest Roy Jr. and me used to hang out and play

there every now and then. Sam Carr and Frank Frost would come in on big nights.

I looked up to Big Jack because he was a fantastic guitar player—one of the best in this part of the country. It made me feel excited when I heard him play in the clubs. It made me want to play in public. In later years he started playing the mandolin. Big as his fingers were, I don't know how he played it. Jack could really play the mandolin!

I started to play in my late teens with Jack. I played with him, Sam Carr, and Frank Frost on and off in the late sixties and early seventies when they called me to play the bass. Frank played bass and lead on the keyboard, and he blew harmonica. When he got up to blow harp I would keep the bass line going.

The sound of the Jelly Roll Kings was a true Delta sound and a hard blues, the low down dirty blues. It was a heart-touching sound. It was true blues, the kind that would pierce your skin. And Jack could lay it on, man. And Frank would be right there with that organ screaming. The sound of the Jelly Roll Kings will stick in my head forever. [*Sam Carr, Frank Frost, and Big Jack Johnson did not call themselves the Jelly Roll Kings until 1978–79 and their first album for Earwig Records,* Rockin' the Juke Joint Down].

You will never hear the sound of the Jelly Roll Kings again. It's gone because nobody could play the keyboard or harmonica like Frank Frost. When Frank played the organ the sound was so much different than a piano. The organ held the notes. I haven't heard a keyboard player yet that sounded better.

Sam Carr was a great drummer—I would sit and watch him play all night. He would show off. Sometimes he'd get up and hit the side of the wall with his sticks. Sam held the band together. He kept Jack out of fights and kept Frank away from the whiskey bottle when he could. I was pretty young. Frank, Sam, and Big Jack were like parents. I considered them mentors. They would tell you right from wrong.

I played with them in juke joints and what they called 'em back then, "redneck clubs." A guy would come up and make a request of something we never heard. He'd say, "Well you're gonna play it tonight, god damn it! You ain't gonna leave here." We tried to make it up. "God damn it, that ain't it! You all ain't playing!" They'd start throwing stuff at us. We'd run out the back door. We'd be hiding in the bushes and what have you. It happened more than once.

One night we was out at Moon Lake. The guy said, "Play 'Wings of a Dove'!" [*Ferlin Husky, 1960*]. We didn't know nothing about "Wings of a Dove." "You gonna play it or we're gonna whup your ass!"

Jack and them knew these guys just wanted to start something. So while our promoter Lee Bass took up for us we ran out the back door—there was nothing but water. You could get under the porch. One guy came out, and yelled, "I know someone's out there somewhere." Frank picked up a big old rock under the porch and threw it in the water. Sam threw another big rock. They started shooting in the water! While they was shooting we crawled from under the porch and around the side of the house. We got to the front and left the car and left there running.

There were more good times than bad. The jukes would be packed before we even got there. People would be screaming when we pull up in the yard: "The Jelly Roll Kings, the Jelly Roll Kings! We're gonna have a good time." That's what the house man would stress. "We're gonna have a good time tonight. Ain't gonna be no shit in here. Anybody think they're gonna fight, you better get it over with now."

People couldn't wait for us to start. As soon as we strike the first note they're on the floor jumpin', dancin'. Sometimes we'd go 'til five in the morning. That's the reason for juke joints, because when you come to town things close up around twelve o'clock. So they would leave and go where the party was, at the juke joints out in the country. And most of them was looking for whiskey and women. And that's where it was.

Out at jukes, Jack was in his own territory. That's why they called him Big Jack. He didn't take nothing off of nobody. The places were pretty rough. That's why I got me a bulletproof guitar made out of solid Plexiglas. I called it my "Saturday night guitar." People would start shooting and I could hold that guitar up and block the bullets.

Big Jack and I both on the stage was like two heaters in one room. I wanted to be different and have my own trend. I'm left handed.

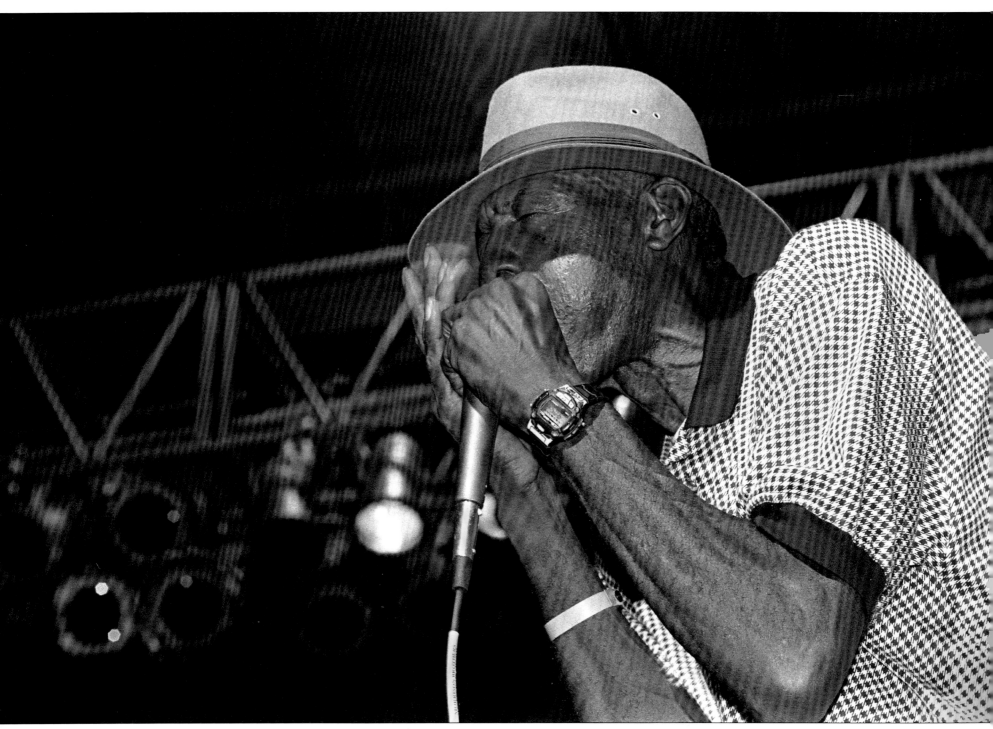

Frank Frost, Sunflower River Blues & Gospel Festival, Clarksdale, Mississippi, August 1998

Andrew "Shine" Turner, Dundee, Mississippi, April 2022

All that was around at the time was right-handed guitars so I had to play righthanded. That made my style different.

I was coming into my own. I got two bands together when I started out. The Funk Thumpers was whoever I and C. V. Veal could get to play for that weekend: Big Jack if he wasn't playing someplace else, sometimes Andrew "Shine" Turner.[7] Ernest Roy Jr. and William Nelson were in and out. The Funk Thumpers played blues and rock 'n' roll. We just thump the funk. I promoted another band, Klazzy—a disco band that accompanied us. I still played with Jack when he needed me.

The Klazzy guys was young cats that was fascinated by me as I was fascinated by Jack and the Jelly Roll Kings. They were studying and singing disco. They didn't have no equipment, so I bought extra equipment. I brought them along with me to get them some recognition.

For a while Klazzy and the Funk Thumpers played the same places. We had music for everybody. That way we could get more people in the clubs. We would play the blues first. Oh man, when Klazzy started playing the place would load up with young people screaming and hollering. Old people got into it, too.

I played small clubs in Clarksdale and jukes out in the country. I was playing local places like the Black Fox, Casablanca, and Smitty's. We'd go down to Rome, Sumner, Tutwiler, Swan Lake, Greenwood, and different places and play. I played whatever was popular at the

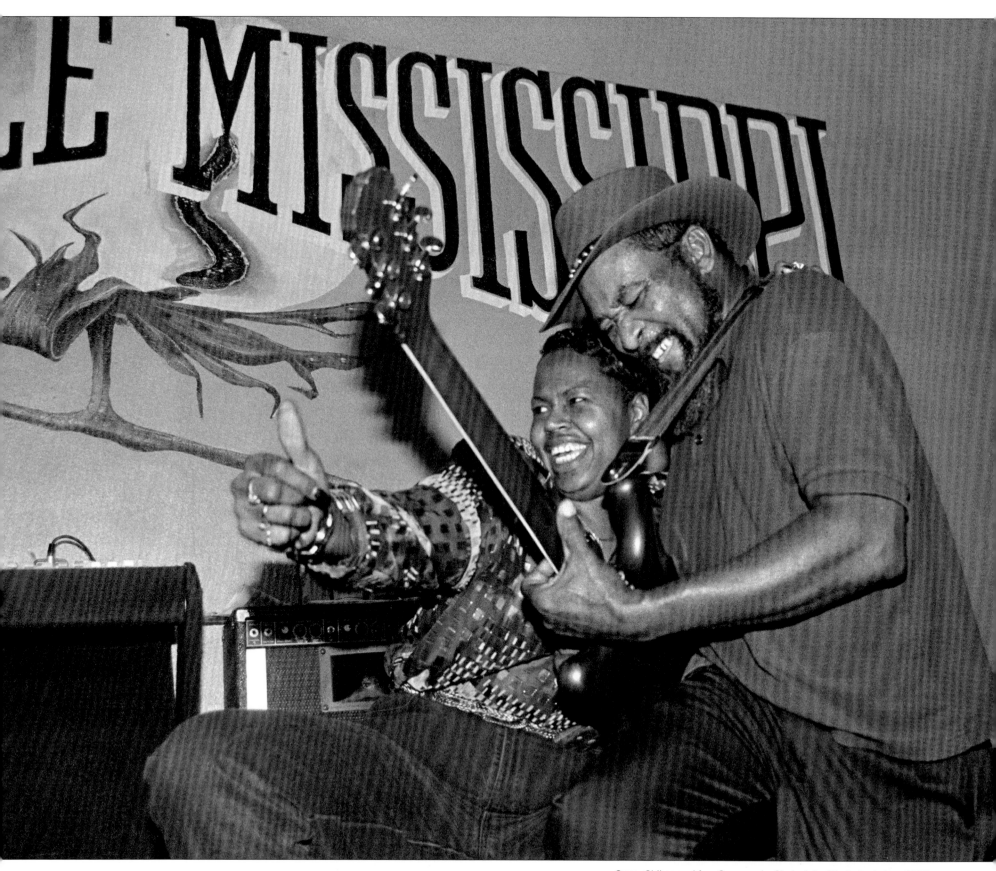

Super Chikan and fan, Crossroads, Clarksdale, Mississippi, June 1998

Super Chikan,
Ground Zero, Clarksdale,
Mississippi, August 2012

time—Muddy Waters, John Lee Hooker, B.B. King, Albert King, Little Milton, and Johnnie Taylor.

The Funk Thumpers evolved into Super Chikan and the Fighting Cocks. In the late eighties and nineties I had a fighting cock that I used to take around with me. Everybody thought he was fascinating. I put him in a little wire cage and put a cup of water in there. Some people would fill his cup with beer, and he'd get a drink and start jumping around while we was playing. They thought he was dancing. One day he got excited and jumped out of the cage. He ran across the piano and back. Word got around the chicken dances and plays the piano. That chicken got me a lot of gigs! I started taking that rooster so much, people wasn't paying me no attention. So I fired him! I finally changed the name of the band to Super Chikan and the Fighting Cocks around 1996.

In the 1990s I was still driving a truck part-time. One day I heard on the radio that songwriters were making more than performers. I started writing songs. I ran up on Bobby Rush and was talking to him about it. He said, "Bring them and let me see them." He read the words and listened to some of the songs. Bobby said, "You got good concepts here, but you need to do these yourself. These songs have personal feelings and meanings in them. They're life stories. They're about *you*." Bobby and Jim O'Neal both told me I should sing them for myself.

In the late nineties I really got Super Chikan and the Fighting Cocks going. [*The band was nominated for a W. C. Handy Award for Best New Artist Debut in 1998, for the CD* Blues Come Home to Roost *(Rooster, 1997).*][8] The original Fighting Cocks were Harvell Thomas [*bass*] and Dione Thomas [*drums*] and Joshua "Razorblade" Stewart [*vocals*]. Razorblade sang soul and rhythm and blues and had his own show.

I played almost every weekend at the Crossroads in Clarksdale. My daughter Jameisa used to hang around there because her mom [*Evelyn Turner*] ran the place. She would get on the drums before we started playing and sometimes on break. I was just about to take a tour, and the Thomas brothers quit on me. Jameisa's uncle, Shine Turner, agreed to go and play bass. Jameisa said, "I'll play the drums!" She was about fifteen years old.[9] Some places we traveled to Jameisa was too young to be in the club, and they wouldn't let her play. One day I stood up and said, "If I can't have my own drummer, you can't have no show!" Shine couldn't go all the time. When La La Craig moved to town she started playing keyboards with me. The Fighting Cocks became all girls [*Jameisa Turner (drums), Laura "LaLa" Craig (keyboards), Heather Tackett Falduto (bass)*].

Jameisa is now in her mid-thirties. She won't play for nobody else. Her playing and timing are great. She knows my moves, my changes. She knows how to back me up and keep it in the pocket. I feel proud of her—the feeling makes my chest stick out, what we've accomplished together.

When Rooster Records closed down I went to Fat Possum in 2000 and recorded *What You See*. Then I went back to Rooster and made *Shoot That Thang*. *Chikan Supe* was made in Clarksdale in 2005 and *Sum' Mo' Chikan* was made in Memphis in 2006.

One year we were touring around the Northeast, the weather was bad; it was snowing and icy. Our last stop was at XM/Sirius satellite radio's station in Washington, DC. Broadcaster Bill Wax had arranged for us to make a CD in the station's studio. I did some songs solo and some with the band. The CD was named *Welcome to Sunny Bluesville* [*released 2010*]. In 2011 I made a CD with Watermelon Slim called *Okiesippi Blues*. A few years later I made the CD *Organic Chikan Free Range Rooster* by myself, without the band, down in McComb, Mississippi.

My first trip out of the country was to Italy in 1995. I went to Norway in 1998 to play at the Notodden Blues Festival.[10] [*Super Chikan and the Fighting Cocks returned to Notodden in 2009 and with the Norwegian band Spoonful of Blues recorded* Chikadelic, *which won the 2010 BMA award from the Blues Foundation for Traditional Blues Album of the Year.*][11]

When I'm not playing music people can find me at home making guitars in my homemade shed. These works of art come from being poor. Back when I was a kid we lived off the land and made do with

what we had and learned to survive. It was hard for us to have toys because there were so many of us. So we started making our own toys. We made wire tractors, wood trucks, big wheels, scooters, and wagons. Anytime we threw something away we took a second look at it, went back and got it, and did something different with it. We was recycling before we knew what recycling was.

I started out making guitars from gas cans. We called them "Chikantars." The gas cans became hard to find so I make them out of found objects, anything and everything: ceiling fans, gas cans, motorcycle gas tanks, cigar boxes, computers, and even toilet seats. Some I just carve out of wood and make what I want them to be. They are hand painted. I use acrylic paint and brushes. I make paintings. I do self-portraits and canvas painting. I use some oil, mostly acrylic on regular canvas, and sometimes on whatever I can find.

There's a gas can guitar in the Memphis airport, the Ogden Museum in New Orleans, and the Mississippi Musicians Hall of Fame in Jackson. Paul Simon, Steven Seagal, Morgan Freeman, and Bill Clinton all own one. Haley Barbour bought one from me after seeing me play one for a delegation in Japan. The people of Clarksdale commissioned me to make one for Caroline Kennedy when she came to town. My handmade guitars are scattered all over the world. That's part of the legacy I'm leaving behind.

I feel pretty proud playing twelve-bar blues. Me, being a poor boy from the cotton fields, who never even dreamed of being a musician, or at least a well-known musician. Here I am—I made three trips to the White House. I did a concert for the Library of Congress and performed at the Kennedy Center.[12] For more than twenty years I've been doing Blues in the Schools in the United States, Canada, and Europe—from Head Start all the way up to college. I've played festivals and concerts around Mississippi, the United States, and the world. I'm just an old cotton rat, you know, an old cotton patch boy. I went to Cognac, France. Isaac Hayes and I were invited to the Hennessy House to have dinner with the United States and French ambassadors. From there I went to the cognac factory and made my own bottle of cognac!

I went to Africa, to Senegal [*January 7–12, 2002, Bouki Blues Festival in Saint-Louis, Senegal*].[13] I got a chance to go to the island of Gorée where the slaves were sold. During the whole week I was there I did Blues in the Schools. I went to elementary schools, high schools, and colleges. I learned a lot.

What keeps me in Mississippi? It's home good or bad. The blues is our roots and the father of all music. I'm one of the last of the original Delta blues musicians from the 1950s and '60s. The young people are playing the blues today but they don't really know what the original Delta blues is—I lived the blues life. I've had blues all my life. I went through the sharecropping experience and all those hard times. I play from my soul, and the blues is soul-soothing music. Yes, it brings me comfort and joy to play my own music and reminisce about the old times. Sometimes when I'm up there playing I'll get to feeling good, feeling happy, and think about those guys—Big Jack, Frank Frost, Sam Carr, Sonny Boy Williamson, Jimmy Reed, Muddy Waters, and John Lee Hooker.

I'm thankful for the old guys being there. If it hadn't been for them I wouldn't be doing what I'm doing. There were good times as well as bad times. You take the bitter with the sweet. The good times was the happiness of family, when you could all sit down and eat something together. Being together, being able to live through all of this and be able to sit down and talk about it. Then, at the same time you had to survive from it.

Super Chikan, Mighty Mississippi Music Festival, Greenville, Mississippi, October 2015

Joshua "Razorblade" Stewart

I was born on December 22, 1946, in Jonestown, about six miles from Clarksdale. My mama's name was Lizzie Stewart. She was a teenager when I was born and lived with her parents. Some of my brothers and sisters is named Gates because she married their father. She didn't marry mine. I'm the only one in my mama's family that plays music and went into the military.

My mother's parents were James Stewart Sr. and Mary Stewart. That's who really raised me and ten other grandchildren. My grandfather didn't have a whole lot of education, but he was a smart old man. My grandma only had like a third-grade education but she could read just like a twelfth-grade student. They was poor but they had their own home. [*According to Betty Vaughn: "The Stewarts bought their land the same year daddy and them bought our place, 1927, the year I was born. It was just full of water and deers was running around. That's the reason they call it Deer Park. The bayou out back is called Moore Bayou. . . . I know Joshua's mother; she was four years old when they moved right here."*][1]

My grandparents were God-fearin' people. Back in those days people did right because it was right to do. My grandmother is one of the reasons I sing. She whupped me 'til I didn't have no more water to cry. I started singing, somebody come help me. She would whup you, take a lunch break, sit down and talk to you, then go back to work on you. We wasn't no bad kids 'cause she made sure we wasn't. She used to tell me, "You get caught stealin' something or go to jail for somethin', I done give you a thousand dollars worth of training. If that don't keep you out, you just gonna be in there."

They raised three generations of kids in that old house when I was growing up—my mama, my mama's children, her sister Florida and Florida's son, and my baby uncle's son. There were cracks everywhere. You could see the moon and stars when you lay down to go to sleep. It was *cold* when it was cold and *hot* when it was hot. We didn't have no fans. We didn't get no screens 'til later. We didn't have no bathroom like they have inside now. We had an outhouse.

There was no blacktop out here. The dirt would be so deep in the road, the dust was between your toes like water. It was a rough life but it made you experience something. Make you realize how blessed you are when you come through it.

My mom was an amazing lady. What I admired her for, she raised four boys and three girls and worked to take care of them. She would iron for a white family; she cooked for them too. Later on when I was about thirteen or fourteen she got a job as a hospital maid at Coahoma County Hospital.

My father's name was James Robinson. I didn't meet him 'til I got out of the army. I had a half-brother, James Jr. We ended up in Vietnam together. When we got out we wanted to see who our dad was. We drove to Chicago to find him. We just got to meet him for a short while. He was married to another woman.

We didn't live on anybody's plantation or farm, but farming was about the only work we could do. We didn't get a chance to

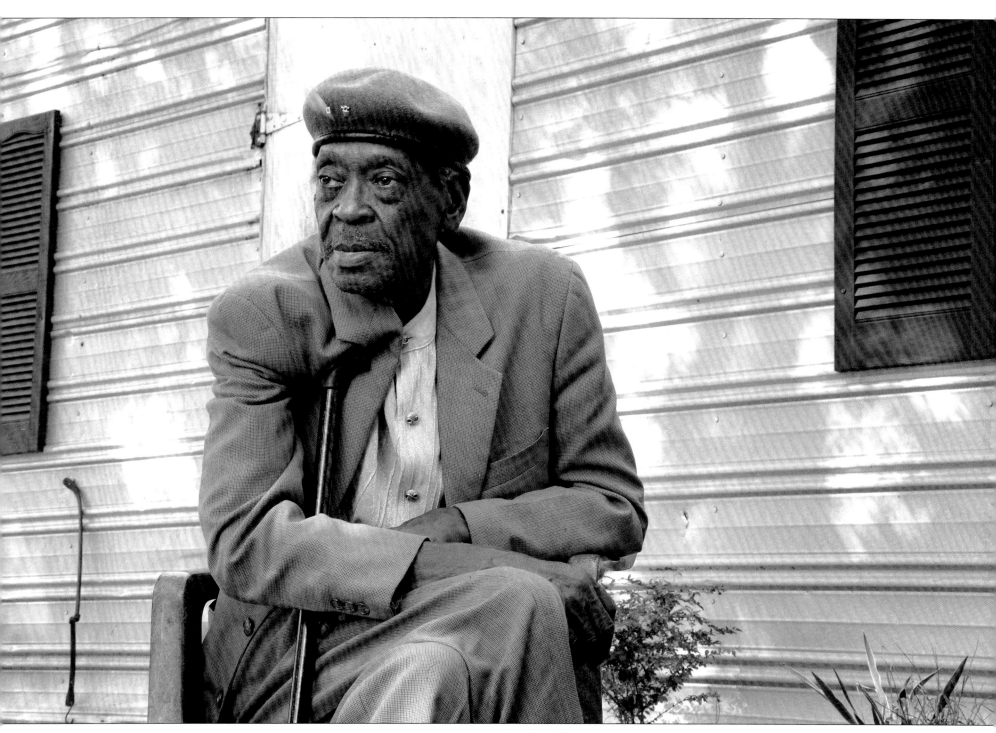

Joshua "Razorblade" Stewart, outside the home of Betty Vaughn, Jonestown, Mississippi, October 2016

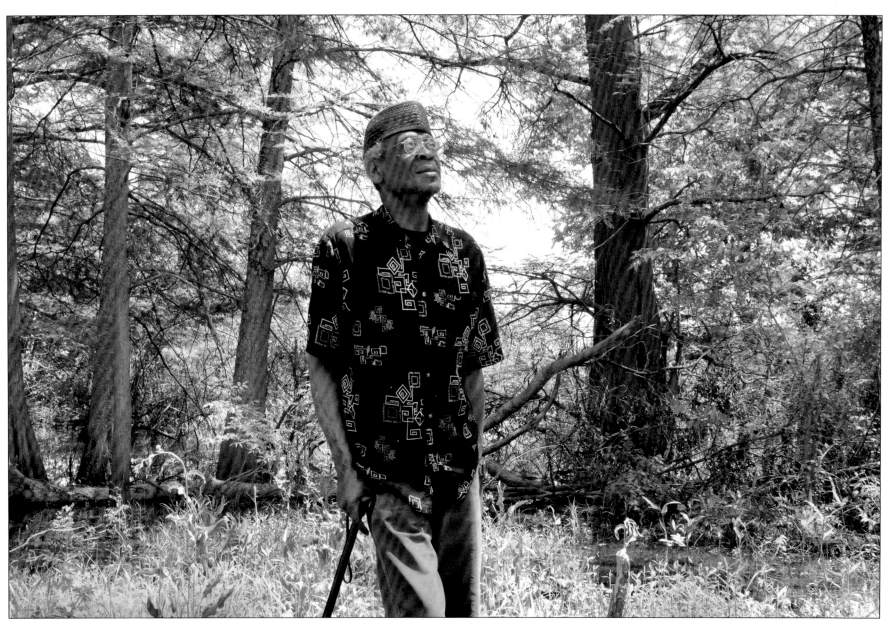

Joshua "Razorblade" Stewart, Deer Park, Jonestown, Mississippi, May 2015

get much food out of the store so my grandfather taught me how to hunt and fish for our food. We kill us rabbits, squirrels, coons. There was a bayou right where we were raised. I'd catch a bunch of crawfish. I frog-hunted at night. When the rainy season come, I'd catch turtles crossing the road. Mom would cook them. We had to eat what we could.

We owned enough land to raise a garden. All the kids worked in it. We grew eye potatoes, sweet potatoes, corn, beans, butterbeans, greens, tomatoes, all kinds of peas, and okra. To store the food, we had a hole dug up under the front room of the house with straw stuffed in it. We'd store potatoes and root vegetables there.

My grandfather built a smokehouse and chicken house. We raised chickens and hogs. Then we had eggs and meat. You could take a ham and hang it out in the smokehouse. My grandfather would take a cut out of the meat when we needed it. We didn't have electric lights at the beginning. We didn't have no refrigerators. We had iceboxes. We had to buy a block of ice and put it in there. We weren't able to buy ice all the time.

We worked by the day for somebody else. They'd have a big bus get the workers when the farming season come around. You'd go chop cotton for whatever farm needed us. I started chopping and picking cotton at the age of six or so. We worked five, six days a week, ten hours a day in the hot sun, as long as it didn't rain. If I didn't pick two hundred pounds Mama pulled a cotton stalk up and go to whuppin' me. So I'd come up with two hundred pounds. I used to ride the mule. They'd holler, "Mule boy!" They'd be out there, picking cotton and I'd put six sacks on top of the mules, balance them, and get them to the trailer where they could weigh them with the scales.

If it didn't rain we'd make fifteen dollars a week. They'd give me one quarter each day out of that. They took the rest of the money to provide food for everybody. The only time we got off was when it rained. We'd be glad to see the rain come sometimes, but we'd be sad, too, because you wouldn't have no money. Back then the dollar meant more. I could take a quarter and go get some lunchmeat, crackers, and a drink.

We depended on the harvesting season. That's all we worked for. That's when you buy your clothes and shoes for school. I'd get three pairs of overalls and three cotton flannel shirts and a jumper, overalls and something like a jean jacket, a pair of brogans, like a work boot, and a pair of low quarters, that's a nice shoe. We used to be ashamed to wear brogans. If you wore them out before the school year was out, you had to go the rest of the year barefoot. For Sunday we would get a pair of gabardine blue pants, a cheap white shirt, and a bow tie. I buy suits all the time now because I never wore a suit when I was growing up.

I went to elementary school in Jonestown when I wasn't working. It was all Black. They had coal and wood heaters. The school got the coal and wood. Every so often a student would get an assignment to make a fire. It would really get cold. The ground would be hard. We didn't have a gymnasium. We played outdoors. During harvesting season school would get out early so we could go to the fields. As long as there was work to do, you always do it. The harvesting season used to last much longer than it do now.

My family was churchgoing. That's why my grandmother named me Joshua. She wanted me to be a preacher. She could tell me, "The Devil gonna get you!" and I wouldn't do whatever I did anymore. But you can't talk to these kids about nothin' like that anymore. They don't understand.

I never belonged to but two churches in my life—Mary Bethel Missionary Baptist #1 in Jonestown, and the church I belong to today in Clarksdale, Union Grove Baptist Church. Mary Bethel #1 is the church I was raised in. Every Sunday we went to church and Sunday school. My granddaddy was the maintenance man. We used to mow the lawn with a little bitty mower. It would take us all day long on Saturday. They wouldn't pay him no money.

We formed baseball teams. Whatever little money we chopped and picked cotton for we put it together. Each town played one another on Sunday. We might play teams from Lula, Friars Point and Clarksdale. That was really the only activity we enjoyed.

Music was always an outlet for me to get away from all the stuff clouding my head. All my life I was singing. We didn't have a TV.

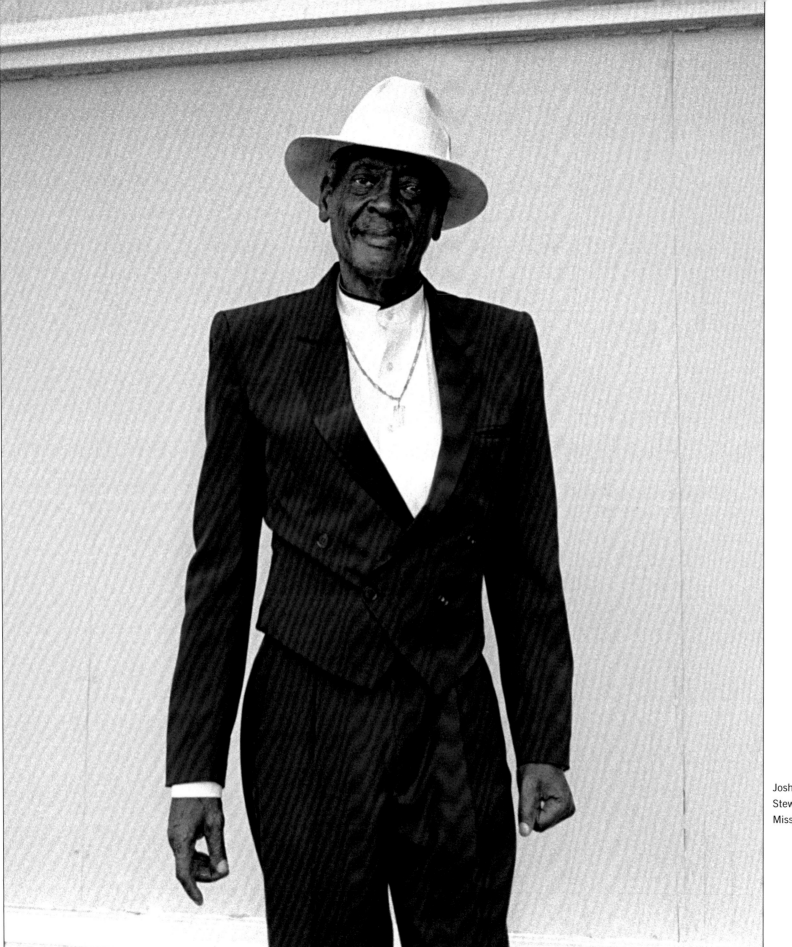

Joshua "Razorblade" Stewart, Clarksdale, Mississippi, April 2012

We only had a radio. My grandma put it way up on a high shelf. Wouldn't nobody mess with it. We listened to WHBQ, a mostly white station from Memphis. They played people like Elvis Presley, country music. [*WHBQ was the first radio station in the United States to broadcast Elvis—performing Arthur Crudup's "That's All Right"—in 1954, when Josh was eight years old.*]² I used to listen to WROX, a Black station out of Clarksdale, when it came on the air. Early Wright played mostly local people like Sam Cooke and the Jonestown Crusaders.³ He used to record those people. They'd go down to the station and perform live.

There used to be houses everywhere in Jonestown. They had a general store. The Chinese had grocery stores. All that stuff is gone from when I grew up. When I was six I seen this marching band. They used to come to Jonestown to perform, to lead the parades. The horn section was dancing in the street, playing, and putting on a show. It was very exciting. I was fascinated and followed the band everywhere they went. They couldn't hardly march because there'd be so many people around them. There was nothing for kids to do in Jonestown. I knew I had to be part of the marching band.

Peter Price lived down the street from me. He played clarinet in the marching band. I'd see him in church. He played piano and most anything. I used to go down to his house, and he let me play on the keys. Peter Price inspired me. He could read and write music. And he more or less taught himself.⁴

Sometime we'd hear a musician play around their house. Sometime we'd hear them on the other side of town. People hear a guitar and it would just draw them. I'd go find where they're at, sit around and listen to them. They had a few houses and joints in the country where they shoot dice, drink whiskey and bootleg liquor. There ain't no police, ain't no nothing, just on a dirt road. You could call it a house party, but it was a juke joint. I wasn't old enough to go in. You could hide under the house just to hear the music. An old man named Frank Sykes was one of the people who would play at these juke joints. He'd play, just him and a guitar.⁵

My mother always bought me some type of musical instrument from the time I was a child. I will never forget this. She bought me a Baldwin piano. I was about nine years old. It was a toy really, but I could play the keys. I learned by ear. I could play all the church hymns on it.

My mother was proud of me. She used to tell me, "Boy I could always tell you was coming home 'cause you'd be singing." Everybody could hear me singing across the cotton fields. Cotton was tall then. You couldn't see nobody, but you could hear people singing. I'd sing Sam Cooke, Elvis Presley, some church hymns like "I'll Fly Away," and all the popular voices you would hear back in the day. Singing was something to help me get through the day. Because you are always tired no matter how young you are.

Coahoma Agricultural High School was all Black students when I went. I really wanted to play an instrument. The first one I tried was a slide trombone. I had a band director, Ms. Consuella Carter. She is one of the biggest reasons I done what I done with kids. I don't think they make them kinds of people anymore. She put me in a general music class where they taught you how to read the notes, count the music. After I came out of that class I could play anything that got a tone to it.

Slide trombone became my primary instrument. Being gifted, I easily picked up the keyboard and saxophone. I could play trumpet, bass, and drums. I played everything except clarinet. I could fit wherever I was needed. Besides playing music, I used to be a good dancer. I used to choreograph for the majorettes.

At home I'd be practicing "St. Louis Blues" on the trombone. I'd get whuppins from my grandmother for playing and singing the blues. My grandmother would tell me it was "Devil's music." When she got through whuppin' me, I'd go right back out there. She finally gave up. She said, "I'm not gonna kill you and send you to hell. I'm gonna let you go on your own."

I played in that band for six years—four years in high school and two years in college. The band was a combination of the elementary, high school, and Coahoma Junior College students. I finished my AA degree when I came back from the army.

They would take each class of students to the fields to pick cotton to buy the band and football uniforms. We wore maroon and white uniforms and big, tall hats with feathers in them. We wore stepping white shoes. The Tiger was the school mascot. The first Tiger bus, we

bought that by picking cotton with our hands. It made us appreciate life, just being alive.

The band played at football games, concerts, and parades. We paraded everywhere, all the small towns—Jonestown, Ruleville, Lula, Prides Point. We was the number one marching band—the baddest band in the land.

In eleventh grade it rained for weeks and months during harvesting season. We didn't get a chance to pick any cotton. Here it was September, and I didn't have any clothes to wear to school. So I wasn't able to go. Ms. Carter came to Jonestown and found me. She bought me clothes and shoes and put me back in school. She got me a job driving the school bus—thirty-five dollars a month and I could get one hot meal a day. That was the best meal I had 'cause we just didn't have it.

When my mother got the job at Coahoma County Hospital, she moved to Clarksdale to a house down on Fifth and Tallahatchie behind a funeral home. I was the oldest, so she kept me with her. They had juke joints up and down the street. Blacks lived in the Black neighborhood, and whites lived in the white neighborhood. The music was in the Black neighborhoods. My friend Barry was hip to the streets. We'd go to the jukes around Yazoo, Ashton, Harrison, and Sixth Streets—Smitty's Red Top Lounge, Margaret's, Big James, Ruth's Café, the Casablanca, Messingers, the Black Fox, and Café on Sixth. I always chased music. I was underage. My mother didn't want me there. I used to get all kinds of whuppins for slipping in the juke joints.

You walk in a juke joint, be so much smoke you can't see. Everybody dress up like they're going to church. There'd be buck jumping and dancing going on. Those cats could dance, man! Guitar players, old men was playing rock down, low down, dirty gut blues. B.B. King had a song out, "I Don't Want Nobody Hanging Around My Back Door When I'm Not at Home."[6] That was really popular.

One of the men was my future father-in-law, Earnest Roy Sr. He was a big band schoolteacher and one hell of a guitar player. Earnest Roy, Sr. could play the guitar and draw a snake. He played every juke joint downtown and out in the country where we didn't have to be around the police. People would turn their homes into jukes just for the weekend. We'd follow him. People would be waiting on him. Everybody was dressed up, smoking cigarettes, drinking corn liquor, dancing, and having a real good time.

They drafted me into the army in 1965. I had to do an extra year so I could finish high school. So I did three years in the military instead of two. The draft was two years, but they was snatching people out of school.

I took basic training and advanced infantry training, and school for fuel and electrical repair. I went to jump school. I spent eighteen months with the 82nd Airborne Division at Fort Bragg. I jumped everything the military had to jump. I hurt my back and leg on one jump; that's why I have a limp. The last year they decided to send me to Vietnam.[7] They gave me a seven-day leave before I had to go. I came home to Jonestown. During that time they were having funerals for two of my high school classmates—just killed over there, ain't been in but four or five months. I told mama I didn't want to go because everyone was coming back in a box. She said, "You better go before they come for you."

I was in the 173rd Airborne Brigade Combat Team in Vietnam.[8] They sent me on two or three patrols. That's when I decided, "This shit ain't for me." One thing about the military, they always had some type of entertainment. They had bands. I made it because I didn't want to go back out there. The guys treated me good, except being the only Black in the band, I had to do more than the average member. I sang some of everything—a lot of Otis Redding, Sam Cooke, country and western songs, anything they wanted. When I wasn't singing I had to play some instrument, and I was talented enough to play different ones.

At times we had to go in where the war zone was. Sometimes we'd be entertaining on the stage and mortars would start coming in. We'd have to take off for the bunker.

At night we'd pull guard duty. We had infrared scopes that you could see in the dark. It was so dark you can't see your hand in front of your face. That was one experience I didn't like. They always had three of us in a bunker. One soldier pulls four hours of duty while the other two sleep. But you had to stay awake. The bunker down from me was set up on top of a hill. This kid in that bunker must

have got drunk or something, and fell out. The Vietnamese went in there and cut the other two guys' heads off and put them on bamboo sticks. They was like that when daylight came. This kid, I don't think he ever recovered.

I came back from Vietnam. I had a wife and daughter when I went in. When I returned, I had a seven-day-old newborn by another man. I raised the baby up 'til she was seventeen, but my wife and I didn't stay together.

I picked and chopped cotton when I could. It was hard to function. I had a lot of stress, bad dreams. I became an alcoholic. I went through Skid Row. They just took us out of Vietnam and dropped us back in society. People called you "baby killers" and all kinds of stuff. You didn't tell nobody you done time in Vietnam. I used to look forward to dying. Today I'm glad to be living.

One thing I can say about Vietnam, being there with the white boy, if they call you "brother" they really meant it. Your life depends on his, and his depends on yours. The difference is, when you come back here, it's a totally different story. You come back to the same thing you left.

Clarksdale always was racial. You had certain fountains you couldn't use, certain restaurants you couldn't eat in. When I was a teenager I worked for a drug store in Clarksdale. I had to use the bathroom. The owner's nephew told me I couldn't use it because it was a "white" bathroom.

When you crossed the railroad tracks—Yazoo, Second Street, Maple Street, that was the white side of town. Blacks could go over in the daytime and buy things. But at night they could pick you up on the white side and lock you up for seventy-two hours without explanation. When I was fifteen or sixteen they picked me up and carried me to jail in Clarksdale for three days They didn't give me no meal. I wasn't no criminal. It was just the way it was back in those days.

In the seventies, I was one of the first Black policemen in Clarksdale. At that time Black officers weren't allowed to ride in the police cars. When I started to walk the beat, we didn't get no Friday or Saturday off. When I did get so I could ride in the police car I had to ride in the back seat while the white patrolman drove. When we did get so we could drive the police cars we still couldn't arrest any white people. When we did get so we could pick them up we had to take them to Clark Street, where no eyes would be looking, and let them out of our car. The white officers would put them in their car. Some of them they would take to jail, some of them they wouldn't.

After Vietnam I played with Jesse Gresham Plus Three.[9] I joined when they lost their singer, W. L. Pryor. He had a great voice. I used to break my neck to watch him and hear him sing. All of us could read music. They was all schoolteachers. When I wasn't singing I played my trombone.[10] When we performed at the VFW in Clarksdale it would be standing room only.[11] They called me "The Fabulous Stew Baby." I had long hair. Women'd be arguing about who was going home with Josh. That was back in the day.

We played at Black clubs and white clubs. We played at the Italian-American Club just outside Clarksdale. They didn't want us to mix with the white peoples but they loved our music. They had a little bannister around the area we played, to keep us in there. We couldn't go in the bar and get a drink. The man said, "Don't you fellows come to the bar. Just let me know what you want and I'll bring it to you." What we did, we kept ordering drinks to where he got tired of it. "That's all right, you just go get your own damn drinks!"

A lot of musicians used to be jukin' at Earnest Roy Sr.'s in the seventies. Ernest Sr. taught a lot of people. He liked to pass on what he knew. Musicians would set up and play. The next thing you know there's a yard full of folks. [*According to Earnest "Guitar" Roy Jr.: "Josh would check on dad every day and come over when daddy played. My daddy couldn't read or write but he could play what he heard, what he felt. You could appreciate every lick he hit."*][12]

There was a group of people who loved music. Some of us would get together and play blues and rhythm and blues. We covered B.B. King, Albert King, Johnnie Taylor, Tyrone Davis, Bobby Bland, Latimore, and Al Green. We played around Lena's corner grocery on Ritchie and Fourth Street. It's gone. And Margaret's and Casablanca. We didn't have a lot of money or transportation, but

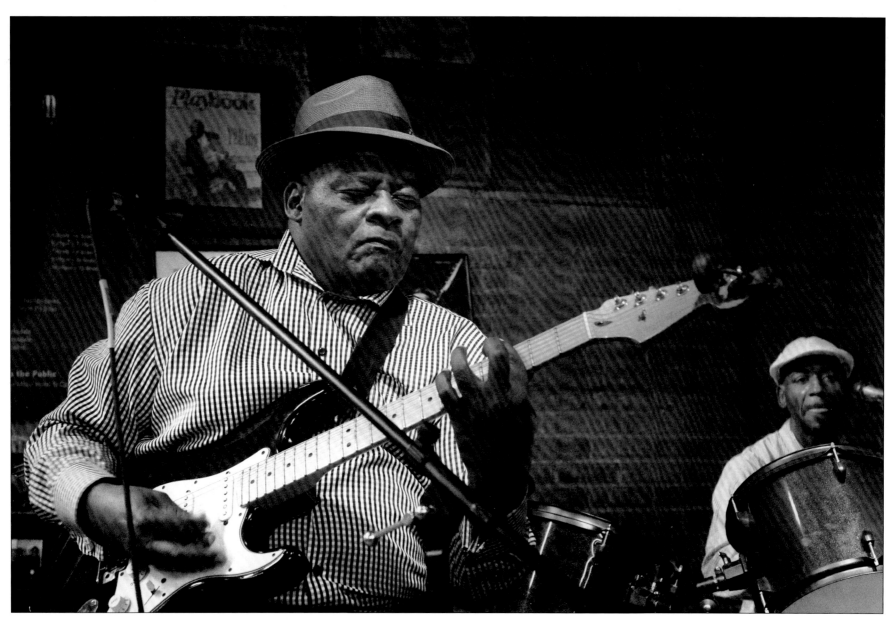
Earnest "Guitar" Roy, Jr. (Dion Thomas, drums), The Stovall Store, Stovall, Mississippi, October 2022

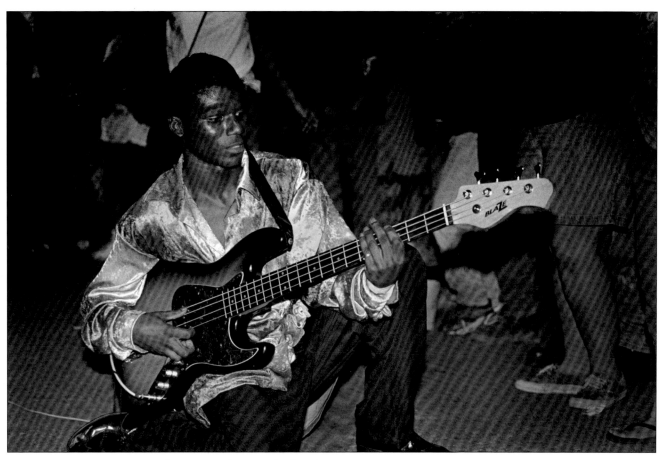
Anthony "Switchblade" Sherrod, King Biscuit Blues Festival, Helena, Arkansas, October 2002

we would save us enough to get to whatever spot we were playing. It wasn't about the money. It was about the love of the music.

Frank Frost, Sam Carr, and Big Jack Johnson—the Jelly Roll Kings—were playing around this area. They packed the little juke joints in Clarksdale. They would wear nice outfits. They dressed in loud colors. I wanted to be like that. Frank Frost played keyboards, harp, and could sing. You could tell he feels what he does. Sam Carr was one of the best drummers I've seen. Nobody played a shuffle like him. Big Jack's sound was awesome. They had a sound singing about hard times. The music would make you move.

The last part of the seventies I went to Memphis to get work. I got a job as a security guard at the VA medical center. Seeing people like Earnest Roy Sr. and the Jelly Roll Kings motivated me to go farther with my music. After nine and a half years I moved back to Clarksdale. Super Chikan and I always know of one another. He was a cab driver. He'd go *zip-zip-zip* around town. He would play the blues at night. The police be chasin' him for speeding. He'd run somewhere and hide his car. He'd come back on the streets with the same car, but he'd paint it a different color. I was supposed to catch him, but I never could.

Chikan was always smiling. I couldn't figure out what he was smiling about. Couldn't nobody in the world be this happy—not being Black in Mississippi. He was playing at Crossroads. I went down and been hanging with him ever since. I'm one of the first "Fighting Cocks." I spent four years with Super Chikan in the nineties. He was the driving force behind the music. I consider Super Chikan a link to the past. He plays like the old Black cats back in the day. People love his music.

He gave me the name "Razorblade." My wife Ethel [*Earnest Roy Sr.'s daughter*] made me a bling type of vest. She wanted me to wear it. I wanted to wear me some gold pants and a purple coat. She blocked the door, but I got out and I wore it. When I got to the club, Chikan looked at me and said, "Man, there's something *wrong* with you, but you're sharp as a razorblade." Ever since then they call me "Razorblade."

After I played with Chikan I went down to Sarah's Kitchen. Me, Dr. Mike [*Michael James*], Big T [*Terry Williams*], and Johnny Billington were teaching the kids there. Dr. Mike was an extraordinary guitar player. His talent had to be God-given. We formed a group called the Deep Cuts. I called Dr. Mike "Butcher Knife." Anthony Sherrod played second guitar and was known as "Switchblade." Lee Williams was the drummer; I called him "Pocket Knife." [*Another young guitarist, Jacqueline Gooch Nassar, was "Butter Knife."*]

We played at Sarah's Kitchen five and a half years, every Thursday night. We didn't make any money but I went down to give the kids an opportunity to play. Anthony and Lee had some training at the school at the Delta Blues Museum. The Deep Cuts got really popular. We went to Greenwood one year and won the battle of the bands. We had the right chemistry.

The Deep Cuts went their own way. I can see Dr. Mike's legacy in some of the kids. Anthony and Lee became monsters in the way they play. I could tell Anthony was gonna become an entertainer when he was thirteen or fourteen. Lee is very talented. He can play drums, bass guitar, keyboards, and sing. I'm proud of all of them. I hope they go much further than I did.

I got in the male choir at my church in Clarksdale. There was a Williams Brothers' song, "Still Here."[13] I could relate to that song because I'd been to Vietnam. They started playing; I walked to the mike and ad libbed it. The preacher came up to me; "Boy, you put the *spirit* in the people!" Yes, I'm still here—I was left here to do the type of music I've been doing.

I opened shows for Bobby Blue Bland, Otis Clay, Tyrone Davis, Johnnie Taylor, and other musicians who came through Clarksdale.[14] I kept playing at Ground Zero. I made one CD in 2007 called *Joshua Razorblade Stewart Live at Ground Zero*. I performed at the Coahoma Junior College for six or seven years. It was an honor for me. I've been playing the Juke Joint and Sunflower River Blues festivals in Clarksdale.[15]

Hearing music was a relief from all the hard work. When people ask, "How did I go through those times?" I tell them, I learned to live like that. Sometime it make you feel bad just thinking about it. But you got to live. A change's got to come. It might not come as fast as it should, but somebody got to do it. I sing for the love of the music, and that's the best way to be. I love to see people happy, especially when I'm performing.

Music is one of my biggest outlets; it's like medicine to me. I can express all of my emotions whatever I'm singing. I won't sing a song unless I can feel it. I feel free. I can just be free of everything. Every worry I ever had, it's gone. You got to do music for the love of it—you got to do if from the heart.

Josh Stewart died April 21, 2018, at the VA hospital in Memphis. He was seventy-two.

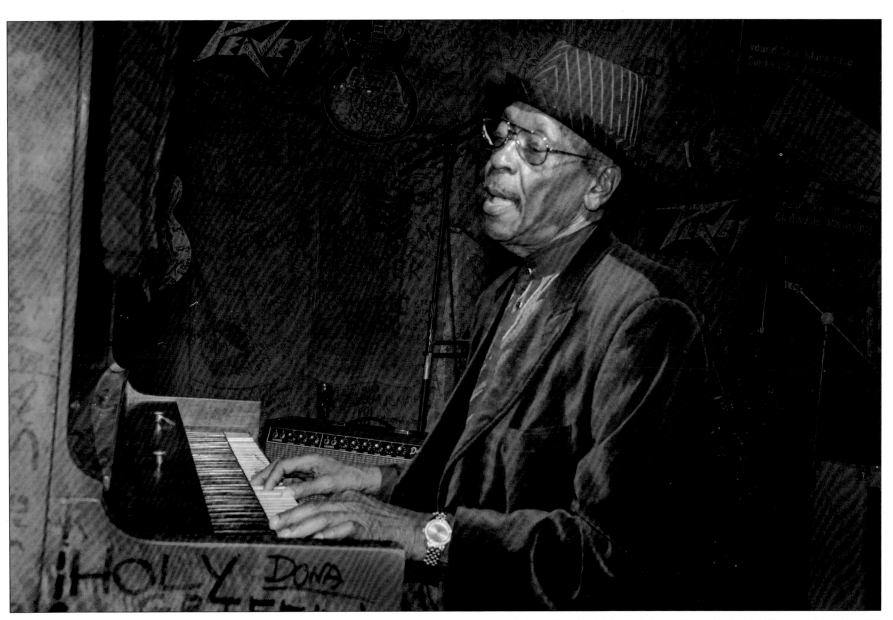

Joshua "Razorblade" Stewart, Ground Zero, Clarksdale, Mississippi, October 2015

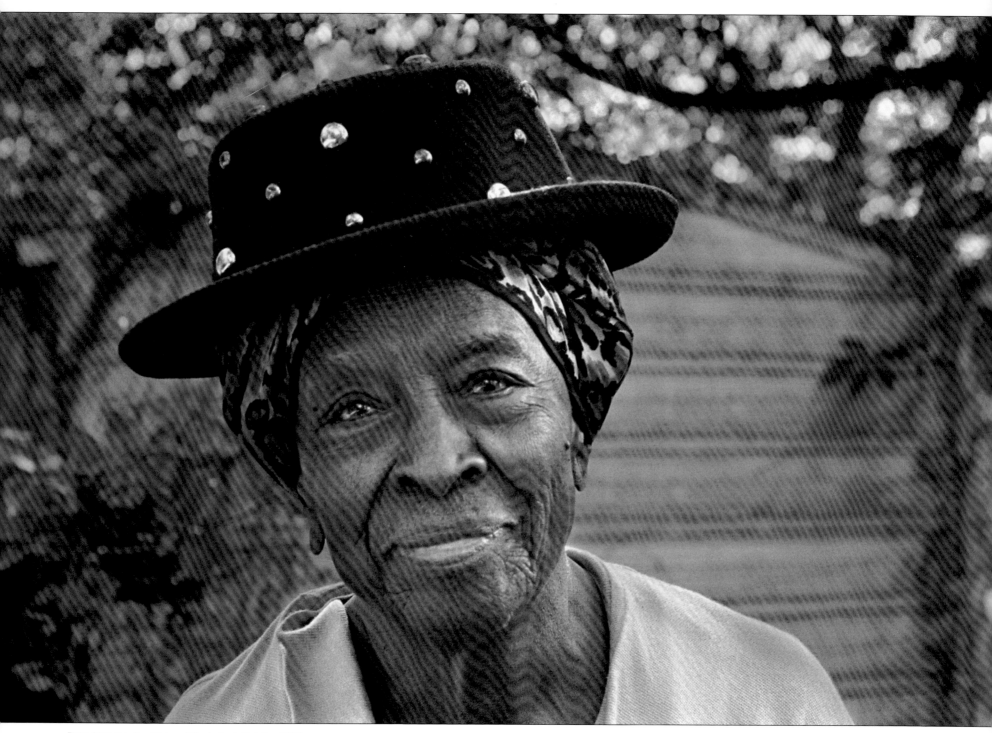
Betty Vaughn, Jonestown, Mississippi, October 2015

Betty Vaughn

I was born on December 27, 1927, right here in Jonestown. You couldn't hardly walk down where I grew up, for the trees. There's not a white family there. The white people sold to Black people because it's lowland.

We weren't allowed to go to the white schools. We were only allowed to go to the Black schools. Some schoolbooks they had we did not have. When I went to school it was in an African American church. When the school burned down a Jewish organization going through the South building schools built a Rosenwald school for the Afro-American children. You could only go to school when there was no farming; that was only a few months a year.

I know everything that happened here in Jonestown. Yes, I heard about people being lynched in Jonestown. My mother did talk about it. They said there was a white man wanted to buy some colored people's property. They owned a piece of land in an all-white area of town. The owner told the white man it wasn't for sale. They found a Black man swinging in the tree the next morning. I know the spot where my mother and them said it was.

I went to Chicago. When I left home Black people couldn't vote. I was trying to find a better job, something other than working in the cotton fields. I went to Emmett Till's funeral. It was sad up there in Chicago. When they had his body out for viewing his face was crushed. After Emmett Till was killed the Bryants moved to Jonestown. They started a store and car lot. The citizens here just decided not to trade there. They didn't march but they wouldn't buy from them.

I returned to Mississippi in 1968. I worked for the employment office. I used to have a café, a spot where the old people hung out. It was called Betty's Café. I opened it in 1989. Me and my husband ran it on Friday and Saturday nights. I played some blues and some gospel records—for the older people Mahalia Jackson, Al Green, B.B. King, and Little Milton were favorites. I cooked soul food—fried chicken, greens, peas, and ribs, you name it. Oh yes, I cooked catfish, buffalo fish, chitlins, French fries, the food of the day. I ran it about twenty years.

You had to know how to survive here to make it.

Wall of Bryant's Grocery, Money, Mississippi, October 2006

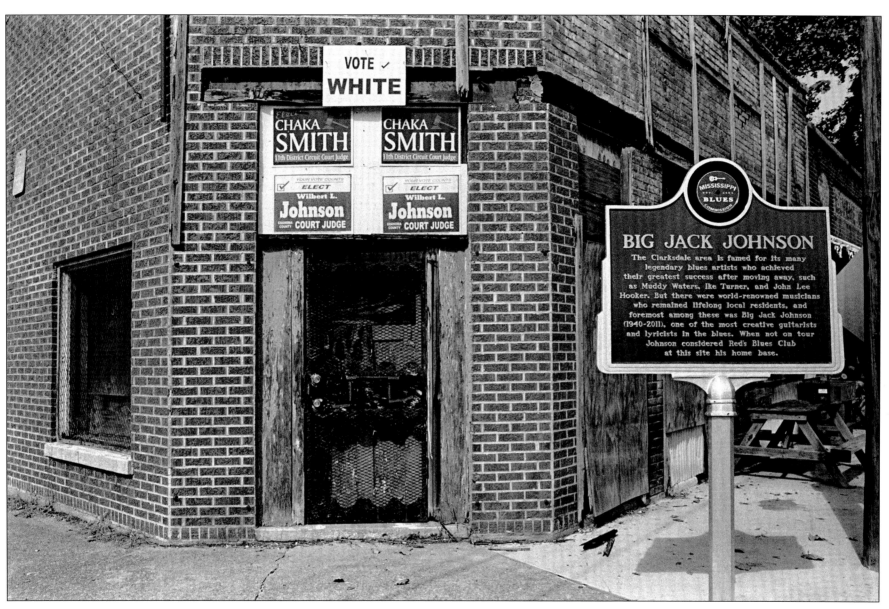

"Vote White," Clarksdale, Mississippi, October 2014

Joe Cole

I was born in Alabama on June 17, 1921.[1] I went to the army in World War II—Okinawa and Japan.[2] When you come out you don't want to be back down like a slave. When he got overseas a man was a man. When you come back here they want you to bow on your knees to them. A man fought in the army, and risked his life, he should be recognized.

When I come back from the army I lived in Charleston, Mississippi. I had trouble with a man in Tallahatchie County, the owner of a plantation, that's right. They used to whup colored people. They used to do that, you know. I put my life up for the United States. I wasn't gonna be a slave. That's the reason I left there—I wasn't gonna be whupped by nobody. I left there running. There had been a time they used to hang people. Man didn't want to pay me what I thought I should be paid. I had gone overseas. That was too much.

I moved here. It was called Eastover Plantation.[3] The place was in a bloom. Had seventy-five families and they were big families. People used to clear seventeen, eighteen, nineteen hundred dollars from their crop. Wages were three dollars a day. That was money, wasn't it? I had cleared as high as twelve hundred dollars out of a crop. My farm wasn't as large as the other families.

We used to have a lot of juke houses around here. Used to be two juke houses on this place. I started picking on the guitar when I was right young. I mostly played by myself. I used to play country blues, songs I made up. My blues was different, but everybody was crazy about my music. "Joe Cole is gonna play! Joe Cole is gonna play tonight!" They would pay me a little something. They would have a good time.

Women used to carry all over me and their husbands get jealous. I never will forget, I was playing guitar one night. She had been drinking some and got kind of high. The music was sounding good, and she sat in my lap. Her husband said, "Get out of Joe's lap!" She wouldn't get up. He hit her and knocked her out of my lap. She popped him with a knife in the forehead.

I finally stopped going to them juke houses. The man quit farming and the juke houses went down. People started leaving here. The man gave me the house. I have the paper. Now I'm the only one on this road 'til you get to the end.

Joe Cole died February 22, 2005. He is buried in a military cemetery at Jefferson Barracks, outside St. Louis.

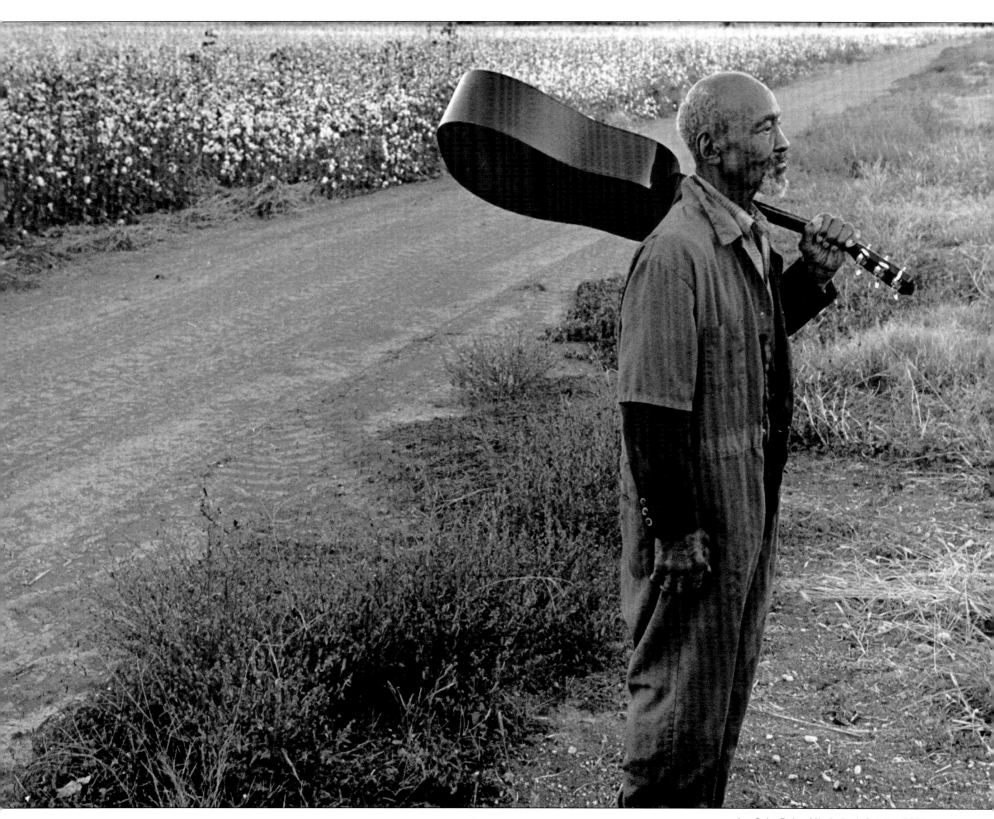

Joe Cole, Bobo, Mississippi, October 2001

Abandoned juke, West Point, Mississippi, September 2008

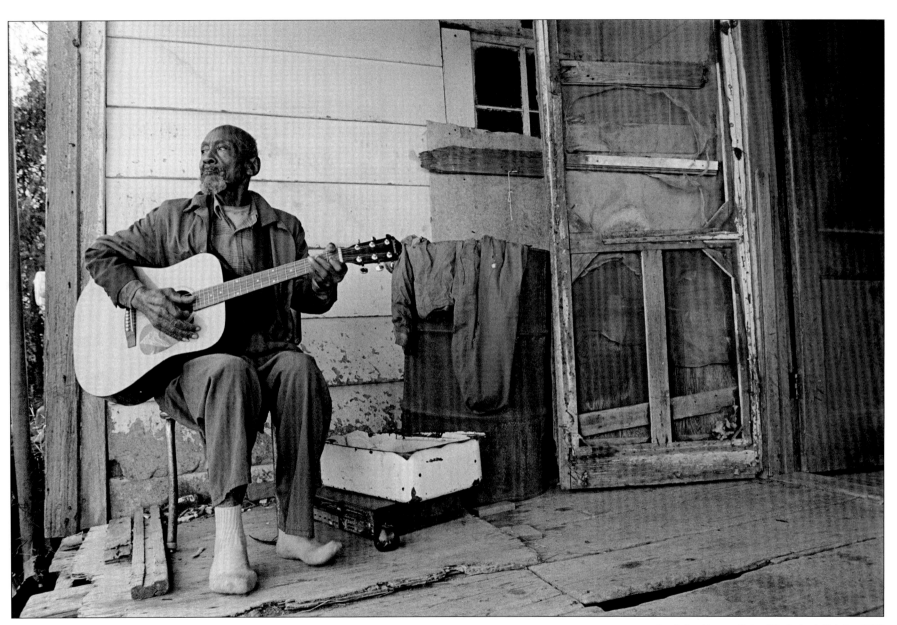

Joe Cole at home, Bobo, Mississippi, October 2001

Irene Williams, Do Drop Inn, Shelby, Mississippi, August 2000

Irene "Ma Rene" Williams

I grew up in a little town on Highway 1 called Round Lake. There was a white church right in front of our house. Sit on the porches and the whites would have a service. The next house was a white couple. The next house was a Black couple. The next house was a white house, like that. And they all gathered in my mom's yard and played, because she had a couple of big trees. Plus she had a fence around the yard, and I guess they felt a little safe there. I don't know but they all gathered there. It was biracial. My mother kept a little strap in her pocket. She'd be on the porch. We had a swing and the kids be out there playing and if anyone got unruly, it didn't make no difference what color, you came to her and she spank you with that strap. Nothing was said. When she cooks, everybody would go in there and eat. If something needed to be done everybody go do it.

I ran a blues club here in Mound Bayou for nineteen, twenty years—the Glass House. My husband and I built the club. It was a beautiful place. People would come from near and far to ventilate and let out stress. We'd have pool tournaments Saturday and Sunday nights. I'd have dance contests on Sunday afternoons. People would get all dressed up and win a little money. My favorite dances were the jitterbug and the Madison. Oh man, I would wear out a pair of shoes on the weekend doing the jitterbug.

We was outside the city limits so back in the sixties and seventies we could stay open all night long. At twelve midnight a new crowd would come in from other towns when the locals went home. I'd be there all night long Friday, Saturday, and Sunday. I worked at the Delta Health Center in Mound Bayou for thirty-three years. I just got accustomed to not need much sleep.

The Glass House burned down. After three or four years, I decided to open this club in Shelby. I rented it for about a year. Then the man wanted to sell it. I didn't want to go out of the club business so I purchased it. We called it Do Drop Inn.

We had blues every Sunday afternoon. Wesley Jefferson was the main band. He'd start playing at six or seven p.m. and go on 'til twelve or one a.m. Super Chikan would play sometimes. People had a good time so we kept them coming for years. We had a jukebox with mostly blues on it. Favorite musicians were B.B. King, Tyrone Davis, Bobby Rush, and Johnny Taylor.

I cooked every weekend. Friday evening I'd start doing ribs, chitlins, spaghetti, and fish. I'm president of a co-op farm. We purchased the land in 1969 and grow vegetables there. So I'd go out there and get my greens, green beans, peas, and butter beans. To make the food taste right you have to add TLC. I always add that TLC. Oh Lord I did some cooking there.

"Ma Rene"—I got that name from the young folks that I dealt with in Shelby. When I saw them do something that wasn't right I would chastise them. It didn't make any difference what they were doing or who they were, I'd tell them right from wrong. And in my

Do Drop Inn, Shelby, Mississippi, August 2000

place the peoples really respected me. If I said something to them, they would always listen.

My father was a sharecropper. You really didn't make any money. I think I got off into the club business to make money, to do better. When I started you could make some money. I did until the casinos came. After that, my business dwindled down. The last five to six years I was open I was accommodating the people so they had somewhere to go.

When you used to go through Shelby on a Saturday or Sunday there'd be cars and people everywhere. Oh my Lord, Shelby used to have several dry goods and grocery stores, a ten-cent store, a drug store, a soda fountain, a furniture store, a lumber shed, and restaurants. People would leave home and go to town and park by the railroad tracks to look at the peoples go to and fro, just sit in the car and socialize. Now you don't see nobody on the streets on Sunday. Now you go through Shelby you don't see nothing.

Irene Williams passed away on May 2, 2010.

David Lee Durham

I was born on a plantation on May 1, 1943, in Sunflower, Mississippi. My parents were sharecroppers. I started working in the fields when I was about twelve years old. Chopping, picking cotton, and working in the deadening where they clean up the wood. You cut the wood down. You pick up the scrap wood and let it burn. You clear the land so you can grow more crops.

We'd always get to the field about eight a.m. Let the dew dry off. I'd get off around four p.m. Then I'd go squab hunting 'til sundown. My mama would cook them. That's how we made it. My dad used to hunt rabbits. Been hunting rabbits all my life. I raise beagles and train them for hunting rabbits.

Howlin' Wolf used to come to the Harlem Club in Inverness. I loved to see him blow that harp. Jimmy Reed came down, too. He mostly played by himself. He had a drum, harmonica rack, and guitar. People loved him.

I wanted to play the blues because I loved the blues. I heard a lick of a guitar at a house party when I was sixteen. That made me want to play. I put a broom wire up the side of the wall. I'd take an empty snuff bottle, put it against the wall, tighten it and get a sound out of it. Then I moved up and got me a guitar from Sears Roebuck. Mr. Jean Lester, a man I worked for, bought it for me. I paid him back fifty dollars. I wanted to play guitar to make a little more money.

I started playing in front of people when I was twenty-five, twenty-six at a juke in Isola run by Walter Brown. He'd play the bass on the guitar and I'd play the lead. We'd get a beat going, and people would juke off it. I played in jukes around Holly Ridge, Isola, Belzoni, Leland, Greenville, Hollandale, and Rolling Fork. [*David and his band frequently performed at Club Ebony in Indianola.*]

The blues gonna be here forever. Someone's always gonna play the blues. Playing the blues makes you feel good.

David Durham died in Indianola on January 24, 2008.

David Durham, Indianola, Mississippi, October 2003

"Cadillac John" Nolden, Mighty Mississippi Music Festival, Greenville, Mississippi, October 2015

"Cadillac John" Nolden

I was born on the Harris Plantation in Sunflower, Mississippi, on April 12, 1927.[1] We moved to Harry Dattel's plantation about seven or eight years later.[2] His plantation ran right from the edge of Sunflower up to the Sunflower River.

My parents were sharecroppers. My father, Walter Nolden, grew cotton, corn, and grains. He raised watermelon on the side and had a garden for the family. My father was hard working. Daddy filed and kept peoples' hoes sharp when the people called him. He taught me. On the weekend you could make a little change to put in your pocket. He was a good person. He went to church every so often. I didn't know his parents.

My daddy used to have all kinds of chickens: Dominick, Rhode Island, and Bantam. He'd sell some, and some were for the family. Them little old white Bantam game chickens could whup all the other chickens. We had to separate them to keep them from fighting.

Daddy would sit around the fireside and blow a harp. When we were little he'd play, "John Henry was a Steel Driving Man," and another song, he'd call "Freight Train." He blowed his own way. I never heard anyone blow like him.

My mother's name was Lovie Spearman. Mama worked in the fields. She'd quit early to fix dinner. She went to church a lot, almost every Sunday. We went to the Methodist Church with our mother. Mama worked hard and treated everybody the best she could.

We were five brothers and four sisters.[3] We all worked in the fields. The men would be singing and hollering. They'd be singing blues. I started off as a water boy. The boss man hired me when I was about eight. It get hot. The people would sing, "Water boy, water boy, bring your water 'round. / Don't like your job, set your bucket down."

There was a bunch of them yelling at me to bring the water. They used to have a mule and a "slide" [*a sled*]. They put a barrel of water up on the slide and the mule would pull the slide out into the field. There were a lot of people out there choppin' cotton. I carried a dipper and a cup. I had to work from sun to sun. I had no choice. I'd get a little something.

The school was in Sunflower. It was for Blacks only. I didn't have a chance to go to school too much. You had to help the family keep food at the house. I went to school in the winter. It wasn't nothing good. Sometimes you'd be too cold to learn. The school had a coal heater. You start it with kindling and then put coals on it. The kids had to keep it going. The fire was all right, but after you get there you done got so cold it would take time before you warm up. You warm up too fast your hands start hurtin'. You best not get too close to the fire.

For fun I liked to fish and hunt. Mostly we'd catch catfish, a brim or two. Every now and then we'd catch an old turtle down there, carry him home, and mama would cook him. I'd hunt mostly rabbits, squirrels, whatever I run across. I had a .22. You had to have good eyes to hit with it.

I was about ten before they let me fool with the cotton. I plowed and chopped cotton from sunup to sundown. I'd have to get the

mules ready before daylight. A brother or sister would bring me salt pork and a biscuit for breakfast. I had two lines to guide the mule and bring him to the field.

I had a girl mule. She was smart and fast. The old boy mule would let the other one do all the plowin'. That was wrong. He'd just sit there like he was sleeping and let the other mule pull the plow. You had to work to keep things level. She'd pull on one side and the plow would go across the row. Oh boy, that was trouble. If you don't watch him, you gonna cut up some cotton.

I plowed those mules many a day. They get stubborn sometimes, and don't want to go. But keep laying it to them, they'll come on. I started driving tractor when I was about seventeen. The tractor was a big release. I could make it then.

My parents listened to music all the time. My daddy had a wind-up Gramophone. He had all kinds of gospel and blues records—Memphis Minnie, Sonny Boy Williamson, Robert Johnson, and Blind Lemon Jefferson. Robert Johnson put out that song I liked—"If you see my milk cow won't you please drive her home" [*"Milkcow's Calf Blues," Vocalion, 1937*]. I don't hear nobody singing it now. Hearing the records made me want to try and play.

In my teens I'd slip into town and go where the music was at. If you wanted to hear a song, you'd go to the café and hear it on the Seeburg. Blacks went to the cafés run by Black folks. Miss Amerine had a café and so did Mr. Bama. I'd hear records by Robert Johnson, Sonny Boy Williamson, and Robert Nighthawk.

There was a fella three doors down from us, Charley Booker.[4] He worked for a Black farmer, Pat Knight. People would go to Pat's house to hear Charley play. I was fourteen or fifteen when I first heard him. They say he played with Charley Patton.[5] Most of the time people would go to Pat's to listen to the radio. We'd sit and listen to the Carter Family and Bill Monroe and his Bluegrass Boys. They be sounding so *good*.

Charley was a slim, brown-skinned fellow. He had a big head of hair and was kind of tall. Charlie played straight out country blues. He could make that guitar *talk*. He had a band called Charley Booker and the Downbeats.

Every now and then my daddy asked him to come to our house. Charley'd come down and play with his brother-in-law, Robert Banks. Robert would light it up on the harmonica. You couldn't be still when he started blowing. My Dad would shoo us out, but we'd listen any way we could.

People would crowd in the house as long as you let them. Some people are rough, and he didn't want them there. They'd get drinkin' and actin'. You didn't want that. Them that couldn't get in the house be on the outside listenin'.

People would dance and some of them would get down. They'd be drinking that corn liquor and get drunk off of it. Charley was doing some of his own music. He used a slide every now and then and tapped his foot like a drum while he played. He played "Catfish Blues," "Highway Fifty-One" and "Just Like a Rabbit."

After Charley went to doing it, I got it in my mind I wanted to try and do it. I liked the way he sang, "I'm just like a rabbit. I ain't got no special home. I'm here like today and tomorrow I might be gone." That tune did something to me. It made me feel good. They put that song out on a record.[6]

My brothers and I stayed close to Charley Booker—Charley had everything in a bloom for a while. He carried a crowd with him and went wherever they wanted him to play—Sunflower, Ruleville, Leland and Greenville. I went to Leland two or three times to hear Charley.[7] Sure enough, you couldn't get in the place, there'd be so many people inside. When Charley had shows, he'd say, "I got your back. Just go on in. I'm gonna take care of you." He'd set that place on fire. Charley was number one.

A fellow by the name of Lloyd McGee played music in the area. He just sit down, don't care where, on the railroad track, our house, on the street corner for tips. He played country blues. Oh Lord, could he play. Lloyd could push the strings down and pick with his fingers. When he played, you couldn't get close to Lloyd, there'd be so many people around him.

Me and my brothers—Jesse James, Henderson and Walter Jr.—sang gospel music. I started singing with my brothers when I was fifteen or sixteen years old [*1942–43*]. We grew up in the church and

sang in the church, so we all kinda understood how it went. I was the lead singer and my brothers would harmonize with me. Some of my favorite songs were "You Got to Move," "Oh Noah," "Old Jonah," and "I'm a Poor Pilgrim of Sorrow."[8] We called ourselves the Four Nolden Brothers. My oldest brother, Albert, never wanted to learn to sing; he just liked to follow us around.[9]

We sang anywhere they called us—from Greenwood to St. Louis to Chicago. My daddy let us use his car. Folks would come and be shouting and hollering. Mostly, we was just trying to make a living. We'd make a little bit of money, not too much. We never made a forty-five. There wasn't no millionaires' money around to do it. Sometimes we'd be on the streets of Sunflower. We'd mix up some church songs and some blues. When people asked us to sing blues, we'd sing maybe one. We wouldn't go too far with it.

Jesse James and I played blues on the streets of Sunflower, in front of John Gibson's place.[10] We played some of everything. We'd play for fun, to be out with the people and to make a little extra money. I did most of the singing and Jesse played guitar. Charley Booker used to play outside John Gibson's sometimes too. He had a '41 Chevrolet with the instruments stuck on top of it. He carried guitars and horns when he played with a band. It looked funny to see the car coming down the road with all the stuff on top. It was a wonder it didn't fall off.

Every now and then we'd see B.B. King playing in front of Nelson's Café. Nelson Brinston and his wife, Big Baby, ran the café-juke joint. Riley [*B.B.'s given name*] was just like we was at that time. He would be straight down from us on the same side of the street, with a cup for tips. We would go around and look at him, and he'd do the same with us. We'd see him at WGRM in Greenwood. WGRM broadcast a gospel show on Sundays.[11] Everybody would head out to the station and be getting ready for their time on the air and sing their head off. Riley was the lead with the St. John's Gospel Singers. He'd be there with his group waiting to go on. [*According to John's brother, James Nolden, B.B. sometimes performed with the brothers on WGRM. James recalled B.B. singing with the Noldens on a version of the gospel classic "Farther Along."*][12]

You'd give the radio show a little something. We'd get fifteen minutes to sing. We got jobs from different churches that heard us on the radio. We broadcast down there a good while.

Sonny Boy Williamson went to coming on over to Sunflower ever so regular. Sonny Boy was advertising for King Biscuit flour on KFFA on the radio. He would start his show singing, "Good Evening, everybody. People tell me, how do you do? We the King Biscuit Boys comin' out to welcome you . . ." They had King Biscuit caps and shirts that said "Sonny Boy Williamson and the King Biscuit Entertainers." A colored woman, Miss Bit, ran a café in town where he would play. People would pay fifty cents to go in and hear him. When Sonny Boy came down, that was tops. He'd come with different people. One night I saw him—I was getting twenty years. [*1947*].[13] Robert Junior Lockwood was on guitar, Dudlow (Robert "Dudlow" Taylor) piano and Peck (James "Peck" Curtis) came with them, on drums. That Peck was something else. He tap danced, too. *OO-ee* he could move his feet fast.[14] That made a show there. You couldn't beat their sound.

Sonny Boy's music inspired me. I was just itching to do it. I had a little old cheap harp. It didn't do nothing. I was practicing, but it take a little time to do things. You just can't jump up and do it.

I left my parents house when I was about twenty-one. I got married to Sarah.[15] We were classmates when I did get to school. I got grown and run across her again. She never did forget me. I needed me a wife and told her. She come back two or three days later and said she was willing to get married.

I had a good life with Sarah. We had twelve children. We moved around to different plantations. I always believed in working. You work, you won't be hungry. (When) I get worried about things I try to find a way to make it a little lighter, a little better. You can't let it take you out. You got to press on.

My brothers broke up, decided to give it up. I didn't want to. I started a new gospel group, the Four Stars. I was the lead singer. James Washington, John Williams, Jessie Russell, Johnny Raymond, Joshua Moore, Albert Harris, Fred Hampton and Johnny Nichols

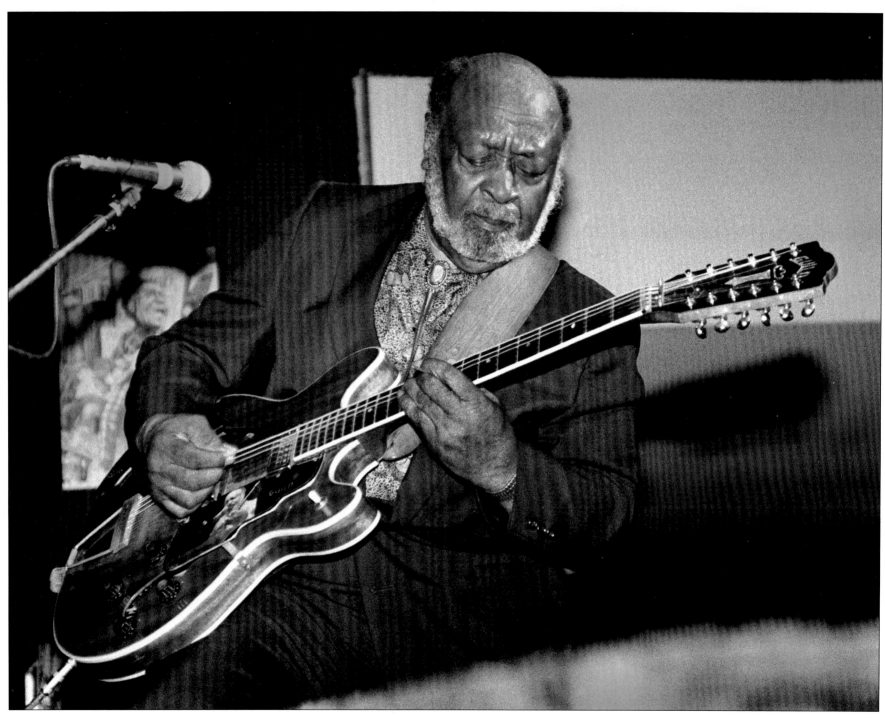
Robert Lockwood Jr., Harpers Ferry, Boston, Massachusetts, July 1995

sang with me at different times. We'd sing four at a time. I could sing baritone, but I really sung tenor and lead. Every man got a chance to sing.

Eddie Davis was the main guitar player. He could play some good licks. He was short and real young when he started playing with us, but his music made a big difference. It made the group stronger. We could really get down to what we had to do. We used to tie Eddie in the chair to make sure he didn't fall or drop his guitar. Eddie can *go*, that's all I can tell you.

Eddie Davis: "I was a little bitty guy, like John said. They tied me by the waist to the chair so I could hold the guitar and wouldn't fall. The guitar was actually bigger than I was—an electric guitar, a Gibson or something."[16]

The Four Stars was *good*. Our voices blended, and we could really harmonize. We sang in Methodist and Baptist Churches.[17] Every Sunday we would go down to Indianola and sing on the radio. WNLA had a gospel show, and different gospel groups would come in and sing, about fifteen minutes each.

Eddie Davis: "Every Sunday we were somewhere singing. We sang at churches all around the state. In the summer we'd take trips up north to Missouri and Illinois.

"John had a little of the old and the new in his singing. That's the reason I loved to play behind him when he led—so I could kind of jazz the music up. The song, "God Gonna Move This Wicked Race," he'd sing it like the old Nightingales sang it, but a little jazzy. Which could have been a hit, if we had ever recorded it. [Harry Belafonte recorded the song in 1963].

"The Four Stars had that harmony and a solid bass sound. I put a little style in the group, modernized them a little bit. Other groups didn't have a guitar; they sung a cappella. After that, other groups started getting guitars and keyboards, drums. We could go and compete with any professional group.

"There used to be a big anniversary get-together in August at Persimmon Grove. We did that a long time, about twenty or thirty years. That was a big day for the Four Stars. We'd celebrate another year's singing."[18]

You can't hardly beat the church songs. They touch your heart. But you don't get too much money out of the church songs. Sometimes you stay awake all night trying to study how you gonna pay a bill. If you can't get no money, then you get a bad name. And, oh Lord, it was hard to get money to keep things clear.

People ain't got no money they want a boss man who will help them more. That's the one you go to. Most times back then I took things to the white people. I'd get in such a jam, I'd have to walk up to one and talk with them. They would help you, lend you money.[19] You tell them how you gonna pay it back. A lot of them don't ask. Just pay it back when you get it. But you want to pay it back quick as you could.

I was working for Preacher Moon [*Baptist minister, Lester Elijah Moon, 1910–1995*][20] His plantation was out from Ruleville.

According to Preacher Moon's daughter, Rachel Zundel, "The community where we lived was called 'Fog Bottom.' It was about eight miles west of Minter City. About ten families, Black and white, lived around our land in the community, about a quarter to a half-mile away from our house. Everybody helped one another.

"My daddy respected his workers and took care of his people. He was a calm, soft-spoken man. Daddy treated people like human beings. He lived by the Golden Rule—treat people like you want to be treated. Anyone in the community who needed something, they'd always come to him. He'd give them money, not always expecting to be paid back. He got to know Christ and felt God compelled him to be a preacher when he was in his early 20s. Daddy had a church called Lowland Baptist Church in Booger Den—approximately four miles from our house. Everyone called him Preacher Moon."[21]

He was about as good a man as you would ever meet. His family stands up for the right; you will never find another like him. Preacher Moon bought me a Ford truck in 1959. I was scared to

take that truck. He didn't tell me how he was gonna take it out or nothing. You let a man do what he want to do, it will work out. I made a good crop. I didn't have no trouble paying for that truck.

I had a mob crowd come after me in the 1960s. One Friday night a white guy asked me to take him to town. I told him "I ain't got no gas; I ain't got no money." He said he was gonna give me the gas money. I said, "That's all I need." I took a chance because he lived behind us on the plantation and was a sharecropper. I took him to Ruleville. I said I ain't gonna be up there late. I went uptown. He was drinking whiskey; he got drunk. After a while I went to him and asked, is he ready to go 'cause I got to get back home. He said, "No. I ain't ready and you ain't gonna leave me." I had to wait over an hour for him.

When we got back I asked for the gas money. He got mad at me and was using cuss words. He said, "You Black son of a bitch, I ain't gonna give you a god damn thing!"

Well, there wasn't anything I could do. I went on home. The mob turned out while I was asleep. They went to my house and parked there. Lights flashing, all kinds of folks were out there. More than one hundred cars were lined up from Minter City to the front of my door. It looked like a funeral on the side of the road.

Some people came on the porch. I knew I would have been dead if I didn't get out. I told my wife and kids to be still. The back door made a lot of racket when you opened it. So I picked it up and crawled on out through the cotton. The cotton growed up tall. It was a wonder a snake didn't get me. I eased up and peeked, see how close I was to Preacher Moon's house. I crawled through the fields 'til I got to my boss man's house. God gave me the power to get there.

I was scared. I knocked on the door. I told him what we was into. Preacher Moon said, "Hold on. I'm gonna catch everyone of 'em. You're the only help I got. I ain't gonna go for that stuff. Come in the car with me."

He took me home. When they saw Preacher Moon they went to taking off. You could hear the car tires hollerin'.

Preacher Moon didn't put up with that. He talked to them. "I don't want anybody else at the house meddling with John." He said I was the best worker he ever had. He told them he would give me a gun if they didn't leave. He said, "If I catch you back on the plantation I'll shoot every one of you." Preacher Moon said he was sorry for what they did. Preacher Moon, He's gone now. God love him.

I had not a bit of trouble after that. All I ever did was work. I escaped, thank God. I let it go. Afterwards some of them come and said they were sorry and begged their pardon. The one who was really mad at me tried to make friends with me. Whether Black or white, you just have to treat people right. I treat people the same. That's all I ever knowed. I believe in going the right way.

Sarah and me moved back to Sunflower. I was getting older and wanted to be closer to my brothers. I got a job working for a service station. I came home one day and everything was gone, children and all. It was somewhere around 1970. People met me with it and said, "You know your wife is gone?" I said, "No, I didn't." I went on in the house and went to sleep in the clothes closet to keep people from seeing me. I couldn't turn no lights on. I didn't have no curtains on the windows. I was stuck with the bills. It was hard stuff. The woman worried me just that bad. It was hard to get over. I want to tell you something—I'm older than anybody around. You can be hurt that way. Don't think you can't.

I bought a six-dollar harp from a hardware store to keep me company through the night. I just started trying. The music is sad. I wanted to see her. She's with somebody else. She warned me, "I put trouble on you!" That was hard. I was lonesome and hurting some kind of bad. That's when I learned to play the harmonica.

It looked like the harmonica helped me. The blues helped me a lot. You just have to sing 'til you sing them off. Then you can rest a little bit. Different songs come to me overnight in my sleep. I'd get up the next morning and play a song, just like it come to me. I could go on across the harp and make the sounds I heard. It sounded like Sonny Boy Williamson.

Before the year was out, I met another woman, Luveda.[22] We got married and moved to Cleveland [*Mississippi*].

I used to own two or three Cadillacs. I had two '76 Cadillacs, and peoples would call me "Cadillac." One day my Cadillac backfired

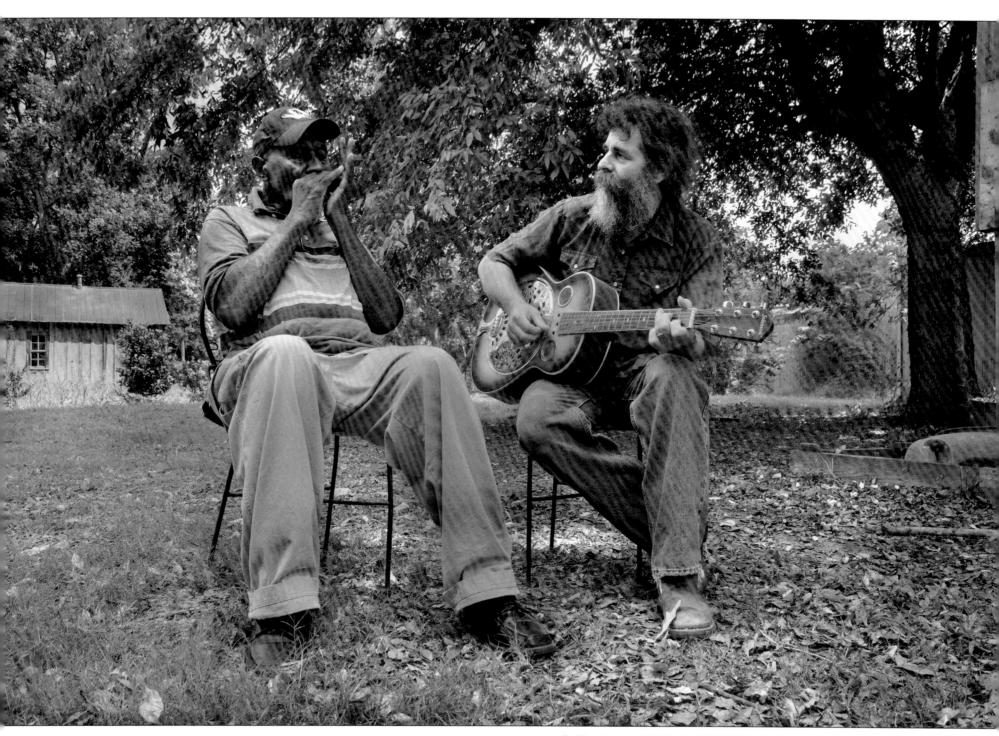

Cadillac John and Bill Abel, at Bill Abel's home, Duncan, Mississippi, August 2012

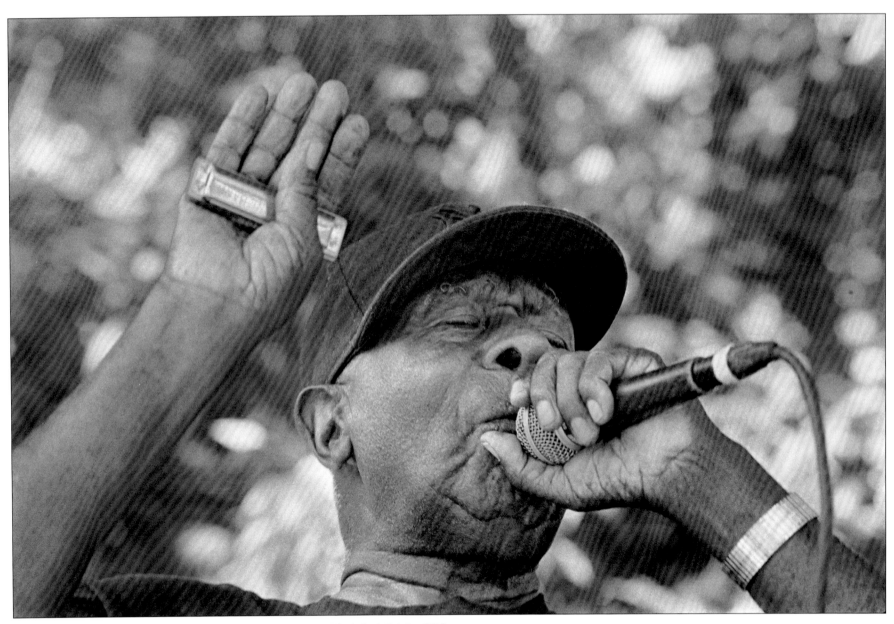
"Cadillac John" Nolden, Mighty Mississippi Music Festival, Greenville, Mississippi, October 2016

and tore that muffler up. I first thought someone with a 12-gauge was shooting at me. Everyone came up laughing and called me "Cadillac." So that's where the name came from. It got around, and everybody started calling me "Cadillac."

In the Nineties I had a band with Jesse Guy and Shane Thornberry. We were called "Cadillac John." We played the Greenville and Clarksdale festivals and sometimes hooked up with Monroe Jones. Me and Monroe played together in spots, but Monroe mostly did his own singing and playing. Like, he'd sing a song then I'd sing one. Monroe has his own style. I'd blow behind him.

Bill Abel: "They had a good little band. It was John, a drummer named Shane Thornberry, a guitar player named Jesse Guy (from Cleveland), and Jimmy Fickle, a great white musician who died in 2011, on bass. Monroe would play sometimes."[23]

Euzella Kizart: "In the eighties and early nineties they played in clubs around Cleveland—Airport Grocery, Frog's Place and Moore's Lounge. They played at Po' Monkey's."[24]

Then Bill Abel came calling on me. That's when I got hooked up again. Bill got me out playing at festivals and clubs. [*Says Bill Abel: "We been from Idaho to Pennsylvania, and a couple of times to Italy and Sweden."*][25]

I'm playing some of my own music now. I don't believe in just copying from people. I have a song, "My Baby Left Me This Morning. She Didn't Tell Me Goodbye." It's based on my ex-wife leaving me—"*She didn't tell me goodbye. She just left and I feel like going to the river jumping overboard and drowning.*" That's true. Well, I felt like doing more than that but I didn't. I tried to pray a little bit, too. I was in a bad way, Lord. But the Lord heard me. It's real mean when something like that happens. That song is on the CD I made with Bill Abel, *Crazy About You*.[26] I got another song that come to me in my sleep, "Give It All to Me Baby, Don't Hold Back On Me." Ain't nobody teach me nothing. I got up the next morning and went on it with my harp. Bill and I have it on tape.

I love the way Bill plays—the sound of his guitar and the time he carries. He matches me. I like the tune that it's in. He's a *bluesman*. You talking about the blues, he's one of the people that help carry it on . . . Sometimes he makes me think about Lightnin' Hopkins.

Blues comes out of my life experience: the hard times, the lonely times, the poor times. Gospel music makes you feel good. It works on your heart.

I can do more than before. I hope my music makes people feel good. I bring the feeling from the gospel music to the blues. That brings me joy, and that's what I want the audience to feel. I feel happy about it when the spirit get on you. When the real feeling gets you, I think the people know it because you can't hardly keep yourself together. When I sing I feel like I have no weight. When you feel light, something is taking place.

Bill Abel

I was born in Belzoni, Mississippi in 1963. I grew up in the Delta knowing some people that played a raw blues. You play what you feel. I played with local blues musicians, most notably Paul "Wine" Jones. He was a major influence on my music. I was overjoyed and excited to be able to find a harmonica player like Cadillac John and to learn from him.

I met John in the year 2000. I was in a record store in Cleveland and Monroe Jones walked in. The owner told Monroe about the music I play. Monroe said, "It sounds like you be able to play with John. Nobody can figure out how to play with his harmonica." He gave me John's address and number. I called John and brought him to my house. I hit the record button from the first notes we played together and that's what's on the record, *Crazy About You*. John's lyrics move me. His lyrics are rooted in the heritage of the music. They come from his community—old sayings that you never heard before.

John had his own style, similar to Muddy Waters. I just followed him. John's a rhythm harmonica player. The beauty of John's music comes out in the space between the notes. For me to get to where John was playing musically was an awesome challenge.

There is a connection between the old spiritual music and the blues. That's what Son House said. John and his brothers were raised on this old spiritual music that you can't hardly find any more. There's a part of the blues that's in him that comes from the spiritual music and the way he learned it. John knows more than two hundred old spiritual songs.

John always played the real blues—a slow blues that you can't sing without crying. He sang and wrote blues but he didn't start playing harmonica until 1970 when his wife left him. Blues *drove* him. He went home and locked himself away and learned how to play the blues on the harp. Musically he already had the blues in this singing. He just transposed it to the harmonica.

"The most sad lonesome blues, that's what they had back then," says John.

Right: Bill Abel, Highway 61 Blues Festival, Leland, Mississippi, September 2012

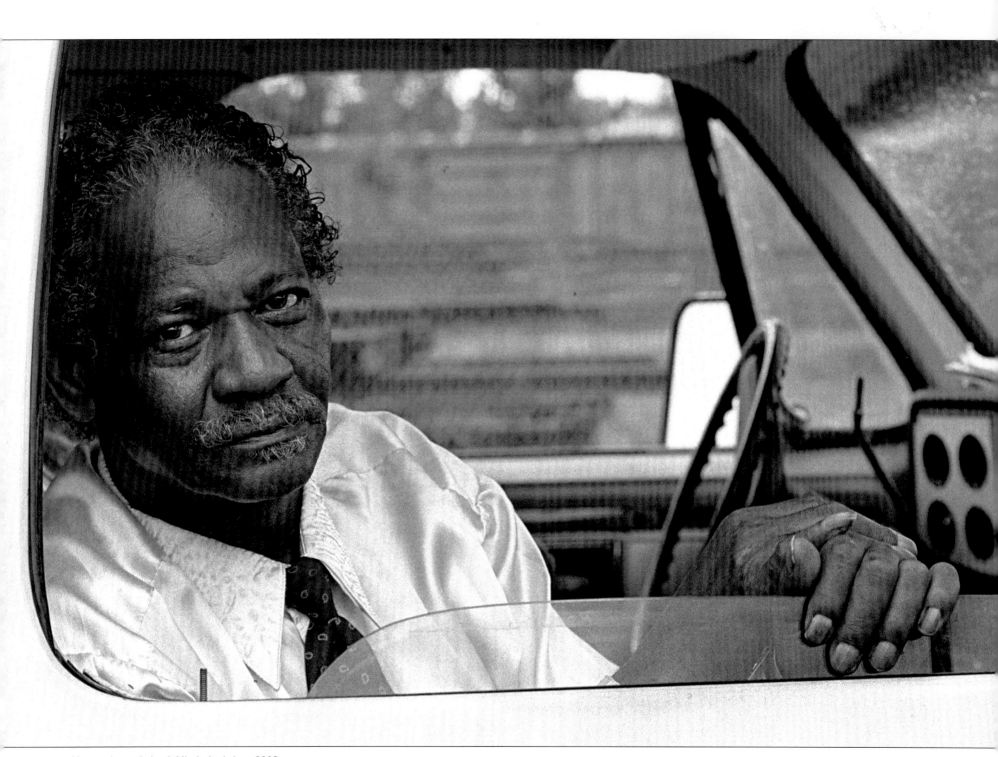

Monroe Jones, Leland, Mississippi, June 2003

Monroe Jones

I started playing guitar out of Shaw, Mississippi. All the kids were going to school. I had been down on the Swift place, chopping cotton. I was about fourteen, and I just couldn't read a first-grade book! I said, "I got to do something like going to school!" I bought me a one string guitar. I'm gonna learn the guitar. I started playing. I tried hard.

At sixteen I went to Chicago. That was in 1956. I worked at the Cotton Club. I played with Earl Hooker about two years, and I did some gigs with Elmore James. I'd sit in with Sonny Boy Williamson. In my younger days I was good on the guitar.

I came back and started playing down here in '71. I missed my mom.

—MONROE JONES (1939–2011)

When Monroe went to Chicago, Little Walter was on the same train—on his way back to Chicago. Little Walter pulled one of his suits out of his suitcase and gave it to Monroe.

Monroe was a hit in Chicago in the early sixties . . . He was playing B.B. King songs, but he had his own guitar style. It was as good as B.B.'s and it just took over the town they say. Monroe's band was the house band at the Cotton Club.

Something happened in Chicago. Some say he had a stroke; some say he fell out of a two-story window. Monroe moved back to Mississippi in 1971. He became known as the best blues guitar guy in the Delta in the early seventies. Then he got out of it for some reason. He would just play every now and again. But Monroe still had the fire in him. On a couple of songs that greatness would come out. He would start off slow, then he would just grab everybody in the place. It would make your head spin. He had something really special.

Monroe carried the torch of the blues.

—BILL ABEL

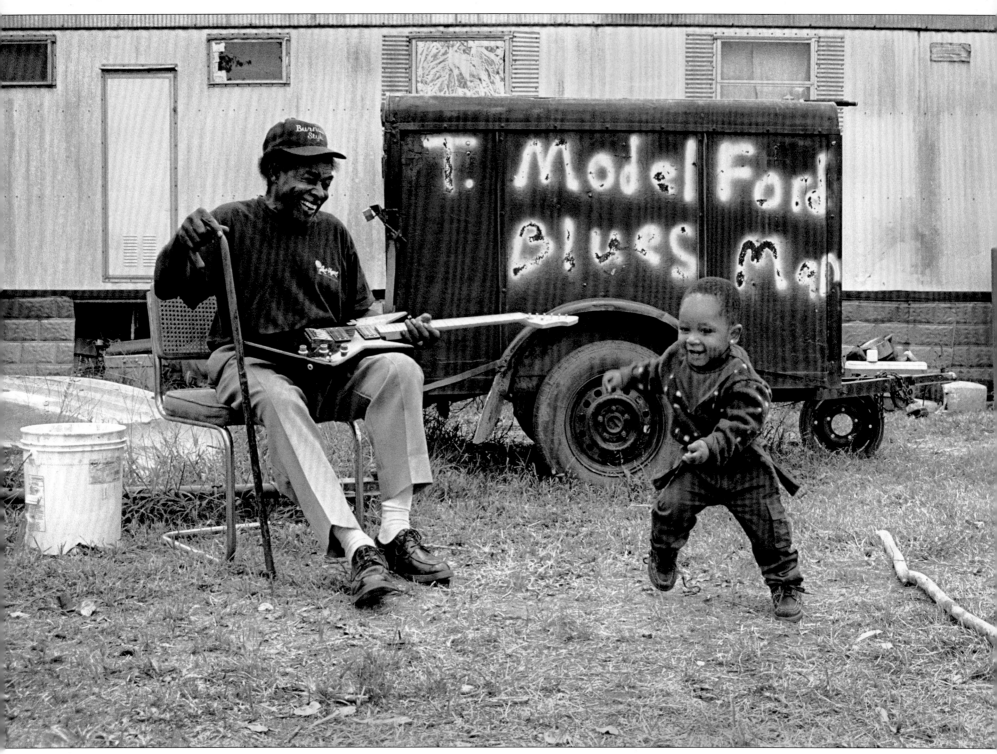
T-Model Ford and "Gentle" aka "Stud," Greenville, Mississippi, September 1999

"T-Model" Ford

I don't know when I was born. They tell me I'll be eighty-six on June 24.[1] White folks and some colored have told me. I was born in Forest, Mississippi, in Scott County. I wasn't born on a plantation. I was born on the edge of a swamp, in a ditch that came out from the woods. We was living with my grandmother, my daddy's mother; her name was Ogenia Ford.[2] Daddy and Mama always lived with her. I never saw her husband, Preacher Carter Ford.[3] He was a traveling preacher. A Black man killed him, that's the way I heard it told by my daddy. I don't know why. I wasn't even born.

My mama was named Annie Ellis. When she married her name became Annie Ford. My dad's name was James Ford. I got his first name. My full name is James Lewis Carter Ford.

Daddy worked in the woods cutting cross ties to build the train tracks on. I was the firstborn. There were four boys and one girl.[4] They're all dead now. It was a tough life. We worked every day. I never got to play with no children. Daddy was a mean man, he whupped me a lot. Mama was the sweetest thing that was ever born.

Never been to school a day in my life. Daddy never let me go. He was a sharecropper, farming on halves. He put me to work every day. When I was six years old I was plowing a mule. He showed me what to do. I plowed the cotton with a middlebuster, throwing dirt both ways. You plow down the middle of each side. It was a full days work. I got up early in the morning and worked 'til quitting time, close to dark. I picked cotton; I cut corn and cotton stalks. Piled and burned them to clean the fields up. I cleared the land with a hoe and axe.

My brothers had to help me in the fields and garden when they got older. We took all the corn and put it in a crib. Some corn we carried to the grist mill to make corn meal out of it. We had to feed and take care of the cows, mules and hogs. Daddy killed the hogs for food once a year. Then he smoked the meat in the smokehouses he built. We helped. We'd go to the woods and cut down the hickory trees. Let the wood dry out then we'd cut them in blocks, put them in a washtub. Bricks and dirt were under the tub. The wood would burn slow and start smoking. The meat was good then. My daddy taught me to use a single barrel shotgun. I hunted squirrels, rabbits, coons, possums, all that.

I was raised up in the church, but I don't go now. Sometimes we'd go in the wagon and sometimes me and my brothers and sister walked. For Sunday clothes we'd wear what people gave us—our best overalls, big old shoes. I never wore new shoes that fit my feet 'til I got seventeen years of age. I was working for my own self then.

Forest was a big town, between Jackson and Meridian. There were three or four sawmills around Forest. There were logging companies all through them woods. I've done all of it. They had big farms back in there too, all the way up and down the highway.

Forest had about three main streets go down through there. It had a bunch of grocery and hardware stores, a jailhouse, gas station, post office and courthouse. There were cafés. I didn't go where the

blues men were. Youngsters could hardly go out like they do now. Anyone could whup you back then.

One night the KKK came to kill my daddy.[5] I was about twelve years old. They came and knocked on the door. Daddy looked through the keyhole and seen who it was. He woke me up. He said, "Son, go out the back window, and tell Mr. Bill, (the boss man), to come up here, some white men are here to murder me." I went there and knocked on his door. He got up—tall white fellow. He wore a .44 on his side.

I said, "Mr. Bill, my daddy said to come on up. Some white men are at the house to murder him. He said for you to come." He got up there by the house and shouted, "Hey, who is this?" Someone yelled, "We're going to whup this n-----'s ass!" Mr. Bill said, "Well, you'll have to whup Mr. Bill first. This man, Jim Ford, is the best worker. As long as he's working on my place, don't interfere with him. Go home. I don't want to hear this mess on my place no more or you all going to jail." They didn't bother daddy no more.

They were after daddy because a white woman was slipping in the fields, going with my daddy. The white men didn't have no business doing that. They were pushing over Black men. Well, some of us stood up for ourselves. I did.

I was nothing but a sixteen-year-old boy when a white boy came in the yard to whup me. But I whupped his ass! He hit me first. I would have never hit him if he didn't hit me first. He ran home and told his daddy. That night they came after me, but I got away. The boss man found out where I was and told them to tell me to come back home, nobody gonna bother me.

When I got home, he got all his hands and they built a boxing ring out there. Every Saturday morning, if some of the boys got in a fight trying to hurt the Blacks or the Blacks tried to hurt them they carried them to the boxing ring. If I whupped his ass it was all right. If he whupped my ass it was all right. That was it. That broke that up. There'd be so many people around that thing it would be pitiful.

When I was about fourteen years old, I started working at the sawmills. My first job was toting slabs and strips, pushing them up a runway to the pit and burn them up. The sawmill man cut the slab off, put it into the edger and he done edge it. I took them off the edger and lay them on the runners, go out to the pit. I'd put grease on the poles and shove them off into the pit.

I left and went to another sawmill after four or five years.[6] I was a good worker and the people wanted me. At my second job I was a one man dogger. They'd bring the logs in by trucks, wagons, and mules. They'd unload them and roll them onto the roller beds that run down into the carriage. I could take a cane hook, spin it, and grab a log. I'd bring it to the carriage, hold the log with one hand and dog it down with the other. I had that job five years. I was the best dogger in the state of Mississippi they tell me.

Men who worked at the sawmills were Black and white. We all got along, like me and you get along. I worked five or six days a week. Some days I worked twelve hours. On Sunday I might be somewhere gambling. I picked it up on my own, going around people shooting dice and watching them. I knew when they was a crook and when they wasn't. You'd be there so long as the police didn't catch you.

I left Forest and went so many places—Morton, Pelahatchie, Jackson, Brandon. They had sawmills all in them different counties. I drove log trucks and bulldozers. We'd cut and tow the logs. A log was about twelve feet; it might have weighed two thousand pounds. Six men could tote a log back then. You had to be a man to reach back there, grab and hold a log. I don't think there's men like that now.

Logging is dangerous anytime. You have to be careful and keep your mind on what you be doing. I seen men killed out there. I been hurt so bad in the woods and never got nothing out of it. A log came off the truck end ways and hit me and almost broke my rib. I still hurt on that side back there. One day a log truck got away from me and turned over. I jumped off. The trailer come down and broke my leg. Another time the logging truck jackknifed. The cab went into the gulley. The steering wheel hit me in the face and broke my teeth. My left arm was crushed.

My brother was living in Humboldt, Tennessee. He told a man about me. He offered me more money to come with him and carried

T-Model Ford, The Middle East, Cambridge, Massachusetts, September 1997

me and my uncle back. People come from out of town to see us working at the sawmill. I could do everything on the carriage. So could he.

One day I was in a café. Some women came and asked me to sit with them. I saw a man standing and watching for something. I asked the women, "Is that one of your boyfriends?" They said no. I said, "Why don't you all get an extra glass and call him and give him some beer 'cause I'm buying." He came over. All of a sudden he was out with a knife and cut at me. I got out of my chair and hit him with that chair. That made him mad. I had a knife but didn't open it. He got behind me and hit me in the back and left the knife in my back. I snatched my knife open and hit him in the neck. I killed him, but he done it.

I dodged two days from the police. The boss man I was working for sent word for me. I was staying down in the fields in a ditch, that's where I was sleeping at night. The boss man told me to give up; he'd stick with me. He stuck with me, but he didn't keep me from going to prison on the chain gang.

Two police were at the sawmill office. They said, "You're under arrest. I had a trial. I didn't have a lawyer. I knew it was self-defense. I told the judge what happened. I told the truth. I was an honest man. The judge said, "You're free." The boy's mama kept arguing. The judge ruled it back. They put the handcuffs on me and took me to prison. The man's mama could have freed me. She knew how he was. As soon as somebody new came to that town, them guys was beating them up, make them run off and leave their cars.

The judge gave me ten years. I didn't stay but two years. The white folks down where I was born and raised, they knowed me. They came with mama and got me out of there. It was hell in prison. They made me work in the fields and tow logs too. I had a big ball and chain on my leg. You cant' run with it. It rubbed a scar on my leg. They had a barrel. They'd take your britches down and bend you across the barrel and whip you. They did it to me because I fought with the men. This happened the last month in 1949.

I also went to Parchman. I forgot how old I was there. I had cut a man in Forest. I don't know what we were fighting for. Parchman wasn't hard at all. I picked cotton, pulled corn, and cleared up new ground. I was there about a couple of months.

Before I lived in Greenville I did logging work around the Delta and Arkansas. A white man, Maynard Johnson, had contracts in the Delta. He come from Carthage, Mississippi, and hired me. I was the fastest man at loading big old logs onto trucks and driving trucks. The white people liked me. I was quiet and I would work. He told them I'd work—"But don't fuss at him or he'll fight you."

One day Maynard said, "I'm gonna give you a new name. I'm gonna name you 'T-Model Ford.'" I don't know why he gave me that name. I started calling myself T-Model after that. Everywhere I've been I been T-Model. But if you go down where I was born and raised, everybody knows me by "Son."[7] I was a little baby when they gave me that nickname.

We hauled logs around Rosedale, the banks of the Mississippi, Memphis and everywhere. We lived in the woods sometimes. Then we'd find something else and move back in the cities. I lived in Friars Point. I lived in Clarksdale. In Clarksdale we stayed on Issaquena Street. In one of the cafés I heard Muddy Waters, Howlin' Wolf, and Jimmy Reed on the Seeburg.

My old lady and I moved from Clarksdale to Florida. She tried to poison me there. They pumped that stuff out of me. And the Good Lord kept me here. I got over it. I ain't seen her since. I went to Wauchula, Florida. That's where my mama was. I had to move to Clarksdale. They called me back to work.

I came to Greenville in 1973. I was looking for a job. The Ford place, a mechanic shop, hired me. In the 1970s Greenville had a lot of places you could go to work at; now it got thin. Greenville was rough. Yes, indeed. The Black and white people were raising sin. They didn't get along too good. They'd fight and shoot. You couldn't get the whites to go on Nelson Street. Yeah, they were afraid.

I've had twenty-six children between five wives and some outside women. Johnnie Mae was the fifth wife. I met her down in Inverness. I was a gambler there on my days off. I was fifty-eight

T-Model Ford outside his home, Greenville, Mississippi, June 2006

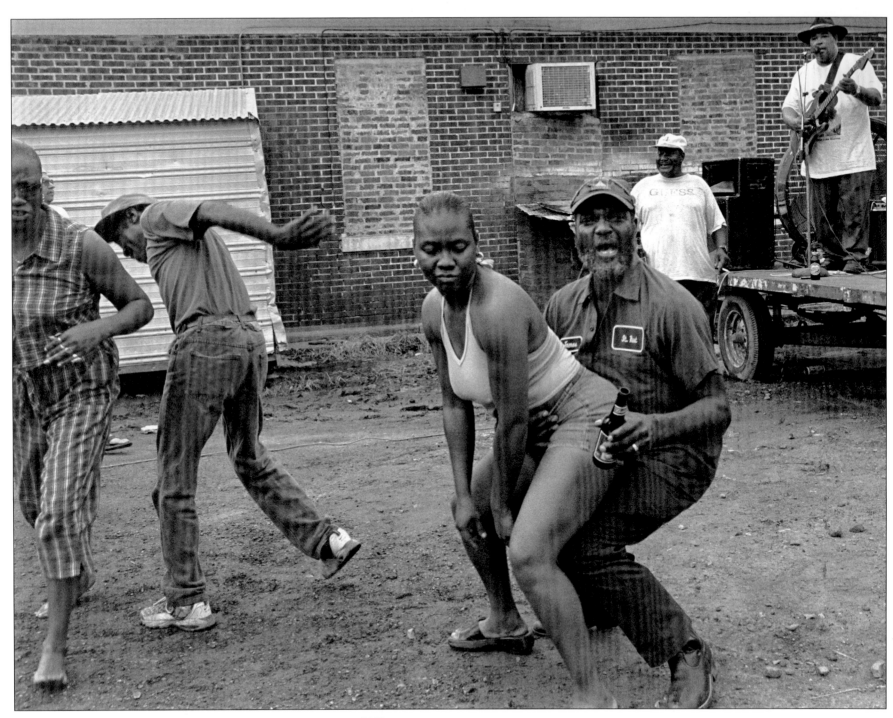
"Jukin'," (John Horton on guitar, background), Holly Ridge, Mississippi, June 2003

when Johnnie Mae left me. We had three little children and she was pregnant with another baby of mine. When I came in from work on payday, I'd bring her my money and give it to her.

I came home one evening. I was sitting enjoying my children. Johnnie Mae was in the kitchen cooking. She came in and said, "Look behind the bed. I bought you a guitar and an amplifier."

I said, "Darling, why are you spending my money like that? You know I can't play no guitar."

So the next Friday evening I see this car sitting in my driveway. I got out of my big truck, walked on in. My mother-in-law, brother-in-law and Johnny Mae was sitting there. My mother-in-law said, "I got a phone call from Johnnie Mae saying come get me." Johnny Mae didn't say nothing. They all got up and left. The little boy said, "Daddy, go with us!" I said, "Darling, Daddy can't go. He has to stay here and work."

I took it like a man. I went in the house and picked up the guitar. It was a cute little Gibson. I had Muddy Waters and Howlin' Wolf's sounds in my head. I hear Howlin' Wolf playing "How many more years you gonna dog me around?"[8] and Muddy Waters wishing he had his baby in his arms.[9] That guitar was *talking*.

I learned how to play pretty good at my house. People would stop by and ask me to come to play in the yard for them. They was crazy about me. One Saturday morning I was sitting up at some woman's house playing the blues, an old fellow pulled up in a pickup to her house on Nelson Street. He asked, "Why don't you quit throwing your good time away and make you some money?"

I said, "Well, I don't think I'm good enough to go out there and play guitar and make money."

He said, "You can play as good as any of them. A guy just opened a new place. If I can get you to play tonight, will you play?"

We went down to the old man's place on Edison and Nelson, right across from the whiskey house. It was called Mister Ed's. I set my stuff up. He said, "Play three of your favorites. I played one song by Muddy Water and another by Howlin' Wolf. He said, "Hold it; you play good enough." He hired me to play for thirty dollars a night. He said, "Be back here at seven!"

All the people up on Nelson Street,[10] they came in and got tables. Just enough room for me to stand up. Everyone was going to hear T-Model Ford, the one-man band. I used to play at that old man's place every Friday and Saturday night. I just picked up my own sound. I ain't scared of no one with a guitar.

Guitarist Bill Abel elaborates, "When T-Model played Howlin' Wolf stuff, he played all the parts . . . Howlin' Wolf had two guitar players, bass and drum, sometimes a saxophone—and he was playing a guitar and harmonica. T-Model did it all on the guitar.

"T-Model's sound was more complicated than the average country blues player. Most country blues guys play two parts—bass line and melody. Somehow T-Model pulled off three parts—bass, melody, and rhythm. On top of doing those three things, he did his bass line intermittently. That's what made him really great, plus his voice. Just raw and with ease he got down to the blues."[11]

Willie Foster was the first man I played guitar with when I learned it. I liked Willie's singing and harmonica blowing. He could blow insane. The first time I saw Willie, him and Asie Payton[12] and a drummer from Holly Ridge [*probably Sam Thompson, father of Little Dave Thompson*][13] were playing down yonder in Rolling Fork. They played at a big old house sitting next to the levee. I went to hear them. I was trying to make out what Willie was doing. They sounded about the best I had heard. I met them. Then Willie would call me. We'd do house parties all on Nelson Street. We toured around playing jukes. Willie and I played a long time around here. We were like that—[*tight, T-Model crossed two fingers*].

Me, Willie, Asie and John Price played in Holly Ridge. Holly Ridge used to be lively. There were two big stores; we played inside and outside. It would be packed on the weekend. People would be jumping, dancing, and drinking. They had tables for shooting dice.

There was a time when John Price managed me, Willie, and Frank Frost. Price was the drummer. I told Price, Foster's good. Price told me, "You just wait a while; you'll find out." One time him and Price done had a round. Willie slapped Price. Price knocked him out and I got Price off him. Willie eased around on the floor,

got on his hands and knees. He took a knife out and cut my cord in two to keep me from playing. But I had another one.

Another time Willie pulled a knife on me. I don't know what it was about. That was in the middle of a show in Indianola. John Price, Asie Payton, Frank Frost, and Sam Carr, all of us played.[14] Before playing Willie had words with me. I was coming back up to get my guitar and start playing. Price and Frank saw the knife. "Watch him T-Model, he got a knife open!" He eased and put the knife back in his pocket.

John Horton recalled the nights when Willie Foster, Frank Frost, and T-Model played at his cousin's juke, outside Greenville. "They did pretty good at the beginning of the night, but when they got to hitting them bottles and arguing with one another they didn't sound too good. But Willie and T-Model had a really good friendship . . ."[15]

John Horton's father, "Farmer John," often witnessed T-Model's and Willie's antics. "They had themselves a ball. They used to play and argue all night. I believe both of them were scared of each other. They had another boy who used to beat drums with them, John Price. When they'd get into it, he'd separate them. He didn't believe in no hell raising. He'd come out the worst end of it all the time. They'd tear his suit off! Then they'd go back to playing. He got to sit up there and beat the drums half-dressed."[16]

"T-Model and Willie would have a falling out and Willie would quit T-Model and go to church and get on the deacon seat for two or three weeks. T-Model would get full of whiskey and go next door to the church where Willie could hear and next thing you know Willie would be out there with his harmonica. T-Model said, 'I got him off that deacon seat many times!'"[17]

Frank Frost was a music man. He could do it all—guitar, bass, blow harmonica. Me and Frank were bad. Everywhere we went, if they was spinning a record, me and Frank would make them burn that record. Sometimes I'd sing then Frank sang. We'd switch it across. Sometimes John Price would play drums. Other times Sam Carr played drums with us.

Willie learned "Spam" (Tommy Lee Miles) how to beat drums. Price quit one night and Foster told "Spam" to come beat drums. I heard some good licks from "Spam." I took him and I've been with "Spam" ever since.

I still play on Nelson Street. That's where I met Stella—right there on Nelson Street. I was up there playing a guitar. There were other women with eyes on me. She asked me to be her man. [*Stella Smith-Ford became T-Model's sixth wife.*]

I'm the first man who played the Bait Shop on Walnut Street. That's where people used to buy their medicine, worms, and fishing poles. Every now and then I'd go to Belzoni and run up on Paul "Wine" Jones [1946–2005]. Paul gave me the name "Tale Dragger"[18] when I first met him. I drag my tracks where I go along at, I don't leave no sign for them to see. They can't trace me nowhere. We'd have fun together. We played some jukes around Belzoni, Inverness, and Moorhead. We went overseas together.

Paul was with Fat Possum before I knowed him, then Fat Possum came looking for me.[19] I made four albums for Fat Possum.[20] Bruce Watson and Matthew Johnson took me to so many places I've never been.[21] I feel proud God let me have strength to go out and play music. I feel great about the blues. [*In addition to his works on Fat Possum, T-Model recorded three other CDs—*Jack Daniel Time*, an acoustic album on Mudpuppy (2008), with appearances by Terry "Harmonica" Bean, Bill Abel, and Sam Carr; and two CDs for Alive Records—*Taledragger *and* The Ladies Man*, both released in 2010.*]

I'm glad that I learnt what I did. When I play the blues I feel just like an apple on a tree. I'm hanging. You see me smile. I'm happy. Every day. I don't let nothing worry me. When I get my guitar to sound right, like I like it, I'm ready for anything, anytime. I don't *have* the blues. I got the feeling for it and I give it to other people. As far as lonesome, or something like that, that's not in me. The people treat me so kindly, that gets me up just like that. I'm in a good mood and I stay that way. As long as God lets me live, I'm gonna keep playing. That's what I love and what I know. You can't find anybody else who plays the blues like me.

T-Model died in Greenville, July 16, 2013.

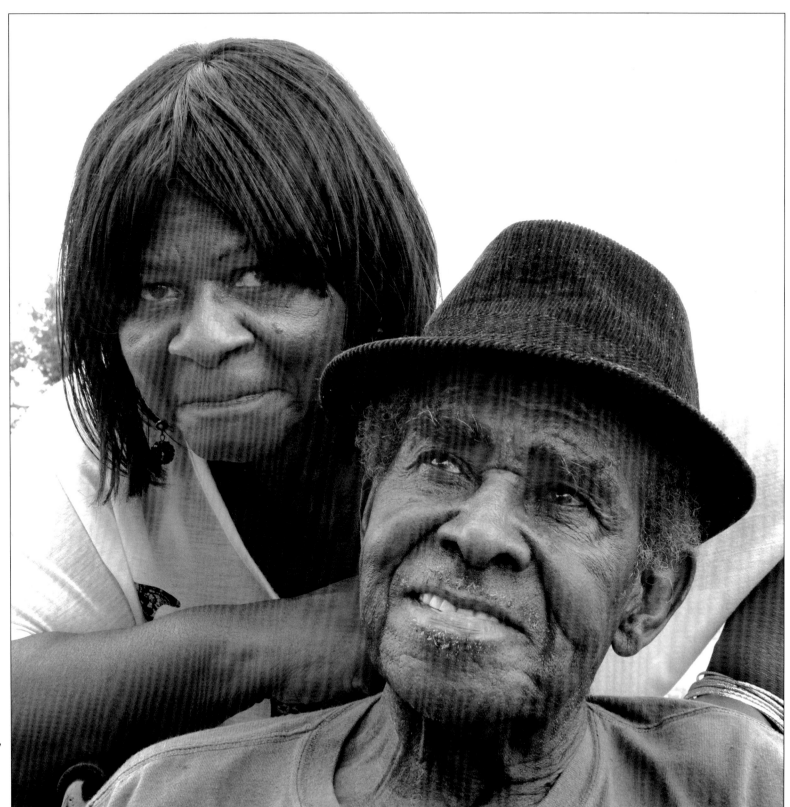

T-Model Ford and his wife Stella, Leland, Mississippi, September 2012

Eddie Cusic

I was born on the Wilmot Plantation, across the creek from the Wilmot store, in Wilmot, Mississippi. My date of birth was the first and the third in '26 [*January 3, 1926*].[1] My mother's name was Lillie.[2] She and my father married young—and separated, from what I understand, when I was six months old.[3] She was living with her parents, Oscar and Donie Ware. All I know is my grandparents were farming out in the country. I know my daddy some when I got up in size.

My mother wasn't but seventeen years older than me. I was raised without a father. That was rough. She did the best she could. I have some more sisters, but they weren't with me. Just me and my brother, Willie Holmes, was with my mother. Me and him had different fathers. We little kids moved from place to place, plantation to plantation—from out on Sunflower River and around Indianola and Washington County, different places. We ended up there on Kinloch Plantation, not far from Indianola, where B.B. King came from.

My mother worked in the fields, picking and chopping cotton—that's all she knowed. I started toting water in the fields when I was about seven or eight years old. I used to pick me about two or three hundred pounds of cotton when I was about thirteen or fourteen. I started way before that. I was plowing a two by four, a middlebuster, at twelve years old. You didn't need no teaching. You see what others was doing. That's the way you was raised, watching the grownups. You just go out there and do like they do.

We belonged to the Baptist Church. Went every Sunday. My mother seen to that. St. Paul Baptist Church, that's where I was baptized. They put some stakes out in the water so you wouldn't go too far. I'd go to Sunday School. When I got older I sang in the choir down there in Bourbon, Mississippi. I guess I sang in the choir about three or four years.

Wintertime we went to school at the church house in the country. The school was segregated. The little time we did go, them white children would pass by on the school bus yelling "Hey n-----!" One of them hit me with a rock one time, throwed it. We was walking to school and they was riding.

I wanted to learn to read and write and everything. I'd go to school about two months a year, maybe. We had to quit school to work in the fields. They had day workers to plow the widows' land, break up so-and-so's property. My mama would say, "My boy is big enough to plow my cotton." Well, my mom, by being young, she didn't know no better way back then. Take me out of school to break up the land. I think about that sometimes.

I'll tell you, you wouldn't want to be born when I come along. We come on the hard way. You had to do the best you could to stay warm. The house was heated by burning wood in the fireplace. When I was too young to haul wood, I had to scrap what I could. My brother and me, we'd go out and scrap roots and things across the fields. The coal trains used to run down the railroad and drop coal. I'd go grab the hot coals and carry 'em to the house.

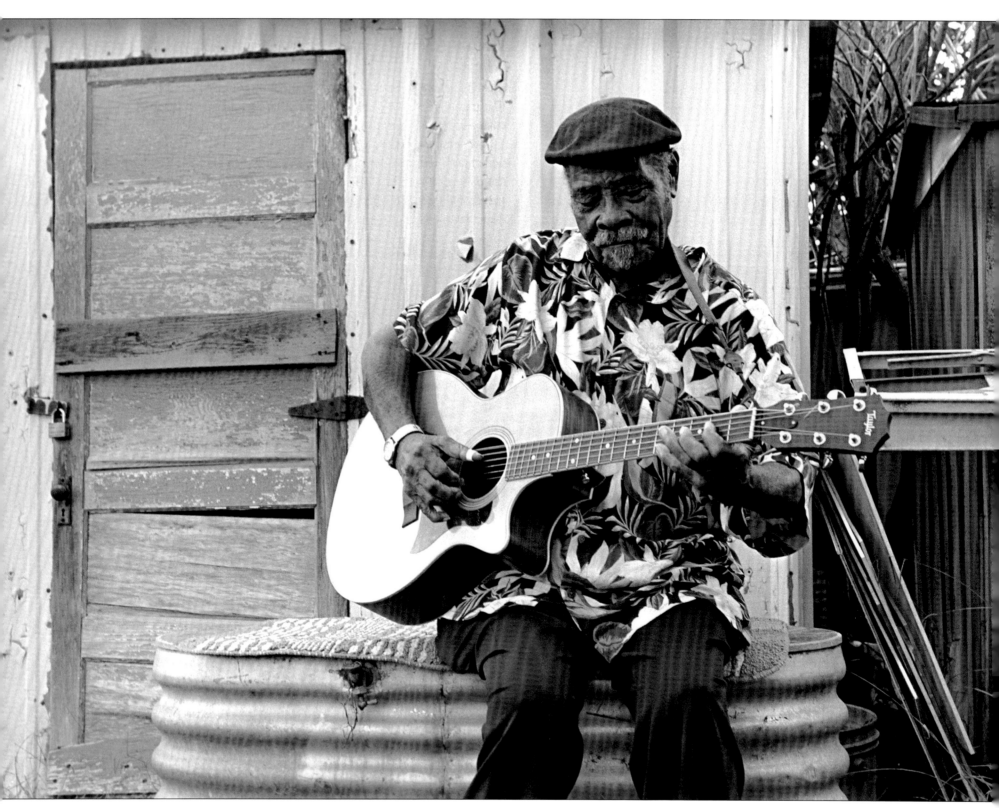

Eddie Cusic at home, Leland, Mississippi, October 2006

When I got older, the man would tell you, "You can haul all the wood you want, but I don't want my mules in the woods and break their legs." Every time it would be too bad to work in the fields, I'd be cutting and hauling wood. The woodpile would get just as high as the house.

The house you stayed in was so raggedy when you bring your wood in the house, pile it up by the cord by the door, when you got ready to put the wood on the fire, there was as much snow on the wood as there was outdoors—or more. Snow came into the house through the cracks; it was just that raggedy. You got to dust some snow off to put it on the fire. You could count the chickens under the house because the cracks were that big in the floor. [Eddie's wife Lucinda, recalled his telling her, "When it really rained, it would rain *inside*, the house was in such bad shape."]

Chinches [*bedbugs*] used to be so bad in the house, in them beds, they used to call it moving your chinches, your bed bugs. If the man made you move, you put your things on the wagon, you'd pass them on to the next house. They called it "putting the chinches on the road."

There were oil lights and lanterns. You had to have a lantern when you went to the outhouse. Sometime you might step on a snake out there. If you didn't have no door, it had a cotton sack hanging up there. When you go out, they had newspapers or them old Sears catalogues by the toilet seat. When that run out, you tear a piece of sack up.

You put water in a round tub, that's your washtub. In the summer you put it in the sun and let the sun warm the water. When they went to making big, long tubs, if you got one of them, you was uptown. You was *somewhere*.

When I was growing up, if one person had a radio on the place, everybody would be at his house, like for the Joe Louis fight.[4] Them people so poor in the country, if you had a battery radio you was doing pretty good. Maybe one or two of them would have a radio on the place.

My mother had a boyfriend. In them bad days that he couldn't come, we sure enough caught hell. I was almost raised on hog meat; that's all we had. We'd raise pigs and kill the old ones. I believe it was one whole week he couldn't make it, my mom waited to eat that meat. She boiled porridge. That's what we had the whole week, corn and bread. Couldn't get out; the snow was too deep.

I remember another time it got real cold. What I'd scrapped up had about done run out. We went back across the field and broke the cotton up. Cut the stalk off and everything. Looked over and there was a possum. We went to the house and told mama. We didn't know what it was. She got the axe. We went back out and showed her. She got him by the tail and threw him down broke his neck. I wouldn't put my hand on that thing. I was scared of it. She carried him to the house. Cleaned the possum, cut that thing up and seasoned him. That was the best meat we ever had! From then I'd always be looking for a possum.

I never had to worry about nothing to eat when I got grown because I raised chickens and hogs. I had a vegetable garden. Mama had a garden when I growed up. I did what I saw her do. You had to, not too much you could get on your money. Then during the wintertime your money plum run out. Whoever stayed on the plantation and want to borrow money from the bossman, he gonna cut you short 'cause there's nothing to do 'til the weather breaks.

When mama got me a pair of new shoes to go to church or something, if they was too little, I'd be too scared to tell her. Scared she was gonna take 'em back and wouldn't get no more. Then you got one pair of work shoes a year. When they wore out you went barefoot 'cause you couldn't get no more 'til the next fall. If you was working in them old shoes, and the rubber sole on the bottom cut loose, you get a piece of baling wire and tie that up and wear them on out.

On Saturdays you had to work. If you didn't work too good, slacked down, you'd have to work 'til night. The ones from the country would go to town and buy what they wanted. If you were up there after twelve o'clock, they'd say, "N-----, where you *stay*?" "I stay on Mr. So-and-So's plantation." "Well get your ass down to Mr. So-and-So's. You ain't got no business hanging around town after twelve o'clock." The chief of police would say that. He'd run all the Black folks out of town. If you didn't leave or if they didn't know where you stayed, they're gonna put your ass in jail.

Eddie Cusic, Walnut Street Bait Shop, Greenville, Mississippi, June 1998

Here and everywhere else them years ago, little old cities like Leland, they was in on that. The Blacks better get out of town. That's why you didn't see blues musicians in the streets of Leland. Go back to the country where the Black people could stay up all night, have fun, gamble and do what they wanted. You got Saturday evening, all day Sunday. You can lay out there and drink that corn whiskey and get drunk. Wasn't nobody going to bother you with no jail.

There's a saying, "I keep you out of jail if you stay out of the ground." What they mean is, if they're sharecropping or something like that, you work two or three more acres of land. You get out there and do anything you want to, you wouldn't go to jail. That's what made them guys so bad, I reckon. You stay on them different peoples place and they're good hands. You tell 'em, well if you stay out of the grave, I'll keep you out of jail. Them fools that's what they had in their mind, I guess.

We stayed on Smythe Deadening Plantation.[5] Every Saturday night my mama used to give jukes at the house. What they used to do was work all week in the fields. They'd go to town and get what they need. Go back to the country and juke in their houses. You lived in a shotgun house. You put everything in the back room, get the front room clear. They'd gamble, drink whiskey. When they gambled at the house it was cards and dice. Mama

she'd buy whiskey from the people who peddled whiskey and sell it at her party.

I always kinda stay up and be watching. Folks would be playing them guitars. There was no electric then. Sounded so good I said, I'm gonna learn me to play a guitar if I live. When they put the guitar down, sometime I think some of them got drunk and went home. Sunday I'd pick up the guitar. They would let me fool with it. My mama said, "Don't bother that boy. One day he might be something."

Bumblebee and another guy, Frank Nash, they'd play them acoustic guitars. They played the real blues. Don't nobody know them. They've been dead so long. Frank and Bumblebee played together sometimes. But mostly they played by themselves, just like I do now. Bumblebee and Frank worked on plantations. Frank lived on Bourbon Plantation and he'd come up to the country where the people gave the jukes. Bumblebee stayed down back of us, across the field, in a shotgun house. He used to give a few parties himself. Mama and them would go back down when he'd give one. I liked their blues, kind of like Delta blues, country blues. That's what I learned from the old folks years ago.

I was always trying to play music when I was little. I always tried to make a sound on something. Must have been born in me, I guess. I used to get a plow-point and hang it up on a piece of wire just to hear it. That sounded pretty good. I put a wire up on the side of the wall. That sounded good. Then I got a little old guitar with catgut strings on it. That *didn't* sound too good. So when they used to get them brooms with those big knobs and a silver wire on there, I got me a piece off of that. That sounded pretty good.

I've seen Sonny Boy Williamson—Rice Miller. He was the best harp player there ever was as far I was concerned. I heard him at one of them jukes on Woodburn Plantation, in the country out from Leland.[6] He used to cut his voice short and stomp his foot. His one foot so big and out of shape we called him "Goosefoot Miller." He'd be stomping on the wood floor, really kicking up dust.

Whenever I went to town, like Inverness, I'd hear records on a Seeburg. They was playing real blues then—"My Baby Gone She Won't Be Back No More."[7] When you sing blues, it's always something about the woman.

I'd be picking cotton, plowing the mules, and I'd be singing the blues. That helped solve problems. You don't know if you'll get to the other side of the field. You sing, it pacifies your mind. You go further than you think. I'd sing "Baby Please Don't Go," the older blues. People would tell my mama, "That brown boy gonna be something!"

I ordered me a guitar from a Sears Roebuck catalogue when I got older. It was a Gene Autry guitar. They mailed it to me. Mama said, "What are you meeting the mailman for?" She found out I got a guitar. She said, "I don't want you playing no blues." I'd play straight-out blues.

I didn't really learn from records. If you had a record or two, the old wind-up Gramophone, half the time it wouldn't play. The needle was broken. There were only about two or three blues songs at home. That's all you know. I bought music books. I couldn't read no music book or nothing like that. I threw them books away. A lot of music I learned from my own self. I played by ear, making my own sounds. That's how I started. You'd sit on the porch, the wind blowing across there, playing a guitar. Just glad to get out from behind that mule and cottonsack.

I started to stray from home, and mama got scared. "If he leaves home I got nobody to help me." She needed me to pick that cotton. I started looking out for myself. They wouldn't know where I was at. I'd be around Indianola. That's where I met B.B. King before he got started. He was a rookie just like me. We never played together. I was just out there trying to learn how to play. He was playing by himself on Church Street for tips. If I didn't play I'd be around the musicians. Everybody I hear, I try to learn something from. But I always rhyme it my own ways.

I just wanted to play music. A lot of it I made up. I was playing by myself at country stores and country jukes to get tips. I started playing house parties on the Kinloch Plantation. Then I played at house parties, going from house to house on plantations outside of Leland out there on Sunflower River. I'd travel all down south and on back out to the river and all around this section here. I'd leave home after the work week and be home to catch that mule on Monday. When it was time to work you couldn't be nowhere else. You had to be on time.

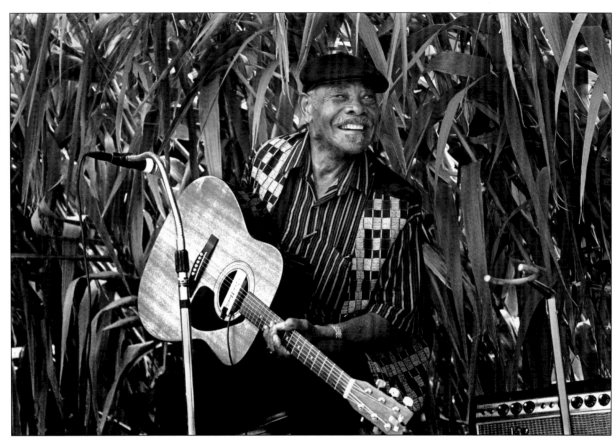

Eddie Cusic, Sunflower River Blues and Gospel Festival, Clarksdale, Mississippi, August 1998

I played about five or six years on my own. I reckon I was twenty-something when I got me a little band called the Rhythm Aces. James McGary and R. C. Johnson played guitar and Roosevelt Miles was the drummer. We played mostly jukes around here. I used to play for Ruby Edwards before I went in the army. I played the Rum Boogie too.[8] We didn't go too many places. There wasn't no money. We played about two or three years before I got drafted.

Little Milton [*James Milton Campbell Jr., 1934–2005*] was staying out there in the country, on Knox Lake, right on the edge of Leland on Dean Hebron's place [*Cunningham Plantation*]. He worked in the cotton fields. I was living on the other side of the lake, on the edge of town, on Fratesi's Plantation.[9] Little Milton used to come 'round to my house with cutoff boots on. He knew I could play guitar, and said he sure wanted to learn. I'd take and place his fingers on the frets and show him how to make chords. I taught him how to tune the guitar and play. Little Milton learned fast. He got good enough to play in my band. He said he used to sing in the choir in church. His voice was beautiful, now. When I found out he was good, I sing and then I let him sing a while.[10]

I knowed Elmore James. Elmore used to play around Leland and Greenville years ago. Sometimes me and the Rhythm Aces played juke joints outside Jackson, McComb, and Canton.[11] We used to go

EDDIE CUSIC 179

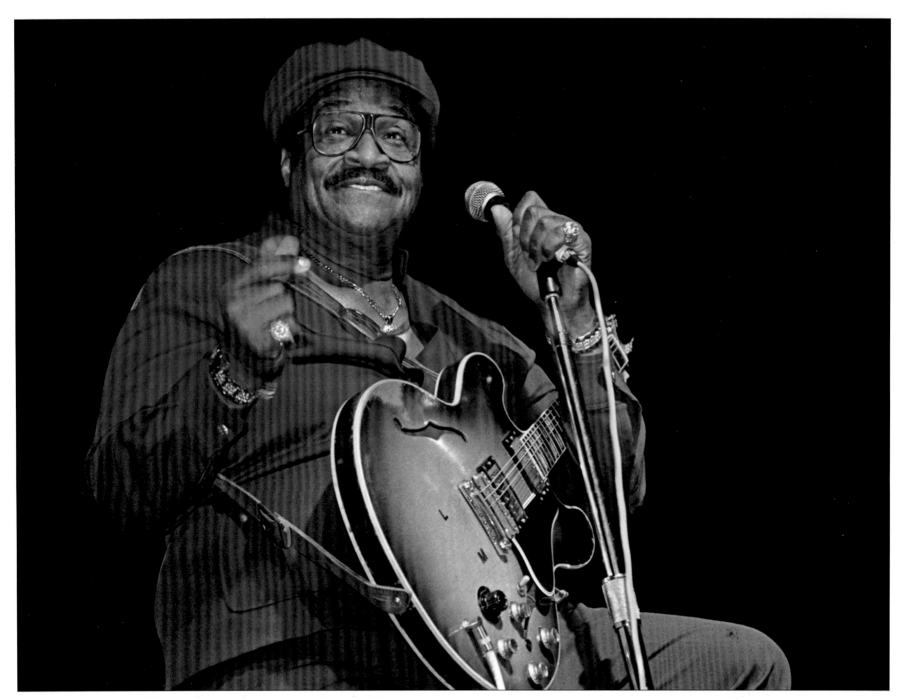

"Little Milton" Campbell, Mississippi Delta Blues & Heritage Festival, Greenville, Mississippi, September 1999

to a place not far from where he stayed.[12] He used to come down and play with us.

With the band, we'd get out and ride looking for gigs in the country juke joints. People would find out we could play, and they'd come to hear us. Sometimes we'd stay a week. Sometimes we played out there in the country in a big old house; there'd be so many people, the damn floor be shakin'.

I was drafted in the army in 1952. That split me and Little Milton up. He wasn't drafted. He went on up the road. I was stationed in California. I was discharged from the army in 1954. I came home to Leland and started working. When I got out of the service I said I wasn't gonna play no more; I wasn't making enough money to take care of myself.

Leland was in a bloom in the 1950s and '60s. If you kinda be late coming to town there'd be so many people up and down those streets. You had to be out walking in the middle of the road where the cars was at. Leland had lots of dry goods stores, grocery stores, and cafés. You didn't have to go to Greenville if you didn't want to. There were a bunch of honky-tonks—Chick's Inn, the Rum Boogie, Ruby's Nite Spot, McKnight's [*aka the Hole in the Wall Club*]. They had Seeburgs inside. You could listen to records by Muddy Waters, Howlin' Wolf, Elmore James.

All the blues musicians I know come from the Delta. Why? I guess it's because we had such a hard time. Leland was a Black community. Race was bad here. Whites had their own places. There were restaurants Blacks couldn't go to. If you gonna try and see someone, you had to go around to the back. They ain't gonna sell no n----- Coca-Cola. You wasn't good enough for it. You're Black.

Jimmy "Duck" Holmes remembered his parents encountered the same discrimination when they ran the Blue Front Café in Bentonia: "At one time the people who sold Coca-Cola wouldn't even sell the product to my parents. Instead, they sold fruit-flavored pop. You wouldn't order Coca-Cola if you was African American; it was a no-no. When you look at it now, it was rough. You didn't expect nothing. That's just the way it was around here. It let up in the mid- to late fifties."[13]

They wouldn't sell you no cigarettes already rolled, a pack of cigarettes, either. You had to be a good worker on the plantation before you could get some. If you want to buy a can of Prince Albert, you better say, "I want a can of *Mister* Prince Albert tobacco."

Out in the country there would be nothing but Black around there. You went to the doctor, there'd be a white side and a Black side. I don't give a damn how sick you was, he gonna wait on them whites before he get to you. You could die if you want, that's true. You'd go somewhere and they'd have a fountain, but there ain't no Black folks allowed to drink out of that fountain.

If a white woman come down the road or something, you better not even pass. You go around the other way. We used to call, "Young man, yonder comes Miss Lynch." They gonna find the nearest tree they can to hang you if they catch you trying to like their ladies, flirt. Flirt means trying to court. Baby, that's prejudice, to treat a Black person like they ain't human.

I ain't never seen no one lynched. But people just before me they used to show me some places where they used to hang people here in Leland years ago.[14] Guy's dead who told me about it. Said he was about twelve years old. "Mama, I'm going to the hanging," he said. Mama told him, "You *ain't* going!" He said he slipped out anyhow. He showed me the tree where they used to hang the Blacks.

When I got old enough to understand, one human being was just as good as another the way I see it. I'm about eighty-seven years old. It's much different now than when I was coming up. I was treated like I wasn't a person in them days. In the old days they catch you interviewing me in my house they find the nearest tree and hang my ass up in it! Now me and you, you're human like me. That's the way we see it now.

I got the Rhythm Aces back together. In the late 1950s and '60s we played jukes around Leland and Greenville. We had a regular gig at the Tin Top, a club between Arcola and Wayside. We played Ruby's on Wednesday nights, Saturday and Sunday nights sometimes when them big bands wasn't in there. Elmore James, a lot of them played at Ruby's years ago. Ruby's Night Spot was the most popular place around here.[15]

In the jukes they'd shoot you in a minute. Someone might throw something in the juke, shoot a gun and the lights go out. You'd have to get the hell out. It got so rough one night in the country, an old juke, the house lady chopped through the door and cut a man in the head with an axe. He came out running and hollering like I don't know what. I couldn't run. The house was tall and had long steps up there. I just fell down the steps and rolled under the house. While I was under there he was running so fast you could see the cigarette lighting up going across that cotton field.

I played at Rexburg with my band. It was about five or six miles from Leland. There was a big country juke out there. They had gambling. They'd get to fighting and sometimes they'd pull out shotguns and shoot. Lucinda had sense to get out of the way; she'd hide under a table. I'd be looking for her: "Where are you, Cindy?" Once I found Cindy we'd get away from there.

Lucinda Cusic remembered: "Rexburg was the place everyone go to. Hundreds of people would show up. What I remember is there'd be so many cars it would look like a funeral. People would come from everywhere. I was dancing my heels off my shoes. Another place Eddie and I used to go is the Bogue, before Rexburg. They'd play ball games during the daytime. At night they'd have jukes. Eddie and them would play the guitar."

People used to get killed out there. Rexburg was so rough, when the police come out they had to lock your hands to the pole. That was the jailhouse 'til they carry you to the big jail.[16]

Son Thomas [*James "Son" Thomas, 1926–1993*] was staying out in the hills in Bentonia.[17] His mama stayed in Leland. His uncle, Joe Cooper, was already here. Son used to dig graves. He came up to his mama and said he'd like someone to play with—"But I don't want to play with nobody who raise sin." His mama told him, "Find Eddie Cusic." So me and him got together. Son Thomas used to play like Elmore James, slide music. Son would sing and I'd sing. We played at Ruby's, the Rum Boogie and different places out from Leland. We played together a couple of years.

Eddie's association with Son Thomas continued for many years, playing together from local juke houses around Leland in the 1960s to the National Mall in Washington, DC, for the American Folklife Festival in 1974.[18] *In the late 1970s they made field recordings together for Italian and German labels.*[19] *They remained friends until the end of Son Thomas's life. Eddie played a birthday concert for him at the Delta Blues Museum in 1992, a few months before Son died.*

I started my family. I couldn't make nothing out of music. I went to Stoneville around 1966. I worked out there as a mechanic for the state for twenty-five years.[20] A lot of people tried to get me to play. You couldn't make enough money from playing to do anything. I had to have a steady job to raise my children and help my wife and family.[21] I'd go to a festival; I went to the Greenville Festival a lot of times, but I felt I needed a job.

Son Thomas had chances to go to these different places.[22] He tried to get me to go. I said, "Hell no." I was scared to take a chance 'cause I wasn't making no money before. I was still working at Stoneville. They used to come out there from Washington, DC, and try to get me to go. My boss man told me, "Well you can go sometime. You've got leave time, you could take off." I didn't want to trust that.[23]

When Son Thomas got sick,[24] he said, "What you gonna do? Are you gonna play anymore?" I said, "I don't think I am." He said, "If I was you, I wouldn't quit playing. I've been overseas and they've got all your records playing up and down the street—my records with him made before he left here. He said, "If I were you I wouldn't throw my talent away like that. I would play some more. There's people out there can't play a third as good as you and get rich."

So, after I retired in '91, I said, "Well, now I could go where I want to go." I got to thinking what Son told me. I went to Washington, DC, and toured the White House. I've been to a lot of places, ever since. I just came back from Portland, Oregon. I'm nationwide and didn't go no higher than tenth grade. That's pretty good, ain't it? I made a name for myself, my own self.

These days I play at festivals around the Delta.[25]

"Drink Coca-Cola," Doddsville, Mississippi, October 2003

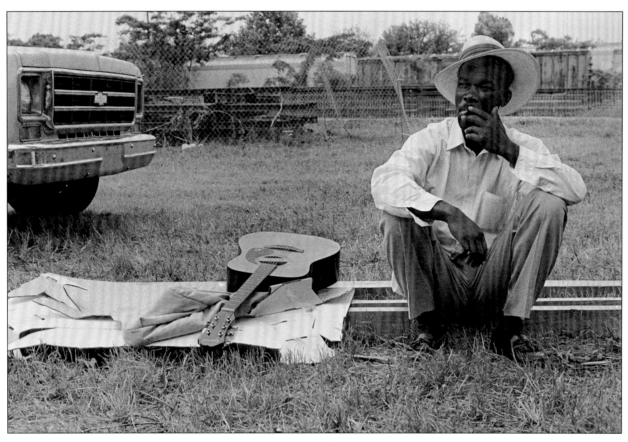

Pat Thomas (son of James "Son" Thomas), Highway 61 Blues Festival, Leland, Mississippi, June 2003

*Until he was nearly seventy-two, Eddie's body of recorded work consisted of only three tracks on three different compilation albums issued in Europe. Only in December 1997 did he record an entire album under his own name—*I Want to Boogie *(HighTone, 1998). Blues writer Cub Koda hailed it as "Pure back-porch country blues . . . a strong debut that also makes the first new 'blues discovery' since the halcyon days of the 1960s."*[26]

They say the blues is nothing but a good man feeling bad. You and your old lady separate, quit, that's the blues. After a while the dog's rolling his eyes at you, hell, that's the blues. He's gone. After a while the damn cat be gone. Anything that goes wrong is the blues.

Blues is like I come up—*hard*. Things just ain't right. Blues is just like you want to pay your bills or you owe somebody and want to pay 'em, you can't get the money. Anything that you know you need to do, look like you can't do nothing about it—that's the blues. I reckon if I went to school I wouldn't know what I know now. If I had education I might have gone some other way. I found out I could do better than when I was raised. I have to say I'm brilliant myself compared to the way I come up and from where I came from and raised without a father. The Lord spared me. I'm kind of enjoying myself now. Living better than I ever lived in my life.

Eddie Cusic died in Greenville on August 11, 2015.

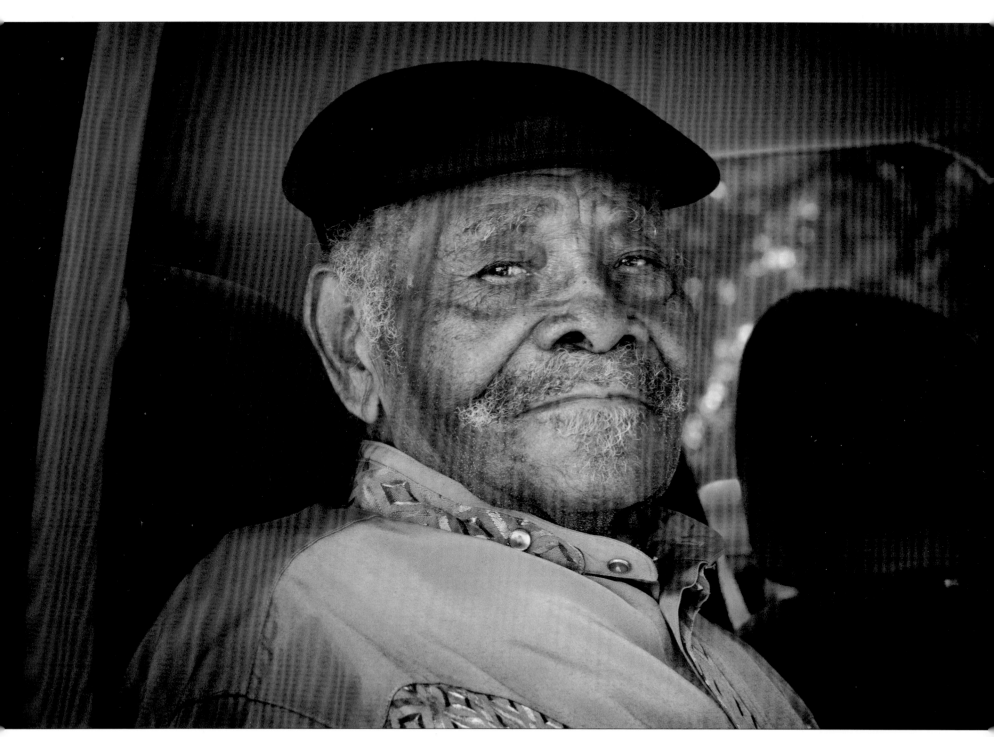

Eddie Cusic, Greenville, Mississippi, October 2014

"Farmer John" (John Horton Jr.)

Holly Ridge is where I was born at, May 6, 1932. When we moved down here [*Swiftwater, just outside Greenville*], I was ten years old, 1942. They bought the land while we was still farming up there. My daddy used to lease land from a white man, Mr. Ed Holmes. He owned the Holly Ridge store and a big old plantation about three miles south of Holly Ridge. My daddy sharecropped. He cleared up land and they let him work it so many years free, then he would rent it from him. To clear the land you use a hoe, axe, Kaiser blade—that's a long-handled blade to cut weeds and stuff. Swing it back and forth.

My daddy mostly worked for himself. But he was working somebody else's land. He asked some white friends to help him buy this land. He was about near white as them. My dad had seventy-two acres of land. It ain't nothing if you're trying to make a living. You have to farm a lot of ground to make a living from it. Insects and stuff got so bad. It was supposed to be eighty acres but eight acres was in the levee. When it rained I had to ride a mule out there, water get so high I'd have to stand up on the mule.

My mama would feed us and pay the bills out of her garden. She made more cash than Daddy would out at the farm. My mama used to tell this is where I get all this from, fooling with a garden, raising greens. Mama had everything out there—beets, peas, butterbeans, okra, tomatoes, spinach, all kinds of greens. Go to town we'd sell it—come to Leland one day and Indianola the other. They told me she had a mule and buggy. The old mule knew the way home; Mama would sit up in the buggy and go to sleep and the mule would bring her home. He'd pull up in the yard and stop.

How did I get the nickname "Farmer John"? Farming, raising cotton at the time. You could stop by any cotton field and pick some cotton and make fifteen or twenty dollars. I used to pick four hundred pounds of cotton. They'd see me going to the gin. Know I like to gamble. They set a trap for me. "They gambling down there. Better come on down, man." They start calling me "Farmer John." They say, "I saw Farmer John going to the gin again!" Go to the gin and sell the cotton off. Then you go to the honky-tonk where they gamble at. Gonna win some more!—and wind up losing it. I come off broke plenty of times. Have to go back to the field and pick another bale. That's how I got the nickname "Farmer John."

I went and bought me a little guitar so I could slip up and learn. I was about eighteen, nineteen. Couldn't play shit. I liked the way Eddie Cusic and James McGary played. Eddie sings with a feeling and plays with it. He's got a deep voice and sounds like he's down by them woods when he sings. James—man, that guy would *bend* them strings. Make it do what he wanted. He had a pick on all his fingers. He could play with all five of them fingers. He had picks with a clamp on them. He had them on a ring, something metal. He could tighten them up and they wouldn't fling off. He could *whip* a guitar. We called him "Big Hand James." He could really juke.

They were playing the hard, low-down blues. James played lead guitar, but he played bass all the time unless he played by himself.

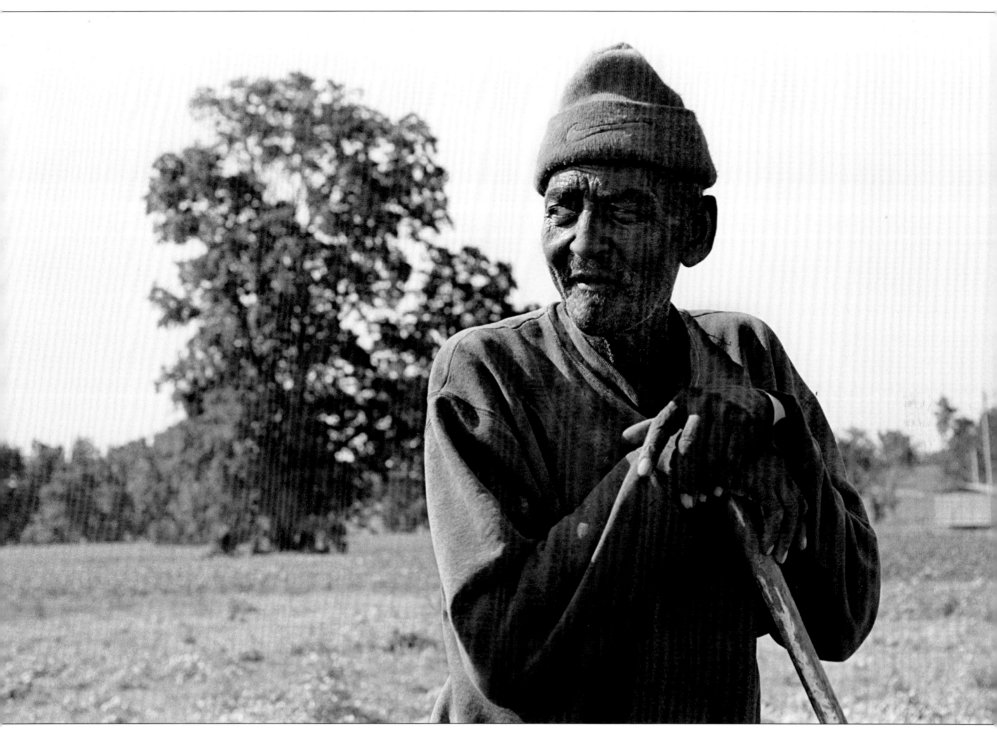

"Farmer John" Horton, Swiftwater, Mississippi, June 2006

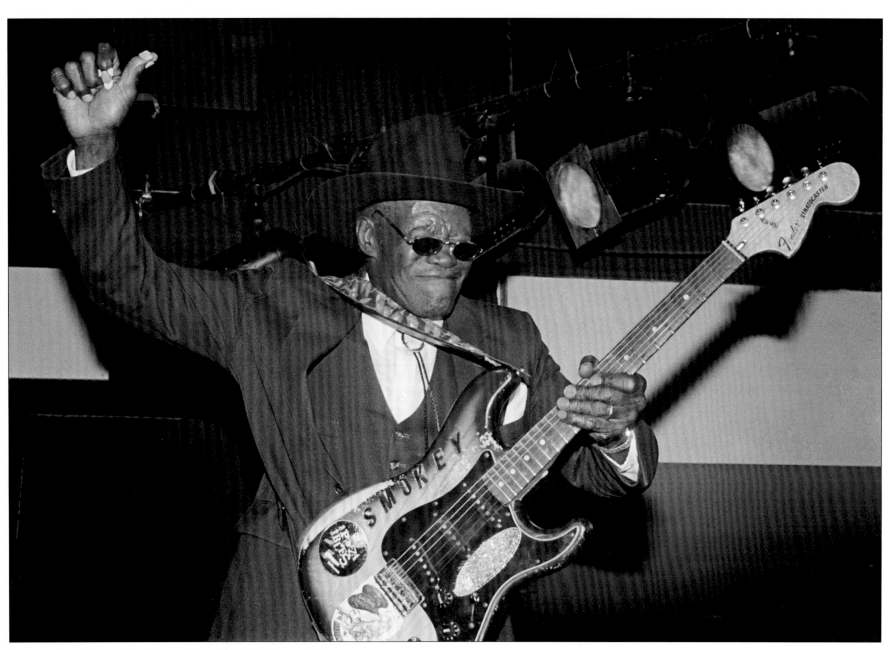

Smokey Wilson, Harpers Ferry, Boston, Massachusetts, February 1999

Eddie would play the whole guitar. They played Muddy Waters, B.B. King, Louis Jordan. James was the first one who tuned my guitar and showed me how to do some songs. I learned to play slide watching him. He liked the slide better than the finger. The piece of iron they put on—my old friends called it a five-eight socket [*a ⅝-inch socket wrench*].

I was playing the blues every night. We would hang at the Monkey Store. [*"The Monkey Store was on 454 (Washington County)," said Farmer John's son, John Horton. "They had a cage of monkeys out there. That's where my old man and 'em used to do their thing when they were young. They shot dice, hung out. The Monkey Store was a happy spot."*][1] Eugene Powell would be there. I would watch Eddie Cusic on stage. My mom said, "you're playing the blues. Get your ass out of here."

I used to go to Red Ruby's Lounge in Leland with a truckload of boys every night it opened. Remember when B.B. King put out that record "Sweet Sixteen"? B.B. was playing at his wife's mama's place, that was *her*—"Sweetest thing you'd ever seen." Ruby was real light-skinned and tall, a good-looking woman. She had a big club in Leland. It used to be packed two or three times a week. [*"In the mid-1950s Ruby Edwards took over the Club Ebony in Indianola, where her daughter Sue met her husband-to-be, B.B. King."*]

I remember Eddie, Little Milton, Lonnie Holmes, Lil' Bill, and Smokey Wilson playing there. Lil' Bill could sing like a bird. Little Milton and Lonnie always backed him up on bass. Eddie learned Little Milton how to tune the guitar and play. Little Milton learned Smokey Wilson.[2] I met Smokey in the fifties. He had one leg amputated almost to the knee but he could out-dance anyone. He could dance his ass off. He could spin around, do the Hucklebuck, jitterbug just as good as anyone else. His playing was tremendous. Milton let him sit in and take it through the break.

Ooh man, they used to juke at Leroy Grayson's. Leroy Grayson's go seven days a week around the clock. You could get anything you want there from a foot race to a funeral. Leroy owned land in the resettlement—a whole lot of Black people lived there. Somebody played every night. Sometimes they would have two bands in a night. That's where Eddie and James started playing at. Little Milton and Charley Booker came there. Then you had the boys from out of town like Muddy Waters, Elmore James, Howlin' Wolf, John Lee Hooker, all of them used to meet up there and have a good time. LeRoy had a liquor store out there in the yard. There was gambling twenty-four hours. They had a little room on the outside for gambling. We used to go over there and box every Sunday evening. The boxing ring was in front of the juke. All the young boys would meet up and show our strength over one another. Leroy Grayson got it going day and night. He had been open since around '47. People came from far and near—four, five hundred a night. Cars parked all up and down the road. People stealing. Wasn't much killing, just a few got killed. Mostly stealing—tires and batteries. He was shut down in 1970.

I was working on the bulldozers. And I was good with the bulldozer. I could run it blindfolded. I used to travel with nothing but white men. We were clearing land and building highways. We'd go into little towns, all white, where I couldn't be seen. They wanted to get some beer. I'd lay down in the car and stay hid. They would come back and forth and bring me beer.

I used to have people down here on Sunday afternoons 'til a fellow started calling the sheriff. He complained we were selling beer; there was too much noise. We were on my property. We'd get together; everybody that plays if they didn't have nothing to do that Sunday—Lil' Dave [*Thompson*] be comin', Otis [*Taylor*], Eddie Green, Willie Foster, he came down. Frank Frost came down. Wasn't doing nothing but having a good time. Whites *and* Blacks.

I just wanted to learn for myself, play to enjoy myself or if some friends came around the house. A few times I'd sit in with the boys and play a number. Mostly they liked me on to play "Wang Dang Doodle." I used to play it the old-fashioned way, make the guitar sing. I can play in two or three different tunes. Mostly with a slide. Most guitar players played in C-natural. Some of them old players couldn't play in natural, they played in "Cross Spanish."

Fat Possum wanted me. I cut a CD for them in 1998—*Wrongdoers Respect Me* [*CD credited to "Johnny Farmer"*].

Farmer John died in Greenville on April 29, 2018.

John Horton

I was born October 8, 1959. My father ["Farmer John"] was John Horton, Jr. I'm John Horton the Third. I heard my daddy playing music growing up. He had an acoustic guitar. He played the old "Catfish Blues," some of that old Muddy Waters stuff, and some Jimmy Reed songs. He would play the slide on his fingers, which I can't do today. It would just amaze me.

He's the one who taught me to tune and play chords. Tuning, that's the number one thing he taught me. Back in them days wasn't no tuning. You just did it by ear.

When I was a teenager T-Model Ford started coming around. He used to come over to the house. He and my father pull their guitars out. Boy, they'd sit down, hit the old git. That's another saying for guitar. You talking about some fun. The old man playing the slide, T-Model take the other part of the music, the bass line or whatever. The old man put on that slide and go. I remember them playing "Put on your hi-heel sneakers"—that was one of my favorites.

T-Model plays the old style, and you can sit back and really see where it all started at. The music we play today has the same timing and changes. T-Model's style of playing, he changes when he wants to. That's why when I play with T-Model I watch him, but I don't listen to him. When he gets ready to move his hand, I move mine. It takes me way back to what they call the front porch blues. Front porch is that old style. We just call it the raw blues.

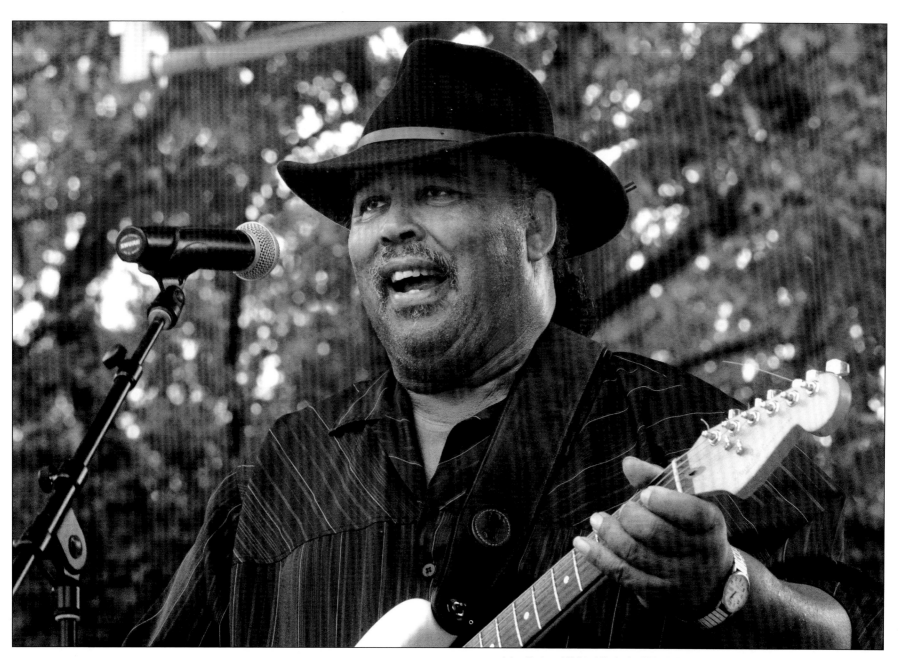

John Horton, Mighty Mississippi Music Festival, Greenville, Mississippi, October 2018

Mary Shepard · Club Ebony

My Aunt Sadie raised me from two years old. My mother had died and then my daddy had gotten killed. When Sadie's husband passed, she asked me to come home and see after her. I said to my husband, "Let's go home and take care of her." He said, "Okay." He was ready because his parents were here, too. We was in North Carolina at the base. My husband was in a wheelchair. He had got hurt in Vietnam. We called the army and told them we wanted to move. We sold our house; the army sent someone out to move us, and we came back to Indianola.

My husband said, "The club [Club Ebony] is for sale. Do you want to take it?" I said, "I'll take it for you because I know you'll want to shoot pool and be around other fellows."

When Johnny Jones built the club it was called the Jones Place. He had another place downtown on Church Street [Jones Night Spot]. B.B. King told me he first played here in 1945. Johnny had Fats Domino, Ike and Tina Turner, Wilson Pickett played here. I know because I found some posters when he called it the Jones Place. Then it went from the Jones Place to the Ebony Club. It was a blues club. I think when Miss Ruby Edwards bought it, she changed it to Club Ebony.

We opened in 1974. I let the Club Ebony name stay. [*Mary first leased the club from then-owner Ruby Edwards and purchased it outright in January 1974.*] I called B.B. when I opened and asked him if he would play for me, but he was booked. Little Milton was open the date I wanted, and he was the first one to play for me. When he got here we ended up having a nice crowd. I gave him his money and took the rest and bought more beer. Some of the other musicians I brought here were B.B. King, Albert King, Bobby Bland, Tyrone Davis, the Impressions, the Staple Singers, and Bobby Rush.

I talked to B.B. about the Homecoming. [*B.B. King Homecoming Festival, Indianola, Mississippi*]. I said, "It's very important to us. Would you come back home?" He said yes. The Homecoming started with donations [*in 1980*]. B.B. always said he wanted to do something where the money would go back to the parks and city to do things for the children. After the Homecoming concert, he would play Club Ebony.

There have been good times and hard times running the club—but I pray a lot. My success has been from the Man Above. What's it been like as a club owner? I enjoyed it. I loved it. I never had any problems as a woman. I try to treat everyone right. My slogan was, "It's nice to be important and it's important to be nice." [*After Mary retired in 2008, B.B. King bought Club Ebony and donated it to the B.B. King Museum and Delta Interpretive Center in Indianola.*]

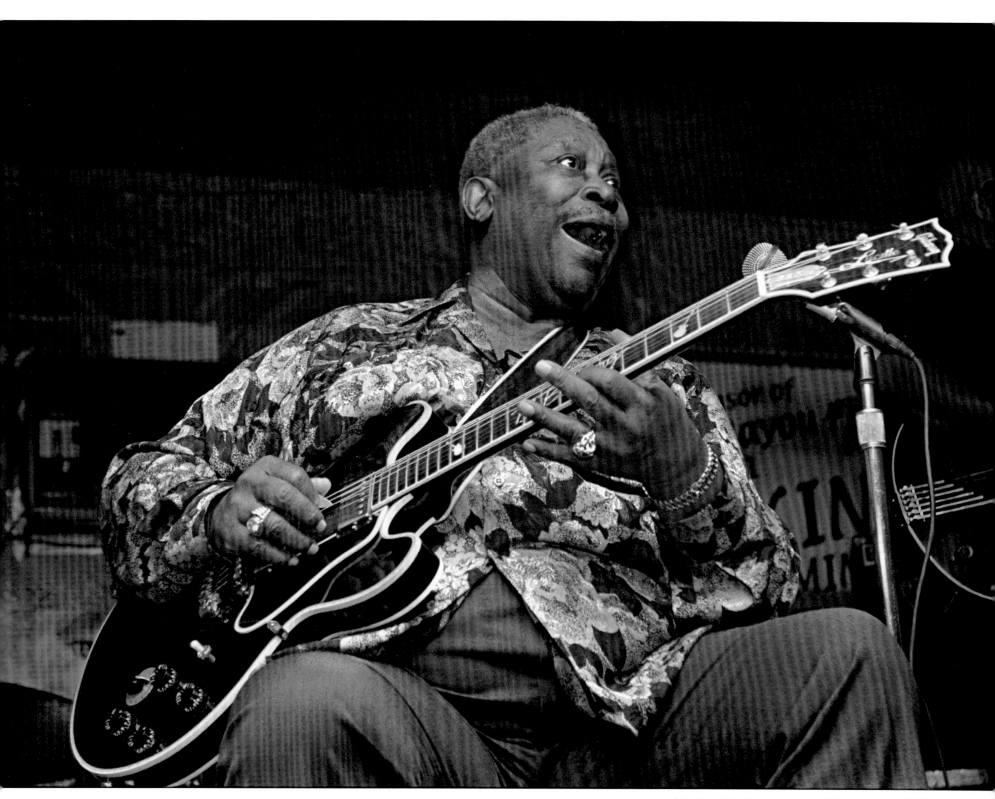

B.B. King, Club Ebony, Indianola, Mississippi, June 2001

Eden Brent

I don't remember exactly when I met [*Alex*] Lil' Bill Wallace,[1] but I know I performed with him at the casinos and some of the bars here in Greenville and at private parties around the Delta. We started playing together around 1995 or so.

Bill enjoyed the sound of an organ behind him, but the organ is quite different than piano. Lil' Bill would often tell me to "Hold that chord!" But I had no experience playing organ. "Boogaloo" [*Abie "Boogaloo" Ames*] taught me how to play the piano, which is more of a percussive instrument. It's impossible to sustain a note or chord on piano; organ technique utilizes more held notes and much less motion. It took probably a few years and listening to my rather awkward organ accompaniment behind Lil' Bill, but finally I understood what he meant and learned to "hold that chord!" I credit Boogaloo with teaching me how to play piano, but it was Lil' Bill Wallace who taught me how to play organ behind a lead guitar blues man.

Over the years, Lil' Bill and I played together and hung out together. We played at local festivals and clubs, casinos and private parties. We played at the Las Vegas Casino, the Mississippi Delta Blues & Heritage Festival, Walnut Street Blues Bar, and One Block East nightclub here in Greenville; the Highway 61 Blues Festival in Leland and countless private gigs including wedding receptions and parties all over the Delta. We drank at the bars. Bill drank Chivas straight. We often went to breakfast in the middle of the night after the bars had closed. We used to stop at the Truck Stop just outside of Greenville on the way to Leland. He lived at 111 Beale Street in Leland, which I always got a kick out of.

He had a fairly debilitating stroke in his later years, and Lil' Bill was unable to talk anymore really, except to say, "Shit" or "Goddam" or "Eden" out of frustration that he couldn't really make his mouth make the words he was saying. In his last couple of years he lived in a nursing home, and I used to pick him up there. I would take him out to the Walnut Street Blues Bar, and then take him back to the nursing home after.

When B.B. King would come to Indianola for his annual Homecoming, I took Lil' Bill over there and to Mississippi Valley State University to visit with B.B. They were contemporaries when they were young, in the late forties I think. One night at Club Ebony, Bill was sitting with B.B. in the backroom while he signed autographs. That room is lost to the remodel and expansion, but it was in that room, with B.B. sitting on the bed and Bill in a chair nearby, that B.B. made mention of Bill's advice to young Riley King way back when. Lil' Bill told B.B., "Riley, you ain't never going to make any money playing gospel, you got to play the blues." Lil' Bill said that when Riley left for Memphis he called him to tell him that he was going, and he asked Lil' Bill if he wanted to go with him. By that time, Lil' Bill had his wife Sarah, and he couldn't go. He had responsibilities. That was the trip that turned Riley into the Beale

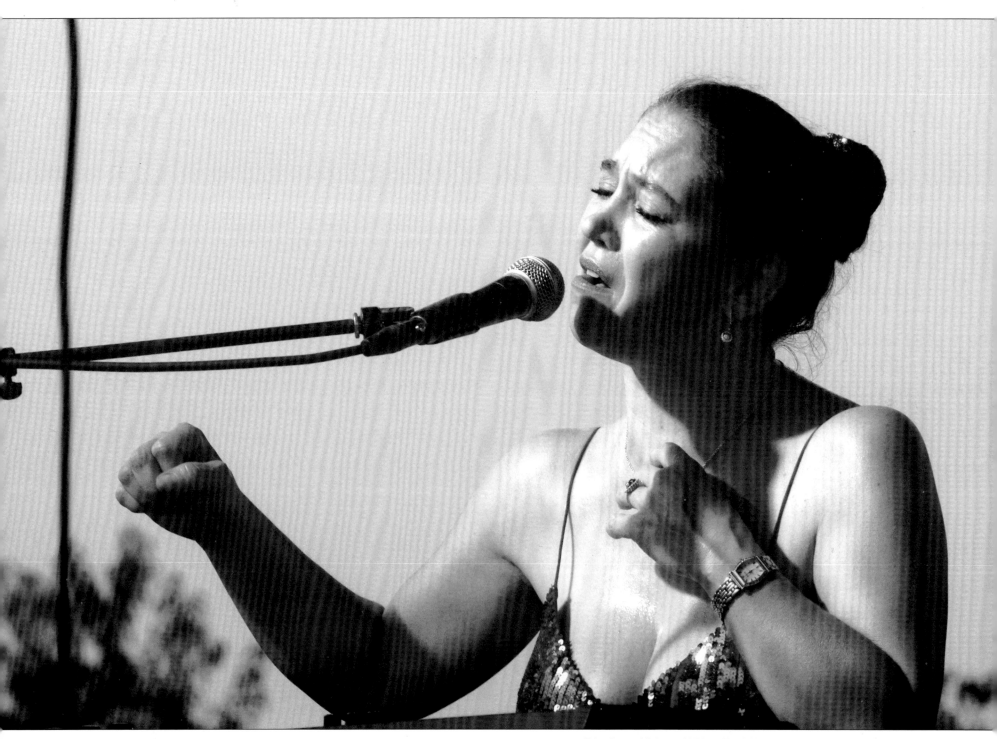

Eden Brent, Highway 61 Blues Festival, Leland, Mississippi, September 2012

Street Blues Boy, B.B. King. I've seen B.B. hand Bill a wad of money in Club Ebony at another homecoming occasion. B.B. was a very generous man. In his later years, I drove Lil' Bill to see B.B. King at these events, just so they could hang out and visit. I didn't hear much of what they discussed because I gave them space to chat without me joining. But I could clearly see a mutual affection, a true lifelong friendship. B.B. and Bill were only a year apart in age.

Bill was great at performing the blues, a real master. He had a very strong, expressive voice and performed lots of single-note lead blues guitar in a style similar to B.B. But Bill played chords too. I was told that he was one of the first guitarists in the Delta who played electric guitar. Bill was an inspiration to many others like Little Milton Campbell. Bill knew everybody. All of the famous bluesmen who came home to play the Mississippi festivals knew Lil' Bill and would be happy to see him.

Lil' Bill drove a truck over the road for many years before I knew him, and he could tell me how many miles and hours the trip would take, and the very best route for any two points on a map. He had an incredible memory.

Bill also could sense the fire between myself and a fella I eventually had an affair with during my first marriage. Bill saw us in a bar across the room from each other, and came over to me and said, "Baby, you're fucking up." He was right, I was. But some mistakes you just have to learn the hard way. Bill's intuition and good advice provided the inspiration for the song "Everybody Already Knows."

At the spur of the moment, I played the piano at Lil' Bill's funeral in 2008. There were no musicians or choir. One of the coordinators of the funeral came over and asked if I would play and I agreed to do it. I got up from my seat in the congregation and walked over to the piano in a panic because I couldn't think of anything but raunchy blues! I finally thought of a few tunes like "Precious Lord" and "People Get Ready" and "Amazing Grace." Bill was a very strong man and he loved me lots. I loved him lots too.

Left: Eden Brent and Lil' Bill Wallace,
Highway 61 Blues Festival, Leland,
Mississippi, June 2005

"Mississippi Slim" (Walter Horn Jr.)

I was born August 13, 1943, in Shelby, Mississippi, on a plantation out on Highway 32 in Bolivar County. My mother's name was Lula Mae Martin. My dad's name was Walter Horn, same as mine—I'm a junior.[1] His parents were sharecroppers. We lived with them 'til I was about eight years old.

My dad was a sharecropper and tractor driver. My mom used to help dad pick and chop the crops. Back then they picked cotton by hand. We raised our own food.

They start you carrying water real early then. The grown-ups would be in the field chopping cotton. The kids would have to take them water to the field.

About eight months a year they let the little children go to school. The school was a church house. It was only for Blacks. One teacher taught everybody from first to twelfth grade.

My dad just left us. My mom's grandmother was living in Greenville. That's how we got here. My great grandmother's name was Lula Love. She was a sweet old lady. She was glad to have us stay with her. Mom got a job at the King's Daughters Hospital in Greenville. That one was for whites. She was a cook in the kitchen. Mound Bayou was an all-Black town. When the Black folks got really sick here and needed a hospital that's where they would go.

The first house we had was on Arnold Avenue. This end of Arnold was where all the Black folks lived. That end of Arnold was where all the white people lived. It was like the railroad tracks—the Blacks lived on this side of the track, and the whites lived on that side. So if you was a stranger in town, looking for the Black people, you cross the tracks.

I remember when the town was really segregated. I remember the signs. If you wanted to go to the bathroom, say like if you went to that gas station over there, one bathroom would say "Colored" and the other one would say "White." And if you wanted some water, one fountain would say "Colored" and one would say "White." If you went to a restaurant, they wouldn't serve you in the restaurant. You could go to the back door and order a sandwich. They'd serve it to you, but you better eat it out there. You couldn't come in and sit down and eat.

We'd get on the bus to go to Clarksdale, you couldn't sit in the front of the bus. If you were Black, you sit in the back. I never had to do it, but if there were more whites on the bus that day than Blacks, and you were sitting down on the seat, a lot of times they would ask you to get up and let the white person sit down and you stand up. I remember all of that real good.

My mother was working and trying to raise three kids by herself. I started shining shoes at a white barbershop up on Washington Avenue. I was like twelve, thirteen. I'd shine shoes after school and on the weekend. That's how we'd make our tips. I'd go and give my mom money. I felt like I needed to help her out.

There was a white supper club; I'd wash dishes there. The guy would bring me home when I got off at night. Once I started going to high school there was a place on Highway 82 called Beuhler's.[2]

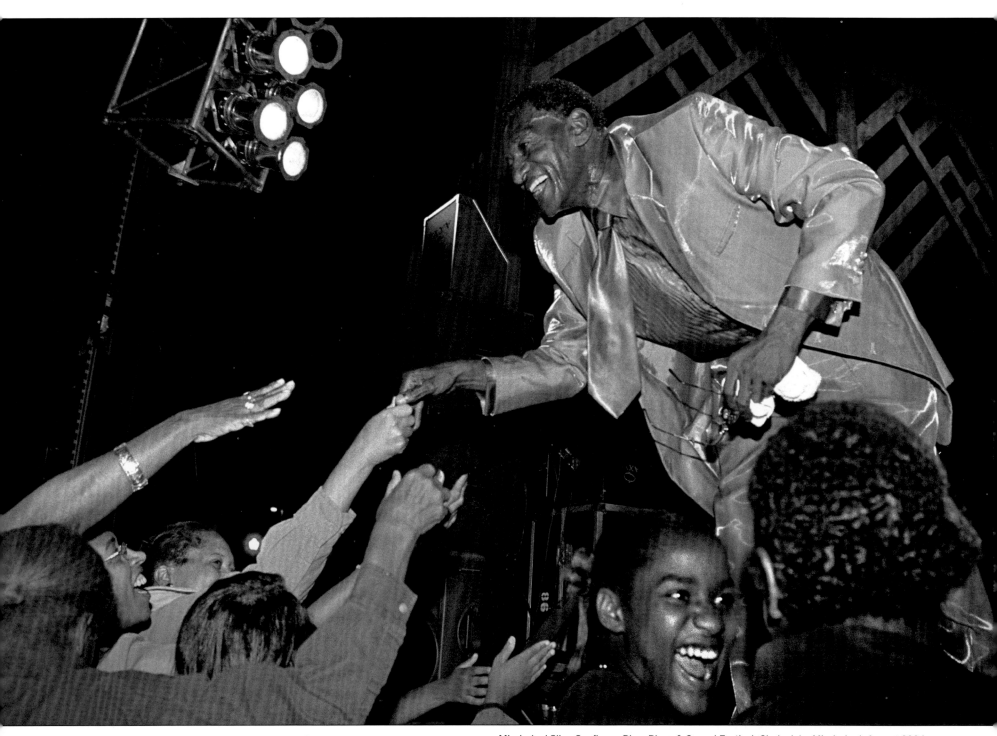

Mississippi Slim, Sunflower River Blues & Gospel Festival, Clarksdale, Mississippi, August 2004

Mississippi Slim, Holly Ridge, Mississippi, June 2005

It was like a Sonic's where you serve people in the cars. They used to hire the Black kids in the evening to serve.

The employers treated you good if you know how to mind your own business. You knew you was Black, so you kinda know your place. It would depend on your attitude how you was treated. They had you in a box. The salary wasn't that great but the tips were great. Sometimes I'd come home with sixteen, seventeen dollars in my pocket.

You never really got a chance to mingle and play with the white kids like teenagers usually do. They were working too. You'd see them at their parents' place of business. When they closed their stores, they'd go on across the tracks.

To be honest you wasn't really asking any questions. It was a thing you knew. You followed the old people. Your parents would tell you, you just had to wait for the change to come. And the change did finally come. In the 1960s we had leaders like Martin Luther King come along.

Even though we had community leaders from the beginning, they always went along with the status quo for the jobs and everything. You know, a lot of things *have* changed. You know things have changed when you got a Black president.

There was a church on almost every corner of Greenville. When we was getting religion, in other words, when you was giving yourself to God, you go there. You get on the mourning bench they call it. When you get religion, a lot of kids would shout. I didn't understand it then. That's all it was—you accepting Jesus Christ as your savior. You didn't have to shout. But people back then, they did it. Because the older folks would say if you didn't feel it, then you really didn't have it. I understood it after I grew up.

There was always a piano player in the church. People just got up and sing. We used to sing mostly a cappella. I started singing in the church when I was about ten. I'd sing by myself. I've always had a voice. So it wasn't so much like I was brave and do it, they'd volunteer me to do it. Somebody heard my voice and said "Wow, you got a great voice!" That's how I got started.

I used to sing "This Little Light of Mine" and "Amazing Grace." Then the deacon would get up in church, and he'd moan, "I know the Lord hear me cry!" It was just moaning. I could feel what they were feeling. They had the feeling in their voices.

I was about thirteen when we formed a group. We'd get in the alleys; we'd sing in the street corners on the north end of Greenville. We'd spend hours singing on the streets, almost every day. People come by and listen. Frankie Lymon and the Teenagers were big then. You'd see them in the movies.[3] The Platters, Chuck Berry, Little Richard, Fats Domino, La Vern Baker, and Lloyd Price were all popular.

A lot of people had harmonicas. If you was gonna blow harmonica, you had to blow mostly blues because nobody could blow with the Platters. There was another group that was very popular; they used to sing "Silhouettes in the Shade."[4] And the Drifters, everybody used to sing their song, "There Goes My Baby." When you hear groups like this sing that give you a lot of inspiration.[5]

I'd go out to the fields. You get on a bus, right on Nelson Street at five in the morning. I'd chop and pick cotton all day and make that three dollars. I'd sing in the fields, but they'd stop me. They'd say when I sing, I stop the people from working. "When you sing, that person over in that row, or that person over there, they're not really chopping cotton, they're listening to you sing. This is not what we're looking for here. I mean, you're stopping my workers!" That's why I started working places like Buehler's.

Where I really got to hear our music was on Nelson Street. Mom didn't want me to go, but I used to go up there. Nelson Street had clubs like Beale Street in Memphis, back to back. You could walk out of one right into another. You had little jukes and restaurants all the way down Nelson Street. The music you'd hear was blues. You could hear Jimmy Reed, Howlin' Wolf, Muddy Waters, Bobby Bland, and B.B. King on the Seeburgs. You had Ike Turner and Little Milton playing jukes and dives. I'd walk in front of the Flowing Fountain and places like that and they'd just be playing. I couldn't go in, I was too young; I just stood outside and listen. That's how I got introduced to that kind of music. Hearing them left a real good impression on me.

They started having talent shows. There was a place called Wright's Barbeque Pit on Nelson Street. I won the talent show one night. I was like eighteen [*1961*]. That started me really to singing.

There was four or five good blues bands in Greenville at that time. Eddie Shaw, Little Johnny Burton; Buddy Hicks was a great bass player. I used to sing with Eddie Shaw on Nelson Street in the early sixties. He was in Howlin' Wolf's band.

Mamie Galore [*Mamie Davis, 1940–2001*] was a great talent. All the good musicians got with her and played behind her. They showed her the ropes. She left with Ike and Tina Turner. She was one of the first Ikettes. Then she was doing shows with Little Milton. Then she was out on her own for a while.[6]

There was a place out in the country called Leroy Grayson's where everybody used to go.[7] There was another place out from Leland called Rexburg. Everybody used to go there, too. Sunday afternoons you could go out to the Playhouse on Arcola Road. You'd have to park at least a mile from the place. It was a little hole in the wall out in the middle of nowhere. Everybody played there.

We're in the sixties. Probably thirty or forty people—that was a full joint. Booba Barnes would play in Belzoni, Indianola, Sunflower, Lake Village. I'd follow him. Sometimes I'd travel with him. Booba was like a magnet. He'd draw people. There was just something about him.

You had a lot of great singers coming out of here.

[*And Mississippi Slim was one of them. He went to Chicago in 1968 and returned to the Delta in 1994. We had just gotten started on his oral history when Mississippi Slim died in Greenville, April 14, 2010.*]

John Horton, who often played with Slim during his last years, told me in 2016:

"*Mississippi Slim had been in Chicago for years, but he came back to Greenville and moved in with his mother. He came to One Block East, I believe. That's the first place I met him. I had a song list and he picked out a few songs. He started sitting in with my band. We did shows together. We had a blast. We'd get out there. Slim would have some kind of little old dance. He used to be clowning, pulling up his pants with mismatched socks. Man, me and him were cool. I would set it up for him and let him knock 'em down. I always started the show off, get it going—'All right, you all get ready for the mighty Mississippi Slim!'*

"*Of all the musicians that passed, Slim was the one that got stuck in my mind. I was working in Louisiana. We used to talk every night after I got off work. One night Slim called and said he was sweating like he was going to the electric chair. He had passed out at home. They thought he had a heart attack or something and called the paramedic. Slim told me the paramedic couldn't find nothing wrong. In the morning he was going to check himself into the hospital. I got the sad call the very next morning that Slim died. That was a sad day.*"[8]

Mississippi Slim and John Horton, Highway 61 Blues Festival, Leland, Mississippi, June 2005

Mickey Rogers, Panther Burn, Mississippi, October 2014

Mickey Rogers

I was born on December 17, 1944. My full name is Roosevelt Rogers Jr. Ever since I was little they called me Mickey. My mother had ten kids, five boys and five girls. I have an older sister, Jessica. We called her Teddi. I'm the oldest boy.

My mother was named Willeva, and my father's name was Roosevelt. I was born in Panther Burn, Mississippi. They call it a plantation town, but it's a village, outside Hollandale.

My father went into the army right after World War II. When he got out he went to Chicago, where his oldest sister, Luberta, and some of his peoples were living. He and my aunt brought me and my sister Mimi to Chicago. He was just getting situated. I was around two years old. Then he brought my mother and the other kids up about a year later. We lived on the West Side. My mother was a lot of fun. She worked all the time, washing the clothes in the tub with a board. She was a churchgoer.

Auntie 'Berta brought me down to Mississippi when I was five or six to visit my grandparents, John and Annabelle Rogers. I started school in a one-room building out in the country before I came back to Chicago. The dust was so deep in the road, our feet used to be sucking in the sand. School was for the Black children. There was one big room divided into different sections according to your grade. Later they turned the school into a church.

I was about ten years old when my mother's father died. His name was Kineas Dennis, and his wife's name was Lucille. They were sharecroppers on Baker's Plantation, next to Panther Burn. My mom took the kids down to Mississippi for the funeral. My grandmother asked her to stay. A few weeks later my grandmother, mother, aunties, and uncles and a whole bunch of cousins moved to the Bourbon Plantation out from Leland. My mother went to work on the Bourbon Plantation pickin' and choppin' cotton with my younger brothers and sisters.

I heard an old musician; his nickname was "Son," playing country blues around the Bourbon Plantation store. He'd let me touch his guitar. The sound caught my ear and got me interested in playing. I'd tack two sticks with baling wire on the side of the house or the big tree in the yard. I'd take a smaller stick and slide it under the wire to tighten it up and get different sounds. I'd be around there all day playing 'til they run me out. One day Son offered to sell me a guitar for two dollars. I picked pecans and killed a rabbit to earn the money to buy that guitar.

I used to come down to Mississippi every year after school got out. They'd put me on the train by myself. Emmett Till was in class with my older cousin, Roy, in Chicago. Emmett was three years older than me, and he had gone to Mississippi to visit his family in the summer of 1955. I was there that same summer, visiting my mother and grandmother, when Emmett got killed. [*Glendora, Mississippi, where Emmett Till's body was discovered, is only forty-eight miles from where the Rogers family lived.*]

My mother and grandmother told me how prejudice went down. They said Emmett whistled at a white lady. I asked, "Why did they kill him?"

They said, "That's what they killed him for."

"Just for whistling?—you can kill somebody for *that*?"

My grandmother looked like she didn't want to tell me too much. My mother said, "You can't associate with the white girl like you can the Black."

"I can talk to them, can't I?"

"Not down here. The best thing you can do is keep your mouth shut."

They didn't let me stay after Emmett got killed. They sent me and Mimi right on back to Chicago. I told my auntie, "I ain't never in my life going back there no more." People were upset in Chicago. Everybody talked about that racist thing. The grown-ups said, "Ain't nothing you can do or we can do about that."

I went to Mississippi a few years later. I missed my peoples. One thing about visiting Mississippi, I loved hearing the music. I was beginning to learn music in Chicago, and I started sneaking into the clubs around Leland with an uncle and some cousins. I was going to places like Ruby's Nite Spot. Ruby's was a jumping place. All the singers and musicians showed up there. I was really too young to be in the joints, but back then, age didn't matter too much. We'd slip in there, and they wouldn't bother us. I'd be sittin' on the floor watching Eddie Cusic and Little Milton. Son Thomas played guitar by hisself all the time.

I met Tyrone Davis [1937–2005] while I was visiting. Tyrone and his family worked on the Wilmot Plantation, just a few miles from where my peoples was at. We would talk about the music. Tyrone told me he wanted to be a singer like Bobby Bland and Little Milton.

I went back to Chicago before school started. Then I experienced something else the next summer: prejudice. I had just come back to Mississippi. My cousins had gone to school. My school was out, and I didn't want to go to school with them. When I got up I walked to the store.

My grandmother worked for a white family doing their cooking and cleaning. They had a grocery store in the front of their house. A couple of old guys were around. I gets up there and spoke to them and my grandmother. In the afternoon the school bus for the white children dropped them off.

A girl named Barbara Ann and her sisters got off the bus. She was around my age [*about fifteen*], maybe a year younger. She dropped one of her books. I walked out there and said, "Let me help you." We started talking and went to the store. We sat on a bench and talked. Then, we started walking.

Her father came out of the store, calling her name. He was *screaming*. We turned around. He come racing down there, and he was fussin'. Then he struck her! He slapped her in the face! She was trying to explain to him.

Her mother came out. She tried explaining to her mother. Her mother said, "That's all right." Her dad went back in fussin'. I was just lookin', wonderin', "Wow, what *is* all this?" My grandmother came out and said, "Come on, Mickey, get in the car." She still wasn't telling me nothing. I said, "What's wrong?" She said, "You ought to know better." What did I do? She said, "We're gonna take you back to the train station."

When we got home I said, "Mama, what's wrong?" My mother put the clothes in the bags. I was a little upset and mad. My mom was crying. Her mother had the control. I said, "I'm never coming back, Mama."

Mama said, "You see what happened to your friend, Emmett. You was talking to her. You knew what they was going to do to you."

I talked to Tyrone. I told him my grandmother said I had to go back to Chicago the next evening. Tyrone said he had been saving his money and was ready to go and try his luck. We agreed to meet at the train station in Leland. My mother and grandmother took me to the train. Tyrone was already there. We sat together on the train and talked until we fell sleep. Tyrone's relatives met him in Chicago.

Over the years I'd say to Mama, "Why don't you just leave and come back to Chicago?" I didn't think my mom should be picking and chopping cotton. I knew what it was like working on the plantation. Mama was set in her ways. She didn't like the city.

Mickey Rogers, outside the Cotton House, near Bourbon Plantation, Washington County, Mississippi, October 2014

I spent most of my growing up in Chicago. My aunt, Luberta Branch, mostly raised me. Auntie was loving and good with kids. She was a seamstress and lived at 1533 South St. Louis Avenue on the West Side. She had us go to a Baptist church and put us in all kinds of events at the church. Just about all the Baptist churches had a piano, so auntie bought one. Auntie's brother, my uncle Robert Rogers, showed me how to play chords on the piano. I started playing a little bit for the church when I was about thirteen. I sang in the choir for about three years.

I heard plenty of records at auntie's. She had rock 'n' roll records we could listen to when she wasn't around—Little Richard, Bobby Darin, Chuck Berry, Fats Domino, and Elvis Presley.

I used to stay with my uncle Robert a lot. He lived just a few blocks from us. He was a DJ at radio station WVON [*Voice of the Negro*].[1] They played mostly Black music, especially blues, rhythm and blues, and gospel. He was hired as a DJ for cabarets and record hops. He had a big record collection—a whole bunch of blues, rhythm and blues, and rock. I could learn what the musicians were doing when I listened to the records.

My friend Robert Lee Price and I used to be together all the time, playing and singing. I was playing keyboard, but I didn't like staying in one spot. So I started fooling with my uncle's bass guitar. He taught me how to play the bass notes. I could dance with the guitar.

My uncle bought me a bass guitar and put me in school three nights a week. Jimmy Guyan and Jackie Bates's parents put them in the same school. Jimmy played bass, and Jackie played guitar. They started to rehearse with us. My uncle coached us. He called us the Shades because we wore dark shades, day and night.

At that time my uncle lived on Avers Avenue on the West Side, and Howlin' Wolf didn't stay far from him. They knew each other. Howlin' Wolf and Hubert Sumlin would be practicing at my uncle's. I'd be sitting there listening to Hubert, thinking, "I'm gonna be like *that*!" He wasn't just playing chords; he was playing licks and notes. That's what I wanted to learn.

Hubert started showing me how to play from the time I met him. By then I could easily play what my uncle could play. The bass guitar was just four strings. Hubert was teaching me on the guitar while I played the bass. Hubert just had to tell me what notes he wanted me to play, and I would play them. Then Hubert started showing me lead guitar. He said, "Your fingers are playing so fast you need to play lead." Hubert was the number one musician who left an impression on me. By fourteen I could play everything on the bass that Howlin' Wolf was singing. Wolf told my uncle, "He'll be real good on the guitar. See how fast he learns. He pays a lot of attention."

I played five or six times with them at Silvio's. It was no problem sneaking me into the club. They had big, tall custom-made amps. I was short. If the police came in, Wolf would say, "Go behind that amp." I'd come out when they left.

I was deep off into the music. To hear Wolf howl and play the harmonica would send chills down my back. The audience'd scream and holler. Wolf would clown on the stage. He would kick up with his legs and get down on the floor with the harmonica, then come back up howlin'.

If Wolf and Hubert needed a bass player they would call me when they were in town or gonna go somewhere not too far from Chicago. I'd go to gigs where I could come back home because I was still in school.

Wolf's music was about the hard times in his coming up. You could hear that in his singing. You could tell that's blues there. Wolf would sing and Hubert knew exactly what to play to fit with what Howlin' Wolf was feeling because he could feel it, too. Together they was a powerhouse. That's what made them two so fantastic.

B.B. King had another one of the first blues sounds that I paid attention to. He let the guitar do the talking. I loved that because I could understand what the guitar was saying without him singing. He would sing a verse or two, then let his guitar sing a verse or two.

My dad and uncle knew B.B. because they were from Mississippi, down in his area. I was fourteen or fifteen when I talked to him the first time in Chicago. It was at the Regal Theater.[2] B.B. showed me some licks and let me feel his guitar. He told me, "Learn all you can. Never quit. Musicians never learn it all. But one thing, find your own self. Don't try to be me or nobody else. Be you. Have

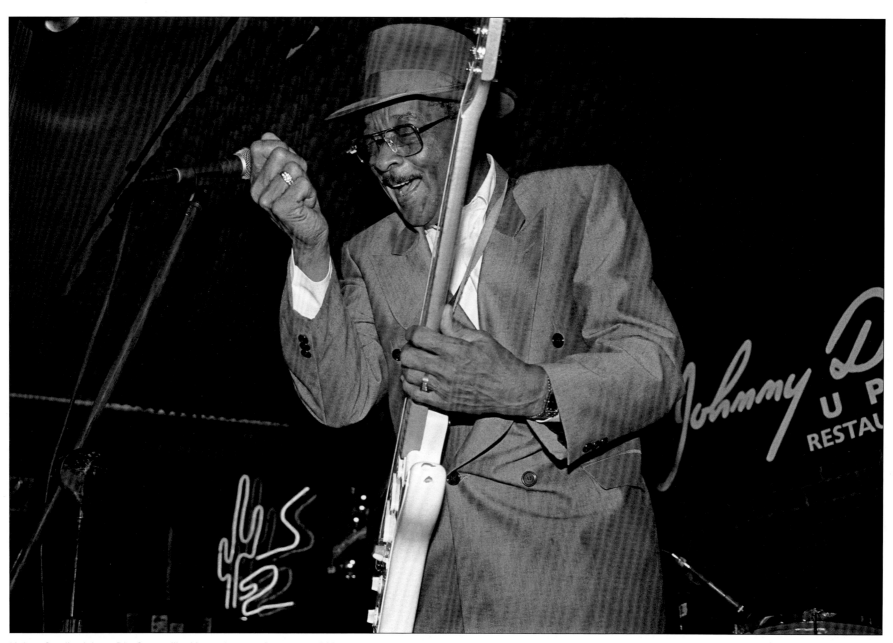

Hubert Sumlin, Johnny D's, Somerville, Massachusetts, December 1999

your own identity." In the future I would be the opening act for B.B. at his Homecoming festivals in Indianola [*2007–14*]. I'd get a chance to talk to him every time I saw him. He would tell me he was proud of me, the way I handled my guitar.

I was still playing with the Shades. We stayed together for years. Sometimes we'd split up to go with different bands. We played around Chicago and for friends' parties. There would be hardly no money in it. We just liked to play.

A good little singer and writer, Maurice MacAlister, wanted to start a group. He had his own songs written up. I was in my late teens when we formed a singing group called the Radiants. We met in high school. We was street corner singers. You know how it is at night? You just get on the streets and start to sing doo-wop. We be on the corner singing on the West Side, 15th Street and St. Louis Avenue or the Robert Taylor projects on the South Side where Maurice lived.[3] All over Chicago you would run into groups singing doo-wop, especially at night. Sometimes we would get tips.

Talent shows would pick up these groups. The shows would be in theatres in Chicago. The Regal Theater on 47th Street and South Parkway had something big going on every other week or so. If you got there, you were the top of the line. That's where all the big entertainers came.

I did talent shows with the Shades and the Radiants once or twice a month. Sometimes we competed at talent shows in Gary, Indiana. You might win money or get a little record deal. That's how the Radiants got our record deal, after we won a competition. We had a forty-five called "Shy Guy" [*Chess, 1963*]. It sold pretty good around Chicago. [*Winners of competitions at the Regal Theater were also rewarded with opening act slots for major performers like B.B. King and Etta James.*][4]

I was out on Maxwell Street during this time, styling clothes. I worked for two clothing stores—Johnny Walker's and Smokey Joe's. I'd style three or four suits a day and sell watches on the street. I'd have about ten or fifteen watches all the way up my arm. Anytime they had a new style of clothes or suit come in, I'd be the first to wear it. I'd step out at eight o'clock in the morning and put a suit on. People would ask, "How much do the suits run?" I'd tell them the price and get them to step inside. I owned something like twenty-one tuxedos, all in different colors.

Chicago was real big on music. Musicians were meeting one another at schools, in the neighborhood, the talent shows, and the clubs. On the West Side there was a big building at Garfield Park—"the Dome"—where bands could practice. Mayor Daley set it up so that young musicians had a place to rehearse.

I met the Chi-Lites at the Dome. They were practicing and I was with the Shades in a room next door. Eugene [*Record*] heard me and liked my style. He asked if I would do some shows with them. They needed a guitar player. I started to fool around with the group when I was in high school. They weren't big yet. Later on they became one of the best groups in Chicago. I played on and off with them over the years.

I started working with Tyrone. We came to Greenville and played at the VFW, anywhere he could get a gig. Before that I had refused to come back to Mississippi because of what happened. Once we were down here we would stay for a week or two to visit family. At night I was going to places like Ruby's, the Rum Boogie, and Club Ebony to see what was going on. I started to appreciate Mississippi on this trip because of the music.

I started coming back more often to see my peoples. Sometimes I played with Eddie Shaw. In the early 1960s Eddie would bring me with him to play gigs in Mississippi. We played at Ruby's and other juke joints out in the country.

Then I started getting my own gigs at Ruby's, the Rum Boogie, and out in Rexburg. One time, later in my teens, I played with my band, the Shades, at Ruby's. I gave a local DJ, "Rockin' Eddie" Williams, a forty-five by Robert Tenard, a singer out of Chicago. Eddie set us up for a couple of shows in Greenville and Leland. The Shades played behind Robert.

Ruby's was more like a club, and the Rum Boogie was a plain juke house. Every weekend Ruby's would be packed. It would be so crowded you couldn't get no seat. They'd take out the little tables and put them in a corner. Ruby's had a band stage; at the

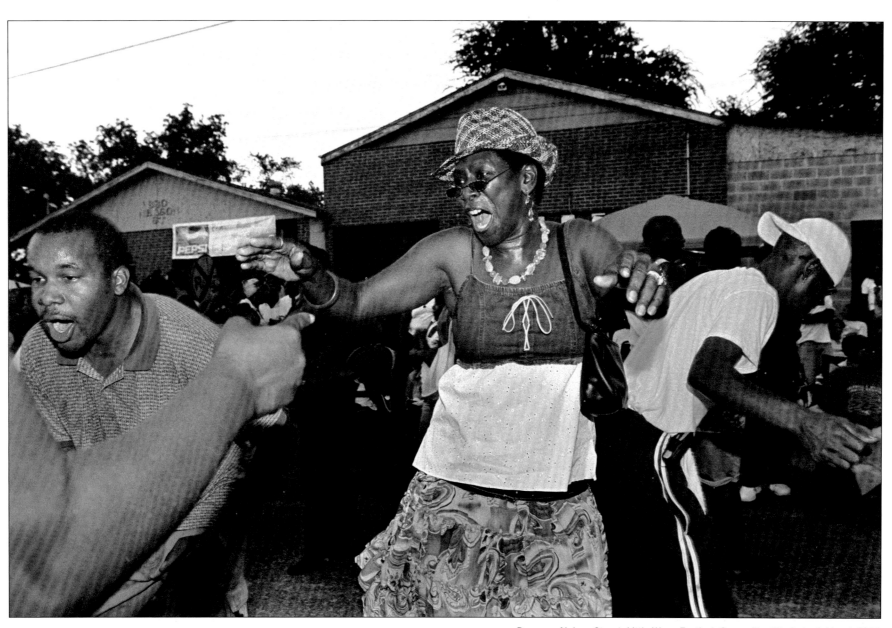

Dancers, Nelson Street, Little Wynn Festival, Greenville, Mississippi, March 2000

Mickey Rogers, Greenville, Mississippi, April 2013

Rum Boogie they'd play mostly in the corner. Honeyboy Edwards, Smokey Wilson, Little Bill Wallace, and Elmore James played there.

I used to see Ike and Tina playing at Ruby's, Club Ebony, and the Elks. Tina was a sight to see. Ike and Tina came to Chicago to perform, and they needed some dancers to go on tour with them. They had people come down to Big Bill Hill's to try out [*Copa Cabana Club, West Roosevelt Road and South Homan Avenue*].[5] Tina started singing and making her moves. Me and my cousin Rose were good dancers. We were right there with her. Tina said, "I want *them*." We toured for four or five weeks around Detroit, St. Louis, Kansas City, and Cleveland.

By this time I was playing with everybody. I met Jimi Hendrix on a show in Detroit in the sixties. He was with the Isley Brothers. [*Hendrix was part of the Isley Brothers' band in 1964–65.*] We sat in the dressing room and exchanged some licks on the guitar. I wasn't used to using the foot pedal the way Jimi was doing, making the wah-wah sound. Jimi's licks was rooted in the blues, but the way he played took it up to another level. You could call it rock or blues, acid rock. If you listen to the direction he was playing, it was still based on the blues.

I had work with other musicians in Chicago. Otis Clay, Tyrone Davis, and the Chi-Lites would always call me to come play with

them. Otis and Tyrone had steady gigs every weekend. I performed with Otis Clay for many years. He was one of my idols. Otis came from gospel music and is a soulful singer. I loved playing behind him because of the feeling he embraced. His singing will reach you. [*Otis Clay: "Mickey's a musician's musician, a road warrior who can organize a band, hold it together, and get the job done."*][6]

My dad moved to Detroit. He was working for Ford Motor Company. I came to visit. My sister Teddi was singing for Motown. Her stage name was Rhonda. She sang with the Marvelettes, backing up Motown headliners like Marvin Gaye and Jimmy Ruffin.

I knew Marvin from Chicago.[7] We'd hang out and shoot pool. I toured with him and Tammy Terrell. I also went on tour with the Temptations down South and through the Midwest. In Detroit I worked with the Funk Brothers, the Pips, and was part of a back-up band, with the Elgins, at the 20 Grand Club [*a famous venue at 14th Street and West Warren Avenue in the Woodbridge section*]. All the big Motown artists played there when they were home. I also started to arrange songs for Martha Reeves.

I was in Detroit about eight to ten years, but I was always back and forth between Chicago and Detroit, depending on who had work. In my late thirties I moved back to Chicago. I got day jobs but never stopped playing my music. Before the sun go down I was always somewhere playing. When people needed me I'd put some session lines down. Any time Hubert and Wolf were in the area, Hubert would call, "Hey boy. Can you come over there with us?" If I wasn't playing with anyone I'd go with them.

I played on and off with Tyrone for about sixteen or seventeen years. His songs told a story—always about someone's life. People could easily relate to his lyrics. I played lead guitar on his recording of "Can I Change My Mind." The A side of the forty-five was "A Woman Need to be Loved." They played that for two or three days. and didn't get no response. Then a DJ accidentally played the B-side. "Can I Change My Mind" started playing. Overnight it became a hit. The next day the neighborhood was singing it. Tyrone's music had a drive. I still perform Tyrone's songs when I play today because it's part of me. Tyrone and I came together to create that sound.

I met Bobby Rush in Chicago at Walton's Corner on the West Side. Back in the day, my Uncle Robert brought me there to check him out. One night I sat in with Bobby and his band for one or two songs. Then I didn't see him no more 'til I moved back to Mississippi. We were booked on the same festival in Greenville.

Bobby was the headliner and asked me to play with him. At the end of the show Bobby asked me to play another gig with him. I went on back to Jackson with Bobby—he had a studio deal and he hired me to be the bandleader. He's the biggest drawing card down here. [*Bobby Rush: "Mickey's one of the sweetest people I know. He played in my band off and on for eighteen years. He's a fine guitar player and overdue for recognition. He can really groove."*][8]

When I came back to Mississippi in the eighties, you could still play in Greenville. Nelson Street had clubs like the Flowing Fountain, the Playboy Club, and the High Five, and all them was open and jumping. You could hear blues all the time—Willie Foster, Boogaloo Ames, Bill Wallace, Booba Barnes, John Horton, Mississippi Slim, Eden Brent, John Price, and Eddie Cusic were playing. I made a CD, *Are You Serious*, in Greenville. The casinos changed this area, killed the clubs. In the nineties Brad and Brenda Jordan opened the Walnut Street Bait Shop; it's the one place where blues is still happening.

I was also playing with Willie Foster during these years. He asked me to help him, and I went overseas with Willie three times. I was his opening act. I did two CDs with him.[9] Willie respected me, but he was a mean old joker. He'd get on someone's case if they weren't playing like he wanted.

Willie could "cross over" on the harmonica—if he had an A harmonica he could play it in B. You seldom find that. He could take one harmonica and play five or six different keys with it.

It didn't bother Willie at all when he had to have his first leg cut off [*1994*]. They cut it off above the ankle. Then, they had to cut it to the knee. He said, "Just take it off!" as if it wasn't anything. He was operated on a Monday evening. We had a festival to do that Friday. I said I would take care of it. "What time the show gonna be?" he said. "You pick me up. I got to make the festival. I'm going!"

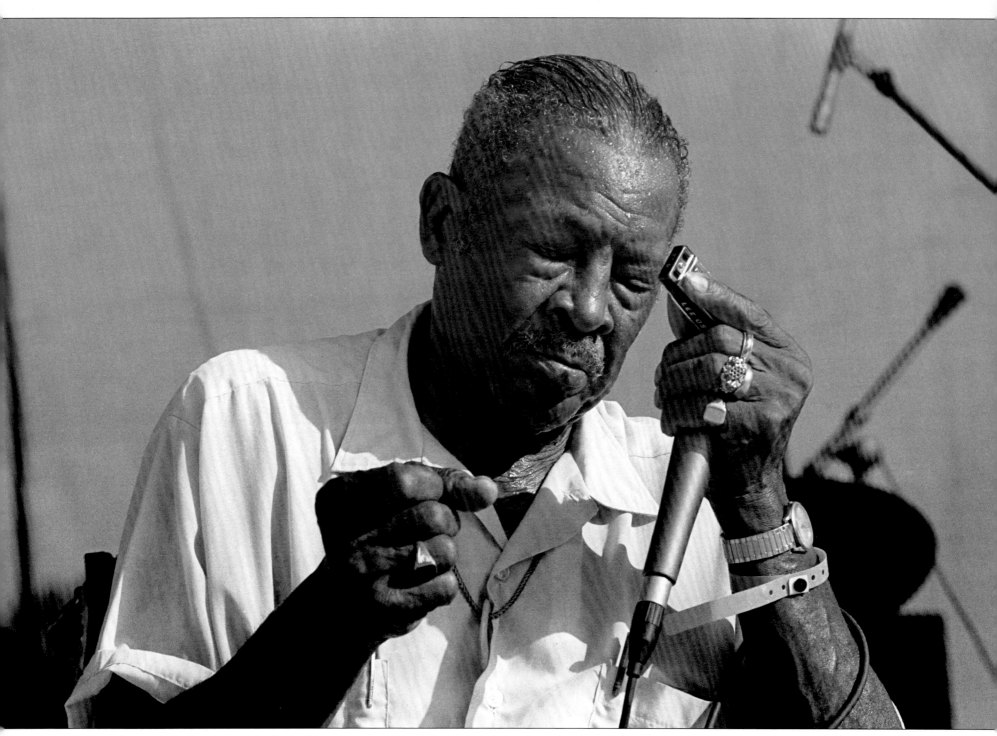
Willie Foster, Sunflower River Blues and Gospel Festival, Clarksdale, Mississippi, August 1998

I pulled up. He was sitting in the wheelchair, looking at me, grinning. He put on the best show. He was something else.

They got him another leg to put on there. Foster put that leg on. "I ain't got no time to let a leg be slowing me down. That's what they made these extra legs for."

Then he got sick. The same thing. They cut the other leg. It was like it wasn't bothering him. You talking about a die-hard. Doctor checked him out. "We gonna have to cut another piece of that leg off." I stood there and looked at Foster. It was hurting me to see it. "Well, just cut it off even with the other one," he said.

About three or four months after he had that one amputated we went to Amsterdam, just me and him. We played at the 1999 Kwadendamme Blues Festival, and then we went over to Germany and played two gigs. We drove to Belgium. We went there for ten days and ended up staying twenty-one days. Back by popular demand. Look like Willie got stronger after the amputation. He loved to be out there and entertain. Tired? He'd say, "I'm tired of this *wheelchair*."

We had a gig the same day we flew back to the US. They met us in Memphis with a limousine to bring us to Rosedale, Mississippi. We played in Rosedale. Then we had to go to Indianola and do a gig. We left there and went on to Jackson, Tennessee, for a doctors' association event in the evening.

We came back to the motel. It was just beginning to get dark. Willie went to his room and I went to mine. He had no complaints. I found him dead in his room. I dialed 911, but I knew he was gone. [*Willie had a heart attack in his sleep, May 20, 2001.*]

After he died I proceeded to take the band and keep on playing. I knew that's what he wanted me to do. I'm still playing. I call my band Mickey Rogers and the Soul Blues Band.

The blues come from Mississippi—out of hard labor. Work all day long from sunup to sundown and you ain't got a dollar when the day's over. You ain't made nothing but make yourself tired. By the time you lay down and take a nap you got to get up and get tired again. End of the year, you still ain't made nothing. If you look at the real side, you ain't did nothing for yourself but survived. It's a blessing to be survived. So we couldn't do nothing but sing the blues. Those things that happened in Mississippi don't bother me anymore. And the people who did them in the past no longer exist. Time changes. Mississippi isn't anything like it was forty or fifty years ago.

Part III
BEYOND THE DELTA

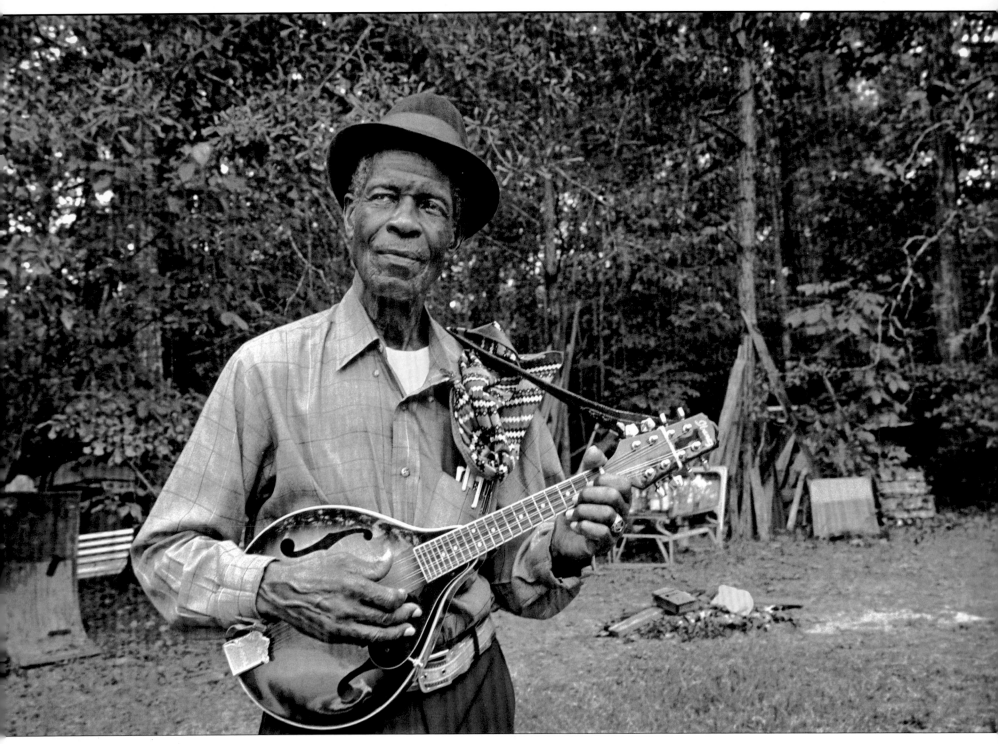

L. C. Ulmer, Ellisville, Mississippi, October 2008

L. C. Ulmer

My mama called me "L. C." from the day I was born 'til she passed away. All my family, that's what they called me.[1] Back in them days a midwife visit you when you have a kid. God give the midwife that name and she give it to my mama.

"L" stands for one of the greatest things in the world—Love—ain't nothing no greater. "C!"—Stands for one of the greatest names there ever been on earth—and it's still with us today—*Christ*, God's son. It stands for "*Call* me, call on your God" and "*Carry*"—that's the "C" yet—"Carry all your troubles to the Lord and leave them there."[2]

I was born August the 28th, 1928, in Stringer, Mississippi, fifteen miles from Laurel.[3] Wasn't none of them plantations down here; they was in the Delta. Here you just sharecrop with different people.

My granddaddy Ulmer didn't sharecrop; he had his own land.[4] My granddaddy farmed by hisself after my daddy and his brothers got grown. I seen him all the time. He was a big strong man, taller than a door. He carried his cotton to the gin by horse and wagon. If a wheel run off, he just reached down and picked up the end of the wagon with a bale of cotton on it and put the wheel back on.

Me and my sister wouldn't stay with him. He too mean. He drove oxen. He had that ox whip he want to use on you. He could take that whip and take a cigar out of a man's mouth. Or cut the ashes off the end of it and never move the cigar. We didn't stay with him, no.

My daddy was Luther Ulmer and my mama was Mattie Ulmer. She was a Brown before she married my daddy—Mattie Brown.[5] She was born in Lake Como, out of Bay Springs on Highway 528. Her people were farmers. That's all you could do.

I had seven brothers, seven sisters.[6] My parents moved around but we never did get too far that we couldn't go back to where we were raised up at. My dad farmed for different people. He was moving toward Laurel mostly; we didn't get no farther than Mossville.

My daddy was a fine man. A hard worker. What needs to be done, he didn't fuss about it. He'd just get there and do it. He would never hardly ever sit down. Go to bed early and get up early. For as long as I can remember, he was on the floor, every morning four o'clock and start a fire if it was cold. Put his shoes and clothes on, and go around in the community, house to house, and asked everybody how they was feeling. That's the way they all did.

My dad was a sharecropper ever since I knew him. Don't think I can't tell you what he growed 'cause I had to help get it. Cotton, number one; corn, number two. Sweet potatoes, peanuts, eye potatoes, onions, collards, mustard and turnip greens, tomatoes, okra, garlic, peppers, butter beans, snap beans, the whole shebang on a farm, everything—watermelon, mush melon. I ain't going to forget 'cause I use to get a whuppin' by stealing them.

In the early 1930s we were staying on Jake Parish's [*Alfred Franklin "Jake" Parish (1875–1955)*] place outside Stringer. There were about twenty sharecroppers,[7] and my daddy's farm was one of the biggest. Sometimes Daddy, he'd have fifty acres of cotton. It didn't

take us long to pick that 'cause there were fourteen of us.[8] He was on halves. That means if you make eighty loads, he [land owner] got forty. Them old folks could walk down through the field way before the gathering time and see how much corn they were going to make to an acre—and they couldn't read or write! I used to read and write and I could never figure that out. But I know from my back I went *somewhere* because the back would be getting on you when you come out of the field. Bent over all day, be glad when I got to the last row, so I could go home.

I was about five when I first went to the fields. They learn you how to work. Don't say you don't want to! My daddy give me a twenty-four-pound flour sack—"Boy, you can sit at that table and eat just like me. You going to learn."

Mama took care of the house and when she had time she would come out and exercise herself picking cotton, but she always had to go back to the house and start supper. Now here the way they cook: Don't care how early they got through with breakfast, they put dinner right on. They went out in that garden and got all the stuff they going to cook for dinner.

They didn't let you waste anything. They couldn't have anything shut in [*refrigerated*]; so, in the morning it's going to be right there for you. You going to learn to eat that food and you won't push that plate back no more. It'd be a switch for you. Women in them days wore an apron and they had that switch right down in there, stuck right down in your mother's apron.

Mama was quiet but keep you laughing all the time. Everybody would come 'round mama. The White folks visited her every day. She cooked and washed for white folks. They would pick mama up and take her to town.

Mama made everyone at home. From the time you come in the yard. "Come on in, son and daughter"—you ain't got to *be* her daughter—"I'm cooking, I'm going to fix you all some food, too. You all are going to sit down and eat when we eat."

My mama was the law with my daddy. What he said is gonna be is what she gonna *do*. You gonna get a whuppin'?—Mama gonna whup you. Everybody like her for that. She whupped them white children too—*and* tell their mama! They say, "I'm glad you did it, Mattie. You learned them some sense. Whup them like you whup your children. Whup 'em girls and all."

Four-thirty my mama was on the floor, and five o'clock everybody in the house was up. Six o'clock, we was eating. Six-thirty the fields right there. Everybody in the fields before it gets hot up in the day. You going to stay there 'til just before the sun almost down and you way over yonder. Dusk, dark, you just could see, coming out of the fields. By the time you got to the house it's night.

Singing in the fields was the thing where everything come from. All the blues come out of the field. They sung, "Hurry up sundown, see what tomorrow gonna bring. Hurry up sundown, see what tomorrow gonna bring. It may bring sunshine, Lord, it may bring rain. I'm trying to get a hundred before it starts to rain."[9] You be hearing the song and boy, they be picking the cotton.

"Hey, baby!" You singing and pointing at somebody way over in some rows across the field. "You know I love you!" That's how he get over 'cause they didn't allow you to court in them days. "If we meet somewhere, I tell you the story about my life someday." I ain't forgetting, and I be just picking cotton, humming, listening to someone else sing.

I hear somebody way over yonder sing "I woke up this morning my head was bad. My baby done left me and I was all so sad." He going to pick about nine hundred pounds that day. "Hey baby," he's getting louder and everybody is listening, "Come home with me." Hat raggedy, coat raggedy, shirt raggedy, red handkerchief in his pocket. Overalls grown, shoes tied up with wire, patches on his knee. Lord have mercy, now I'm fixing to tell you about the *blues*! Them folks get to singing like that you couldn't hear nothing but picking cotton. And don't think they couldn't play it on the guitar! They didn't know no notes, they didn't know no chords, but they could make that guitar *talk*. Yes sir! Every day of the week—all glorified from God.

Up at Stringer, you wasn't old enough to go to no school 'til you get to be seven and eight. The school started in October after the harvest. You had about five months to go to school. March you had

to come out and be in the field. The school was in a big old church, same church we went to Sundays.

There was no mixing in them days. But I can tell you this: the white boys and girls that I knew and was raised up around—we got along like brothers and sisters. Lord have mercy, we did! Them daddies would kill 'em if they didn't. We couldn't meddle, call each other names. I can prove that today, 'cause a lot of folks are still living.

We worked for the white folks in our community. If we needed something, we got it. People didn't care who you was. A white fellow come by your house and see your kids didn't have nothing to eat, he gonna get them something to eat. It just makes you cry to see how we got along—and to see how much prejudice there was everywhere else.[10] When God made everybody, nobody can help how they made. Now, if they can help it they might change their self. You know what I'm saying? They ain't *nobody* can help it. God made a bouquet. Like you got a bouquet of flowers. Different colors. You ever see them flowers growling at one another? No, you don't. You ever see trees fighting?

We went to the Baseline Baptist Church every Sunday. You was going whether you wanted or not. Won't be long before Sunday school—nine o'clock. Preaching start at eleven. First, you had to iron your clothes. They learn you how to iron. Oh, you going to do it, if they had to stand you up on a homemade box.

There was a lot of singing in church and I loved going. All of my sisters and brothers could sing. We'd be running. We be at the church when you got there. Run and get me a seat near the preacher, see what he going to say.

My daddy wouldn't go but every now and then. When my mama couldn't go, she turned us over to one of the other mothers from church who come by. She said, "Them your kids." You wouldn't get out of line because they whup you like your mama and daddy.

Them was your mother. When you got into the church, don't make no noise. I mean *quiet*. You couldn't stomp your feet. They didn't allow you to talk—not unless you was asked something. I don't care if you were sitting right up under the preacher, they whupped you. Didn't nobody say anything about it! You sitting up there whispering in the church. They look at you. You keep making that noise?—Thump your head so hard you could hear it thunder in there. Bam! You going to stop whispering. And boy, that head ain't quit hurting you. They didn't have to whup you when they got you home. You already had a headache; you went to bed. And I wasn't bad, but Lord have mercy!

When it wasn't cotton pickin' time, and we wasn't in school, we were in the Masonite woods. My daddy started me pulling a saw when I was eight years old, doing it under his orders, helping him cut cross-ties and Masonite. Every rainy day you couldn't work in the fields, we be cutting timber. When you go out to the woods you'd say you're going to cut "Masonite wood." You'd haul the wood to the Masonite plant in Laurel—they had three shifts, worked around the clock—every load they pay you.[11] The Masonite plant was there before I was born. [*Laurel is in the heart of what was known as the "Pine Belt." In the early 1900s, Laurel milled and shipped more yellow pine than anywhere else in the world.*]

Back then they didn't have a place you go to run the water. They had a water *shelf*—a big old shelf up high on the porch and your water bucket sit here with the water in it and a dipper. The soap and a pan are right there to wash your hands in. Everybody is standing waiting 'til you wash up. Then they go in the kitchen to the table....

Twelve o'clock you had one hour off for dinner. If we didn't have a well, we had to go down to the spring and tote the water back to the house. I get my tub and set it out in the back and fill it up. When you got home that water was so hot from the sun, you couldn't put your foot in it. That's where you took your bath.

This here "number three" was the first bathtub that folks took a bath in years ago. The round tub—number two—is littler than that one. Many folks had the old tubs. They couldn't get nothing else. The oval tubs came out later. That tub you can fill it with water and sit down and take a full bath.

My mama had about six or seven tubs. Girls had theirs over yonder and boys had theirs around over here. There wasn't no inside rest room. Your rest room is out here. You got two toilets. They got about a ten-foot drop and then they set the restroom over that, and they kept cleaning stuff and disinfectants for that. People was healthy, wasn't no disease. You might have a flu, or you might have

Bathtubs, Leland, Mississippi, October 2006

chicken pox, or you might have the itch, stay out of school for a few days, but your mama was going to doctor you. She was the doctor.

If you had a sore on you or a swelling, they would go out there and get red clay. They would get vinegar and saltpeter and make it up out of that. Then they make it hard and wrap it round your leg like a cast, or wherever your swelling was. Tomorrow your swelling is gone. That was the stuff God made for you to learn. He learnt those old folks, they were wise. They didn't have no schooling, they had mother wit and understanding. Above all He gave them that. Sometimes make your eye run water they ain't here no more to tell you how healthy you can be.

It was way back there, when folks didn't have much, but they had one another. If you killed your beef, you give beef to everybody in the settlement; when I kill mine, I give to everybody. You kill your hog, and I didn't have none, you brought me some. And God provided for you to have enough that year. Love was among people in them days.

You fixed to kill a beef, there be folks at your house before day. They make a fire down yonder in the woods where they going to slaughter at. Everybody would come and do their part. Bring their knives. They have a big tub and dish pan. When they take certain parts off the beef—the way they manufacture it was better than

the government. They took care of the meat; they would have a machine that would ground that beef up. Then they would put it in jars and have their own canned beef.

There would be people sitting down on the ground watching this. People went to see things that was interesting, to learn from the old people.

When it gets to the hogs, you say, "I'm going to kill five hogs." There's gonna be a wagonload of people coming to help. They be all day from dark in the morning 'til dark at night handling the meat and putting it in the salt boxes six to seven feet long. They put whole sacks of salt over the meat and draw all the poison out of the hog before they hang it up in the smokehouse. Then one is cutting up all the crackling and putting it in a big pot and boiling it out and taking the lard and putting it in the lard can. That's how they got their lard.

Everybody got a smokehouse. You dig a big old hole and get your hickory wood and sassafras and make a smoke and keep that smoke in there for weeks drying that meat out. You could smell that meat way down the road. Now you got your meat for winter.

Lay-by time is in July, just before the Fourth. Everybody in the community would go to fishing.[12] The cotton and corn crops were planted. The crops laid by. They ain't got to go back to the fields until the last of August to start pickin' cotton. They loaded up their wagons with food, blankets, skillets, pans, utensils, kettles, coffee. And everybody, the colored people and the white people, get together; they all go to the Tallahoma Creek and build a "pine top house"—a house out of pine—and it wouldn't rain in it.[13] They stay up there for weeks. [*L. C.'s longtime friend, Grant Lloyd Boone: "We'd go up there—swim, camp out, cook out, sleep with the frogs."*] Carry their horse feed and keep the horses there.

Look, there wasn't no color. Where we were, in Stringer and Mossville, nobody jumped on no Black people, and Black people didn't jump on them. There were more white folks working for other white folk living on the same place my daddy was.[14] We go to one another's houses and sit up on the porch and laugh and talk, go fishing together, stay out all night.

If anybody died, the church bell would ring. I don't care what time of day or night. If you know somebody died, you go ring the church bell. Everybody would quit work and find the person that rung the church bell. They were big old church bells. Huge. Way up yonder with a big, long rope. You could hear it all in the town. The white folks too, they had a bell.

They didn't have an embalming place. They lay you out on a cooling board. A cooling board is when you died years ago, there weren't no ambulance service. They dress the body right there where it died at. And they made a cooling board—like an ironing board [*note: perforated*], but wider.[15] They made the coffin right there in the yard—out of yellow pine. They fit it to your body, with rulers and things. The men work all day long 'til they got that made, then they dress it off inside and lay the body over in there. They couldn't keep you out but three days then. They carry you to the burial ground in a mule and a wagon, and there'd be a string of folks behind. Everybody in the settlement, white and Black, would go—and they would hate that feeling of one gone.

All Daddy's kinfolk were musicians. Daddy's cousins Howard Ulmer and Sam McCollum played the banjo; Ken Jenkins played guitar.[16] They played anywhere. The Hoseys—my daddy's sister's kids—were church people. They were quartet singers, musicians, playing and singing. My mama's cousins, Jeff and Charlie Lindsey, played anything you put before them—piano, organ, guitar, banjo, mandolin.[17]

Grandpa Ulmer played guitar, like my daddy did. They played church songs—"When I lay my burden down, I'm going home to be with Jesus. . . ."[18] Grandpa wouldn't play blues but he wasn't against them. Oh, but could he and his boys dance! Folks danced in them days—"Breaking the Chicken Neck," "The Suzy-Q," the "Big Apple." Tap dancing and buck dancing, them was the head two. Buck dancing is jumping straight up and down. Making your feet talk—talk to the floor and talk to the people!

They'd have big parties at the holidays at my grandpa's. My cousins would come with their instruments. Sometimes when people had a house party they'd have a Black guy used to stay in Laurel

called "Boxcar" playing the piano. They had them big old upright pianos. They'd bring it on a flatbed. It would take five men to put the thing in the house.

To hear somebody playing an instrument and making the prettiest music that I ever heard, that was the greatest thing in the world—'cause in them days that's all you *could* hear.[19] Neighbors, they get lonesome and bring their instruments to your house and sit there and play with your daddy. Or he'd leave and go yonder and play at someone else's house. We'd be glad when he come back so we could hear him.

He would play us a church song, then he would play the blues. The church song was "If you don't like your brother don't carry his name abroad / Put him in your bosom and carry it to the Lord."[20] That song was big all through the South. One of the blues was "Tell Me Which Way Do the Red River Run."[21]

Daddy and Mama's kinfolk played for the breakdowns—the old "Saturday night fish fry." Daddy and the other guitar pickers and banjo players, they would play Friday, Saturday, and Sunday 'til midnight. You could take one guitar to the country and a million people would dance to the music 'til daylight. Me and my baby sister Corrine would be down yonder dancing the leaves off the ground.

They start on Friday twelve o'clock. Women start to frying fish. The men would come out of the field. Everybody in the community be getting ready to come to your place. Now, you already cooking—black-eyed peas, turnip greens, mustard greens, fried onions, fried eggs, and egg custard—rice pudding, banana pudding. They sold everything you wanted to eat. Everybody took turns having a breakdown. Everybody had a chance to make money.

They fried the fish in the same big old wash pot that they wash the clothes in. They take that fish and throw 'em in there. That grease be hopping up out of the pot. They go down and come up, ready, soft. You pick it up it's falling off the bone. They had perch fish, garfish, whiting, and jack fish. Turtle meat! Folks loved turtle meat. And a chicken sandwich. They kill the chicken off in the yard—and chicken and dumpling. And there was sweet potato custard. Stewed sweet potatoes. Boy, we put nutmeg and cinnamon in 'em and you ready. They make pecan pie, lemon pie, blackberry pie, chocolate cake, stacked pecan cake, and jelly cake. I'm talking about way back yonder now. I'm still in the thirties and forties. I ain't talking about nothing that was born yesterday.

When we were staying on Jake Parish's place, his son and my daddy had a whiskey still down in the swamp back there in between two gullies, down in them thickets where a snake wouldn't go. They made that white lightning whiskey. People be coming all through the week getting whiskey for Friday and Saturday night. Put a gallon or two or three in the middle of the floor. Folks drank that and would sing and play and dance all night long. They called it that "Georgia Texas Stomp."[22] Me and baby sister we'd sneak close to the door and be listening. They didn't allow kids nowhere close to grown folks. You get one of the worstest whuppins of your life!

Country blues and cotton picking blues carried people across the week 'til the next house party. They were playing Tampa Red and Blind Boy Fuller, and what's that man's name got poisoned in the Delta? Robert Johnson—he died in 1937.[23] They were playing his new tune. And Lonnie Johnson and Peetie Wheatstraw, "the Devil's son-in-law" out of St. Louis, and Blind Lemon—"Dig my grave with a silver spade let me down with a silver chain."[24] I used to sing all them songs when I was little.

The white folks would be there at the breakdown to get their fish sandwich and see the Black folks dance. You'd hear them say, "We going to the colored dance tonight." Yeah, they dance, too—when you play that old banjo and that old mandolin.

Sometimes it would be white and Black together playing.[25] One had the banjo, one had the guitar, and one had the fiddle. You sit and wait your turn to play your song, take turns backing each other up.[26] I was little but I ain't forgetting. And I say, "One day I got to do that!"

I had been trying to play the guitar since I was nine years old. My daddy had a Melody King—one of the best guitars they ever built in the United States. You were a big shot among the people if you had one. I'd be dragging the thing across the floor. I couldn't

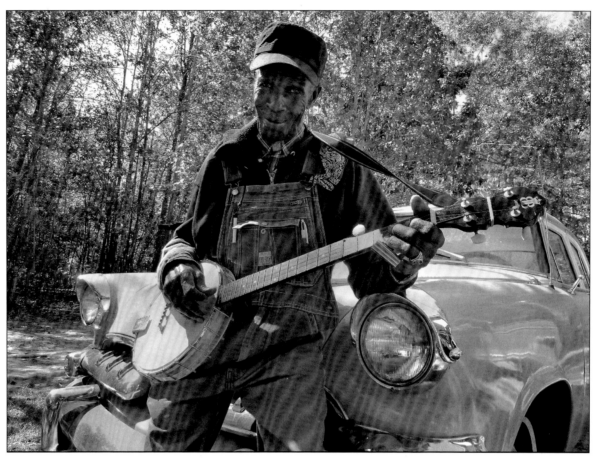

L. C. Ulmer, Ellisville, Mississippi, October 2010

put it back like it was. You moved the old folks stuff in them days and they know it. . . . When they get through eating supper he going to get it down to play. He say, "Who's been bothering this guitar? It ain't like I left it." Get a whuppin' about that.

Then I got big enough to have me one of my own. My mama carried me to Lott's Furniture Company in Laurel. I got me one for ten dollars—a Gene Autry guitar. His picture was on the side.[27] When I went to bed I'd hide the guitar in my room and play it under the covers. They didn't want no noise when they went to bed. I'd wake up at night, a sound would come to me, just like a thought come to you. You hear folks walking, going down the road with their guitars . . . That music be sounding so good, you get up out of bed and never want to go back to sleep. You want to learn it. Well, I get that guitar and forgot what they told me and get another whuppin'! Didn't thought I was gonna ever learn neither 'cause I got so many whuppins about that. But look where the whuppins got me! It's got you sitting down here interviewing me, a man who got the whuppin' by playing the guitar!

After I got my own guitar, Daddy would show me a whole lot at night. "Hit that right there!" he say. I'd hit it. "Do it again. Do it

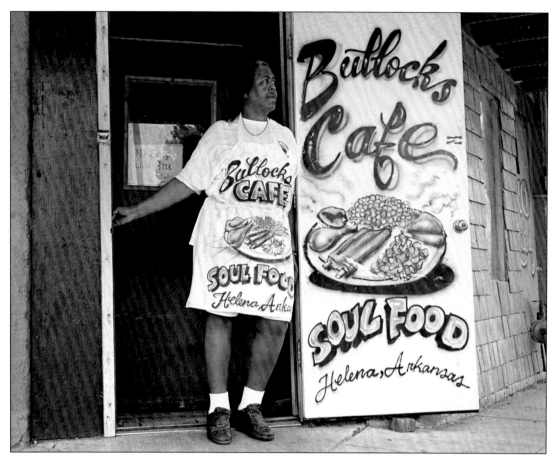

Bullock's Café, Helena, Arkansas, August 2001

again... You want to learn? I'm going to show you. You going to get *tired* of learning." I didn't get tired. That was my fun! I never hunted. I fished just a very little; that wasn't my game. That's up to other folks. I don't go to the ball game; I don't go to the fair. I'm going to make a goal with this guitar.

We didn't stay too far from my mama's cousins the Lindseys. Sometimes Charlie Lindsey, he come over to the house and taught me a whole lot of songs. Charlie taught me a beat, how to play for folks to dance to. Some of it was the blues and some of it was country. He says, "You ain't got to sing with it all the time." Back then folks danced instrumental. He learnt me how to play open E in Spanish tuning.[28]

A man named Benny Lott was married to my first cousin Barbara.[29] He taught me that song "Would a matchbox hold my clothes?" [*Match Box Blues," by Blind Lemon Jefferson, 1927*]. He took the guitar and played "I'm going to buy me a brand-new V-8 Ford. And the prettiest woman you ever seen going to be in that Ford right side of me...."[30] Bennie taught me to put the guitar in different tunings. He said, "When you learn how to tune your guitar real good, son, you gonna be up there on the top."

My oldest brother, James, bought a wind-up gramophone down in Laurel—a "talking machine"—to play records. Boy, I was hitting the tunes then! They had a song—"I wore my .44 so long 'til it made my shoulder sore."[31] I played that a different way than they play it today. I played like I heard it played back in the last of the thirties and forties.

Blind Boy Fuller put out a record—"I got a big fat woman meat shaking on her bone! Hey, hey meat shaking on her bone. Every time she shakes some man's dollar gone!"[32] I heard the songs for years and manufactured them in my mind. That's how I learnt playing behind them old guitar players—the old way.

James and my brother Lester played the guitar before me. Then they bought harmonicas. They walked the road blowing like Sonny Boy Williamson—"Good morning little schoolgirl, can I go home with you?" I'm listening and thinking, "I'm going to learn that!" Oh, Lord! Sometimes I wanted to learn it so bad, I wouldn't even eat.... They say, "Boy, we ain't going to let you blow our harp." When they went to bed, they put them under their pillows so we couldn't steal them.

I'm thinking, "I'm going to be better than you all. I'm going to learn this thing. I'm going to get on it as hard as I can." And you know what? I learned how to blow *better* than they did. I'd pick up them old harps they throwed down in the dirt in the yard when they'd buy them another. Me and Corrine take the sides off, clean them, straighten the notes out with a pocketknife, sing the notes back out and blow through them harps the best we could 'til we got able to buy us a harp. Harp didn't cost but sixty cents, something like that. But you didn't have the sixty cents, and it was hard to get.

We got a radio in 1938.[33] They had the Grand Ole Opry on, and I'd sit up and listen to it—Nashville, Tennessee—Hot *dog*! Boy, me and my sister did not leave that radio 'til it went off. That man come on playing the banjo! [*probably "Uncle David" Macon*].[34] I tried to tune my guitar to make a banjo sound.

Roy Acuff and his Smoky Mountain Boys—and Bill Monroe, them were my main people.[35] And the man who blowed the harp on there—DeFord Bailey.[36] He could make the harmonica sound like a freight train [*"Pan American Blues"*] or like dogs chasing a fox [*"Fox Chase"*]. He played that song, "Going down to the station, down in the yard, gonna catch me a freight train . . ." [*"Sittin' on Top of the World"*]. I listened and practiced right behind him and learned how to blow that song. I hit town on Saturday, made a pocket full—folks throwing me money, up and down Front Street in Laurel.

Did you know that Laurel used to be a big city?[37] You couldn't hardly get through Laurel on the weekends. Laurel was a city to be seen; it had all kinds of jobs. That was *the city*. Everybody out of every end of the country—Soso, Summerland, Taylorville . . . Hattiesburg wasn't nothing! Folks come from New Orleans here. Laurel was one of the outstandingest towns they had in Mississippi besides Natchez. We had our own colored show—the Lincoln Theater.[38]

We would come into town, walk up and down Front Street. There were lines of people. They had any kind of food you wanted. I'm talking about soul food there!—Chicken and dumpling, egg custard, pecan pie, cake cooked from scratch. Fish. Chicken! Boiled chicken, fried chicken, and chicken in gravy and onion, stewed beef, stewed down with rice. Hot dog, pork chop and rice. You had stewed sweet potatoes, potatoes and onion together. Biscuits, corn bread, hog head cheese—what they call "Hog Head South." Pig feet! There is no call for this food now. Collard greens, turnip greens, mustard greens. Lettuce, radish, beets, carrots, green onions, raw and cooked cabbage. Cafés were loaded down with food.

Front Street had hardware and drug stores, a five-and-dime, dry cleaners, tailors, and barber shops. The Lott Furniture Company was on there.[39] A blind fellow, Roosevelt Graves [*LeMoise Roosevelt Graves, 1909–1962*], sang and played church songs outside their door.[40] Folks put money in Roosevelt's cup; he had it fixed out there on the neck of his guitar right where his keys is.

The police would bring Roosevelt downtown from up in the quarter where he stayed. Roosevelt Graves was a very special man to them. They love to hear him sing. They put money in that cup just like you did—and they looked after him. Nobody better not bother him.

Lott Furniture Company had a chair for Roosevelt they sit him down in all day—right there in the door. Lott's sold guitars.[41] If he broke a string, they give him a set. Yeah, he brings people to the business. I used to stand by that man every Saturday and listen to him sing. He had cut records before I was born.[42]

He'd be playing the guitar and hitting it; you see me doing it now; I learned that from him. He said, "You done learnt your A, B, C's Mister Ulmer! You going to do that one day, Mr. Ulmer. Try that." I jumped right on it. Then he tell me my mistakes. I'd go off and play for tips and then come back to him.

Sometimes I might be in town before Roosevelt got downtown, and I go up in the quarters where my sister lived and bring him down if the law didn't. They had "quarters" in Laurel for everybody that worked for the sawmills. They had "Bruce Quarters," "Eastman-Gardiner Quarters"—what you call "Red Line."[43] The Green Lumber Company—everybody that worked for them lived in their quarters. Roosevelt lived with people that he knew in the "Newcomers' Quarters."

Roosevelt say, "Hey boy! Time to step up now and get to singing! I'm going to sing it. And I'm going to play it and you going to play behind me." His brother Aaron beat the tambourine. Roosevelt starts singing a song, "I stepped in the water, about one ankle deep. Lord, I got on my travelling shoes . . ."[44] I'm watching his fingers and I'm bent over seeing what he do and trying to do it just like him. He said, "You doing it! Go on with it!" He stopped his guitar and I pick up . . . And I lead him back home in the evening time.

We was living in Stringer in 1939. The old house is still standing there. There was a storm—tore the house down and left a little bit of floor and the back room. It was an old "stompin'-down house." Means you dance all around in it.

After my daddy built the house back they stayed there a little while longer. Then, in 1942 we moved down to sharecrop for a man named Will Legg in Mossville. That's where we grew up and was raised to maturity and to life. When the war broke out, I was fifteen. Farmers had to plant "government" crops. I helped other folks with the crops—and they helped you with yours. Folks pulled together.

Stringer and Mossville wasn't too far apart. We could walk between them. Mossville was the real name; some people called it "Moss." Mossville was a lively place. It had five or six stores—grocery stores, one filling station, a beer store. There was a cotton gin and a big old wood yard for the train. Folks would load the train cars at night. The roads were gravel roads—T-Model Fords, horses and horses and buggies, big and little wagons. On the weekends you couldn't come down this road for walking, you had to jump to the side.

L. C. introduced me to his old friends Robert Gregory and Grant Lloyd Boone, sons of neighboring white farming families. L. C., Robert, and Grant were the third generation of their families to play with one another. The Ulmers sharecropped on the Gregory's land in Stringer in the 1930s.

Robert described the scene: "At the house parties and breakdowns whites and Blacks from Stringer and Mossville would play together. There was a lot of talent in the community. C's daddy and the Lindseys played with my cousin and my granddaddy, Kinson Gregory—he played fiddle. There'd be square dances and breakdowns in front of the store. Everybody knew one another. If two people were playing, other people, Black and white, would come by and bring their instruments. A lot of young people would watch and learn. Everybody would go to C's house, eat, sing and stay 'til midnight."

Lloyd grew up in Mossville. L. C.'s family lived down the road from the Boones. The men talked about the old days when Black and white "was all together and breakdowns took place in people's barns."

L. C. and Lloyd formed a band in the forties. Lloyd played fiddle and guitar; L. C. played harmonica. They had three other guitar players and a bass player. The group played blues and bluegrass and performed on radio station WMAL in Laurel.

When the band didn't have a gig on a Saturday evening, they practiced at L. C.'s house. They weren't able to buy a bass; they made one. Lloyd explained: "We got a tub, put a hole in it, got a stick and put a string up there. Make every chord you did on the

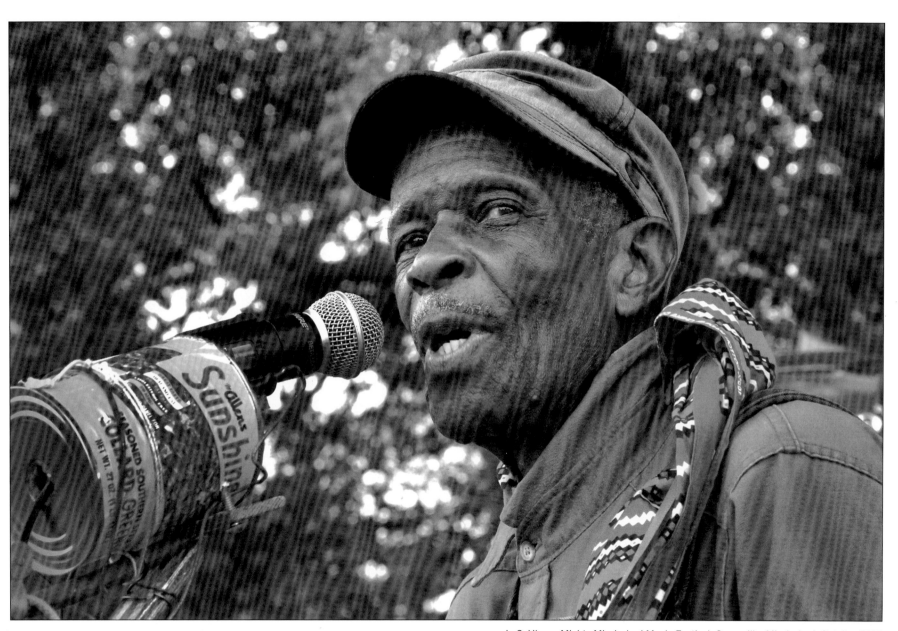

L. C. Ulmer, Mighty Mississippi Music Festival, Greenville, Mississippi, October 2013

guitar. We played anywhere folks wanted us. We wasn't making no money. Didn't nobody have no money. I drove an old pickup truck with a flat body on it to and from shows. Before that we went in a mule and wagon. We went all over the country. We had a horse and wagon with tires. Man, that horse would run down the road and we'd be flying!"

People would come from everywhere to see movies at Mossville—tent show movies. A man would put up a big old tent and show the show. You better get there early if you wanted a seat. It was a big night out!

Robert Gregory: "They'd show old westerns—Tom Mix, Lone Ranger, Sunset Carson, Wild Bill—one night in Moss, then Stringer. They'd put the tent up right beside my daddy's store and start playing records to draw everybody. This hill would be covered with people. They'd bring a platform stage for the musicians built on the truck."[45]

Lloyd recalled: "When L. C. was playing by himself he had all kinds of tubs and all kinds of junk. He blowing a harp, playing a guitar, and beating drums with his foot. He had a whole band."

Mossville was where I met Jack Crosby. Me and Jack would come to Laurel every Saturday. He'd have his guitar and I'd have mine. We'd hear records on the jukebox—and start singing it on the street. Folks would put a nickel in my box: "I want you to sing three songs"—*clink, clink, clink*—fifteen cents. We do that all day.

Laurel was a jumping place. We had plenty of jukes. The Cotton Bowl and the Navy Yard were famous. Jimmy Reed, Louis Jordan, T-Bone Walker, Fats Domino—all them came through. The Navy Yard had a big dance hall. That's where all the big bands went. Me and Jack was too young to go in there; we stayed on the outside and listened.[46]

During the war, they took every man that was able to go. That left the railroad without men, so the railroad got to calling the young boys out. About a hundred of us got to Heidelburg, that's fifteen miles north of Laurel. We put down new tracks for the oil well companies. [*Oil was discovered at Eucutta Field near Laurel in September 1943 and in Heidelburg in January 1944.*][47] We got paid thirty dollars a month. The railroad had camping cars they put up and down the track for us to stay in. I'd be sitting on top of the car every evening when I got cleaned up. I had my pretty guitar and played until I fall asleep, singing, "Baby, how long since that evening train been gone?" and "Hate to see that evening sun go down."[48] Wake up early in the morning that guitar laying across me.

I learned railroad songs by a guy named Bill Morgan. He could call that steel. We'd be working near town, packin' ties and layin' rail. People come from everywhere to stand around and listen at him.

When you putting new ties down you got to clean all that old gravel out—but then you got to put that old gravel right back in there. Somebody shoveling it in ahead of you. The timing got to be right. You got to get down low and throw it from the wrist—and kick it with this knee. Then you come along packing the tie, nip that tie up to the track—we got a line of men over here, packing this side of the tie, a line of men over there, packing that side tight.[49] You work with the song. Bill had everything in time. And when he sung that song out, you better have that packed up right—so it ain't going to give when that "Big Jack 99" come down the track.

Layin' steel, all the men had to move with the song.[50] You got to drive the head of that spike just right. Keep that arm up and bring that hammer down from your wrist and when you bring it down—you drive it right *there*. Two whacks, that spike is *hit*. And when he call "Johnny!" that was it.[51] For two years we worked—driving spikes, laying rail, packing in new ties—from here in Mississippi down to Lake Pontchartrain until we finished the job. Then I got work with the big lumber companies. My first job was for E. L. Bruce, a huge mill. I worked for Bruce Lumber a year.

Then Jack and me worked for ourselves in the woods, night and day. We were working in the Masonite woods, cutting Masonite logs. Hired someone to haul our wood to the plant. We'd sleep out in the woods and play our guitars 'til daylight.

We fixed up two bicycles and started bringin' our guitars to Laurel every weekend, riding on Highway 15. Them bicycles were

pretty—I had a silver one, Jack had a red one. We had lights on the handles and lights on back for taillights, squirrel tails hanging off the handlebars. Wasn't many folks that had bicycles in them days.

Many times when we come out of town, we'd hear Neville Sims, one of the top guitar players at the jukes out in the country. Neville Sims and Roosevelt [*Graves*] were in the same time. I'd hear Roosevelt Saturday in the daytime and Friday if I was in town. On Saturday night when I come out of town and go to the juke in Mossville, Neville would be sitting up there drinking and playing. One song I always did like—"If I was a catfish I'd have all these girls swimming after me" ["*Catfish Blues*"]. He was singing that before Muddy Waters.[52]

All the Sims could do anything on the guitar—the mother, too. There was a gang of them. I saw Roosevelt Sims at the breakdowns.[53] He played his own country blues. He played guitar with my father sometimes.

Jack split off from me. I played guitar by myself 'til I left Laurel. I used to sing across from Sid's Trading Post [*est. 1947*], near the railroad station. I'd stop under them old magnolia and oak trees and sit under the shade and play. Then I'd go to the edge of town and play in the jukes. The blues is all you better play. I was playing Blind Lemon Jefferson, Peetie Wheatstraw, Tampa Red. In the cafés they'd be frying fish so fast they couldn't keep up with the orders. Down in the woods behind the juke they had dice games.

I'd be singing, "Baby please don't go back to New Orleans, 'cause I love you so!"[54] "Come on baby, don't you want to go back to Chicago?" Boogie woogie—"Cow Cow Boogie" and "Pine Top Boogie Woogie,"[55] that's one of the prettiest pieces that ever come out—from Uncle Gene [*Gene Nobles, a white DJ playing Black music, beginning in 1943*] on WLAC coming out of Nashville.[56] That's how I learned. I used to mark everybody.

I was about twenty-three when I went to California. I heard so much talk of Hollywood I wanted to see it. A man was going as far as Holbrook, Arizona. I pawned one of my guitars and left with him. Everywhere I stopped folks was giving me money. That's how the Lord started me on. And then He put me in a position to know folks working at a twenty-four-hour motel and restaurant—the Motoraunt Café in Holbrook. He knew all this was gonna happen.

I got a job as the head janitor at the Motoraunt. Some nights I was playing blues in the cocktail lounge when bands took an intermission. You could ask for any song, I could play it. The music lives inside my thoughts. In my mind and my head I can hear it ringin'. The sounds come right back. The minute people mention a song, if you heard it and knowed it, it's computered in your head.

I came back to Mississippi about two years later. I was traveling around the South playing for money. I named the guitar the "Starvation Box" 'cause you had to play it to keep from starving.

I had a woman that I was courting—Clenniss Portericker. She said to me, "You going to marry me!" I said, "I ain't marrying nobody." She said, "Yes you is! If you don't marry me you ain't going to marry nobody!" She talked good that time—gooder than I ever heard her talk. She snatched a knife off that table. I was sitting on the edge of the bed. I just went on back on that bed and that knife went right into the wall. I could understand *that*.

We got married that same day and drove to San Bernardino, California.[57] Clenniss had a sister there, Suzie May.[58] We got a house out there. [*Clenniss had another sister, Juanita, married to Jasper McGee, both originally from Laurel. They lived in Los Angeles.*]

San Bernardino was a jumpin' town about an hour from L.A. They had jukes every which way you looked. You could juke all night. I worked detailing cars at a car wash. The owner was a preacher from Ohio. He was a singer and had his own quartet, called the Traveling Gospel Four. He had me playing guitar with the group for about a year. We went to L.A. every Sunday to perform on a gospel radio program—and on television. After the show the quartet played in the sanctified churches around L.A., San Bernardino, and San Diego. Sometimes we weren't home 'til one or two o'clock Monday morning.

Folks had me hired to play at house parties and juke joints. Most of the time, in the fifties, you play rock 'n' roll. If you played the blues, you played it fast. I'd be playing so they'd be wanting to dance—playing Chuck Berry and Brook Benton, Louis Jordan:

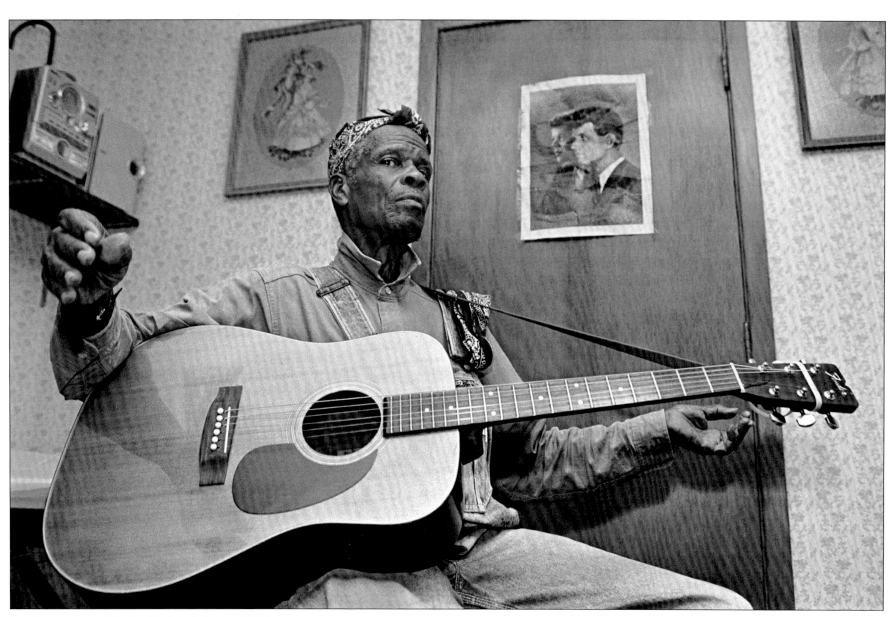

L. C. Ulmer at home, Ellisville, Mississippi, October 2009

[*sings*] "Oh, ain't nobody here but us chickens . . ."⁵⁹ Every night of the week in California was like Saturday night.

I was a one-man band for forty years—drums, harmonica, guitar, jazz horn, tambourine. I had a tambourine on top of one of my cymbals. Some drums had the bell and clapper boarded across the top. My snare drum was sittin' right between my legs. I had them sticks where I could take and play the guitar, make everybody dance with the drum, then come back and hit the guitar. Time will carry music. People used to come from far away to see me.

Clenniss died in childbirth about two years after we were married.⁶⁰ She died in a Los Angeles hospital. A blood vessel busted in her head. I stood by, held her hand. Sure enough, she was the one good wife I ever had. The baby didn't make it, either.

She had birthed me twins the first year we were married. I sent our children to Juanita and Jasper. They raised the children because I was traveling. I come back to Mississippi in 1959. I sent money to the children's auntie.

I done everything to feed my kids. I started bootlegging. Then I was a construction worker and landscaper on a missile base in Picayune, Mississippi.⁶¹ We'd go to Biloxi and be on the television every Sunday morning singing gospel, about 1963 or '64.⁶²

W. C. Jones was the first guy who played drums for me when I come back to Mississippi. He said "Lets get a band!" I said, "All right. Who's the drummer?" He said, "I am!" "Who's the bass man?" He said, "J. C."—J. C. McCurty. His cousin Clyde Jr. played alto sax. I put up my drums and got a band. They just come out of high school, and we *ripped* it. We had a few more guys that would come in. Ernest Sims [*"Junior" Sims*] was a singer. We played blues, rock 'n' roll, soul, whatever the people wanted to hear. We played dancin' music. We'd say, "You're rockin' with the Bel Air Clowns."

We played in Laurel, Heidelberg, Waynesboro, Meridian, Raleigh, Bay Spring, and Taylorsville, Mississippi, and in Alabama, up and down that 45 Highway all the way to Mobile. We stayed together from 1962 to right about '64.

Some of them places we would go were bad, but I stood my ground and they didn't bother me. I took care of my band., I took care of my music. If you start trouble, I would end it.

Up there where I played at, when I come home to Mossville, my mama's porch would be full of folks, Black and white. In Jasper County, all of us patronized one another in the neighborhood where I lived. If somebody needed something, we all got together and got it. It always stayed that way. Outside Jasper County you had to stay in your place. The law would say, "Boy, what you doing down here? Don't you be down here meddlin' with nobody." See, them *harsh* words. I didn't come down to mess with nobody.

It was bad times here in Laurel. When you worked for some white folks, they fed you out in the yard—brought your food to you in a dishpan, fed you right under the tree. You didn't hardly know how to accept that. You had a water fountain way out yonder for you, and all that sort of stuff. You stop at a café, most of them owned by white folks, but they had colored people cooking in the back. They had to serve you out the back window. And the other folks went in the front. That's a heck of a feeling. Just be glad you weren't in it. They talk—"Them folks ain't no good." But we done all their cooking. If we wasn't no good, you shouldn't eat our food. Me and my brothers didn't hardly eat at them kind of places. We going on up there where we was born and raised, and eat face to face with other folks.

When Nat King Cole come here, they liked to kill him in Birmingham.⁶³ Folks jumped on him and beat him up and he never did come back here no more. When Chuck Berry come they liked to kill him up in Meridian, so I heard.⁶⁴

They weren't gonna run over *me*—nobody. I carried a pistol and kept one in the back of every amplifier. That's how I went outside of Jasper County. I didn't have to carry no gun in Jasper County, but when you hit Jones you better protect yourself. Yeah, I was gonna let them know who I was. They might have gotten me, but they'd say "He carried some of us down."

I can show you where they hung a man on Sixteenth Street in the early forties [*Howard Wash, lynched outside Laurel on October 17, 1942*]. Right there in Jones County, it ain't too far. He was working for a white man. This man had been beating his tenant up every morning. One morning the Black man said, "I'm tired of you hittin'

me all the time." He took a milk bucket and beat his landlord to death. He got away. They finally caught him, and they hung him.[65] I could take you to the bridge where they hung him at, right now.[66]

My brother-in-law was Jasper McGee. They put his brother Willie in the electric chair right here in 1951.[67] Ask anybody in Laurel. Jasper ain't been back to Mississippi since.[68] I think he come back to see his brother, but when he got back to California he forgot about this place. [*Jasper McGee died in L.A. in 1995.*]

Yes, Lord, I heard about lynchings in other places from my parents and other people. Good gracious alive. Dragging them up and down the road. Burning them and torturing them.

You better make sure when you were in Laurel that you were with a lot of people. The white police were bad in them days. They'd give you so many hours to get out of there. If you didn't live in Laurel you better be on the ten p.m. bus or else they'd put you in jail. The police wanted the Blacks outside the downtown area.

The Blacks had their own hospitals, doctors, and lawyers. I can show you where there were no Blacks allowed in Laurel. You know who got the places now? Make a guess. Blacks have it—they live right up there with the white folk.

I made a speech one day in Jackson, and I told all this here for Farmers Insurance. When I got through, I thought folks would be angry at me but they just gave me money. I said, "What, are we getting paid for telling the truth?" But it *is* the truth. I can tell it because the folks told me about it. Later on, folks stopped that. The state of Mississippi has made a lot of changes and come a long way.

I went to Illinois in 1965. My brother Lester had been living in Joliet since the 1940s. He said, "They're hirin'. Get up here!" They hired me at Commonwealth Edison, that's the biggest light company. I went to Illinois to make some money. I went up there to work six months; I stayed thirty-six years.[69]

In Joliet I was the host to play in big places: Joe Howard's [*"Club 99"*], the Black Diamond, Big Ten, Sidney Edwards, and one called South Korea—way out on the east side. I was a one-man band.

They hired me in Harvey, Macomb, Argo, Kankakee, Morris, and Gardner, Illinois. I had them drums *on fire*.

Towards the end of the sixties, I started playing at Anne's Lounge, a club on the West Side of Chicago, around Roosevelt and Pulaski.[70] I had it jumpin' and hoppin'. I became a regular at her place 'til she sold it in the seventies. I played on Maxwell Street in the seventies, every now and then in the eighties. Jukes in Joliet went to closing down. They're shuttin' jobs down. The Joliet Arsenal [*closed 1993*] went down. Folks ain't got no money. I left Illinois in 2001 and returned to Mississippi.

L. C.'s return coincided with renewed interest in old-style Mississippi country blues and an explosion of blues tourism, festivals, documentary films, and academic symposiums. L. C. was in demand. Now it was time for others to "mark" him as he had marked his mentors.

I've been playin' everywhere since I've come back—all over Mississippi[71] and overseas. I'm teachin' students whatever instrument they want to learn. [*In 2008, L. C. and his seventeen-year-old student, Chase Holifield, won the Mississippi Delta Regional Blues Challenge in the Solo-Duo category.*] I can play a six- or twelve-string guitar, a banjo, mandolin, fiddle, and piano.

Bass player Justin Showah, from Oxford, toured with L. C. and backed him on his later CDs. For Justin, "Playing with L. C. was like chasing a rabbit through a corn field! He never played any 'songs'—he would play whatever came to mind. I don't remember ever playing the same thing twice with him. He was a true artist—if he felt something, he sang about it. Sometimes it seemed the more confused the band was, the happier he was. I'd say his greatest strengths as a musician were his ability to get into a rhythm and lead style on an acoustic guitar that would make Keith Richards jealous. L. C. got to the heart and soul of the rural blues . . . and when he had a good band behind him, he would get into a cutting, dissonant, slicing lead mode that bore a punk rock edge."[72]

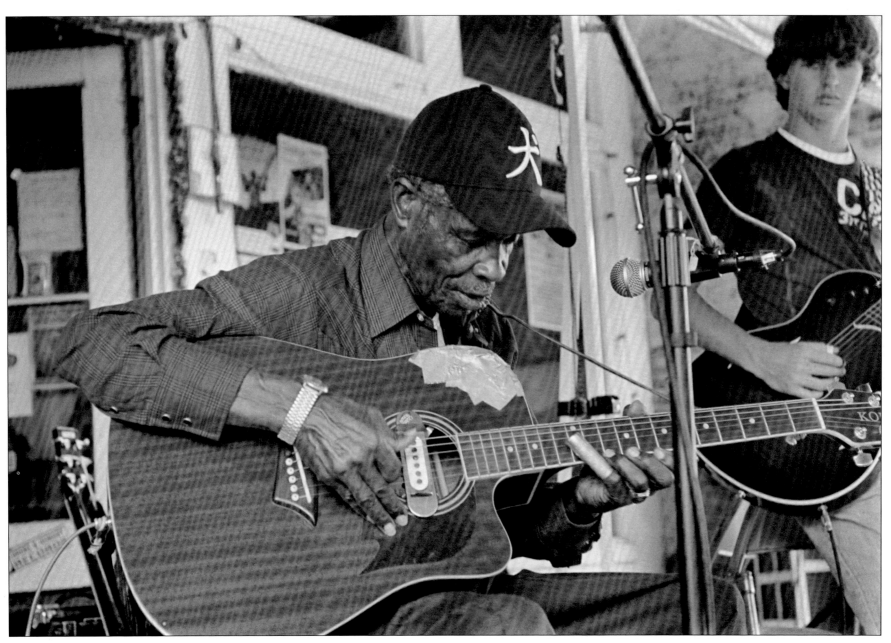

L. C. Ulmer and Chase Holifield, outside Cat Head store, Clarksdale, Mississippi, October 2008

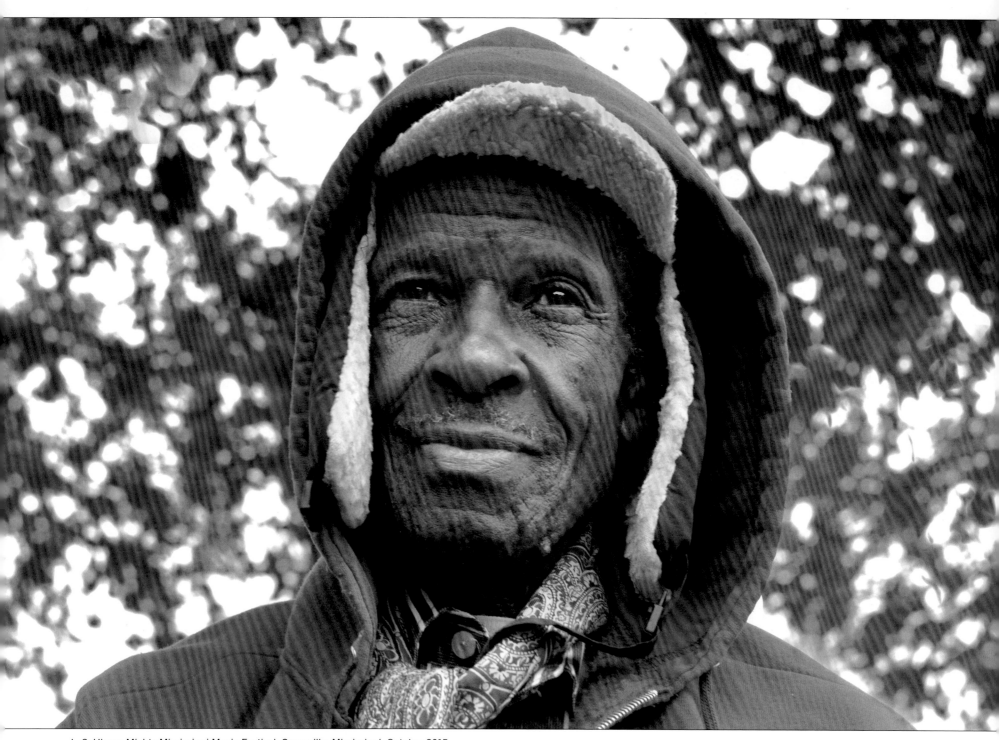

L. C. Ulmer, Mighty Mississippi Music Festival, Greenville, Mississippi, October 2015

For the last decade of his life, L C. played local, national, and international festivals with the frequency and energy of a man half his age. He performed in Norway, France, Italy, and Switzerland, where he wowed an audience of thirty thousand at the St. Gallen Open Air music festival. In 2013, he toured Israel, appearing at the Intimidbar Festival in the Negev, and gave solo concerts in Tel Aviv and Jaffa.

In the United States during these years, L. C. performed far and wide—from the Portland (Oregon) Pickathon to the Chicago Blues Festival, and south to the Muddy Roots Festival in Cookeville, Tennessee (east of Nashville), and Ponderosa Stomp in New Orleans. Closer to home, he played the King Biscuit, Mighty Mississippi, and Bentonia music festivals in the Delta, the Shedhead Blues Fest in Ocean Springs, and at the Jimmie Rodgers Museum in Meridian, Mississippi. L. C. appeared in the films M for Mississippi *and the Canadian documentary* I Am the Blues.

For all of this, however, L. C.'s music had never been recorded until 2009, when he was eighty-three. Finally and fortunately, Justin Showah produced a CD from L. C.'s 2007 live performance at the Rootsway Festival in Parma, Italy, titled Long Ways from Home *(Hill Country Records, 2009),[73] and got him into the studio in Como to record* Blues Come Yonder *(Hill Country, 2010)—a legacy CD showcasing L. C.'s many influences and styles on guitar, banjo, and mandolin.[74]*

"What I realize from being around L. C.," said Justin in 2021, "is that he is a touchstone for all the rural music traditions from the southern and eastern parts of Mississippi—Jimmie Rodgers, logging camps, Choctaw Indians, and the Graves Brothers. He combines all those influences from the area to create his own music."[75]

Reviewing Blues Come Yonder *in* Living Blues, *Mississippi writer Melanie Young compared the CD favorably to Muddy Waters' iconic 1964* Folk Singer *album: "'Folk singer' would be an apt description for Mr. Ulmer, for his music contains the history of a time in America long past and echoes of those he has met throughout his journeys . . ."[76]*

L. C. fulfilled his dream to bring the sounds and songs he heard as a youngster—the blues and gospel as sung and played by musicians he heard growing up—to a wider audience with vigor and passion. By performing, recording, and teaching, L. C. ensured the music, knowledge, and ways of his community would be passed on to the next generation.

I saw L. C. perform on the blues stage at the Mighty Mississippi Music Festival in October 2015. L. C. was dressed in overalls, sweatshirt, and jacket, wearing a lined hat during a chilly weekend in the Delta. Grinning from ear to ear, eighty-nine years old, L. C. gleefully sat on his guitar with a slide on his finger, at times crouched over the guitar, playing blues he heard long ago, and made his own. I left the festival feeling confident I'd see L. C. on my next trip to Mississippi in 2016.

To my dismay I learned L. C. died at his home in Ellisville, on February 14—Valentine's Day, of all days!—2016.

I'm playin' blues no one ever heard. The music comes out of my heart. I take the sound of the guitar, the way it sounded in the old days and put my thoughts and words with that. That's what *holds* the people. I go back to the old times so people will know about those times.

If I should make it big before I leave this world, if my record ever made a hit, I won't be needing the money for myself. I want to help the widows and the orphans. It'll help the unable; there's plenty of them on this earth. And where they got a home, folks seeing after kids, they ain't got enough money. Money don't bother me. I'd help if someone came by and said they're hungry. I'd say "Follow me. I'll take you to the café, buy what you want." I'd pay for it and give you some money. Make it where you're goin'. Find some sick person, he ain't got enough money to buy medicine. Leave a donation there. You got to look out. Know you comin' to that one day. You're gonna get there too. If you do a good will, and God sees it's good, he'll progress you on in life. He'll keep you with a good bill of health. That's part of His commandment: Do unto others as you will have others do onto you.

Willie King, Highway 61 Blues Festival, Leland, Mississippi, June 2005

Willie King

My grandmother started having jukes in her house, 1925. She'd have my mother there. The Duck Brothers used to be there, too; they played country and blues mixed together. Back then a lot of African Americans played that fiddle in the blues. I used to love to hear that fiddle talk when I was a boy, make you feel so good.

"Brook" Duck told me in 1928 him and his brothers were playing for my grandmother in Prairie Point, Mississippi.[1] Mr. Duck said, "Please believe what I say. Your mother was fourteen years old. She said, 'You all sure can play the blues. When I'm old enough I want a blues child.'" That was in 1928. Fourteen years later I was born. The prayer was answered. Here I am. Doing what I was born to do—singing, preaching the blues.

In Macon, when I was about nine or ten years old, I seen this water fountain on the street and said I want to go and get me a drink of water. A white man came running out of the store, hit at me, but I was young and fast then, he missed me. He said, "You can't drink no water out of that fountain there! They don't allow that around here!" Now here in Macon today, there's a blues marker [*"Black Prairie Blues"*]. In 2008 the mayor read my proclamation in the same place.[2] Lord have mercy! How things change. As my granddad said, "Let God fix it. Everything will be all right."

The Lord wants me to use the blues to bring all walks of life together. That's my mission. The name Willie King and the Liberators, I got the message years ago, this is what the good Lord wants me to do, to liberate, to bring people together, get away from that separation. This is why I came up with the name "the Liberators." We all can live together, work together, be together. It used to be the civil rights movement but now it's the human rights movement. It's for everybody, to come together and love one another like we have been told to do. Sit down and try to reason together our differences and we can work out something that both sides would be pleased, to make both sides as one. Respect everybody for who they is. None of us own anything. The Spirit gave everybody their own heritage, culture for their own survival. He wants us to share it with the world to serve everybody. When the quilt unfolds, like Jacob's coat, when it unfolds of many different colors, many different walks of life, many different cultures and heritages come together to make this quilt. You got protection against the cold weather to keep warm together. And it beautifies the world just like the flowers, different flowers come together. Red, yellow, blue all come up together. None of them fight each other about I'm more than you or you're more than me 'cause the purpose is to beautify the world. It's a light for the world to beautify, that we can come together.

Willie King died in Memphis, March 8, 2009.

Jimmy "Duck" Holmes

I've owned the Blue Front Café fifty-two years. I acquired it from my parents. They ran the café for twenty-some-odd years [*opened in Bentonia, Mississippi, 1948*] before I came on board in 1970. It was like I was grown into it. Being the owner makes me feel good when I see what it means to other people.

My dad, from what my mom told me, hung around with the old blues players. He bought my first guitar back in 1957. As I grew up and came in contact with the older blues players I got interested in it and started playing and having blues sets here.

When my parents owned the café, there was a lot of blues musicians in this community—harp players, guitar players. They would come by; some would blow along with the juke box, some would blow by themselves. It was informal. Some played for tips, some just for the sake of playing. Jack Owens and Jacob Stuckey used to come by a lot. Bud Spires would come by every now and then. Some of the guys, it just made them feel good to know someone wanted to hear them play. That was a reward in itself. These guys all played what I call a Bentonia style of music.

Bentonia style originated here. It goes back to Henry Stuckey. It is played in open E—but the guys who played it, like Jack and Jacob, called it "crossnote." Jack couldn't read or write but he could tune the guitar. Jack played an older style of music, like Skip James and Henry played it. "Hard Time Killing Floor" and "Cherry Ball Blues" come to mind. Jack played that music and recorded it [*Wolf Records, 1981*], Skip James recorded it [*Paramount, 1931*].

Jack Owens was the one who inspired me and taught me. I feel I owe it to him to let the public know who he was. I felt good I was associated with him. The Blue Front Café was his second home after his wife died.

My mom said my dad would always do a community event, and I wanted to do the same. I started the festival in 1972 [*Bentonia Blues Festival*]. I gave food and beer, everything, away. I put money aside before the festival; the café paid for the entertainment from the sales it generated. Jack was there at the beginning. Later, Eddie Cusic, Son Thomas, and T-Model were a part of it. As long as my health allows me, I'm gonna continue to do it. I'm gonna push it to the limit.

Jimmy Holmes, King Biscuit Blues Festival, Helena, Arkansas, October 2017

Bud Spires

I remember when I was a little boy we'd walk down the streets by the sidewalk in front of the stores. If we met a white lady we got to pull off our hat and step on the side and let her walk on by. That was rough. Colored and white, we all have the same blood.

I liked to hear Martin Luther King talk. He was like a God-sent child, sent to preach. What he said came out true: One day we will all be free. Years ago they would have killed me for you walking in my house.

My daddy got me interested in playing the harp. He was called Big Boy Spires [*Arthur "Big Boy" Spires*]. He played by himself. He started off with a harp. Then he put the harp down and started picking the guitar. My daddy would tell me, "Go on, that's the way I learnt. Just keep on blowing. After a while you're gonna learn. If you hear some songs you can blow with them. That's the way I done."

I started back in the sixties. One day I had my harp and went over to Jack Owens. Jack used to plow mules all day. Then he'd ride the mule to different places to play the guitar at house parties. He got the guitar and picked one of his old pieces. I got the harp and just went to blowing. He said, "Boy you're good!" Me and him played all evening. That's where we started, right there.

Bud Spires passed away at home in Bentonia on March 20, 2014.

Benjamin "Bud" Spires, Bentonia, Mississippi, June 2005

Part IV

HILL COUNTRY

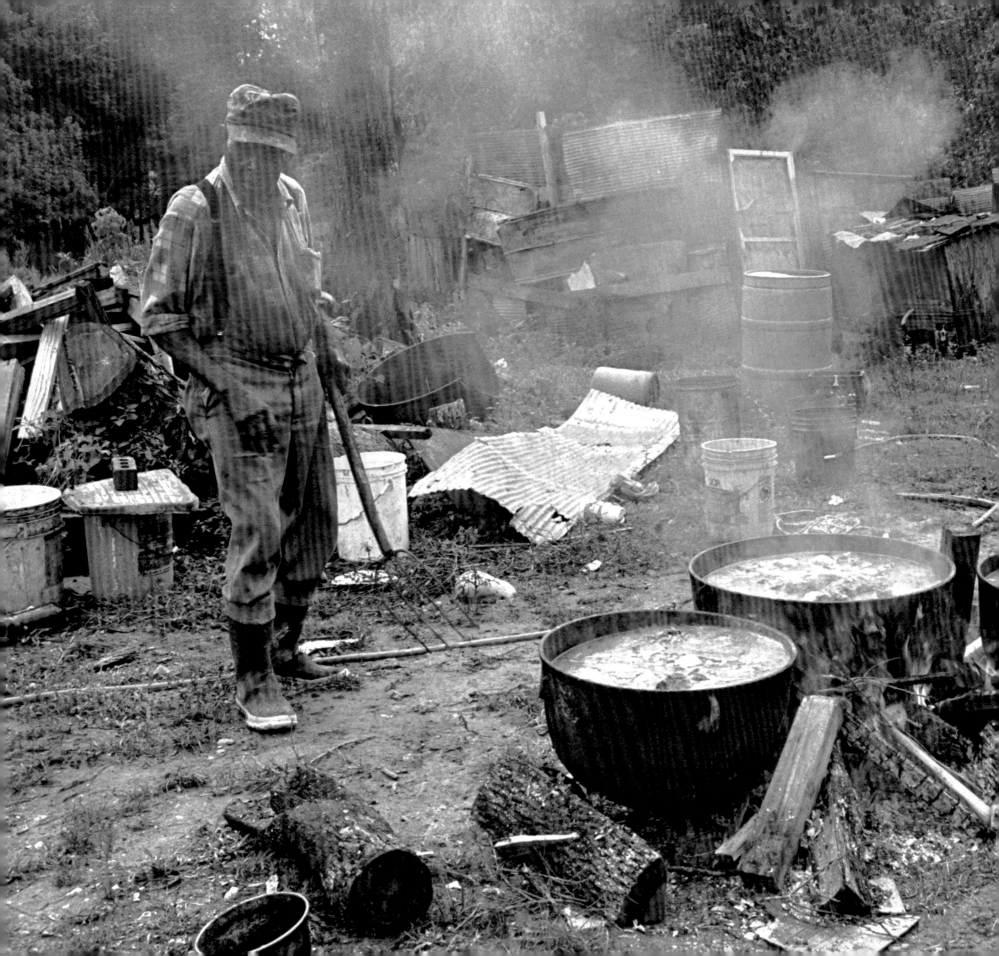

Remembering Otha Turner
(1907–2003)

Otha Turner, Gravel Springs, Mississippi, September 2001

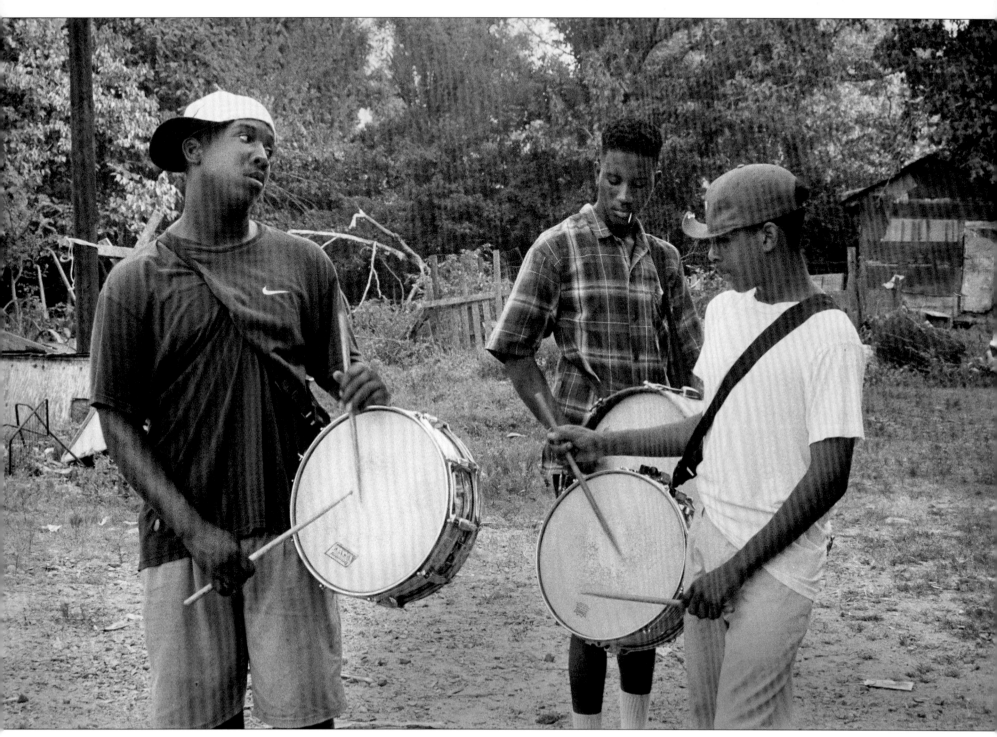
Otha Turner's grandsons (left to right): Rodney Evans, Otha Andre Evans, and Aubrey "Bill" Turner, Gravel Springs, Mississippi, August 1997

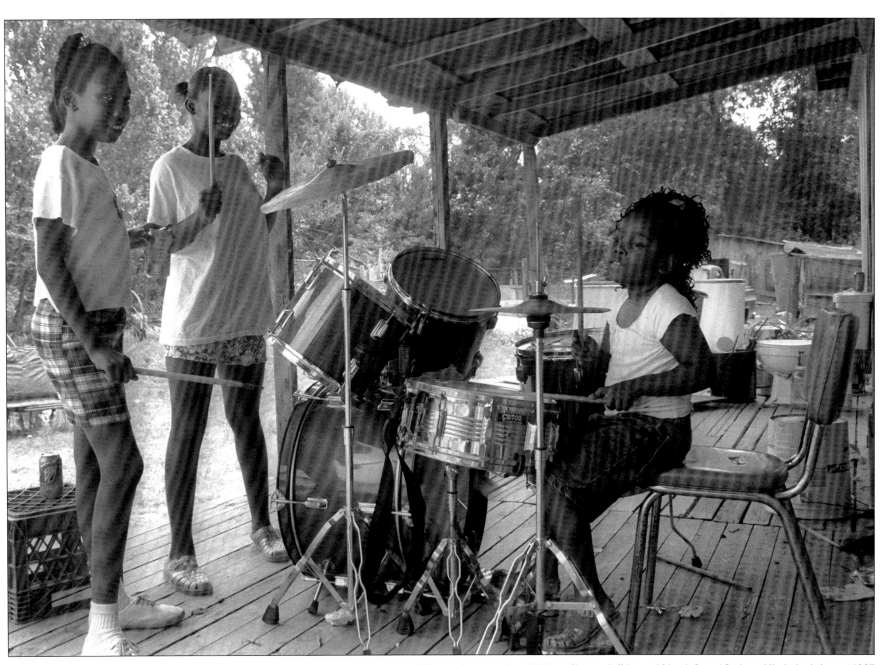

Otha Turner's granddaughters Shardé Thomas (on drums) and Whitney Simone Jeffries and friend, Gravel Springs, Mississippi, August 1997

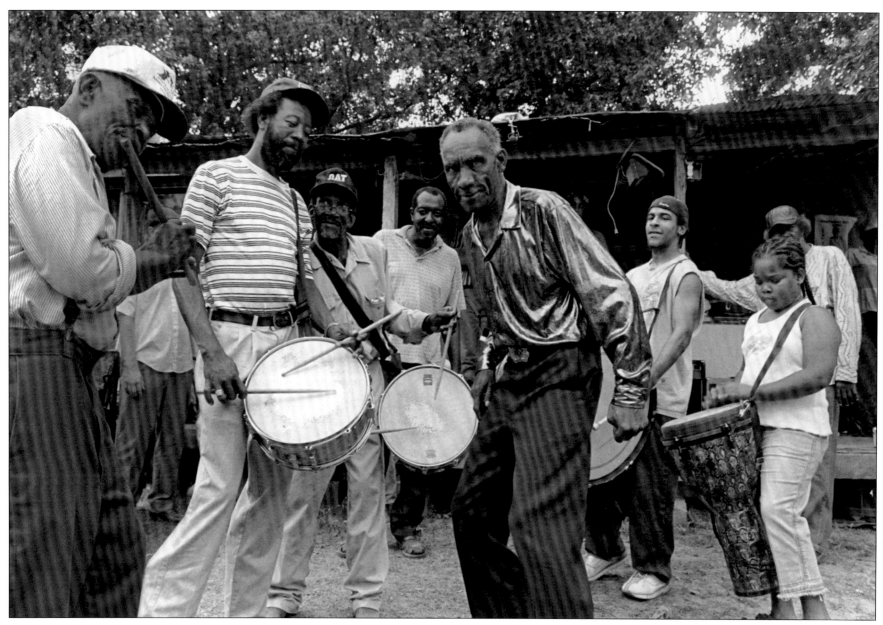

Otha Turner Picnic, Gravel Springs, Mississippi, August 2002 (musicians left to right: Otha Turner on fife, R. L. Boyce, Abe "Keg" Young, Aubrey "Bill" Turner, and Shardé Thomas on drums. Center foreground, Harvey "Red" Ramsey)

Otha Turner, Gravel Springs, Mississippi, August 1998

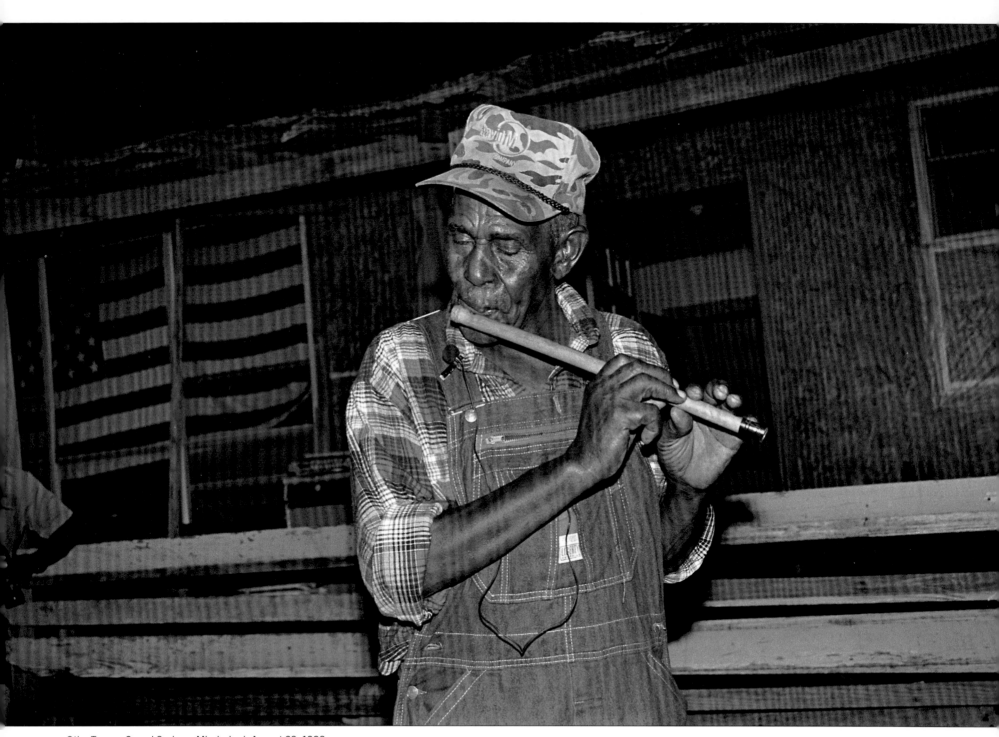

Otha Turner, Gravel Springs, Mississippi, August 29, 1999

Shardé Thomas, Gravel Springs, Mississippi, September 2001

Otha Turner's grandson Andre Evans (on drum), Gravel Springs, Mississippi, August 2007

Otha Turner, Gravel Springs, Mississippi, August 1999

Funeral for Otha Turner and his daughter, Bernice Turner Pratcher, Como, Mississippi, March 2003. (Left to right: Otha's daughter Ada, granddaughter Shardé Thomas on fife, and grandsons Andre Evans, Rodney Evans, and Aubrey "Bill" Turner on drums.)

"I started playing fife at age seven. I feel like I was the Chosen One. Otha said, 'If something happens, you will carry on.' He chose me, the smallest one."

—SHARDÉ THOMAS, *Otha Turner's granddaughter*

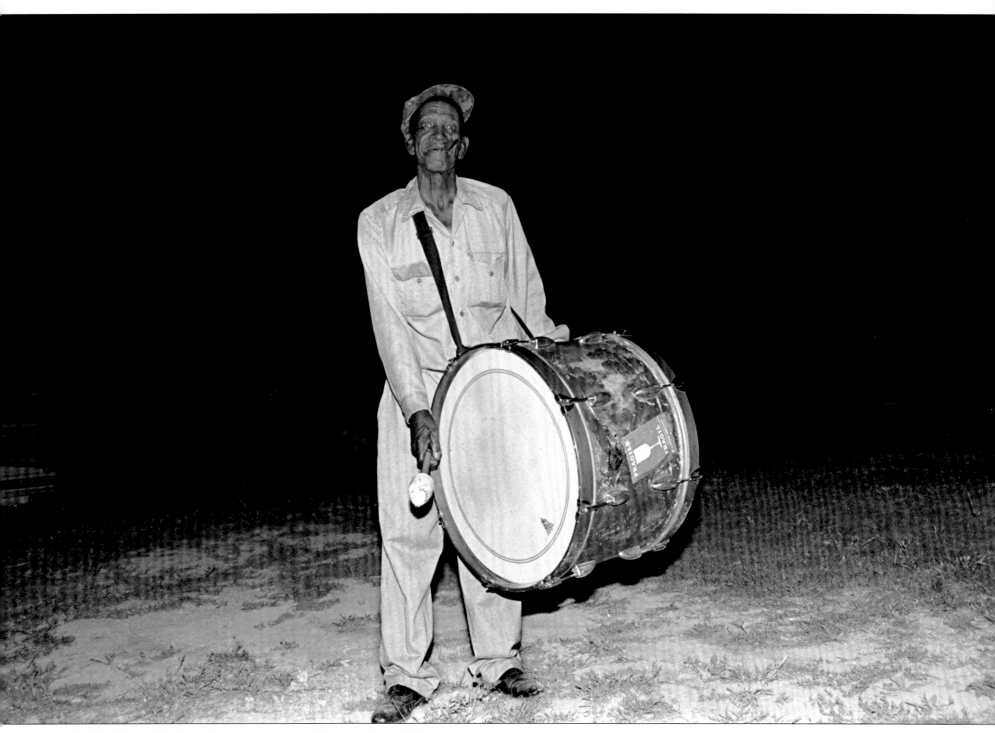

Abe "Keg" Young, Otha Turner Picnic, Gravel Springs, Mississippi, August 1999

Abe "Keg" Young

I was born on September 18, 1932, in Lafayette County, Mississippi. Yes, on a plantation. There was a big farm. Seven or eight families lived on the land. We were sharecroppers.

My dad's name was Lonnie Young [*1903–1976*]. My mom's name was Lillian [*b. 1905, maiden name Wilbourne*]. There were six of us—four brothers and two sisters. John Williams [*b. 1924*] was the oldest. He went to the army. My uncle nicknamed me "Keg" when I was small; I don't know why.[1]

I started helping when I was seven. I had to get out there. My dad wasn't gonna let me sit down. He had me chopping. All of us did it who were big enough. I went to school some and worked in the fields. We had to work in the house, too—cooking, washing dishes, whatever needed to be done.

I was nine years old when we moved out to Harmontown, still in Lafayette County. Dad was renting then. He worked about ninety acres, maybe a hundred. Yes sir, everybody worked full time every day. Had to get them mules, plant and pick the cotton.

Ever since I can remember I heard my dad play. He played fife and drums. My dad started to blow fife after my uncle Ed done got where his wind got short and he couldn't blow. G. D. Young, my cousin, he played drums with them. I loved to hear the music. It excited me. It made me feel good. They played, do their acts, rolling with the drums.

They were called the Tanksley Band. Dick Tanksley, he was old fellow, played kettle drums. Dad played bass drum. They all played 'til he [*Tanksley*] got sick and quit. That's when I started.

I don't know who taught my dad and his brother. I wasn't born. My granddaddy, he blowed harp. That's all he did. My grandma, she picked banjo and Jew's harp.

Chill Wilburn, he died when I was about eight or nine [*1941*].[2] I seen him blowing. Sometime he'd blow around where my daddy and them was. Now, he taught them some but I don't know what he taught them. Professor Wilburn and them they all played together. Actually, they called him "the Rising Star." So daddy and them kept the name. The Rising Star Fife and Drum Band was the name Daddy and them used when I started playing with them. But whoever gave them the name I don't know.

I was about nine. My dad taught me. I had a gas can that I played. Sometimes he blowed the fife, and I beat it. My brothers and sisters, they started playing. My older sister played fife. Daddy taught her. She never did go out and play none. My younger sister played drums around the house. I started first, playing the bass drum.

I put the bass drum around my neck. That's all I ever played. I mocked my dad. He had to listen. He started blowing for me. I could blow a little fife but I never tried too much. I didn't want to fool with it.

I heard A. G. Avant and Johnny Woods [*1917–1990*], all them blowing harmonica around where we lived. On Saturday night I'd slip off to them frolics and listen. There were several of us boys go there. They'd let us in for a while, then they'd make us go home. Sometime they go to cutting or shooting around there. They were drinking that white lightning, home brew.

When I heard the music at the house parties I'd feel good about that. Sometimes there were two guitars, two harmonicas or one. That's where I first heard the harmonica. They played that old "Catfish Blues." That's way back. They played Sonny Boy Williamson. They played a bunch. I can't name all of it.

I thought the harmonica was good. Glen, he run the store up there and he gave me a harmonica to play with. I blowed and blowed and blowed 'til Daddy made me put it down. I still blow a harmonica once in a while.

I loved playing with my dad and my uncle. I started playing drums with them when I was nine or ten. We rehearsed once or twice a week. Sometimes they'd last two or three hours. If you didn't know a song, Daddy was gonna learn it to you. We played "Chevrolet," "Catfish Blues," "Rock, Daniel."[3] Yes, we played "Sitting on Top of the World," "Glory Hallelujah," and "The Saints Go Marching In."[4] We played all the church songs. "Sitting on Top of the World" was my favorite song. There's a lot of fun in beating the drums. There's a lot in it if a man cares for it.

When I was a teenager I went around with them. Sometimes we'd leave on Monday, go and make music at the picnics—Monday night barbecue, Tuesday picnic. We didn't come home. We'd keep on going. Sometimes we'd play days in a row, a week, week and a half. We played all around Como down there. We played at people's homes. Everybody be done—lay by (wait for the crops to harvest). You ain't got nothing else to do.

L. P. Buford would send for us.[5] My daddy and uncle [*Lonnie and Ed Young*] stayed down there.[6] L. P. had a set of drums but he didn't have nobody to beat them. He'd get us down there about twice a year when we wasn't tied up. He wanted us all the time. We had other places to go.

Alan Lomax, he got dad [*recorded him*], I remember that. I played down at Fred McDowell's [*1904–1972*] house.[7] I'm on some of it. I started driving truck. I wasn't with them when he [*Lomax*] sent daddy and them to Newport, Rhode Island.[8] Someone got daddy and them to go to Washington.

Lonnie, Ed, and G. D. Young performed at the first Festival of American Folklife at the National Mall in Washington, DC, in 1967, under the heading "Afro-American fife and drum group, Mississippi."[9] *They played the festival again in 1968 and 1969.*[10] *Lonnie and G. D. Young also performed in 1974.*[11]

Mimi from Canada came and got me and my dad and his brother. We played over there at a festival [*the 1972 Mariposa Folk Festival lineup included Lonnie Young's Fife and Drum Band*].[12]

I settled down here in Looxahoma. I drove truck, local. I took up the drums again. In the seventies I had my own band. I kept a band together 'til about '89, I believe. I played at L. P. Buford's picnics. It wasn't but just the two drums, me and Ollie Watson. He played the kettle drums. The people who were having a picnic, they'd put us on the back of trucks. We'd play the drums and draw the crowd. Yes sir, people would *dance*.

I'd be playing for a night or two with Ollie, when he was sober. If not I'd get somebody else. Sometimes I'd send for Eddie Ware. He come. I liked to keep it up. Yeah, I wanted to keep the tradition going. My dad was dead.

I played with Napolian Strickland 'til he got sick.[13] Napolian played the fife, that's all I ever seen him do. Napolian, he blowed. I'm talking about *blowing*. He blow all night. He had some strong wind. The longer he blow the stronger he got.

Otha had the Turner band. He come get me. I got him to play with me two times. Before the sixties, on the weekends, I couldn't rest for him. I played with Ollie, but when I didn't have nothing to do I played with Otha. Otha blow fife and we played drums. We were the Otha Turner Band. Otha didn't start calling it the Rising Star 'til later.

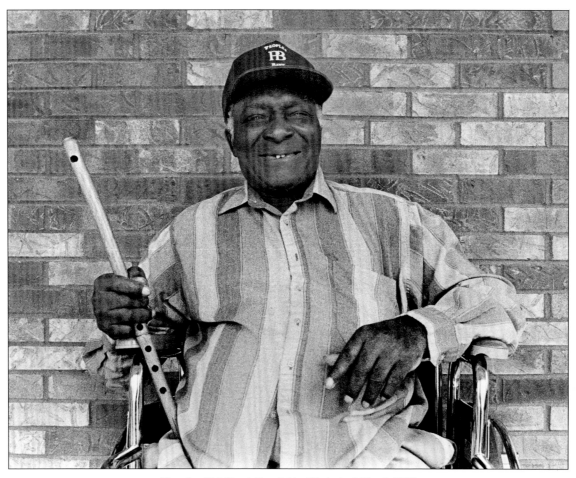

Napolian Strickland, Senatobia, Mississippi, March 2000

I started turning down picnics. My drum players wouldn't show up. Some of 'em stay drunk all the time. I'd still come over to the Otha Turner picnics. I thought I'd come to hear him. I'd play a piece or two.

I think about it. I got my set of drums out there. Sometimes I beat a piece or two here by myself. It feels good. I think about memories, what I used to do. I ain't able to do it like I used to. Sometimes it brings me back to my dad.

Sometimes I have to wake myself. I be at a picnic I be looking for my dad. Yeah, my dad would sing. My uncle was funny. He'd keep you laughing. He was as serious as my dad about the music.

Yes, I hope the Turner kids will keep it going.

Abe Young died August 7, 2010.

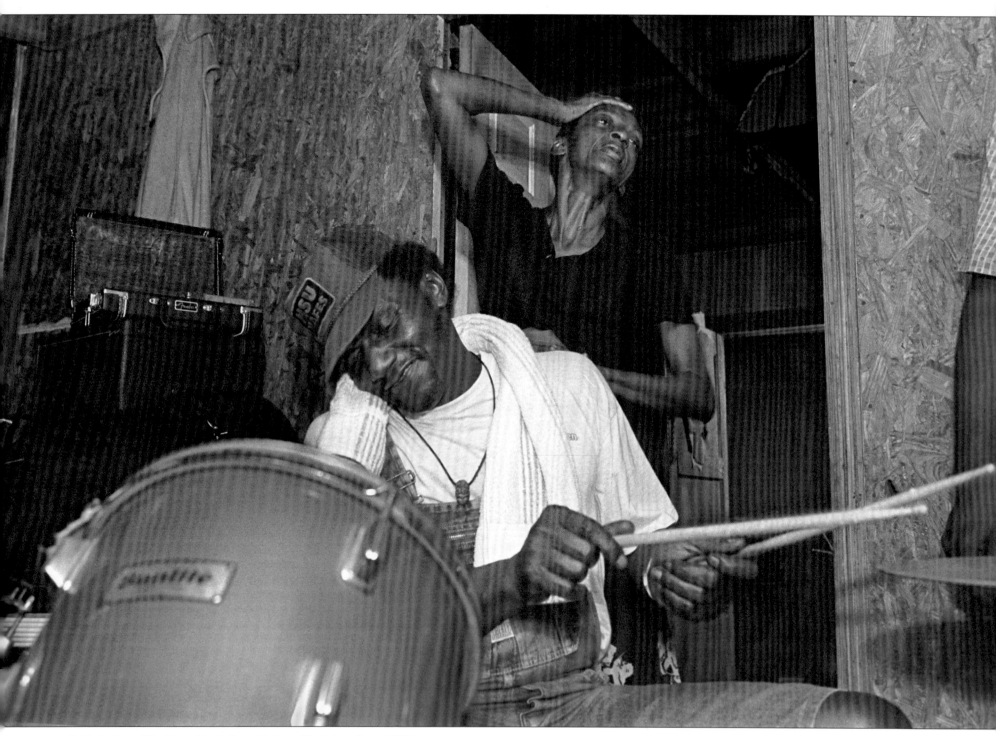

Calvin Jackson, Otha Turner Picnic, Gravel Springs, Mississippi, August 2002

Calvin Jackson

I was born on January 22, 1961, right here in Looxahoma, nine miles east of Senatobia, Mississippi. My mother, Earnmell, known as Remell, grew up in Arkansas. Later her family moved down to the Delta where my parents met. My mother's parents were farmers.[1]

My father's name was Ashley Jackson Jr. They called him "A. J." My daddy grew up in the Delta around the Tunica area. His father died when he was young. My daddy was the oldest and had to take care of the family. They lived on a plantation.

My father was a farmer. He started out sharecropping before he bought the place here. He had his own way of doing things. He could keep his own seed money instead of going to borrow to do his next crop. He didn't depend on many other people and saved mostly everything. My father raised cotton and vegetables. He would send the corn, peas, butterbeans, and watermelon to the stands and truck patches. We had cows for milk and hogs for the market. He was moonshining too.

Every morning before we go to school we would catch the mules for my father. We had to keep the mules fed. It was a busy thing on the farm. There really was no day off unless it rained. Especially when the crop is growing. Many days I plowed a mule. We put the fertilizer around the cotton. You had to chop the cotton. I used to cry to go to the fields. Me and my brothers, we always wanted to be with our father and help. After I started going, there was no turning back.

We did a lot of hunting and fishing. We had three pools stocked with catfish, bass, and trout. My daddy used to do some commercial fishing. We hunted squirrels, rabbits, and coon. We had a deep freezer with different meats and fish in it. Daddy killed a beef every year. We always had more than we could use. If someone needed food at the holidays, he'd give it to them. Everybody helped each other. Back then it was just that way of living.

My daddy knew everybody. In his spare time he would plant gardens for the neighbors. We would always go with our father. So we played with the white boys before our school was integrated. My elementary school wasn't integrated until I was in fourth grade. Color didn't mean very much to me. I felt that from a very small age. That's the way our parents always taught us.

My parents would take us to fife and drum picnics when we were real young. The picnics used to be at L. P. Buford's. We could sit on the porch and hear the drums all the way from down there and Otha's on a good, clear night. The drums did something to me. I just loved the sound.

We'd hear Otha Turner, Napolian Strickland, and my cousins Abe Young [*"Keg"*], [*George*] "Pump" Toney, and Eddie Ware.[2] The Young Brothers was a famous band; fife and drum was a family tradition. They had the old style and stuck with it. They had the biggest reputation until they quit. [*Ed Young died in 1974 and Lonnie Young in March 1976.*]

Mr. Otha was good, but Napolian, back in them days, was just as good as he wanted to be. He had so much funk about himself. I

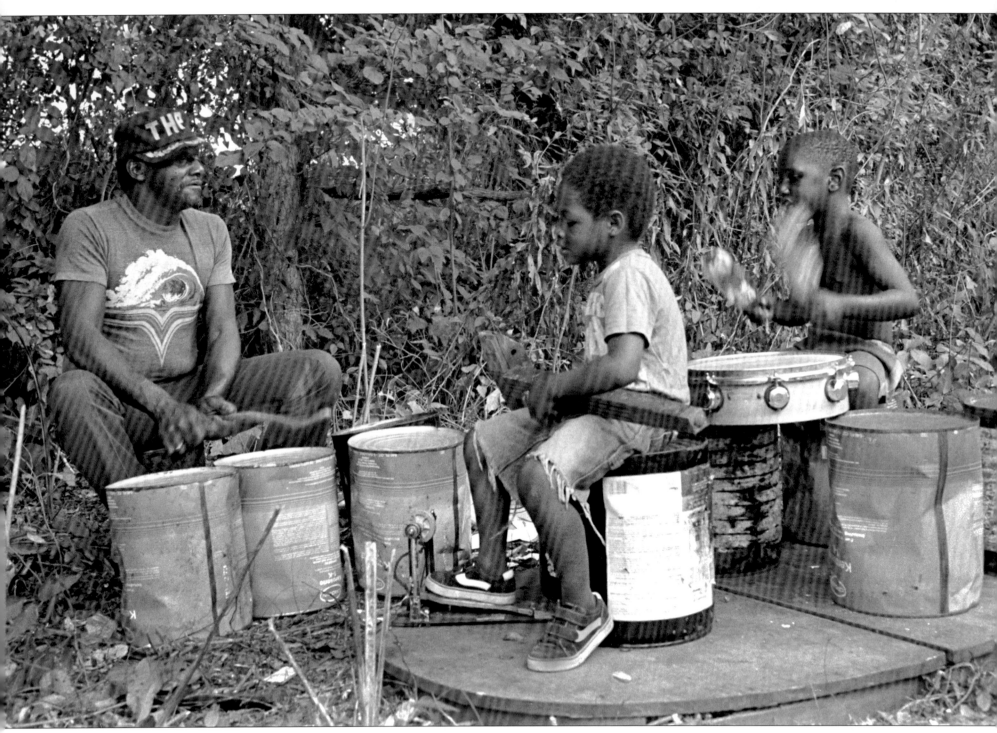

Calvin Jackson with grandson "Phat" (Marveontae Burnside) on drum (far right) and Jeremiah Scott, Byhalia, Mississippi, August 2006

used to love to see him blowing. When he got to feeling good, he'd say, "Oh I'll blow a little fife for you all tonight."

Napolian would talk some. They'd hit the drums, start playing something like "My Babe Don't Stand No Cheatin'." He'd blow one long note, then he'd run out from the guys. They come behind him. Then he'd turn around, walk back to them a little bit. "Now play it to me, boys!" Ooh, it would sound so *good*. It's like a hot cup of coffee on a cold morning. It just stimulates. The sound gave me a rush. That definitely made me want to play drums. Back then drums had real hides and they made the sticks out of different stuff, unlike the sticks you buy in the store these days. When I first heard the drums it seemed like the sound was so much more clear, so deep and real.

The picnic drums is the ones that really caught me. I used to get behind Keg and pull down on his shirt and beg him if I could play. I'd watch and watch. I'd try and beat any drum I got to. I would hit anything Mama had around, buckets or whatever, 'til she run me off. I started playing drums in seventh grade. They made me the first drummer 'til I was caught smoking cigarettes.

When I was young I always went to church—the New Salem Missionary Baptist Church, in Senatobia—on Sundays. I was the lead singer in the choir when I was twelve, thirteen, something like that. I started singing at home, me and my baby sisters, Martha and Renna. We started harmonizing—"folk music" they used to call it. I put a belt like a guitar strap around my neck and put a piece of poke iron through there, and I'd take another little piece of iron and hit it.[3] It made a real nice sound when you got to singing with it.

One night the Jubilee Hummingbirds was at church. My cousin, Al Banks [*Reverend Almore Banks*], was the lead singer. He was the preacher, too. I had another cousin who was a backup singer, E. L. Whitaker.[4] One time Al called me up on stage. I believe I sang "Don't Let the Devil Ride." I made my one or two little moves. People started standing up, clapping. They told me to keep it up. I sang in the gospel choir two or three years. Sometimes I played drums behind the Jubilee Hummingbirds.

I was sixteen or seventeen when I started playing with Daniel and Joseph Burnside. Daniel played bass guitar and Joseph was the lead guitar player. We all went to school together. One Sunday they came by and we went to their father's—R. L. Burnside. He was living outside Coldwater in a neighborhood called Beartail Bottom. They hooked up the guitars and I got the drums set up. Joseph started playing, Daniel fell in with the bass, and I hit the drums. After a while people were coming up and looking. The next Sunday we played again. The Sunday after that people came out of Coldwater like they were coming to a show. The news got around. Two or three weeks after that, cars were all over the yard. Daniel and Joseph came to me when I got out of the car. "Calvin, they heard about you and us all the way down to Senatobia!" R. L. said, "Yeah, he is my drummer." He done claimed me already.

We started playing. People started dancing. I bet you after one or two songs I had five beers sitting beside me. They said "I ain't never seen anybody this bad, man!" I said to myself, I ain't even done nothing yet. I really hadn't got turned loose because they didn't have enough drums. I was just making things work with what we had.

R. L. was still working on the farm. He would do house parties and I would back him up on drums. When R. L. would get off the guitar I would back Daniel and Joseph. R. L. would take the mike and sing. That's the way it became "R. L. and the Sound Machine." We could have really made something. People started going different ways. Daniel moved to Jonesboro, Arkansas. Duwayne Burnside got in.

Dave Evans knew about the Sound Machine [*David Evans, ethnomusicologist from the University of Memphis*]. They called him "Doctor Dave." He recorded us at High Water.[5] Dave asked me could I play fife and drums. Sometimes I played at Mr. Otha's and sometimes at the baseball field down there at Buford's.

I went overseas with Dave when I was nineteen. He's the one that toured us—Jessie Mae Hemphill, Keg Young, Napolian Strickland, and myself. It was exciting. It was our first time flying.

According to David Evans, "I was looking for a drummer who could play a drum set with Jessie and drum in the fife and drum band. Calvin was talented, ideal for both roles. He had a strong

beat. The group went overseas in November 1980. They spent two weeks in West Berlin. performed five gigs in Sweden and played at one festival in the Netherlands."[6]

I played with Jessie Mae, then we had to turn around and play fife and drums. There was no handling Jessie Mae. Neither of us would take anything. She didn't like me at first. I was a little bit outspoken. I'd make her so mad 'til she got where she liked me. We became really good friends. We got where we would be flirting with each other all the time. I'd say, "Jessie Mae, you be looking so *good*." She did look good for her age. [*Ms. Hemphill was fifty-seven.*] "Don't be doing that or I'll have to come to your room tonight."

"Oh, what would you *do*?" She used to call me crazy. "Boy, you just crazy." I would laugh. I would always say something to make her laugh. I'd say something, "You're mad now."

"I ain't mad."

"You mad."

"I *ain't* mad."

"You didn't act like that last night when we was together. It was *good* then."

"I ain't studying *you*. You ain't gonna get no more!" I got to laugh then. I always said something to bring her back to reality.

She would order the guys around. "Keg, you get this. Napolian, you get that. Calvin he's gonna get my bags too."

I said, "I ain't grabbing shit."

She'd say, "Boy, you help them." Jessie Mae would tell Keg and Napolian, "You can't talk to him. He's crazy."

Jessie Mae had a style that only she could really play. Her voice, pretty much the same thing. She would take her shoe off or have a mismatched pair of shoes on stage. That was very unique. One shoe she would have to play tambourine with. She'd hook the toes of her feet into the tambourine and shook it while she sang. You'd hear the song "Boogie Baby, All Night Long," that's where that rattling came from. With the other shoe she'd keep time tapping on the floor.

Jessie Mae mostly played bass drums. She'd be saying she don't want to get sweaty and then have to play guitar. When I first heard her guitar playing I thought it was very strange. It put me in the mind of Junior Kimbrough. They have a different way of playing until you get to know it; it all fits together.

I played with R. L. Burnside and Junior Kimbrough in the eighties and nineties. I was playing with R. L. one night in Marshall County at a big old house party when I first met Junior. They built a stage and gave an outside party for about two days. R. L. and Junior knew of one another. They played first. Me, Daniel, and Joseph knew what we could do. We played "Cleo's Back." It's an old song, up-tempo and mostly instrumental.[7] Junior said, "I didn't know you were all that god damn *bad*." Junior fired his drummer that night after he heard me.

We started playing a lot of shows together. We was like one happy family. I'd play with Junior, turn around and play with R. L. Everyone liked to be around R. L. and Junior. They had a great sense of humor. People would come from miles around just to hear R. L. tell jokes on a Sunday under the big oak tree in the yard.

I started going back out on the road with R. L.—California, New York, and Chicago. He asked would I like to go overseas again. R. L. said, "I need you to go with me." We played festivals in Holland. The booking agent gave me a contract and I went back on my own. I made an album over there, *Goin' Down South*, with my band, Mississippi Bound.[8] [*Calvin moved to Oss, the Netherlands (south of Amsterdam) in the mid-1990s.*[9] *According to his son, Cedric Burnside, he lived there for ten or eleven years.*][10]

R. L. played straight blues, straight from the hills. He mixed it with Delta blues. Fred McDowell is one of R. L.'s influences; Ranie Burnette is another, and Bill Moore.[11] Them the three that I know of taught R. L. some things on the guitar.

Junior played country and blues. He had a very unique style. Jessie Mae and Junior played a mix of cotton patch blues, country blues, singing in a blues style. The beat and the strumming didn't go with the singing, but it works. Junior had a good voice. Ain't nobody else could put that soul blues voice in the way Junior did. Junior made up his own sounds. You have to work with that.

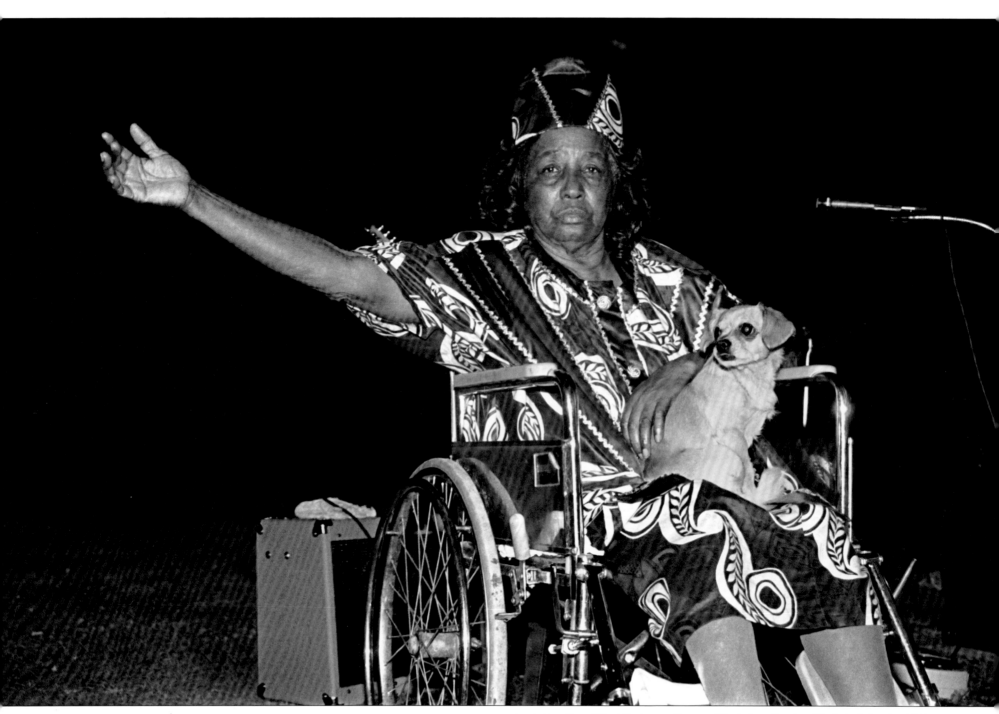
Jessie Mae Hemphill, at the home of Sam and Doris Carr, Dundee, Mississippi, October 1999

Calvin Jackson and son Cedric Burnside, Byhalia, Mississippi, October 2011

George Scales, Junior's bass player, found a way to play behind Junior.[12] They been knowing each other their whole life. No one else could play the bass like George could to back Junior up.

George Scales: "Junior's music was hard to play bass to but I grew up with him. I knew him since I was about five years old. I'd say I was around seventeen, me and Junior would go play at house parties and around a little country store. I switched over to bass from guitar in the early sixties. He'd tell me, 'I'd rather you to play bass with me than anybody else I know.' I was on the first record me and him ever cut, a forty-five—'Can't leave me with tears running all down my cheek.'"[13] ("You Can't Leave Me," written by Junior Kimbrough, the B-side of "Tramp" [Philwood, 1967]).

Once I started following George everything sort of blended in together. Me and him got together a style that was more comfortable with Junior playing. Junior made up his own songs. You had to work with that. When I started playing drums with Junior it was different than the way his drummer played it. I either added something or took out something that shouldn't have been there. That's the way I played the blues, and he liked that. If you play it and you can't feel it, it's not worth doing it, to me. So that's the way we started doing it, and I put some licks in. Any time Junior used to turn around, look back [*and say*], "Play it to me, boy!" I knew it's got to be all right. We became Junior Kimbrough and the Soul Blues Boys.[14]

Two types of music I definitely love—good country music and blues. There's two things about it—you got to love it, and the next things is, all of it has meaning to it. You done it or you know somebody else has done it—a man or woman mistreating the other; cheating on the other, if he can get her back again; my woman and your woman is the same lady. Nine times out of ten some people have lived that life. It has some true things to it. When you put it all together, that's what cotton patch blues is. When you was in the cotton patch you see a lot of peoples.

I know what I want to say but I don't know how to say it. A lot of people will say Black people have all the worry and white people got all the money. I have seen a lot of white people who have problems too. They don't have a whole lot of money. They've had the blues too. You can't color music, especially country and blues. Everybody had their ups and downs.

Me and R. L. used to stay on the same farm, working tractor two or three years. I was dating R. L. and Alice's daughter, Linda. R. L. would say I'm his adopted son. Alice would say I'm the son she didn't have.[15] When R. L. moved, we moved with them. We lived with R. L. on and off seven, eight years.

I showed our son Cedric some things on the drums. He used to come sit on my knees when I was playing drums. He would always walk around the house beating on something. His mama would say, "That boy look just like you. Now he wanna do everything you do." I gave him a set of drumsticks, and sure enough he got busy beating on everything in the house, around the house. His mother would say, "You need to get him some buckets and let him go out there and play them." That's the way he started, the way I did. He got intrigued with the drums and stayed there. My grandson Phat picked up the drums watching me and Cedric or whoever backed up Garry. He'd beat on pretty much everything that was around, just like me and Cedric.

Calvin Jackson passed away in Senatobia on February 10, 2015.

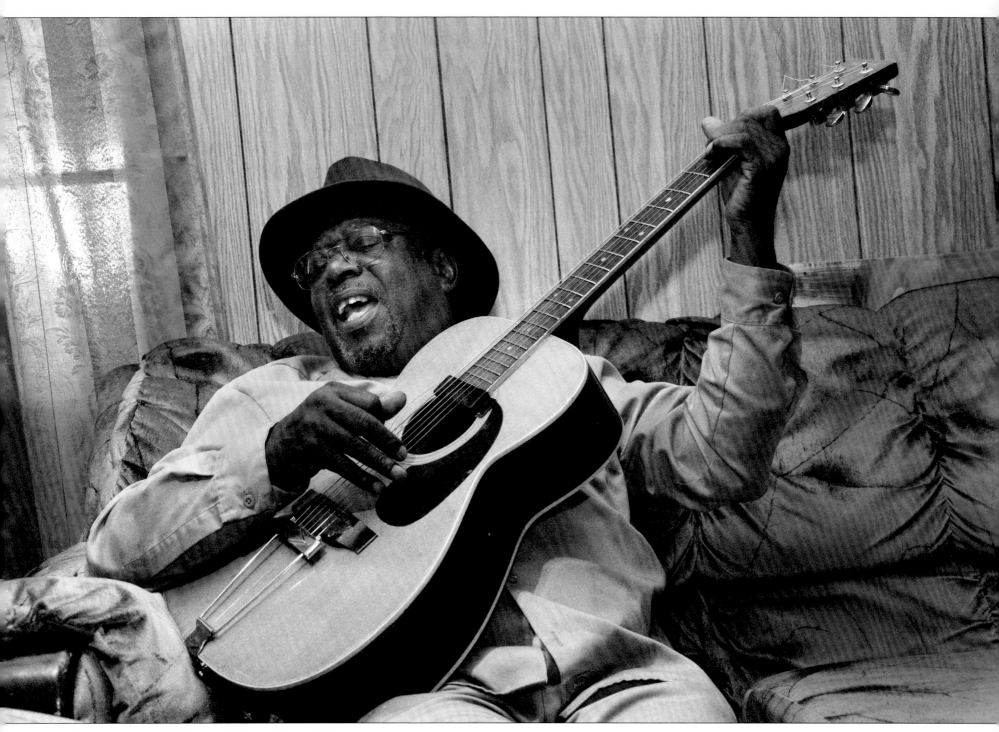

Joe Ayers at home, Holly Springs, Mississippi, October 2017

Earl "Little Joe" Ayers

I was born between Lamar and Ashland, Mississippi, on November 28, 1944. My parents were Ethellene Godwin and Lester B. Boga Ayers.[1] Earl is what they named me. I don't know how I got the nickname "Little Joe." I been having it ever since I knowed it. Everyone calls me Joe today.

I ain't got much I can tell you about my father because he and my mom left Benton County and moved to Memphis in 1948, when I was four. I'd see him every blue moon; he'd come back to visit. He left here due to hard times.[2] He got a job doing construction. He sent for Mama. They stayed in Memphis for a while. Then Mama left him and went to New York and stayed up there until 1957. I don't know what she did.

My daddy's father was Malcolm Boga. He lived in Ashland. My grandfather did a little farming. He got my daddy by my Grandmama Sarah before she got married to Gus Ayers.[3] Grandfather Malcolm was a big timer. When he died all the women looked up to him 'cause he had money and a whole lot of land. I don't know how he got it. Back in the day no white folk owned land near him because the area was a Black settlement [*Little Egypt*].[4] There was some wealthy Black folk down through there. Malcolm sold land to Black families to homestead and built a store on his land. During the civil rights movement white people put Black people off their places and got rid of all of them. Later the government, the FHA [*Federal Housing Administration*] started buying all that land and building these homes for the Black folks.[5] That's how I got my home.

My great uncle, Ples McKenzie, raised my mom and her brother. He raised me and my older brother, Jimmy Louis. Jimmy drowned in 1955. Everyone called my great uncle "Candy." Candy and his wife Frances raised thirteen children—all of them children of relatives. They didn't have any of their own.

Candy was a hard worker, a good survivor, and he made sure everything went right. He was rentin' the land we lived on. He was never a sharecropper, but it was just about the same. He raised cotton, corn, and food to eat. He had a garden of all kinds of vegetables.

My great auntie prepared the meals. She couldn't walk. I was told she fell on a pile of bricks and it crippled her up real bad. Relatives were there just about all the time, visiting and making sure she was all right. My great aunt taught me everything I know.

We heated the house with wood. I had to cut it. We had a hand pump for water. We heated the water for teakettles, pots, and them big old wash pots. That's how they used to wash quilts and all of that. They made their own soap out of lye and different things. People used to fix their hair with it. That stuff will burn you up.

The whole area was just one community. Everybody knowed everybody, Black and white. Lamar was a little old town, and Ashland was the county seat of Benton County. You roam on the weekends one side of town to the other. You could run from my great uncle's house to where my dad's family lived. You could run from one house to the other, right across the bottom. That's how everybody met.

We all went to the same church pretty much, the Greenwood Baptist Church in Lamar. Sometimes I used to skip church and go to my great uncle Ben Thomas Boga's house. Somebody would make him homebrew, and he'd get somebody to take his wife to church. We'd be sitting on his great big porch. He'd be playing an old guitar and get drunk on that home brew. He played and sang one old church song over and over—"I'm gonna walk to the Milky White Way one of these days."[6]

Uncle Ben Thomas told me "I would give the guitar to you, but I'm gonna make you say 'I *bought* my first guitar.'" He sold me his guitar, a resonator, for four dollars. I had to pay him a dollar down. I worked hard to pay for that guitar. I was about eight years old. I was the guitar player for one or two years for a gospel group called the Starlight Junior Girls. They sang at different churches wherever they wanted them. I was in grade school when I started.

My great uncle had a son, my second cousin Lindsey, who was a great guitar player. I got interested in playing guitar seeing Lindsey and Junior Kimbrough play. They came up together. I'd see them working in the fields, going to the barn, going in out of their houses, and playing music on peoples' porches.

George Scales, later Junior Kimbrough's bass player, also recalled seeing Junior and Lindsey Boga during this time: "I used to listen to my cousin Lindsey. He come down to Hudsonville and play on the store porch. People would be crowding around. Junior would play with him."[7]

We had an old wind-up record player, a Grafonola. My Auntie Frances used to order records from Sears & Roebuck. We had a whole lot of seventy-eights—Blind Lemon Jefferson, T-Bone Walker, Fats Domino, and Sonny Boy Williamson I. No one near us had a record player, so people would come to our house and dance all night, on Saturday night mostly. That's the only thing they had going for them except for drinking corn liquor. Our house would be full of folks. The old song "Boogie Chillen" got everybody dancing.[8] Candy had a still down in the woods where he made his whiskey. That's how I learned to make my home brew, watching him.

We had an old battery radio with an antenna on it. You start inside the house, bore a hole through the wall, and run a wire from the radio to a post on the outside of the house. We could pick up music from stations in Memphis anytime and from Nashville after ten o'clock at night. We were listening to blues on WLAC in Nashville and WDIA in Memphis.

I went to school until I was about thirteen years old. The school, when I started, was in the wood plank church in Lamar. It was just for Afro-American children. There was one teacher for all the grades—first through seventh. We had the books that the white kids used when they got new books. Children of all ages would be sitting together. She would say, "Everybody in first grade, get up!" If I could beat you spelling you drop back one. That's the way it was. Same with reading, math, and geography.

The PTA got together in the fall every year. They cut a whole lot of wood for the school. The boys had to carry the wood inside and put it in the heater. Girls and boys drew the water. Some schools had a well and some had pumps. We had two or three buckets. Everybody was drinking out of the same dipper. That's the reason I don't believe there's such a thing as "catching" anything. Everybody was just as happy and healthy as a goat back in the day.

The junior high school and high school near Ashland were all under one roof. They divided rooms halfway down. If you lived in the rural area, you went from pre-kindergarten all the way through high school in one school.

Please believe me it wasn't but four months out of a year Black kids went to school. I went to school something like November through February. The other eight months of the year we were working. If you weren't in the field, you were doing something. You know to get in the wood, feed the pigs and horses, and tend the garden and all of that. At seven years old I was plowing a mule.

I left school at thirteen to work. I helped my great uncle [*Candy*] whenever I had a chance. I was working for the man my great uncle rented from. For two dollars a day I was driving a tractor, putting

in corn, picking cotton. I worked for all the big white folks. They respected me and kept a whole lot for me to do, year-round.

The white people got along with you if you stood up for yourself. If you was man enough to look him in his eye and tell him how you feel about him, what you was gonna do, what he wasn't gonna do, you would get what you want from him. But if you would start scratching your head, say yes sir, no sir, well then he'd handle you just like he wanted to.

They said a white man burned up another white man who owned a country store in Ashland.[9] When we'd go to the gin carrying a bale of cotton we'd pass the tree where two Black boys got hung for what the white man did.[10] Lots of folks were scared of that place. They'd say they'd see or hear the brothers, the Jacks—"Happy Jack" and "Corn Jack"—hollering.[11]

I've known Junior Kimbrough my whole life. Junior lived in the neighborhood a few miles away from us. He was older than me [*Junior was born in 1930*]. Junior said he learned to play guitar from his brothers and from Willie Jenkins. Willie worked in a brickyard. He lived maybe five miles from where Junior lived. Sometimes I used to see Willie and Junior together at different places playing their guitars.

They had house parties around the community mostly every weekend and some weeknights when they weren't working. Sometimes Junior and Lindsey would be at our house. The people would dance, gamble, and drink whiskey. Junior and Lindsey were playing blues. The feeling when I heard them was great. I liked what they were getting from the peoples. They got to drink free. They got a little money and all the womens they wanted. I'm seeing that at a very young age.

Everybody could pick up a guitar and do a little something. Those songs way back were very easy to deal with. I'd look where the guitar player put their hands. If you look at something hard enough and want to do it hard enough you ain't got to ask no questions. All you got to do is act like you ain't paying no attention but *be* paying a whole lot of attention. I'd watch Junior and Lindsey, then I'd get my guitar and start doing what they did. The next thing you know I got it. You better play it all night, a long time, 'til you just can't forget it. Once you get the first song, that's the base of music, the rest will fall in place.

Whatever time we got off of work I always made time for the guitar. Just like it's part of the job. You ain't made your day until you play something on the guitar. I kept teaching myself 'til I got enough of it.

At nighttime I'd get my guitar and go out on the porch. You could hear good at night. There wasn't much going on. Every blue moon you hear a bullfrog, some old cow holler way over there. You could hear a car coming three miles before he got there. People riding a horse, that hard ground, you could hear the horse coming.

Some nights I'd leave my house to go somewhere where I'd play. I had to pass the neighbors' houses and they'd hear me coming. Somebody sitting out on the porch would holler, "Play it, Joe! Play it!" Sometimes I would be playing or singing as I went up the road. I'd play and sing whatever be in my mind—Muddy Waters, Lightnin' Hopkins, and Jimmy Reed songs I heard on the radio.

People sung every day wherever they worked, not just in the fields. Picking cotton, everybody in the field, all the women, they'd be singing church songs, some old hymn or another. They sang, "I'm So Glad I Got Good Religion."[12] One woman way up front would lead the song. Another time she might sing, "There is a cross for everyone."[13] She would send a signal with her hand. Everybody would be singing with her. They ain't never taken their head up until they get to the end or they take a break. They picked one hundred pounds of cotton before you know it by singing those songs.

Some of them old people could sing a hymn make you cry. Some of 'em could sing old blues and make you cry. It all has to do with your feelings within the body of a human. It don't make no difference if it's blues or gospel. It's all got the same feeling. Church songs and blues come from the heart. You don't know if you feel good. You don't know if you want to cry. You don't know if you want to enjoy. You got something. You don't know what it is. Feeling ain't got no color. It's all about the feeling.

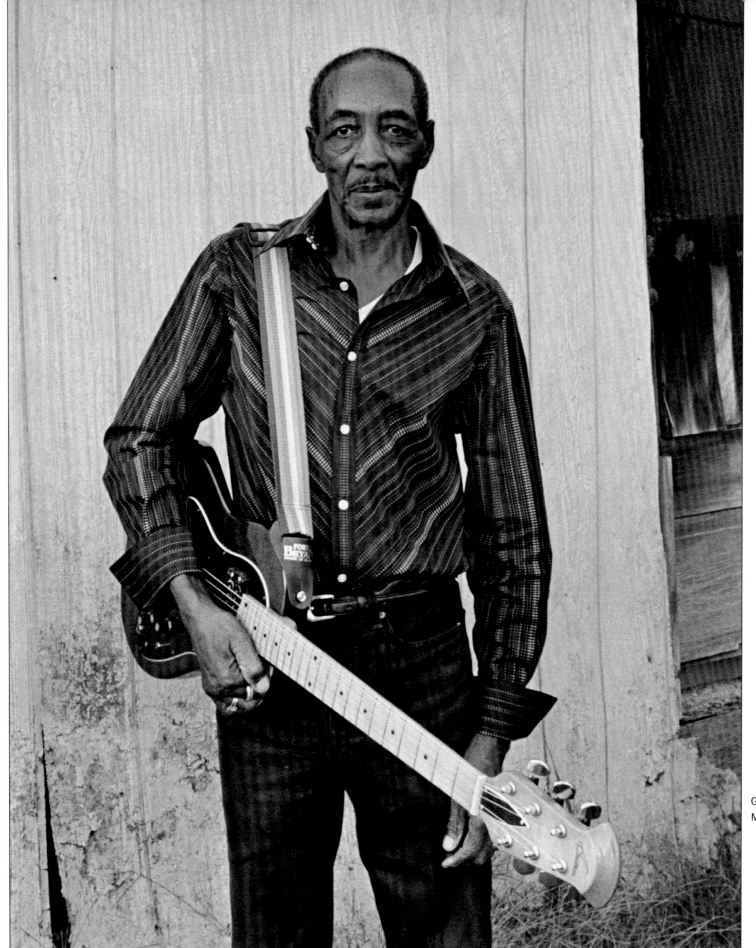

George Scales, Looxahoma,
Mississippi, October 2005

If you sing the blues in the cotton field, I don't care how long the rows is, you won't ever know from the time you start until the time you get to the other end. That's the blues. You been sung all the way up there and if you got tired you didn't know it 'cause the blues will help you keep your mind offa what you were doing. The blues got you there 'cause you can't remember going up the row. All you can remember is singing the blues. You couldn't did it without singing the blues.

When you plowing a mule you sung from one end of the row to the other. You tell that mule "Whoa!" (stop), "Gee!" (right), "Haw!" (left), "Come in here!" He'll level out (turn around), then you start back plowing and singing. You done plow that mule from one end of the row to another never recognize that you went that far. As a boy I was singing "Good Morning Little School Girl," "Don't Them Peaches Look Mellow Way Up in That Top Limb," and all them old songs.

The mules get the blues too. They would enjoy peoples singing behind their labor. You won't believe this but it's the truth. If you sing a fast song a mule will walk fast, but if you sing a slow song a mule will walk slow. The mules stepped to what you were singing the best they could.

I started driving tractor when I was thirteen. That's when Junior, he'd be in one field, and I'd be in another next to him. We were both singing. I'd be singing some old Muddy Waters song—"Trouble No More," "Forty Days and Forty Nights," and "Two Trains Running" ["*Still a Fool*"]. Junior, he'd be singing one of his songs: "I Done Got Old, I Can't Do the Things I Used to Do." Those songs are new to you all but they ain't new to us. Before I was a teenager Junior used to sing that song, "Keep Your Hands Off Her." Junior been singing them songs all his life.

I was in my late teens, just about grown, when I started playing house parties with Junior. There used to be houses on both sides of Lamar Road we played at all the time. When Junior get tired playing guitar at these house parties I always be there. He called me "Runt." He'd say, "Come on, Runt. Help me out here. I'm gonna take a break." He'd play his style of music. He didn't want nobody to play his music so I'd play something like Muddy Waters or Howlin' Wolf. Sometimes we played at Juppe's, a little joint in Hudsonville.

When I started I was playing in open E and open G. Junior always played in straight Spanish. Later I made a change and went to straight Spanish standard tuning. I been playing that ever since.

Playing at house parties was nothing but fun. Take all the furniture down, move it out on the porch. They wouldn't be doing nothing but jumping and dancing. They'd be breaking the house down. The wood was pulling loose from where it was nailed together. They called that a "nail stretcher." There was too much weight and bouncing on the floor. They'd holler, "Somebody got to get out of the house!" Not too many were getting out. Somebody would shout, "You all lighten up!"

You could hear the guitar playing half a mile away. You could hear peoples dancing, good timing. People get up, and here they come. They would ride horses and mules to a house party. The next thing you know you got a house full of folks. Some back there gambling by lantern, drinking whiskey, just doing everything. We're talking about Benton County. That's where the Hill Country music originated from, from North Mississippi.

I moved to Holly Springs in 1962 for a better-paying job. I run bulldozer for the high sheriff wherever he needed me to go. When I first come to Holly Springs it was a small town. There were separate drinking fountains for Black people and white people in the courthouse yard—they weren't used after civil rights. I was told they used to hang Black people in the steeple of the courthouse.[14]

There were a lot of musicians and Black cafés in Holly Springs. People would pick up and start playing in the middle of the street, in front of cafés, and on the corners of the square. People would listen and throw money at musicians. Fred McDowell would be playing at Shoemaker Corner off the square.

I bought me a brand new Stella guitar, a little white one. I thought I was some big stuff! It *was* big stuff. Anything anybody got back in them days was big to them because they weren't used to anything new.

Guitar players would meet up with one another. Everybody had a guitar in their car mostly. I'd ride uptown. Junior be out there

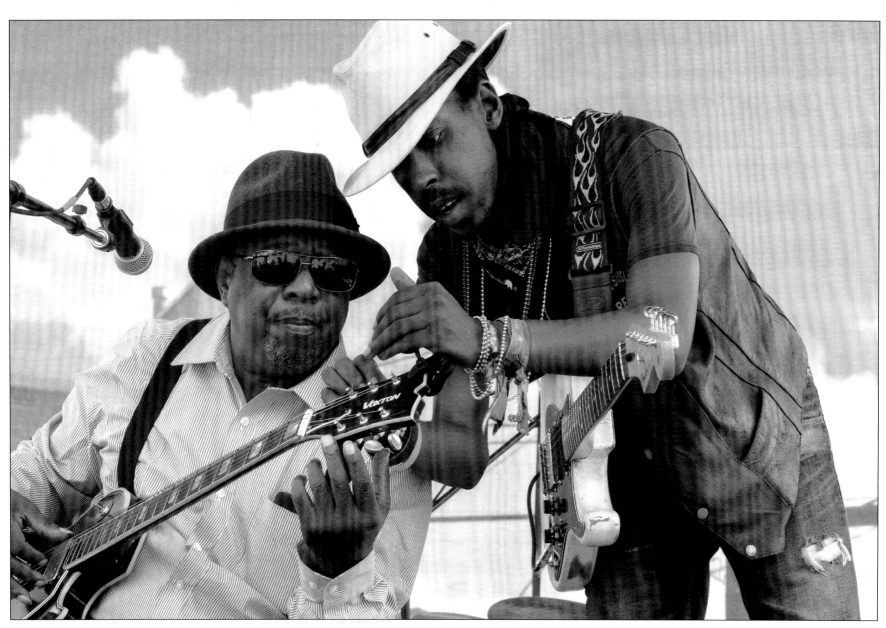
Joe Ayers and son Trent, King Biscuit Blues Festival, Helena, Arkansas, October 2018

in the street. I'd sit in the back of the car playing. He'd say, "Come on man, let's play one. Come help me out." Junior and I used to ride up and down Clear Creek Road in Marshall County going to people's houses to play.

There was music everywhere. I'd stop over at R. L. Burnside's. There'd be a house party going on. Sometimes I'd sit in and play with the Burnsides. Sometimes R. L. and Junior [*Kimbrough*] played the same shows. B.B. King and Howlin' Wolf used to play in Holly Springs and clubs on Highway 72 in Benton County.

Junior had a dedicated place where he gonna be playing at in Benton and Marshall Counties—Marshall Scruggs, the Harlem Club, the Rainbow Club, and the Hut. Every Friday night we'd play at Marshall Scruggs from the mid-sixties until '75 when Junior moved out on his own. Marshall used to have big fish fries and parties out there. He'd get Otha Turner to come with the fife and drum. We were playing all over then, mostly on Saturdays—Holly Springs, Memphis, Pontotoc, and Clarksdale.

Junior, he couldn't keep his mind off of women. He could play all night long just to meet a woman he wanted to be with. He often was successful. We used to take those guitars and tell a woman everything that we wanted her to know.

George Scales played with Junior back in the 1950s. George was older than me and went to school with Junior. They grew up together and ran around in the same neck of the woods. When I started playing with Junior, George was playing bass. At first he was around more and I played second guitar, rhythm guitar. George worked construction. When he worked out of town, I'd play bass. When George started working out of town for good, I became Junior's regular bass player.

George and I were the Soul Blues Boys, with Junior. John Henry Smith joined us in the mid-sixties. That's when we did the first forty-five—"Tramp." There always been some scout people. They had heard about us. We were playing at the Hut in Holly Springs one night. We recorded the forty-five in a studio in Memphis on the Philwood label.[15] It was a big-time seller, but the company's warehouse got burnt up and pretty much all the cases of 'em. We didn't get nothing but the royalties off the record.

When I wasn't able to be with Junior due to being out on a job somewhere, he'd have Garry Burnside play with him. Junior wanted the music played his way. Garry learned how to play bass from Junior. He pretty much listened and caught on to Junior's style. Couldn't just nobody play with Junior. Only a few peoples could play Junior's music.

Junior got changes in there, but when and what time, you got to feel Junior to know when to change. There's a deep secret. George and I could've told the world, everybody, what to look for when Junior getting ready to change and everybody could've played with him. We could tell by the expression in his forehead. When he do something like he's fitting to change then he be getting ready to jump. He be tightening up whatever he gonna change. George and I talked about it. Calvin Jackson, Garry's brother-in-law, told Garry what to look for. Garry paid attention and fell right in it.

Junior always did have somebody play drums. We started playing with somebody beating a five-gallon lard can. You turn it upside down. Whoop one side, whoop the other. Billy Joyner played with Junior many years. He put the lard can between his legs and hit the bottom of the can with one hand and the side with the other hand. That made pretty music. John Henry Smith was the first one to start playing real drums with us. He played off and on for five, six years. He got sick. John Henry McGee, he come in there whenever Junior needed him. Off and on Bob Horn come in. Once in a while Allabu Juju—Winston Doxey, everybody call him "Juju"—he come in there. Calvin Jackson played drums until Junior passed. All them dead. Sometimes Junior's son Kinney played drums with us.

There were plenty of harmonica players back in the time. But they just about all died out. Edward Johnson was a good harmonica player in the fifties. He played a whole lot with Junior. We called him "Pillar." He died of leukemia when he was eighteen years old. The sound of the harmonicas was so sad and so lonesome in the old days. And there were some peoples who could whistle the blues so good 'til it make you cry.

My cousin Lindsey left Mississippi when he was real young. He wouldn't go behind no mule. He went to Arkansas. He started to play with Willie Dixon and James Cotton. Then he got drafted in

the army. Lindsey tried to get Junior to go with him. Junior said, "No, I ain't going nowhere." He got out of the army and come to New York. He told me he played with many different bands—James Brown was one. He returned to Mississippi a little before Junior died, January 17, 1998.

I found Lindsey and asked if he'd play at Junior's funeral. Sylvester Oliver, our promoter with High Water Records for many years, rehearsed the songs we were gonna play, a day or two before. I played lead. Lindsey played rhythm guitar, and George Scales played bass. One of Junior's little grandsons was sitting back on drums. Sylvester brought us up on stage. He had Junior's guitar sitting in a chair where Junior would be. I always played to his right. I can't hear tuning no more on guitar. Junior played the loudest guitar. My guitar would fall out of tune. Junior would feel the neck, the string and ease up on it. He'd be singing until he hear my guitar direct in tune with his then he go on back to playing. It was hard playing at Junior's funeral. There were a lot of good memories.

I retired off the bulldozer and from the Holly Springs School District the same day, November 18, 2009. I maintained the heat and air conditioning for all the public schools in Holly Springs.

I have more guitars than I have dollars. I keep one acoustic guitar in the bed with me all the time. There's so many times I wake up; I have something on my mind. I play a lick or two and lay it back down. I lay there and think about what I had did. I know the chords on it. I know the fretboard. I know where it's supposed to sit—any one of them keys on that guitar. You put all that together, then you reach over there and get it.

My son Trent was around guitars his whole life. Trent learned to play on his own. It was always something he wanted to do. Yes, it's a special feeling when he plays with me. Trent knows exactly how to back me up.

I recorded my CD, *Backatchya*, at Kenny Brown's home.

Backatchya *(Devil Down Records, 2011) won the 2012* Living Blues *Critics' Award for Best New Recording/Best Debut. Joe sang and played acoustic guitar for this solo recording on Kenny Brown's front porch. Kenny recalls: "I'd been after Joe to make a recording for a long time. I finally got him over to the house, had somebody here to record him, and got Joe to sit down and agree to record some songs. Joe is a great guy and one of my best friends. Joe's got the old style of singing and playing blues and Hill Country down and makes it his own. Joe knows everybody around Marshall County. He's an encyclopedia of Junior Kimbrough's music. Joe really loves to play."*[16]

I still play festivals when I want to. I've played at Juke Joint Festival in Clarksdale, King Biscuit Festival in Helena, North Mississippi Hill Country Picnic in Potts Camp, the Kimbroughs' Cotton Patch Blues Festival in Holly Springs, and Red's Old Timers Blues Festival in Clarksdale.

I can sing them old songs. Singing is all about something on your mind. Singing brings back memories. When you hear and play those old lonesome songs you're saying you've been there too. Black folks they can feel that music, and the more they feel it, the more they can play it. Peoples cry when you start playing. A musician gets lonesome or something like that, they might cry all day and play that guitar to death. If a musician is by himself or around a whole lot of folks, he may get up and walk over there, cut the amplifier off, go somewhere, and start crying. That's what you call soul. You can call it blues. It's the same thing.

From my experience all the blues comes from hard labor, Black labor, a hard day's work—pulling corn, chopping and picking cotton, being behind the mule, and swinging the axes. That and your woman done quit you or with some other man, gone away and left you, you staying at the house all alone. All that falls right back, makes men sing the blues. To sing and play the blues you have to have the feeling.

My feeling for the blues and the way I play the blues come deeply from my heart and from my life experiences. Playing to get a dollar, a woman, to get out from behind the mule was a big thing back in the day. You feel from what you been through, what you going through. You be singing from your heart and soul 'cause you been there. You know what it's all about.

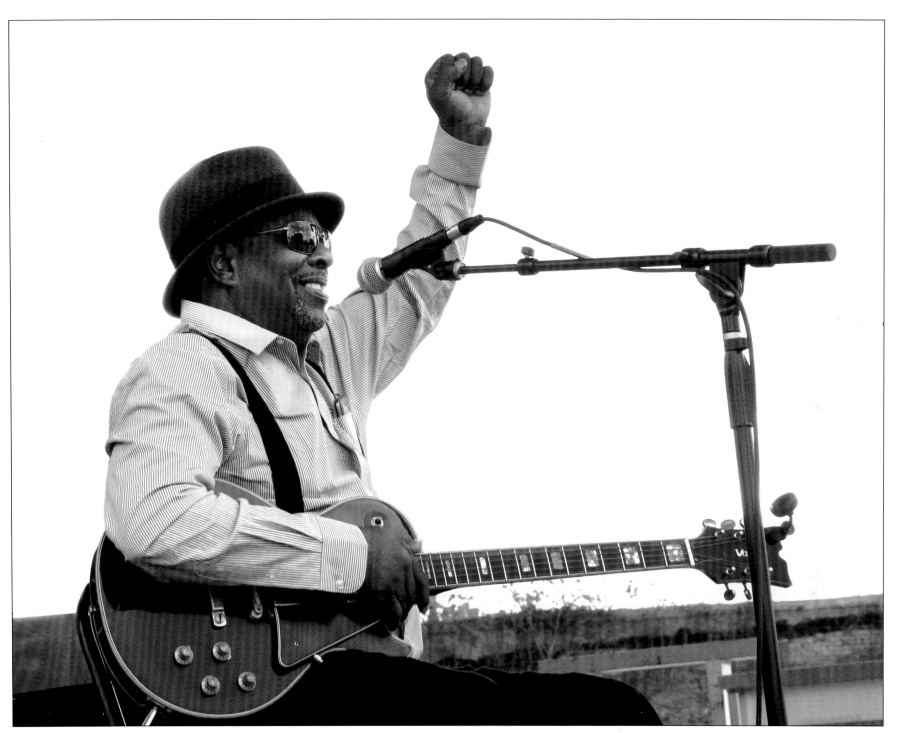

Joe Ayers, King Biscuit Blues Festival, Helena, Arkansas, October 2018

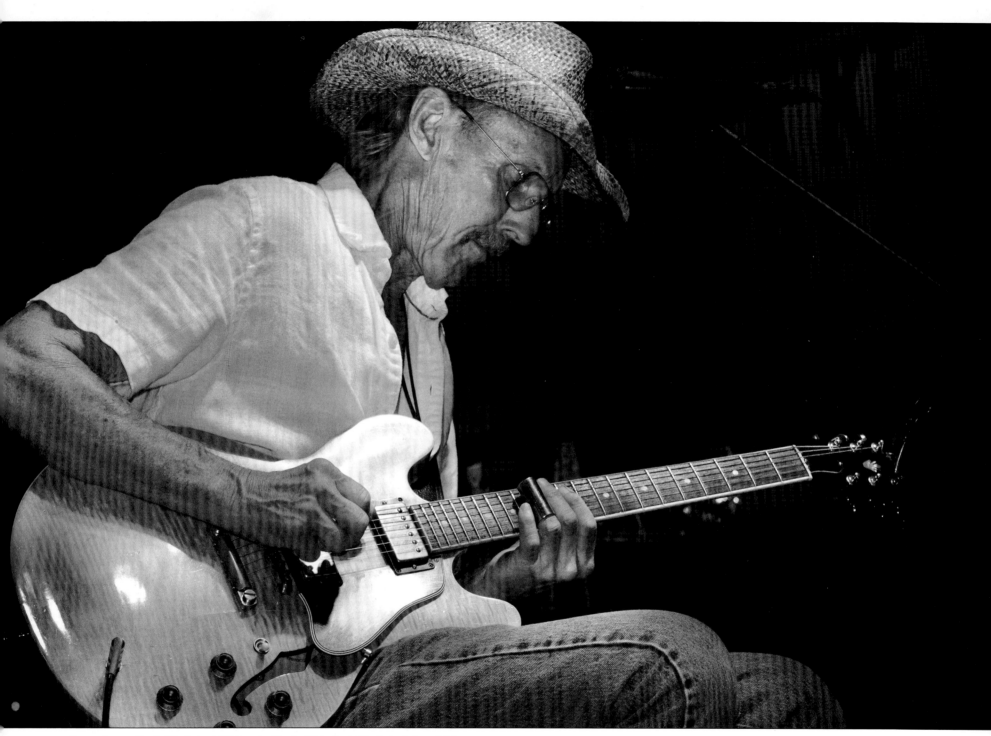

Kenny Brown, North Mississippi Hill Country Picnic, Waterford, Mississippi, June 2021

Kenny Brown

My dad was in the military, stationed in Selma, Alabama, and that's where I was born on July 5, 1953. I grew up in Nesbit, Mississippi, fifteen miles south of Memphis. Our neighbors, the Jacksons, had picnics across the road from the house we moved to. When people were gonna have a picnic they would put the fife and drum band in the back of a truck and ride around the community to let everybody know there was a picnic going on. Sometimes they'd start on Friday and go until Sunday night. They had them for several years as I was growing up.

I remember being out in the yard when I was about six or seven and heard this fife and drum music coming down the road for the first time. I thought, "Wow, what is *that*?" It kept getting closer and closer; then they turned in to the Jacksons. My mom said that when they were playing music over there I'd be standing on the edge of the hill leaning as far as I could towards the music, trying to hear it. They'd go on all during the weekend. I loved hearing the music. My mom told me later on they used to have to *spank* me to make me come in the house.

I think that and other things that happened in my life—it was all kind of laid out, I guess. I got a guitar at the age of ten and was taking lessons but they were teaching me to read music. I wasn't doing too good at that. Joe Callicott moved next door and showed me how to play. [*Joe Callicott was a pioneering bluesman who recorded on the Brunswick label as far back as 1930. He was in his late sixties when Kenny met him.*] He'd just say, "Hit it like *this*, boy." I'd describe his style as country blues, real similar like Mississippi John Hurt. He was singing songs—"Jesus on My Mind," "Laughing to Keep from Crying," "You Don't Know My Mind," "Going Back to the Junction," and "Fare Thee Well Blues."[1] That's where I went every day before and after school. Joe was like a best friend.[2] He played with Frank Stokes and Garfield Akers.[3] He had played in medicine shows and levee camps, when they were building a levee along the river.

After Joe died [*1969*], I started hanging out and then playing with Johnny Woods. Johnny was a great musician and the best Hill Country harmonica player around here. Sometimes I'd pick Johnny up on a Friday evening when I got off from work and he got off the tractor. Sometimes it would be Monday morning before I dropped him off. We'd just ride, stop by different friends' houses and play, or go somewhere to a party. We wasn't making any money but we had a hell of a lot of fun.

Johnny and Fred McDowell played so good together, it's hard to believe that two separate people would think the same way. I learned indirectly from Fred [*died 1972*] by listening to his records and playing with Johnny.

I didn't know anything about R. L. Burnside the first time I heard him. I just went and introduced myself to R. L. at the end of a show. I told him I liked what he was doing, that I played a little

guitar, and I'd like to learn some guitar licks from him. R. L. told me where he lived and to come on down to the house.

I started hanging out with R. L. two to three nights a week. He showed me what he was doing, and then we'd play together. R. L. had a somewhat similar style to Fred McDowell, that Hill Country one chord stuff. I learned the way R. L. played. His songs were grooving, real tied in with the fife and drum style. A lot of R. L.'s songs you can play with one finger on the left hand while the right hand's the one that is doing most of the work and playing the rhythm. That's how he and I got the sound that we got because our right hands were doing so much. Sometimes we'd be playing the same thing but you're not playing it exactly the split second the other person is doing it. Especially when you got with electric guitars and crank 'em up a little bit, you start getting all these harmonics. That's what made our sound so full. I've been on stage with R. L. and swear that someone had walked on stage and started playing piano or harmonica. I turn around and look and nobody's there—but you'd be hearing it.

R. L. showed me how he was playing slide, and I incorporated that into my playing. I was learning slide anywhere I could. My cousin had a guitar. My dad, he didn't even play, but he took the guitar, pulled out his pocketknife, and slid it on the strings. That was the first time I saw anybody do that. Joe Callicott would take a knife and lay it in his lap, tune to open tuning and show me some slide on there. I just loved the sound it made. After Joe died, a student of his, Bobby Ray Watson,[4] showed me how to take a piece of pipe or glass bottle and put it on your finger and play it upright like a regular guitar. Using a slide has always been a part of my playing, and all the Hill Country people I learned from played slide.

At the time I met R. L. the family was living in a two- or three-room concrete blockhouse between Hernando and Coldwater. There were at least ten people living in that house. Duwayne was maybe four. Joseph was young, and I'd party with Daniel, Junior, and Melvin. Later on, Joseph and Daniel started playing guitar and bass. Then Calvin Jackson, a friend of Joseph and Daniel's, got to playing drums with them and R. L. If it was during the week and it was just family, they'd dance, party, hang out, and listen to the music. If it was a weekend, people came by drinking. Anywhere there was some music there'd be a party. R. L. and I started going places regularly—country jukes and house parties.

At the same time I was learning from R. L. I was still hanging with Johnny Woods. I went to picnics around Batesville and Como and other places with both R. L. and Johnny. R. L. and Otha Turner were friendly. I remember being at small picnics with Otha and different people playing. When Otha played the fife or drums, it would almost float through the air, the connection to Africa.

Otha was strict about his music. He knew what he wanted and how he wanted people to act—and he enforced it. Later on, I did some shows out on the road with Otha and Sam Carr.

When I first started going to Junior Kimbrough's, Johnny's the one who took me. I was probably twenty-five or thirty. Junior had a house right outside Holly Springs where he started rehearsing his band on Sunday afternoons. Junior sold a little whiskey and beer. The yard would be full of cars. People would be dancing. You'd be packed in there tight trying to play amongst the dancers. After the crowd kept growing Junior got the little log cabin outside of Holly Springs. It was a little more like a juke joint. Then he got the juke joint over on Highway 4. That became the famous one [*Chewalla Rib Shack, opened in 1990*].[5] *Deep Blues* was filmed there.[6]

Junior was a great cat. We hit it off as soon as we met. Junior was all laid back. He loved women and drinking. R. L. and Junior's sounds were very distinct, but both were grounded in Hill Country tradition. I never really knew of R. L. and Junior playing together. But they would play the same night. One would drink while the other was playing.

I lived in New Orleans and different places. Whenever I come back around I'd go see R. L. We'd get together and play. I was playing with Mojo Buford, a harmonica player from Hernando. He played with Muddy Waters and moved back down to Memphis. We did a tour in Canada and the East Coast. Our last show was in Clarksdale, on Muddy's birthday. We were gonna make it a tribute to Muddy. I

Kenny Brown, Potts Camp, Mississippi, May 2007

invited R. L. to play some Muddy Waters songs. [*R. L. and Muddy were friends in Chicago, from 1946.*][7] During the show me and R. L. played four or five songs. It wasn't long after that Fat Possum called. They were going to record R. L. and wanted to know if I'd play. They wanted it to rock a little more, using two guitars and a drummer.

Too Bad Jim was recorded at Junior's Juke Joint in 1993.[8] The next day I played on Junior's record, *Sad Days, Lonely Nights*.[9] I think I'm on all of R. L.'s recordings after *Too Bad Jim* and a couple more of Junior's.[10] I was also with R. L. in Fat Possum's documentary *You See Me Laughin'*.[11]

Too Bad Jim was my first recording with R. L. [*The CD won a* Living Blues *award for Best Traditional Blues Album of 1994.*] It wasn't long after the reviews came out we started getting more gigs. We had some gigs come up in Canada, and we needed a drummer. Calvin Jackson had moved to Holland. R. L. said he had a grandson that played pretty good—Calvin's son, Cedric Burnside. So Cedric took his dad's place and helped us pull off the shows.

When we started with Fat Possum it wasn't like some well-organized machine. I was doing the booking, driving the van, and supplying the van with half or more of the equipment. When we

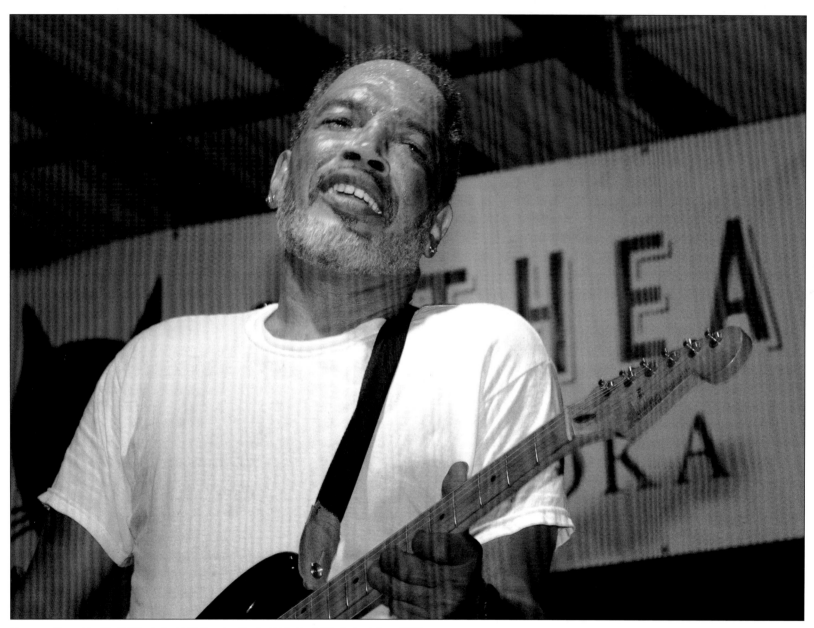

Duwayne Burnside, North Mississippi Hill Country Picnic, Waterford, Mississippi, June 2021

started traveling a lot I'd go to Cedric's school and get two weeks of homework. Cedric would do his homework in the van or in the hotel room. He'd turn it in when he'd go back to school.

There was a real bond between R. L. and Cedric, all of us. R. L. was proud to have Cedric playing drums. R. L. was the patriarch of the family, and he was a big support for everybody. He loved his family and the kids. R. L. loved to have fun and tell jokes.

We played pretty regular 'til R. L. quit playing. Then Cedric and I played together for several years. We went to Europe a couple of times, to Canada, and around the States a lot. We made one CD together, *Stingray*. Fat Possum put that one out under my name in 2003.

Cedric's always been a strong drummer. He's really a force. We always have a ball when we play together. It's kind of magical. He's part of keeping Hill Country music alive, that's for sure. I can look at Cedric sometimes and see the resemblance to R. L. When I hear Cedric play drums, his dad had his own style, I think Cedric's got a lot of that in him, and he's got his own style, too. Those guys, they didn't take lessons. The only school was the juke joint and out under a shade tree.

There's times when Cedric and I still get together and play. Playing with Duwayne, Garry, and Cedric—it's family. It's just the way it's supposed to be.

Hill Country music is more popular now than I ever thought it would have been when I started playing. There were years if I hadn't been doing construction work I would have starved to death. Thanks to R. L. and Fat Possum I made a living playing.

I started the North Mississippi Hill Country Picnic in 2006. I thought about growing up here, everybody was having picnics. I was traveling all over the world, and people were crazy about Hill Country music. Yet there wasn't a festival that was focused on that music and hiring the people from this area. My wife Sara organized the Picnic after I kept talking about it, and she made it work. We have two days and nights of music on the main stage. We formed a non-profit association to keep educating people about Hill Country music. People come and have a blast.

I love making people feel good. Hill Country music is all I've ever known. The music never gets old. There's something with the rhythms, making it good for your heart and your soul. It makes me happy when I play. Everybody has a purpose. When I was a kid, I wanted to play guitar. If I'd'a figured out how I wanted my life to go I don't think I could have planned it or had things fall in my life any better.

Garry Burnside

My parents were R. L. and Alice Burnside. I was always surrounded by music. My daddy played all the time. Johnny Woods would come over and blow harp with my dad. I got brothers that played. All of them are older than me. I'm the baby, born October 22, 1976, the last one of fourteen children. I was like ten or eleven when I started fooling around with the guitar. I wanted to learn. I was watching my brothers, my dad, and a little bit of everybody. They didn't have no problem showing me what I wanted to know.

My dad had the family band, the Sound Machine. [When] Daniel moved and Joseph got married and moved away, me and Duwayne started playing with my dad and Calvin Jackson. I was about thirteen. My dad didn't have no bass player, just two guitars and a drum. My dad had his own band with Calvin and Kenny Brown, but if daddy get a show around here, like these little house parties, he'd go with the family band. Cedric came along and played with us when Calvin gone overseas. I know my dad was happy watching all of us play.

My dad moved next door to Junior Kimbrough's club in Chulahoma. I started to go over there. Junior taught me how to play bass the way he wanted his bass man to sound, note for note and lick for lick. Whatever Junior did on the guitar he wanted his bass man to do. Junior showed me everything—his songs, his bass lines. For an older man to take his time to show me the way meant Junior took me seriously. I felt proud. Junior motivated me to learn. I wanted to be a musician.

Junior's Place was packed inside and out every Sunday. You could just hardly get past the cars. So many people came in this little club in the woods to hear us perform.

Wherever Junior went, we went with him. Playing with Junior really grew me up fast. He talked to me like a dad. That's why I know what to do and what not to do. I feel like Junior's music was real, affecting. You listen to it, it teach you a lot about life. I'm on every CD he did after I became his bass player. I was with Junior all the way 'til he died in 1998.

After Junior died I started playing a bit behind Duwayne. Then I played bass with David Kimbrough about three or four years. I joined the North Mississippi Allstars when their bass player Chris Chew couldn't play. When Chris came back I stayed on and played rhythm guitar. I played bass on the band's first CD, *Shake Hands with Shorty*. Me, Duwayne, my nephew Cody, and my dad and mom were all there for *Live at Bonnaroo* (2004).

Cedric and I decided to play together. We called ourselves the Burnside Exploration. We practiced every day for months and was a tight two-piece band. We made a CD, *The Record* [2006]. Our fans loved it and felt the music sounded traditional in the Hill Country style. We toured the CD but had different ideas where we wanted to go with our music. Cedric wanted a two-piece band, and I wanted a fuller band to reflect the way I write my songs. [*Garry and Cedric*

Garry Burnside, Potts Camp, Mississippi, October 2017

Shardé Thomas and Otha Turner's grandson, Robert Patterson, Gravel Springs, Mississippi, August 2011

made another CD in 2015 with Hill Country musician Trent Ayers.] We worked on *Descendants of Hill Country* a long time to get it great like we did. We wrote our hearts out, and, by the grace of God, we got nominated for a Grammy.

I started the Garry Burnside Band. We play at house parties, clubs, and festivals. We perform at the Hill Country Picnic every year for Sara and Kenny Brown. I released the band's first CD, *The Promise*, in 2014.

In 2017 I recorded *Come into My World*. I sang and played every instrument on the CD: the drums, bass, and lead. I showed my techniques of writing on this CD and covered a range of styles: blues, a boogie song, some feel good music-from the old to the new-some type of Lightning Hopkins stuff to Tyrone Davis style. *Come into My World* is totally Hill Country: funk blues like I do. It's got that soul of the Hill Country sound.

Hill Country's got that mesmerizing, hypnotic feeling that my daddy and Junior had. My music might be a little funkier but it's still got that same mesmerizing feeling that I got from them when I played with them. It's like you play with your feelings. You might hold the note a little bit longer than anybody else would because you feel that note. You can bend that note to where your soul is at. It's almost like you come up in church singing. The preacher hits a good note for you; you can feel it at the time. That's the way I feel Hill Country is. Whatever you feel, that feeling comes from your soul.

Like prejudice you encounter, you get over it with your music, the feeling you create. It's just like there ain't no problem in the world. You just relax like you don't see nothing. You're flying. It's electrifying.

Our music is gonna bring all of us together. When we start playing the type of blues we do, I have people come up to me saying, "You're too young to be playing that type of music!" But I come from an old soul. I learned from older people—It was an honor to play with Mr. Cedell Davis and all them other old guys.

When I play behind people now, I can play all different styles because I came up playing behind so many musicians, and everybody had different timing. I was around so long 'til I locked up with them. It didn't happen overnight. It took time, and time paid off. I was probably about fifteen when I went out with the Fat Possum Caravan Tours. I mostly played bass with my dad and a little bit with T-Model and Paul Wine Jones. We all played behind Robert Belfour. T-Model, Paul, and Mr. Belfour had their own unique tuning and style they played in. It all come out to rocking juke music to me. You want to learn, and you're gonna learn their history and their music. We all come from the Hill Country music style. Me and Cedric could feel their music. It was just in us to do.

You only experience this once in a lifetime, and we were lucky to be there. I put the older musicians' blues with my generation's music: funk. By the end of the night, it don't matter what color you is. Everybody's feeling the music. Everybody's feeling awesome.

I met Otha Turner a few times. Him and daddy were friends. We went over to his home and played at his picnics. I loved hearing Mr. Otha and his friends and family play fife and drums. I love hearing Otha's granddaughter Shardé now. That's how it goes. Pass the music down and hope somebody gets it and grabs on to it.

Carrying on this music means a lot to me. I want to do as much as I can with it. It's a way of paying my father back for exposing the music to me and showing him that I care as much about the music as he did. I feel the same love for the music as my daddy did. He passed the love of the music down to me and my brothers, and Cedric, all of us. For that I'm grateful.

Cedell Davis, Clarksdale, Mississippi, April 2008 (left) and Cedell Davis using kitchen knife as a slide, Sunflower River Blues and Gospel Festival, Clarksdale, Mississippi, August 2000

Calvin Burnside

The love was unthinkable and unimaginable, even to this day . . . The joy that two people [Calvin's parents, R. L. and Alice Burnside] should have together was beyond my imagination even right now. It seemed like they had more than enough love for everybody—for one another, their kids and grandkids, and people in the community.

There was nothing fake about that. There was a whole lot of hard times, broke times, wearing the same pair of shoes and pants—the shoes especially—the whole school year. But there was never a lack of love or respect. I don't ever remember ever having a hungry day as a child. That alone, in the state of Mississippi, is saying more than a lot of people believe.

Calvin Burnside passed away on August 2, 2015.

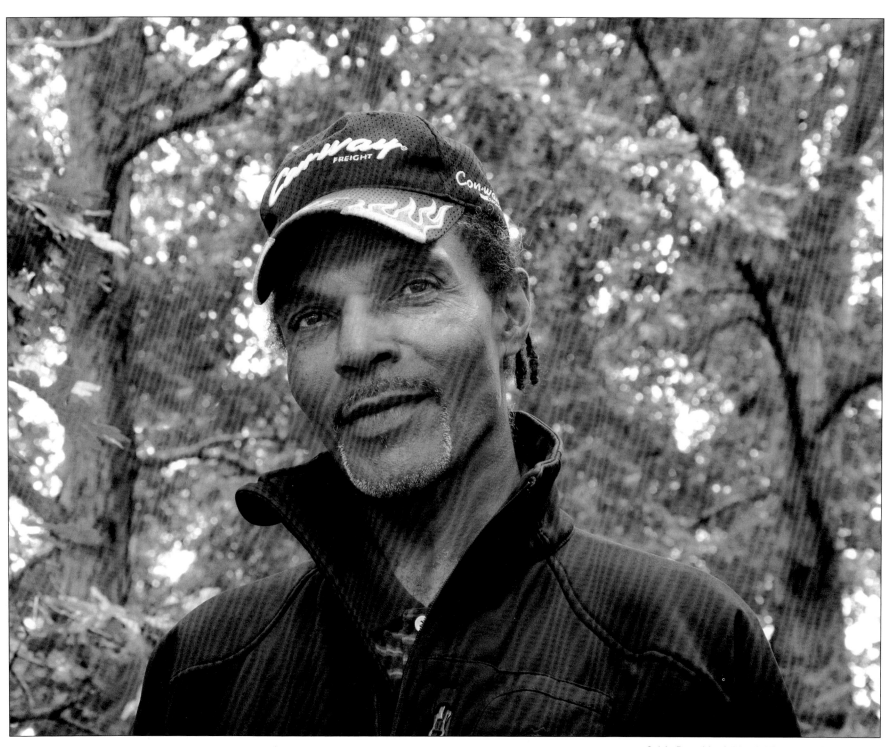

Calvin Burnside, Ashland, Mississippi, October 2014

Cedric Burnside

I was born on August 26, 1978. My grandparents and mother were coming back to the house when my mom's water broke. They drove to a clinic in Shelby County, Tennessee, where I was born. My parents were Linda Burnside Jackson and Calvin Jackson. They had three children. I'm the oldest, then Sonya and Cody. My mom was a very strong woman and a sweet lady and took real good care of us. My dad was a drummer. He inspired me a lot. He had a strong heart, a strong mind, and was very determined. I didn't see much of my dad after I was twelve years old until I was grown because he moved and played overseas. My dad was proud of my drumming and that I took his place behind my grandfather, R. L. Burnside.

I was raised in Holly Springs, Mississippi. We lived with my mother's parents, Alice and R. L. Burnside. We called them "Big Mama" and "Big Daddy." They really guided the family. Some of their kids was still at home; some of the kids' kids, the grandkids was there. It was about fifteen or sixteen people, at least, in a four-room house. My mom lived there with her kids; my dad was in and out. My auntie Mildred Jean and four or five of her kids was there, my Aunt Pam, my Uncle Garry, and sometimes my Uncle Melvin and some of his kids would be there, my Uncle Junior and maybe a few other cousins: Michael, Joe, and Dexter.

Big Mama and Big Daddy took care of the family. I can remember Big Mama getting up at five in the morning fixing breakfast for everybody in the house. After that she'd start on lunch for everybody whether you were going to school or out in the fields or at home. I learned a lot from Big Daddy, not just playing blues and loving the music. I learned how to live in the world. He taught me how to live on the road and the way to treat people.

Big Daddy and Big Mama was humble, the kind of people who will feed anybody, even a bum off the street. They will give you the shirt off their back, and I mean that literally. You instantly knew their heart was beautiful. But you also knew in an instant if you made them mad. They're gonna let you know a little about yourself. They didn't let nobody run over them.

Big Daddy told me so much about how things was back in the old days. Blacks was treated different from whites. They had a Black bathroom and a white bathroom. Blacks had to go in the back to get their food and some of it wasn't the same as the food they would have for the white people. And even if you wanted to buy the food that the white people had, they wasn't supposed to sell it to you. If a Black person had a Jheri Curl or a relaxer, the white sheriff would wash it out of their hair because he would tell them they're trying to be white.

Big Daddy moved to Chicago because of all that—it was so messed up in Mississippi. A lot of his uncles and his dad was in Chicago. [*R. L. Burnside arrived in Chicago in 1946. His father, Earnest Burnside, lived on 14th Street on the West Side.*] He was back and forth; I think he called it hopping the train, when he met Big Mama. Big Daddy moved back to Mississippi and married Big Mama.

Cedric Burnside and Uncle Melvin Burnside, Byhalia, Mississippi, September 2005

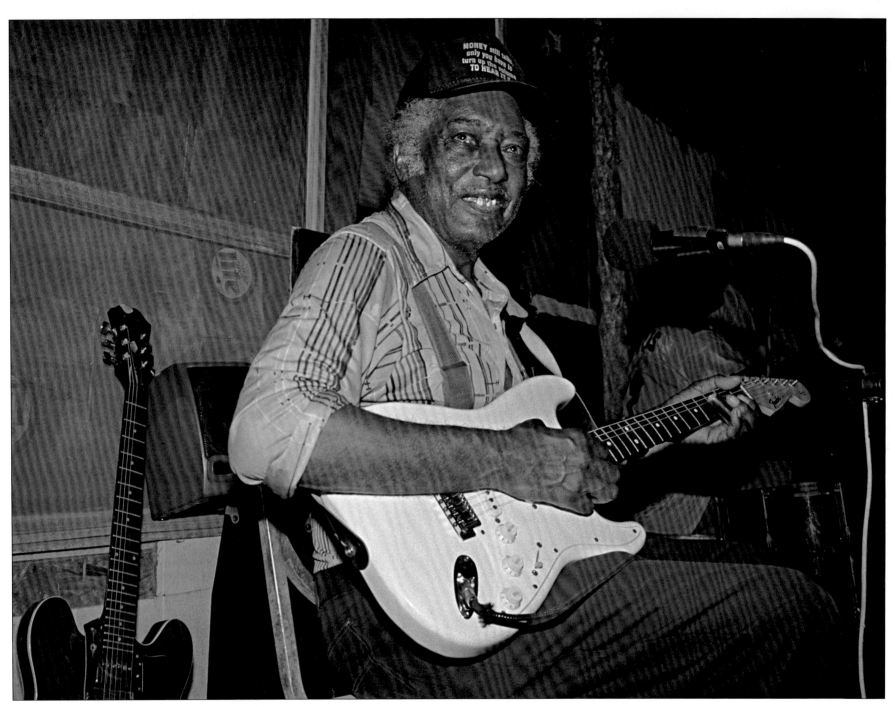

R. L. Burnside, Gravel Springs, Mississippi, August 2000

As we was coming up, Big Daddy sharecropped for food and shelter. He lived in a house the landlord let us live in. Big Daddy got on the tractor and planted gardens. He'd leave home at six in the morning and sometimes he didn't get home until eight or nine at night. This went on for several years. He worked five or six days a week. He might be gone on Sunday. He stayed there for as long as he needed.

Me and Garry used to love helping him cause we used to play in the field. The dirt smelled so good. It was so soft. We'd throw it at each other. We'd plant plenty of purple hull peas and corn. They had this grinder like a seed thrower. We would shoot the seeds, then get some fertilizer with a sack on our side to carry the extra fertilizer. We helped Big Daddy a lot, especially to pick the peas.

Big Daddy would harvest the crop. The landlord would give us our share, and he'd take a part. The rest of it the landlord and Big Daddy would take to the market and sell. We had chickens and a few goats and hogs at one time. We killed them in the wintertime for food.

Big Daddy and Big Mama loved fishing. Sometimes Big Daddy would stay all day alone fishing. He'd come back with about thirty or forty fish. Man, I'm talking about enough to feed us for two and a half, three weeks. Big Daddy would hunt a deer every now and then.

We hauled water for years, sometimes two or three times a day just to have enough. We didn't have a bathtub; we took a bath in buckets. We didn't have a toilet. We had to get enough water to wash ourselves, clean the house, and cook with. We had neighbors, about a half mile to two miles away. They had running water and a hydrant outside. Me and Garry would walk down there. We'd put four or five jugs on our backs, put a belt through the jugs and put it on our shoulders.

We had this gigantic iron pot, and we heated it up on the stove every morning and every evening. I bet four or five gallons of water would fit in the pot. That's how we made our hot water. We had a wood heater made out of an old tin barrel. Big Daddy would go in the fields and cut down a few trees. We'd go with him and load up two or three truckloads. Then we'd split the wood with an axe and pile it up.

Big Daddy said he started playing when he was twenty, twenty-one years old. Big Daddy said he was friends with Muddy Waters, knew Mr. Howlin' Wolf, and played with Fred McDowell.

Big Daddy and my father played guitars and drums around the house along with my uncles: Junior, Joseph, Duwayne, and Dexter. The whole Burnside family would sit around and jam. That was our music growing up.

They used to have house parties. All our neighbors down the road and people from Tate County came to hear the family play. They'd pack the dirt yard. Me and Garry, we'd dance and kick up the dust to the music. People came even when it rained. If it rained, they set up in the front room, and all the little kids had to go in one room. Imagine people piling up so close, just enough for the drums to be here and the guitar to be here. Big Daddy might be in the crowd playing the guitar because that's all he could do. People just loved it. Boy, they be trying their best to dance. Some of them even be standing up on furniture. I mean up on the couches, on the tables, trying to watch the music, it was that crowded. But they came every weekend.

My dad was the first person I heard play drums behind Big Daddy. I watched my dad, and I just knew I wanted to play drums. I was fascinated. One day they took a break. I built up the courage and jumped on the drums. I tried to play back what my memory saw. That's how I learned to play.

My dad's playing was unique. I try and imitate him as much as I can. He had this style where he would stay on the right cymbal the whole song. When it's time to break it down, most likely, the drummer's gonna go to the high hat. But with my dad, he could bring it down on the right cymbal, and take it low if they wanted it low, and if they wanted to bring it up he could bring it up. He could have a snare, a kick drum, and a cymbal, and play like he had a five- or six-piece set of drums.

At home I didn't have a set of drums. I drove my mother nuts beating on buckets and pans at the table. She'd be like, "Boy, get

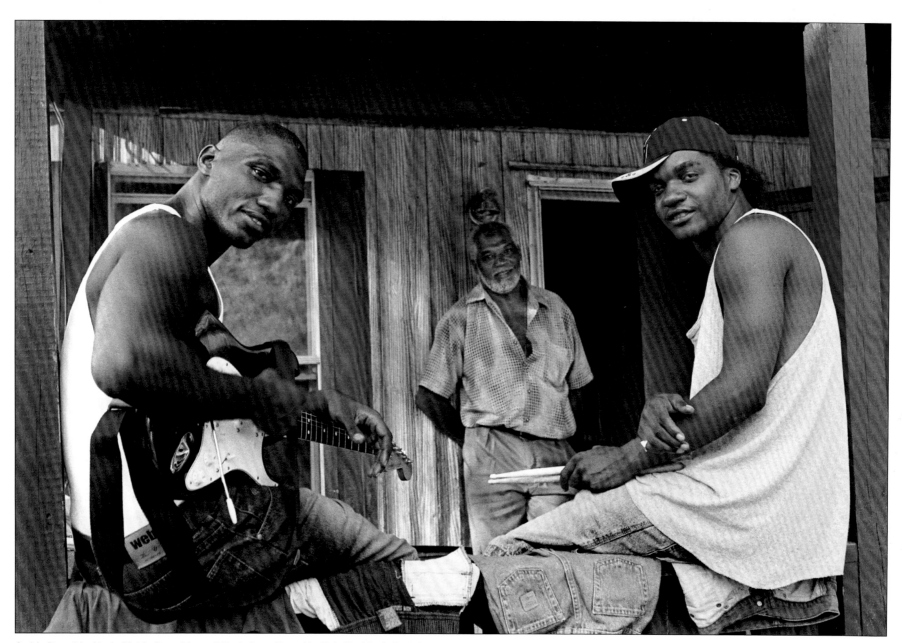
Cedric Burnside, Uncle Melvin Burnside, and Uncle Garry Burnside, Byhalia, Mississippi, September 2005

out of here. I'm tired of hearing that stuff!" I'd go outside and set up all kinds of buckets, Crisco lard cans that we used to fry some chicken in and homemade lard jugs they used to put the lard in after killing a hog. I had me a little bucket drum set.

When daddy set up the raggedy set of drums to practice for the house parties, believe me they was *raggedy*. That was all they had. So every time the weekend was over, they take the drums and put them up. They might even put them in a friend's house or storage. They couldn't risk us messing them up, busting the heads because they couldn't pay for nothing.

Mr. Otha Turner and Big Daddy was good friends. Of course, Mr. Turner used to come to the house and hang out. Now and then he'd bring the fife and drums, and they'd play in the front yard. When Big Daddy take us to Otha's I *had* to get on the drums. Otha Turner had his own picnic. People would come from all over the world to it. I would get on the snare a little bit. If they had enough snare drum players, I would get on the bass drum. I just kinda fell off in that environment because music was always in my blood. I loved that sound. Hearing that as a little kid, you kinda wonder, what is this? It was a sound you knew had to make people happy.

I was twelve when we moved to Chulahoma on the outskirts of Holly Springs. We moved to a little abandoned house. It should have been condemned. But it was bigger than our house in Holly Springs and had running water.

Junior Kimbrough had a club right beside the house called Junior Kimbrough's Juke Joint. At that time Mr. Kimbrough opened the juke joint on some Saturdays and most every Sunday. I used to love to wait for Mr. Kimbrough to open that club so I could play some real drums. That's all I wanted. My heart screamed for it.

Mr. Kimbrough would come in Friday evenings and early Saturday mornings to make sure the club is right for the people. Me and Garry would run over. I'd get on the drums and Garry would get on the bass. By me not knowing how to read music or go to school for it, I just tried to do what I see my dad do, and when Kinney [*Kimbrough*] Malone started coming to the juke joint I would watch him.

On the nights Mr. Kimbrough was getting everything ready he'd practice on the guitar. Me and Garry would practice with him. Garry was trying to play guitar at the same time he was playing bass. Mr. Kimbrough would teach him a little on the guitar. One of the reasons Mr. Kimbrough practiced with us was because he never knew when he might need us to fill in.

That juke joint is a big part of who I am today. Mr. Kimbrough was a kind, gentle person. He didn't bother nobody but you damn sure didn't bother him, and that was made clear. He kept a little .38 special in his pocket. Big Daddy did too, of course.

Mr. Kimbrough played at the juke joint every time it was open. When Big Daddy would come back from playing out of town, he would play with Mr. Kimbrough and some by himself. Mr. Kimbrough had his grooves; he was the hipster. Mr. Kimbrough's music felt good, sounded good. When you're down and out, you can't do it no more, you can instantly feel everything that he's telling you. It was like a slow motion, more hypnotic trance of the Hill Country blues. Everything he did, he did in a medium or slow range, like a hypnotizing story that he tries to tell and it gets you off in that story.

Big Daddy, his music would hypnotize you, too. Big Daddy would hold one note for one, two, or three minutes until he felt he should change it. That note would drive straight through you just like a train and put you in a trance. Big Daddy and Mr. Kimbrough's music had a rhythm that was very much their own, a very unorthodox rhythm.

I started playing with Big Daddy at some of the house parties before we moved. Garry and I played good enough to become the back-up musicians for Junior and Big Daddy when the drummer or bass player wouldn't show up. They used to hide us behind the beer cooler when the police came in. That's how me and Garry grew up. We played together until Garry started traveling with Mr. Kimbrough, and I started playing with Big Daddy.

Big Daddy and Mr. Kimbrough was on the Fat Possum label. They recorded a CD at Mr. Kimbrough's juke joint [*Junior Kimbrough & the Soul Blues Boys,* All Night Long, *Fat Possum, 1992*].[1]

I was standing there watching everything. They turned Junior's juke joint into a studio.

The owners from Fat Possum heard me playing behind Big Daddy. When it came time for Big Daddy to start traveling again, they was like, "Well what about Cedric?" Big Daddy said, "Yeah, he can do the job." So I went on my first tour with Big Daddy. It hadn't been that long since I stopped hauling that water.

We went to Toronto. Me coming out of Mississippi, it was totally different, playing to a different audience. It wasn't like growing up in a juke joint playing around the same people I been playing around all my life. I had butterflies. Big Daddy said, "It's gonna be okay. Don't worry. We're gonna go out there and rock it like we always do." We got out there and my stomach was knotted up. We did the first song. The audience clapped so hard. They loved it! "That's R. L.'s grandson!" The butterflies went away. I haven't had a single butterfly ever since.

After the tour Big Daddy bought the brick house down on Walhill Road on the outskirts of Chulahoma. I played drums behind Big Daddy from the age of thirteen into my early twenties, when Big Daddy got sick. I missed school a lot. Even though I needed school and wanted school, I was happy to go out and make money for my family, which was well needed. It was a great opportunity to provide for family and learn. The eleven or twelve years I played with Big Daddy we went to a bunch of places—Australia, Europe, and Japan a couple of times. We toured all over the United States.

Big Daddy was still himself on the road, but a lot more tender and laid back. He laughed and told jokes. At home he was the backbone of the family. He had to be upright and firm. Although he was a funny guy, they had to know he was serious because he took care of the whole family, the kids, grandkids, and some of the great-grandkids. He kept food on the table for everybody. That was amazing to me, to sit there and watch him do all of this. Sometimes he was discouraged, and sometimes he might not know where he was gonna have the next money to pay the bills, the rent, or the bank note. Somehow the Good Lord made a way for him.

Fat Possum kept getting the gigs, and he knew that eventually he would have the money. He never let the family down.

Me and my Big Daddy developed a very strong bond. I was a teenager. Sometimes I was a little hardheaded, wanted to go out and mingle, stay out a little later than I should. Big Daddy took real good care of me; he watched out for me. He always told me he was proud of me for taking drumming serious and always told me I sounded great.

For three years we did this tour for Fat Possum called Juke Joint Caravan. That's where I played with Big Daddy, Paul Wine Jones, Robert Cage, and Junior Kimbrough. Each person had their own timing and rhythm. I played four hours a night. Sometimes we might have twenty-five shows, and we might be on the road thirty days. I was about sixteen, seventeen years old.

When I played with Paul, his rhythm was good, but man, to keep up with his timing, to keep that rhythm going, you had to do that timing right. I had to use everything I had to listen at Paul. I knew where he was gonna start to go after a little while. The same with Junior Kimbrough. Even though I played with Mr. Kimbrough in a juke joint I still had to listen so hard because his rhythm and timing was different than my Big Daddy's. I called it *feel music*. You're either there; you feel it and do it; or you don't got it.

Paul was from Belzoni. His music was Delta style, and heartfelt. Paul played his feelings. What came out of Paul was pure happiness. Paul used to love to tap dance. He said back in the day him and a friend of his used to tap dance before a show would start. And apparently he was pretty good. He used to mimic a few moves. Man, I used to trip out when he would do it.

Robert Cage was another good guy. Mr. Cage was one of the most unique guitar players I ever played with. I know he played these songs that I listen at now and say "Wow." The timing was amazing. One of his songs went, "Mama put the chicken in a frying pan, scared of a jealous man, let's go, let's go, let's get on out of here." Fat Possum thought it would be cool if I tried to put drums behind it because no one ever had. So I did.

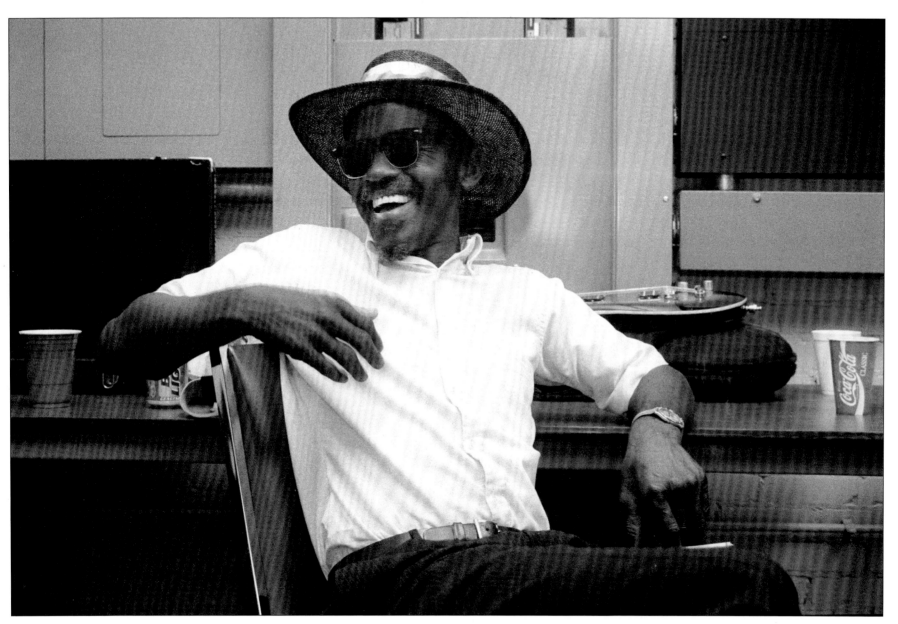

Paul Wine Jones, Howlin' Wolf Memorial Blues Festival, West Point, Mississippi, August 1997

I welcome all challenges, all styles of music. Not only did Mr. Cage challenge me, he was an angel to me. He reminded me of Big Daddy. If I was in a bad mood, he would say, "Hey Cedric, do you want to go get something to eat or drink and talk about it?" He was willing to help anybody under any circumstances, to be right there to lend a helping hand.

On those tours, I used to love watching Elmo Williams and Hezekiah Early. Elmo had this crazy guitar riff, and Hezekiah had a crazy drum roll. Couldn't nobody play that sound but them. Hezekiah sang and played the drums at the same time. It was something I had started to do, but when I saw Hezekiah do it with no problem, it inspired me.

Jessie Mae Hemphill—Oh man, I loved that lady. I did get to play with her a few times before she passed. [*Jessie Mae died in Memphis, July 23, 2006.*] She definitely followed her own drum. Nobody could steer her off the path she didn't want to be steered off of. She wasn't going to go for that bull. She wasn't that type. Miss Jessie Mae, I always remember her keeping a .38 Special in her purse—but she was a sweet lady, a purehearted woman.

She had a little dog that she loved so much—"Sweet Pea." That's all she needed was her dog and her guitar. She was from Senatobia, which is Hill Country. Her style of playing was very close to Fred McDowell's but she made it her own. She had this voice that you *knew*—when she started singing, you knew instantly who it was.

Watching T-Model and "Spam" [*Tommy Lee Miles*] play, I learnt a lot. When Spam played with T-Model, even though they argued when they was on stage, the music was so tight and locked in like Elmo and Hezekiah. I used to love to watch Spam do his thing with one stick. He would put one stick in his mouth and still carry the beat with one hand. And he'd be doing it with T-Model! That right there is amazing considering T-Model's timing. Spam was not only able to lay down a funky beat with T-Model, he was able to do some fancy stuff at the same time.

It was a bunch of fun with those cats. There never was a boring moment. They taught me about life, being on the road, what to do, things that will help you as you grow and to become a man. Every morning on these tours, I had to find the McDonald's, the Burger King to get them breakfast or lunch. I had to do chores for them. Sometimes I was tired and didn't want to do it. I knew I had to. Sometimes I was like I'm blessed being I'm so young and playing on the road with these old dudes, playing drums behind every last one of them. And every one of them had a story and their own personality. It was funny; it was sad; some of it was annoying, but just me being there and taking all that in, I learnt from that experience.

As an older blues man I feel very honored to have been a part of that as a kid, especially since all those cats is on the other side now. They *gone*. I'm so glad to have a piece of that inside of me that I can tell people about, even write about, and play in my music.

I got to do four CDs with Big Daddy and Kenny Brown on the Fat Possum label. I really love the songs, "Come On In" and "Miss Maybelle." "Miss Maybelle" has always been a favorite of mine. The beat is almost like it's about to go out but it comes back in. Kenny had this distinct sound that he put on all the Fat Possum albums with Big Daddy. The minute someone heard that slide, they know that's Kenny Brown right there.

I remember seeing him at some of the house parties when I was younger. He would laugh and talk with the grownups and play music. Kenny would pick up Big Daddy, and they would go out of town to perform. Kenny was a big part of my growing up. I was out there at a young age. You need a grownup. [*Kenny is twenty-five years older than Cedric.*] So Kenny and Big Daddy raised me on the road. Kenny looked out for me and took care of me when big Daddy wasn't there.

Kenny is a legend. He made a name for himself for his slide guitar. People all over the world try to imitate him. Kenny is as Hill Country as they come. He developed his own style with Hill Country blues and perfected it with my Big Daddy. They just had that chemistry together. When Big Daddy played his guitar, Kenny would find a nice rhythm whether he had the slide or just played second guitar. Kenny played with Big Daddy for over thirty years

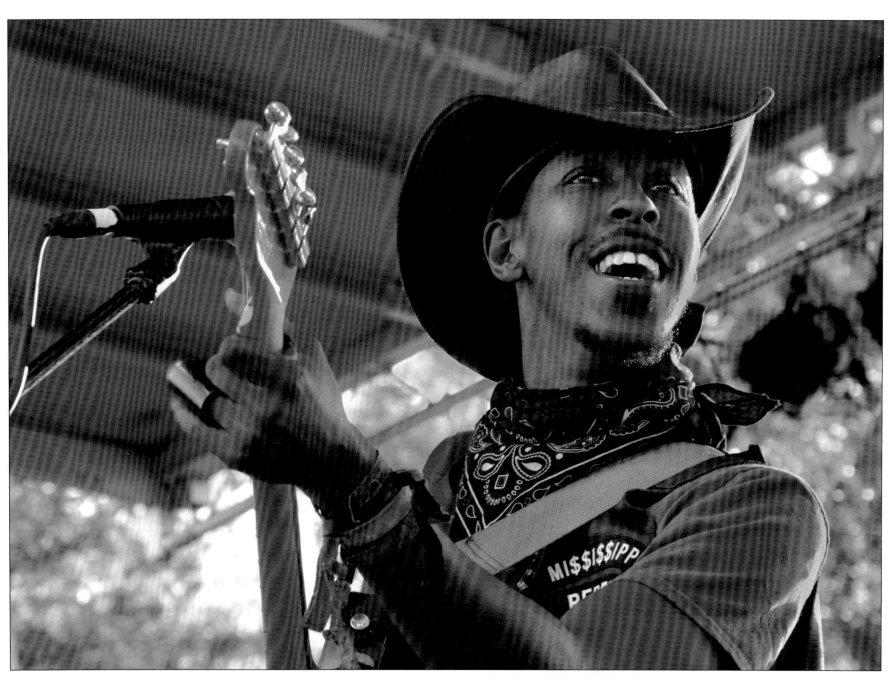

Trent Ayers, Mighty Mississippi Music Festival, Greenville, Mississippi, September 2017

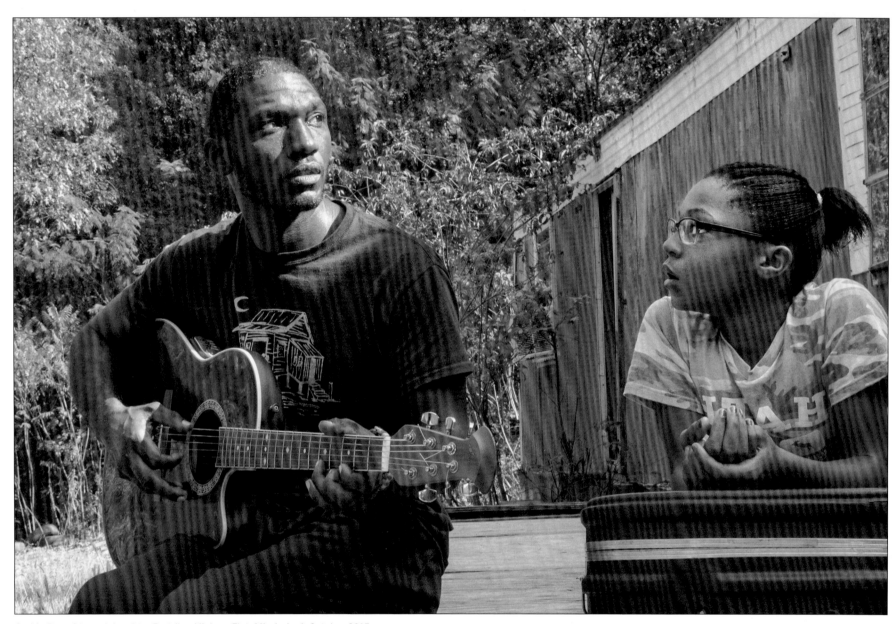
Cedric Burnside and daughter Portrika, Hickory Flat, Mississippi, October 2015

and had been playing with him for twenty-odd years when I started. So I had to find a way to click with both of them, and I did.

Kenny and I also had parts in three movies together—*Tempted* [2001], *Big Bad Love* [2002], and *Black Snake Moan* [2006], doing little juke joint scenes. Now I'm in a major role as Texas Red.[2] Travis Mills said he came upon my music while he was writing the second half of *Texas Red*. He said the music grabbed him. He listened to all my music for the four or five months it took to finish the script. Then he looked at a few of my videos online. He loved my onstage aura and messaged me. "Man, I know this is a long shot but I would like for you to play the role of Texas Red." That was in 2018. We didn't shoot it 'til the end of 2019. The movie came out in February 2021.

Even though it was a movie, a lot of it felt like real life. It's based on a true story of a Black guy owned a juke joint. It was adrenaline-pumping! It made me imagine how Texas Red would have felt with a posse of three hundred men after him, trying to shoot him dead. I had to try to put myself in his footsteps. I say *footsteps* 'cause he ran without shoes. I did a lot of scenes bare feet—in twenty-five, twenty-eight-degree weather! Because I wanted the real feeling of what he had. If I put myself there then the movie will look more realistic, it will feel more real to me, so I ran through the swamp bare feet. I couldn't see anything at the bottom. There could have been anything down there. I did that and it was awesome.

Garry and I came back together in our early twenties. Big Daddy had to do his first bypass surgery. Me and Garry formed a band, Burnside Exploration. I always thought, and always will, that Garry is an excellent musician as well as a phenomenal songwriter. In five minutes Garry could have a song. We recorded a CD released in 2006, *Burnside Exploration*. We locked ourselves in a room for three or four months and came up with original music.[3] It was just me and Garry for a couple of years, then Trent Ayers joined us. He stayed with us for a few years before he went on to play with another band, Electric Mud.

Big Daddy got real ill. Garry formed his own band. I started performing with Lightnin' Malcolm, and we became the Cedric Burnside and Lightnin' Malcolm band. "Juke Joint Duo" is what people called us. Malcolm is a kind person, a great musician and songwriter.

I played with Malcolm for about six years. We toured around the world. It was a beautiful little time. We played Hill Country music, songs performed by people we was around—Big Daddy, Junior Kimbrough, T-Model Ford, Robert Belfour, and Paul Wine Jones, and new songs that we wrote. We made a CD, *Juke Joint Duo*, and then another one in 2008 with Delta Groove, called *2 Man Wrecking Crew*. This CD won a Blues Music Award for Best New Artist Debut in 2009. We toured with Big Head Todd and his band: Hubert Sumlin, Honeyboy Edwards, and James Cotton. The tour was called "100 years of Robert Johnson." Eventually Malcolm and I decided to go our own way.

At times when I played with Garry and Malcolm, my brother Cody helped me drive, load in the equipment, and take it out. He was known for his rap, what I call the "Hill Country flows." He was one of my biggest supporters and fans. He always told me, "Things was gonna be great. Just keep on doing what you're doing and it's all gonna be all right."

We got to make a CD together in 2010 called *The Way I Am*. We jammed out as we had been doing for a couple of years. All the songs were originals, a little Mississippi "flow" and Hill Country blues. Hill Country flow is a name I made up. Flow is rap. Cody wrote the hip-hop, and I wrote the lyrics. I thank God we got a chance to collaborate before Cody passed. [*Cody Burnside died October 17, 2012, age twenty-nine.*]

I've known Trent Ayers pretty much his whole life. Trent's dad, Joe, used to bring him to the house parties Big Daddy threw back in the day. Trent learned to play from his father. When he became a teenager he would come to the juke joint and sit in with us and jam.

I got back to Holly Springs after a show and pulled into Trent's yard. The first thing I heard was the guitar—a Jimi Hendrix song played loud as hell. I banged on the door. Trent came to the door. I said I need a guitar player. Trent said, "Are you kidding me? I'm

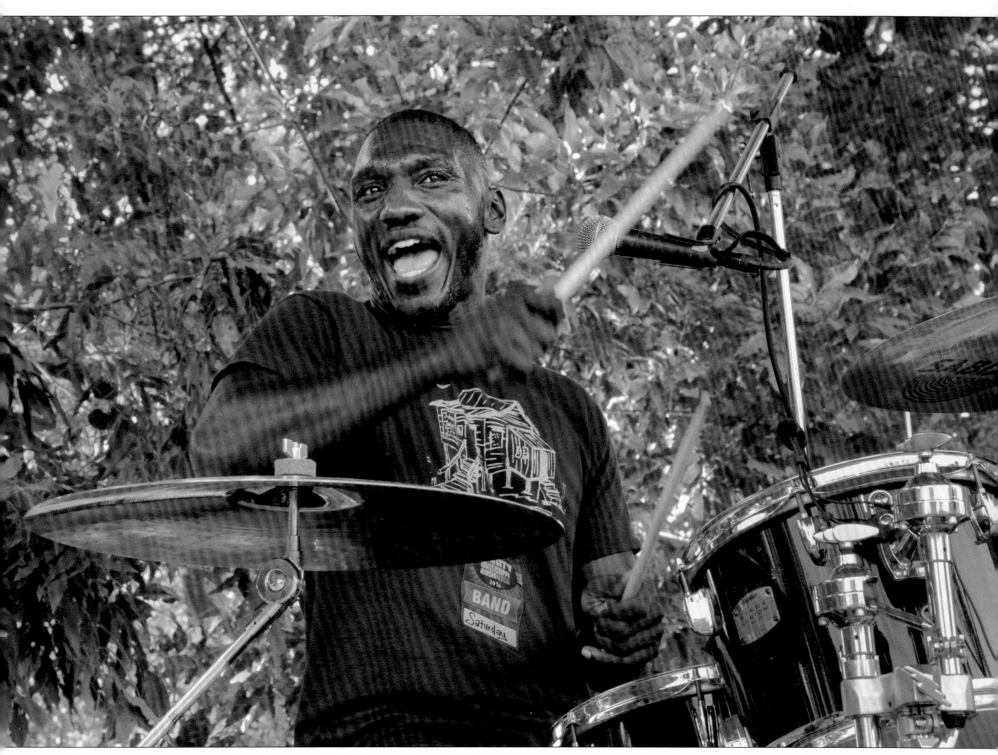
Cedric Burnside, Mighty Mississippi Music Festival, Greenville, Mississippi, October 2016

not doing anything. The Mud stopped playing for a while." It was perfect timing. This was about a month and a half before I had to go on tour. We practiced, trying to get a set list together that we can get tight on. We did it!

We toured quite a bit in the United States and overseas. Our music is modern but old school. That's the signature of our music, especially mine.

Trent and I made two CDs. *Hear Me When I Say* was released in 2013. We collaborated with some musicians out of New Orleans and a friend of ours, Vasti Jackson. Trent and I recorded our next CD with Garry. We put a couple of songs on *Descendants of Hill Country* as a tribute to Big Daddy—"Skinny Woman" and "Going Away Baby." The CD won a Blues Music Award for Best Traditional Blues Album.

There are some moments when I'm on stage and I'm getting ready to do a solo on the drums . . . I look up in the sky, people think I'm daydreaming or in this zone but sometimes I might look up and I see my dad. I say to myself, "Dad this is for you. Thanks for the confidence, for the energy." Then I'll go in my zone. And when I come from that place I don't see the people. Sometimes it's like I'm in a room by myself. But when I come out of that zone, get done with that solo, people tell me, "That was amazing!"

I started playing guitar around 2003, 2004. Luther Dickinson gave me my first one. I got really serious about the guitar and wrote more songs. Every day I'd find two or three hours, if not more, to play, come up with new riffs and try to add new lyrics to it. I started out playing in open G tuning, which is what my Big Daddy used to play in a lot. He also played in standard. Now I can pretty much do all the tunings. I always said before I leave this world I want to learn all I can.

I think about Big Daddy all the time when I play the guitar. I don't try to fill his shoes because that's impossible. I just try to keep his music alive. Sometimes the spirit and energy be so strong and powerful, I'll be like, "Big Daddy, thank you so much for everything. If I got anything to do with it, you're gonna live through me, from now on and forever." And I'll get on that guitar and once again it will be blank to me, the room will be empty to me, and when I'm done all I hear is people telling me "Your granddad would be proud of you."

When I go to some of the same places, clubs where I played with Big Daddy, the energy and all the power that goes through me, it's something special. It's almost like when I walk up in there Big Daddy's right beside me saying like, "Now I'm gonna sit here and see what you done learned, what you done come up with . . ."

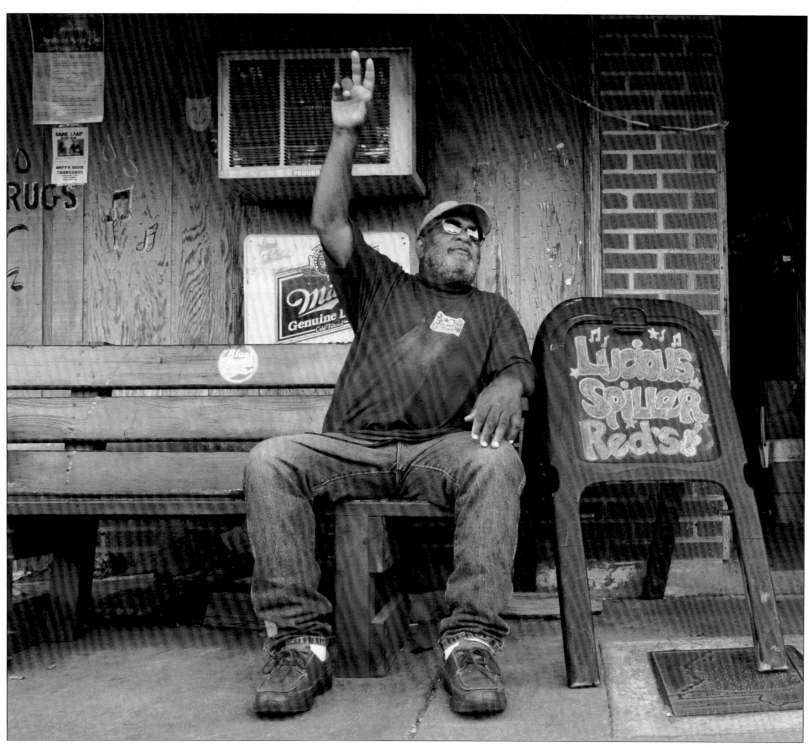

"Red" Paden, Red's, Clarksdale, Mississippi, October 2018

Acknowledgments

When I walked into the blues clubs in Cambridge and Somerville in the early nineties, I didn't know any of the musicians. Today I am indebted and grateful to many people for their support and friendship. I would first like to thank all the musicians, their families, and people I photographed and recorded—people who intimately shared their lives with me, becoming the heartbeat, the emotional center of *Deep Inside the Blues*. In addition, my thanks to the many other musicians who generously shared their memories, among them Bob Margolin, Michael "Mudcat" Ward, Peter Ward, Gordon Beadle, Lonnie Shields, Justin Showah, Bob Lohr, and Billy Gibson. Thanks to the Otha Turner family for all the memories—the picnics, fife and drum music, goat sandwiches, and community! Thanks to Earnest "Guitar" Roy Jr., Andrew "Shine" Turner, and Stone Gas Band members Dione and Harvell Thomas, Billy Gibson, and Howard Stovall—I only wish I could have fit their equally important stories here.

Thanks to the men and women quietly working behind the scenes, creating, and running blues museums, clubs, festivals, and programs throughout Mississippi and in Helena, Arkansas—Billy Johnson, Randy Magee, Red Paden, Richard Ramsey, Dr. Joe Stephens, Roger Stolle, Munnie Jordan, Carla Robinson, and Shelley Ritter. And to those who, like me, have dedicated themselves to documenting, photographing, and writing about the blues—Jim O'Neal and David Evans, especially; and Ted Drozdowski, Butch Ruth, Bill Steber, and Joe Rosen. Also, my thanks and appreciation to Patty Johnson, Michael Frank, Bruce Iglauer, Paul Kahn, and fayemi shakur. Thanks to everyone for sharing their knowledge and answering my many questions.

Thanks to David Nelson, Scott Baretta, and Brett Bonner, editors of *Living Blues*, for providing a place for my photographs and oral histories. And to Harry Sleeper, founder and editor of *BluesWire*, my first blues publication.

Thanks to Hilary Anderson at the National Heritage Museum, Pam Shanley at the Arlington Center for the Arts, and Kristin Eshelman at the University of Connecticut for exhibiting photographs from *Deep Inside the Blues* at their institutions. Also to the Arlington Arts Council and the Massachusetts Cultural Council for their support.

My appreciation to the great Jerry Berndt showing me the way through the expressive and compassionate eye of his work, for his friendship, for encouraging and believing in me. To photographer Sylvia Plachy for taking the time to edit and sequence my photographs and text at an early stage in this process, creating a roadmap for the future and helping me to visualize the possibilities and move forward. Thanks to my photography teachers—Polly Brown at the Art Institute of Boston, and Nick Johnson and Jim Triquet at the New England School of Photography. Thanks to Glenn Ruga, photographer and founder of Social Documentary Network.

La Vern Baker, Scullers Jazz Club, Cambridge, Massachusetts, January 1997

Special thanks to fellow-photographer, writer, blues-lover, and long-time friend John Suiter, now in Chicago, for his in-depth research and editing of the text and photographs in this book. Thanks also to the rest of my team and my friends who contributed in so many ways to the life of this book—Lisa Abitbol, Joanne Ciccarello, Susan Daitch, Marissa Fiorucci, Meg Guernsey, Ruth Greenberg, Bob Nakashian, and Paula Tognarelli. And to Dr. Michele Crage, for her wisdom, dedication, and compassionate care of our friend Luther Johnson over the years.

Thanks to Elizabeth Branch Dyson and Dean Blobaum of the University of Chicago Press who introduced me to my editor Craig Gill at the University Press of Mississippi, who led me through the process, forever patient and encouraging. And to Bill Ferris, for his ongoing support from the day we met in 2015 at the International Blues Conference at Delta State University.

Finally, my deepest gratitude to my parents, Ronna and Harold Cooper, who gave me unconditional love and fostered my independence and curiosity, my love of stories, photography . . . and adventure. "You are my guiding light. Your memory is a blessing."

Notes

Preface

1. "David Maxwell: 88 Blue Keys," *Blues Wire* 11 (February 1995).
2. "Luther 'Guitar Junior' Johnson," *Blues Wire* 26 (June 1996).
3. "Luther 'Guitar Junior' Johnson: 'You Got to Have Feeling for People,'" *Living Blues* 132, vol. 29, no. 6 (November–December 1998).
4. "Calvin 'Fuzz' Jones: 'The Blues Is Everything I Was Raised Up With,'" *Living Blues* 194, vol. 39, no. 1 (January–February 2008).
5. "Sam Carr: 'The Drums Got to Be Heard Just Right,'" *Living Blues* 171, vol. 35, no. 1 (2004).
6. "Shirley Lewis: 'When I Sing, I Send Out Love,'" *Living Blues* 222, vol. 43, no. 6 (December 2012).
7. "Toni Lynn Washington: 'Music Is My Passion. Music Is My Life,'" *Living Blues* 243, vol. 47, no. 3 (June 2016).

Willie "Big Eyes" Smith

1. William McKinley Smith was born October 21, 1917, in Friar's Point, Mississippi; he died in Chicago, March 29, 1987. Lizzie Mae Smith was born March 20, 1919, at Lambrook Plantation, Phillips County, Arkansas; she died in Chicago, October 25, 1998. William McKinley Smith and Lizzie Mae Wilson were married March 22, 1936, in Phillips County, Arkansas. See Arkansas County Marriages, 1838–1957.
2. Willie turned four in January of 1940. By the time of the US Census in April 1940, his parents were separated. Willie and his father were living with Will and Lela Smith in Lake Township, Phillips County, a few miles south of Helena, Arkansas. Willie's mother was living with her parents, Pott and Janie Wilson, also in Lake Township.
3. This date is corroborated by Pott Wilson's death certificate. He was fifty-nine years old. See Arkansas Department of Vital Records, Little Rock, Arkansas; *Death Certificates*; Year: 1945; Roll: 2.
4. Janie Williams died in Chicago, October 8, 1979.
5. Plantation owned by L. E. Berard of Helena. See Willie's father's (William McKinley Smith) October 1940 Selective Service registration.
6. The antilynching activist Ida B. Wells wrote a report on the massacre in 1920, *The Arkansas Race Riot*.
7. The owner of Lambrook Plantation was Gerard B. Lambert. His account of the "Elaine Massacre" is in his autobiography, *All Out of Step: A Personal Chronicle* (1956).
8. According to the Equal Justice Initiative's "Lynching in America," there were at least ten lynchings in Tunica County, Mississippi, between 1900–1924.
9. Willie Smith to Margo Cooper, interview transcript, November 6, 2007: "But the one that lived on the plantation right next to us, that was Robert Nighthawk's son, Sam Carr. He lived on the same plantation for a year. He came down there with his wife [Doris] and raised the crop. But I didn't know that was Sam until one day a couple of years ago we was talking about the plantation. Sam used to ride that bicycle and I had one. And I thought my bicycle was just as pretty as his. He remembered—He said, 'Oh, that was *you*?'"
10. Arthur "Big Boy" Crudup recorded "Rock Me Mamma" December 15, 1944, in Chicago. Released on the RCA Bluebird label in early 1945.
11. This is a lyric from one of Arthur Crudup's earliest songs—"Black Pony Blues" aka "Coal Black Mare," recorded in September 1941 and released on RCA Bluebird label.
12. Robert Gordon, *Can't Be Satisfied: The Life and Times of Muddy Waters*, 97–99. See also, Sandra B. Tooze, *Muddy Waters: The Mojo Man*, 94.
13. "Sonny Boy Williamson achieved local fame through his performances on KFFA before making the journey to West Memphis, where he headlined his own KWEM show from 1948 to 1950. Williamson's show featured several colleagues from the regional blues circuit, including Howlin' Wolf and the legendary B.B. King, whose brief stints on KWEM led to a show of his own on WDIA in Memphis. Blues performers who made appearances on KWEM during this era included Ike Turner,

Junior Parker, James Cotton, Willie Mitchell, Elmore James, Hubert Sumlin, Bobby 'Blue' Bland, Rosco Gordon, Willie Nix, and one-man band Joe Hill Louis (aka 'The Be-Bop Boy')." "KWEM," Encyclopedia of Arkansas, https://encyclopediaofarkansas.net/entries/kwem-radio-station-8240/.

14. There is a Blues Trail marker for Sonny Boy Williamson II in the middle of the block.

15. The Hucklebuck became a wildly successful dance craze in 1949, partly due to its sexual connotations. LeRoi Jones reported that people danced at rent parties in Newark night after night "until they dropped." LeRoi Jones, *Blues People: The Negro Experience in White America and the Negro Music That Developed from It*, 200.

16. Jimmy Reed song, but not written until 1961, so Willie would not have been using those exact words in 1953.

17. Henry "Pot" Strong performed but never recorded with Muddy Waters. He joined the band at Club Zanzibar in 1953, replacing Big Walter Horton. Strong was killed by his girlfriend on June 3, 1954. Willie told Muddy's biographer Sandra Tooze that he considered Henry Strong to be the equal of Little Walter on the harmonica. See Tooze, *Muddy Waters: The Mojo Man*, 121–22.

18. Little Walter's "Juke" was released on Chess Records in July 1952 and became one of the company's greatest hits. To this day, it is still the only harmonica instrumental ever to be a #1 hit on the *Billboard* R&B chart.

19. In 1964 Willie played drums on Big Walter Horton's first album, *The Soul of Blues Harmonica*, on the Chess label.

20. The "1145" refers to the address of an otherwise unnamed club at 1145 West Madison Street on Chicago's Near West Side, between North May Street and Racine Avenue. The club is identified ["unknown name"] on Mike Rowe's map "Chicago Clubs in the Fifties," in Mike Rowe, *Chicago Blues: The City & the Music*, 216–17. The area has been completely gentrified since the 1950s; no buildings from that era remain.

21. Clifton James played drums for Bo Diddley on his Chess recordings from 1955–59.

22. Written by Willie Dixon and with "Little Willie" Smith on harmonica, "Diddy Wah Diddy" was released on the Checker label in 1956.

23. "The famous blues shuffle beat is based on swinging eighth-note triplets, and should sound something like four sets of train wheels bumping along the tracks. . . . The two most common forms are the Chicago shuffle, which emphasizes the second and fourth beat, and the Texas shuffle, which emphasizes the first and third." Debra Devi, *The Language of the Blues from Alcorub to Zuzu*, 211–12.

24. Bob Margolin to Margo Cooper, telephone notes, March 3, 2021. See also Peter Ward to Margo Cooper, email, September 22, 2007: "Willie totally understood the use of restraint in drumming—delaying the beat on 2's and 4's. He understood *tension*—the idea of building up to an intense moment. Willie used the sticks to hit a drum or cymbals in succession—in a fury, a whirl—as we changed into the next chord . . . You'd hear clicking as he did this—sticks hitting stands, sticks hitting sticks. You'd look back at him, and his eyes were wide when he did this—he was *driving* the band. The look said, 'You're with me or get out of the way!' I loved Willie's endings. As the band took a tune out, he'd carry the whole thing and then slow up the last few beats."

25. *Muddy Waters Sings Big Bill* was recorded from June to August 1959 and released on Chess in June 1960. Willie is listed as drummer on four of the ten tracks. Francis Clay plays on the others.

26. Gordon, *Can't Be Satisfied: The Life and Times of Muddy Waters*, 180.

27. "Mayor to Name Street for Muddy Waters," *Chicago Tribune*, August 2, 1985, 4, 9. "43rd Street, from South Oakenwald Avene to State Street, will be named Muddy Waters Drive." The designation was later reduced to the blocks between 900 and 1000 East 43rd.

28. Tens of thousands of people lined the street outside Rayner's funeral home for Till's viewing, and days later thousands more attended his funeral. Photographs of his battered body, made by Black photojournalist David Jackson with the permission of Till's mother, Mamie, appeared first in *Jet* magazine and the *Chicago Defender*, then circulated in Black publications across the US, generating intense outrage. Many years later, *Time* magazine listed Jackson's photo among "the 100 most influential images of all time"; but no white-owned magazine or newspaper would print any photographs of Till's open casket at that time.

29. The Muddy Waters band was reported in a "music contest" with the band of Howlin' Wolf in Tuscaloosa, Alabama, on June 24, 1961 (five weeks after the Birmingham riot). Tuscaloosa is fifty-five miles west of Birmingham. See *Alabama Citizen*, June 24, 1961, 8.

30. Paul Oscher to Margo Cooper, telephone notes, January 26, 2021.

31. Paul Oscher to Margo Cooper, telephone notes, January 26, 2021.

32. Willie left the band sometime after May 1964. As of May 4, 1964, he was still with the band, touring in England. On that day, he recorded in London with Muddy on Otis Spann's album *The Blues of Otis Spann*.

33. "Put Me in Your Lay Away Plan"/"Still a Fool," September 1964; "St. John the Conquer Root"/"Short Dress Woman," May 1965; and "Hoochie Coochie Man"/"Corrine, Corrine," June 22–23, 1966. And *Muddy Waters: Brass and the Blues* (1966).

34. According to setlist.fm, the gig was at the Kinetic Playground, a club in Uptown at North Clark and Lawrence. Muddy was on a New Year's bill with Fleetwood Mac and the Byrds. The Kinetic Playground was featured in Haskell Wexler's film *Medium Cool*.

35. Muddy left the hospital January 8, 1970.

36. The album, recorded November 10, 1969, was released on Delmark in 2013 under the title *Sunny Road*, two years after Willie's death—and forty years after Arthur's. It features not only Arthur Crudup and Willie but also Jimmy Dawkins.

37. Muddy Waters' Band won Grammy awards for the following albums: *They Call Me Muddy Waters* (1972); *The London Muddy Waters Sessions* (1973); *Muddy Waters Woodstock* (1976); *Hard Again* (1978); *I'm Ready* (1979); *Muddy Mississippi Waters Live* (1980).

38. Bob Margolin to Margo Cooper, email, December 30, 2022. "Muddy told me, after a magical gig, that this was the best band he had since the early 1950's with Little Walter, Jimmy Rogers and Otis Spann."

39. The album was recorded in the fall of 1980 in Carlisle, Massachusetts, produced by Jerry Portnoy. It was released simultaneously on the French label Black & Blue and Rounder Records on January 1, 1981.

40. The Legendary Blues Band recorded seven albums between 1980 and 1993—two on Rounder, four on Ichiban, and one on Wild Dog.

41. See Jon Ferguson, "Blues Band Ekes Out Living," *Intelligencer-Journal* (Lancaster, Pennsylvania), September 13, 1985, 25. "... the real fresh face is Darryl Davis, who plays piano. Davis replaced the truly legendary Pinetop Perkins about two weeks ago."

42. The last documented mention of Calvin Jones appearing with the Legendary Blues Band is from a performance at Ames, Iowa, in March 1992. See *Des Moines Register*, March 19, 1992. By the end of July 1992, Nick Moss is listed as the band's bass player. See Bob Lowe, "'Big Eyes Coming Up From Chicago," *Post-Crescent* (Appleton, Wisconsin), July 30, 1992, C3.

43. In June 2005 the band performed at the Rehoboth Convention Center. The group featured Willie, Calvin, Pinetop, and Bob Margolin but with James Cotton replacing Jerry Portnoy on harmonica and John Primer instead of Luther "Guitar Junior" Johnson.

44. Bob Margolin to Margo Cooper, email, October 16, 2007. "His son, Kenny 'Beedy Eyes' Smith is the only drummer I've ever heard who can sound like Willie. Kenny can also play more conventionally."

45. *Joined at the Hip*, released June 2010. Willie returned to his roots, singing vocals on Big Bill Broonzy's "I Feel So Good" and Sonny Boy Williamson II's "Eyesight to the Blind." Willie and Pinetop shared vocals on Sonny Boy Williamson I's "Cut That Out." Willie was on harmonica, his son Kenny on drums.

46. Margaret Moser, "Last of the Delta Bluesmen," *Austin Chronicle*, April 22, 2011, https://www.austinchronicle.com/music/2011-04-22/last-of-the-delta-bluesmen/.

Calvin "Fuzz" Jones

1. Lessie Jones to Margo Cooper, interview notes, August 28, 1997.

2. See Calvin's January 26, 1944, draft registration. His name is recorded only as "C. W. Jones" with the notation "i.o." (Initials Only). He also signs the draft registration "C. W. Jones."

3. Before federal flood control projects undertaken during the Great Depression, the Tallahatchie River was prone to flooding. In 1930 a blues woman named Mattie Delaney made a record titled "Tallahatchie River Blues."

4. Note: After my oral history of Calvin Jones was published in *Living Blues* in 2008, I was contacted by Joe B. Lee's son, Joe T. Lee, then seventy-nine years old, living in Jonesboro, Arkansas. He had seen Calvin's story in *LB*, he told me, and was making plans to meet up with his old boyhood friend after seventy years. Regarding plantation life in those days, he recalled: "My dad respected everybody. There was no sharecropping on his land. Dad furnished the homes and paid the people who worked for him. The plantation was west of Inverness. We housed maybe twelve families. Calvin was one of the workers' children I played with as a kid." As it turned out, Joe B. Lee grew up to be a musician himself—a studio musician in Memphis, from the time he was in high school. "On one album I backed up Bobby Blue Bland on sax. I played piano on two songs for Elvis on the *Elvis Is Back* album [1960]." Joe T. Lee eventually owned his own music studio, Variety Recording Studio in Jonesboro, home of Alley Records. Joe T. Lee died May 19, 2013.—Margo Cooper

5. The plantation encompassed five thousand acres. See Tom J. Gary, *A History of Wildwood Plantation and Adjoining Gary Land* (abstract, included in National Register of Historic Places Registration form, August 2, 2013), https://www.nps.gov/nr/feature/places/pdfs/13000734.pdf.

6. The Wildwood Plantation Commissary & Store is now in the National Register of Historic Places. For a detailed description of the commissary and store, and a history of the Wildwood Plantation, visit https://www.nps.gov/nr/feature/places/13000734.htm. For more on the "furnish system," see Mississippi State College Agriculture Experiment Station, *The Plantation Land Tenure System in Mississippi*, Bulletin 385, June 1943, 31–32.

7. Carolyn Madge Holloway and Roy Bryant married in 1951 in Charleston and did not arrive in Money until sometime after that. The grocery store had been built earlier in the 1900s and had passed through several owners before the Bryants.

8. According to the NAACP, 4,743 people were lynched in the United States between 1882 and 1968. Mississippi had the highest number, by state: 539 African Americans lynched during the period. Leflore County, where Money is located, had the most lynchings of any county in Mississippi—48. Even during Calvin's childhood and teen years, there were a half-dozen lynchings in Leflore and Sunflower counties alone (those were the counties he lived in).

As late as 1937, when Calvin was eleven years old, one of the most gruesome and notorious lynchings of the 1930s took place just twenty-eight miles east of Money, in Duck Hill, Mississippi: the torture and burning of Roosevelt Townes and Robert McDaniels, two Black men who had been arrested for the alleged murder of a white store owner. Photographs of their killing were published in *Time* and *Life* magazine—the first photographs of lynchings published in national mainstream magazines.

9. Edward Komara, ed., *Encyclopedia of the Blues*. "In 1937, Williamson recorded his first tracks for Bluebird Records, a subsidiary of Victor Records.... During those first sessions, Williamson recorded 'Sugar Mama,' 'Early in the Morning,' 'Check Up on My Baby,' and 'Bluebird Blues.' All were extremely successful and influential."

10. Lessie Jones to Margo Cooper, interview notes, August 28, 1997.

11. The Chicago Stadium was the largest sports arena in the United States at the time. It also hosted political conventions. FDR had been nominated there in 1932, 1936, and 1944. It was also the scene of many championship prize fights, and was the home arena of the Chicago Black Hawks, and later the Chicago Bulls. It was demolished to make way for the present-day United Center.

12. The intersection of Damen Avenue and West Madison Street in the 1950s had bars on three of its corners—Red's Lounge, Chuck's, and the Globetrotter Lounge. The entire area is now paved over with parking lots for the United Center.

13. According to the *Encyclopedia of Chicago*, "The center of the Jewish business community, the Maxwell Street Market, or 'Jew town,' came to life at the intersection of Halsted and Maxwell . . . For about one hundred years, Maxwell Street was one of Chicago's most unconventional business—and residential—districts. It was a place where businesses grew selling anything from shoestrings to expensive clothes. . . . Goods on card tables and blankets competed with goods in sidewalk kiosks and stores. Sunday was its busiest day since Jews worked on the Christian Sabbath, when stores were closed in most other parts of the city."

14. Jerry Portnoy, whose father sold carpets on Maxwell Street, recalled, as a boy, seeing Little Walter in a regular spot across the street from Lyon's Delicatessen. Jerry was born in 1943, so he must have been remembering Walter from the early 1950s. See Gordon, *Can't Be Satisfied*, 240.

15. Lover's Lounge, Paulina Avenue and West Madison Street, listed in "Chicago Clubs in the Fifties," Mike Rowe, *Chicago Blues: The City and the Music*, 216–17.

16. Muddy, Jimmy Rogers, and Little Walter were playing as a group at Club Zanzibar before Calvin arrived in Chicago. The club opened in 1946, and Muddy, Jimmy, and Walter began playing there from the first, and continued to do so for the next eight years. See Gordon, *Can't Be Satisfied*, 88; Wayne Everett Goins, *Blues All Day Long: The Jimmy Rogers Story*, 61.

17. According to the *Encyclopedia of the Blues*, "From the time Muddy and Jimmy first played together, they knew they had a good sound. Rogers understood how to play bass parts and how to play licks that complemented Muddy's slide. If Muddy's playing was a diamond, Jimmy was the jeweler's black velvet that made it shine."

18. Howlin' Wolf was twenty-one years older than Hubert. According to statements by each man, their association was something of a father-son relationship. See *Living Blues*, vol. I, no. 1, Spring 1970. Howlin' Wolf: "I always let Hubert play because he's a young man [Hubert was thirty-nine years old when HW said this] and I want him to be seen. I partly raised him, you know. Always keep him out there to the front and I do the singing. But if he get kinda sluggish with it, then I play." In my own 2008 interview with Hubert Sumlin, he said, "Wolf was like a father to me—the father I didn't have. He learned me so much when I was coming up. . . ."

19. Calvin was still with Howlin' Wolf in July 1969. He is listed in the personnel of a 45 issued on the Chess label in July 1969—"Mary Sue"/"Hard Luck." The band is Wolf on vocals, harmonica, and tenor sax; Hubert Sumlin, rhythm guitar; Calvin, bass; Lafayette Leake, piano; and Cassell Burrows, drums. The date of this recording session is July 14, 1969. See also "Howlin' Wolf Interview" in *Living Blues*, Vol. I, No. 1, Spring 1970. The interview with Howlin' Wolf was conducted in October 1969. See Jim O'Neal to Margo Cooper, telephone notes, February 8, 2021.

20. Before joining the band full time in 1971, Calvin had been working occasionally with Muddy for at least seven years, going back to a series of mid-1960s Chess singles—"John the Conqueror Root"/"Short Dress Woman" and "Put Me In Your Lay Away"/"Still a Fool" September 1964; "My Dog Can't Bark"/"I Got a Rich Man's Woman" May 1965; and "Hootchie Cootchie Man"/"Corrine, Corrina" June 1966. He also performed on Muddy Waters' 1966 LP, *Muddy Waters: Brass and the Blues*, and the single "Going Home" (Chess, 1969).

21. See Gordon, *Can't Be Satisfied*, 229–30. "Mr. Kelly's marked a turning point in Muddy's career. . . . Mr. Kelley's was a beginning and an end. The Quiet Knight, the White Rose, Pepper's, the Urbanite, Silvio's—these were places that were about to become part of Muddy's past, his pre-Mr. Kelly's days. 'I think I saw the last real regularly booked Black Chicago club that he played,' said Jim O'Neal, one of the founders of *Living Blues*. 'It was New Year's night, 1971. I kept up with the club scene because we printed the listings in *Living Blues*, and the only time after that I can remember that Muddy played at a Black club in Chicago was if a film crew set it up.'" See also Paul Oscher to Margo Cooper, telephone notes, January 26, 2021. "Mr. Kelly's—no blues people ever played there. We were the first blues band. Muddy told us, 'I ain't taking no alcoholic band in this club.' We got rave reviews in every Chicago newspaper. Nancy Wilson and Bill Cosby were there opening night. Every night the crowd went wild. The place was packed for twenty-one days. It was the turning point in Muddy's career."

22. Jerry Portnoy to Margo Cooper, telephone notes, November 13, 2007.

23. Paul Oscher to Margo Cooper, email, February 26, 2008. "When I left at the end of '71, Carey Bell came into the band, then Mojo Buford, then Jerry [Portnoy] in 1974 or '75."

24. Bob Margolin to Margo Cooper, email, October 16, 2007. For another recollection of Calvin Jones's bass style by a fellow musician, see Michael "Mudcat" Ward to Margo Cooper, email, September 15, 2007. "On a musical level, Calvin created a giant, hugely warm and round bass tone. Utilizing fingers, not a pick, he produced his sound in part with a soft, even touch on the strings of his Fender bass . . . Feeling Jones' pumping bass was always a pleasure but hearing him sing was an enormous treat. As with his bass playing, Jones made singing seem effortless. In either voice, vocally or on his Fender, Calvin always managed to make the emotional statement, and did so in a direct and straightforward manner."

25. Bob Margolin to Margo Cooper, telephone notes, March 3, 2021.

26. Bob Margolin to Margo Cooper, email, October 16, 2007.

27. Jerry Portnoy to Margo Cooper, telephone notes, November 13, 2007.

Luther "Guitar Junior" Johnson

1. By the time Luther was a year and a half old, the family had moved north to Avent Plantation, three miles west of Minter City. In October 1940, Luther Johnson Sr. registered with Selective Service at Minter City, giving "Avent Plantation" as his place of employment.

2. Daisy Hardy to Margo Cooper, telephone interview, September 23, 2018.

3. "Forty Mile Bend" is a meander, or loop, in the Tallahatchie River south of Minter City and Philipp in LeFlore County. "Forty Mile" refers to the upstream river mileage from the junction of the Tallahatchie and Yalobusha rivers at Greenwood. (Although as the crow flies Minter City is less than twenty miles from Greenwood.)

4. Archibald Young Sturdivant Jr. (1915–1976).

5. Classic gospel songs, both written by Thomas A. Dorsey.

6. "Ain't No Grave Gonna Hold My Body Down" is a gospel song written by white Holiness minister Brother Claude Ely in 1934. Alan Lomax recorded a version by Arkansas field worker Bozie Sturdivant outside Clarksdale in 1942.

7. Nettie Bea Griffin to Margo Cooper, interview transcript, April 3, 1999.

8. "Peach Tree Blues" recorded by Yank Rachell and Sonny Boy Williamson #1 in 1942. R. L. Burnside later recorded an iconic version. L. C. Ulmer recorded a variation on the theme in "Peaches Falling" on the CD *Blues Come Yonder* (Hill Country, 2011).

9. The Stella company was acquired by Harmony in 1939, the year Luther was born. Harmony produced many "parlor guitars" in the 1940s and '50s with pictures of the cowboy Roy Rogers on the body.

10. Daisy Hardy to Margo Cooper, telephone interview, September 23, 2018.

11. Nettie Bea Griffin to Margo Cooper, interview transcript, April 3, 1999.

12. Begun in 1948, the Goodwill Revue was an annual show put on by radio station WDIA in Memphis, to benefit African American children. Many great blues, R&B, and gospel artists performed, including B.B. King, the Staple Singers, and Elvis Presley.

Radio station WDIA in Memphis began broadcasting and pioneering black programming throughout the South in June 1947. Known as "the Mother Station of the Negroes," with the first black DJ, Nat D. Williams (1907–1983). B.B. King and Rufus Thomas were later DJs on the station.

13. Muddy Waters and Little Walter performed for the Goodwill Revue on December 3, 1954. According to Muddy's biographer Sandra B. Tooze, Muddy also performed at the Goodwill Revue in December 1953. See Tooze, *Muddy Waters: The Mojo Man*, 128. B.B. King performed at the Goodwill Revue on December 7, 1956. The Staples Singers performed at the Goodwill Revue in December 1957, according to Mavis Staples. See Greg Kot, *I'll Take You There: Mavis Staples, the Staple Singers, and the Music that Shaped the Civil Rights Era*, 57–58.

14. That Jimmy Rogers grew up on the same plantation as Luther is documented in Jimmy's 1942 registration for Selective Service. At that time, he was known as Jay Arthur Lane (his birth name). He recorded his employer's name as "A. Y. Sturdivant"—the father of the man Luther worked for. In 1942, "Archie" Sturdivant was in the Armed Services.

15. This foursome of Muddy Waters, Jimmy Rogers, Otis Spann, and Little Walter first recorded together in October 1953 on the Chess single, "Blow Wind Blow/Mad Love" under the name "Muddy Waters and His Guitar." The group also recorded in 1954 as "Jimmy Rogers and His Rockin' Four."

16. Ray Scott to Margo Cooper, telephone notes, ca. 1996, "Luther Johnson Notebook," 32.

17. Daisy Hardy to Margo Cooper, telephone notes, December 14, 2020.

18. Ray Scott to Margo Cooper, telephone interview notes, ca. 1996, "Luther Johnson Notebook," 32.

19. Ray Scott to Margo Cooper, telephone interview notes, ca. 1996, "Luther Johnson Notebook," 32.

20. Luther also played with the bands of his friends Eddie Clearwater, Tyrone Davis, Freddie King, Son Seals, Eddie Shaw, Magic Slim, and Mighty Joe Young. Luther Johnson to Margo Cooper, telephone notes, December 15, 2020.

21. Bobby Rush to Margo Cooper, telephone notes, December 12, 2020. "I think we met at the Squeeze Lounge. Late fifties—'58 or '59—before '60. He played with me on and off 'til '63. He went with Magic Sam. He'd play with me and he'd sit in with me. We played every joint you could name in Chicago—Castle Rock, Hideaway, Theresa's, Walton's Corner. . . ."

22. Bobby Rush to Margo Cooper, telephone notes, December 12, 2020. "I first started using the name Bobby Rush and the Four Jivers in Arkansas. I kept the name when I came to Chicago. I came up in '51."

23. Bobby Rush to Margo Cooper, telephone notes, December 12, 2020.

24. Big Beat Records was a small label from Shreveport, Louisiana, a division of M.C.M. Enterprises (no connection with the French label MCM). Big Beat Records were distributed from Greenville, Mississippi, and promoted largely by local DJ Joe Gunn on WESY-AM. Big Beat's discography runs from 1962–72. In the liner notes to Luther's 2001 album *Talkin' About Soul*, his agent Paul Kahn mistakenly identifies Big Beat as a "Chicago label."

25. The name "Guitar Junior" was first used by Louisiana bluesman Lee Baker Jr., who recorded under it on the Goldband label as early as 1956 ("I Got It Made When I Married Shirley Mae"). In the early 1960s, he changed his name from Lee Baker Jr. to Lonnie Brooks, although "Guitar Jr." continued to be printed on his forty-fives for Mercury and Palos until 1965.

Beginning in 1965, on Chess, Brooks dropped the "Guitar Jr.," recording thereafter mostly as Lonnie Brooks. In 1970, however, he released his first LP (*Broke an' Hungry*) on the major Capitol label, once again using the "Guitar Jr." moniker—and there are examples of him using it for club listings in Chicago as late as 1973. See "Silver Moon," *Living Blues* 11, Winter 1972–73, 10.

There are Chicago club listings for Luther "Guitar Jr." Johnson in the early 1970s. (See "Silver Moon," *Living Blues* 11, 10.) Although Luther Johnson was called "Guitar Junior" by his friends on Chicago's West Side in the 1960s, he was not credited on record under the name until the 1978 Adelphi album *Jacks and Kings*, as part of The Nighthawks band with Calvin Jones, Pinetop Perkins, Bob Margolin, and David Maxwell. On his first album with Muddy Waters, *Unk in Funk* (1974) he is listed only as Luther Johnson; even on his own first album, *Ma Bea's Rock* (1975), he is Luther Johnson Jr. After 1978 he is always referred to as Guitar Junior.

26. Probably the National Malleable and Steel Castings Co., aka National Castings, which operated steel mills in the Chicago suburbs of Cicero and Melrose Park throughout the twentieth century.

27. Jack Bodnar, "Waters: Nothing but Blues for Incredible Musician," *Michigan State News*, November 16–17, 1973, https://concerts.fandom.com/wiki/November_1217,_1973_The_Stables,_East_Lansing,_MI?file=IMG_2383.GIF.

28. The Stables was a club on the outskirts of the campus of Michigan State University, at the time one of the largest universities in the US, with an enrollment of thirty-five thousand. The audience would have been many times bigger than those of the West Side bars Luther had been playing for the previous fifteen years—and would have been predominantly, if not almost completely, white college kids. James Cotton, Buddy Guy & Junior Wells, and Jimmy Rogers all played at the Stables in 1973; the venue also featured folk acts (Phil Ochs, Richie Havens) and jazz (Miles Davis, Les McCann).

29. Bruce Iglauer to Margo Cooper, email, January 12, 2023.

30. Bob Margolin to Margo Cooper, email, December 30, 2022.

31. Pinetop Perkins came to Chicago to join Earl Hooker in 1968 to record the album *Two Bugs and a Roach* (Arhoolie, 1969). He had been living in Southern Illinois for a few years prior to that.

32. Brian Bisesi to Margo Cooper, email, October 2, 2021.

33. MCM was the French blues label of the family recording and production team of Jacques and Marcelle Morgantini and their son, Luc. MCM released seventeen albums from their sessions in Chicago over the two years 1975–77, most of them recorded live at Ma Bea's Lounge.

34. *Living Blues* 11, Winter 1972–1973, 9–10. "Ma Bea's Lounge: Home base of Jimmy Dawkins and his band for the past nine months . . . Crowded, lively, and fun."

35. Bruce Iglauer to Margo Cooper, email, January 12, 2023.

36. Willie Kent's first album, *Ghetto*, was also recorded at Ma Bea's by the French MCM team, on October 17, 1975, and was released in October 1976.

37. This is actually Luther's first album completely under his own name and on which he performs every track. It was the direct result of his earlier recording session with Marcelle Morgantini at Ma Bea's in 1975. Marcelle's husband Jacques was a recording supervisor for Black & Blue. In his liner notes for *Luther's Blues*, he writes: "This musician was discovered by us because of a recording that was made live in a Chicago bar in 1975 by the recording company MCM."

Black & Blue produced a second album—*Boogie Woogie King*—for Pinetop Perkins from the same day's recording session, using the same personnel. Luther played guitar on four cuts and was given prominent cover credit.

38. From 1973 to 1980, Muddy Waters released six albums. Luther played on three, as he says. Regarding *Unk in Funk*, which was recorded soon after Luther joined the band, Muddy's biographer Robert Gordon says, "Luther Johnson had come up playing the West Side Sound with Magic Sam, and had a high-pitched, soulful voice. His trebly, tightly-wound sound added a distinct new texture to *Unk in Funk*." Gordon, *Can't Be Satisfied*, 240. *Muddy Mississippi Waters Live* was recorded at two venues—the Masonic Auditorium in Detroit, and Harry Hope's in Cary, Illinois. Luther is only on the four tracks from Harry Hope's. *King Bee* was Muddy Waters' last studio album. The band broke up during the sessions and the album was filled out using outtakes from *Hard Again* (1977) and *I'm Ready* (1978), albums that Luther does not appear on. He is, however, playing on the three tracks of *King Bee* that are considered the best of the album—"Mean Old Frisco," "Sad, Sad Day," and "I Feel Like Going Home."

39. "Harry Hope's joint" was a club in an old ski lodge in Cary, Illinois, forty miles Northwest of downtown Chicago. Muddy Waters' band played regularly there throughout the 1970s. The session for *Muddy Mississippi Waters* was recorded there on March 18, 1977.

40. The Legendary Blues Band consisted of Willie Smith, Calvin Jones, Pinetop Perkins, and Jerry Portnoy from Muddy's band. They recorded their first album, *Life of Ease*, six months after leaving Muddy. The album was released on the French label Black & Blue at the end of 1980, and in the United States immediately after on Rounder (January 1981).

Bob Margolin to Margo Cooper, email, December 17, 2022: "In June 1980, I started my own band with Jeff Lodsun on drums, Terry Benton on bass, and Doug Jay on harp. Brian Smith on bass did occasional gigs with us. In 1981 the band cut one single under the name Bob Margolin Blues Band. Harp player Doug Jay was out of the band by that time."

41. Ron Levy, *Tales of a Road Dog*, 161.

42. Rosa Mae Bentley to Margo Cooper, telephone notes, December 27, 2020. "Everyone called my mother 'Mama Rose.' Her name was Rosie Lee Hooks [1923–1984]. My mom grew up in Alabama. She was a supervisor in housekeeping for Children's Hospital. She lived at 48 Francis Street in Boston. Mom enjoyed cooking. She always had a pot of soup on the stove for people to eat. My mother got her nickname Mama Rose from her cooking and feeding people, letting people stay at her home. She raised us to take care of others, help each other . . . Pinetop [Perkins] was the love of her life. Muddy's band used to come to Boston a lot and the band would come over."

43. The name Magic Rockers first appeared in New England newspapers in a listing for a "Blues Revival" in Lynnfield, Massachusetts, in September 1981. See

Boston Globe, "Calendar," September 3, 1981, 17. Prior to that, Luther was listed in ads simply as Guitar Junior.

Michael Ward to Margo Cooper, telephone notes, December 17, 2022. Originally from Maine, Michael "Mudcat" Ward has been a well-known performer on the New England blues scene for more than forty years. In 1978, Ward formed a band with Ronnie Hovarth (aka Ronnie Earl). Called the Hound Dogs, the band became the house band at the Speakeasy Blues Club in Cambridge and backed many blues artists, including Big Mama Thornton and Roosevelt Sykes. Before joining Luther as a Magic Rocker, Mudcat was a bass player for Ronnie Earl and the Broadcasters and has been associated with Sugar Ray and the Bluetones since the band's formation in the 1970s.

Born in 1943 in South Carolina, Ola Dixon moved to New York City as a teenager. Before joining Luther Johnson's Magic Rockers, she played drums for the Charles Walker New York City Blues Band (*Blues from the Apple*, Oblivion Records, 1974) and as a member of Sugar Ray and the Bluetones. Michael Ward to Margo Cooper, email, December 17, 2020: "Ola lived in the Bronx for most of her musical career. Ola and I joined Luther's band in the late 1980s." See also Michael Ward to Margo Cooper, email, December 20, 2020: "Brian [Bisesi] and I knew one another from the blues scene. He called and asked if I wanted to work with Ola again—Ola was with the Bluetones in '79—and be in Junior's band."

Brian Bisesi was a young road manager and sometimes backup guitarist in the Muddy Waters band in the late 1970s. When Luther injured his arm in a fall during the blizzard of 1978 in Boston, Brian covered for him until he could play again. After the break-up of Muddy's band in 1980, Brian and Luther recorded together on the Alligator compilation album, *Living Chicago Blues, Vol. 6*.

"Magic Rocker" was the name of a song written by Magic Sam and recorded on the Cobra label in May 1957, but not released until 2001 on the compilation CD *The Essential Magic Sam: the Cobra and Chief Recordings, 1957–1961* (True North). Luther would, of course, have known the song from playing with Magic Sam. "Magic Rocker" features Little Brother Montgomery on piano and Willie Dixon on bass.

44. Paul Kahn to Margo Cooper, email, January 27, 2021.

45. The 27th annual Grammy Awards were presented February 26, 1985, at the Shrine Auditorium in Los Angeles. They recognized musical releases from 1984.

46. The Blues Trail marker in Cahors reads: "Gérard Tertre planted the seeds for the Cahors Blues Festival in the '70s and in 1979 presented a concert at the Municipal Theatre near this site. Aided by sponsors and many volunteers, Tertre produced the first festival in 1982, with guests including Mississippian Luther Johnson Jr."

47. As of 2021, Luther's discography includes eight albums with the Magic Rockers—most recently a live CD recorded at the Hideaway Café in St. Petersburg, Florida, on Halloween 2020 (*Once in a Blue Moon*, Crossroads Blue Media, 2021).

48. John May (Chairman of the St. Louis Blues Society) to Margo Cooper, telephone notes, March 29, 2021: "The recording was at Oliver Sain's Archway Studios. It was his home; downstairs was his studio and office. Oliver was considered the 'Godfather of Soul' in St. Louis. He played sax and piano."

Johnnie Johnson co-wrote songs with Chuck Berry and is reputed to have been the "real-life" model for Berry's "Johnny B. Goode."

49. Luther Johnson to Margo Cooper, interview transcript, September 22, 2018. "They wanted Muddy Waters, but Muddy was ill so they got John Lee Hooker and Muddy's band played with him. We're in the scene on Maxwell Street in front of Aretha Franklin's restaurant."

50. Gordon Beadle to Margo Cooper, text message, November 8, 2021.

51. Michael "Mudcat "Ward to Margo Cooper, telephone notes, December 24, 2020.

52. Ron Levy, liner notes for Luther "Guitar Junior" Johnson, *Country Sugar Papa*, Bullseye Blues, NETCD 9546, 1993.

53. Gordon Beadle to Margo Cooper, telephone notes, April 16, 1997.

54. Bob Margolin to Margo Cooper, email, December 30, 2022.

Sam Carr

1. There is further confusion about Sam's place of birth. In 1944, on his Selective Service registration card, he listed his birth place as Coahoma County, Mississippi.

2. Robert McCollum was born in 1909. He falsified his birth date on his 1925 marriage license, adding five years, possibly in order to meet the "age of majority" without parental permission.

3. Frank Alexander was a white farmer listed in the same "beat" of the 1930 US Census in Tunica County, Mississippi. The Garfield Carr and Mary Ford families lived very close by. The Carrs were listed as #256, Mary Ford was #258, and Frank Alexander was #263.

4. "Seven year itch" is an old, vernacular name for scabies. Human scabies is caused by an infestation of the skin by the microscopic human itch mite (*Sarcoptes scabiei*). The most common symptoms of scabies are intense itching and a skin rash.

5. In the 1930 US Census for Tunica County, Mississippi, the couple is listed as Garfield (47) and Mozella Carr (36). "Sam" is listed as "adopted son," age four.

6. Annie Collins Road is in southwest Tunica County, less than a mile from the line with Coahoma County. According to the 1940 US Census, the Carr farm was located "4 miles west of Dundee." The record also noted that they had lived in the same house in 1935.

7. For more on Rosenwald schools, see William Hustwit, "Rosenwald Schools," *Mississippi Encyclopedia*, https://mississippiencyclopedia.org/entries/rosenwald-schools/.

8. In the 1930 US Census, there is a Willie Carr living next door to Garfield and Mozella Carr. He was, however, sixteen years older than Sam, having been born in 1911.

9. Ethel McCollum was born in 1900, according to 1910 US Census.

10. "The studio." According to the *Delta Music Heritage Research Project*, vol. I, 26: "KFFA began broadcasting in 1941 on the second floor of the Floyd Truck Lines building at 215½ York Street. It remained there until 1964, when the station moved to the Helena Bank Building at 302 Cherry Street. . . . Access to the modern studio was via a rickety stairway on the outside of the building. Available photographs show a clean studio which appears to have acoustic tile on the walls and carpet on the floor. The talent and the announcer shared a microphone. The control room that monitored the broadcast was separate, but visible through a small window in one of the walls. The setup was much like any radio station of its time."

Robert Nighthawk played on KFFA for both Mother's Best Flour and Bright Star Flour. Mother's Best Flour was the sponsor of a KFFA show that aired beginning in 1943, begun by Robert Junior Lockwood. Houston Stackhouse and the Starkey Brothers were regulars on the show.

According to the *Delta Music Heritage Research Project*, vol. I, 26: "The distributors of Bright Star Flour sponsored a show featuring Robert Lee McCollum, aka Robert Nighthawk, Joe Willie Wilkins and Pinetop Perkins." See also Robert Palmer, *Deep Blues*, 192. "King Biscuit Time was so popular it had been flattered by several imitations. In 1942 Robert Nighthawk returned to Helena. Within a year of his arrival he was broadcasting over KFFA for Bright Star Flour . . ."

11. C. W. Gatlin to Margo Cooper, telephone notes, March 24, 2020, March 29, 2021, and August 21, 2022. "Albert Vogel's place was out on his farm, in a cotton field in the middle of nowhere. It was a beer joint, mostly a black juke house. When other places closed people would come. I started going down in 1959. Thurlow Brown and Houston Stackhouse got me in it. I played with Robert Nighthawk at Vogel's and some other joints. When Robert came it was a big deal. He might bring Elmore James or Slim Harpo."

12. John Mohead to Margo Cooper, interview transcript, August 12, 2000.

13. Houston Stackhouse to Jim O'Neal, quoted in Jim O'Neal and Amy van Singel, eds., *The Voice of the Blues: Classic Interviews from* Living Blues *Magazine*," 95–96: "In '46 Robert come back to Helena and was playin' around there, and he decided he wanted me to come back and get with him then. . . . Well, he went down home to Crystal Springs lookin' for me. . . . Then I come up there and work with him. We was playin', makin' good money playin' all over in Mississippi, and Arkansas too. Dances and that, playin' every night of the week somewhere. We're makin' 30 and 40, sometimes 50 dollars a piece . . . [The band was] Red Stevenson, you know, Kansas City Red we call him, me, and Albert Davis, and Pinetop Perkins. And he [Robert] had his son with him, too, Sam Carr."

14. "Bloomfield Interviews Night Hawk," *And This Is Maxwell Street*, (disc 3, Catfish Records [KAT3D1], 2000). "Kansas City Red, he's a drummer, Arthur Lee Stevenson. Fact, I learned him to play guitar. I learned him to play with slide."

15. "Maiden name: Doris Godfrey (1928–2008). She was from Dubbs, a hamlet in Tunica County. In the 1940 US Census, her family's farm was located '1 mile east of Dundee.'"

16. Bob Eagle and Eric LeBlanc, eds., *Blues: A Regional Experience*, 207. "Tree Top Slim (Willis Earl Ealy Jr.) August 28, 1926–April 1970). He worked with Joe Williams, 1952 [*Malvina, My Sweet Woman*], and recorded for Baul/Oldie Blues."

17. Earlie B. McCollum (1937–2003). Born Earlie B. Rowe in Joiner, Arkansas, June 22, 1937. It is not known when she married Robert Nighthawk (aka Robert McCollum), or when she played in his band. She is not listed among the known personnel of any of his recordings from the 1950s. According to her 1959 application for a Social Security account, she was unemployed, living in St. Louis on October 8 of that year.

18. Big Jack Johnson to Margo Cooper, in conversation at Red's in Clarksdale, August 11, 2000. See also C. W. Gatlin, to Margo Cooper, telephone notes, March 29, 2021: "Sam was a rhythm machine."

19. According to the original liner notes (unattributed, written in 1962) for *Hey Boss Man!* Sam first hired Frank in 1957. Frank Frost himself, in a 1996 interview for *Blues Access*, set the date of their first meeting in 1954.

20. In Jim O'Neal's 1971 profile of Frank Frost, Frank credits Sonny Boy Williamson with teaching him to play harp. Jim O'Neal, "Frank Frost," *Living Blues* 7 (Winter 1971–72), 26: "Fact of it is, Sonny Boy Williamson taught me to blow harmonica. I met Sonny Boy Williamson in '56. I was guitar player for him '56 to '59."

21. Sikeston, Missouri, was part of the juke-joint circuit for St. Louis–based blues players in the 1950s and early 1960s. Both the Robert Nighthawk band and Little Sam Carr & the Blues Kings are documented playing there in 1959–60. See "Band to Furnish Music for Teen Town New Year's Eve Dance," Sikeston *Daily Standard*, December 31, 1959, 3; display ad for "Little Sam Carr and His Blue [*sic*] Kings," Sikeston *Daily Standard*, June 9, 1960, 5.

22. In his 1971 interview with Jim O'Neal for *Living Blues*, Frank Frost says this happened in 1956, and that he played with Sonny Boy until 1959.

23. The title of the 1960 single on Checker is "It's Sad to Be Alone." The first line of the song is, "It's so sad be lonesome . . ."

24. Between 1956 and 1960 Sonny Boy Williamson recorded eight singles for Chess Records in Chicago, so it's impossible to date this remark of Sam's. All that can be said with certainty is that the session Sam referred to was in the late rather than the early fifties.

25. The Chess studio band in the late 1950s was not just union musicians, but was one of the great assemblies in blues history. Among others, it included Willie Dixon on bass, Otis Spann on piano, Luther Tucker and Robert Junior Lockwood on guitars, and Fred Below on drums.

26. Re: Arthur Lee Williams's harmonica "tone," Robert Lohr to Margo Cooper, interview, October 2005: "The first time I ever heard Arthur was at a place in St. Louis. I was about eighteen. He told me he used to play with Frank Frost. I got his phone number and we started hanging out. I've know Arthur my entire adult life. What makes him one of the best harp players? He's got this suck-in, draw-in vibrato that's got the mark of a world class player. He can sit there and draw in the notes

and vibrate the notes without shaking his head. All the major harp players can do that. Little Walter did it, so did James Cotton. And Arthur is one of those guys."

27. Mississippi harmonica player Billy Gibson to Margo Cooper, email, December 18, 2022: "The 'lead playing' that Sam is referring to is the melody of the song, individual riffs or single note combinations that one of the players would use to express themselves (also called 'taking a solo'). 'Chord playing' is two or more notes played together with rhythm to set up and hold a groove which the lead player can solo over. Usually it just goes back and forth between the musicians sharing the moment, taking turns with lead/rhythm duty and having fun until they have said what they wanted to musically. Both Frank Frost and Arthur Williams were exceptional musicians, so they could take it to the next level, too—blur the lines between lead and rhythm, effectively weaving the two together to become one if they wanted (individually or collectively)."

28. Jim O'Neal, "The Jelly Roll Kings," *Living Blues* 171, (January–February 2004): "Sam admits: 'If I'd a had her kept on singin', then she woulda been the artist in the band, the star—one of 'em anyway . . . She was a good singer, man!'"

29. Lee Bass to Margo Cooper, interview transcript, August 9, 2002: "I was born about two miles outside Lula. My father was in the oil business all his life. He bought a building in Lula and established the Bass Oil Company. On his death my brother and I took it on as partners."

30. "Manage" is probably an exaggeration, but Bass was apparently able to make the arrangements for B.B. King to play a well-attended show in Clarksdale in 1953. Lee Bass to Margo Cooper, interview transcript, August 9, 2002: "I rented the Clarksdale Auditorium and booked B.B. King to give a show there on September 23, 1953. The building was full . . ."

31. Lee Bass to Margo Cooper, interview transcript, August 9, 2002.

32. Houston Stackhouse to Jim O'Neal, quoted in O'Neal and van Singel, *The Voice of the Blues: Classic Interviews from* Living Blues *Magazine*, 126.

33. Margo Cooper, "Sam Chronology" index card: "1965–67 Played with Robert Nighthawk in Mississippi. Backed [him] in the 60s with Arthur, Cedell and Frank Frost." See also Michael Frank's liner notes to *Rockin' the Juke Joint Down*: "Robert Nighthawk also played with them from 1963 to 1967 in Mississippi and Alabama."

34. Gabriel Hearns email to Jim O'Neal, quoted in *Living Blues* 171 (January–February 2004), 18: "He was murdered by his girlfriend—when he allegedly began to beat her. She stabbed him with a long kitchen butcher knife, and the coroner's jury ruled it a justifiable homicide. . . . He was the best drummer I have heard or played with. . . . He is playing on the live stuff I made at Nora's Place. He is the drummer that is playing on *I'm Gabriel*, *The Ginza*, *Every Time I Think of You*, and any and all of the selections that feature the late and great Ace Wallace."

35. Display ad, University of Chicago *Daily Maroon*, May 1, 1964, 8: "University of Chicago Blues Festival, Friday May 8, Mandel Hall, Robert Nighthawk, Johnny Young, Fanny Brewer, Avery Brady . . ."

36. "Bloomfield Interviews Night Hawk," *And This Is Maxwell Street* (disc 3, Catfish Records [KAT3D1], 2000).

37. Houston Stackhouse to Jim O'Neal, in O'Neal and van Singel, *The Voice of the Blues: Classic Interviews from* Living Blues *Magazine*, 127.

38. Houston Stackhouse to Jim O'Neal, in O'Neal and van Singel, *The Voice of the Blues: Classic Interviews from* Living Blues *Magazine*, 132. "George Mitchell recorded me and Robert [Nighthawk], and I got my little taste of change out of that, Testament Records. When George Mitchell recorded us, we were just out in the country at Sam [Carr]'s house."

39. Mitchell's 1967 trip to the Delta became the basis for his master's thesis, and marked the beginning of his years-long documentary of blues and blues musicians. The recordings became part of the 1968 Testament Records album, *Masters of Modern Blues, Vol. 4*. The photographs were published in Mitchell's book, *Blow My Blues Away* (Louisiana State University Press, 1971).

40. Houston Stackhouse to Jim O'Neal, in O'Neal and van Singel, *The Voice of the Blues: Classic Interviews from* Living Blues *Magazine*, 128.

41. Information from Robert McCullom's Certificate of Death, #184, Arkansas State Department of Health, Phillips County, December 1, 1967.

42. In 1966, Scotty Moore (the original guitar player in Elvis Presley's backup band) produced four singles under Frank Frost's name. "My Back Scratcher" made it to the *Billboard* R&B chart. More tracks from the session appeared on the Jewel LP *Frank Frost* (1973) and the Paula CD *Jelly Roll Blues* (1991).

43. Michael Frank's Earwig label issued the Jelly Roll Kings, *Rockin' the Juke Joint Down* (1979); Frank Frost, *Midnight Prowler* (1990); Jack Johnson, *The Oil Man* (1987), *Daddy, When Is Mama Coming Home?* (1989), and *Live in Chicago* (1997).

44. Lonnie Shields to Margo Cooper, telephone notes, March 29, April 1, and April 13, 2021.

45. Lonnie Shields to Margo Cooper, telephone notes, April 1, 2021.

46. Eddie Mae Walton, quoted in Richard Massey, "History Program Looks at Legends," Clarksdale *Press-Register*, August 12, 2000, 1–2.

Robert "Bilbo" Walker

1. The Kline Plantation was owned by Myer Kline (1880–1960), a Jewish immigrant from Lithuania who came to the United States in 1897–98 and became a planter in Coahoma County by 1918.

Some sources give the Borden Plantation as Robert's birthplace. Jim O'Neal to Margo Cooper, telephone notes, May 3, 2021: "Robert told me he was born on the Borden Plantation. His birth certificate states he was born in Clarksdale."

2. Oscar Carr (1923–1977) operated his family's Mascot Planting Company on New Africa Road during the period of Robert Walker's childhood and adolescence. He was also Chairman of First National Bank of Clarksdale. During that period, Carr described himself as "a full-fledged member of the 'Southern way of life' living in a racially segregated society, thinking little of it." However, following the

murder of Emmett Till, and the acquittal of Till's murderers, Carr experienced a political and religious conversion and became a serious advocate for civil rights. See "Oscar Carr, Jr. Dies; Active in Civil Rights," *New York Times*, November 7, 1977, 26. For Oscar Carr's "conversion," see also Sally Palmer Thompson, *Delta Rainbow: The Irrepressible Betty Bobo Pearson*, 111–14.

3. In the 1940 US Census, the Hoye family is listed in Coahoma County, nearby the Robert Walker family.

4. A folk song denouncing Theodore Bilbo's bigoted views, "Listen, Mr. Bilbo" (1946), was recorded by Pete Seeger; and a mocking blues tune, "Bilbo Is Dead" by Andrew Tibbs, was released by Aristocrat Records on the occasion of Bilbo's death in 1947.

5. Adam J. Walker, aka "A.J.," was born in Arkansas 1885; and Althia Journey, aka "Althea" and "Altha," was born in Mississippi 1891 and died 1945.

6. Elizabeth Walker Colenburg, 1935–2014.

7. A local musician nicknamed Kokomo, not to be confused with the famous Kokomo Arnold (1901–1968), who disappeared from the blues scene by 1938, when Robert was only one year old.

8. Richard Thomas to Margo Cooper, interview notes, n.d.

9. Robert Fava Jr. to Margo Cooper, interview transcript, October 10, 2010: "I came here to Alligator with my brother Ronnie in 1964 to open up a general store—Fava Brothers. My wife and I have owned our store, Mary Ann's Variety, for twenty-six years."

10. The Rabbit's Foot Minstrels was a traveling music company—part medicine show, part circus—that performed across the South from 1902 until as late as 1959. The height of its popularity was in the forties and fifties, when the troupe was headquartered in Port Gibson, Mississippi, and toured as far north as Coney Island. Billed as "the Greatest Colored Show on Earth," the company had its own railway cars and an all-Black baseball team that played against local clubs in the towns and cities where the company set up its tents.

There is a Mississippi Blues Trail marker in Port Gibson commemorating "the Foots" and crediting the company for spreading the blues to small towns throughout the state. Indeed, in its early years, the Rabbit's Foot Company employed blues legends Ida Cox, Ma Rainey, and Bessie Smith. Later it provided work for Louis Jordan, Big Joe Williams, Rufus Thomas, and Maxwell Street Jimmy Davis, among others. For more on the Rabbit's Foot Minstrels, see Greg Johnson, "F.S. Wolcott's Rabbit's Foot Minstrels," *Mississippi Encyclopedia*, http://mississippiencyclopedia.org/entries/fs-wolcott-and-his-rabbit-foot-minstrels/.

11. Claudette Romious to Margo Cooper, interview notes, October 13, 2011: "In the sixties and seventies Alligator was thriving. There was a doctor and dentist, two cotton gins, and several stores. The train came through twice a day. The Greyhound bus had a stop on the highway. Before I was born I was told there were hotels. [There were no hotels for Blacks. Black entertainers stayed in people's homes.] Alligator was a railroad cotton town.

"My father was Bill Romious. His store was torn down. It was originally owned by a Chinese family. In about 1960 my father had a grocery store in the front. The previous owner's family had lived in the back, and he turned that into a juke joint. When the family who ran the next section in the building left, daddy rented it. He knocked down the wall and put the jukebox and a pool table inside."

12. Five Blind Boys of Alabama had their first commercial hit in 1949 with "I Can See Everybody's Mother but I Can't See Mine."

13. Muddy Waters' version of "Catfish Blues" (titled "Rollin' Stone") was released on the Chess label in 1950. An earlier "Catfish Blues" by Robert Petway was popular in 1941. But the line, "I wish I was a catfish" probably goes back to the 1920s, according to most blues historians.

14. Jim O'Neal to Margo Cooper, telephone notes, May 3, 2021. The café was called Henry Hill's. It was on 15th Street.

15. "There'll Be Peace in the Valley for Me," 1939 gospel song by Thomas A. Dorsey, first performed by Mahalia Jackson. Sam Cooke did a cover version in 1950, soon after becoming lead singer of the Soul Stirrers.

16. Willie James Kemp (1923–2020). Willie James Kemp to Margo Cooper, interview transcript, October 10, 2010: "Me and my brothers used to sing around the house when we were children. I was about fifteen when I sang with another group of boys. That was the Satellite Brothers. Then I used to sing along with the Moore group off and on about two years. My brothers and I decided we were gonna do something for the Lord instead of running around juke houses. All us boys got together and said, 'We going out singing gospel music.' I was about twenty-five when we started singing as a group. We called ourselves the Kemp Brothers."

17. Willie James Kemp to Margo Cooper, interview transcript, October 10, 2010: "'Man Furniture' was his nickname. I believe he worked in the furniture business. He used to sing with us. I really don't know what became of him."

18. Willie James Kemp to Margo Cooper, interview transcript, October 10, 2010: "Back in those times then, they didn't have no guitars and organs and bands and things playin' at the church. And so you had to sing. It had to come from your heart and your mouth and your thoughts to get it all together."

19. Willie James Kemp to Margo Cooper, interview transcript, October 10, 2010.

20. The title of the song is "When the Gates Swing Open," written by Thomas A. Dorsey. "Through the years I keep on toiling" is the first line.

21. "Just Anyhow" was a 1952 song recorded by the Seven Bells Gospel Singers.

22. Waukegan is a manufacturing town on Lake Michigan, about thirty-five miles north of downtown Chicago. Robert and "Stella" Walker are listed in the 1956 Waukegan city directory at 504 Market Street. Belle Hoye, Estella's father, is also listed at 541 Market. Robert was nineteen years old at the time.

23. A Kenosha, Wisconsin, newspaper display ad for the Gospel Trumpets in 1951 advertises the group as a "Colored Quartet."

24. The Highway QCs were a Chicago gospel group that produced a number of great singers, including Sam Cooke, Lou Rawls, and Johnnie Taylor. Johnnie Taylor

left the Highway QCs in 1957 in order to replace Sam Cooke in the Soul Stirrers. Johnnie Taylor was replaced in the Highway QCs by his brother Spencer Taylor, who would remain the QCs' lead singer for the next sixty years.

25. Tenner Venson, aka "Playboy" and "Coot," was born in 1913 in Belzoni, Mississippi; he died in Chicago in 1985. See Edward Komara, ed., *Encyclopedia of the Blues*, 1035: "Harpist and drummer; lived and played in the Maxwell Street neighborhood from the early 1940s. In later years, accompanied Big Walter Horton, Honeyboy Edwards, Floyd Jones, Homesick James, and other veterans of the street and in clubs. Venson recorded with Big Joe Williams for Storyville in 1964, and with John Wrencher and Buddy Thomas on Barrelhouse in 1969."

26. Jim O'Neal to Margo Cooper, telephone notes, May 3, 2021: "Possibly 'Little Arthur' King."

27. For Robert's account of how he taught Monroe Jones to play guitar in Chicago, see Roger Stolle, *Hidden History of Mississippi Blues*, 98.

28. A lyric from Chuck Berry's song "Johnny B. Goode," released in April 1958. The song reached the *Billboard* Top 10 in June 1958. Chuck Berry did the "duckwalk" on TV for Dick Clark's Saturday night *Beech-Nut Show* on February 22, 1958. This may have been the television show Robert Walker refers to here; however, Berry performed his duckwalk to "Sweet Little Sixteen" on the show, not to "Johnny B. Goode."

29. The title of the song is "Nothing Can Change This Love," released by Sam Cooke in 1962 on RCA.

30. Elmore James song, recorded in Chicago in November 1959 by Elmo James & the Broomdusters, and released in March 1960 on the Fire Music label.

31. Eddie Campbell to Margo Cooper, interview notes, April 14, 2013.

32. Robert Fava to Margo Cooper, interview transcript, October 10, 2010.

33. Claudette Romious to Margo Cooper, interview notes, October 13, 2011.

34. Michael Frank to Margo Cooper, interview notes, April 15, 2011.

35. Jim O'Neal to Margo Cooper, email, August 23, 2022: "I'm not sure how long Robert, Jack, Frank and Sam were together but I know Robert, Jack and Sam (and maybe Frank) played the Hollywood Café in June 1973."

36. Jim O'Neal, liner notes to *Robert Bilbo Walker: Promised Land* (Rooster, 1996): "On the wall of the Carrs' living room Sam still displays a poster advertising his blues revue of the time—pictured along with Carr are Frank Frost, Big Jack Johnson, Mighty Geno (Little Jeno Tucker) and Robert Walker."

37. Robert Walker to Margo Cooper, October 14, 2013, notebook, 103.

38. Jim O'Neal to Margo Cooper, email, August 23, 2022. "'Master Ferguson' I assume means Massey-Ferguson, a brand of tractor that was sold in Clarksdale. Massey-Ferguson Inc. was located at 1401 Highway 49 South."

39. 1941 release by Ernest Tubb, often called the first honky-tonk song.

40. Jim O'Neal to Margo Cooper, email May 10, 2021: "I first saw Robert at the Club Godfather in Merigold on December 19, 1992. Recording dates were July 13 and August 19, 1993. Operating on Delta time with a Delta income from music, we didn't release the CD until 1997 but did a cassette first in 1996."

James "Super Chikan" Johnson

1. The name of the song referred to as "Mama Killed a Chicken and Thought It Was a Duck" is "Stop That Thing," attributed to Sleepy John Estes, 1935. "You Are My Sunshine" was the state song of Louisiana, 1939, covered by everyone from Bing Crosby to Aretha Franklin.

2. Twenty-seven Freedom Riders, headed for New Orleans, were arrested as soon as they arrived in the bus station in Jackson, Mississippi, on May 21, 1961. Many of the Riders were sentenced to two months inside Mississippi's worst prison, Parchman. Within a few months, police arrested more than four hundred Freedom Riders. Eric Etheridge features portraits of the Riders (then and now) in his book *Breach of Peace*. Their journeys are captured in Raymond Arsenault's book, *Freedom Riders: 1961 and the Struggle for Racial Justice*, and Stanley Nelson's documentary, *Freedom Riders*.

3. According to the Equal Justice Initiative database, there were twenty-one lynchings in Tallahatchie and Quitman counties, where Ellis Johnson lived, during the Jim Crow era, but no documented lynchings after 1925.

4. The Mennonites, a long-persecuted pacifist Anabaptist sect, originally from Europe, first established themselves in Mississippi in 1922 in the Gulfport area. Around 1963, they began to settle around Clarksdale.

5. Land leveling refers to the grading of mildly sloping farmland, as in the Mississippi Delta.

6. Ike Turner's signature tune, first released in 1951, credited to Jackie Brenston & His Delta Cats but it actually was Ike Turner & the Kings of Rhythm (Jackie Brenston was Ike Turner's saxophone player). There is a Mississippi Blues Trail marker for "Rocket 88" in Lyon, Coahoma County. Some rock historians consider "Rocket 88" to be the first rock 'n' roll recording.

7. The first appearance of the name Funk Thumpers in the Clarksdale area was in the *Clarksdale Press-Register* in December 1979. The group then was Big Jack, James Johnson (not yet called Super Chikan), and C. V. Veal. The last mention for the group was in July 1985, when the group was C. V., Super Chicken (*sic*) and Shine.

8. *Blues Come Home to Roost* also received Critics Awards from *Living Blues* magazine: Best Blues Album, Best Blues Debut Album, and Best Blues Song of the Year for "Down in the Delta." The CD also received a Critics Award for Jim O'Neal's liner notes.

9. Jameisa Turner graduated the Delta Blues Education Program in Clarksdale in June 1998 at the age of thirteen. See "Seven Young Musicians to be Honored for Completing Delta Blues Education Program," *Clarksdale Press-Register*, May 27, 1998, 3A.

10. For more on Spoonful of Blues and the relationship between Clarksdale and Notodden, see "Spoonful of Blues Set for Invasion," *Clarksdale Press-Register*, August 3, 2001, 1. See also Scott Jennison's 2012 documentary *Echoes 'Cross the Tracks*.

11. *Chickadelic* was the fruit of a ten-year creative relationship between Super Chikan and the members of Spoonful of Blues. Notodden, Norway, and Clarksdale became "sister cities" in 1996. James had first gone to Norway to play at the Notodden Blues Festival in August 1998 and was filmed later that year at Red's in Clarksdale for a Norwegian National Television blues documentary. Spoonful of Blues played the Sunflower River Gospel and Blues Festival in Clarksdale in 2001.

12. On May 23, 2006, Super Chikan was the featured performer at the American Folklife Center of the Library of Congress, as part of the Homegrown: Music of America concert series. The concert was recorded for the permanent collection of the American Folklife Center of the LOC. While in DC, Chikan also played for the Kennedy Center's Millennium Stage program.

13. Robin Rushing, "Music and Heritage Combine to Leave Indelible Impression on the Blues Man Known as 'Super Chikan,'" *Clarksdale Press-Register*, February 2, 2002, 1–4B. For more on Bouki Blues Festival, see http://warccroa.org/booki-blues-festival/.

According to Dr. Ibrahima Seck, director of the Bouki Blues Festival, "Bouki is the Wolof name for the hyena, a character that also survives in folktales from Florida, the Bahamas, and Haiti. Bouki symbolizes the persistence of African culture in America, and African wisdom at large." http://warccroa.org/booki-blues-festival/.

The festival is a program of the West African Research Association and the West African Research Center in Dakar, Senegal.

"The first edition, held on January 7–12, 2002, was primarily devoted to the Mississippi-Louisiana area where African music has survived under the name of Blues, a musical form that evolved in the urban milieu to give birth to jazz and rock 'n' roll. Musicians and scholars from Mali, Mauritania, Senegal, and Mississippi were given the opportunity to interact during that week-long event. The keynote speaker was the late professor Peter Aschoff of the University of Mississippi at Oxford and the guest star was the celebrated blues singer James 'Super Chikan' Johnson from Clarksdale, Mississippi."—Dr. Ibrahima Seck, director of the festival. http://warccroa.org/booki-blues-festival/.

Joshua "Razorblade" Stewart

1. Betty Vaughan to Margo Cooper, interview notes, April 29, 2015.

2. DJ Dewey Phillips (a friend of Sam Phillips, but no relation) played R&B on his nighttime show "Red, Hot & Blue." He was the first DJ to broadcast Elvis Presley on the radio, July 10, 1954.

3. Early Wright (1915–1999) was the first African American DJ in Mississippi, according to the *Mississippi Encyclopedia*.

4. Betty Vaughan to Margo Cooper, interview notes, October 16, 2015. "Peter Price played spirituals. He worked for the Head Start program."

5. Betty Vaughan to Margo Cooper, interview notes, October 16, 2015: "Frank Sykes played house parties. He had a group from Tunica he played with; sometimes he played by himself. Most times he played blues. He was very popular."

6. "Don't Answer the Door," which entered the *Billboard* Hot 100 on October 22, 1966. By this time, however, Razorblade would have been twenty years old, no longer under age. Drinking age was eighteen in Mississippi in 1966, not raised to twenty-one until 1986.

7. There is a photograph of Josh in Vietnam dated 1967, but no month is given, so it's unclear whether the photo was made at the beginning, middle, or end of his tour of duty.

8. The brigade was the first major United States Army ground formation deployed in Vietnam, serving there from 1965 to 1971 and losing 1,533 soldiers. The 173d is best known for the Battle of Dak To (November 1967), where it suffered heavy casualties in close combat with North Vietnamese forces. Brigade members received over 7,700 decorations, including more than 6,000 Purple Hearts.

9. Jesse Gresham to Margo Cooper, interview notes, October 18, 2014: "I was born in Greenwood on August 18, 1947. My mother played piano and was a gospel musician with the church. I've been playing since I was eleven years old. I played for a lot of blues players before I went to college. I played with Bill Wallace out of Leland. He was the one who trained me. I played with Little Bill for about five years. I formed my own band around 1969, 1970. Larry Hagan played bass, Johnny Agnew played guitar, and Nathaniel Jefferson played drums. My songs are mostly instrumental. I recorded 'Penguin I' and 'Penguin II' and 'Get It Where You Find It'/'Bust Out' for Jewel Records. One of the songs, 'Shootin' the Grease,' is on the back of 'Barefootin'' by Robert Parker."

10. Jesse Gresham to Margo Cooper, interview notes, October 18, 2014: "Josh, he had a desire, a passion to sing. He had a gift. I saw that in him. We liked his voice so we gave him a try. He was an asset to the group. He could almost just about imitate any of the guys who were singing back then, like Al Green. He wasn't on the recordings. We were just an instrumental group on those. Josh was with us through most of the seventies."

11. Deloris Gresham to Margo Cooper, interview notes, October 18, 2014: "Jesse was known as one of the best keyboard players in the Delta and state of Mississippi in the seventies and still is. He has his own signature sound. Jesse Gresham Plus Three was one of the hottest bands in the Delta. They played jazz, blues, and instrumentals."

12. Earnest "Guitar" Roy Jr. to Margo Cooper, interview notes, October 11, 2004, and June 24, 2021: "[My father's] inspiration was people like Elmore James and Lightnin' Hopkins. He couldn't read or write but he could play what he heard, what he felt. There's a few artists that God gave a fingerprint sound that nobody has just that person. That's the way my daddy played. You could appreciate every lick he hit. He played scales in a backward kind of way where you wouldn't know what scale it was. Dad taught Wesley Jefferson to play bass. He taught Big Jack, Mississippi Morris. Everybody wanted to learn his style of blues. They would come over to the house and jam. We always had a yard full of people. The Sunday jam would be at the Casablanca."

13. "Still Here" on the CD of the same name, released on Blackberry label in November 2003.

14. Jim O'Neal to Margo Cooper, e-mail, August 23, 2022. "Razorblade did open shows at the City Auditorium for various acts. I vividly remember one show; Josh had the almost all-Black audience excited, with women screaming."

15. In Josh Stewart's obituary, Maie Smith, the organizer of the Sunflower River Blues & Gospel Festival, estimated "Stewart performed 13 to 15 consecutive years [at the Sunflower Festival]." See "Musicians, Fans, Mourn Death of 'Razorblade,'" *Clarksdale Press-Register*, April 25, 2018, 3A.

Joe Cole

1. Joseph Lee Cole was born in the small town of Mulga, in Jefferson County, eight miles west of Birmingham.

2. According to his WWII Selective Service records, Joe Lee Cole enlisted in the army on October 16, 1942, and was discharged on December 8, 1945. His rank was private first class. According to the US Department of Veterans Affairs, he is listed as a "casualty."

3. Eastover Plantation, Young Road, southwest of Clarksdale. Will Young to Margo Cooper, telephone notes, July 1, 2022: "My grandfather William Edmond Young bought this place in 1935. At one time there were sixty-two families on this land. There used to be jukes all over. Whoever worked the land, they helped pay for it, so my grandfather gave people a life tenancy. We still operate as a farm and it's still called Eastover Plantation."

"Cadillac John" Nolden

1. John Nolden's place of birth is corroborated by Mississippi Department of Health Vital Records, which states "Sunflower County"; however, see also *Living Blues* #172, vol. 35, nos. 2–3, March–June 2004, 134. "John Nolden's birth certificate lists his birthplace as 'Yellow Bush County' [probably Yalobusha]." John's mother was born in Coffeeville (Yalobusha County). Euzelia Kizart to Margo Cooper, in conversation, April 12, 2023.

There is some confusion regarding John Nolden's birth date. According to Mississippi Department of Health Vital Records, he was born on April 3, 1927. On his Selective Service registration in July 1946, John Willie Nolden gave his birthday as July 21, 1928.

2. The plantation is probably "Lonesome Pine" farm. According to historian Eugene Dattel, his grandfather, Harry Dattel (1887–1967), emigrated to the United States from Latvia "around 1900." He came to the Mississippi Delta from New York in 1914 and began working as an itinerant peddler. "Harry Dattel peddled and then purchased a store in Sunflower, Mississippi, and then bought a much beloved farm, Lonesome Pine, nearby." Eugene Dattel, "An American Story," 247, https://genedattel.com/wp-content/uploads/2018/07/ImmigrantJourneys-Dattel-2018.pdf. Eugene Dattel is also the author of *Cotton and Race in the Making of America* (2009) and *Reckoning with Race: America's Failure* (2017).

3. Euzelia Kizart to Margo Cooper, telephone notes, April 21, 2020: "There were five Nolden boys—John and four brothers: Albert, Henderson, James, and Walter. James's mother named him Jessie James Nolden. People called him James. John had four sisters."

4. Charley Booker (1925–1989). On his Selective Service registration form, Charley Booker gave his birth year as 1921. Further research indicates that Charley Booker may have been born as early as 1919. For more on Charley Booker, see *Living Blues* #89, November–December 1989, 38–39.

5. John Nolden to Margo Cooper, September 2003, interview transcript, 6: "Charlie Booker lived three doors down. He played guitar. He played with Charlie Patton." Note that Charley Booker's birth year is usually given as 1925, which means that he would have been only nine years old when Charlie Patton died in 1934. Further research indicates that Charley Booker was born earlier, probably in 1919, so that he would have been fifteen when Charlie Patton died.

6. "Rabbit Blues" was recorded in January 1952 on the Modern label, with Charley Booker, vocals; Ike Turner, piano; Houston Boines, harmonica.

7. John's brother James recalled that they saw Charley Booker play at Ruby's Nite Spot in Leland, and that Little Milton would be in the audience, too young to perform at the time. (Jesse) James Nolden to Margo Cooper, telephone notes, April 24, 2020.

8. John is probably referring to the 1946 song "Oh Noah" by the Jubalaires quartet, which recounts the Old Testament fable of Noah and the Ark. The song is sometimes cited as one of the earliest versions of rap music.

The Biblical character Jonah is the subject of numerous gospel songs, none of which are titled specifically "Old Jonah." John may be referring to the standard, "Jonah and the Whale," by Robert MacGimsey, which includes the lyric, "So they pulled old Jonah out of the hold/And they dumped him in the water just to lighten up the load." Louis Armstrong recorded a popular version of it in 1958.

"I'm a Poor Pilgrim of Sorrow" was written by Charles Albert Tindley and first published in the hymnal *Joyful Meeting in Glory* in 1919. The song is also known as "Poor Pilgrim of Sorrow" or simply "Pilgrim's Song."

9. Albert Nolden was in the US Army from September 1942-December 1945. This is corroborated by James Nolden to Margo Cooper, telephone notes, April 24, 2020: "According to James, their brother Albert didn't sing with them. He was in the military." See also Euzelia Kizart to Margo Cooper, telephone notes, April 21. 2020: "Albert told me himself he didn't sing. He wasn't into the singing."

10. "Jesse James" refers to John's younger brother James. There is no separate brother named Jesse. Euzelia Kizart to Margo Cooper, telephone notes, April 21, 2020: "James mother named him Jesse James Nolden. People called him James."

11. John Nolden to Margo Cooper, interview transcript, September 2003: "I had a quartet, four brothers. We used to be there on the radio with B.B. He'd come on in the morning. We would too . . . Someone got us a job on a radio station WGRM in Greenwood. B.B. was there too. The music on the show was all spiritual. We

were called the Four Nolden Brothers." In his autobiography, B.B. King also recalls singing on the radio in Greenwood during this time. However, in his recollection the station was WJPR. See B.B. King with David Ritz, *Blues All Around Me: The Autobiography of B.B. King*, 76–77. "I went with the St. John Singers to Greenwood, Mississippi, where, for the first time, I sang on the radio . . . It was more prestigious than singing on the streets, and when we sent our flyers to the churches, they said: STARS OF RADIO STATION WJPR."

12. (Jesse) James Nolden to Margo Cooper, telephone notes, April 24, 2020.

13. Joseph E. and Maria Campbell Brent, for Department of Arkansas Heritage, *Delta Music Heritage Research Project, Part I*, 20–22:

> In 1947, Interstate Grocer Company took the King Biscuit Entertainers on the road. . . . That summer the King Biscuit Time Entertainers played forty-seven shows—forty in Arkansas . . . and seven in Mississippi.
>
> Before the coming of supermarkets . . . these local stores carried the staples every household needed, but they could also make a sandwich and sold beer and soft drinks. Many had juke boxes and all were community gathering places. Bringing the King Biscuit Entertainers to these stores made sense. It allowed customers who bought the flour and the corn meal to see the people they heard on the radio, and the store owner benefited from the crowds they attracted.
>
> In September 1947, the entertainers began a series of evening shows in Arkansas and Mississippi. One night in Sumner, Mississippi; three nights in Lyons, Mississippi; one night in Marks, Mississippi; two nights in Glendora, Mississippi; two nights in Widner, Arkansas; one night in Parkin, Arkansas; and one night in Sunflower, Mississippi.

14. Joseph E. and Maria Campbell Brent, for Department of Arkansas Heritage, *Delta Music Heritage Research Project, Part I*, 42: "James Curtis was born in Mississippi but raised in Arkansas. In the 1930s, he traveled the South playing washboard, washtub, jug, and drums for medicine shows, carnivals, minstrel shows and vaudeville. Curtis also sang and was known as a hot-stepping tap dancer. . . . In 1942, Curtis, who had worked on radio in Blytheville, Arkansas, joined Robert Junior Lockwood and Sonny Boy Williamson on KFFA-AM's 'King Biscuit Time' in Helena, Arkansas. Curtis began playing washboard but soon switched to drums. Occasionally he would tap dance on a piece of plywood, the sound going out clearly over the airwaves."

15. "Sarah Williams" according to Euzelia Kizart to Margo Cooper, telephone notes, April 24, 2020.

16. Eddie Davis to Margo Cooper, interview notes, October 13, 2012: "I was little—ten or twelve, something like that. My daddy knew Fred Hampton and said, 'Why don't you get Eddie in your group and see what he can do.' That was the beginning of the Four Stars."

17. Crecey McCraney (John Nolden's niece) to Margo Cooper, interview notes, October 13, 2012: "The family would follow the Four Stars from church to church just to hear John sing. People would shout, jump and holler when they hear John sing, 'When the lord get ready you got to move.'"

18. Eddie Davis to Margo Cooper, interview notes, October 13, 2012.

19. Rachel Zundel to Margo Cooper, telephone notes, April 21, 2020.

20. Rachel Zundel to Margo Cooper, telephone notes, April 21, 2020: "My father's name was Lester Elijah Moon Sr. He was born in Camden, Mississippi, on October 14, 1910."

21. Rachel Zundel to Margo Cooper, telephone notes, April 21, 2020.

22. Euzelia Kizart to Margo Cooper, telephone notes, April 21, 2020: "He married Luveda Griffin after Sarah left." John was then with Euzelia Kizart from 1978 until around 1995. Although they never married, John and Euzelia had two daughters together, and as of 2021, have four grandchildren. In 1995 John married a woman named Christine. According to Euzelia, "They [John and Christine] were together until she died in 2009."

23. Bill Abel to Margo Cooper, interview notes, October 9, 2011.

24. Euzelia Kizart to Margo Cooper, telephone notes, April 21, 2020.

25. Bill Abel to Margo Cooper, interview notes, October 9, 2011.

26. *Crazy About You*, released in 2002, not on label, but independently produced by Bill Abel.

"T-Model" Ford

1. T-Model said this in 2006, which would put his birth year at 1920. According to his WWII draft registration, he was born June 20, 1921. Census records in 1930 and 1940 give conflicting birth years of 1924 and 1922. His gravestone is inscribed "b. June 24, 1921."

2. Ogenia Ford was born in Mississippi in 1880, according to the 1910 US Census. In the 1940 Census, her age was given as sixty-five, which puts her birth year at 1875.

3. Preacher Carter Ford was born in Mississippi in 1878, according to the 1910 US Census. He died in 1920.

4. In the 1930 US Census, the family had four boys—James, "Lawyer," Henry, and Erwin. There were two girls—Effie and "Sister." "Sister" was 1½ years old; she may have died in infancy. In the 1940 Census, there is only one girl in the family.

5. While there is no reason to doubt the potentially lethal situation that T-Model describes, it should be mentioned that Scott County, where the Ford family lived at the time, had one of the lowest incidences of racial killings in Mississippi during the twentieth century. The last recorded lynching in Scott County, according to the Equal Justice Initiative, occurred in July 1897.

6. In 1942, when T-Model registered for Selective Service, he gave his employer's name as J. M. Warbington, in Forest, Mississippi.

7. On his Selective Service registration form in February 1942, James is listed as "Son."

8. "How Many More Years," recorded by Howlin' Wolf in July 1951 and released on the Chess label in August 1951.

9. Probably referring to the song "Twenty-four Hours," written by Eddie Boyd and recorded by Muddy Waters in 1963. The lyric is: "Oh I mistreated my baby last night, woman from holding you here in my arms / Oh I mistreated my baby last night, woman from holding you here in my arms / Now you know she been gone 24 hours and that's 23 hours too long."

10. Albert Folk to Margo Cooper, telephone notes, November 23, 2021: "Nelson Street was where the entertainment used to be—live bands, lots of night clubs up and down the street. You come out of one door and go into the next. Mr. Ed's was a little bitty café right on the corner of Nelson and Edison. They had live bands every weekend and sometimes through the week—all blues. I saw T-Model play there. It was the seventies when he started playing, he told me."

11. Bill Abel to Margo Cooper, interview transcript, June 3, 2006. Also in this conversation, Abel said: "There's a video of Son Thomas playing in like '69 or the early seventies. People was dancing in the yard and T-Model was sitting on the steps just looking at Son Thomas's fingers on the guitar. When I saw that I said 'Wow, T-Model is studying Son Thomas!' Bill Abel is referring here to Bill Ferris's 1970 documentary film, *Delta Blues Singer: James "Sonny Ford" Thomas*, which won a number of awards and was later broadcast on Mississippi public television. The film was shot during the summers of 1968 and '69 in Leland.

12. Guitarist and singer Asie Payton, from Holly Ridge, recorded one album for Fat Possum (*Worried*, 1999) and appeared in the film *You See Me Laughin': The Last of the Hill Country Bluesmen*.

13. Billy Johnson to Margo Cooper, email, July 31, 2021: "That drummer was probably Sam Thompson, Little Dave's dad. He was from Holly Ridge and played with them."

14. T-Model, Sam Carr, and Willie Foster performed together as a trio at the first King Biscuit Blues Festival in October 1986. See Robert Palmer, "Blues Lives at the King Biscuit Festival," *New York Times*, October 23, 1986, C-26.

15. John Horton to Margo Cooper, interview transcript, June 3, 2006.

16. "Farmer John" Horton to Margo Cooper, interview transcript, June 4, 2006.

17. "Farmer John" Horton to Margo Cooper, interview transcript, June 4, 2006.

18. Inscribed as "Tale Dragger" on T-Model's gravestone at Green Lawn Cemetery near Greenville. Note also, the name "Tale Dragger" on his guitar in photo on page 169.

19. Fat Possum Records is an Oxford, Mississippi–based label established in 1991 by University of Mississippi graduates Matthew Johnson and Peter Redvers-Lee. Paul Wine Jones's first CD with Fat Possum was *Mule*, released in 1995.

20. *Pee-Wee Get My Gun* (1997); *You Better Keep Still* (1998); *She Ain't None of Your'n* (2000); and *Bad Man* (2002).

21. Bruce Watson was a freelance recording engineer who joined Fat Possum in 1994. Matthew Johnson was one of the founders of Fat Possum Records.

Eddie Cusic

1. This date is corroborated by Mississippi Department of Health, Vital Records. Some other published sources have given Eddie's birth date as January 4, 1926. His tombstone in the "Legends" section of Greenlawn Memorial Gardens in Greenville is inscribed January 4, 1926.

2. In the 1930 and 1940 US Census, Eddie's mother is listed as Lillie Wallace. In the 1930 census she is in the household of Lee Wallace, whom she married in 1929. In the 1940 census she is still listed as Lillie Wallace, but no longer with Lee Wallace. She is listed as the head of the household, with her two sons, Eddie and Willie.

3. Eddie's father was Eddie "Sonny" Cusic Sr.

4. The 1938 boxing rematch between American Joe Louis and German Max Schmeling is believed to have had the largest radio audience in history for a single broadcast—an estimated seventy million listeners.

5. According to a 1977 article in the *Greenwood Commonwealth*, a "deadening" is "a piece of once-swampy land that has been drained and cleared." See Harry Merritt, "Plantation Names Recall Colorful Delta Past," *Greenwood Commonwealth*, May 1, 1977, 13.

6. Woodburn Plantation is on the east bank of the Sunflower River, five miles south of Indianola. Randy Magee to Margo Cooper, telephone notes, May 13, 2021. Randy Magee of the Highway 61 Blues Museum in Leland recalled Eddie Cusic telling him that from his front porch on the Kinloch Plantation he could hear Sonny Boy playing from across the Sunflower River at the Woodburn Plantation.

7. "Seminole Blues," a 1937 recording by Tampa Red.

8. Mickey Rogers to Margo Cooper, interview transcript, April 16, 2013: "A whole bunch of them played there [the Rum Boogie]—Little Milton, Smokey Wilson, Little Bill Wallace."

9. In the 1940 US Census, Eddie, his brother Willie, and his mother Lillie were living adjacent to Lewis Fratesi. Fratesi was the only white man listed on the census page.

10. Little Milton to Jim O'Neal, in Jim O'Neal and Amy van Singel, eds. *The Voice of the Blues: Classic Interviews from Living Blues Magazine*, 192: "I had to be about fifteen, fifteen and a half. I left home to play with the Eddie Cusic band . . . stayed with Cusic off and on for a couple of years." See also "Little Milton Recalls Eddie Cusic," *Living Blues* 187, November–December 2006, 25.

11. On McComb, see "Sweet Potato Festival Another Natural," McComb *Enterprise-Journal*, October 20, 1949, 5. "The dance, featuring the fine music of the Rhythm Aces, will start in the Armory at 9pm."

12. Elmore James lived in Canton, Mississippi, during these years.

13. Jimmy Holmes to Margo Cooper, telephone notes, August 18, 2022.

14. According to *Lynching in America: Confronting the Legacy of Racial Terror*, there were twelve documented lynchings in Washington County during the period 1877–1950. Most of them took place in the years around the turn of the twentieth century, and none were recorded after 1919.

15. Ruby's Nite Spot was owned by Ruby Edwards (1910–2001). There is a marker on the Mississippi Blues Trail in Leland on the site of her club. Text and illustrations of marker available online, https://msbluestrail.org/blues-trail-markers/rubys-nite-spot. See also Harold Hall (son of Ruby Edwards) to Margo Cooper, interview notes, October 24, 2006: "B.B. King, Bobby Blue Bland, Tyrone Davis, Little Milton, Little Bill, Ike and Tina Turner, Howlin' Wolf, all of them used to be here. We'd have a local band from Vicksburg; they were called the Red Tops, they came every Sunday. Little Bill used to play Fridays and Saturdays. Eddie Cusic played on Wednesday nights. Howlin' Wolf would get on his hands and knees and howl like a wolf. The crowd would holler and fall out. It was a big day when any of these musicians would play. Hundreds, thousands of people would fill the streets, especially when B.B. King would come to town."

16. Billy Johnson to Margo Cooper, telephone notes, August 8, 2022, and interview transcript, October 23, 2006: "Club Rexburg was a late-night gambling spot, and it's where the musicians congregated. They played the blues all night out here. It didn't get going good until the towns closed down, like 1 or 2 AM. Whoever was playing in the area would end up sitting in —Albert King, Howlin' Wolf, Little Milton. . . . This is the club where Smokey Wilson said that Howlin' Wolf gave him his voice. The musicians would jam until daylight. They'd sleep in their cars and then go over to Lil' Bill's to hang out and eat. They'd go down the road and play at the Holly Ridge Store on Sunday afternoons. Rexburg was rough. Over the years some brothers from Greenville owned it. They knew the law wasn't going to come. It didn't matter if someone got shot, killed, burned, or whatever. The sheriff wasn't gonna come out here 'til daylight because they were afraid. So they had some bouncers. They'd drag people who started fighting out and handcuffed them to poles."

17. According to Bill Ferris, Son Thomas came to Leland from Eden, Mississippi, in 1961. Eden is twenty-three miles north of Bentonia on Route 49. See note 22.

18. In the summer of 1974, Joe Cooper, Son Thomas, and Eddie represented the Delta in the music category at the 8th annual National Folklife Festival in Washington, DC.

19. Eddie's first recordings were made with Son Thomas in the mid-1970s. The Italian blues documentarian Gianni Marcucci recorded Eddie and Son Thomas in July and August 1976, and included one of their tracks "Once I Had a Car" on the album, *Mississippi Delta & South Tennessee Blues* (Albatross, 1977). Three more tracks featuring Son Thomas and Eddie were later included in Volume 10 of Marcucci's *Blues at Home* series, released October 2013 on the Mbirafon label (digital format only).

20. According to his obituary, "He retired from the Department of Agriculture in Stoneville after 20 years." See "Eddie Cusic, Jr.," obituary, Greenville *Delta Democrat-Times*, August 20, 2015, A5.

21. Eddie married Lucinda around 1965, according to his obituary. They had three sons and a daughter. See "Eddie Cusic, Jr.," obituary, Greenville *Delta Democrat-Times*, August 20, 2015, A5.

22. Son Thomas was "discovered" by Bill Ferris in the summer of 1967, when Ferris was doing fieldwork for his doctorate at the University of Pennsylvania. Son Thomas became one of Ferris's main informants for his thesis and is featured prominently in Ferris's book *Blues from the Delta*. Ferris recorded Son Thomas for the 1970 UK album *The Blues Are Alive and Well*. Son Thomas was also the subject of Ferris's 1970 documentary film, *Delta Blues Singer: James "Sonny Ford" Thomas*, which won a number of awards and was later broadcast on Mississippi public television. Following this exposure, Son Thomas became internationally famous.

23. But Eddie did travel to Washington, DC, as early as 1974 for the 8th annual National Folklife Festival, along with Joe Cooper and Son Thomas.

24. Edward Komara, ed., *Encyclopedia of the Blues*, 986: "[Son Thomas's] health drastically declined in 1991, when he was operated on for a brain tumor. In 1993 he suffered a stroke and died shortly after in a Greenville, Mississippi, hospital at the age of sixty."

25. Even during the years when he worked a forty-hour job to support his family, Eddie occasionally played festivals in the Delta. He performed at the Mississippi Delta Blues and Heritage Festival in Greenville in 1981, and other smaller festivals throughout the 1980s. After 1990 he became a regular at the Delta Blues Festival and the Mighty Mississippi Music Festival (also in Greenville), the Highway 61 Blues Festival in Leland, the Juke Joint and Sunflower River festivals in Clarksdale, and the Sam Chatmon Blues Festival in Hollandale. He also played King Biscuit.

26. Cub Koda, AllMusic review, *I Want to Boogie*: "until this 1998 debut, Cusic had amazingly gone unrecorded. This field recording, done live at Cusic's house, rectifies that situation and consequently brings another fine acoustic blues artist to the light. Cusic's music is pure Mississippi blues, and that stylistic derivation can't be stressed strongly enough. . . . the sound and style delivered is pure back-porch country-blues. The large part of his repertoire relies on old warhorses like 'Good Morning Little Schoolgirl,' 'Ludella,' 'Feelin' Good,' and 'Catfish Blues,' but the individual stamp Cusic brings to these old standbys with nothing more than his rough-hewn voice and simple but driving guitar makes this previously unrecorded bluesman a wonderful repository of tradition with his own wrinkle to it. A strong debut that also makes the first new 'blues discovery' since the halcyon days of the 1960s."

"Farmer John" (John Horton Jr.)

1. John Horton to Margo Cooper, interview transcript, October 2, 2016.

2. Billy Johnson to Margo Cooper, interview transcript, October 23, 2006: "Smokey learned from all the old guys that used to play around Leland. He carried a bass line with his thumb and played lead with his fingers. He always finger picked. Smokey was playing electric blues in the old cotton patch finger picking tradition but with a whole lot more energy and a lot more sound. Those

guys, if you heard them in another room and weren't watching them as they were playing by themselves, you'd think they had a bass player and rhythm guitar player. And you walk in there and there is one guy playing it all. And he is doing it with so much energy and people are hollering and screaming, dancing, moving. You get up in there and you look through all the dust and there is one damn guy sitting there playing his ass off and there's not a dry thread on him. That's Smokey Wilson."

Eden Brent

1. Billy Johnson to Margo Cooper, interview transcript, October 23, 2006, and telephone notes, July 27, 2022: "Little Bill was from Opelousas, Louisiana. Honey Boy brought him to Leland. Little Bill had his own radio show, and he played with Little Wynn's band in Greenville. On Saturday nights, all the hotel lobbies in Greenville would have entertainers come in. Little Bill and Eddie Cusic had things sewed up in this area. The Lindsey Brothers had a music store in Indianola. They had a big panel station wagon with big speakers and in the fifties they'd ride slow around the towns, plantations, and country stores advertising Lil' Bill Wallace and his singing guitar at Red Ruby's. So when everybody got through working on Saturday they'd come out."

"Mississippi Slim" (Walter Horn Jr.)

1. Walter Horn Sr. was born July 25, 1923, in Gunnison, Mississippi. His father (Slim's grandfather) was named George Horn. This is according to Walter Horn's 1942 Selective Service registration.

2. Eden Brent to Margo Cooper, email, August 2, 2021.

3. Frankie Lymon and the Teenagers' signature hit, "Why Do Fools Fall in Love," was a #1 hit in 1956. The group appeared in the movie *Rock, Rock, Rock* the same year.

4. The song was titled simply "Silhouettes," by the Philadelphia group the Rays. The single was a #1 hit on the Cameo label in 1957.

5. Note that Slim is crediting all of these urban doo-wop groups. Frankie Lymon & the Teenagers were from Harlem, as was Ben E. King, who sang lead on "There Goes My Baby." The Rays were from Philadelphia. The Platters were from Los Angeles.

6. Mamie "Galore" Davis (1940–2001), best known for minor soul hits "Special Agent 34-24-38" (1965) and "It Ain't Necessary" (1966) on the Chicago label St. Lawrence. For more on Mamie Davis, see Euphus "Butch" Ruth, *Juke Blues* 80, 2002, https://www.mtzionmemorialfund.org/p/mamie-louise-galore-davis.html. Also, *Living Blues* carried an obituary, *Living Blues* 160, November–December 2001, 87.

7. Curtis Richardson to Margo Cooper, interview notes, June 5, 2009: "Leroy Grayson farmed and ran the juke joint. There used to be a small liquor store on the east side in the yard. He had a grocery store and juke joint combined. He had two or three Seeburgs in there. You could hear it for miles. Grayson's would be packed. People would come from all over and they'd party all night. Cars would be lined both ways. Music was mostly on the weekends: Friday, Saturday and Sunday nights. They had different bands. Bobby Blue Bland played here one time. Little Milton played at LeRoy's." See also Larry Grayson (LeRoy's son) to Margo Cooper, interview notes, June 5, 2009: "My dad was well known. He was very friendly and ran his business in a respectful way. He had a big field in the back where [people] used to come on the weekends and play baseball. Local people played there. They had a lot of fun down there. The juke joint was popular. They'd play baseball all day and they'd party all night. They came from near and far: Arcola, Hollandale, Rosedale. This was the place to come and wind down."

8. John Horton to Margo Cooper, interview notes, October 14, 2022.

Mickey Rogers

1. From WVON's website: "Our story began in 1963, with the debut of radio station WVON—'The Voice of the Negro.'" Its owners were Leonard and Phil Chess, the founders of Chess Records. They were the first to assemble a radio station in Chicago specifically designed to serve the city's growing Black community. WVON created a legendary group of radio personalities known as The Good Guys who made WVON one of the top three stations in Chicago. The station became known nationwide as a powerhouse for cultural relevance and political activism.

2. According to the *Encyclopedia of Chicago*, "The Regal Theater [at 47th and South Park] was a central mainstay of South Side public life from the late 1920s to the early 1970s." Louis Armstrong, Duke Ellington, Billie Holiday, Stevie Wonder, Aretha Franklin, and the Jackson 5 all appeared there. B.B. King recorded *Live at the Regal* there in November 1964. The theater was closed in 1968 and demolished in 1973.

3. Robert Taylor Homes was a public housing project in the Bronzeville neighborhood on the South Side. It was built in 1962–63 and demolished between 1998 and 2007.

4. Aaron Cohen, *Move on Up: Chicago Soul Music and Black Cultural Power*, 15.

5. Big Bill Hill was a blues DJ on radio WOPA in Oak Park. His first show was broadcast live from Silvio's, where he had been emcee for several years. From 1963–68, he also owned his own club, the Copa Cabana, on West Roosevelt Road and Homan Avenue. Chess sometimes recorded live from the club.

6. Otis Clay to Margo Cooper, telephone notes, August 6, 2013.

7. Marvin Gaye lived in Chicago for one year in 1959–60. During this period he was a singer for Harvey Fuqua's group Harvey and the New Moonglows. The group recorded a number of singles for Chess, including "Mama Loochie."

8. Bobby Rush to Margo Cooper, telephone notes, October 16, 2013.

9. *Willie Foster & the Juke Joints* (Black Cat, 1999) and *My Inspiration* (Boogie Barbeque, 2001).

L. C. Ulmer

1. This is borne out in government documents. As early as the US Census of 1930, when he was only 3½ years old, he was listed simply as "L. C." even as all the other members of the family were given their full first names and middle initials.

2. This is a variation of Psalm 55:22: "Cast your burden upon the Lord, and he shall sustain you" (King James Bible). It also refers to the popular gospel song, titled "Take Your Burden to the Lord and Leave It There" (aka "Leave It There"). The song has been recorded many times in various styles and is included in several Christian hymnals. One of the earliest recorded versions was by Roosevelt and Uaroy Graves in the early 1930s.

3. Although later in life L. C. gave his birth year as 1928 and the date inscribed on his tombstone, there are questions about the accuracy of this year of birth. L. C. had no birth certificate. During WWII he registered for the draft on August 28, 1944, claiming that it was his eighteenth birthday, and giving his birth year as 1926. This 1926 birth year is corroborated—by calculation—on US Census forms in both 1930 and 1940. It was not until his marriage in 1956 that he began using the 1928 birth year on official documents. Also, in 2007 when L. C. applied for a passport to travel to Italy, he gave his birth year as 1926. See Lee Chester Ulmer email to Agent No. 6529, National Passport Information Center, June 11, 2007: "I was born at home in rural Mississippi to a midwife in 1926, so no birth record exists . . ." (letter courtesy of Justin Showah).

4. Sebern Ulmer (aka Seborne, Sebron, and Sebe) owned his farm in Jasper County as least as far back as 1900. In the 1900 US Census he was listed as a landowner with a mortgage. By the time of the 1910 Census his land was "owned free."

5. In the 1900 US Census, Mattie Brown's parents are listed as John Brown, age thirty, and Mollie Brown, age twenty-five. Mattie was born in November 1894. Mattie married Luther Ulmer on Christmas Day 1913 in Bay Springs, Jasper County.

6. To be accurate: according to US Census records for 1920, 1930, and 1940, Luther and Mattie Ulmer had no more than eight children between 1915 and 1929. There were never more than seven children in the household at one time. The children were James, Edna, John, Lester, Willie Lee (daughter), Allie (or perhaps Ollie), L. C., and Corrine.

7. In the 1930 census, the Ulmer family was listed as #200 and the Parish home was listed as #221 on the enumeration sheets—a difference of twenty parcels, which might correspond to the "twenty sharecroppers" that L. C. is alluding to here.

8. See note 7 regarding family members. While there were never more than seven familial children in the Luther Ulmer household at any one time, in 1940 the family lived adjacent to farms of Luther's brothers. Together the combined Ulmer families could have easily fielded a team of fourteen workers.

9. A variation on LeRoy Carr's 1934 song "Hurry Down Sunshine."

10. According to the Equal Justice Initiative (EJI), a human rights organization in Montgomery, Alabama, Mississippi had the highest per capita rate of lynching of any state in the United States between 1877–1950 (the Jim Crow era). Jasper was one of only four Mississippi counties to have no documented lynchings during the period. By contrast, in the eight counties surrounding Jasper, the EJI documents thirty-nine lynchings during the same period. For a graphic representation of lynchings by county, see https://plaintalkhistory.com/monroeandflorencework/explore/map2/#3/38/-97.23.

11. According to the website of the city of Laurel, Mississippi, in 1926 William Mason (a friend and protégé of Thomas Edison) discovered a process to make durable, inexpensive hardboard from the massive amounts of wood chips produced by the lumber mills of Laurel. His Mason Fibre Company became the international Masonite Corporation.

12. This is almost verbatim to a quote by the formerly enslaved man, "John Smith," interviewed in Raleigh, North Carolina, for the WPA "Slave Narratives" project in 1936–38: "Dere was not much time for fishin' 'cept at lay-by time at the Fourth of July. Den, slaves an' whites sometime went fishin' in de Neuse River together . . ." Stephen Payseur, ed., *North Carolina Slave Narratives, vol. 2*, 131.

13. Robert Gregory to Margo Cooper, interview transcript, October 14, 2010: "They just put up poles and stuff—wooden posts, tent like, neat on the top, to keep you dry."

14. This is borne out by the 1920, 1930, and 1940 censuses; Luther Ulmer's immediate neighbors were all white farmers, sharecropping as he was.

15. The essential thing about a cooling board was that it had a shelf beneath the main board (which was perforated—either metal or rattan-like webbing, to allow blood and fluids to drain from the body) where ice was packed to keep the corpse cool for a day or so.

"Death Letter Blues" by Son House, "Cooling Board Blues" by Blind Willie McTell, and "Thunder and Lightning" by Lightnin' Hopkins, to name a few blues songs, mention the cooling board.

16. Robert Gregory to Margo Cooper, interview notes, October 2009: "Sam McCullum played the banjo. He'd walk the roads at night playing the banjo, singing. One night he played in the store [Roy Gregory's store in Stringer]. My mama woke up and said, 'I thought I went to heaven, that pretty music.'"

L. C. Ulmer to Margo Cooper, interview transcript, October 14, 2008: "And Ken Jenkins, another one of my daddy's cousins—stayed over at Heidelburg where they got all of them oil wells, about thirty miles from here."

17. Robert Gregory to Margo Cooper, interview notes, October 2009: "Charlie Lindsey could play anything. He'd come to my daddy's general store in Stringer.

He was one of the best musicians. He could play anything you wanted him to play, like L. C. He could play blues, country."

18. "When I lay my burden down" is a lyric from an old spiritual, "Glory, Glory Hallelujah" (not to be confused with the "Battle Hymn of the Republic"). "Glory, Glory Hallelujah" was first recorded by the Elders McIntorsh & Edwards Sanctified Singers December 4, 1928, in Chicago ("Since I Laid My Burden Down," OKeh). Blind Roosevelt Graves and his brother Uaroy recorded it in 1936.

19. The Ulmer family did not own a record player or radio until 1938.

20. "Blessed Be the Name" by Mississippi John Hurt, 1928.

21. "Which Way Do the Red River Run?" John Lomax recorded Lead Belly singing this song in 1935 as part of the WPA folklife project. It is available from the Library of Congress under the title "Red River."

22. "Texas Stomp" is an early 1940s fast-paced, boogie-woogie piano blues by Tampa Red & Big Maceo [Merriweather]. There is also a bluegrass dance song called "Georgia Stomp" on volume 2 ("Social Music") of the *Anthology of American Folk Music*—originally a Victor recording from 1928 by the African American father-and-son duo Andrew (fiddle) and Jim Baxter (guitar and vocals).

23. In Margo Cooper's interview with L. C., he says, "Robert Johnson—he died in '37." We know today that Robert Johnson died on August 16, 1938—but only as the result of research by Gayle Dean Wardlow, who turned up Robert Johnson's death certificate in January 1968. This fact was first published in June 1968 in the British magazine *Blues Unlimited*.

Before that, 1937 was indeed the accepted year of Robert Johnson's death. Sam Charters, in his seminal *The Country Blues*, gave 1937 as Johnson's death year ("sometime in the summer").

24. Peetie Wheatstraw's real name was William Bunch (1902–1941). He was known as "The Devil's Son-in-Law" and also "The High Sheriff from Hell." The song is "See That My Grave Is Kept Clean" by Blind Lemon Jefferson. Jefferson's lyric is "Lower me down with a golden chain."

25. Robert Gregory to Margo Cooper, interview notes, October 14, 2010: "White and Black from the communities of Stringer and Mossville would be at the same breakdowns. My family knew the Ulmers and the Boones, Charlie Lindsey, Sam McCollum, all of them . . . They'd all play together—my granddad, L.C.'s dad, the Boones, Charlie and Sam. My granddaddy and C's daddy—I know they played together."

26. Robert Gregory to Margo Cooper, interview notes, October 2009: "At dances they played mostly hoedown music . . . They'd have places in that store [Robert Gregory's father's store in Stringer] to have square dances."

27. Sears, Roebuck & Co. introduced the Gene Autry Round-up guitar in the autumn of 1932. The Gene Autry guitar was fairly small in size but was a perfect fit for a younger musician. The front of the guitar was stencil-painted with artwork showing a cowboy riding in a cattle roundup while swinging a lariat. The 1932 Round-up was, in fact, a high-quality guitar made with a solid spruce top and solid mahogany back and sides; it sold for $9.75.

28. Randy Magee (Highway 61 Blues Museum) to Margo Cooper, email, May 24, 2020: "Spanish tuning is a generic term for an open tuning whether it be E, D, or G, etc. that these old guys used. Open E would have the guitar tuned E, B, E, G, B, and E. This tuning is pretty hard on a guitar neck as three strings are tuned up to a higher tension. Many players prefer to tune to open D as the strings are tuned down, resulting in less tension on the neck. If Ulmer said open E, that's probably what he meant, but take into account that unless the player had a harmonica to tune to, they usually just tuned to their voice and that might not be anywhere to concert pitch. Son Thomas used to call standard tuning 'natural' and Spanish tuning was an open tuning, though he usually used open G."

29. Benny Lott was born in Jones County in 1898 and had lived continuously in Jones or Jasper counties. He worked as a sawmill laborer in Laurel and as a section hand on the railroad while living in Jasper County in 1930, when L. C. was only four years old.

30. There is a well-known song "V-8 Ford Blues" that has been covered by many bluesmen, including Sonny Boy Williamson and James Cotton. But that song's lyrics do not correspond to these, and it was not written until in 1951 (Willie Love, on Trumpet label).

31. Roosevelt Sykes first recorded "Forty-Four" in "barrel-house" style in 1929. In 1954, Howlin' Wolf, with Hubert Sumlin and Willie Dixon, transformed Sykes's version into a Chicago-style blues.

32. L. C. Ulmer to Margo Cooper, interview notes, October 2009: "I was playing like Blind Boy Fuller. I heard him in 1937. My brother bought his record." Note that "Meat-Shakin' Woman" was released in 1938, not '37, although Fuller had several other popular records out between 1935 and '37. L. C. recorded his own version of the song under the title "Ham and Peas" on his 2011 CD *Blues Come Yonder*.

33. The Ulmers did not have electricity in 1938, but there were "farm radios" or "tube radios" that ran on DC battery power at the time.

34. Uncle Dave Macon (1870–1952), aka "the Dixie Dewdrop," one of the earliest and biggest stars of the Grand Ole Opry. He played an open-backed Gibson banjo and is said to have picked in nineteen identifiable styles.

Note: In 2020 Macon was "called out" for the racist content of some of his songs. Three Macon songs were dropped from the compilation *Anthology of American Folk Music B-Sides*. See Andy Beta, "The Other Side of America's Iconic Folk Anthology," *Washington Post*, October 20, 2020.

35. Roy Acuff (1903–1992) was the lead singer and fiddler for the Smoky Mountain Boys. They joined the Grand Ole Opry in 1938. From 1939 to 1946 Acuff was

also the host of the Opry's Prince Albert radio show. Bill Monroe (1911–1996) mandolin player known as "the Father of Bluegrass." He began playing on the Grand Ole Opry in late 1939. His group was the Blue Grass Boys and the style of music is named after the band.

36. DeFord Bailey (1899–1982) was the first African American musician to join the Grand Ole Opry. He was dismissed from the Opry in May 1941 during a copyright dispute between ASCAP and radio station WSM.

37. The population of Laurel in 1940 was a little more than twenty thousand. The population increased to twenty-five thousand in 1950 and to almost twenty-eight thousand in 1960, when numbers began to decline.

38. The Lincoln Theatre was opened in 1940 with seating listed at 500. The theatre was operated by the Bijou Amusement Company. It was listed as a Negro theatre. It closed in the mid-1950s. L. C. Ulmer to Margo Cooper, interview notes, October 15, 2009: "We started coming to [Laurel in 1940] to watch the shows first. We didn't bring no guitars. Oh, they had any kind of show that you wanted to go to in Laurel. We had our own colored show—the Lincoln Theater. Me and Jack, we came to see the pictures. That's where all the girls were going."

39. Lott Furniture is still in business at this writing (2023) at the same address, 320 Front Street.

40. The Graves brothers sang blues as well. By the time L. C. encountered them, around 1942, they had already recorded two albums of mixed secular and sacred songs. L. C. to Margo Cooper, interview notes, October 15, 2009: "Roosevelt . . . he'd sing church songs, play 'em too. Later on when I played on Front Street, he'd tell me my mistakes. He say, 'Now I'm gonna sing and play it. You play behind me.' He started to sing, him and his brother . . ."

41. There is an historic connection between furniture companies and early recorded music, because furniture stores sold the first gramophones and phonographs and consoles on which the music could be played. In Jackson, Mississippi, for instance, the important "talent broker" H. C. Speir, who "discovered" Blind Roosevelt Graves (as well as Charlie Patton, Robert Johnson, and others) operated from a furniture store. Paramount Records, which produced many of the earliest jazz and blues albums, was a subsidiary of the Wisconsin Chair Manufacturing Company, for the same reason.

42. Roosevelt Graves recorded not before L. C. was born but soon after. Roosevelt Graves first recorded for Paramount Records in 1929; he had a second recording session in 1936 for the American Record Corporation.

43. Eastman, Gardiner & Company sawmill plant occupied twenty-six thousand acres of timberland on the south side of downtown Laurel, Mississippi, from 1891 until 1937.

Willie McGee, who was electrocuted in Laurel in May 1951, lived in Red Line housing during the mid-1940s. Likewise, Jasper McGee—brother of Willie, and later, brother-in-law of L. C. Ulmer—also lived in the Red Line.

44. "Travelin' Shoes" is a traditional gospel song combining the motifs of "Death Come Knockin'" and the perilous "rising waters" of the Book of Ezekiel. A version by the Selah Jubilee Singers was released on Decca in 1939, and Alan Lomax recorded the Golden Gate Quartet performing the song for the Library of Congress in 1940, just a couple of years before L. C. met Roosevelt Graves.

In some versions of "Travelin' Shoes," Death comes for a "sinner," a "laggard," and a "drunkard" in succession, all of whom protest that they cannot go with Death because they don't have their travelin' shoes. Finally Death comes for the righteous Christian who does have his travelin' shoes, and is ready and eager to go with Death, because he knows Death will lead him to Heaven. In other versions, Death comes for the singer's mother, father, brothers, and sisters, all of whom hurry to put on their travelin' shoes to go with Death, because they, too, are confident of salvation.

45. Robert Gregory to Margo Cooper, interview notes, October 14, 2010.

46. L. C. registered with Selective Service on his eighteenth birthday, August 28, 1944.

47. John S. Ezell, "Mississippi's Search for Oil," *Journal of Southern History* 18, no. 3 (August 1952): 320–42. "The biggest news since the Tinsley boom (1939) came on January 27, 1944, when Gulf followed up its December 1943 bulletin by announcing the completion of the Helen Morrison 1 [well] at 4,968 feet, thus opening the Heidelberg field in Jasper County. . . . From the beginning experts claimed Heidelberg as the best strike east of the Mississippi River. . . . By April it was producing over a thousand barrels a day, and Gulf announced plans to sink fifty-four additional wells. . . . $1,600,000 had been appropriated for the Heidelberg operations and for digging twenty-four wells in the Eucutta Field. . . . Jobs were available for everyone under seventy with two arms. . . ."

48. "How long has that evening train been gone?" is a lyric from "How Long, How Long Blues," first recorded by Leroy Carr and Scrapper Blackwell in 1928. "Hate to see that evening sun go down" is a lyric from W. C. Handy's "St. Louis Blues," written in 1914.

49. John and Alan Lomax transcribed a number of "tie-tamping chants" in their 1934 book *American Ballads and Folk Songs*, 10–20; and in their 1941 book, *Our Singing Country: American Folk Songs and Ballads*, 263–64: "All right now, boys / Let me tell you 'bout tampin' ties this time . . ."

50. The Lomaxes also transcribed a number of "hammer songs" in their collections. See Lomax and Lomax, *American Ballads and Folk Songs*, 61–62.

The Library of Congress issued an album of Lomax's sound recordings of "Negro Work Songs and Calls" in 1943. These included "Tamping Chants" and "Hammer Songs"; however, because of the difficulty of making sound recordings in a moving work environment, Lomax "recreated" the tamping chants in a studio, recording a railroad foreman calling out typical chants. About the song "Hammer, Ring!" John Lomax wrote: "The men who drove the spikes that fastened the long steel rails to the wooden ties sang the most thrilling tune of all—the song of the ten-pound hammer . . ."

51. The steel rails were "johnnies" and the end of a rail was the "johnny-head," as in "Go down to the third johnny head and touch it north. . . ." See Lomax and Lomax, *Our Singing Country*, 263.

52. Muddy Waters' version of "Catfish Blues" was recorded in Chicago in February 1950 as "Rollin' Stone" and released on the Chess label. The original recorded version of "Catfish Blues" is credited to bluesman Robert Petway in 1941; however, some "Catfish" lyrics went back to the 1920s and perhaps earlier.

53. Roosevelt Sims (1913–1991), not to be confused with Roosevelt Graves (1909–1962).

54. "Baby Please Don't Go"—probably the Big Joe Williams version from 1935.

55. "Pinetop Boogie Woogie," a 1929 song by Pinetop Smith.

56. See Ben Fong-Torres, "WLAC: Nashville's Late Night R & B Beacon" in *Encyclopedia Britannica*.

WLAC, based in Nashville, Tennessee, blasted 50,000 watts of varied programming, including plenty of rhythm and blues at night. In response to the contention that African Americans in rural areas of the South were still unserved by radio, the Federal Communications Commission granted WLAC permission to have one of the strongest signals in the country, provided that the station broadcast rhythm and blues.

Three white disc jockeys—John Richbourg, Gene Nobles, and Bill ("Hoss") Allen—brought fame to themselves and WLAC by playing rhythm and blues, at least partly in response to the requests of returning World War II veterans who had been exposed to the new music in other parts of the country.

Nobles, who joined WLAC in 1943, was the host of "The Midnight Special"—just one of three programs he hosted on the station. A native of Arkansas and a former carnival barker, Nobles pushed the limits of deejay decorum, assaulting his listeners with insults and double entendres. Nobles retired in 1972 and died in 1989.

57. Her name was Clennis Portericker. According to their Arizona marriage license, she and L. C. were married in Holbrook on November 26, 1956. L. C. gave his name as Lee Chester Ulmer and gave his birthdate as August 28, 1928. This was apparently his first documented use of 1928 as his year of birth.

58. According to the 1930 and 1940 US Census records, Clennis was one of five daughters of Ida Holbert (aka Halbert). One of her sisters was Juanita. The others were Dina, Jeneva, and "Tiny." *San Bernardino Sun*, June 23, 1956, 7: "JONES-PORTERICKER—Henry Eugene Jones, 24, Mississippi; and Suzie May Portericker, 21, Mississippi; both residents of San Bernardino."

59. "Ain't Nobody Here But Us Chickens"—a jump blues song by Louis Jordan from late 1946.

60. According to the California death index, Clennis Ulmer died in San Bernadino on July 19, 1958, age twenty-seven.

61. The Stennis Space Center, which tested the Saturn rockets that were the launch vehicles for the Apollo program. Construction work began there in 1963.

62. From the late 1950s, the Biloxi-Pascagoula area was an important gospel region with many groups, festivals, and competitions. The Gospel Singers of America school was established in the city of Pass Christian in 1958. It's not surprising that L. C. would have been involved in gospel singing during his time there.

Biloxi in the 1960s had only one TV station, WLOX-TV, which began broadcasting in September 1962. The station featured a gospel show, *First Baptist*, Sunday mornings at 11 a.m.

63. Singer Nat King Cole was attacked by members of the KKK while performing before an all-white audience at the Municipal Auditorium in Birmingham on April 10, 1956. After the attack, Cole cancelled three upcoming concerts in the South and returned to Chicago to recuperate. See "The South: Unscheduled Appearance," *Time*, April 23, 1956, 31.

64. Chuck Berry was arrested in Meridian, Mississippi, on September 1, 1959, at a fraternity dance. See "Chuck Berry Incident Again Put State Under Spotlight," *Jackson Advocate*, September 5, 1959, 1, cols. 4–5.

65. Howard Wash had been convicted of the murder of his dairyman employer, Clint Welborn. He was lynched because his sentence was life in prison rather than the death penalty. The lynching was well-documented in newspapers all across the United States.

66. Howard Wash was hung from the Flynt Street bridge on Tallahala Creek, two miles north of downtown Laurel and only seven miles from Mossville, where L. C. was living at the time. Flynt Street becomes 15th Street in Laurel.

67. Willie McGee was electrocuted on May 8, 1951, in a portable "traveling" electric chair that was set up in Laurel. L. C. does not seem to have been in Mississippi at the time of McGee's execution, but he was living in nearby Mossville throughout McGee's long, internationally famous legal ordeal in 1946–51.

68. In March 1951, Jasper McGee's wife, Juanita spoke out in defense of Willie McGee at a Los Angeles event sponsored by the Civil Rights Congress. See Alex Heard, *The Eyes of Willie McGee: A Tragedy of Race, Sex, and Secrets in the Jim Crow South*, 325.

69. According to Scott Baretta's profile of L. C. for the *Mississippi Folklife & Folk Artist Directory*, "In Joliet Ulmer worked construction, ran his own automotive shop, operated a tow truck." https://arts.ms.gov/folklife/artist.php?dirname=ulmer_lc.

70. Location of Anne's Lounge corroborated by Luther Johnson to Margo Cooper, in conversation, July 2021.

71. L. C. became a regular at Clarksdale's Juke Joint and Sunflower Blues and Gospel festivals, Greenville's Mighty Mississippi Blues Festival, the Highway 61 Blues Festival in Leland, and the Shedhead Blues Festival in Ocean Springs, Mississippi.

72. Justin Showah to Margo Cooper, email, November 28, 2020. See also R. T. Lowe to Margo Cooper, telephone interview, November 29, 2020: "Everything he played was spontaneous and absolutely fresh. He played what he felt. There was no pattern with L. C.'s playing whatsoever. He would play until it felt right to change. You literally never knew which way he might be going, especially if he had a slide on. I never took my eyes off his hands." R. T. Lowe is a bass player who performed with L. C. for six years.

73. *Long Ways from Home*, recorded live at the Rootsway Festival in Parma, Italy, in 2007; released on Hill Country Records in 2009.

74. *Blues Come Yonder* was recorded in Como, Mississippi, and released on the Hill Country Records label in 2011. Justin Showah on bass; Jimbo Mathis and Wallace Lester drums; L. C. vocals, guitar, mandolin, and banjo.

75. Justin Showah to Margo Cooper, telephone notes, December 9, 2010.

76. Melanie Young, *Living Blues* 212, March–April 2011, 38–39.

Willie King

1. Jim O'Neal, "Albert 'Brook' Duck," *Living Blues* 154, November–December 2000, 33: "Albert 'Brook' Duck played fiddle, banjo, and guitar. He and his brothers Charlie and Vander performed as 'the Duck Brothers' at plantation jook houses and dances."

2. Willie is featured prominently on the "Black Prairie Blues" marker in Macon, Mississippi, dedicated in August 2008. The marker reads: "Willie King (born in the Grass Hill area in 1943) later led a revival of the local blues tradition and drew widespread acclaim for his political 'struggling songs,' an outgrowth of his civil rights activities in Alabama. . . . In Prairie Point near the Mississippi-Alabama state line, Willie King kindled a new blues movement as the political prophet of the juke joints."

Abe "Keg" Young

1. According to his 1942 Selective Service registration, Lonnie Young Sr. was born December 7, 1903, in Panola County. From US census records in 1910 and 1920, his year of birth was (by calculation) 1900 and 1905, respectively. He died March 1976 in Como, according to the Social Security death index.

Lillian Wilbourne was born in Mississippi in 1905. In the 1910 US Census she is listed with her family in Lafayette County, parents John and Callie Wilbourne. Her son, John William Young, enlisted at Camp Shelby on October 12, 1943.

2. Wilbourne or Willburn was Lillian Young's (Lonnie Young's wife's) maiden name. This is confirmed by John William Young's 1987 Social Security benefits application, which lists his mother's name as Lillian Welbourne.

3. "Chevrolet" was one of the songs Lonnie Young first recorded for Alan Lomax in September 1959. Released on Alan Lomax, *Sounds of the South* (Atlantic, 1960).

4. "Glory Hallelujah" is not to be confused with the "Battle Hymn of the Republic," which is another famous song using the refrain "Glory, Glory Hallelujah." "When I Lay My Burden Down" is the name of this song.

5. L. P. Buford owned a store on the road to Otha Turner's home in Como. See George Mitchell, *Mississippi Hill Country Blues 1967*, 113: "'L.'s' as the local people call it, is more than a store. It is a gathering place where the men can hang out; it has the region's only baseball field, where families congregate on Sundays; and it serves as the meeting grounds for the area's major social events—picnics and barbecues."

6. "Down there" was Como, Mississippi, where L. Buford had his store. According to their Selective Service registration cards, Lonnie Young registered for the draft on February 16, 1942, and his eldest son, John William Young, registered on June 30, 1942. Both were listed as living in Como.

7. In *The Land Where the Blues Began,* Alan Lomax describes how he met Ed, Lonnie, and G. D. Young in Como, Mississippi, in September 1959. An unnamed African American relief worker brought him to meet Ed Young. See Alan Lomax, *The Land Where the Blues Began*, 328: "The relief administrator turned out to be a low-key and friendly black, whom I have never until this moment thanked, because I lost the notebook with his name in it. This kind gentleman insisted that he had never stopped to listen to the picnic music of Panola and Tunica counties but had heard it was quite unusual. He could, however, guide me to it, because some of the musicians were his clients. . . . In a few days I recorded Fred McDowell, a bluesman quite the equal of Son House and Muddy Waters but, musically speaking their granddaddy; the Young Brothers, with fife-and-drum music out of the springtime of the black frontier; and then finally Blind Sid Hemphill. . . ."

8. Fred McDowell appeared at Newport July 23–26, 1964. The Young Brothers played at the festival in July 1966, see Alan Lomax, *Delta Blues, Cajun Two-step: Music from Mississippi and Louisiana, Newport Folk Festival, 1966*. VHS by Rounder.

9. "Smithsonian Institution: Festival of American Folklife, July 1–4, 1967" [program], 3.

10. "Smithsonian Institution: 1968 Festival of American Folklife" [program], 19. See also program "1969 Festival of American Folklife," 12, 13, 15, noting their performances on July 2, 3, and 5.

11. "Mississippians Featured at National Folklife Fest," Jackson *Clarion-Ledger*, June 11, 1974, 16: "G. D. Young, Senatobia, fife and drum; Lonnie Young, Senatobia, fife and drum." See also "1974 Smithsonian Festival of American Folklife" [program], 34–35.

12. The Mariposa Folk Festival Foundation website lists Lonnie Young's Fife and Drum Band on the lineup for the 1972 festival. See https://mariposafolk.com/lineup/past-performers/22.

13. Napolian Strickland (1919–2001), sometimes spelled "Napoleon" or "Napoloan."

Calvin Jackson

1. Calvin Jackson's mother was born Earnmell Ruffin, February 13, 1928, in Senatobia. She died July 8, 1999. His mother's parents were Rayfield Ruffin and Ida Taylor.

2. In our interviews, Calvin said that he was related to Abe Young but the exact familial relationship is unclear. Abe was thirty years older than Calvin. According to his 2010 obituary in the Senatobia newspaper, Abe was married to Bernice Jackson.

3. Poke iron is the sort of iron rod or poker used to stir the coals in a fireplace or wood stove.

4. E. L. Whitaker, not to be confused with the white preacher of the same name. The Jubilee Hummingbirds began to record in 1970, with the single "Stand By Me" and "Something Within Me." The Reverend Al Banks and the Reverend E. L. Whitaker were the leaders of the group, sharing credits on the Hummingbirds' early singles (usually with Al Banks on one side and E. L. Whitaker on the other).

5. David Evans started the High Water Recording Company, a division of the University of Memphis, in 1979 with the support of a National Endowment for the Arts grant to record Mississippi blues artists. Evans recorded R. L. Burnside and the Sound Machine on October 30 and November 3, 1979, at a studio in Memphis. From those sessions, High Water released a single, "Bad Luck City" and "Jumper Hanging Out on the Line" in 1980, and an LP titled *R.L. Burnside: Sound Machine Groove*. See David Evans to Margo Cooper, email, August 23, 2022: "I produced all the tracks on the *Sound Machine Groove* LP of Burnside for High Water, and they were licensed to Vogue."

Prior to that session, however, Evans recorded R. L., Joseph, Daniel, and Calvin in August 1979 at R. L.'s home. Three more recordings were made in Tennessee in 1980. (Seventeen tracks from these recordings were released in 2001: R. L. Burnside & the Sound Machine, *Raw Electric: 1979–1980* (Inside Sounds, 2001). [Duwayne Burnside and Robert Avant each performed on one track.] See David Evans's liner notes March 2001.

6. David Evans to Margo Cooper, telephone notes, October 26, 2021.

7. Written by Willie Woods and first recorded by Junior Walker and the All Stars on their 1965 album, *Shotgun*.

8. *Goin' Down South* was recorded November 1998 in the Netherlands and released in 1999 on the Dutch label Me and My Blues. The CD was nominated for a Blues Music Award in the Best New Artist Debut category. Calvin's band Mississippi Bound was made up of Dutch musicians Cass Ian (guitars/vocals), Carel DeNeeve (acoustic bass), and "Lazy Lew" Beckers (harmonica).

9. David Evans, in his liner notes for *R. L. Burnside and the Sound Machine: Raw Electric 1979–1980* estimates Calvin's move took place "around 1993."

10. Cedric Burnside to Margo Cooper, conversation notes, June 26, 2021. "My dad stayed in Holland ten, eleven years, something like that. He visited a few times."

11. Ranie Burnette (1913–2000) was recorded by David Evans from 1969 to 1980. David Evans to Margo Cooper, email, June 9, 2022. Evans also recorded Bill Moore. "Bill Moore played a guitar, but he used only one string most of the time.... He would play in the slide style. He lived in Senatobia, I recorded him in 1979 and 1980." David Evans to Margo Cooper, email, April 28, 2023.

12. George Scales was born in Marshall County, Mississippi, September 14, 1935. He died October 3, 2015, in Holly Springs.

13. George Scales to Margo Cooper, interview transcript, October 16, 2005.

14. The name the Soul Blues Boys does not appear in newspaper searches until 1984. Perhaps the first "official" (in print) use of the name was on the 1982 High Water single "Keep Your Hands Off Her"/"I Feel Good, Little Girl," produced by David Evans, which is credited to Junior Kimbrough and the Soul Blues Boys. In his liner notes for the single, Sylvester Oliver wrote: "To date Junior has made only three recordings: a 45 with his band in the mid-1960s on the Philwood label (as 'Junior Kimbell'); one selection as a solo artist on a British anthology album; and now this record for High Water. He is featured here with his longtime friend and bass player George Scales and his more recently acquired drummer Calvin Jackson, who together comprise the Soul Blues Boys."

15. Calvin and Linda married in 1979.

Earl "Little Joe" Ayers

1. Lester B. Boga Ayers was born in Lamar, Mississippi, February 12, 1923. He died in Memphis, July 15, 1993.

2. Roy DeBerry, et al., eds., *Voices from the Mississippi Hill Country: The Benton County Civil Rights Movement*, xi: "Benton County has remained sparsely populated, geographically isolated, and economically depressed for the entirety of its existence.... Almost all of its residents, Black and white, are poor, with a per capita income of $15,000, about half the national average and well below the state's modest average of $22,000."

3. Sarah Ayers's maiden name was Sarah Norwood, born in Mississippi in 1903.

4. See DeBerry et al., *Voices from the Mississippi Hill Country*, "Appendix 2: Black Land Ownership in Benton County," 195–96.

5. DeBerry et al., *Voices from the Mississippi Hill Country*, xxxiii: "FHA loans were intended to benefit small landowners and sharecroppers or renters looking to purchase land. The distribution of these benefits, however, was handled by local agricultural committees. In Benton County, no Black had ever served on one or had even been nominated. That changed in November 1964, when the [Black] Citizens Club filed nominating papers for eight Black candidates."

6. A lyric from "Milky White Way," a gospel song written by Lander Coleman in 1944. The song was a hit in 1947 for the CBS Trumpeteers, a black gospel quartet from Baltimore. Sister Rosetta Tharpe recorded a version in 1951, as did Little Richard in 1959 and Elvis Presley in 1960.

7. George Scales to Margo Cooper, interview transcript, October 16, 2005.

8. "Boogie Chillen'" by John Lee Hooker (his first record), released in November 1948 on the Modern label. It reached #1 on the race records charts in February 1949.

9. Joe is clearly making a reference here to the August 1934 lynching of Robert Jones and Smith Houey near Michigan City, Mississippi. The lynching was reported by the Associated Press and appeared in newspapers across the country. See "Mississippi Mobs Lynch Two Negroes," *New York Times*, August 14, 1934, 24. See also DeBerry et. al., *Voices from the Mississippi Hill Country*, xxvi, 49, and 132–33.

10. A Benton County woman, Eldora Johnson, interviewed for *Voices from the Mississippi Hill Country*, 133, recalled: "They lynched them down by Meridian Road. It was a big old oak tree down from the Hardaway Pond. . . ." Hardaway Pond at Meridian Road is five miles south of Michigan City and four miles east of Lamar.

11. The "brothers" who were lynched were Robert Jones and Smith Houey. The names "Happy Jack" and "Corn Jack" must come from local lore.

12. A version of this song by the Starlight Gospel Singers (Greenville, Texas) was field recorded for the Library of Congress and released on Folkways in 1962. Fred McDowell recorded it with his wife Annie Mae and the Hunter's Chapel Singers of Como on his 1966 album *Amazing Grace*.

13. This is a lyric from the traditional gospel song "Must Jesus Bear the Cross Alone?" The Soul Stirrers recorded a version on their album *Jesus Be a Fence Around Me* (SAR, 1961). Sam Cooke recorded an earlier version with the group (1956).

14. The Equal Rights Initiative records five lynchings in Marshall County during the Jim Crow era. None were documented in Holly Springs.

15. "Tramp" was recorded on the Philwood label in Memphis and released in October 1967. On the 45 label, the title was misprinted "Tram?" and credited to "Junior Kimbell." The B-side was "You Can't Leave Me," also credited to Junior Kimbell. "Tramp" was written by Lowell Fulson and first recorded by him in 1966. The song was also covered by Otis Redding and Carla Thomas in 1967.

16. Kenny Brown to Margo Cooper, interview notes, August 17, 2019.

Kenny Brown

1. Callicott recorded "Fare Thee Well Blues" on the Brunswick label in 1930. Kenny recorded it on his CD *Stingray* (Fat Possum, 2003). Kenny also recorded "You Don't Know My Mind" on *Stingray*.

2. George Mitchell recorded Joe Callicott in the summer of 1968, when Callicott was sixty-nine and Kenny was fourteen. See George Mitchell, *Mississippi Hill Country Blues 1967*, 139. "In his liner notes on Callicott, Mitchell mentions a young white boy Callicott had taken on as a student; this youngster was Kenny Brown, who went on to spend his adult years playing guitar with R. L. Burnside, who deemed Brown his 'adopted son.'"

3. Callicott had quit playing out in 1959 after the death of his friend and singing partner, Garfield Akers. He was "discovered" by George Mitchell in the summer of 1967. For more on Joe Callicott, see Gayle Dean Wardlow, "Garfield Akers and Mississippi Joe Callicott: From the Hernando Cotton Fields," in *Chasin' That Devil Music*, 118–24. Reprint of original article in *Living Blues* #50 (Spring 1981), 26–27.

4. For more on Bobby Ray Watson, see T. DeWayne Moore, "The Great Untold Story of Hill Country Blues," Mount Zion Memorial Fund, https://www.mtzionmemorialfund.org/2019/04/the-great-untold-story-of-hill-country.html.

5. Steve Cheseborough, *Blues Traveling: The Holy Sites of Delta Blues*, 237–38.

6. *Deep Blues: A Musical Pilgrimage to the Crossroads*, British documentary written by Robert Palmer and directed by Robert Mugge. Released in April 1992. Junior Kimbrough, Joe Ayers, and Calvin Jackson were among the North Mississippi Hill Country musicians recorded live and featured in the film.

7. R. L.'s cousin, Annie Mae Burnside, lived with Muddy in Chicago in the mid-1940s. R. L. Burnside told Muddy's biographer Robert Gordon: "When I got to Chicago in 1946, my Dad was up there, staying on 14th Street, and he told me, 'Muddy live right over there. . . . I'd go over to Muddy's house about every other night and watch him play.'" Robert Gordon, *Can't Be Satisfied: The Life and Times of Muddy Waters*, 88, 321.

8. Calvin Jackson on drums and Duwayne Burnside on bass; produced by Robert Palmer.

9. Junior Kimbrough & the Soul Blues Boys, *Sad Days, Lonely Nights*, recorded in April 1993, released on Fat Possum 1994. Also produced by Robert Palmer. Junior on guitar and vocals, Kenny on guitar, Garry Burnside on bass, Calvin Jackson on drums.

10. Kenny plays on Junior Kimbrough's Fat Possum CDs, *Most Things Haven't Worked Out* (1997) and *God Knows I Tried* (1998). Kimbrough died in January 1998.

11. *You See Me Laughin'* is a 2002 documentary film directed by Mandy Stein. It features R. L. Burnside, Kenny Brown, and many other Fat Possum "Hill Country" blues performers.

Cedric Burnside

1. *All Night Long*, first released on Fat Possum, fall 1992. Junior Kimbrough, guitar and vocals; Garry Burnside, bass; Kinney Malone, drums. R. L. Burnside's CD *Too Bad Jim* (Fat Possum, 1994) was also recorded at Junior's juke in April 1993.

2. *Texas Red* is a "Western" set in Mississippi in 1940 and directed by Travis Mills, an independent filmmaker based in Brookhaven. The real-life character Texas Red—his true name has never been authenticated—owned a juke in Franklin County in southwestern Mississippi in 1939. He was accused of the alleged murder of a white deputy sheriff and was hunted down in January–February 1940 by a force of local police, FBI, and National Guardsmen. He was killed near Fort Gibson in Claiborne County. See "Dogs Trail Killer to Death," Jackson *Clarion-Ledger*, February 4, 1940, 1.

3. Garry and Cedric wrote eleven original songs, and covered three songs by R. L. Burnside and one by Bob Dylan, "Knockin' on Heaven's Door."

Index

Page numbers in **bold** refer to photographs.

Abel, Bill, **157**, 159, **161**; interview, 160; influence of Paul "Wine" Jones, 160; meets Monroe Jones, 160; first plays with and records "Cadillac John," 160; connection between "spiritual music" and blues, 160; on "Cadillac John" Nolden's blues style, 160; on Monroe Jones, 163; on T-Model Ford's blues style, 171, 325n11
Aces, the, 8
Addison, Nathaniel, "Little Addison," xx, 49
"Ain't Nobody Here But Us Chickens" (Louis Jordan), 233, 331n59
"Ain't No Grave Gonna Hold My Body Down" (Brother Claude Ely), 46, 315n6
Alligator (Bolivar County, Mississippi), xxvi, 84, 94, 98, 100, 320n9, 320n11; town described by Robert "Bilbo" Walker, 89; described by Richard Fava Jr., 89; described by Claudette Romious, 89
Alligator Records, 54
Allison, Luther, 60–61, **96**, 96
All Night Long (Junior Kimbrough and the Soul Blues Boys), 299, 334n3
"All Star Tribute to Muddy Waters," xvi
"All Your Love" (Magic Sam), 59
American Folk Blues Festival, 79
American Folk Life Festival (Washington, DC), 182, 260, 326n18
Ames, Abie, "Boogaloo," 194, 213
And This Is Free: The Life and Times of Chicago's Legendary Maxwell Street (documentary film), 80
Arkansas Race Riot, The (Wells), 4, 311n6
Arnold, "Billy Boy," 8, **10**, 11; meets Sonny Boy Williamson (John Lee Williamson), 11; influence of Little Walter's "Juke," 11; plays with Bo Diddley, 11; forms his own band, 11; Carey Bell compliments, 11
Ayers, "Little Joe" (Earl Ayers), **270**, **276**, **279**; interview, 271–78; family background, 271; Baptist upbringing, 272; first guitar, 272; sees Junior Kimbrough in neighborhood, 272; house parties, 272; schooling, 272; lynching site in neighborhood, 273, 333n9, 334nn10–11; cotton picking, 273, 275; plays house parties and jukes with Junior Kimbrough, 275; moves to Holly Springs, 275; Benton County jukes played, 277; with George Scales as Soul Blues Boys, 277; records with Junior Kimbrough on "Tramp," 277; observations on Junior Kimbrough's style, tuning, personnel, 277; Junior Kimbrough's funeral, 278; playing with son, Trent Ayers, 278; records CD *Backatchya* at Kenny Brown's, 278; Kenny Brown comments on Joe Ayers's importance, 278; *Backatchya* wins Best New Recording/Debut, 278; festival appearances, 278
Ayers, Trent, **276**, 278, **303**, 305, 307

"Baby, Please Don't Go" (Big Joe Williams), 178
"Baby, Please Don't Go" (Muddy Waters), 46
Backatchya (Little Joe Ayers), 278
Bag Full of Blues (Willie "Big Eyes" Smith and His Blues Band), 22
baptism (Moon Lake), **90**, **104**, **105**
Bass, Lee, 79, 116, 319nn29–30
battery radio (also farm radio, tube radio), 6, 7, 46, 87, 176, 227, 272, 329n33
Beadle, Gordon, "Sax," xxxii, 61, 63
Belafonte, Harry, 16, 19
Bell, Carey, xvii, 11
bells (plantation bells), 110, 223
Below, Fred, 8, 12
Bentonia Blues Festival, 240
Berndt, Jerry, xvi
Berry, Chuck, 7, 49, 95, 233, 312n28, 331n64
Big Beat (record label), 54, 315n24
Bilbo, Theodore G., 28, 84, 320n4
"Bilbo Is Dead" (Andrew Tibbs), 320n4
Birmingham, Alabama, 16

Bisesi, Brian, 56, 59, 316n43
Black Bayou Bridge (Emmett Till's body found near), **32–33**
Black Fox, the (Big Jack Johnson's club, Clarksdale), 98, 115, 118, 130
Blind Boy Fuller (Fulton Allen), 6, 224, 227, 329n32
Blind Lemon Jefferson, 152, 224, 226, 231, 272
Bloomfield, Michael, 80, 319n36
Blow My Blues Away (Mitchell), 319n39
"Blue Bird Blues" (Sonny Boy Williamson I), 34, 313n9
Blue Front Café (Bentonia, Mississippi), 181, 240
Blues Brothers (movie), 60
Blues Come Home to Roost (Super Chikan and the Fighting Cocks), 121, 321n8
Blues Come Yonder (L. C. Ulmer), 237
Blues Explosion (Atlantic Records), 59
Blues from the Delta (Ferris), 326n22
"blues revival," early 1960s, 80
Blues Wire: All the Blues in New England, xvii, xx
Bo Diddley (Ellas McDaniel), 8, **9**, 11; Ellas McDaniel and the Hipsters, 11
"Bo Diddley"/"I'm a Man" (Bo Diddley), 11
Bolton, Bo, 40, 56
"Boogie Chillen" (John Lee Hooker), 272, 333n8
Booker, Charley, 152, 152, 189
bootlegging, 6, 48, 87, 129, 233; moonshine, 14, 48, 87, 109
Borden Plantation (Coahoma County, Mississippi), 84, 91, 319n1
Born in Arkansas (Willie "Big Eyes" Smith), 25
Boston blues scene, xvi, 57, 59
Bourbon Plantation (Washington County, Mississippi): Frank Nash, 178; Mickey Rogers, 205, **207**
Boyce, R. L., **250**
Brent, Eden, **195**, **196**; interview, 194–97; association with Lil' Bill Wallace, 194; learns blues organ technique from Lil' Bill, 194; clubs played with Lil' Bill, 194; friendship after Lil' Bill's stroke, taking him places, 194, 197; sings at Lil' Bill Wallace's funeral, 197
Broonzy, "Big Bill," 14
Brown, Kenny, **280**, **283**; interview, 281–85; family background, 281; first hears fife and drum music, 281; meets Joe Callicott, learns guitar from, 281, 334nn1–3; meets and plays with Johnny Woods, 281, 282; meets R. L. Burnside, 281–82; on R. L. Burnside's style, 282; meets Otha Turner, 282; meets Junior Kimbrough, 282; tours with Mojo Buford, 282–83; records with R. L. Burnside for Fat Possum, 283; Cedric Burnside joins R. L. Burnside and Kenny Brown, 283, 285; remarks on Cedric Burnside, 285; with wife Sara organizes North Mississippi Hill Country Picnic, 285; thoughts on Hill Country music, 285; Cedric Burnside on Kenny Brown, 302, 305
Brown, Ruth, xxx

Bryant's Grocery and Meat Market (Roy and Carolyn Bryant), Money, Mississippi, 31, **138**
Bryants, the (Roy and Carolyn) in Jonestown, recalled by Betty Vaughn, 137
Buddy Guy and Junior Wells (as duo), xvi, xx, **xxi**
Buddy Guy's Legends (Chicago), xx, **xxi**, 42
Buford, George, "Mojo," 14, 282
Buford, L. P., 260, 263, 332n5
Bullock's Café (Helena, Arkansas), **226**
Burnett, Chester Arthur. *See* "Howlin' Wolf"
Burnside, Calvin, 292, **293**
Burnside, Cedric, **268**, 269, 283, 288–89, **295**, **298**, **304**, **306**; interview, 294–307; family background, "Big Daddy" (R. L. Burnside) and "Big Mama" (Alice Burnside), 294; gardening and animals for food, 297; supplemental fishing and hunting, 297; learns drums from father, Calvin Jackson, 297; Calvin Jackson's drum style described, 297; family moves to Chulahoma, 299; Junior Kimbrough's juke next door to Burnside home, 299; practices with Junior Kimbrough and Garry Burnside, 299; Junior Kimbrough's style described, 299; R. L. Burnside's style described, 299; tours with R. L. Burnside in Canada, 300; continues touring for eleven years in US, Europe, Japan, Australia, 300; Juke Joint Caravan with R. L. Burnside, Junior Kimbrough, Robert Cage, and Paul "Wine" Jones, 300; thoughts on Kenny Brown, 302, 305; roles in films, 305; plays with Garry Burnside, Burnside Exploration, 305; collaboration with Trent Ayers, 305, 307; begins playing guitar, 307
Burnside, Duwayne, 265, 282, **284**, 285, 286, 297
Burnside, Garry, 277, **287**, **298**; interview, 286, 289; family background, 286; learns bass from Junior Kimbrough, 286; plays with Duwayne Burnside, 286; joins North Mississippi All Stars, 286; collaborates with Cedric Burnside, 286; Burnside Exploration, 286; Grammy nomination for *Descendants of Hill Country*, 289; forms Garry Burnside Band, 289; performs at (North Mississippi) Hill Country Picnic, 289; remarks on Hill Country style, 289; plays with Cedell Davis, 289; Fat Possum Caravan tours, 289; plays with T-Model Ford and Paul "Wine" Jones, 289; meets Otha Turner, 289
Burnside, Melvin, **295**, **298**
Burnside, R. L., 266, **296**; guitar style described by Kenny Brown, 282; in Chicago, 294; guitar style described by Cedric Burnside, 299
Burnside Exploration (Cedric and Garry Burnside duo), 286, 305

Callicott, Joe, 281, 334nn1–3
Campbell, Eddie, 97, **97**
Can't Be Satisfied: The Life and Times of Muddy Waters (Gordon), 311n12, 312n26, 314n14, 314n16, 316n38, 334n7
Carr, Doris (née Godfrey, wife of Sam Carr), xxiv; nicknamed "Long Legged Lizzie," 71; meets Sam Carr, marries, 71; sings with Little Sam Carr and the

Blues Kings, 79, 319n28; recipient of Early Wright Blues Heritage award, 83; death of, 83

Carr, Mozella, "Mama Carr," 68–69, 73; death of, 77

Carr, Oscar, 319n2

Carr, Sam, xi, xxiv, 4, **66**, **70**, **75**, 77, **82**; interview, 67–83; birthplace uncertain, 67, 317n1; father Robert Nighthawk (Robert McCollum, Robert McCoy), 67; mother Mary Griffin, 67; abandoned by parents at one year, 67; adopted by Carr family, 67, 317n5; visited by birth mother once a year, 67; first meets father, Robert Nighthawk, at seven years, 67; town of Dundee, remembered, 68; schooling, 68; Rosenwald school, 68, 317n7; racial pride instilled, 68; self-defense, 68; earliest exposure to blues, 68; T. C. Glisper, 68; "Terraplane Blues," 68; hears "the older Sonny Boy" (John Lee "Sonny Boy" Williamson), 68; Robert Nighthawk buys him suit, brings him to Helena, Arkansas, 68; stays with uncle in West Memphis, 68; mows lawns, buys bicycle, works as ice delivery boy, 68–69; moves to Helena, lives with father, 69; gambling houses and blues clubs in Helena, 69; Nighthawk's radio show at KFFA studio, 69, 318n10; "works door" for Nighthawk at jukes and fairs, 69; Vogel's juke, Wabash, Arkansas, 69; Nighthawk's physical appearance, described by Sam, 71; Nighthawk, as singer, 71; Nighthawk, as guitar player, 71; courts and marries Doris Godfrey, 71; moves to Wooten-Epes Farm, 71; confrontation with overseer, 71, 73; flight from Arkansas to Chicago, 73; move to St. Louis, 73; plays with Tree Top Slim, 73–74; organizes first band, 73–74; Nighthawk's wife, "Earlie B.," drummer, 74, 318n17; names band Little Sam Carr and the Blues Kings, 74; influence of drummer Robert Thomas, 74; importance of "playing time," 74; meets Willie Foster and Frank Frost, 74; Frank Frost joins band as singer and pianist, 74; Frank Frost learns harp, 74, 318n20; Sonny Boy Williamson (II) joins band, 74, 318nn21–22; 1960 return to Mississippi, 77; drumming style, self-described, 77; Arthur Lee Williams joins band, 77; Arthur Lee Williams's harp style described, 77, 318n26, 319n27; Big Jack Johnson joins band, 79; band managed by Lee Bass, 79, 319nn29–31; band records for Phillips International, 79; racism encountered in segregated clubs and on tour, 79; last gigs with Sonny Boy Williamson (II), 79; death of Sonny Boy Williamson (II), 80; plays with Robert Nighthawk, 80; last Nighthawk recordings at Sam Carr's home, 80, 319n38; death of Robert Nighthawk, 80; records for Scotty Moore (Jewel), 80; records for Michael Frank (Earwig), 80, 319n43; plays with Johnny B. Moore, 80; plays with Willie Foster and T-Model Ford, 80–81; plays with Lonnie Shields, et al., 81; last performances with Frank Frost, 83; death of Frank Frost, 83; forms Delta Jukes, 83; international tours, 83; Jelly Roll All Stars, 83; last recordings, 83; *Living Blues* "Outstanding Musician on Drums" award from 1993 to 2005, 83; documentary film appearances, 83; awards and accolades, 83; death of wife, Doris, 83; death of, 83; remembered by James "Super Chikan" Johnson, 116

Carr Plantation (Coahoma County, Mississippi) (also Mascot Planting Company), 84, 319n2

"Catfish Blues" (Robert Petway), 89, 152, 190, 231, 260, 320n13, 331n52

Cat Head Delta Blues & Folk Art ("Cat Head store," Clarksdale), xxvi–xxvii, **102**, 103, **235**

Cat Head Mini Blues Festival, xxvi–xxvii, **102**, 103

Center for the Study of Southern Culture, xx

Chicago Blues: The City and the Music (Rowe), 312n20, 314n15

Chikadelic (Super Chikan and the Fighting Cocks, with Spoonful of Blues), 121, 322n11

Clay, Francis, 14, 312n25

Club Ebony (Indianola, Mississippi), 148, 189, 192, **193**, 194, 197, 210, 212

Coca-Cola, marketing discrimination against Blacks, 181

Cole, Joe, **141**, **143**; interview, 140; experience in WWII, 140; flees Tallahatchie County, 140; settles at Eastover Plantation, 140, 323n3 (Cole); remarks on "juke houses," 140

Cole, Nat King, attacked on stage, 16, 233, 331n63

Como (Panola County, Mississippi), **xxvi**, 237, **256**, 260, 282

Conway Twitty's Club (Moon Lake), 79

Cook, Lynwood, "Cookie," 61

Cooke, Sam, 54, 92, 93, 94, 95, 129, 130

Cooper, Margo: preface, xvi–xxxii; photographic education, xvi; Berndt, Jerry, friend and mentor, xvi; New England blues scene, xvi; first publications, xvii, xx; meets Luther Johnson, xvii; first trip to Chicago, xx; *Living Blues*, xx, xxvi; friendship with Luther "Guitar Junior" Johnson, xx; first trip to Mississippi, xx–xxii; meets Otha Turner, xxii; meets Sam Carr and wife, Doris, xxiv; friendship with Robert "Bilbo" Walker, xxvi–xxvii; friendship with Willie "Big Eyes" Smith, xxvii; friendship with Toni Lynn Washington, xxxii; photography as family value, xxxii; parental influence, xxxii; death of Luther "Guitar Junior" Johnson, 63; last words on Luther, 63–64

Copeland, Johnny, xvii

Copeland, Shemekia, xvii, **xvii**

cotton, chopping and picking: Willie Smith, 5; Calvin Jones, 30; Frank Frost, 77; Robert Walker, 86; James "Super Chikan" Johnson, 111–12; "Razorblade" Stewart, 127; David Lee Durham, 148; "Cadillac John" Nolden, 151; T-Model Ford, 165; Eddie Cusic, 174; "Farmer John" Horton, 186; "Mississippi Slim," 198, 201; L. C. Ulmer, 220; Abe "Keg" Young, 259; Calvin Jackson, 263; Joe Ayers, 272, 275

Cotton Club, the (Chicago), 36, 95, 163

"Crawlback" (Frank Frost), 79

Crossroads, the (Clarksdale), **119**, 121, 134

Crazy About You ("Cadillac John" Nolden), 159, 160

Crudup, Arthur, "Big Boy," 5, 7, 21, 34; covered by Elvis Presley, 129

Curtis, James, "Peck," 80, 153, 324n14
Cusic, Eddie, **175, 177, 179, 185**; interview, 174–84; parents and grandparents, 174; child labor as waterboy, plowing, picking cotton, 174; Baptist church upbringing, 174; schooling, 174; condition of house, 176; bedbugs, 176; tubs for bathing, 176; importance of radio, 176; shoes, importance of, repair of, 176; town curfew for Blacks, 176; childhood home used as "juke," 177–78; diddley bow, 178; hears Sonny Boy Williamson (Rice Miller) at Woodburn Plantation, 178; picking cotton, 178; first guitar, 178; meets B.B. King, 178; forms band, the Rhythm Aces, 179, 181; Rhythm Aces personnel, 179; meets Little Milton, teaches him guitar, 179; plays with Elmore James, 179, 181; drafted into US Army, 181; Leland, Mississippi, description of, 181; on lynchings, 181; relationship with James "Son" Thomas, 182, 326nn17–19; works as mechanic for state of Mississippi, 1966–1991, 182; musical career after 1991, 182, 184; records *I Want to Boogie*, 184
Cusic, Lucinda (wife of Eddie Cusic), 182

Dattel's Plantation (Sunflower County, Mississippi) (also "Lonesome Pine Farm"), 151, 323n2
Davis, Cedell, 80, 289, **291, 292**
Davis, Eddie, 155
Dawkins, Jimmy, 49, 54, 57, 316n34
Deep Blues: A Musical Pilgrimage to the Crossroads (documentary film), 334n6
Delta Blues Museum, 134, 182
Delta Blues Singer: James "Sonny Ford" Thomas (documentary film) (Ferris), 325n11, 326n22
Descendants of Hill Country (Cedric Burnside), 289, 307
"Devil's Music," the: Willie Smith, 7; Luther "Guitar Junior" Johnson, 46; "Razorblade" Stewart, 129
diddley bow: Calvin Jones, 34; Luther "Guitar Junior" Johnson, 48; Robert "Bilbo" Walker, 88; James "Super Chikan" Johnson, 111; David Lee Durham, 148; Eddie Cusic, 178; Mickey Rogers, 205
"Diddy Wah Diddy" (Dixon), 12
Dixie Hummingbirds, the, 7
Dixon, Ola Mae, 59
Do Drop Inn (Shelby, Mississippi), **144,** 145, **146**
Doin' the Sugar Too (Luther "Guitar Junior" and the Magic Rockers), 59
"Don't Let the Devil Ride" (Oris Mays), 265
"Don't Them Peaches Look Mellow," 275. *See also* "Peach Tree Blues"
"Don't Your Peaches Look Mellow," 47. *See also* "Peach Tree Blues"
Dundee, Mississippi, xxiv, **66**, 80, **82, 101, 118, 267**
Durham, David Lee, **149**; interview, 148; cotton chopping and picking, 148; supplemental hunting, 148; sees Howlin' Wolf and Jimmy Reed in Inverness, 148; diddley bow, 148; first guitar, 148; plays jukes in mid-Delta, 148; Club Ebony, 148

Earlie B. *See* McCollum, Earlie B.
Eastover Plantation (Coahoma County, Mississippi), 140, 323n3 (Cole)
Eddie Mae's Café (Helena, Arkansas), **70, 76**
Edmonds, Elgin (also Elga), 7
Edwards, David, "Honeyboy," **vii**
Edwards, Ruby (owner, Ruby's Nite Spot and Club Ebony), 179, 181–82, 189, 192
Eggerson, Annie, xxii, **xxiii**
Elaine Massacre (Phillips County, Arkansas), 4, 311n6
1145, the (Chicago), 8, 34, 36, 54, 312n20
Ellas McDaniel and the Hipsters. *See* Bo Diddley
Equal Justice Initiative (EJI). *See* lynchings
Evans, Andre, "Dre," xxii, **248, 254, 256**
Evans, David, "Doctor Dave," 265–66, 333n5
Evans, Rodney, xxii, **248, 256**

Farmer John ("Johnny Farmer"). *See* Horton, John, Jr.
Fat Possum Records (Oxford, Mississippi), 121, 172, 189, 283, 283, 289, 299, 300, 302, 325nn19–21
Ferris, William, "Bill," ix–xiv, 325n11, 326n22
Five Blind Boys, the (the Five Blind Boys of Alabama), 7, 89
Ford, James, "T-Model," xxii, **164, 167, 169, 173**; interview, 165–72; family background, 165; "whupped" by father, 165; childhood work, 165; cotton ploughing, chopping, picking, 165; Forest, Mississippi, description of, 165; Ford home terrorized by KKK, 166; teenage sawmill work, 166; integrated work force in logging, 166; kills man in Humboldt, Tennessee, 168; serves two years in prison, 168; does "couple of months" in Parchman prison on separate charge, 168; nicknamed "T-Model," 168; moves to Greenville, Mississippi, 1973, 168; wife, Johnnie Mae buys him Gibson guitar, 171; Johnnie Mae leaves T-Model, 171; teaches himself guitar, 171; first paid gigs, Nelson Street, Greenville, 171; guitar style, according to Bill Abel, 171; plays with Willie Foster, Frank Frost, and Asie Payton, 171–72; volatile relationship with Willie Foster, 171–72; meets and marries Stella Smith, 172; Paul Wine Jones nicknames T-Model "Tale Dragger," 172, 325n18; T-Model records for Fat Possum, 172; other late recordings, 172; remembered by "Farmer John" Horton, 172; remembered by John Horton III, 190, 289
Ford, Stella Smith (wife of T-Model), xxii, **xxvii**, 172, **173**
"Forty-four" (Roosevelt Sykes), 329n31
Forty Mile Bend plantation (LeFlore County, Mississippi), 45, 315n3
Foster, Willie, 74, 171–72, **214**; with Mickey Rogers, 213; Willie's harmonica style, described by Mickey Rogers, 213; legs amputated, 213, 215; tours Europe, 215; death of, 215
Frank, Michael, 98, 319n43
Fratesi's Plantation, 179, 325n9

Freedom Riders, 16, 113, 321n2
Frost, Frank, xxii–xxiii, **72**, 319n27; joins Little Sam Carr and the Blues Kings, 74, 318n19; learns harp, 74, 318n20; meets Arthur Lee Williams, 77, 319n27; records as Frank Frost and His Night Hawks, 79; death of, reported by Eddie Mae Walton, 83; remembered by Robert Walker, 99–100; remembered by James "Super Chikan" Johnson, 116, **117**; remembered by Razorblade Stewart, 133; remembered by T-Model Ford, 171–72
Funk Thumpers, the, 118, 121, 321n7
furnish system, 31, 71, 73, 313n6
furniture companies and the blues, historical connection, 330n41

Gene Autry guitar, 178, 225, 329n27
"Glory Hallelujah," 260, 332n4. *See also* "When I Lay My Burden Down"
Godfather, Club (Merigold, Mississippi), 321n40
"Good Morning, School Girl" (John Lee "Sonny Boy" Williamson), 227, 275
Good Rockin' Charles (Charles Edwards), 36
Goodwill Revue, 48, 315nn12–13
Grafonola, 34, 272
Gramophone (wind-up), 152, 178, 227
Gravel Springs (Tate County, Mississippi), home of Otha Turner, xii, **xxiv**, **246–47**, **248**, **249**, **250**, **251**, **252**, **253**, **254**, **255**, **258**, **262**, **288**, **296**
Graves, Aaron (Uaroy Graves, brother of Roosevelt Graves), 228
Graves, Roosevelt, 227–28, 330n40–42
Grayson, LeRoy, 189, 202, 327n7
Gresham, Jesse (Jesse Gresham Plus Three), 131, 322nn9–11
Ground Zero (blues club, Clarksdale), **120**, 134, **135**
Guy, Buddy, xvi, **xxi**

halves, on (the), 5, 165, 220
"Hard Time Killing Floor Blues"/"Cherry Ball Blues" (Skip James), 240
"Hard Times (Have Surely Come)" (Luther "Guitar Junior" Johnson), 59
Harpers Ferry (Boston), xvi–xvii, **9**, **20**, **35**, **44**, **52**, **55**, **154**, **188**
Harry Hope's (Cary, Illinois), 57, 316n39
Hemphill, Jessie Mae, 265, **267**, 302
Hendrix, Jimi, 212
Hey Boss Man! (Frank Frost and His Night Hawks), 79
High Water Recording Company, 265, 333n5
Highway 61 Blues Festival (Leland, Mississippi), **161**, **195**, **196**, **203**, **238**, **306**
Highway QCs, 94, 320n24
"Hi-Heel Sneakers" (Tommy Tucker), 190
Hill, Raymond, 89, 91
Hill Country blues: Joe Ayers, 275, 278; Kenny Brown, 285; Garry Burnside, 289; Cedric Burnside, 299

Hobnob, the (Chicago), 12
Holifield, Chase, 234, **235**
"Hollywood Fats" (Michael Mann), 21, 40, 54
Holmes, Jimmy, "Duck," **241**; on 1950s marketing discrimination by Coca-Cola, 181; interview, 240; Blue Front Café, 240; Bentonia style blues, 240; Henry Stuckey, Skip James, 240; Jack Owens influence, 240; organizes Bentonia Blues Festival, 240
"Homesick James" (James Williamson), 34
Hopson Commissary, xxvii, **3**, **18**
Horton, John, Jr., "Farmer John," 172, **187**; interview, 186–89; parents, 186; nicknamed "Farmer John," 186; cotton picking, 186; musically influenced by Eddie Cusic and James McGary, 186, 189; Monkey Store, 189; LeRoy Grayson's juke recalled, 189; "Cross Spanish" tuning, 189; records *Wrongdoers Respect Me* for Fat Possum, 189; "Farmer Johnny," 189; John Horton III (son of "Farmer John") recalls father playing slide, 190
Horton, John, III, 172, 190, **191**; on playing with "Mississippi Slim," 202, **203**
House of Blues (Cambridge, Massachusetts), xvi, **xvii**, **29**, 61, **96**
"Howlin' Wolf" (Chester Arthur Burnett), xxii, 14, **39**, 148, 297; on radio KWEM, 6, 311n13; remembered by Calvin Jones, 39–40; father-son relationship with Hubert Sumlin, 40, 314n18; remembered by Mickey Rogers, 208, 213; remembered by Harold Hall, 326n15
Howlin' Wolf Memorial Blues Festival (West Point, Mississippi), xx, **301**
"How Many More Years" (Howlin' Wolf), 171, 325n8 (Ford)
Hucklebuck, the, 7, 189, 312n15

"I Been Down So Long" (Magic Sam), 54
"I Can See Everybody's Mother but I Can't See Mine" (Clarence Fountain), 89, 92, 320n12
I Changed (Luther Johnson Jr.), 57
"If I was a catfish I'd have all these girls swimming after me," 231, 331n52. *See also* "Catfish Blues"
"I got a big fat woman meat shakin' on her bone!" 227. *See also* "Meat Shakin' Woman"
Iglauer, Bruce, on Luther "Guitar Junior" Johnson," 54, 57
"I'm gonna walk to the Milky White Way one of these days," 272. *See also* "Milky White Way"
"I'm Ready" (Willie Dixon), 59
I Want to Boogie (Eddie Cusic), 184
"I Wish I Was a Catfish," 89, 320n13. *See also* "Catfish Blues"
"I wore my forty-four so long it made my shoulder sore," 227. *See also* "Forty-four"

Jackson, Calvin, **262**, **264**, **268**; interview, 263–69; family background, 263; cotton, plowing, chopping, picking, 263; supplemental hunting and fishing,

263; fife and drum picnics, 263, 265; Baptist upbringing, 265; sings and drums with Jubilee Hummingbirds, 265; plays with Daniel and Joseph Burnside, 265; meets R. L. Burnside, 265; R. L. Burnside and the Sound Machine, 265; meets David Evans, 265; Sound Machine records at High Water, 265, 333n5; tours in Europe with Evans, 265–66; banter with Jessie Mae Hemphill on tour, 266; plays with R. L. Burnside, 266; remarks on R. L. Burnside's style and influences, 266; plays with Junior Kimbrough, 266; remarks on Kimbrough's style, 266; plays with George Scales, 269; lives with R. L. and Alice Burnside, 269; marries Linda Burnside, 269; teaches drums to son, Cedric, 269

James, Elmore, 36, 95–96, 163, 179, 181

James, Michael, "Dr. Mike," 134

Jefferies, Whitney Simone (granddaughter of Otha Turner), **249**

Jefferson, Blind Lemon, 152, 224, 226, 231, 272

"Jelly Roll King" (Frank Frost), 79

Jelly Roll Kings, 98, 116, 133

Jelly Roll Kings, The (Sam Carr and Frank Frost), 83

"Jew Town" (Maxwell Street, Chicago), 36, 314n13

Johnny D's (Somerville, Massachusetts), xvi, **209**

Johnson, Bertha (Luther Johnson's sister), 53

Johnson, Big Jack, 74, **78, 114,** 116; joins Little Sam Carr and the Blues Kings, 79, 80; remembered by Michael Frank, 98; owner, Black Fox club, Clarksdale, 98, 115

Johnson, Daisy (Daisy Hardy, Luther Johnson's sister), 45, 48–49, 53

Johnson, James, "Super Chikan," **108, 110, 119, 120, 123**; interview, 109–22; family background, 109; Big Jack Johnson is uncle, i.e., brother of James's mother, 109; raised by grandmother "Pearl," 109; porch party music, grandfather Ellis Johnson a fiddler, 109, 111; diddley bow, 111; domestic violence, grandfather killed by grandmother, 111; cotton picking, 111; corporeal punishment, "whuppins" by grandmother, 112; religious upbringing, 112; immersion baptism, 112; tubs for bathing, 112; schooling, 113; white women, warned to avoid, 113; Emmett Till, reaction to murder of, 113; Freedom Riders, 113, 321n2; buys first guitar, 115; marries Ollie Myles, 115; driving taxi in Clarkdale, 115; nicknamed "Super Chicken," 115; admiration for his uncle, Big Jack Johnson, 116; plays with Big Jack, Sam Carr, and Frank Frost, 116; Jelly Roll Kings remembered, 116; forms band, the Funk Thumpers, 118, 321n7; promotes disco band, Klazzy, 118; Super Chikan and the Fighting Cocks, 121; origin of Fighting Cocks name, 121; Bobby Rush, advice on songwriting from, 121; regular gig at the Crossroads, Clarksdale, 121; performs with daughter, Jameisa Turner, 121; Fighting Cocks becomes all-female band, 121; records for Rooster and Fat Possum labels, 121; Notodden Blues Festival (Norway), 121, 321n10, 322n11; makes custom guitars ("gas can guitars," "Chikantars") from found materials, 122; international travels, 121–22; records *Chikadelic* with Norwegian blues band, Spoonful of Blues, 121, 322n11; performances at Library of Congress and Kennedy Center, 122, 322n12; Senegal trip, 122, 322n13; homage to elder bluesmen, 122

Johnson, Jimmy, 57

Johnson, Johnnie, 60

Johnson, Luther, "Guitar Junior," xvii, xx, 21–22, **44, 47, 52, 55, 58, 60, 62**; interview, 45–64; family background, 45; supplemental hunting and fishing, 45; schooling, 45; childhood labor, 45–46; segregation, early experience of, 46; racial pride instilled, 46; religious upbringing, 46; leads church choir, 46; form gospel group, Spirit of Minter City, 46; music in home, 46; influence of radio, 46; Minter City, Mississippi, description of, 46–47; Arthur Johnson, uncle, influence and exemplar, 47–48; Saturday night fish fries, 47; "Don't Your Peaches Look Mellow Hanging Way Up in Top of Your Tree," 47, 315n8; first guitar, 48; makes diddley bow, 48; electric guitar, first exposure to, 48; WDAI Goodwill Revue, 48, 315nn12–13; Muddy Waters visits Forty Mile Bend, 48, 315n15; Chicago, dreams of, 48; first visit to Chicago, 48; moves to Chicago, stays with sisters, 48; sings at Scotty & Darlene's Rock 'n Roll Inn, 48–49; first visits to West Side clubs, 49; meets Ray Scott, 49; joins Little Ray Scott and his Rock 'n Roll Band, 49; learns guitar from Ray Scott, 49; visits St. Louis, plays with Little Junior Robinson, 49; jams with Otis Rush and Magic Sam, 49; forms own band, Little Junior's Blues Band, 49; band personnel, 49; plays with Bobby Rush, 50, 315nn21–22; works at sister Bertha's restaurant, 53; guns, 53; joins Magic Sam, 53–54; West Side sound, 54; records first single, "I Been Down So Long," 54; nicknamed "Guitar Junior," 54, 315–16n25; friendship with Calvin Jones, 54; joins Muddy Waters' band, 54; first meets Willie Smith, 56; first meets Pinetop Perkins, 56; Luther's showmanship, Brian Bisesi on, 56; preparing food on tour, 56; gambling on tour, 56–57; travels world with Muddy Waters' band, 57; records for European label Black & Blue, 57, 316n37; appearances on Muddy Waters' albums, 57, 316n38; leaves Chicago, relocates to Boston, 57; stays with "Mama Rose" during transition to Boston, 57, 59; forms the Magic Rockers, 59, 316n43; agented by Paul Kahn (Concerted Efforts), 59; records *Doin' the Sugar Too*, first album with Magic Rockers, 59; wins Grammy for contribution to *Blues Explosion*, 59; records for St. Louis Pulsar label, 60, 317n48; wins Handy award for Best Blues Single of 1988 for "Woman Look What You're Doing to Me," 60; performs in *Blues Brothers* film, 60; plays Shanghai and Hong Kong, 61; Distinguished Achievement Award from University of Massachusetts Amherst, 61; records solo acoustic CD, *Won't Be Back No More*, 61; records final album, *Once in a Blue Moon*, 61; death of, 63; remembered by Margo Cooper, 63–64

Johnson, Margaret (Luther Johnson's sister), 45, 48, 53

Johnson, Robert, 68, 152, 224, 305, 329n23

Joined at the Hip (Willie Smith and Pinetop Perkins), 23, 27, 313n45

Jones, Calvin, "Fuzz," xvi, xx, **29, 41, 42**; interview, 28–43; family background, 28; made homeless by 1932 Tallahatchie River flood, 28, 313n3; relocation to

Inverness, 28; childhood labor, 28; boyhood friendship with son of plantation owner, 28, 313n4; schooling, 28, 30; segregation, early experience of, 30; moves to Wildwood Plantation, 30; Wildwood, description of, 30–31, 313n5; furnish system, 31, 313n6; gardening and animals, 31; hunting and fishing, 31; swimming, Tallahatchie River, 31; Money, Mississippi, description of, 31; memories of segregation, 31; lynchings, stories told by father, 31; thoughts on Emmett Till murder, 31; impact of Sonny Boy Williamson's "Blue Bird," 34, 313n9; hears King Biscuit Time radio, 34; makes diddley bow on side of house, 34; mother leaves for Chicago, 34; Calvin moves to Chicago, first impressions of city, 34; first musicians heard in Chicago clubs, 34; meets Muddy Waters, Little Walter, Jimmy Rogers, 36; rooms with Jimmy Rogers, 36; nicknamed "Fuzzy" and "Fuzz," 36; buys first guitar, learns from Homesick James, 36; meets Freddie King, 36; "sits in" with Elmore James, 36; acquires first bass, 36; organizes first band, Chicago Flames, 36; first gigs, 36; plays with Junior Wells, Sonny Boy Williamson (Rice Miller), J. B. Lenoir, 38; Little Walter, 38–39; joins Howlin' Wolf's band, 38–39; plays and records with Johnny Littlejohn, 40; plays with Fenton Robinson, 40; joins Muddy Waters band, 40, 314n20; gambling on tour with Muddy Waters band, 40; member of Legendary Blues Band, 40; Calvin as vocalist, 40, 43; death of, 43; remembered by Willie Smith, 43; bass style described by Bob Margolin and Jerry Portnoy, 43; style described by Michael "Mudcat" Ward, 314n24; remembered by Luther "Guitar Junior" Johnson, 56

Jones, Eva Jean, "Mama Jean," xxii, **106**

Jones, Lessie (mother of Calvin Jones), xx, xxii, 28, 34

Jones, Monroe, "Little Monroe," 159, **162**; with Robert "Bilbo" Walker, 95; buys first guitar, 163; moves to Chicago, 163; plays at Cotton Club, 163; plays two years with Earl Hooker, 163; return to Mississippi, 163; remembered by Bill Abel, 163

Jones, Paul, "Wine," 160, 172, 289, 300, **301**

Jordan, Louis, 7, 189, 230, 231, 233, 331n59

Jubilee Hummingbirds, 265, 333n4

"Juke" (Little Walter and the Nightcaps), 8, 11

Junior Kimbrough's Juke Joint (Chulahoma, Mississippi), 282, 283, 286, 299–300, 334nn5–6

"Just Like a Rabbit." *See* "Rabbit Blues"

Kahn, Paul (agent, Concerted Efforts), 59

Kansas City Red (Arthur Lee Stevenson), 71, 318n14

Kemp, Willie James (also Willie Kemp, James Kemp), **85**, 92, **93**, 94, 320nn16–18

Kennedy Brothers, photos of, xxii, 232

Kent, Willie, 49, 54, 57

KFFA radio (Helena, Arkansas): Muddy Waters show, 6; Robert Nighthawk show, 69, 318n10; Nighthawk returns to, 80; Sonny Boy Williamson on, 74, 153; Sonny Boy Williamson II returns to, 79

Kimbrough, Junior, 266, 269, 300; Junior Kimbrough and the Soul Blues Boys, 269, 282, 286, 273, 277, 278, 333n14; style described by Cedric Burnside, 299

King, B.B., xxviii, 48; playing for tips in Sunflower, 153; on radio in Greenwood, 153, 323n11; Eddie Cusic meets, 178; Homecoming Festival, Indianola, 192; plays Club Ebony, 192; purchases Club Ebony, 192, **193**; with Lil' Bill Wallace, 194, 197; Mickey Rogers meets at Regal Theater, 208; Mickey Rogers plays with, 210

King, Freddie, 36, 53

King, Martin Luther, Jr., xxii, 16, 201, 243

King, Willie, **238**; interview, 239; jukes at grandmother's house, 239; Duck Brothers, "Brook" Duck, 239; segregation in Macon, Mississippi, 239; Black Prairie Blues marker in Macon, 239, 332n2; mission of his music, 239; Willie King and the Liberators, meaning, 239

King Biscuit Blues Festival, **vii**, xxiv, **xxxi**, **26**, 27, **75**, **81**, 83, **88**, 103, **133**, **241**, **276**, **279**

King Biscuit Boys (King Biscuit Entertainers), 87, 153, 324n13

King Biscuit radio show, 6, 34, 46, 74, 79, 80, 87

Kinloch Plantation (Sunflower County, Mississippi), Eddie Cusic, 174, 178, 325n6

Kinsey, "Big Daddy," xvi, **41**

KKK. *See* Ku Klux Klan

Kline Plantation (Coahoma County, Mississippi), 84, 319n1

Ku Klux Klan, 4, 16, 84, 166

KWEM radio (West Memphis, Arkansas), 6, 311n13

Lambrook Plantation (Phillips County, Arkansas), 4, 311n7

Land Where the Blues Began, The (Lomax), 332n7

Latisha (Latisha Gardiner, daughter of R. L. Boyce), xxii, **xxvi**

lay-by, lay-by time, 223, 260, 328n12

Legendary Blues Band, 21 22, 25, 40, 57, 313nn39–42, 316n40

Legends (Chicago night club). *See* Buddy Guy's Legends

Lenoir, J. B., 38

Lewis, Shirley, xxvii, xxviii, **xxix**, xxxii

Life of Ease (Legendary Blues Band), 21

"Listen, Mr. Bilbo" (Woody Guthrie), 320n4

Littlejohn, Johnny, 40

Little Milton (James Milton Campbell, Jr.), 179n10, **180**, 181, 192, 201, 202, 206, 323n7, 325n10; first performer at Club Ebony, 192

Little Sam Carr and the Blues Kings, 74, 77

Little Walter (Marian Walter Jacobs), 8, 11, 36, 38–39

Live at Mr. Kelly's (Muddy Waters), 40

Living Blues magazine, xxvi; Margo Cooper's oral histories listed, 311nn1–7; Jim O'Neal, founder of, 100; *The Voice of the Blues: Classic Interviews from Living Blues Magazine* (O'Neal and van Singel), 318n13, 319n40, 325n10

Lockwood, Robert Junior, xvii, 6, 153, **154**; on radio KFFA, 318n10, 324n14

Lomax, Alan, 260, 332n7

Lomax, John, 329n21

Long Ways from Home (L. C. Ulmer), 237

Lott's Furniture Company, 225, 227, 228, 330nn39–41

Luther's Blues (Luther Johnson Jr.), 57, 316n37

Lynching in America: Confronting the Legacy of Racial Terror (Equal Justice Initiative). *See* lynchings

lynchings, 4, 31, 115, 137, 181, 233, 234, 273, 275, 311n8, 313n8, 321n3, 326n14, 331nn65–66, 333n9, 334nn10–11; number of, Leflore County, 313n8; statistics compiled by Equal Justice Initiative (EJI): Jasper and surrounding counties, 328n10; Marshall County, 334n14; Scott County, 324n5; Tallahatchie and Quitman counties, 321n3; Tunica County, 311n8; Washington County, 326n14

Ma Bea's Lounge (Chicago), 57, 316 n34

Ma Bea's Rock (Jimmy Johnson and Luther Johnson Jr.), 57

Madison Street clubs (Chicago), 34

"Magic Rocker" (Sam Maghett), 316n43

Magic Rockers, 57, 61, 63; original personnel, 59, 316n43; origin of name, 59, 316n43

Magic Sam (Sam Maghett): remembered by Ray Scott, 49; remembered by Luther "Guitar Junior" Johnson, 53–54

"Mama, He Treats Your Daughter Mean" (Ruth Brown), xxx

"Mama Jean." *See* Jones, Eva Jean

"Mama Rose" (Rosie Lee Hooks), 57, 59, 316n42

Mann, Michael, "Hollywood Fats," 21, 40

Margolin, Bob, 27, 40, 54; on Willie Smith's drumming style, 12, 312n24; replaces Sammy Lawhorn in Muddy Waters' band, 21; 1993 reunion of Muddy Waters band personnel, 22; on Kenny "Beedy Eyes" Smith, 22, 313n44; on Calvin Jones, 43; on Luther "Guitar Junior" Johnson, 56, 63; goes on own after break-up of Muddy Waters' band, 57, 316n40

"Match Box Blues" (Blind Lemon Jefferson), 226

Maxwell, David, xvi–xvii, **xviii**, xix

Maxwell Street (Chicago): Calvin Jones observing musicians on, 36; Little Walter plays on, 36, 314n14; *Blues Brothers* movie, opening scene, 60; Robert "Bilbo" Walker sings on, 94–95; Mickey Rogers styles clothes on, 210; L. C. Ulmer plays on, 234

Mayweather, "Earring George," xvii, 34, **35**, 36

McCollum, Earlie B. (wife of Robert Nighthawk), 74, 318n17

McCollum, Robert. *See* Nighthawk, Robert

McDowell, Fred, 260, 266, 275, 281, 297, 332n7; R. L. Burnside's style compared to, 282; Jessie Mae Hemphill's style compared to, 302

MCM (French blues label), 57, 316n33

"Meat Shakin' Woman" (Blind Boy Fuller), 227, 329n32

"Mellow Chick Swing"/"G.M.&O. Blues" (John Lee "Sonny Boy" Williams), 11

Melody King guitar, 224

"Messin' with the Kid" (Buddy Guy & Junior Wells), xvi, xx

M for Mississippi (documentary film), 237

middle buster (cotton plow), 165, 174

Mighty Clouds of Joy, the, 7

Mighty Mississippi Music Festival (Greenville, Mississippi), **123**, **150**, **158**, **191**, **229**, **236**, 237, **303**

"Milkcow's Calf Blues" (Robert Johnson), 152

"Milky White Way" (Lander Coleman), 333n6

Miller Theater (Helena, Arkansas), 6

Minter City (LeFlore County, Mississippi), 45–46, 48, 155–56

Mississippi Hill Country Blues, 1967 (Mitchell), 332n5, 334n2

Mississippi Slim (Walter Horn Jr.), **199**, **200**; interview, 198–202; schooling, 198; abandonment by father, 198; mother and children move to Greenville, 198; segregation in Greenville, early 1950s, 198, 201; childhood labor as water boy, teen work as shoe shine boy, dishwasher, 198; Martin Luther King, 201; religious background, 201; church singing, 201; cotton, chopping and picking, 201; street singing, doo-wop and blues, 201nn3–5; Nelson Street, Greenville, described, 201–2; Seeburg music, 201; sings with Eddie Shaw's band, 202; Mamie Galore remembered, 202, 327n6; LeRoy Grayson's juke, 202; Rexburg, 202; Booba Barnes, remembered, 202; death of, 202; remembered by John Horton, 202

Mitchell, George, 80, 319nn38–39, 332n5

Money, Mississippi, 28, 30–31, 34, **138**

Money Talks (Legendary Blues Band), 22, 25

Montreux Jazz Festival, 56, 59

Moon Lake, **xi**, xxiv, 4, 69, 73, 116; Conway Twitty's Club on, 79; immersion baptism in, 89, **90**, **104**, **105**

Morgantini, Marcelle (MCM label), 316n33

Mother's Best Flour, 69, 74

Mound Bayou (Bolivar County, Mississippi), 89, 145, 198

Mr. Kelly's (Chicago), 40, 314n21

Muddy Mississippi Waters Live (Muddy Waters), 57, 316nn38–39

Muddy Waters (McKinley Morganfield), **62**; on radio KFFA, 6; 1953 band personnel, 7; "junior band," 14; 1961 band personnel, 14; "Muddy Waters Drive," Chicago, 14, 312n27; reputation in Black community, 16; 1969 band personnel, 19; gambling on tour, 21; car accident, 21; 1970–1980 band personnel, 21, 40, 313n38; plays Jimmy Carter White House, 21; Grammy Awards, 21, 313n37; 1980 breakup of band, 21, 57; reunion of 1974–1980 band members in Boston, 22; remembered by Kenny Smith, 25; Calvin Jones replaces Sonny Wimberly, joins band, 40; *Live at Mr. Kelly's*, 40, 314n20; Luther "Guitar Junior" Johnson

342 INDEX

replaces Hollywood Fats, joins band, 54; 1973 band personnel, 54; life on the road, remembered by Luther "Guitar Junior" Johnson, 56
Muddy Waters All-Stars, **41**
Muddy Waters Sings Big Bill (Muddy Waters), 14, 312n25
Muddy Waters Tribute Band, xx, 22, 61
Must Be Jelly (Jelly Roll All-Stars), 83
"My Babe" (Little Walter), 265

Nelson, David, xxii
Nelson Street (Greenville, Mississippi), 168, 171–72, 201–2, **211**, 213, 325n10 (T-Model Ford)
Nighthawk, Robert (Robert McCollum, Robert McCoy), xxiv, 6; sits in with Muddy Waters band at Pepper's Lounge, 14; plays jukes near Minter City, 48; father of Sam Carr, 67–69; KFFA radio show for Mother's Best Flour, 69, 318n10; in Chicago, mid-1960s "blues revival," 80; appears in documentary *And This Is Free*, 80; interviewed by Michael Bloomfield, 80; plays with Sam Carr and Frank Frost, 80, 319nn32–33; last recordings, 80, 319nn38–39; death of, 80
Nolden, "Cadillac John," xxvi, **150, 157, 158**; interview, 151–59; parents, 151; raising chickens, 151; works as water boy in cotton fields, 151; supplemental hunting, 151; schooling, 151; ploughing with mules, 152; earliest musical influences, 152; wind-up Gramophone, 152; influence of neighbor, Charley Booker, 152; forms gospel group, the Four Nolden Brothers, 152–53; sings gospel and blues on streets of Sunflower, Mississippi, 153; meets B.B. King, 153; performing on radio WGRM (Greenwood, Mississippi), 153; inspired by Sonny Boy Williamson and King Biscuit Boys, 153; sees Sonny Boy Williamson live in Sunflower, 153, 324n13; marriage to Sarah (née Williams), 153; break up of Nolden Brothers gospel group, 153; forms new group, the Four Stars, 153–55; with Eddie Davis, 155; Preacher Moon, 155–56; attempted lynching of John, 156; abandoned by wife, Sarah, 156; finds solace in blues, learns harmonica, 156; remarries (Luveda Griffin), 156; with Euzelia Kizart, 159, 324n22; nicknamed "Cadillac," 159; forms band, "Cadillac John," 159; plays with Monroe Jones, 159; meets guitarist Bill Abel, 159; records *Crazy About You* with Bill Abel, 159
North Mississippi Hill Country Picnic (Waterford, Mississippi), **280, 284**, 285
Notodden Blues Festival (Norway), 121, 321n10, 322n11

Obama, Barack, election of, xxvii
Ole Miss, 14–15
Once in a Blue Moon (Luther "Guitar Junior" Johnson), 61
O'Neal, Jim, 100, 121, 314n19, 318n13, 325n10, 332n1
Oscher, Paul, xvi, 16, 19, 40, **41**
Otha Turner Picnic. *See* Turner, Otha

Paden, Red (owner of Reds, Clarksdale, Mississippi), **308**
"Peach Tree Blues" (Yank Rachell), 315n8
Peoples, Ann, owner, Ann People's Club, Anne's Lounge (Chicago), 36, 234
Pepper's Lounge (Chicago), 14, 40, 312nn26–27
Perkins, Joe Willie, "Pinetop," xvi–xvii, **xviii**, xix, 6, **20**, 21, 22; oldest recipient of Grammy, 23; death of, 23; remembered by Kenny Smith, 27; on King Biscuit radio, 34, 40, **41**, 54, 56; as guitar player, 71; with Robert Nighthawk's band, 71, 318n13; *Boogie Woogie King*, 316n37
Phillips, Sam, 79
Phillips County (Arkansas), 2, 4
Phillips International (record label), 79
Phillips Street (Helena, Arkansas): description of, 6; cafes and clubs, 6
picnics, fife and drum, xxii, Abe "Keg" Young, 260, 261, 332n5; Calvin Jackson, 263; Kenny Brown, 281–82, 285; Garry Burnside, 289
"Pinetop Boogie Woogie" (Pinetop Smith), 231, 331n55
Po' Monkey's (Merigold, Mississippi), **xiii**, **xv**
Portnoy, Jerry, 21; on Calvin Jones as gambler, 40; on Calvin Jones's bass style, 43, 54; producer, *Life of Ease*, 313n39; with Legendary Blues Band, 316n40
Pratcher, Bernice Turner (daughter of Otha Turner), xxii, **xxiv**
Presley, Elvis, 12, 129, 322n2
Prime Time Blues (Legendary Blues Band), 21
Promised Land (Robert "Bilbo" Walker), 100

"Rabbit Blues" (Charley Booker), 152, 323n6
Rabbit's Foot Minstrel Show, 89, 320n10
Ramsey, Harvey, "Red," **250**
Randle, Alex, "Easy Baby," 12, **13**
Red's (Clarksdale), **99**
Red Ruby's Lounge. *See* Ruby's Nite Spot
Regal Theater (Chicago), 208, 210, 327n2
Rexburg (Club Rexburg) (Washington County, Mississippi), 182, 202, 210, 326n16
Robinson, Fenton, 40
"Rocket 88" (Ike Turner), 115, 321n6
Rockin' the Juke Joint Down (Jelly Roll Kings), 116, 319n43
"Rock Me Mamma" (Arthur "Big Boy" Crudup), 5, 311n10
Rogers, Jimmy, 7, 36, **37**, **41**, 48
Rogers, Mickey, **204, 207, 212**; interview, 205–15; family background, 205; childhood in Chicago and Mississippi, 205; Bourbon Plantation, 205; makes diddley bow, 205; first guitar, 205; questions about killing of Emmett Till, 205–6; sneaks in Ruby's Nite Spot, sees Eddie Cusic, Little Milton, Son Thomas, live, 206; meets Tyrone Davis, 206; forbidden to associate with white girl, 206; return to Chicago, West Side, 208; Baptist religious upbringing, 208; plays piano and sings in church, 208; Uncle Robert, DJ for WVON, 208; access

to uncle's record collection, 208; learns bass guitar from uncle, 208; forms group, the Shades, 208; meets Howlin' Wolf and Hubert Sumlin, 208; learns lead guitar from Hubert Sumlin, 208; plays with Wolf and Hubert at Silvio's, 208; meets B.B. King ca. 1958 at Regal Theater, 208, 210; talent shows with the Shades, 210; forms doo-wop group, the Radiants, 210; Radiants record "Shy Guy" for Chess, 210; plays with the Chi-Lites, 210; revisits Mississippi, 210; plays with Eddie Shaw at Ruby's Nite Spot, 210; tours with Ike and Tina Turner, 212; meets Jimi Hendrix, 212; performs with Otis Clay, 213; moves to Detroit, 213; tours with Marvin Gaye and Temptations, 213; returns to Chicago, meets Bobby Rush, 213; return to Mississippi, 1980s, plays with Bobby Rush, 213; plays with Willie Foster, 213; death of Willie Foster, 213; forms Mickey Rogers and the Soul Blues Band, 215

Rooster Blues Records, 100, 121

Rosenwald schools, 86 n7, 137

Roy, Earnest, "Guitar," Jr., 131, **132**, 322n12

Roy, Earnest, "Guitar," Sr., 130–31, 133, 134, 322n12

"Roy Rogers Special" guitar, 48n9

Ruby's Nite Spot (Washington County, Mississippi), 181, 182, 189, 206, 210–11, 212, 323n7, 326n15

Rum Boogie (Washington County, Mississippi), 179, 181–82, 210, 212

Rush, Bobby, xxii, **xxv**, 49, 50, **50**, 61, 121, 213

Rush, Otis, 34, 49, **60**, 61

Ryder's Plantation (Phillips County, Arkansas), 2

Rynborn, the (Antrim, New Hampshire), xvii, **51**

Sad Days, Lonely Nights (Junior Kimbrough), 283, 334n9

Sain, Oliver, 60, 317n48

Saturday night fish fries, 47, 224, 277

"Saturday Night Fish Fry" (Louis Jordan), 7

Sawdust Trail, the (Chicago), 8

Scales, George, 269, 272, **274**, 277, 278, 333n12

Scott, Ray (Walter Spriggs), "Scottie," 39, 49

Scotty & Darlene's Rock 'n Roll Inn (Chicago), 48–49, 53

Seeburg (juke box): Willie Smith, 5, 6, 7; Calvin Jones, 34; Luther "Guitar Junior" Johnson, 46; Sam Carr, 68; Robert "Bilbo" Walker, 89; "Cadillac John" Nolden, 152; T-Model Ford, 168; Eddie Cusic, 178, 181; "Mississippi Slim," 201

"See That My Grave Is Kept Clean" (Blind Lemon Jefferson), 329n24

708, the (Chicago), 7, 36, 40

Shaw, Eddie, xx, 49, **51**, 61, 202, 210

Shepard, Mary: interview, 192; background of Club Ebony, 192; Mary and husband assume ownership of Club Ebony, 192; Little Milton, performs at club opening, 192; first B.B. King Homecoming Festival, 192; club purchased by B.B. King, 192

Sherrod, Anthony, "Switchblade," **133**, 134

Shields, Lonnie, 81, **81**

Showah, Justin, 234, 237

Shower, "Little Hudson," 12, 56

"shuffle drumming," "shuffle beat," 12, 133, 312n23

Silvio's (Chicago), 7–8, 36, 208

"Sky Is Crying, The" (Elmore James), 95

Smith, Kenny, "Beedy Eyes," xx, **24**, **26**; interview, 25–27

Smith, Lizzie Mae (mother of Willie Smith), *Born in Arkansas* dedicated to, 25

Smith, Willie, "Big Eyes," **3**, **17**, **18**, **24**, **41**; interview, 2–23; family background, 2; religious upbringing, 2; schooling, 4; racial discrimination, early experience of, 4; moves to Wooten-Epes Farm, 4; childhood labor, 5; picking cotton, 5; gardening and animals, 5; hunting and fishing, 5; segregation, Helena, Arkansas, 6; influence of radio, 6, 22; meets Sonny Boy Williamson (Rice Miller), 6; the "Devil's Music," 7; teenage choir, 7; arrival in Chicago, 7; first sees Muddy Waters live, 7; meets "Little Walter," 8; learns harmonica, 8; joins first band, Bobby Lee and the Rockers, 8; first gig at "the 1145," 8; meets Bo Diddley, 8; plays with Arthur "Big Boy" Spires, 8; records with Bo Diddley, 12; "Little Willie" nickname, 12; meets Little Hudson Shower, joins Red Devil Trio, 12; transition to drums, 12; Bob Margolin, on Willie's style, 12, 312n24; meets Muddy Waters, records with and joins band, 14; tours South, plays Ole Miss, 14; attends Emmett Till's viewing, 15–16; stops touring with Muddy Waters band, 1964–1969, 19; rejoins Muddy Waters band, 19; "Big Eyes" nickname, 19; as "leader" of Muddy Waters band, 21; with Arthur "Big Boy" Crudup, 21; with Legendary Blues Band, 21–22; transition from drums to harmonica, 22; collaboration with son, Kenny, 22–23; death of Pinetop Perkins, 23; remembering relationship with Calvin Jones, 43

Smitty's Corner (Chicago), 14

Smythe Deadening Plantation, 177, 325n5

Soul Stirrers, the, 94

Spanish tuning, 189, 226, 275, 329n28

Spann, Otis, 7, 14, 19, 21, 48, 315n15, 318n25

Spires, Arthur, "Big Boy," 8, 242

Spires, Bud (Benjamin Spires), **243**; interview, 242; Big Boy Spires (father), 242; Jack Owens, 242

Spoonful of Blues (Norwegian blues band), 121, 321n10, 322n11

Stables, the (East Lansing, Michigan), 54

Stackhouse, Houston, 6, 71, 80

Stella guitar, 48

Stewart, Joshua, "Razorblade," 121, **125**, **126**, **128**, **135**; interview, 124–34; family background, 124; raised by grandparents, 124; meets father in Chicago after military service, 124; corporeal punishment, "whuppins" by grandmother, 124, 129; supplemental hunting and fishing, 127; gardening, 127; raising chickens

and hogs, 127; cotton chopping and picking, 127; annual post-harvest clothes and shoe buying, 127; segregated school, 127; Baptist religious upbringing, named after Joshua of the Old Testament, 127; influence of radio, WHBQ (Memphis), WROX (Clarksdale), Early Wright, 129; Jonestown, description of, 129; Coahoma Agricultural High School, 129; musical education, 129; high school band, 129; trombone primary instrument, 129; move to Clarksdale, 130; Clarksdale juke joints, descriptions of, 130; meets Earnest Roy, Sr., 130, 131; drafted into US Army, 130; sent to Vietnam with 173rd Airborne Brigade, 130, 322n8; combat experience, 130–31; return to US post-Vietnam, alcoholism, PTSD, 131; segregation in 1970s Clarksdale, 131; joins Clarksdale police force, 131; plays with Jesse Gresham Plus Three, 131, 322nn9–11; meets James "Super Chikan" Johnson, 133; original member, Super Chikan and the Fighting Cocks, 134; nicknamed "Razorblade," 134; teaches blues at Sarah's Kitchen, Clarksdale, 134; forms student band "the Deep Cuts," 134; sings in church choir, 134; plays Ground Zero, 134; records *Joshua Razorblade Stewart Live at Ground Zero*, 134; festivals, 134; death of, 134

Strickland, Napolian (also Napoleon, Napoloan), 260, **261**; remembered by Abe Young, 260; remembered by Calvin Jackson, 263, 265

Strong, Henry, "Pot," 7, 312n17

Sumlin, Hubert, 27, **39**, 40, 208, **209**

Sunflower River Blues & Gospel Festival, **50**, 72, 78, 83, **97**, **114**, **117**, 179, **199**, 214, **292**

"Sunnyland Slim" (Albert Luandrew), 34

Super Chikan and the Fighting Cocks: band formed, 121; Handy Award nominee for Best New Artist Debut, 1998, 121; *Blues Come Home to Roost*, 121, 321n8

"Sweet Sixteen" (B.B. King), 95, 189

Tallahatchie River, 28, 31, 313n3

"Tallahatchie River Blues" (Mattie Delaney), 313n3

Tampa Red (Hudson Whittaker), 5, 6, 224, 231

Taylor, Robert Dudlow, "Dudlow," 6, 69, 153

"Terraplane Blues" (Robert Johnson), 68

Texas Red (film), 305, 334n4

"That's All Right" (Arthur Crudup), 34

"There'll Be Peace in the Valley for Me" (Thomas A. Dorsey), 92, 320n15

"This Little Light of Mine" (traditional), 201

Thomas, James, "Son," 182, 206, 240, 326n17, 326n19, 326n22

Thomas, Pat, **184**

Thomas, Robert, 74, 80, 319n34

Thomas, Shardé, xxii, **xxiv**, 249, 250, 253, **256**, 257, **288**, 289

"Through the Years I Keep on Toiling," 93. *See also* "When the Gates Swing Open"

Till, Emmett, 15; funeral in Chicago, 15–16, 312n28; mortuary in Tutwiler, Mississippi, **15**; Calvin Jones's reaction to killing of, 31; Black Bayou Bridge, body found near, **32–33**; James "Super Chikan" Johnson, questions about killing when boy, 113; Betty Vaughn attends funeral, 137; Mickey Rogers, questions about killing when boy, 205

Too Bad Jim (R. L. Burnside), 283

"Tramp" (Lowell Fulson), 269, 277, 334n15

"Travelin' Shoes" (traditional), 228, 330n44

Tree Top Slim (Willie Ealy), 73–74

tubs for bathing: "number three" tub, James "Super Chikan" Johnson, 112; Eddie Cusic, 176; L. C. Ulmer, 221, **222**

Turner, Ada (daughter of Otha Turner), **256**

Turner, Andrew, "Shine," **66**, 81, 83, **118**, 121

Turner, Bill (Aubrey), xxii, **248**, **250**, **256**

Turner, Ike, **88**, 89, 91; "Rocket 88," 115, 321n6

Turner, Ike and Tina, xxix, 192, 201, 212

Turner, Otha, xxii, **246–47**, **250**, 251, 252, 255, 277; remembered by Abe "Keg" Young, 260–61; remembered by Calvin Jackson, 263, 265; remembered by Kenny Brown, 282; remembered by Garry Burnside, 289; remembered by Cedric Burnside, 299

Ulmer, L. C., **218**, **225**, **229**, **232**, **235**, **236**; interview, 219–37; origin and meaning of "L. C." name, 219; family background, 219–20; corporeal punishment, "whuppins," 220–21, 225; cotton picking, 220; schooling, 220–21; racial harmony in Jasper County, 221, 223, 224, 233; Baptist upbringing, 220; woodcutting, "Masonite wood," 221; folk remedies, 222; community meat preparation, 222–23; "lay-by" time, 223; bells to mark deaths, 223; funerary practices, cooling board, 223, 328n15; family musicians, 223–24; "breakdowns," "Saturday night fish fries," 224; first guitar (Gene Autry), mother buys, 225; father teaches guitar, 226; learns Spanish tuning from cousin Charlie Lindsey, 226; gramophone, wind-up, 227; family acquires radio, 227; Grand Ole Opry, 227; influence of DeFord Bailey, 227, 330n36; Laurel, Mississippi, description of, 227; Front Street, Lott Furniture Company, 227–28; meets Roosevelt Graves, 227–28; family moves to Mossville, 228; Mossville, described, 228; forms band with Lloyd Boone, white neighbor, 228; performs on radio WMAL (Laurel), 228; tent-show movies, 230; meets Jack Crosby, 230; Laurel jukes, 230; railroad work during WWII, 230; learns railroad songs, 230, 330nn49–50; plays jukes around Laurel, songs performed, 231; travels to Holbrook, Arizona, works at Motoraunt Café, 231; returns to Mississippi, 231; marries Clennis Portericker, 231; moves to San Bernardino, California, 231; joins gospel group, sings blues in jukes, 231; Clennis, death in childbirth, 233; return to Mississippi, 233; sings gospel on WLOX-TV, 233, 331n62; forms group, the Bel Air Clowns, 233; segregation in Laurel, early sixties, 233–34; carries guns for self-defense, 233; lynching of Howard Wash, 233–34, 331nn65–66; execution of Willie McGee, 234, 331nn67–68; 1965 move to Illinois, 234; plays clubs in Joliet,

Illinois, 234; plays in Chicago, 234; 2001 return to Mississippi, 234; teaching music, 234; wins Mississippi Delta Regional Blues Challenge with student Chase Holifield, 234; as bandleader, 234, 332n72; festivals played, 237; meets Justin Showah, 237; records *Long Ways from Home* and *Blues Come Yonder*, 237; *Blues Come Yonder* reviewed, 237; last performances, recalled by Margo Cooper, 237; death of, 237

Vaughn, Betty, 124, **125**, **136**; interview, 137; segregated schooling, 137; Rosenwald school, 137; lynching in Jonestown, 137; moves to Chicago, 137; attends Emmett Till's funeral, 137; returns to Jonestown, 137; opens Betty's Café, 137
Veal, Richard, "the Nub Finger Man," 87
Venson, Tenner ("Playboy," "Coot"), 95, 97, 98, 321n25
Voice of the Blues, The (O'Neal and van Singel), 318n13, 325n10
Voices from the Mississippi Hill Country (DeBerry, et al.), 333n2, 333n9, 334n10

Walker, Robert, Jr., "Bilbo," xxvi–xxvii, **85**, **93**, **99**, **102**; interview, 84–103; parents and grandparents, 84; origin of "Bilbo" nickname, 84; parental alcoholism, effect on family, 86; picking cotton, 86; lack of education, 86; supplemental hunting, 86; influence of radio, 87; King Biscuit Boys, 87; earliest music making, piano, diddley bow, 88; home turned into a juke, 87–88; Alligator, description of town, 89; Clarksdale, description of, 89; segregated sections of town, 89; Ike Turner's Kings of Rhythm, 89, 91; hears Muddy Waters' "I Wish I Was a Catfish," 89, 320n13; Baptist churches, 91; baptism in Sunflower River, remembered, 91; becomes a young gospel singer, 91–93; called "Little Sam Cooke," 92–93; Hickory Grove Church and Hickory Grove Specials, 92–93; "Through the Years I Keep on Toiling" ("When the Gates Swing Open"), 92, 320n20; family moves to Waukegan, Illinois, 94; sings with Gospel Trumpets, 94; sings with Highway QCs, 94; sings on Maxwell Street, 94; forms band, Robert Walker and the Starlights, 95, 98; competition with Monroe Jones, 95; inspired by Chuck Berry, 95; promotes himself as "Chuck Berry Junior," 95, 97, 100; plays with Luther Allison and Eddie Campbell, 96–97; meets Big Jack Johnson, 98; meets Sam Carr and Frank Frost, 98; becomes one of Sam Carr's Blues Kings, 98; respect for country music, 100; forms band with David "Pecan" Porter and Rip Butler, 100; meets Jim O'Neal, 100; records first album, *Promised Land*, 100; with wife and daughters, **101**; final appearances in the Delta, 103; death of, 103
"Walkin' the Dog" (Rufus Thomas), 59
Wallace, Alex, "Lil' Bill," **196**; association with Eden Brent, 194; debilitating stroke, 194; friendship with B.B. King, 194, 197; Jesse Gresham trains with, 322n9; remembered by Billy Johnson, 327n1
Walnut Street Bait Shop (Greenville, Mississippi), 172, **177**, 194, 213
Walton, Eddie Mae, 83
Walton's Corner (Chicago), 49, 50, 213, 315n21

Ward, Michael, "Mudcat," 59, 61, 63, 316n43; on Calvin Jones's bass style, 314n24
Ward, Peter, 40, 312n24
Washington, Toni Lynn, xxx, **xxxi**, xxxii
Waters, Muddy. *See* Muddy Waters
WDAI radio (Memphis), 6, 48, 272
Wells, Ida B., 4, 311n6
Wells, Junior, xvi, **xxi**, 8, 12, 38, **38**, 54
West Side sound, 54, 56
WGRM radio (Greenwood, Mississippi), 153, 323n11
WHBQ radio (Memphis), 129, 322n2
Wheatstraw, Peetie (William Bunch), 231; "the Devil's Son-in-Law," 224, 329n24
"When I Lay My Burden Down" (traditional), 223, 329n18
"When the Gates Swing Open" (Thomas A. Dorsey), 320n20
"Which Way Do the Red River Run?" (Lead Belly), 224, 329n21
Wildwood Plantation (LeFlore County, Mississippi), 30, 31, 313nn5–6
Williams, Arthur Lee, **76**, 77, 79; harp style, 77, 318n26, 319n27; member, Jelly Roll All-Stars, 83
Williams, Irene, "Ma Rene," **144**, 145; interview, 145–47; childhood in Round Lake (Bolivar County, Mississippi), 145; runs Glass House blues club in Mound Bayou, twenty years, 145; runs Do Drop Inn, 145, **146**; Wesley Jefferson main band, 145; nicknamed "Ma Rene," 145; Shelby, Mississippi, description of, decline of, 147
Williamson, Sonny Boy, I (John Lee Williamson), 11, 34, 68
Williamson, Sonny Boy, II (Rice Miller), 6, 38; joins Little Sam Carr and the Blues Kings, 74nn21–22, 77; tours Europe with American Folk Blues Festival, 79; death of, 80; Sonny Boy and King Biscuit Boys (King Biscuit Entertainers), 153, 324n13
Willie King and the Liberators, 239
Wilmot Plantation (Washington County, Mississippi): Eddie Cusic, 174; Tyrone Davis, 206
Wilson, "Smokey," xvii, **188**, 189, 212, 327n2
Wimberley, Sonny, 40
WLAC radio (Nashville), 6, 231, 272, 331n56
WLOX-TV (Biloxi, Mississippi), *First Baptist* gospel show, 233, 331n62
WMAL radio (Laurel, Mississippi), 228
"Woman Look What You're Doing to Me" (Luther "Guitar Junior" Johnson), 60
Won't Be Back No More (Luther "Guitar Junior" Johnson), 61
Woodburn Plantation (Sunflower County, Mississippi), 178, 325n6
Woods, Johnny, 260, 281, 282, 286
Wooten-Epes Farm, 4, 71
Wrapped in My Baby (Spires), 8
Wright, Early, 129, 322n3
WROX radio (Clarksdale), 6, 7, 129
WVON radio (Chicago), "Voice of the Negro," 208, 327n1

"You Are My Sunshine," 111, 112, 321n1

Young, Abe, "Keg," **250**, **258**; interview, 259–61; family background, 259; cotton, chopping and picking, 259; father's fife and drum music, 259; Dick Tanksley band, 259; Rising Star Fife and Drum Band, 259; plays with Young Brothers, 260; L. P. Buford, fife and drum picnics, 260, 332n5; plays with father (Lonnie Young) on Alan Lomax field recordings, 260, 332n7; Fred McDowell, 260; plays with Napolian Strickland, 260; plays with Otha Turner, 260

Young Brothers (Lonnie and Ed), 263; recorded by Alan Lomax, 260, 332n7

You're Gonna Miss Me (When I'm Dead and Gone), Muddy Waters Tribute Band, xx, 22, 61

You See Me Laughin': The Last of the Hill Country Bluesmen (documentary film), 283, 334n11

Zanzibar, Club (Chicago), 7, 36, 314n16

About the Author

Margo Cooper is a photographer and oral historian working in the documentary tradition. She is a longtime contributing writer and photographer for *Living Blues* magazine. Some of the photographs from *Deep Inside the Blues* were previously published in the *New York Times Lens* blog. Her photographs have also been exhibited at the National Heritage Museum in Lexington, Massachusetts, the Thomas J. Dodd Research Center Gallery at the University of Connecticut, the Danforth Museum of Art, the Griffin Museum of Photography, the Lancaster Museum of Art, the Photographic Resource Center (Boston), the Arlington Center for the Arts, and the Soho Photo Gallery. Photo © Lisa Abitbol. All Rights Reserved.